The NEW ENCYCLOPEDIA *of* SOUTHERN CULTURE

VOLUME 23 : FOLK ART

Volumes to appear in

The New Encyclopedia of Southern Culture

are:

Agriculture and Industry Law and Politics

Art and Architecture Literature

Education Media

Environment Music

Ethnicity Myth, Manners, and Memory

Folk Art Race

Folklife Religion

Foodways Science and Medicine

Gender Social Class

Geography Sports and Recreation

History Urbanization

Language Violence

The NEW

ENCYCLOPEDIA *of* SOUTHERN CULTURE

CHARLES REAGAN WILSON General Editor

JAMES G. THOMAS JR. Managing Editor

ANN J. ABADIE Associate Editor

VOLUME 23

Folk Art

CAROL CROWN & CHERYL RIVERS

Volume Editors

Sponsored by

THE CENTER FOR THE STUDY OF SOUTHERN CULTURE

at the University of Mississippi

THE UNIVERSITY OF NORTH CAROLINA PRESS

Chapel Hill

This book was published with the generous assistance of
JOHN JERIT.

The Anniversary Endowment Fund
of the University of North Carolina Press provided
additional support for publication of this book.

Designed by Richard Hendel
Set in Minion types by Tseng Information Systems, Inc.
Manufactured in the United States of America
The paper in this book meets the guidelines for permanence and durability
of the Committee on Production Guidelines for Book Longevity of the
Council on Library Resources.
The University of North Carolina Press has been a member
of the Green Press Initiative since 2003.

Library of Congress Cataloging-in-Publication Data
Folk art / Carol Crown and Cheryl Rivers, volume editors.
p. cm. — (The new encyclopedia of Southern culture ; v. 23)
"Published with the assistance of John Jerit and of the Anniversary
Endowment Fund of the University of North Carolina Press."
"Sponsored by the Center for the Study of Southern Culture at the
University of Mississippi."
Includes bibliographical references and index.
ISBN 978-0-8078-3442-8 (alk. paper) —
ISBN 978-0-8078-7174-4 (pbk.: alk. paper)
1. Folk art—Southern States—Encyclopedias. 2. Outsider art—
Southern States—Encyclopedias. 3. Art, American—Southern
States—Encyclopedias. 4. Architecture—Southern States—
Encyclopedias. I. Crown, Carol. II. Rivers, Cheryl, 1949–.
III. University of Mississippi. Center for the Study of
Southern Culture. IV. Series.
F209 .N47 2006 vol. 23
[NK811]
975.003 s—dc22
2012473073

The *Encyclopedia of Southern Culture*, sponsored by the Center for
the Study of Southern Culture at the University of Mississippi, was
published by the University of North Carolina Press in 1989.

cloth 17 16 15 14 13 5 4 3 2 1
paper 17 16 15 14 13 5 4 3 2 1

Tell about the South. What's it like there.

What do they do there. Why do they live there.

Why do they live at all.

WILLIAM FAULKNER

Absalom, Absalom!

CONTENTS

In 1989 years of planning and hard work came to fruition when the University of North Carolina Press joined the Center for the Study of Southern Culture at the University of Mississippi to publish the *Encyclopedia of Southern Culture*. While all those involved in writing, reviewing, editing, and producing the volume believed it would be received as a vital contribution to our understanding of the American South, no one could have anticipated fully the widespread acclaim it would receive from reviewers and other commentators. But the *Encyclopedia* was indeed celebrated, not only by scholars but also by popular audiences with a deep, abiding interest in the region. At a time when some people talked of the "vanishing South," the book helped remind a national audience that the region was alive and well, and it has continued to shape national perceptions of the South through the work of its many users—journalists, scholars, teachers, students, and general readers.

As the introduction to the *Encyclopedia* noted, its conceptualization and organization reflected a cultural approach to the South. It highlighted such issues as the core zones and margins of southern culture, the boundaries where "the South" overlapped with other cultures, the role of history in contemporary culture, and the centrality of regional consciousness, symbolism, and mythology. By 1989 scholars had moved beyond the idea of cultures as real, tangible entities, viewing them instead as abstractions. The *Encyclopedia*'s editors and contributors thus included a full range of social indicators, trait groupings, literary concepts, and historical evidence typically used in regional studies, carefully working to address the distinctive and characteristic traits that made the American South a particular place. The introduction to the *Encyclopedia* concluded that the fundamental uniqueness of southern culture was reflected in the volume's composite portrait of the South. We asked contributors to consider aspects that were unique to the region but also those that suggested its internal diversity. The volume was not a reference book of southern history, which explained something of the design of entries. There were fewer essays on colonial and antebellum history than on the postbellum and modern periods, befitting our conception of the volume as one trying not only to chart the cultural landscape of the South but also to illuminate the contemporary era.

When C. Vann Woodward reviewed the *Encyclopedia* in the *New York Review of Books*, he concluded his review by noting "the continued liveliness of

interest in the South and its seeming inexhaustibility as a field of study." Research on the South, he wrote, furnishes "proof of the value of the *Encyclopedia* as a scholarly undertaking as well as suggesting future needs for revision or supplement to keep up with ongoing scholarship." The two decades since the publication of the *Encyclopedia of Southern Culture* have certainly suggested that Woodward was correct. The American South has undergone significant changes that make for a different context for the study of the region. The South has undergone social, economic, political, intellectual, and literary transformations, creating the need for a new edition of the *Encyclopedia* that will remain relevant to a changing region. Globalization has become a major issue, seen in the South through the appearance of Japanese automobile factories, Hispanic workers who have immigrated from Latin America or Cuba, and a new prominence for Asian and Middle Eastern religions that were hardly present in the 1980s South. The African American return migration to the South, which started in the 1970s, dramatically increased in the 1990s, as countless books simultaneously appeared asserting powerfully the claims of African Americans as formative influences on southern culture. Politically, southerners from both parties have played crucial leadership roles in national politics, and the Republican Party has dominated a near-solid South in national elections. Meanwhile, new forms of music, like hip-hop, have emerged with distinct southern expressions, and the term "dirty South" has taken on new musical meanings not thought of in 1989. New genres of writing by creative southerners, such as gay and lesbian literature and "white trash" writing, extend the southern literary tradition.

Meanwhile, as Woodward foresaw, scholars have continued their engagement with the history and culture of the South since the publication of the *Encyclopedia*, raising new scholarly issues and opening new areas of study. Historians have moved beyond their earlier preoccupation with social history to write new cultural history as well. They have used the categories of race, social class, and gender to illuminate the diversity of the South, rather than a unified "mind of the South." Previously underexplored areas within the field of southern historical studies, such as the colonial era, are now seen as formative periods of the region's character, with the South's positioning within a larger Atlantic world a productive new area of study. Cultural memory has become a major topic in the exploration of how the social construction of "the South" benefited some social groups and exploited others. Scholars in many disciplines have made the southern identity a major topic, and they have used a variety of methodologies to suggest what that identity has meant to different social groups. Literary critics have adapted cultural theories to the South and have

raised the issue of postsouthern literature to a major category of concern as well as exploring the links between the literature of the American South and that of the Caribbean. Anthropologists have used different theoretical formulations from literary critics, providing models for their fieldwork in southern communities. In the past 30 years anthropologists have set increasing numbers of their ethnographic studies in the South, with many of them now exploring topics specifically linked to southern cultural issues. Scholars now place the Native American story, from prehistory to the contemporary era, as a central part of southern history. Comparative and interdisciplinary approaches to the South have encouraged scholars to look at such issues as the borders and boundaries of the South, specific places and spaces with distinct identities within the American South, and the global and transnational Souths, linking the American South with many formerly colonial societies around the world.

The first edition of the *Encyclopedia of Southern Culture* anticipated many of these approaches and indeed stimulated the growth of Southern Studies as a distinct interdisciplinary field. The Center for the Study of Southern Culture has worked for more than three decades to encourage research and teaching about the American South. Its academic programs have produced graduates who have gone on to write interdisciplinary studies of the South, while others have staffed the cultural institutions of the region and in turn encouraged those institutions to document and present the South's culture to broad public audiences. The center's conferences and publications have continued its long tradition of promoting understanding of the history, literature, and music of the South, with new initiatives focused on southern foodways, the future of the South, and the global Souths, expressing the center's mission to bring the best current scholarship to broad public audiences. Its documentary studies projects build oral and visual archives, and the New Directions in Southern Studies book series, published by the University of North Carolina Press, offers an important venue for innovative scholarship.

Since the *Encyclopedia of Southern Culture* appeared, the field of Southern Studies has dramatically developed, with an extensive network now of academic and research institutions whose projects focus specifically on the interdisciplinary study of the South. The Center for the Study of the American South at the University of North Carolina at Chapel Hill, led by Director Jocelyn Neal and Associate Director and *Encyclopedia* coeditor William Ferris, publishes the lively journal *Southern Cultures* and is now at the organizational center of many other Southern Studies projects. The Institute for Southern Studies at the University of South Carolina, the Southern Intellectual History Circle, the Society for the Study of Southern Literature, the Southern Studies Forum of the Euro-

pean American Studies Association, Emory University's SouthernSpaces.org, and the South Atlantic Humanities Center (at the Virginia Foundation for the Humanities, the University of Virginia, and Virginia Polytechnic Institute and State University) express the recent expansion of interest in regional study.

Observers of the American South have had much to absorb, given the rapid pace of recent change. The institutional framework for studying the South is broader and deeper than ever, yet the relationship between the older verities of regional study and new realities remains unclear. Given the extent of changes in the American South and in Southern Studies since the publication of the *Encyclopedia of Southern Culture*, the need for a new edition of that work is clear. Therefore, the Center for the Study of Southern Culture has once again joined the University of North Carolina Press to produce *The New Encyclopedia of Southern Culture*. As readers of the original edition will quickly see, *The New Encyclopedia* follows many of the scholarly principles and editorial conventions established in the original, but with one key difference; rather than being published in a single hardback volume, *The New Encyclopedia* is presented in a series of shorter individual volumes that build on the 24 original subject categories used in the *Encyclopedia* and adapt them to new scholarly developments. Some earlier *Encyclopedia* categories have been reconceptualized in light of new academic interests. For example, the subject section originally titled "Women's Life" is reconceived as a new volume, *Gender*, and the original "Black Life" section is more broadly interpreted as a volume on race. These changes reflect new analytical concerns that place the study of women and blacks in broader cultural systems, reflecting the emergence of, among other topics, the study of male culture and of whiteness. Both volumes draw as well from the rich recent scholarship on women's life and black life. In addition, topics with some thematic coherence are combined in a volume, such as *Law and Politics* and *Agriculture and Industry*. One new topic, *Foodways*, is the basis of a separate volume, reflecting its new prominence in the interdisciplinary study of southern culture.

Numerous individual topical volumes together make up *The New Encyclopedia of Southern Culture* and extend the reach of the reference work to wider audiences. This approach should enhance the use of the *Encyclopedia* in academic courses and is intended to be convenient for readers with more focused interests within the larger context of southern culture. Readers will have handy access to one-volume, authoritative, and comprehensive scholarly treatments of the major areas of southern culture.

We have been fortunate that, in nearly all cases, subject consultants who offered crucial direction in shaping the topical sections for the original edi-

tion have agreed to join us in this new endeavor as volume editors. When new volume editors have been added, we have again looked for respected figures who can provide not only their own expertise but also strong networks of scholars to help develop relevant lists of topics and to serve as contributors in their areas. The reputations of all our volume editors as leading scholars in their areas encouraged the contributions of other scholars and added to *The New Encyclopedia*'s authority as a reference work.

The New Encyclopedia of Southern Culture builds on the strengths of articles in the original edition in several ways. For many existing articles, original authors agreed to update their contributions with new interpretations and theoretical perspectives, current statistics, new bibliographies, or simple factual developments that needed to be included. If the original contributor was unable to update an article, the editorial staff added new material or sent it to another scholar for assessment. In some cases, the general editor and volume editors selected a new contributor if an article seemed particularly dated and new work indicated the need for a fresh perspective. And importantly, where new developments have warranted treatment of topics not addressed in the original edition, volume editors have commissioned entirely new essays and articles that are published here for the first time.

The American South embodies a powerful historical and mythical presence, both a complex environmental and geographic landscape and a place of the imagination. Changes in the region's contemporary socioeconomic realities and new developments in scholarship have been incorporated in the conceptualization and approach of *The New Encyclopedia of Southern Culture*. Anthropologist Clifford Geertz has spoken of culture as context, and this encyclopedia looks at the American South as a complex place that has served as the context for cultural expression. This volume provides information and perspective on the diversity of cultures in a geographic and imaginative place with a long history and distinctive character.

The *Encyclopedia of Southern Culture* was produced through major grants from the Program for Research Tools and Reference Works of the National Endowment for the Humanities, the Ford Foundation, the Atlantic-Richfield Foundation, and the Mary Doyle Trust. We are grateful as well to the College of Liberal Arts at the University of Mississippi for support and to the individual donors to the Center for the Study of Southern Culture who have directly or indirectly supported work on *The New Encyclopedia of Southern Culture*. We thank the volume editors for their ideas in reimagining their subjects and the contributors of articles for their work in extending the usefulness of the book in new ways. We acknowledge the support and contributions of the faculty and

staff at the Center for the Study of Southern Culture. Finally, we want especially to honor the work of William Ferris and Mary Hart on the *Encyclopedia of Southern Culture*. Bill, the founding director of the Center for the Study of Southern Culture, was coeditor, and his good work recruiting authors, editing text, selecting images, and publicizing the volume among a wide network of people was, of course, invaluable. Despite the many changes in the new encyclopedia, Bill's influence remains. Mary "Sue" Hart was also an invaluable member of the original encyclopedia team, bringing the careful and precise eye of the librarian, and an iconoclastic spirit, to our work.

Folk art was not one of the original 24 categories in the *Encyclopedia of Southern Culture*. Eighteen articles in the Art and Folklife sections covered the topic, but since then an explosion of scholarship has made folk art a new focus of interdisciplinary work on the South. Much of that scholarship has been divided between colonial and 19th-century works and modern, 20th-century folk art, with the relationship between them unexplored. Much scholarship has been scattered through exhibition catalogs, specialized journals, and museum publications, with limited accessibility to broader audiences. This volume of *The New Encyclopedia of Southern Culture* comes out of a need for a comprehensive survey of folk art in its relationship to the context of the American South. Following the other volumes in the series, this one is organized around an overview essay, thematic articles, and shorter topical/biographical entries. The goal is to point readers interested in the South to an area of southern creativity that is often less known than other areas of regional culture and to explore its long history.

The overview essay is a substantial work in itself, one that sorts out definitional issues that are fraught ones in the study of American folk art in general. The essay evaluates the usefulness of such terms as "self-taught," "primitive," "parochial," "naive," and "outsider," but settles on "folk art" as the most useful descriptor. The overview delineates the process involved in the early 20th-century "invention" of American folk art as a distinctive aesthetic concern, traces how national observers ignored southern work, and discusses how the South itself undervalued its folk art traditions. The overview provides an interpretive framework for understanding the late 20th-century flowering of folk art in the region. Race, religion, rurality, the Civil War, the civil rights movement—all these familiar social-cultural categories enter into the story, but their relationships to folk art provide fresh perspectives on them. This regional context made folk art in the South an expression of a particular southern creativity.

This volume offers a sweeping panorama through 51 thematic articles and more than 200 shorter entries, providing access to a wide range of information that for the first time shows the historical and cultural connections among topics from pottery to paintings to prison art to schoolgirl samplers to weathervanes to calligraphy to roadside art. Ethnic traditions are explored through entries on Latino folk art, Moravian material culture, and Jewish ceremonial

and decorative arts. Attention to places within the South is seen in articles on Lowcountry baskets, Cajun and Creole folk art, Caribbean American folk art, and the distinctive furniture traditions in Texas. Prisons, yards, playgrounds, and museums offer particular settings for folk art to flourish, and they are explored herein. This volume is a contribution to the study of material culture in the South, with such entries as bottle trees, carved canes, face jugs, gravestones, quilts, rugs, toys, and trade signs. It also extends our understanding of the South's visual tradition, through extensive thematic and topical coverage of southern folk painting. The study of southern folk art is truly an interdisciplinary effort, with academic and nonacademic contributions. In this volume readers will meet artists themselves but also will read about art historians, folklorists, art collectors, gallery owners, agents, and key figures in defining the field, from Holger Cahill to Bill Arnett.

Folk and fine arts are closely and intimately related, and this volume has been planned in combination with the forthcoming *Art and Architecture* volume of *The New Encyclopedia*. The line between folk art and fine art is not always a clear one, though, and some artists included in this volume could easily fit in the other volume (a few actually do). Careful and informed judgments were made, in any event, in terms of inclusion of artists in this volume, reflecting existing scholarship that does not always show consensus. *The New Encyclopedia* project is more than one volume, in any event, and between these two volumes the editors hope to document the extensive achievements of the region's artistic traditions. Folk art represents a distinctive aspect of Southern Studies that will benefit readers who think about it in terms of its relationship to other aspects of southern culture.

The NEW ENCYCLOPEDIA *of* SOUTHERN CULTURE

VOLUME 23 : FOLK ART

FOLK ART OF THE
AMERICAN SOUTH

When readers of *The New Encyclopedia of Southern Culture* pick up the volumes called *Geography* or *History* or *Literature*, they can anticipate what kind of information they will find. The *Folk Art* volume, on the other hand, discusses art and artists whose connections to each other are far from obvious. Despite continuous proposals of alternate terms, including the more current "self-taught," "American folk art" remains the most common name for the art of ordinary people with little or no academic training in art. This umbrella term preserves a notion of lasting cultural significance—that "the unconventional side of the American tradition in the fine arts" somehow captures the very essence of national identity. Understanding "southern folk art" requires attention to the artistic nationalism embraced by historians, intellectuals, and artists during the first half of the 20th century, to the South's own regional patriotism, and to the South's complex relationship to national patterns.

The concept of folk art as expression of national identities did not originate in the United States but had its roots in 19th-century Europe. Although ordinary folk have always made art—in all places and in all times—the term "folk art" first appears in print in 1845. Even then the term was invested with political meaning. Writing to promote German nationalism, the author of an essay on German wood carving praised peasant art—*Volkskunst*—as being a holy art, "rooted in the soil of the fatherland." In 1894 Austrian art historian Alois Riegl's *Volkskunst, Hausfleiss und Hausindustrie* proposed folk art as both the expression of a cultural essence of a people and a preserver of regional and national identities during periods of social change.

Similarly, "folk art" entered the American vocabulary during a period of nationalistic fervor when American artists, many of whom had studied in Europe, were declaring their independence from the Old World. The artists, art dealers, and collectors of modern art who discovered American folk art during the 1910s and 1920s celebrated the power of art as an expression of national identity. In his 1910 essay entitled "The New York Independent Artists," Robert Henri, whose Ashcan School was already painting scenes of working-class life, expressed the populist tenor of the time: "There is only one reason for the development of art in America, and that is that the people of America learn the means of expressing themselves in their own time and in their own land. In this

1

country we have no need for art as a culture; no need of art as a refined and elegant performance; no need of art for poetry's sake, or any of these things for their own sake. What we do need is art that expresses the *spirit* of the people today."

Traditional American Folk Art. The writers, artists, art dealers, and collectors of modern art who "discovered" American folk art during the 1910s and 1920s embraced artistic nationalism, seized upon untrained artists as narrators of a homemade American identity, and claimed folk art as the native precedent for their own work. The abstraction of form, exaggeration, linearity, saturated blocks of color, limited palette, and immediacy that stemmed from folk artists' individual solutions to the challenges of representation paralleled modernist aesthetics; for the discoverers' quirky portraits of well-appointed gentlemen and prim New England ladies in outlandish headgear, improbably faux-grained furniture, bombastic ships' figure heads, exaggerated cigar-store figures, elegantly stylized decoys, earnest girlhood samplers, and other such work revealed the remarkable resourcefulness of folk artists who followed their own paths. This myth of the independent artist in a democratic society was, of course, a version of the myth of the self-made man whose self-reliance and self-discipline served himself, his family, and his nation.

Interpretations of American history that emphasize commonalities and gloss over conflict have been a mainstay of American thought. Every schoolchild learned that European settlers who arrived in search of liberty could easily become self-made men enjoying a "comfortable sufficiency." For the discoverers of folk art, New England folk portraits, surely the most common examples of 17th-, 18th-, and 19th-century folk art, became icons of American self-determination. The discoverers relished the self-taught artists' careful renderings of conventional signs of prosperity, such as jewelry, property, or dress, as well as their penetrating representations of character. They likewise admired self-taught artists' idealized landscapes of New England's cultivated fields and pleasant towns and embraced these and other New England creations as emblems of a simpler, bygone era free of war, economic insecurity, and social unrest.

During the first decades of the 20th century, a number of modernist artists became collectors and devotees of American folk art. Sculptor Elie Nadelman amassed a considerable collection of American folk art and in 1926 established a short-lived folk art museum on his property in Riverdale, in Bronx County, N.Y. Other modernists who sought out folk art were Charles Sheeler and Charles Demuth, whose own works include images of folk art and demonstrate their appreciation of folk art's spare renderings of the American scene.

Perhaps more significant in introducing folk art to the New York art world were artists Marsden Hartley, Bernard Karfiol, Yasuo Kuniyoshi, Robert Laurent, and William and Marguerite Zorach, who came under folk art's spell in Ogunquit, Me. There, collector and artist Hamilton Easter Field decorated cabins he rented to summering artists with inexpensive homemade objects and paintings he had picked up at auctions and in antique stores. Excited by reports from the modernist artists working in Ogunquit, Holger Cahill, a freelance journalist, publicist, and Newark Museum staff member, and Edith Gregor Halpert, a dealer of modern art, were also visitors. These two soon traveled back roads in pursuit of folk art treasures. Halpert, who represented many of the Ogunquit artists as well as Sheeler and Demuth at her Downtown Gallery in New York's Greenwich Village, established in 1931 the American Folk Art Gallery, the first commercial gallery dedicated to American folk art. Cahill, who served as Halpert's adviser, introduced folk ark to the museum world.

Cahill, who had served as the publicity director for Henri's Society of Independent Artists and who had visited open-air museums of folk culture in Sweden, Norway, and Germany, was an ideal advocate for American folk art. The catalogs that accompanied Cahill's three seminal exhibitions remain classics. The first two exhibitions, which Cahill organized for the Newark Museum, *American Primitives: An Exhibit of the Paintings of Nineteenth Century Folk Artists* (1930) and *American Folk Sculpture: The Work of Eighteenth and Nineteenth Century Craftsmen* (1931), adopt conventional fine art categories "painting" and "sculpture" and demonstrate Cahill's definition of folk art as "the unconventional side of the American tradition in the fine arts." For Cahill, American folk art could never be the equivalent of European folk art, defined as the community-based crafts or material culture of discrete peasant groups, each with its own shared ethnicity, religion, construction techniques, and decorative conventions. In American narratives, there were no peasants. In fact, only a few American groups have created folk art in the European sense, like the Moravians, who established their own communities in Pennsylvania and North Carolina, interrelated families of potters who developed distinct local styles passed on through generations, or groups like Alabama's Gee's Bend quilters, whose remarkable vocabulary of form resulted from geographic isolation. Emphasizing formal qualities over cultural context, Cahill excluded the utilitarian work of craftsmen—by which he meant the "makers of furniture, pottery, textiles, glass, and silverware"—but included the inventive, idiosyncratic creations of "the rare craftsman who is an artist by nature if not training." Cahill's so-called folk artists were not members of a well-defined community but ordinary Americans: tradesmen, farmers, schoolteachers, dance instructors, physicians,

housewives, middle-class schoolgirls, slaves and former slaves, sailors, and an assortment of others who made exceptional art.

Cahill was certainly aware that his novel, specifically American, definitions of folk art and folk artists were problematic. The titles of his first two catalogs label the creators both as "folk artists" and as "craftsmen." In the texts of those two catalogs Cahill employs almost interchangeably such terms as "primitive," "naive," and "folk." In the catalog to his third and final folk art exhibition, *American Folk Art: The Art of the Common Man, 1750–1900* (1932), Cahill, who had joined the staff of the Museum of Modern Art, speaks directly to difficulties of giving a single name to the diverse art made by American artists with little or no academic training: "The work of these men is folk art because it is the expression of the common people, made by them and intended for their use and enjoyment. It is not the expression of professional artists made for a small cultured class, and it has little to do with the fashionable art of its period."

"Folk art" became the most durable name for this art not only because Cahill was a fluent writer and well-known art world figure but also because Cahill and Edith Gregor Halpert had become advisers to Abby Aldrich Rockefeller. A founder of the Museum of Modern Art and a prominent collector of modern art, Rockefeller had begun collecting folk art during the 1920s. While Rockefeller valued the art's historical character, she was smitten, above all, by its aesthetic similarities to modernist art. Rockefeller's collection of more than 400 works, almost all from the Northeast, continues to exemplify the traditional art of the United States. The 173 artworks featured in Cahill's Museum of Modern Art 1932 exhibition *American Folk Art: Art of the Common Man, 1750–1900* came from Rockefeller's collection. Although the Museum of Modern Art's sponsorship of this exhibition might have seemed unlikely to some enthusiasts of modern art, the exhibition was a runaway success, appealing to both the art world and the casual museumgoer. It featured two- and three-dimensional works, toured to six additional venues between 1933 and 1934, and thus introduced the work and term "American folk art" to a wide audience. Rockefeller's subsequent 1939 donation of the bulk of her collection to Colonial Williamsburg resulted in further national recognition of folk art.

Cahill's argument for the term "American folk art" and its adoption by prominent members of New York's art world did not, however, enshrine the term. The urge to define folk art according to both aesthetic qualities and the artist's social status led inexorably to the continuing dispute. The "term warfare," as writer, editor, and collector Didi Barrett wittily named the continuing rancorous debates about terminology, began soon after Cahill's important publications.

The term "provincial painting" interprets American folk paintings as less polished versions of English paintings and draws attention to the artists' lack of mastery. This use of "provincial," implying that all colonists immigrated from England and that American artists followed the specific aesthetic norms of a school of English painters, is clearly incorrect. "Provincial" cannot describe all of the artists Cahill, Rockefeller, and others called "folk." The term "provincial," however, does have some limited use, as it correctly describes the training and practice of some important southern artists like José Francisco Xavier de Salazar y Mendoza, Louisiana's foremost painter during the Spanish colonial period, who arrived in New Orleans in 1782 from Mérida in Yucatán. Although details of Salazar's training are unknown, his portraits reveal his familiarity with Mexican provincial styles and Spanish painting conventions probably learned in Mexico, a Spanish province.

Unlike "provincial," the term "primitive" has become obsolete. The concept of "primitive art" emerged at the end of the 19th century as a label for all non-Western artistic traditions. Museums lumped together in single departments such subjects as Japanese, African, Oceanic, and Pre-Columbian art; some museums maintained this nomenclature and organization until the beginning of the 21st century, when recognition of the term's ethnocentricity and outdated notions of racial and cultural inferiority made the term unacceptable. Inevitably, "primitive" implies that the artist himself or herself is ignorant and that the art is defective; applied to American folk art, the term perpetuates the notion of deficiency.

"Naive" is another troublesome label. This term entered the modernist lexicon as a description of the idiosyncratic works of artists like Henri Rousseau, whose lack of academic training gives their attempts at naturalism a childlike quality. Like "primitive," "naive" is often an expression of racial, religious, and class bias. "Naive" has further connotations antithetic to genuine understanding of the art by self-taught artists: the association of "naive" with words like "cute" and "quaint" has allowed cynical makers of merchandise to reduce folk art to a style of décor.

The discovery of 20th-century self-taught artists during the 1960s and 1970s renewed term warfare. While many collectors, scholars, and museum professionals committed to traditional American folk art were happy to trace continuities between the newly discovered work and pre-20th-century genres such as quilts, weathervanes, and trade figures, other enthusiasts preferred to view the work of 20th-century self-taught artists in relationship to mainstream contemporary art. Museums, especially, bore the burden of redefining "folk art" or coming up with new terms for art created by 20th-century artists with little

or no formal training. Herbert W. Hemphill Jr., a founder and first curator of the Museum of American Folk Art, now the American Folk Art Museum, after much consideration settled on "contemporary folk art" because, like Holger Cahill, he felt that "folk art" was still the most recognizable name. Hemphill and Julia Weissman's 1974 *Twentieth-Century Folk Art and Artists* gave currency to the name. Robert Bishop, the Museum of American Folk Art's director from 1977 until 1991, followed suit when he included contemporary artists in his 1979 book *Folk Painters of America*.

Since the 1970s, members of the folk art world have proposed new labels. Some have advanced portmanteau names to replace the general term "folk art," while others have tried to formulate names for specific subgroups of artists or types of creation. "Visionary," an attempt to describe the remarkable individualism of artists unbound by academic convention, may also convey the impression that a visionary is given to wild enthusiasms or delusions. Although inappropriate for the field as a whole, the term "visionary" does recognize the religious or visionary experiences that artists, frequently southern artists, recall as the stimulus to their art making. Visionary may also describe artists who envision new worlds.

Rarely applied to traditional folk art, except in the case of "faux folk," is the especially pernicious term "outsider." An infelicitous translation of *art brut*, originally proposed as a label for the art made by artists whose mental states freed them from cultural art norms, "outsider" is now employed indiscriminately not only to describe the work of artists with atypical mental states or makers of highly individualistic art but also to describe the art of poor people, black people, children, and makers who simply choose to call themselves "outsiders" or produce materials for an "outsider" market. The pathology and otherness implied by "outsider" renders the term untenable.

On the other hand, "vernacular," a recent characterization of the work of black artists, is a precise and necessary term, as it acknowledges a distinctive visual vocabulary shared by African Americans. "Vernacular" confronts a once-dominant assumption that the experience of slavery erased connections to the religions, worldviews, and artistic cultures brought to America by those captured in Africa and enslaved in the Americas. Beginning in the 1920s, Melville J. Herskovits, the father of African American anthropology, undertook extensive fieldwork in Africa and the Americas and documented continuities of African cultures in the Americas in scholarly and popular magazines. This insight did not meet with wide acceptance until the 1960s and 1970s, when Africanists like art historian Robert Farris Thompson, with expertise in African art

and culture, further documented African philosophical and visual continuities in the New World. The "discovery" of living black folk artists in the South during the late 1960s and 1970s and the groundbreaking 1982 Corcoran Gallery of Art exhibition *Black Folk Art in America, 1930–1980* made African American and southern visual and cultural traditions a focus of national attention.

More recently, the two-volume *Souls Grown Deep*, published in 2000 and 2001, and edited by William Arnett and Paul Arnett, along with other books published by Tinwood Books, have provided access to critical evaluation and superb photographs of the work of 20th- and 21st-century African American artists of the American South, including African American artists who took southern culture with them as they migrated elsewhere. These publications have also drawn attention to 17th-, 18th-, and 19th-century African American pottery, textiles, and sculpture. Archaeologists excavating 17th-, 18th-, and 19th-century African American settlements have unearthed numerous material examples that demonstrate continuities between African creative traditions and 20th-century art making in the New World. Such discoveries as Colono ware, marked with the Kongo cosmogram, having survived the passage of time, the depredations of the southern climate, and hard use, document spiritual and aesthetic continuities. Research also reveals the interactions of European American and African American makers and paves the way for further inquiries into the traditional folk art of the South.

Although Holger Cahill's "folk art" remains the most recognized name for institutions and a general audience, most advocates now prefer "self-taught." Like "folk," "self-taught" can describe artists from the 16th to the 21st centuries. Furthermore, "self-taught," a term without class and racial connotations, explains why scholars, museums, dealers, and collectors display self-taught art from all centuries of American history side by side: the makers are all artists with little or no training in art. However, though "self-taught" is clearer and more inclusive than "folk," it too requires amplification. Art school graduates do not only learn in classrooms but also teach themselves through making art.

Many self-taught artists have had no craft or artistic training; others have adapted technical skills learned at the side of a master craftsman or in a workplace to create individualistic art. A few painters and sculptors who acquired brief, haphazard educations in art or studied with local, sketchily educated or other self-taught artists simply had to trust in their own devices. Many, like colonial portraitist William Dering, have no doubt derived compositional and pictorial formulas from print sources; in Dering's bombastic and comical circa 1740 portrait of George Booth, the young boy, dressed in wig and stylish

clothing, stands between stone plinths holding busts of generously endowed naked women. Researchers have not found any version of such sculpture in colonial Virginia.

Other artists' careers demonstrate further qualifications of the term "self-taught." Some painters, both immigrants and native born, may have staked claims to educations or accomplishments they had not truly achieved. Although New Orleans portraitist Julien Hudson claimed to have received a complete education in miniature painting in Paris, France, his folky style owes little to academic conventions. Many less accomplished immigrant portraitists, who settled in America hoping to find success among unsophisticated patrons, soon taught themselves the simplified styles that American patrons often preferred. The itinerant artist known as Dupue or the Guilford Limner, thought to be an immigrant from France, employed a linear and simplified New England style for the watercolor portraits he painted for patrons in North Carolina and Kentucky during the 1820s. These portraits repeat the conventions of middle-class New England portraiture during the colonial and early national periods, lending clarity to the subjects' presentations of self by using emblems of piety, success, and refinement.

Like their middle-class patrons, American self-taught artists can derive special satisfaction in being self-made, independent Americans. Joshua Johnson, for example, thought to be the nation's first African American professional artist, may have enjoyed some exposure to works of the Peale family of Philadelphia and Baltimore or some brief, unrecorded training. In 1798, however, the Baltimore portraitist proudly advertised himself as a "self-taught genius deriving from nature and industry his knowledge of the Art; and having experienced many insuperable obstacles in the pursuit of his studies." Johnson's use of "self-taught" is the earliest known application of the term to art making, but the term was commonly used during the 1830s to describe any number of self-made men. English visitor Frances Trollope's 1832 *Domestic Manners of the Americans* recounts her amusement at the phrase "self-taught," which she reports "had met me at every corner from the time I first entered the country."

At this point, after nearly 100 years of term warfare, no one has hit upon a term pleasing to all; but "folk art" still carries more meaning to more people than does any other label. Academics, institutions, and collectors know what they mean by the name; and while some new museum visitors may expect to see only traditional forms like quilts, more and more visitors expect to see a full range of works by self-taught artists. The Abby Aldrich Rockefeller Folk Art Museum, opened in 1957 as the Abby Aldrich Rockefeller Folk Art Center, collects 20th- and 21st-century work but still honors its major donor with the

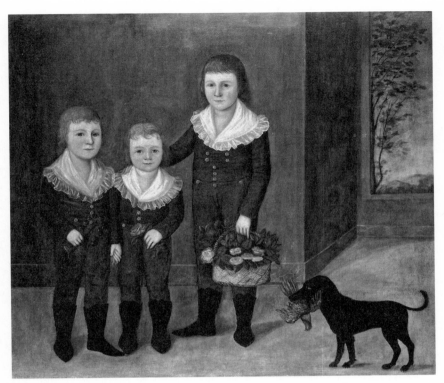

Joshua Johnson, The Westwood Children, ca. 1807, oil on canvas, 41⅛″ × 46″
(Courtesy the National Gallery of Art)

name she preferred. The American Folk Art Museum has retained "folk art" in its name through two changes. Established in 1961 as the Museum of Early American Folk Arts, a name that limited folk art to a period of creation and seemed to concentrate on utilitarian decorative arts, the institution became the Museum of American Folk Art in 1966. In 2001 the museum adopted the name American Folk Art Museum to indicate more clearly its mission to display American art from all centuries as well as art made outside the United States. Major generalist museums also continue to refer to works in their collections as folk art, even as they define folk art as the art of self-taught artists. Atlanta's High Museum of Art, a leader in the folk art field, is the only generalist American museum with a curator of folk art; its department of folk art provides a dynamic model for other institutions. Most heartening is the Smithsonian American Art Museum's recent establishment of the position of curator of folk and self-taught art.

The concept of folk art has, obviously, expanded tremendously since its

formulation in the early 20th-century Northeast. This expansion has allowed scholars to claim new bodies of work and to refine perceptions of traditional folk art. Careful research into the art making of ethnic groups, into artists working in specific locales, and into reciprocal influences has also expanded the concept of folk art. Scholarship in traditional folk art has flourished; sophisticated, intellectually, and visually pleasing exhibitions and publications address artists' aesthetic choices and elucidate cultural contexts that confirm Cahill's assertion that folk art is a living form of unconventional expression. The explosion of interest in folk art that followed the discovery of living folk artists in the 20th century expanded the self-taught art world in previously unimaginable directions. During the 1970s and 1980s, art dealers, institutions, and collectors sought out and celebrated new artists. Not only did scholars, dealers, and collectors meet with artists, but they also had the opportunity to hear artists' descriptions of their art, lives, and ideas. Intellectuals and experts in many academic disciplines contributed to a deeper understanding and appreciation of self-taught artists past and present. The extraordinary creativity of living African American artists made clear the contributions of both self-taught and academically trained black artists to American art. Interest in self-taught American artists naturally led to interest in self-taught art as a global phenomenon.

Remarkably, however, many people and institutions still define traditional American folk art as the 19th-century art of New England. To be sure, the early discoverers of "folk art" found most of their treasures in New England, New York, and Pennsylvania and patronized dealers in the region. Succeeding generations of folk art collectors from the Northeast sought out additional examples from folk art's golden age before mass production. As these collectors, in turn, have become donors to major museums, the exhibitions and catalogs published by these museums tend to keep the focus on New England. And, despite an almost instinctual impulse to hail American folk art as a portrait of the entire nation, few have asked where the traditional folk art of the South might be.

Why is it so difficult to learn about—or even see—the portraits, quilts, weathervanes, samplers, and other forms of traditional folk art created in the South? A student of folk art today is more likely to be more familiar with the details of the careers and art-making practices of 20th- and 21st-century masters and southerners like Thornton Dial and William Edmondson than with the makers of the South's masterpieces of traditional folk art: among many others, the singular, deservedly iconic portrait, circa 1815, of Jean Baptiste Wiltz, a duck-hunting Louisiana gentleman blacksmith, now in the Louisiana State

Museum; lovely portraits of Louisiana's free persons of color, including the exquisite self-portrait of free man of color Julien Hudson; the circa 1865 sampler stitched by Salem, N.C., schoolgirl Mary Lou Hawkes, whose depiction of high-stepping former slaves, based on stereotypical prints of Jim Crow, reveals this young girl's reaction to abolition; colorful and beautifully proportioned 19th-century chests from Virginia, the Carolinas, and Tennessee; or Texas artist Samuel Chamberlain's watercolor depictions of his dalliances with voluptuous Mexican maidens, vivid accounts of the Mexican American War, and other scenes of 19th-century frontier life. We have to ask why early dealers and collectors did not scour the South for additions to their collections. Were there no southern collectors? Why is there no museum devoted to the traditional folk art of the South? In short, we still have to ask, where is the traditional folk art of the South?

Where Is the South's Traditional Folk Art? The history of southern folk art begins in the 16th century during the Age of Discovery, when European explorers arrived in and began to document New World scenes and colonial settlements. Because scholars identify the art making of Native Americans as fine art or simply as art, the South's first folk artists were European men, some engineers or architects with training in technical drawing, some with no known training. Their paintings and drawings became part of a historical record held in colonial archives or sent back to Europe to satisfy curiosity about strange lands. These early works did not receive the attention of art historians for centuries. The obscurity of a colony's early works is not uncommon; recognition comes only when writers and collectors decide that a region or nation requires a historical survey of its art. The works of self-taught artists often remain in the shadows, as chroniclers with nationalistic purpose almost always lionize accomplishments in the so-called fine arts. Fashions in art making, however, change from time to time; the modernist artists living in proximity to New York during the first decades of the 20th century who discovered American folk art happily rejected the academic American art previously put forth as America's finest achievements in order to celebrate direct and appealing works of folk art. But the craze for folk art did not take immediate root in the South. Appreciation of the art made by ordinary citizens of the South still lags because of the South's peculiar history and mythmaking. The history of the South's traditional folk art is one missed opportunity for recognition after another.

During the 1920s and 1930s, the South held little attraction for advocates of folk art. Hot summers and poor roads discouraged collecting trips, as did newspaper reports of racial violence. The resurgence of the Ku Klux Klan, ac-

counts of the 1925 Scopes Trial, and memories of the 1915 Georgia lynching of Leo Frank portrayed a benighted South. H. L. Mencken's 1920 essay "The Sahara of the Bozart" did not paint a particularly welcoming picture either. W. J. Cash's influential 1941 book *Mind of the South* again painted a dark picture of the region's racism, violence, and old-time tribal religion. Images of crushing poverty published in popular magazines enforced an assumption that southern culture was itself impoverished. The explicitly democratic assumptions of American folk art simply could not find firm footing in the South. Early collectors outside the South saw the region as "a negation of America." As historian James C. Cobb further explains, Americans were supposed to be tolerant, peaceful, rational, enlightened, cosmopolitan, ingenious, moral, just, pragmatic, and prosperous. For the early discoverers of American folk art and others who have emphasized consensus history, the South was outside the national patriotic narrative of "independence and freedom."

Although the certainty that ordinary people have made art everywhere and in all times was the first article of faith for folk art advocates like Holger Cahill, Cahill had included only a handful of southern objects in his three exhibitions of folk art, and his aesthetic and ahistorical approach had allowed him to avoid mention of the burden of southern history that must engage southern historians. Cahill was delighted to display an Edgefield, S.C., face jug, but he did not draw attention to African American artists or to southern racism. Cahill had little information about many of the objects labeled southern in his three folk art exhibitions and catalogs. Indeed, Cahill became an advocate for southern folk art only by accident.

In 1934 Abby Aldrich Rockefeller offered to lend part of her folk art collection to Colonial Williamsburg, whose restoration was supported by her husband, John D. Rockefeller Jr. Encouraged to save the decrepit colonial buildings of the former Virginia capital, Rockefeller had bought land and numerous colonial buildings, which he then moved to a tract stretching from the colonial governor's mansion to the Virginia House of Burgesses. Officials of Williamsburg Restoration, Inc., charged with obtaining furniture, art, and other décor from Virginia's colonial period, questioned the propriety of exhibiting Rockefeller's 19th-century materials, almost all from the Northeast. Rockefeller called upon her old friend and adviser Holger Cahill to negotiate the loan. Cahill argued that the art of resourceful, self-reliant Americans was an important adjunct to Williamsburg's mission. This argument mollified officials, but they suggested that, even so, a collection with few examples of southern folk art was not desirable. Rockefeller quickly agreed to send Cahill in search of southern folk art.

In 1934 and 1935, Cahill made hurried and haphazard collecting jour-

neys throughout the South. Lighting down in Charleston, Savannah, St. Augustine, Miami, New Orleans, Nashville, and many stops in between, Cahill sought equivalents to the New England portraits, landscapes, weathervanes, trade signs, and other such creations he had named folk art. Cahill visited museums and historical societies whose holdings might give pointers on what art he might find. He visited antique shops, junk shops, and private collections. In Charleston, a center of southern culture in the 18th century, Cahill visited the Charleston Museum and the Gibbes Memorial Art Gallery, now named the Gibbes Museum of Art, where, among other things, he saw portraits by Jeremiah Theus and Henrietta Johnson, miniatures, ceramics, and embroideries. He found that graveyards in Charleston offered "a regular picture gallery," with stones that equaled stones he had admired in the Northeast. Cahill wrote that he had gotten "a real haul" in Charleston. In Winston-Salem, N.C., he visited the Salem Academy, where he saw embroideries and memorial paintings made by Moravian schoolgirls, and the Wachovia Historical Society, where he learned of Frederick Kemmelmeyer. In Salem, he purchased four "schoolgirl type" works. During a visit to Richmond, where the Virginia Museum of Fine Art was under construction, Cahill became excited by the possibility of future collaborations but found little to purchase. Cahill saw colonial portraits in Florida and Louisiana institutions but had no luck in locating colonial art for purchase.

On his second trip to Columbia, S.C., a scout for antiques dealers took Cahill to visit Mary Earle Lyles, who was persuaded to sell *The Old Plantation*, one of the icons of American art history. He was delighted that he had managed to acquire the work for a mere $20. A rare depiction of the private lives of slaves, the painting by slave owner John Rose provides a detailed image of enslaved Africans performing a dance immediately understood as African derived. Since the 1970s, *The Old Plantation* has served to illustrate the presence of African cultural traditions in the Americas.

Cahill, however, like many who have since attempted to find traditional folk art in the South, was at times stymied by the scarcity of works on the antiques market and by owners who were not willing to sell. In notes prepared for Rockefeller, for example, he reports his difficulties in obtaining even one weathervane. The sellers of a number of works of art had little information about makers. The fine face jug Cahill bought in Nashville, Tenn., differs from jugs made in Edgefield, S.C., but cannot with any certainty be attributed to a Tennessee maker.

Although Rockefeller's southern works, originally exhibited in the restored 18th-century Lowell-Paradise House at Williamsburg, impressed many

viewers, including prominent southern museum professionals, Cahill had little time or inclination to draw attention to the work. He did not publish a catalog on the southern art he had collected, and the lost opportunity to challenge the common assumption that folk art was a creation of New England's preindustrial golden age has undoubtedly had long-term effects.

Cahill's close involvement with Colonial Williamsburg came to an end in March 1935. In August of that year, he became National Director of the Works Project Administration's Federal Art Project, where he remained until 1943, when the program came to an end. The Federal Art Project, a relief program designed to provide work for artists who could not earn livelihoods during the Great Depression, established art centers in more than 100 towns and cities, engaged artists to produce murals highlighting local scenes for post offices, and created the Index of American Design, whose artists produced nearly 18,000 watercolor depictions of traditional arts and crafts that ordinary Americans had produced prior to circa 1890. These images of America's material culture, undertaken to encourage a greater understanding of American iconographic imagery and the quality and variety of objects produced by American artists and artisans, were allocated to the National Gallery of Art. In 1950, *The Index of American Design*, edited by the index's curator Erwin O. Christensen and with an introduction by Holger Cahill, made a selection of the illustrations available to the public. This book contained images of Hispanic art but gave scant attention to the folk creations of the South. Cahill realized this shortcoming. He explained that fewer artists lived in the South and that Federal Art Project fieldworkers in the South had enjoyed more success with offering art and theater activities at community art centers. He noted that, despite intentions to represent objects from all sections of the country, the index project had been most active in the Northeast. Thus, this publication made for another lost opportunity.

Southerners, of course, had created folk art for centuries, and many southern contemporaries of the early collectors of northeastern material and their successors cherished the works of self-taught artists. Southern collectors of works made before the 20th century, however, sought "antiques" such as quilts, portraits, and landscapes that might buttress the myth of an aristocratic past and assert their own claims to gentility and accomplishment. The legend of the Lost Cause, which celebrated the backward-looking romanticization of the Old South and the Confederacy, dominated generations of southern lives. Mention of racial conflict was taboo, and white supremacy became deeply entrenched in a racially segregated culture creating a society distrustful of critical thought and departures from traditional ways. Class differences in the region were taken for

granted; and many southerners, black and white, could not aspire to middle-class status. Elite southerners feared the "common man" and turned a blind eye to the lives—and art making—of those living on the other side of class and racial divides. The collecting pattern that arose from racism and class prejudice favored decorative sentimental landscapes, still lifes, and portraits—preferably old portraits of ancestors. A tendency to hold onto family objects—even those with obvious aesthetic shortcomings—has greatly hindered the establishment of public collections of southern folk art and continues to frustrate scholars who cannot easily locate art or make judgments of quality. While the southern art collectors, academics, and artists who discovered 20th-century self-taught artists William Edmondson and Bill Traylor saw these artists through the lens of modernism, many southerners did not respond to the aesthetics of modernism. Their definition of art certainly did not include unconventional art made by ordinary folk.

Some collectors of "antiques," however, sidestepped Lost Cause myths and instead devoted themselves to the discovery and recognition of creations made in narrowly defined locales. Indeed, a local-history approach was compelling; the South as we know it is a mosaic of areas settled at different times by diverse peoples. In geographic terms, the South expanded enormously between the late colonial period and the middle of the 19th century, the three centuries that early folk art devotees had proclaimed as the golden age of traditional American folk art. Between the colonial period and the mid-19th century, the South redefined itself continuously. In fact, defining the term "the South" is as challenging as defining "folk art." In art-historical terms, for example, Maryland was a key southern landscape from the colonial period to the middle of the 19th century, when Maryland was more attuned to the South's culture than to the Northeast's. Artists practicing in Maryland exerted their influence in Virginia and the coastal South, and they helped establish the expectations of southern patrons.

During the golden age of American folk art, some sections of today's South were neither English colonies nor possessions nor states of the United States. Louisiana, Florida, and sections of other southern states did not look to England or to former English colonies for artistic models but to the European nations that had claimed and settled them. After years of uprisings and military actions, Texas declared its independence from Mexico only in 1836 and did not enter the union until 1845. Thus, Texas, like Louisiana, inherited Mexican provincial artistic traditions. After soliciting white settlers from Europe, 19th-century Texas added European traditions to its artistic resources. In Texas and elsewhere, ethnic groups, for example, German-speaking immigrants to Virginia and North Carolina, brought Germanic visual conventions to communi-

ties they established. Twentieth-century scholars and collectors who approach "the South" in terms of today's geography may not be familiar with Spanish, French, Mexican, or German artistic conventions and, thus, easily ignore or misread the provincial folk art of these regions.

From the 16th to the 19th century, large sections of the South were the country's always-changing western frontier. In the territories granted statehood during the 19th century, an aspiring middle class with the means to acquire goods or commission portraits grew slowly. Some rural and small-town southern patrons, particularly in river and coastal cities, relied on itinerant artists. Opportunities for southern self-taught portraitists were limited, though, by the mid-19th-century introduction of photography. Makers of regional furniture and pottery found that their creations were replaced by industrially produced goods. Some portrait painters took up photography, while others, straining to replicate the naturalism of photography, produced stiff, strangely detailed portraits that did little to reveal the personality of the sitter. Some artists colored photographs with paint or collaged photographed heads onto painted bodies. These awkward portraits, which can give the impression that the 19th-century South was a haven for talentless artists, demonstrate the impact of social and economic conditions on southern art making, and especially on portrait painting in the mid-19th-century South. The frontier heritage of the South's inland areas and the brief careers of artists made redundant by photographic processes discouraged the formulation of an all-embracing southern portrait style.

Pride in locale, however, has fostered intensive research as well as the founding of museums and historical societies with a local, state, or regional focus. This antiquarian approach has preserved art and gathered information about the lives and times of art makers. For folk art historians, an antiquarian approach has been felicitous, as works of art that did not adhere to fine art principles in fashion when collected or those that referred to social problems were nonetheless seen as valuable documents. The antiquarian approach also meant that collectors and institutions often brought together local furniture, pottery, textiles, birth certificates, and many other creations called "folk art" in northeastern collections as integral elements of a particular cultural context. Southern scholars steeped in cultural context and respectful of the intents and achievements of ordinary folk also recognized the aesthetic qualities of works of art originally collected for their historical meanings. These experts in local history and culture became the discoverers and pioneer collectors of traditional southern folk—even if they did not adopt the term "folk art."

Although not the first collector/scholar to identify regional styles, Paul H.

Burroughs, who published *Southern Antiques* in 1931, was one of the first serious writers to consider the South as a context for creative expression. Dealing only with furniture, Burroughs traced European roots of colonial furniture, furniture forms and styles brought to the South by later immigrants, and the emergence of stylistic types of furniture peculiar to the southern locales. Other major advocates for recognition of the South's artistic achievements were antique dealers Theo Taliaferro (Theodosia Horton) and her son Frank L. Horton, who had begun to collect southern furniture during the 1940s. Horton redoubled his efforts after hearing of remarks made by Joseph Downs, curator of the Metropolitan Museum's American Wing, at Colonial Williamsburg's first Antiques Forum in 1949. Speaking on regional furniture styles, Downs had declared that "little of artistic merit was made south of Baltimore." This declaration, indicating how little impressions of southern art making had changed since Mencken's description of the South as "the Sahara of the Bozart," became a challenge to collectors, dealers, and museum professionals. Horton and Taliaferro became founders of the Museum of Early Southern Decorative Art (MESDA), dedicated solely to collecting, exhibiting, and researching pre-1820 decorative arts in the South. Founded in 1965 in Salem, N.C., MESDA displays the art making of the Moravians who established Salem and showcases more than 2,500 objects made by artists and artisans working in Maryland, Virginia, North Carolina, South Carolina, Georgia, Kentucky, and Tennessee.

Other collectors and influential museum donors were Colonel Edgar William Garbisch and Bernice Chrysler Garbisch, who began collecting folk art to furnish Pokety, the Cambridge, Md., hunting lodge they inherited after the death in 1940 of Mrs. Garbisch's father, car maker Walter P. Chrysler. The Garbisches, who had furnished their New York apartment with French antiques and impressionist and postimpressionist paintings, decided that folk art would be more appropriate for the country house they were restoring. The couple collected voraciously, amassing some 2,500 examples of folk art, both masterpieces and less important works. The Garbisches acquired most of their collection from art and antique dealers in the Northeast but also patronized dealers in Maryland and Virginia. Taking the aesthetic approach established by the early collectors, the Garbisches did not always record provenances or information about the works they collected, and identifications of artists and circumstances of creation still require unraveling. While much of the Garbisch collection consisted of art made in the Northeast, the collection also contained exceptional works by such southern artists as Frederick Kemmelmeyer, Gustavus Hesselius, John Hesselius, Justus Engelhardt Kühn, and Joshua Johnson. In 1953 the Garbisches donated a large part of their collection to the National

Gallery of Art, which refers to the art as "naive." The couple also donated to 21 additional museums. The Garbisches' donations to the Metropolitan Museum of Art form the core of that museum's folk art holdings; among those holdings is their southern masterpiece, *The Plantation*, painted circa 1825, a marvelously stylized landscape with plantation house and shipping docks—all within a frame of grapes and leaves. Little is known about this work, one of the most celebrated of all American folk paintings.

Emphasis on local traditions also characterizes the research into southern folkways and crafts undertaken by anthropologists and folklorists. The study of folklore and the study of folk art both grew out of a desire to investigate the creations of ordinary people. Allen H. Eaton, a key figure in directing attention to Appalachian folk art as well as to folk traditions of ethnic immigrant groups, began a long association with the Russell Sage Foundation in 1920. Six years later he created the foundation's Department of Arts and Social Work "to study the influence of art in everyday life." In 1930 Eaton helped found the Southern Highland Handicraft Guild to promote Appalachian crafts—wood carving, textiles, pottery, furniture, and other domestic products—in order to provide income for families hard hit by the Depression. In 1934 Eaton organized an exhibition of crafts made by guild members for the first National Folk Festival. Eaton's seminal book, *Handicrafts of the Southern Highlands* (1937), was the first major study of Appalachian crafts. Eaton's interest in crafts made by living makers established the anthropological and folkloristic approach to the study of utilitarian handmade products.

For decades, folk art historians and folklorists have contested the meaning of the term "folk art," each group passionately rejecting the other group's interpretation. Folklorists define "folk" not as the common man or woman—writ large as "we the people"—but as members of a community defined by locale, ethnicity, or tradition. They define "art" as Eaton did—the communally shared manner of making rather than the aesthetically pleasing, exceptional creations produced by an artist with an individualistic vocabulary of form. One can say that folklorists emphasize "folk" while participants in the art world associated with dealers, collectors, art professionals, museums, and individual artists emphasize "art." Participants in the folk art world define art as a transformative aesthetic experience and differentiate "art" from "craft." In this art-historical view, skillfully made, attractive craft objects are nonetheless examples of goods made in multiples according to community expectations and therefore the antithesis of art. In recent years, the two groups have enjoyed some convergence; the notion of a continuum linking folk art and folk craft respects the skills and inventiveness of craftsmen as well as individual artists' transforma-

tions of communal forms. Folklorists have begun to appreciate makers' aesthetic intents and to recognize that aesthetic choices are in themselves meaningful. Charles G. Zug III has reported that many potters have seen no reason to make pottery with ornamentation or artistic profiles, whereas other potters have consciously created utilitarian pots with remarkable glazes and sculptural grace even though aesthetic considerations lower productivity and income. At the same time, the art world has come to appreciate the value of the field study that gives folklorists a depth of information about the work and communities they observe. Folk art historians can thank folklorists for the preservation of many creations ignored or unknown to past generations of folk art enthusiasts. Folklorists such as John A. Burrison have not only donated their extensive and exquisite collections to museums and study centers but have also expanded our understanding of "artfulness." Zug's appreciation of Brown family pottery with its exceptional height, fluid profiles, and refined sculptural presence argues for its inclusion in folk art museums and collections. Currently, folk art historians and folklorists share the conviction that art and craft are tied to broad cultural, historical, social, and political contexts.

Throughout the 1960s, 1970s, and 1980s, southern and national institutions added to their collections of traditional southern folk art and directed resources to their research programs. Among museums with local or regional emphasis and strong folk art holdings are the Historic New Orleans Collection, with a focus on New Orleans and the Gulf South, and the Louisiana State Museum, which holds many traditional paintings and other genres as well as works by 20th- and 21st-century artists. The Winterthur Museum, Garden, and Library, formerly the family home of Henry Francis du Pont in Winterthur, Del., has a preeminent collection of American antiques and art, including extraordinary examples of traditional southern folk art.

No institution with a significant collection of southern material, however, was ready to respond to the remarkable surge of interest in traditional folk art occasioned by the 1976 celebration of the nation's bicentennial. Southern museums had not yet taken on the task of producing guides to the study of traditional folk art in the South or organizing exhibitions that would gather excellent work from a number of institutions. Indeed, major efforts to highlight the folk art of the South came to fruition in New York. Publishing executive Robert Morton's 1976 *Southern Antiques and Folk Art* was the first illustrated survey of decorative arts, folk art, and ornamented machine-made objects in common use in the pre-20th-century South. Morton's volume with many color illustrations, however, did not accompany an exhibition or receive as much attention as it might have if issued by a major publisher. Robert Bishop's pioneering *Folk*

Paintings of America, published in 1979, was the first book to consider regional folk art within a national context; his chapter on the South contains 75 illustrations of paintings beginning with Jacques Le Moyne's 1564 oil on canvas *Indians of Florida Collecting Gold in the Streams*. The book contains works by such painters as colonial pastelist Henrietta Johnson and 19th-century portrait artist Joshua Johnson and concludes with works by 20th-century self-taught artists, including Howard Finster and Mose Tolliver. Bishop's book, which alluded to the biracial context of southern folk art, like Morton's, did not accompany an exhibition and had less impact than it deserved.

Two well-publicized and well-attended exhibitions of traditional folk art held during the years surrounding America's bicentennial and their lavishly produced large-format catalogs may also have drawn attention away from southern folk art. The 1974 exhibition *The Flowering of American Folk Art, 1776–1876*, organized by Jean Lipman and Alice Winchester for the Whitney Museum of American Art, showcased 239 objects from public and private collections across the country, and the catalog for the exhibition presented 410 illustrations selected from some 10,000 examples. But less than 5 percent of the works illustrated in the catalog came from the South, and the organizers had made little attempt to locate work held by smaller museums or private collectors. The distinctive portraits of middle-class southerners do not appear in this pivotal exhibition or in classic books on folk art, even though they share the intents and aesthetics of New England. The art of areas not colonized by the English and any mention of race did not fit into this bicentennial narrative. The Whitney's second bicentennial era folk art exhibition, entitled *American Folk Painters of Three Centuries*, presented the works of individual folk artists chosen to represent the 17th, 18th, and 19th centuries. This 1980 exhibition, organized by Lipman and Tom Armstrong, presented the work of only one artist who worked in the South—Pennsylvanian Lewis Miller, who painted lively watercolors that record his visits to Virginia. Though never intended as textbooks, *The Flowering of American Folk Art* and *American Folk Painters of Three Centuries* have served this purpose. As a result, these two books, widely available in libraries and in used book stores, continue to perpetuate the New England bias.

Missing Pieces: Georgia Folk Art, 1776–1976, another exhibition inspired by the celebration of the U.S. bicentennial, was the first major exhibition on both traditional and contemporary self-taught artists working in a southern state. The exhibition transformed conceptions of southern folk art. Accompanied by a catalog written by Anna Wadsworth as well as a film, the exhibition traveled in 1977 to the Telfair Academy of Arts and Sciences in Savannah and then to the

Columbus Museum of Arts and Crafts in Columbus, Ga. In 1978 the American Folklife Center, under the direction of Alan Jabbour, brought the exhibition to the Library of Congress (where First Lady Rosalyn Carter and daughter Amy helped open the show). Sparked by the bicentennial and its celebration of the country's heritage, shows like *Missing Pieces* expanded national consciousness of the folk art traditions of the South.

The first exhibition exclusively devoted to the traditional folk art produced throughout the South took place only in 1985. Organized by Cynthia Elyce Rubin for the Museum of American Folk Art, *Southern Folk Art* presented works illustrated in Bishop's *American Folk Painting* as well as many remarkable works borrowed from institutions and private collections. Rubin's catalog, with images of numerous works of art never before located or illustrated, remains the most significant presentation of the South's 17th-, 18th-, and 19th-century folk art. However, the ground-breaking exhibition did not receive the attention it deserved. The small museum, now the American Folk Art Museum, still receives fewer visitors than it should; and the catalog, offering description rather than cultural analysis, was less informative than it might have been. The exhibition did not travel. The museum's pioneering attempt to introduce pre-20th-century southern material into American folk art discourse had little impact.

Southern Folk Art was not only the first exhibition presenting the South's traditional folk art but the last. Still, since 1985, traditional southern folk art has received considerable attention. Fine monographs on southern artists have appeared, and institutions have worked to gather information on southern art making. MESDA supports an active research program, photographing and describing objects identified as southern and made prior to 1820. MESDA's Object Database, a collection of approximately 20,000 images of southern-made objects, and the MESDA Craftsman Database, a collection of primary source information on nearly 80,000 artisans working in 127 different trades, are valuable resources for scholars of southern folk art. MESDA's publications, including the *Journal of Early Southern Decorative Arts*, have illustrated its holdings and encouraged inclusion of southern work in considerations of American folk art. Colonial Williamsburg's Abby Aldrich Rockefeller Folk Art Museum (AARFAM) has produced many well-researched publications, a remarkable EMuseum online catalog that reproduces and examines the folk art in its collection, and many exhibitions that present southern folk art within contexts of time and place as well as in the context of American folk art history. Winterthur, MESDA, and AARFAM also sponsor frequent seminars on specific aspects of southern folk art. *The Magazine Antiques*, with both general and academic audiences,

has published numerous articles on the South's folk artists; the now-defunct *Folk Art Magazine*, a publication of the American Folk Art Museum, published many articles with insights into southern art.

Books devoted to the history of southern art almost always include traditional folk art. Jessie Poesch's *The Art of the Old South: Painting, Sculpture, Architecture, and the Products of Craftsmen, 1560–1860* (1983) and *Painting in the South, 1564–1980* (1983) with essays by eminent scholars are invaluable. The exhibition *Painting in the South* traveled to six museums in Virginia, Alabama, Mississippi, Kentucky, Louisiana, and New York. Several well-produced volumes devoted to the art of specific states have made important contributions. Patti Carr Black's *Art in Mississippi, 1720–1980* (1998) includes both traditional and contemporary folk artists. Another fine study with excellent color plates and many scholarly essays is Benjamin H. Caldwell Jr., Robert Hicks, and Mark W. Scala's *Art of Tennessee* (2003). In addition to state books, southern states, such as Texas and Georgia, have published online encyclopedias that discuss the work of folk artists. Numerous books on folk or backcountry furniture, pottery, painting, gravestones, needlework, quilting, and other textiles have illustrated and examined the art making in individual states or specific regions of the South.

Scholars specializing in forms of folk art that demonstrate women's participation in folk art making—quilting, embroidery, and other genres—have published a wealth of books that call special attention to the contributions of southern women; these well-illustrated scholarly books go a long way in correcting the assumption that the South produced little folk art. Under the direction of Shelly Zegart, Eleanor Bingham Miller, and Eunice Ray, the Kentucky Quilt Project, initiated in 1981, established a movement to document quilts across the country. Quilts, such as those that southern women created and raffled to support the health needs of Confederate soldiers, and quilts created to raise funds for the construction of Confederate gunships underline women's involvement in political affairs. Surveys of needlework in printed books and online demonstrate pride in place and the special pride that women and girls took in their participation in the progress of education and refinement in established cities and in frontier territories.

Museums currently seek southern additions to their collections, closing gaps and refining conceptions of southern folk art. The High Museum of Art, for example, has added remarkable works of traditional folk art to its strong collection of contemporary self-taught art. More and more generalist museums call attention to the southern origins of their holdings in 16th-, 17th-, 18th-, and 19th-century art.

Nonetheless, the traditional folk art of the South is underappreciated and offers many opportunities for research. Colonial Williamsburg decorative arts librarian Susan P. Shames's 2010 *The Old Plantation: The Artist Revealed*, for example, provides an excellent model for the identification of unknown artists. A narrative account of her identification of South Carolina slave owner John Rose, the watercolorist who painted *The Old Plantation*, reveals this artist's background and intents. Such investigations of original documents like censuses; birth, death, and probate records; and property deeds, undertaken for decades by scholars of Northeast and Eastern Seaboard folk art, are necessary to our understanding of the careers of southern painters. The compilations of portraits published by state chapters of the National Society of Colonial Dames of America as aids to genealogical research point the way to further identification of artists, their training, and practice. Recent compilations such as the survey of Tennessee portraits, now available online, document the large number of artists who worked in that state and reveal groups of portraits with strong stylistic similarities that suggest that they were produced by single or connected artists. Information about ownership gathered during the preparation of the Colonial Dames' recent surveys further allow scholars to locate the many southern portraits held by local historical societies, historic houses, and individual owners.

The recognition of the South's rich biracial culture has revolutionized the study of art making in the South. Black and white artists have pursued many of the same themes and reciprocal influences, now obvious, suggesting opportunities for future research. Folk art depictions of daily activities document the centrality of African Americans in southern life and are thus important resources in studying slavery. These paintings also call for investigations into artists' experiences and intentions. A search for additional paintings of southern scenes and reexaminations of known work may further elucidate African continuities in southern folk art.

Anyone wishing to see the rich range of the South's traditional folk art will travel widely. The South's traditional folk art resides in museums located throughout the nation, museums with a local or regional focus, historical societies, genealogical societies, historic houses, churches, cemeteries, state archives, and private hands. We look forward to new discoveries and interpretations. We also look forward to a time when narratives of American folk art embrace the traditional folk art of the South and the South's many complexities.

Contemporary Folk Art: Where Is the South Now? The concept of contemporary folk art entered the art discourse in the early 20th century in the work

of three men—Holger Cahill, Sydney Janis, and Otto Kallir. In 1938, Cahill, the doyen of traditional folk art, organized the exhibition *Masters of Popular Painting* for the Museum of Modern Art. The exhibition surveyed the work of several contemporary self-taught artists, including John Kane, Joseph Pickett, Horace Pippin, and the lone southerner, Kentuckian Patrick Sullivan, alongside the art of 19th-century artists. In the show's catalog, Alfred H. Barr Jr., MoMA's director, described nonacademic art as one of the "major . . . movements of modern art," on a par with cubism and surrealism. Cahill went on to argue that folk art did not belong only to the past but that "splendid examples of it are in existence, from the work of the earliest anonymous limners of 17th-century New England to the contemporary work displayed in this exhibition."

In 1939 Otto Kallir, an exponent of German and Austrian modernism, who had escaped from Nazi-occupied Austria, established the Galerie St. Etienne in New York. Kallir, having a keen appreciation of folk art, soon became the dealer of the untutored artist Anna Mary "Grandma Moses" Robertson. The dealer arranged the 1940 exhibition *The Farm Woman Painted*, which was the elderly woman's first public exhibition in New York, and launched Moses on her way to becoming an internationally known celebrity. In the 1940s and 1950s, Galerie St. Etienne gained a reputation for its inclusion of self-taught artists within the framework of modernism.

In 1942, Sydney Janis, an influential collector, dealer, and author, wrote *They Taught Themselves: American Primitive Painters of the 20th Century*, the first book to analyze the work of 20th-century self-taught artists. Many of the artists he showcased had been featured in Cahill's 1938 exhibition *Masters of Popular Painting*, but there were some newcomers, including Moses and Morris Hirshfield, a retired president of the EZ Walk Slipper Manufacturing Company. Still hailed as a classic, the book established the foundation and parameters of the field of contemporary self-taught art.

Janis was, in fact, the first person to introduce the term "self-taught" in the conversation on modern art. Asserting that untrained artists could be found in every period of history, come from all walks of life, practice all kinds of vocations, and burn with creative zeal, he preferred the term "self-taught," over "folk," "primitive," or "naive." Because self-taught artists worked at a distance from academic norms, he argued that they were "spiritually independent" of the established art world. Janis also affirmed, just as Cahill had, that 20th-century self-taught artists were "worthy successors to our 18th- and 19th-century anonymous portraitists."

In the late 1930s and in the early 1940s, everything seemed in place for a groundswell of support within the New York art world for the work of con-

temporary self-taught artists. Indeed, during this time two remarkable exhibitions of southern self-taught artists took place in New York. The earliest occurred in 1937 when sculptor William Edmondson received an invitation for a one-person show at MoMA. In 1935 Sidney Hirsch, who taught at the Peabody College for Teachers (now a component of Vanderbilt University) and had seen Edmondson's carvings during walks around his neighborhood, introduced Edmondson's work to the fashion photographer Louise Dahl-Wolfe. Her wonderfully shot photographs of Edmondson, his work, and environs caught the eye of Alfred H. Barr Jr., MoMA's director, who arranged for the display of 12 of Edmondson's statues in the fall of 1937. This exhibition was the first one-person show featuring the work of an African American and a self-taught artist at MoMA. There was a good deal of press coverage, including articles in the *New York Times* and the *New Yorker*. Instead of drawing attention to his art, however, the reviews focused on Edmondson's illiteracy and religious visions. In the following year, nonetheless, Barr showed Edmondson's work in *Trois siècles d'arts aux États-Unis* at the Jeu de Paumes in Paris.

The second exhibition of a southern self-taught artist in New York presented the drawings of Alabama's 87-year-old Bill Traylor. A former slave, Traylor created his drawings on the streets of Montgomery. In 1939 a local white artist, Charles Shannon, had befriended Traylor, providing him with art supplies and organizing an exhibit of his work at New South, a community arts center in Montgomery. Shannon photographed Traylor, collected his drawings, many on scraps of cardboard, and in 1941 took examples of his work to New York, where he showed them to Victor d'Amico, MoMA's director of education. D'Amico organized a show for Traylor at the prestigious Fieldston School in the exclusive neighborhood of Riverdale in the Bronx. The press took no notice. D'Amico also showed the drawings to Barr, who chose several of them for MoMA's collection and some for his own. However, Barr's offer to pay Shannon only a dollar or two for each drawing outraged the southerner, who demanded the objects' return. It would be more than 30 years before Shannon tried again to introduce Traylor's work to the New York art world.

In the first half of the 20th century, the champions of nonacademic art—Cahill, Kallir, and Janis—were members of the art world's elite. They made the work of untutored artists a focus of the American art world, identifying many major self-taught artists of the 20th century and laying down the basic framework of the field. Nonetheless, in the prewar art world of the 1940s, the window of opportunity for self-taught art soon closed. When Morris Hirshfield was given a retrospective at MoMA in 1943, critics scorned the exhibition, asserting that MoMA had passed over so-called legitimate artists in favor of a self-taught

artist. In the scandal that followed, Barr lost his position as director. Many untrained masters of the 20th century slipped from memory. Only Grandma Moses, who was "relegated to a vast populist backwater" of greeting cards and calendars, remained in the public eye. The art world embraced abstract expressionism as America's new form of creative expression. Contemporary folk art would have to wait for its rediscovery in the second half of the century.

In 1968 sculptor Michael Hall and art historian Julie Hall, living in Lexington, Ky., where Michael was a member of the University of Kentucky's studio art faculty, finally tracked down carver Edgar Tolson. They already owned some of Tolson's carvings, but they wanted to meet the backwoods preacher and mountain carver, who lived near the small town of Campton in eastern Kentucky. Later that year, when the couple was visiting New York City, they stumbled onto the Museum of American Folk Art, where they discovered an exhibition called *Collector's Choice*. The two were immediately smitten with the show, and as they walked through the exhibition, they made a chance encounter with Herbert W. Hemphill Jr., the exhibition's cocurator and one of the museum's founding trustees. Hemphill asked if they would like to see more pieces. The Halls said yes and ended up in Hemphill's apartment, which was full of artworks. The three spent hours talking about folk art and became fast friends. Michael returned the next day to show Hemphill photographs of Tolson's carvings. Hemphill liked what he saw. He purchased his first Tolson—an Adam and Eve—in early 1969, and in the spring of 1970 Hemphill traveled with the Halls to Campton to meet Tolson. The work of self-taught artists was on the road to rediscovery.

Even before the Halls had met Tolson, the carver's reputation had spread beyond Kentucky. Tolson, who had carved since childhood, began selling his works in 1967 through the Kentucky Grassroots Craftsmen, a cooperative that marketed local crafts. When, in November 1967, members of the Grassroots Craftsmen went to Washington, D.C., seeking ways to increase the co-op's profits, they visited the Smithsonian National Museum of History and Technology, now the National Museum of American History. There they met with Carl Fox, manager of the Smithsonian's gift shop, and showed him Tolson's work. Fox purchased the pieces outright, requested more, and in early December wrote the carver telling him the gift shop would like to mount a large sales exhibition of his work and inviting him to Washington. Tolson accepted, and in 1968 he went to the capital, bringing several works, including a tableau of Adam and Eve, a half-dozen dolls, and a large carved horse. He met with Smithsonian officials, appeared on television, and became the subject of an article in the *Washington Post*. Between 1968 and 1976, the museum show-

cased Tolson's work and the carvings of Hispanic folk artist George Lopez of New Mexico in *American Folk Craft Survivals*.

Tolson's visit to Washington was propitious. Folklorist Ralph Rinzler was just then organizing the second Smithsonian Folklife Festival, and he invited Tolson to participate in both the 1968 and 1969 festivals. In 1973, when the festival honored the state of Kentucky, Rinzler invited Tolson as a featured artist. The festival's program carried a photograph of Tolson's work. That same year—1973—Tolson was featured (along with Michael Hall) in the Whitney Museum of American Art's Biennial, an exhibition that presents artists whose work exemplifies the current state of American art.

Just at the time that artists, art collectors, and folklife scholars were discovering Tolson, Kansas painter Gregg Blasdell was scouring the countryside for what he called grass-roots artists. He was searching for a kind of art that "has no definition in art history: the term 'grassroots' is only the best of a number of inadequate classifications such as 'primitive,' 'folk,' and 'naïve.'" Blasdell's 1968 photo essay, which appeared in *Art in America*, pioneered the study of folk art environments and featured ones that would become fixtures of American contemporary folk art, such as Simon Rodia's *Watts Tower* in Los Angeles and S. P. Dinsmoor's *Garden of Eden* in Lucas, Kan. In the South, he documented Brother Joseph Zoettl's *Ave Maria Grotto* in Cullman, Ala., and Stephen Sykes's now defunct towering *In-Curiosity* near Aberdeen, Miss. In 1974 Blasdell's research inspired *Naïves and Visionaries*, a landmark exhibition of environments at the Walker Art Center in Minneapolis, which relied heavily on photographic documentation.

Two unrelated but extraordinary events, one in Washington, D.C., and the other in New York, made 1970 a pivotal year for the history of contemporary folk art. In 1970, the Smithsonian American Art Museum acquired the contemporary masterpiece James Hampton's *The Throne of the Third Heaven of the Nation's Millennium General Assembly*. Also in 1970, the Museum of American Folk Art held a wide-ranging and well-researched exhibition entitled *Twentieth Century Art and Artists*, which exhibited many remarkable works known only to a few. During the 1960s, when the Smithsonian Institution exhibited Tolson's and Lopez's art, the works were displayed as craft in a museum devoted to American history and technology. The institution's influential Folklife Program celebrated the creativity of the common man and woman as the product of craft survivals. Emphasizing geographic or ethnic craft traditions that have endured over time, the institution contextualized the works of self-taught artists as craft and exhibited it alongside such objects as canoes, baskets, and utilitarian goods. By the end of the decade, however, staff members of the Smith-

sonian National Museum of Fine Arts (now the Smithsonian American Art Museum) were reconceptualizing the creative production of self-taught makers as art.

The Smithsonian American Art Museum's commitment to contemporary self-taught art began in 1964 soon after the death of James Hampton, a reclusive, soft-spoken janitor, born the son of a black itinerant preacher in South Carolina. What James Hampton left behind in the Washington, D. C., garage he rented was a stunning, three-tiered assemblage, composed of foil-wrapped cast-off pieces of wood furniture, jelly jars, light bulbs, flower vases, desk blotters, mirror shards, strips of metal cut from coffee cans, as well as paper, plastic, cardboard, conduit, glue, tablets, tacks, and pins. Labeled *The Throne of the Third Heaven of the Nations' Millennium General Assembly* in Hampton's own handwriting, the glittering gold and silver construction featured chairs, pedestals, and lecterns symmetrically disposed on either side of a majestic throne crowned with the words "Fear Not." The garage owner, Meyer Wertlieb, discovered the assemblage after Hampton's death, and, realizing the importance of Hampton's radiant installation, contacted a newspaper reporter. The *Washington Post* announced the story on 15 December 1964, under the headline, "Tinsel, Mystery Are Sole Legacy of Lonely Man's Strange Vision." Soon thereafter, Harry Lowe, curator of exhibition and design at the National Collection of Fine Arts, visited the garage to see the astonishing assemblage.

The second momentous folk art event of 1970 was the New York exhibition *Twentieth-Century American Folk Art and Artists*. Curated by Herbert W. Hemphill Jr., the exhibition, shown at the Museum of American Folk Art, was composed of the work of 50 self-taught artists. The works of William Edmondson and artists discovered by Cahill, Kallir, and Janis—Grandma Moses, Morris Hirschfield, and Patrick Sullivan—shared the spotlight with 30 newly discovered artists, many of them southern: Eddie Arning, Minnie Evans, Theora Hamblett, Clementine Hunter, Sister Gertrude Morgan, and, of course, Edgar Tolson. The Kentucky artist was also featured in the introduction to Hemphill and coauthor Julia Weismann's subsequent book *Twentieth-Century American Folk Art and Artists*, which expanded on the 1970 exhibition and featured 145 artists. Insisting that folk art was not a thing of the past, Hemphill's ground-breaking work established contemporary folk art as a wide-ranging phenomenon, made its presence known in the broad context of the art world, and inspired countless folk art hunters to persevere.

The exhibition of Hemphill's own folk art collection parlayed these pioneering efforts into a full-blown movement. Shown at 24 museums between 1973 and 1988, Hemphill's collection geographically extended his vision. In

1976 the American Bicentennial Commission even sent it to Japan on a goodwill tour. Ultimately, the Smithsonian American Art Museum became the repository of more than 400 works from Hemphill's collection, an acquisition marked by the 1990 exhibition and book *Made with Passion: The Hemphill Folk Art Collection in the National Museum of American Art* (1991).

Collectors, artists, and curators made the 1970s a decade of discovery. Hemphill crisscrossed the country making finds in West Virginia, Virginia, Kentucky, Alabama, the two Carolinas, and Georgia. Oftentimes, he traveled with Jeff Camp, a dealer who conducted folk-art-collecting marathons throughout the South. Indeed, the decade of the seventies was a whirlwind of folk art traffic as collectors and dealers scoured the South looking for art, as the terms "contemporary folk art" and the "South" were quickly becoming one and the same in many minds.

Michael and Jane Hall visited collections all over the nation, and Michael's students, whom he often referred to as his "army," became a corps of folk art finders. Another pair of influential collectors, lawyers Chuck and Jan Rosenak of Washington, D.C., saw Tolson's work in Washington, drove to Kentucky to meet him, and began to amass a folk art collection. They met other collectors and remained especially close to their mentor, Robert Bishop, appointed director of the American Folk Art Museum in 1977 and serving there until his death in 1991. Growing out of their extensive focused collecting, the Rosenaks published two books and donated works from their collection to the Smithsonian American Art Museum and the Smithsonian Archives of American Art.

In the White Cube: Aesthetics in Context, 1976–1990. In 1976 the Atlanta Historical Society hosted *Missing Pieces: Georgia Folk Art, 1776–1976*. Modeled on Hemphill's *Twentieth-Century American Folk Art and Artists*, the exhibition *Missing Pieces* featured objects that ranged from colonial to contemporary times, seeking to serve, Wadsworth wrote, "as a first step toward discovering Southern pieces missing, until now, from the continuum of American Folk Art." Objects ranged from portraiture, paintings, drawings, textiles, and quilts (including a Harriet Powers's *Bible Quilt*) to carved figures, canes, stoneware jars, and face jugs. Most startling was the large number of contemporary self-taught artists, many previously unknown. Among them were Ulysses Davis, Howard Finster, Eddie Owens Martin, Mattie Lou O'Kelly, and Nellie Mae Rowe. Of these, Finster would soon become the best known. His astonishing creativity and larger-than-life persona would make him an icon of southern art.

Born in Alabama, Finster lived in northwest Georgia in the small town of Summerville. He retired from his career as a Baptist preacher in 1965 and

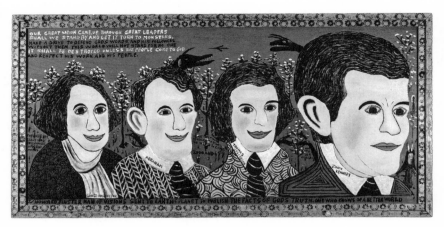

Howard Finster, *Four Presidents*, 1981, enamel on wood, 28″ x 48″,
including wood-burned frame (*Courtesy John and Susan Jerit*)

worked at home as a repairman to support his family. After a vision in 1961 that
instructed him to "get on the altar" and build a garden, he began construction
on an outdoor display near his house. It gained its sobriquet *Paradise Garden*
in 1975 from an article in *Esquire*. The garden was an ongoing labor of love, one
that helped to define a major genre of southern folk art—yard gardens. Fin-
ster's paintings with homey aphorisms were inspired by the famous 1976 vision
in which God called the preacher to paint "sacred art." Ultimately, Finster's offi-
cial website asserts, he created and numbered more than 46,000 works of art.

Finster's rise to national fame helped make the term "folk art" synonymous
with the South. On Hemphill's first visit to meet Finster, in 1976, he bought sev-
eral paintings. By 1977 Jeff Camp had agreed to serve as Finster's agent, and
the preacher's new career as a full-time artist accelerated. In 1982 he had a one-
person show in New York at the New Museum of Contemporary Art; in 1983
his art appeared in 15 exhibitions across the country, and in 1984 he was invited
to participate in the Venice Biennale, a prestigious international exhibition
founded in 1895. As a guest on Johnny Carson's *Tonight Show*, Finster played
his banjo, sang, joked, and generally outperformed the host. By the 1990s he
had appeared in all major media, become the subject of books, and, like Jesus,
Martin Luther King Jr., and Coca-Cola, the stuff of southern legend. His work
had traveled coast to coast, and his creations hung in some of the nation's most
prestigious institutions. In 1995 the High Museum of Art feted the reverend
with an art exhibition and 70th birthday party, but the artist's heyday was over.
Finster had sold his first $20,000 artwork in 1988, but complaints soon ap-
peared about high prices for his work and his use of family members in an "as-

sembly line" approach to making art. His *Paradise Garden* fell into disrepair, and by the 1990s the phenomenon known as Finster, which had blazed like a meteor through the folk art skies, had burned out.

During the 1980s and 1990s, a flurry of exhibitions added a myriad of names to the roster of southern contemporary folk artists. Among such shows were the ground-breaking *Black Folk Art in America, 1930–1980*, curated by Jane Livingston and John Beardsley, which opened at the Corcoran Gallery of Art in Washington, D.C., and traveled throughout the country; *Baking in the Sun*, a 1987 traveling exhibition with catalog essays by Maude Southwell Wahlman and Andy Nasisse; and the 1989 exhibition *Signs and Wonders* with a catalog written by Roger Manley. The year 1993 saw *Passionate Visions of the American South*, a traveling exhibition with catalog by Alice Rae Yelen, and in 1995, *Pictured in My Mind*, a traveling exhibition organized by the Birmingham Museum of Art.

Black Folk Art in America, a blockbuster exhibition that featured 391 works of art from 78 collections, was the most significant to the study of art making in the South. Traveling to six major museums throughout the country, *Black Folk Art in America* showcased 20 artists, of whom 19 were born in the South. Hailed for the aesthetic power of its astonishing works of art and its stunning installation, the exhibition was praised above all for revealing an enthralling body of art and a new chapter in American art history. James Hampton's glistening foil-wrapped *Throne* was set against a brick wall to simulate the garage where the artist built it. Similarly, the bone-white walls of the space displaying the art of Sister Gertrude Morgan, a New Orleans street preacher, replicated the prayer room in her home.

Despite such success, *Black Folk Art in America* and its catalog also drew criticism. Faultfinders argued that the curators' overemphasis on a formalist approach effectively divorced the art from the cultural context in which it was created. Some failed to see how the art could be categorized as being what its curators described as communally African American and yet highly individualized. Others believed that the catalog perpetuated, as one writer put it, "retrogressive myths about black people."

Livingston and Beardsley's stress on aesthetics in *Black Folk Art in America* demonstrated the abiding influence of Holger Cahill's ideas about American folk art. His fine arts approach to folk art became in the 20th century an art-historical thread sewn into the very fabric of the field. From the 1970s onward, however, an increasing number of art historians and scholars began to examine folk art from a historical, political, social, and cultural perspective. In the forefront were scholars of African American art. Yale University art his-

torian Robert Farris Thompson documented the transmission of Africa's cultural heritage and its impact on the art of the Americas. Thompson's 1969 essay "African Influences on the Art of the United States," which appeared in *Black Studies in the University: A Symposium*, and his 1984 book *Flash of the Spirit: African and Afro-American Art and Philosophy* wielded a decisive influence on subsequent scholarship. Folklorist John Michael Vlach also contributed to the scholarly conversation about African continuities with his 1978 book *Afro-American Tradition in Decorative Arts*, which accompanied a nationally traveling exhibition organized for the Cleveland Museum of Art. Both exhibition and book focused on utilitarian artifacts and traditional crafts. *Another Face of the Diamond: Pathways through the Black Atlantic South*, an exhibition that appeared at INTAR Latin America Gallery in New York (1988) and curated by University of Georgia professor Judith McWillie, examined iconographic motifs, oral traditions, and spiritual beliefs to demonstrate a continuum between African and African American artistic traditions. Such an analysis amplified the understanding of African American art works, specifically the work of self-taught artists in terms of their makers' life experiences and their African heritage.

Aesthetics and Changing Contexts: An Enduring Argument. Necessary discussions of how to balance formalism or artfulness with a variety of contexts continue to this day. In a field of art defined by the social situation of the maker as self-taught, discussions of biography are necessary but can assume primary focus. However, as biography consists of artists' projections of self and writers' own personal assumptions, analyzing art through biography alone is problematic. During the mid-1940s, Jean Dubuffet, the modernist French artist and collector, relied on biography to coin the term "art brut" or "raw art." Dubuffet developed a profound interest in the drawings, paintings, and other creations of psychiatric patients, which he believed to be a spontaneous expressive outpouring from the inner self. Unsullied by cultural tradition and artistic precedent, this form of art was, according to Dubuffet, in its raw state, "uncooked" by culture and artistic tradition. Persuaded by the creative authenticity of the work produced by such schizophrenic and self-taught artists as Adolf Wölfli and Aloïse Corbaz, Dubuffet began to collect art brut, soon broadening the term to include the untutored work made by such trance mediums as Madge Gill and Jean Tripier and by people with little formal education who were often social and emotional outcasts. Ultimately, the artist amassed a collection of more than 5,000 pieces, the Collection de l'Art Brut, located today in Lausanne, Switzerland.

Eliminating the idea of beauty and, with it, the West's concept of aesthetic standards, Dubuffet admired instead art brut's expressive, transgressive, and mystical nature. Although modernist artists had traditionally been drawn to the work of self-taught artists by its formal qualities, such as its treatment of line, shape, color, light, and space, Dubuffet promoted the idea that art should be about the unimpeded, direct expression of feeling. Dubuffet's emphasis on the psychological and the instinctual directed attention to biography and insisted that the creativity of these artists originated in their "otherness." At the same time, Dubuffet's approach and the current climate of modernism unintentionally encouraged a formalist appreciation of l'art brut.

Roger Cardinal's 1972 book *Outsider Art* further popularlized and refined Dubuffet's art theories in English-speaking countries with the effect in the United States of substituting the term "outsider art" for "art brut." Chicago, Los Angeles, and Baltimore became centers for study and exhibition of outsider art, but as the term "outsider art" became progressively well known, the term's meaning grew less and less distinct. Not only was the term ambiguous but also misleading and often offensive. Critics began to hurl other charges against the term, especially against its conception of the mad artist working within a hermetically sealed universe. In 1984 artist and collector Michael Hall criticized the argument that the artist outside was more privy to create authenticity than the trained artist and decried the formalist interpretation of self-taught art that often posed questions that the formalist dogma could not answer. Similar criticisms were offered not only by other members of the art world but also by folklorists, such as Daniel Wojcik, who indicated that the assumptions underlying the study of so-called outside art are "deeply problematic." Wojcik observed how Finster has been called "crazy" and a "wacko" and his "classic outsider" status emphasized, yet his art is clearly a vernacular expression of southern evangelical Christianity.

The divide between the formalist appreciation of contemporary folk art and the contextualist concern to move beyond biography has found some resolution. Scholars are increasingly examining the creativity of artists within the broad contexts of history—local, regional, and national—class, economics, education, gender, politics, race, and religion. Particularly fruitful has been research into African American vernacular art in the South. The documentation and exhibition of African American artists throughout the Americas within the context of an African legacy owes a profound debt to the Atlanta collector William Arnett.

Arnett, who was born in Columbus, Ga., has been an obsessive collector from childhood. He compiled everything from an enormous set of marbles

to a stockpile of rock and roll records, including 45s of Fats Domino and Chuck Berry. After graduating from the University of Georgia, Arnett traveled throughout Europe, returning to Columbus to become an art dealer. After relocating to Atlanta, Arnett spent several decades collecting Chinese, African, and Pre-Columbian art as well as the art of the Near East, India, and Southeast Asia. Introduced to the carving of the self-taught Florida artist Jesse Aaron in the 1970s, Arnett soon embraced the work of African American artists Sam Doyle from South Carolina, Alabama's Mose Tolliver, and Mississippi's Mary T. Smith. By the mid-1980s, Arnett's road trips were taking him throughout the South as he found other black artists, including Alabama's Charlie Lucas, Lonnie Holley, and Thornton Dial, and Tennessee's Bessie Harvey and Joe Light. Arnett ultimately formed a huge collection of African American vernacular art and became increasingly confident that he had discovered a new generation of untrained artists active in the South. Unlike those featured in *Black Folk Art in America*, however, the artists Arnett uncovered were for the most part artists active after the Great Depression and flourishing in the wake of the civil rights movement. Their art bridges the 20th and 21st centuries. Even more importantly in Arnett's mind, the work of these black self-taught artists was the equal—qualitatively, intellectually, and historically—of contemporary fine art.

By the early 1990s, Arnett had begun to introduce his discoveries to the art world. In 1993, while the American Folk Art Museum and the New Museum of Art were celebrating Thornton Dial's work in a major New York exhibition, a controversial segment of the television show *60 Minutes* interviewed Dial and other black self-taught artists. The program's thesis that white collectors were exploiting black artists practically ruined both Arnett and Dial. Yet, the scholar Eugene W. Metcalf compares Arnett "and his four sons who work with him, to the renowned Lomax family who discovered, documented, and saved American indigenous music."

In the heady days of the age of discovery during the 1970s and 1980s, some collectors, with nothing but good intentions, developed relationships with artists, became promoters, and sometimes became dealers. Some enthusiastic collectors, however—both southerners and nonsoutherners alike—were unaware of the South's peculiar social and racial etiquette; they did not recognize the feigned acquiescence that African Americans have long used to avoid conflict and preserve their privacy nor the deference that poor people have paid to elite classes for the same reasons. Thus, some early collectors, misreading feigned acquiescence as innocence, purchased work cheaply from artists who felt that they could not demand higher prices or refuse offers of representation. Undoubtedly, a few collectors saw an opportunity to make some money for them-

selves. Luckily for the artists and for the folk art world, the age of discovery, and its unfortunate paternalistic assumptions about artists "who didn't know they were artists," is now over.

The dismal *60 Minutes* affair did not keep Arnett from formulating an ambitious project to further legitimize African American vernacular art. He planned an art exhibition with lavishly illustrated publications. In collaboration with the Michael C. Carlos Museum at Emory University, Arnett presented a show of 300 artworks by 20 African American vernacular artists living in the South. *Souls Grown Deep* was displayed in Atlanta during the 1996 Olympics and opened to rave reviews from critics around the country. A two-volume book followed: *Souls Grown Deep* received nearly universal praise and led to the founding of Tinwood Alliance, a nonprofit organization established by Arnett and actress Jane Fonda to further the study of African American vernacular art. Both volumes included numerous essays, authored by a group of diverse writers, including civil rights leaders, art historians, museum curators, and folklorists, as well as commentaries by the artists themselves, who presented not only artists' biographies but also stylistic, thematic, and historical overviews crucial to an understanding of African American vernacular art. Both the exhibition and the two-volume work celebrated not only the extraordinary aesthetic nature of African American vernacular art but also its dual roots in Africa and America.

Arnett next focused his energies on exhibiting and writing about the quilts of Gee's Bend, a tiny secluded, rural community in southern Alabama. Opening in 2002 at the Museum of Fine Arts, Houston, *The Quilts of Gee's Bend* moved to the Whitney Museum and then appeared at a dozen museums across the country. The exhibition closed in 2008, but by then two follow-up shows were touring the nation. Tinwood Alliance, now called the Soul's Grown Deep Foundation, next organized a series of eye-opening exhibitions focused on the work of Thornton Dial Sr. The 2012 *Creation Story: Gee's Bend Quilts and the Art of Thornton Dial*, organized by the Frist Center for the Visual Arts and the Soul's Grown Deep Foundation, showcased the shared debt that the quilters and Dial owed to African American aesthetic traditions.

Like the volumes of *Souls Grown Deep*, the books that accompanied these exhibitions are richly illustrated for those who want to take pleasure in their aesthetic nature. For those who want to understand the art's miraculous presence in the midst of 21st-century America, essayists investigate the artistic, historical, and social contexts in which these artists created. For those who desired both, aesthetics and context are uniquely married in these books, which set the standard for subsequent assessments of folk art in the South.

Scholars sharing Arnett's passion for African American vernacular art include Howard Dodson Jr., former director of the Schomburg Center for Research in Black Culture of the New York Public Library. He was the curator of the traveling exhibition *Testimony: Vernacular Art of the African-American South; The Ronald and June Shelp Collection*, which showcased more than two dozen artists whose works bear witness to social injustice in the 20th-century South. Similarly illuminating are the publications of Grey Gundaker, a professor at the College of William and Mary, whose books *Keep Your Head to the Sky: Interpreting African American Home Ground*, edited with Tynes Cowan, and *Signs of Diaspora / Diaspora of Signs: Literacies, Creolization, and Vernacular Practice in African America* were published in 1998. Gundaker and Judith McWillie's book *No Space Hidden: The Spirit of African American Yard Work* (2005) examines numerous examples of African American yard art to demonstrate a remarkable consistency of form and meaning. Equally committed to elucidating the context of vernacular art is Mechal Sobel, whose book *Painting a Hidden Life: The Art of Bill Traylor* (2005) challenges scholars to reexamine Traylor's work in light of his experiences and art making in the Jim Crow South. In particular, Sobel asserts that Traylor's covert imagery both masks and expresses his anguish at the murder or lynching of his son Will.

Other exhibitions, often accompanied by catalogs and books, demonstrate the nature of approaches to the study of contemporary self-taught art in the South. The range of exhibitions has included the American Folk Art Museum, the High Museum of Art, the Cheekwood Botanical Garden and Museum of Art, the University of Richmond Museums, the Mennolo Museum, Intuit: The Center for Intuitive and Outside Art, the Georgia Museum of Art, the Krannert Art Museum of the University of Illinois at Urbana-Champagne, the Art Museum of the University of Memphis, the Montgomery Museum of Art, and the Smithsonian American Art Museum.

Numerous exhibitions looking at specific genres of southern folk art also demonstrate advances in folk art scholarship and appreciation. The International Quilts Study Center and Museum at the University of Nebraska at Lincoln became the repository of Helen and Robert Cargo's African American quilts, which were featured in the 2003 traveling exhibition, *African American Quilts from the Helen and Robert Cargo Collection*, organized by the Textile Museum in Washington, D.C. The International Quilts Study Center and Museum also organized in 2011 an exhibition called *Yvonne Wells: Quilted Messages*. Quilts are a favorite form of folk art, and numerous museums have featured quilt exhibitions, most focusing on the quilts of individual states.

Scholars and collectors have made southern folk pottery a hot topic. The Mc-Kissick Museum at the University of South Carolina and the Mint Museum in Charlotte, N.C., have both organized striking exhibitions with well-illustrated catalogs. The McKissick's *Cross Roads of Clay: The Southern Alkaline-Glazed Stoneware Tradition*, which opened in Columbia, S.C., traveled throughout the South in 1990–91. Other trailblazing pottery exhibitions organized by the Mc-Kissick include *Great and Noble Jar: Traditional Stoneware of South Carolina* (1993) and the traveling exhibition *I Made This Jar: Life and Works of the En-slaved African American Potter Dave* (1998). The Mint Museum has organized notable exhibitions on North Carolina pottery, such as *North Carolina Pottery from the Kohn Collection* (2006) and *A Thriving Tradition: 75 Years of North Carolina Pottery* (2011). *The Potter's Eye: Art and Tradition in North Carolina Pottery* (2005) by Mark Hewitt and Nancy Sweezy is a catalog of the folk pot-tery that appeared in a special exhibition at the North Carolina Museum of Art in 2005–6. In 2008 the Museum for African Art in New York organized *Grass-roots: African Origins of an American Art*, an exhibition about sweet grass bas-kets. The 1995 exhibition and accompanying catalog *A Portion of the People: Three Hundred Years of Southern Jewish Life*, which was the product of a seven-year collaboration among the Jewish Historical Society of South Carolina, McKissick Museum of the University of South Carolina, and the College of Charleston, offers scholars a stellar model for future studies.

Nearly 100 years after its discovery, however, American folk art has yet to find a secure place in American art history. While a few major generalist mu-seums have integrated the work of self-taught artists into their chronological permanent installations of American art, most generalist museums define their missions as presenters of American fine art, European fine art, and world art. Even those generalist museums with collections of self-taught art may display it only in rare exhibitions that treat American self-taught art as a separate ex-pression of creation, a mere adjunct to American art history. Museums, in-cluding the Metropolitan Museum of Art; the Museum of Fine Arts, Boston; and other recipients of stellar donations of traditional folk art collected before the discovery of 20th-century folk art, have not made significant additions to their holdings. Folk art museums and enthusiasts of this work even today must actively advocate for the art they prize.

Advocates of traditional folk art argue most frequently for the inclusion of folk art within installations that purport to interpret the whole of American art history before the 20th century, whereas advocates for contemporary self-taught art often argue fervently for the inclusion of contemporary self-taught

artists within the framework of contemporary art. Comparisons of the work of 20th- and 21st-century self-taught to the work of the quasi-official mainstream art world, however, reveal sharp differences in markets, patronage, and collecting patterns. Participants in the art world concerned with self-taught art have to ask if equal aesthetic quality should result in equal prices and if evaluations of quality depend on pricing. These questions, which could not have been asked during the 1970s or 1980s, arise from the special history of folk art collecting. While the works of masters such as Bill Traylor and William Edmonson can be priced in the $100,000s and the works of other prominent artists like Howard Finster can fetch prices in the $10,000s, collectors and dealers of southern self-taught art have, for the most part, paid considerably lower prices for the work they admire. Indeed, many collectors of self-taught art are drawn to the art not just for the art's aesthetic directness but also by the fact that the art is affordable. In the South, however, the collecting of contemporary self-taught art, bound inextricably with racial and economic difference, has from time to time invited charges of exploitation.

The makers of contemporary self-taught art in the South have fashioned works of art that capture the imagination of people everywhere. From Patrick Sullivan's mention in *They Taught Themselves* to the feisty mixed-media creations of southern preachers, the yard show displays of African Americans, and the work of newly arrived immigrant artists, such as Cuban American Felipe Consalvos, southern folk art has forged a singular reputation as an authentic form of aesthetic expression entwined with everyday life. Because of the growing scholarly interest in folk art, the work of collectors, gallery owners, and museum professionals who espouse the significance of education, the growing presence of immigrant communities within the South, and art teachers at every level who incorporate folk art's study into their classrooms, southern self-taught art has become, in many ways, the field's best-known face in America. Coupled with the elemental role of folk art in modernist art, the exhibition and educational programming of a growing number of museums, the burgeoning numbers of folk art festivals and fairs, and collaborative projects that involve art, history, social studies, and technology, postsecondary classrooms' increasing recognition of art outside the mainstream assures that the South's contemporary folk art tradition will thrive in the 21st century.

CHERYL RIVERS
Brooklyn, New York

CAROL CROWN
University of Memphis

Julia S. Ardery, *The Temptation: Edgar Tolson and the Genesis of Twentieth-Century Folk Art* (1998); Paul Arnett and William Arnett, eds., *Souls Grown Deep: African American Vernacular Art of the South*, vol. 1 (2000); Paul Arnett, Joanne Cubbs, and Eugene W. Metcalf Jr., *Thornton Dial in the 21st Century* (2006); William Arnett and Paul Arnett, eds., *Souls Grown Deep: African American Vernacular Art*, vol. 2 (2001); John Beardsley, *Gee's Bend: The Women and Their Quilts* (2002); Cuesta Benberry, *Always There: The African-American Presence in American Quilts* (1992); John Bivins, Forsyth Alexander, and Museum of Early Southern Decorative Arts, *Regional Arts of the Early South: A Sampling from the Collection of the Museum of Early Southern Decorative Arts* (1991); John A. Burrison, *Brothers in Clay: The Story of Georgia Folk Pottery* (1983); *Roots of a Region: Southern Folk Culture* (2007); Richard L. Bushman, *The Refinement of America: Persons, Houses, Cities* (1992); Ashley Callahan, *A Colorful Past: Decorative Arts of Georgia* (2010); Deborah Chotner, *American Naive Paintings* (1992); Ronald Cohn and Jesse Russell, *The Historic New Orleans Collection* (2012); Kinshasha Conwill and Arthur C. Danto, *Testimony: Vernacular Art of the African-American South* (2001); Susan M. Crawley, *The Life and Art of Jimmy Sudduth* (2005), *The Treasure of Ulysses Davis: Sculpture from a Savannah Barbershop* (2008); Susan M. Crawley et al., *Drawings from the Collection of the High Museum of Art and the Montgomery Museum of Fine Art* (2012); Carol Crown, ed., *Coming Home! Self-Taught Artists, the Bible, and the American South* (2004), ed., *Wonders to Behold: The Visionary Art of Myrtice West* (1999); Carol Crown and Charles Russell, eds., *Sacred and Profane: Voice and Vision in Southern Self-Taught Art* (2007); Glen C. Davis, *Stranger in Paradise: The Worlds of Reverend Howard Finster* (2010); Andrew Dietz, *The Last Folk Hero: A True Story of Race and Art, Power and Profit* (2006); David C. Driskell et al., *Hard Truths: The Art of Thornton Dial* (2011); Allen H. Eaton, *Handicrafts of the Southern Highlands* (1937); William A. Fagaly, *Sister Gertrude Morgan: The Tools of Her Ministry* (2004); Howard Finster and Tom Patterson, *Howard Finster, Stranger from Another World: Man of Visions Now on This Earth* (1989); Gladys-Marie Fry, *Stitched from the Soul: Slave Quilts from the Antebellum South* (2002); Wendell Garrett, Virginia Mecklenburg, and Carolyn J. Weekley, *Earl Cunningham's America* (2007); Shelby R. Gilley, *Painting by Heart: The Life and Art of Clementine Hunter* (2000); Grey Gundaker, *Signs of Diaspora / Diaspora of Signs: Literacies, Creolization, and Vernacular Practice in African America* (1998); Grey Gundaker, with Tynes Cowan, ed., *Keep Your Head to the Sky: Interpreting African American Home Ground* (1998); Grey Gundaker and Judith McWillie, *No Space Hidden: The Spirit of African American Yard Work* (2005); Michael D. Hall and E. W. Metcalf, with Roger Cardinal, eds., *The Artist Outsider: Creativity and the Boundaries of Culture* (1994); Lynda Roscoe Hartigan, *Made with Passion: The Hemphill Folk Art Collection in the National Museum of American Art* (1991); Jeffrey Russell Hayes, Lucy R. Lippard, and Kenneth L. Ames, *Common Ground / Uncommon Vision: The Michael and Julie*

Hall Collection of American Folk Art (1993); Josef Helfenstein and Roman Kurzmeyer, eds., *Deep Blues: Bill Traylor, 1854–1949* (1999); Josef Helfenstein and Roxanne Stanulis, eds., *Bill Traylor, William Edmondson, and the Modernist Impulse* (2005); Herbert W. Hemphill Jr. and Julia Weismann, *Twentieth-Century American Folk Art and Artists* (1974); Robert Henri, *The Craftsman* (18 May 1910); Bernard L. Herman, ed., *Thornton Dial: Thoughts on Paper* (2012); Mark Hewitt and Nancy Sweezy, *The Potter's Eye: Art and Tradition in North Carolina Pottery* (2005); Jack D. Holden, *Furnishing Louisiana: Creole and Acadian Furniture, 1735–1835* (2010); Stacy Hollander, *American Radiance: The Ralph Esmerian Gift to the American Folk Art Museum* (2011); Stacy C. Hollander and Brooke Davis Anderson, *American Anthem: Masterworks from the American Folk Art Museum* (2022); Laurel Horton, *Quiltmaking in America: Beyond the Myths* (1994); Ronald Hurst and Jonathan Prown, *Southern Furniture, 1680–1830: The Williamsburg Collection* (1997); David Jaffee, *A New Nation of Goods: The Material Culture of Early America* (2010); Mitchell D. Kahan, *Heavenly Visions: The Art of Minnie Evans* (1986); Norman L. Kleebatt and Gerard C. Wertkin, *The Jewish Heritage in American Folk Art* (1984); Lee Kogan, *The Art of Nellie Mae Rowe: Ninety-Nine and a Half Won't Do* (1998); Donald B. Kuspit et al., *Painting in the South, 1564–1980* (1983); Betty M. Kuyk, *African Voices in the African American Heritage* (2003); Ramona Lampell and Millard Lampell, with David Larkin, *O Appalachia: Artists of the Southern Mountains* (1989); Jean Lipman and Alice Winchester, *The Flowering of American Folk Art, 1776–1876* (1974); Paula W. Locklair, *Quilts, Coverlets, and Counterpanes: Bedcovering from the Museum of Early Southern Decorative Arts and Old Salem* (1997); Elsa Longhauser and Harald Szeeman, eds., *Self-Taught Artists of the 20th Century: An American Anthology* (1998); McKissick Museum, *Carolina Folk: The Cradle of a Southern Tradition* (1986); Eugene Metcalf and Michael Hall, *Folk Art in Contemporary American Culture: The Ties That Bind* (1986); Museum of Early Southern Decorative Arts, *Southern Perspective: A Sampling from the Museum of Early Southern Decorative Arts* (2005); Jessie Poesch, *The Art of the Old South: Painting, Sculpture, Architecture, and the Products of Craftsmen, 1560–1860* (1983); Bet Ramsey and Merikay Waldvogel, *Southern Quilts: Surviving Relics of the Civil War* (1998); Cynthia Elyce Rubin, ed., *Southern Folk Art* (1985); William Keyse Rudolph and Patricia Brady, *In Search of Julien Hudson: Free Artist of Color in Pre-Civil War New Orleans* (2011); Beatrix T. Rumford, *American Folk Portraits: Paintings and Drawings from the Abby Aldrich Rockefeller Folk Art Center* (1988), *American Folk Paintings: Paintings and Drawings Other Than Portraits from the Abby Aldrich Rockefeller Folk Art Center* (1989); Beatrix T. Rumford and Carolyn J. Weekley, *Treasures of American Folk Art from the Abby Aldrich Rockefeller Folk Art Center* (1989); Charles Russell, ed., *Self-Taught Art: The Culture and Aesthetics of American Vernacular Art* (2001), *Groundwaters: A Century of Art by Self-Taught and Outsider Artists* (2011); Mark W. Scala, *Creation Story: Gee's Bend Quilts and the Art of Thornton Dial* (2012); Lynne E. Spriggs, *Local Heroes: Paint-*

ings and Sculpture by Sam Doyle (2000); Lynne E. Spriggs et al., *Let It Shine: Self-Taught Art from the T. Marshall Hall Collection* (2001); Mechal Sobel, *Painting a Hidden Life: The Art of Bill Traylor* (2005); Cecilia Steinfeldt, *Art for History's Sake: The Texas Collection of the Witte Museum* (1993); Nancy Sweezy, *Raised in Clay: The Southern Pottery Tradition* (1995); Robert Farris Thompson, *Flash of the Spirit: African and Afro-American Art and Philosophy* (1984), *The Art of William Edmondson* (1999); Maurice Tuchman and Carol S. Eliel, eds., *Parallel Visions: Modern Artists and Outsider Art* (1992); John Turner, *Howard Finster: Man of Visions* (1989); Alvia J. Wardlaw, *Black Art / Ancestral Legacy: The African Impulse in African American Art* (1990); Elizabeth Warren, *Quilts: Masterworks from the American Folk Art Museum* (2010); Carolyn J. Weekley et al., *Joshua Johnson: Freeman an Early American Portrait Painter* (1987); Alice Rae Yelen, *Passionate Visions of the American South: Self-Taught Artists from 1940 to the Present* (1993); Charles G. Zug III, *Turners and Burners: The Folk Potters of North Carolina* (1990).

African American Expressions

Because Africans enslaved in America received only the basic necessities of life, many captives in antebellum America as well as free blacks had to improvise with whatever material they could find, relying, for the most part, on memories of their African pasts. A carved wooden spoon discovered in the 1930s in the Old Fort area of Savannah, Ga., and estimated to "be more than a century old," demonstrates a strong association with African forms. Its anthropomorphized handle, especially its "hands akimbo," recalls ancient wooden ceremonial ladles or scoops found among the Dan, Senufo, and Baule peoples of West Africa. Pottery fragments of the so-called Colono ware excavated from plantations in the South and dated to the late 17th and middle of the 18th centuries bear decorative motifs—crosses enclosed in circles and triangles—reminiscent of cosmograms from Kongo and Yombe cultures in present-day Democratic Republic of Congo. The diamond-shaped patterns, each with a banded background, a six-point star with tiny circles on each point, and denticulate lines found on 17th-century pipes excavated from sites in Virginia and Maryland, hint at an African connection as well. Strikingly similar patterns known as *kwardata* appear on pottery from Ghana and Nigeria—two areas from which many slaves were imported to Virginia in the 17th and 18th centuries. Equally important is the close resemblance between coiled baskets from South Carolina and baskets from different parts of the western Guinea Coast, especially among the Wollof, Serer, Mende, Kissi, Temne, and Gola. The similarity may be more than mere coincidence, since the South imported many blacks from this part of West Africa known as the "Rice Coast" in the slavery era to boost rice farming in the Carolina and Georgian Lowcountry. Recent research has revealed other African carryovers, or Africanisms, in musical instruments, dance styles, religious rituals, wood carving, blacksmithing, quilting, architecture, and graveyard decoration, most especially in the Deep South.

A review of these carryovers reveals a wide range of skills—from the highly professional to the amateurish—suggesting that the more accomplished works might have been made by slaves with previous training in Africa, and the lesser pieces, by novices. A wooden drum reportedly seized from slaves in 17th-century Virginia and remarkably similar to the *atumpan* talking-drums of the Akan of present-day Ghana and Côte d'Ivoire suggests that its maker might have created similar ones in Africa before being enslaved. In Colonial Virginia, names such as "Quacko," "Cuffy," and "Quame" are no more than Anglicized versions of "Kwaku," "Kofi," and "Kwame"—Akan names for persons born on Wednesday, Friday, and Saturday. The influence of Kongo culture on the South is also extensive. The bulging kaolin eyes and bared teeth of the glazed "face

vessels" produced in the mid-19th century by African slaves in Edgefield, S.C., recall the typical *nkisi* "power" figures of the Kongo. The stylistic similarity is not surprising, as large numbers of Kongo slaves lived in the antebellum South. Most of the last consignment of Kongo people, who arrived on the *Wanderer* in 1858, were sold to Edgefield planters. One Edgefield pottery factory ledger includes a potter called Romeo, aka Tahro, now thought to be one of the Kongo captives brought by the *Wanderer*. The same Romeo later built a Kongo-type house in Edgefield, thus suggesting that some carvers-turned-potters from Equatorial Africa created Edgefield face vessels.

While makers of the Virginia drum and the Edgefield face vessels might have had formal art training in Africa, they were not recognized as artists; Euro-American concepts of "fine arts" focused on naturalism—the opposite of the African emphasis on stylization, which the slave masters ridiculed as "primitive" attempts to imitate nature. However, the coexistence of stylized and realistic forms in African art from prehistoric times to the present suggests that disregard for naturalism was deliberate. The emphasis on stylization seems to arise from a belief in duality, necessitating artists to create a rationalized rather than a descriptive image to present reality as an interface of spirit and matter. The head dominates a typical African figure sculpture because of its perception as the "lord" of the body and the locus of the vital force that constitutes the sine qua non of life. The devaluation of African stylization during the slavery era impelled African American artists like Robert S. Duncanson, Edward M. Bannister, Mary E. Lewis, Henry O. Tanner, and others to disconnect from their African artistic heritage and acquire formal training in Euro-American aesthetics. Nonetheless, white patronage of black-made products such as basketry and quilts enabled some families to transmit African carryovers from one generation to another. At the same time, the circumstances of slavery and use of visual symbols for empowerment resulted in an exponential increase in the number of *bricoleurs* and self-taught black artists who continued African aesthetic carryovers. These artists also drew inspiration from specialists such as diviners, root doctors, and Vodun priests noted for their deep knowledge of the African past.

A walking stick now in the collection of the Yale University Art Gallery carved by Henry Gudgell in 1867 so resembles wooden canes and staffs from Equatorial Africa that one might be led to assume that its carver came from that area. Yet Gudgell, born into slavery in Kentucky in 1826, apparently inherited aesthetic traditions from a carver who had produced similar canes in Africa. Mississippi-born carver Leon Rucker (b. 1894) tutored by his enslaved African-born grandfather Lewis Rucker, a herbalist, claimed that the inspiration for

the reptile and bird motifs on his walking sticks came from a vision during which a strange voice spoke to him. Although self-taught artists still produce similar walking sticks in many parts of the South today, the exact meaning of the snake motif on them has since been forgotten. It is possible, however, that past generations may have chosen the motif because of its alleged magical, life-sustaining powers. For instance, in the African/Fon-derived Vodou religion, called Voodoo in New Orleans, the snake signifies the celestial serpent Damballah, the source of dynamic motion and regeneration. Because Gudgell gave the snake walking stick to John Bryan, who was badly wounded during the Civil War, Gudgell may well have had the healing power of Damballah in mind.

In short, the first batch of African captives laid the foundation of what we now identify as African American self-taught art, informally passing down their visual reminiscences to American-born descendants. The legacy has since been transformed through individual efforts into a mosaic; some aesthetic approaches are recognizably African, some are Euro-American. Other creations synthesize the African and American reflecting W. E. B. Du Bois's "double-consciousness," the twoness of the black experience in the United States.

Thanks to the influence of African and non-Western abstraction on modern art at the turn of the 20th century, the boundary formerly separating the conceptual approach of the self-taught artist from that of the formally taught artist virtually disappeared and, along with it, the bias that previously prevented art critics from recognizing self-taught artists' inventiveness. Today, the works of the formally and informally trained artists hang side by side in major museums, attesting to the dawn of a new era in art production and appreciation not dependent on artists' educational backgrounds.

Though found all over the United States, many self-taught black artists hail from the Deep South. Many of them did not complete primary or high school education before dropping out to satisfy their creative impulses or to take advantage of the growing market in self-taught art. Some became artists after retiring from a full-time job or as a result of a physical handicap. Others claimed to have had a vision during which a strange voice commanded them to draw, paint, or carve. The content of their works may be inspired by a variety of sources, such as creative family members, folklore, historical or topical events, found objects, the mass media, popular art, biblical stories, rituals, and dreams, as well as ancient and recent African influences. The images are characterized by schematized or highly simplified forms, sometimes with a touch of humor and a decorative use of color. There is less emphasis on technique and craftsmanship but more on improvisation and personalized and direct expression of feelings and ideas.

QUILTS AS COMFORTERS AND VISUAL METAPHORS. The "Do-It-Yourself" imperative of the slavery era found one of its most eloquent artistic expressions in quilts. African Americans tailored their own clothes, fashioning warm clothes from hand-me-downs and from plain cloth given them by owners. African captives did not have to build their own looms. Instead, weavers worked on European looms set to produce European-type textiles. As a result, it is very difficult today to distinguish between textiles woven or sewn by slaves and those created by Euro-American craftsmen, especially since slaves frequently worked under the supervision or in collaboration with slave mistresses or masters' wives. However, slaves had more freedom when making personal quilts that reflected their taste and skills. Quilts for personal use also continued African textile design traditions—particularly, the use of colors and complex patterning with aesthetic, social, political, or spiritual implications. As Robert Thompson, Cuesta Benberry, Maude Southwell Wahlman, Carolyn Mazloomi, and many others have pointed out, African American quilts display both ancient and also more recent African influences not only in their emphasis on strip construction, large-scale designs, a wide array of colors, and asymmetrical, improvised/offbeat patterns but also in the use of designs as visual metaphors. Many quilters both consciously and unconsciously synthesized African with Euro-American elements, while other African American quilters were not aware of African aesthetic traditions or preferred other styles.

Students of African art recognize that many African-derived motifs such as the snake continue to appear as symbols or visual metaphors in African American art. A clear use of symbolism appears in Harriet Powers's *1886 Bible Quilt*. Although illustrating Old and New Testament events, Powers seems to have added African-derived symbols and folkloric references. Her figural forms, and indeed her use of appliqué, closely resemble the textile traditions of the Fon people of Dahomey, the present-day Benin Republic. However, Harriet Powers was born in Athens, Ga. Is this similarity fortuitous or the result of Powers's direct or indirect contact with West African textiles or with the Fon culture, whose impact in the South is evident in the Voodoo religion of New Orleans?

The scholarly emphasis on symbolism, while fruitful, has in recent years led to assertions that well-known quilt patterns may have encoded messages that could lead escaping slaves to the Underground Railroad, a network of clandestine escape routes maintained by free blacks and abolitionists between the late 18th century and the end of the Civil War. This assertion is certainly appealing. However, scholars from many disciplines reject the theory, arguing that some patterns in the so-called Underground Railroad quilts were not cur-

rent until much later and that the theory lacks documentation. Assertions that some African American quilts use African motifs and labyrinthine patterning to confuse evil spirits and so prevent them from harming their targets have more support. The hand motif, which African American folklore associates with mojo—a spell of African origin with powers to attract good luck or protect an individual from negative forces appears in many quilts. Incidentally, the African American term "mojo" may derive from *mooyo*, the Kongo word for the belly or cavity of an *nkisi* power figure in which the charm, or *bilongo*, for activating it is kept.

By and large, while contemporary African American quilts have become much more sophisticated in response to the dynamics of change and the availability of new materials, a lot of them still attempt to relate the past to the present. A recent exhibition of the works of 45 quilters (covering four generations) from Gee's Bend, Ala., reflects this dynamic of continuity and change in the simplicity, complexity, and modernization of material and design, and the coexistence of the old and the new in form, style, and iconography.

YARD SHOWS, BOTTLE TREES, SITE-SPECIFIC INSTALLATIONS, AND GRAVE-YARD DECORATION. The "picturesque" house or garden is a conspicuous aspect of the southern landscape. Black sites often draw attention by improvisational combinations of discarded articles such as auto parts, dolls, toys, assorted plastic objects, glassware, ceramics, pipes, and wooden cabinets strategically or randomly displayed among plants and flowers. The yard show, also described as an art environment, began in antebellum times when, in continuation of visual practice on the other side of the Atlantic, captives decorated their residences with odds and ends that fulfilled aesthetic, social, or spiritual customs. Since the end of the Civil War, the practice has become more complex: old symbols, such as plants, driftwood, particular colors, ideograms, sculptures, paintings, and texts, now mix with new ones such as castoff tires, wheels, clocks, and lamps to convey various messages. The recurrence of motifs such as hubcaps, pinwheels, whirligigs, and rotary blades has led art historian Robert F. Thompson to compare these motifs to the circular movement of the "ring shout" dance that entered Christian worship in the South. According to Thompson, the motifs, like the circles on Colono ware, might have evolved from the cosmograms of the Kongo, such as the *dikenga*—a cross within a circle alluding to the crossroads, cosmic motion, spiritual strength, and the eternal cycle of the soul. The reflective objects found in many yard shows have been compared to the mirrors on some Kongo *nkisi* "power" figures expected to monitor, repel, or deflect evil forces. Scholars have noted the presence of reflective and circular objects and

monitory signage in the yard shows of such artists as Joe Minter, David Butler, Lonnie Holley, Dilmus Hall, Rev. Herman D. Dennis, Joe Light, Mary T. Smith, and Hawkins Bolden. In many parts of Africa, charms and bottlelike gourds may be suspended conspicuously on long poles or trees to protect one's property or ward off negative forces. The attachment of glass and plastic bottles to trees or poles in African American yards for identical purposes continues this tradition, though some artists claim that their installations have purely aesthetic functions.

Black graveyards were easily identified in antebellum times by objects displayed on them including carved images. Mourners intended certain articles for the use in the afterlife. In some cases, plaster was used to stick coins, medals, shells, and other objects onto ceramic vessels, so-called memory jars, a tradition that continued into the early 20th century. In the Sunbury Baptist Church Cemetery in Liberty County, Ga., Cyrus Bowens decorated the circa 1920 graves of family members with stylized wooden sculptures (one resembling a serpent), concrete slabs adorned with mirrors, automobile headlights, glasses, and various bottles. Recent grave articles documented in other parts of the South include sewing machines, lamps, flashlights, medicine bottles, cutlery, dishes, peppershakers, saltcellars, piggy banks, plastic toys, glass pitchers, flowerpots, clocks, eyeglasses, and flashlights. Some sites may feature conch and oyster shells, which are deemed to have the spiritual power to guide souls back to the ancestral homeland via the sea. In the past, custom demanded that the items last used by the deceased also be displayed to prevent his or her soul from coming back to ask for them or from wandering about, harassing relatives. Nowadays, flowers frequently serve as symbolic substitutes for traditional articles.

IMAGING THE SACRED. Admittedly, contemporary African American belief in an afterlife has been heavily influenced by the book of Revelation's prediction of an approaching "end of time," after which the souls of the dead would be resurrected and judged according to their deeds on earth. Yet the idea that a soul can wander about or return to ask for previously used articles hints at a pre–Christian African ancestral notion of reality as an interface of spirit and matter. The notion stems from a popular myth that the body is a divinely inspired work of art empowered by a vital force or soul. An individual is alive so long as the soul resides in his or her body; death results when the soul leaves the body. However, death is not the end of existence but a separation of spirit from matter and the return of a soul to the hereafter, from where it may reincarnate as

a newborn baby to begin another life on earth. In short, the belief that the body, as a work of art, manifests and mediates the spirit or soul on earth also explains the popularity of spirit possession in indigenous African religions. This phenomenon is often interpreted as the moment when a supernatural power takes over a medium's body, using it as a mask for interacting with mortals. Consequently, the medium behaves differently, speaking in tongues. It is enough to say that the phenomenon has encouraged the use of stylized altar figures as functional substitutes for the body to facilitate communication between the physical and metaphysical worlds. And as several African cosmologies trace the origin of art and the body to supernatural beings (or a supreme deity), it is not surprising that the creative process is often ritualized to link the artist to the source of creation. Little wonder that many indigenous or traditionally trained African artists make offerings to their tools, frequently undergoing trances or spiritual guidance before or while executing important commissions.

There is ample evidence that much of this worldview survived the middle passage, even if in hybrid forms. For instance, eyewitness accounts of church services during the antebellum period described black worshipers as displaying gestures and movements that suggested possession. In the 1930s, Robert Pinckney, a former slave in his eighties recalled, in his interview with members of the Georgia Writers' Project, occasions when African slaves produced clay figures and danced around them in remembrance of their ancestors. One of the figures holding a spear in his hand brings to mind the use of "sentinel" figures in different parts of Africa to honor deceased ancestors and at the same time implore them to protect the living. Chances are that some of the Edgefield face vessels, sometimes called voodoo pots, performed similar functions, though their original contexts remain obscure. Self-taught artists continue to create similar images for ritual purposes in many parts of the South, and in Santeria—the worship of Yoruba deities in the guise of Roman Catholic saints—introduced to the United States in the early 20th century by Afro-Cubans. Since then, Santeria has attracted hundreds of thousands of African American followers. The ancient African association of tree roots with herbal medicine and magic would seem to have survived in the African American tradition of using root sculptures for conjure and healing purposes.

Simply put, such was the interconnectedness of art, life, and religion in their homelands that African captives held on to it after the middle passage, despite their conversion to Christianity.

BABTUNDE LAWAL
Virginia Commonwealth University

Paul Arnett and William Arnett, eds., *Souls Grown Deep: African American Vernacular Art of the South*, vol. 1 (2000); William Arnett et al., *Gee's Bend: Architecture of the Quilt* (2006); William Arnett and Paul Arnett, eds., *Souls Grown Deep: African American Vernacular Art*, vol. 2 (2001); Cinda K. Baldwin, *American Visions: The Magazine of Afro-American Culture* (1990); Cuesta Benberry, *Always There: The African-American Presence in American Quilts* (1992); Carol Crown, ed., *Coming Home! Self-Taught Artists, the Bible, and the American South* (2004); Georgia Writers' Project, *Drums and Shadows: Survival Studies among the Georgian Coastal Negroes* (1940); Paul Harrison, Victor L. Walker, and Gus Edwards, eds., *Ritual Performance in the African Diaspora* (2002); Lynda Roscoe Hartigan, *Made with Passion* (1990); Joseph. E. Holloway, ed., *Africanisms in American Culture* (2005); Jane Livingston and John Beardsley, *Black Folk Art in America, 1930–1980* (1982); Wyatt MacGaffey and Michael Harris, *Astonishment and Power* (1993); Geoffrey Parrinder, *African Mythology* (1967); Albert J. Raboteau, *Canaan Land: A Religious History of African Americans* (2001); Armstead L. Robinson et al., eds., *Black Studies in the University* (1969); Dale Rosengarten, Theodore Rosengarten, and Enid Schildkrout, *Grass Roots: African Origins of an American Art* (2008); Theophilus H. Smith, *Conjuring Culture: Biblical Formations of Black America* (1994); Robert Farris Thompson, *Flash of the Spirit: African and Afro-American Art and Philosophy* (1984); Robert Farris Thompson and Joseph Cornet, *The Four Moments of the Sun: Kongo Art in Two Worlds* (1981); Robert Ferris Thompson, Don Mason Johnson, and Judith McWillie, *Another Face of the Diamond: Pathways through the Black Atlantic South* (1988); John M. Vlach, *The Afro-American Tradition in Decorative Arts* (1990); Maude Southwell Wahlman, *Signs and Symbols: African Images in African American Quilts* (1993); Richard Westmacott, *African American Gardens and Yards in the Rural South* (1992).

African American Protective Arts

Although African Americans incorporated African beliefs into Christianity, the Vodun (or Vodou) religion did not openly fuse with Protestant Christianity but usually led an underground existence involving rituals to call up the power of spirits or ancestors for advice or protection. Recently deceased relatives were thought to be links between the world of the living and the realm of gods or ancestors. They could work for good or evil, and so must be wooed or protected against, sometimes with charms. "Haints" or "haunts" were troublesome ghosts, evil spirits of those ancestors who were not honored or were without descendants to help, protect, or heal.

To conjure is to call upon spiritual powers to activate a charm, cure a sickness, or heal an emotional or physical wound. African Americans with physical and spiritual talents are sometimes referred to as conjuremen, conjurewomen,

root doctors, or hoodoo doctors—hoodoo being a derivation of Vodou. Born a slave in 1855, Sarah Colbert, who grew up in Kentucky, later told how slaves sometimes "went to one of the witchcrafters for a charm against cruel owners." "Gullah Jack" (Jack Pritchard) came from Angola and lived in South Carolina in the 19th century. He "had his conjuring implements with him in a bag which he brought on board the ship and always retained them." The 19th-century quilter Harriet Powers may have been a conjurewoman, as she was photographed wearing a ceremonial apron with appliquéd symbols for Christian, Fon, Kongo, and Masonic images. Images in contemporary paintings, such as Sam Doyle's *Doctor Buzzard*, refer to root doctors or conjuremen. J. B. Murray and Nellie Mae Rowe also painted images of conjuremen and spirits.

Archaeological excavations have uncovered ritual artifacts used in African American healing and divination rituals. One protective cache, dated 1790–1800, included quartz crystals, bone disks, a ceramic fragment, and other artifacts, which have been interpreted as evidence of "root men and root women." Quartz crystals are found in important Kongo charms, representing special ancestral *simbi* spirits, and perforated bone disks are worn to protect the circle of the soul.

Another collection, from a conjureman's cabin in southern Texas, includes cast-iron-kettle bases, chalk fragments, bird skulls, weighing-scale fragments, an animal's paw, medicine samples, seashells, bottles, doll parts, spoons, nails, knives, chert scrapers, and a flintlike rock. This collection recalls Kongo assemblages of medicines found in *Minkisi* charms and African Cuban artifacts used in association with a ritual pot, called a *prenda*, which is often marked with chalk crosses. Cowrie shell beads, a form of currency in West Africa, were later worn as symbols of wealth and as charms. Cowrie shells and colored glass beads have been found in Virginia, North Carolina, Louisiana, and Texas. Blue beads are thought to be particularly protective, a practice that may relate to the Muslim belief that a single blue bead worn or sewn on clothing protects one against "the evil eye." Five of the slave women photographed in 1862 at the Drayton Plantation on Hilton Head Island, S.C., wear beaded necklaces, probably "charm strings," designed to bring good luck to the wearer. In *Huckleberry Finn*, "Jim always kept that five-center piece around his neck with a string and said it was the charm the devil give to him with his own hand and told him he could cure anybody with it and fetch witches when ever he wanted to, just by saying something to it." The flash of the round silver nickel could protect his spirit and bring him money.

An African American amulet is often called a "mojo" or an "and," as in "helping hand." Two brass charms, each stamped with a clenched fist and dated

to 1820, were found in African American housing at the Hermitage, home of Andrew Jackson near Nashville, Tenn. The hand-shaped charms of African-oriented spiritualist societies were widely used from at least 1850. Hands often appear in paintings by Nellie Mae Rowe. Dilmus Hall made a protective cement house charm with two blue hands.

Most African American cloth charms, also called "mojo" or "hand," are worn around the neck or carried in a pocket, even by people who profess not to believe in Vodou. Charles Joyner writes, "slaves wore herbs in pouches as a preventative." In South Carolina, the Gullah people have several terms (conjure bag, goofa bag, hand, mojo, and *wanga*) for their cloth charms. Hair is considered a powerful ingredient to include in a charm, because it grows near the brain, and "a hand made of hair can sure affect the brain." Conjurers "mixed hair, nails, thimbles, and needles in a 'conjure bag' or 'a little bottle' and have roots and water in it and sulpher." A Mystic Mojo Love Sachet is thought to make one popular, successful, and happy. An African American from Florida recalled that an "old witch doctor, he want ten dollars for a piece of string, what he say some kinds words over. . . . I didn't have no ten dollars so he ifen I git up five dollar he make me a hand—you know what colored folks call a jack. Dat be a charm what will keep witches away. I knows how to make em, but day donan do no good thout de magic words, and I doan know dem."

Zora Neale Hurston found the magic words for how to make a "hand" charm:

> Take a piece of the fig leaf, sycamore bark, John de Conquer root, John de Conquer vine, three paradise seeds. Take a piece of paper and draw a square and let the party write his wishes. Begin, "I want to be successful in all my undertakings." Then cut the paper from around the square and let him tear it up fine and throw it in front of the business place or house or wherever he wants. Put the square in the "hand" and sew all up in red flannel. Sew with a strong thread and when seams are closed, pass the thread back and forth through the bag 'til all the thread is used up. To pour on "hand": oil of anise, oil of rose geranium, violet perfume, oil of lavender, verbena, bay rum. "Hand must be renewed every six months."

A gnarled and twisted root, or a black snakeroot, known as "High John the Conqueror," may be ground into powder, carved, or left in its natural state.

Contemporary African American artists carry on Kongo root traditions. Jesse Aaron protected his home by carving his trees to create living charms. He used roots and found wood to create his protective animal forms. Dilmus Hall made protective house charms from roots. Mose Tolliver recalled that as a child

he gathered and painted roots. The root and stick sculptures of Bessie Harvey and Steve Ashby may derive from Kongo twisted root charms. Hawkins Bolden used roots consistently, as did Archie Byron. Joe Light said, "I like to attach certain things to my pictures. . . . Place mats, toys, reflectors, roots." Thornton Dial's sculptures and assemblages, such as *The Refugees*, incorporate roots. Dial says, "Roots symbolize the oldest things, all those things that come to be part of a man's life."

African American graves are also charms, often decorated with clocks, glass, lamps, headlights, mirrors, white objects, tinfoil, shells, and containers that probably refer to the watery realm of African Kongo ancestors. A 1943 reference to African American graves in Georgia reads "sometimes they carved rude wooden figures like images or idols, and sometimes a patchwork quilt was laid upon the grave." Clocks on graves may refer to the Kongo cosmogram that maps the circle of life or the hourglass that marks the passing (death in African American lingo) into another world.

Trees are symbols of the vertical link between the living and ancestors. The graves in Siras Bowen's family burial ground in Sunbury, Ga., incorporated writing as well as calligraphic forms created from crooked trees and twisted roots. Wooden sculptures crafted from roots were adapted to create a circle and a cross. A yellow clay marker honoring Rachel Bowen is incised with her name, the date 1937, some indecipherable signs, and "the outline of an open hand with a small mirror glittering in the palm." The mirror may represent water, ancestral power, or the flash of a spirit. The hand may represent the person herself or a helping hand.

Numerous African American graves are also decorated with shells, a recurring motif that refers to the watery realm of the ancestors. In Sam Doyle's paintings of Dr. Buzzard, the Gullah root doctor holds a conch shell to his ear as he listens to ancestral voices. Large shells decorate some graves even in northern Alabama, a long way from the coast. Lamps also guide the deceased to the ancestors. A white lamp on an Alabama grave may be a symbol of the light needed to guide one's soul. The color refers to white kaolin clay found under the water, site of ancestral power in Kongo religion. Graveyard dust, a key ingredient in mojo charms, activates ancestral power.

Like graves, spirit jugs or memory bottles are embellished with magical substances to ensure the safe passage of the deceased. Such jugs were sometimes placed on African American graves. However, many ethnic groups made such objects during (and, in some cases, before) the Victorian era, and so it is difficult to know who invented the idea. One is tempted to credit African Americans, because these objects fall so nicely in the African American tradition of

accumulating "medicines" inside or outside a form, as charms. They are another way of honoring an ancestral spirit and calling on its power for insight, guidance, luck, protection, and healing. An anonymous and seemingly innocent household object, a 1920 African American sewing box from North Carolina, was transformed with additional symbolic elements into a charm box. It was probably made by a woman, who added pearls, beads, shells, and water-worn pebbles around a stuffed center, originally a pincushion.

In Africa and in the Americas, ceramic pots with faces were made to commemorate the dead and protect the grave. The face sculptures of Dilmus Hall, Nellie Mae Rowe, James "Son Ford" Thomas, and Lonnie Holley are key links in a long chain of protective clay charms. Some examples, notably those by Thomas, who worked as gravedigger, grew consciously from the funerary tradition.

Numerous devices protect African American homes and yards. Lights, porch mirrors, door jars, moving wheels and fans, protective herbs, rock boundaries, root sculpture, signs, scripts, tree sculptures, and bottle trees function as visual medicines. Porch mirrors "keep certain forces at a distance," and pots placed near a doorway "send back evil to its sources." The yard constructions of David Butler, Lonnie Holley, Hawkins Bolden, Joe Minter, and George Kornegay continue to reinvent these protective traditions. Mardi Gras beaded costumes may also serve as a link to African textiles that protect, heal, and encode ideas. The New Orleans vodou doll probably originated in Kongo traditions brought to the United States by enslaved Africans and later by Haitian emigrants. One also sees spirit figures in contemporary African American vernacular art. Clementine Hunter made a charm doll from a calabash with secret compartments for magical, protective substances. The painter Nellie Mae Rowe made red cloth dolls. Quilters Sarah Mary Taylor and her mother, Pearlie Posey, appliquéd designs with red figures reminiscent of vodou dolls. Taylor's *Mermaid* quilt with appliquéd vodou dolls, red squares, and blue hands demonstrates the persistence of African traditions.

MAUDE SOUTHWELL WAHLMAN
University of Missouri at Kansas City

Robert Farris Thompson, *Flash of the Spirit: African and Afro-American Art and Philosophy* (1983); Maude Southwell Wahlman, in *Self-Taught Art: The Culture and Aesthetics of American Vernacular Art*, ed. Charles Russell (1997).

Art Cars

Part expression of freedom, part public art, part personal altar, and part self-promotion device, "art cars" have become lasting icons of American individu-

alism and spirit. Referring to any road-worthy vehicle that has been transformed into a unique creation, art cars convert our most recognizable mass-produced commodities into moving sculpture.

A phenomenon linked most closely with California car culture, art cars have variegated roots. Although customizing and racing automobiles began in the 1920s, America's passion for cars burgeoned after the end of World War II, when the American dream of owning a new car became reality for the average family. The automobile became a highly visible and mobile front upon which individuals could declare their personas. In the urban areas of California and Texas in particular, Anglo Americans and Mexican Americans, or Chicanos, took the customizing of cars in opposing directions, making vehicles the very embodiment of cultural affiliation.

Mechanically inclined Anglo American youths, often called greasers, focused largely on souped-up engines and the flashy paint jobs that would characterize "hot rods." The *pachucos*, a subculture of Chicano youth, were more intrigued with style, class, and over-the-top decoration. "Lowriders," named for modified suspensions that brought the car extremely low to the ground, were not tricked out for racing but for a slow, flamboyant cruise.

Both hotrods and lowriders were streams that fed that greater American imagination. Also in Los Angeles, Russian immigrant Nudie Cohn (Nutya Kotlyrenko) would become famous not only for his over-the-top western wear but also as an early maker of art cars. *Life* magazine ran a feature story on Cohn and his customized 1950 Pontiac Hudson, prompting Pontiac to give Cohn a new car to decorate every year; the previous year's models were ceremoniously passed on to various Nashville and Texas musicians, sprinkling the outrageous creations throughout the country. In 1971 Pontiac ended the promotion, and Cohn purchased a Cadillac El Dorado, which he encrusted in silver dollars, detailed with a hand-tooled leather interior, outfitted with door handles shaped like pistols, and crowned with his signature steer horns on the hood. When driving, Cohn played at high volume an eight-track tape recording of horses neighing and cows lowing.

Rooted perhaps in equal measure to lowriders, hotrods, and the American entrepreneurial spirit, art cars celebrate not the speed with which you arrive, but the panache with which you do it. Texas has become particularly associated with art cars ever since the Orange Show Foundation for Visionary Art in Houston auctioned off a donated art car in 1984. The winner in turn donated the "Fruit Mobile" back to the Orange Show, where it became an automotive ambassador for this organization dedicated to celebrating individual vision in art. Some years later the Orange Show organized a traveling show of art cars

and established an annual art car parade that draws tourists and art lovers to Houston. Filmmaker Harrod Blank of California furthered the fan appeal of art cars in his 1992 documentary *Wild Wheels*. Also in Houston is the Art Car Museum, which opened in 1998.

LESLIE UMBERGER
Smithsonian American Art Museum

Jeffrey Kastner, *Raw Vision* (Summer 1993).

Art Education

Folk art—both traditional and contemporary—plays an important role in elementary, secondary, and university art education programs throughout the South. Whether integrated in comprehensive art lessons taught by arts specialists or cotaught with folk artists in school residencies or intergenerational community initiatives, folk art in education provides meaningful curricula and addresses state and national academic standards. In many rural and urban areas of the South with limited access to museums, integrating folk art into the curriculum also provides access to real works of art that are culturally significant. Moreover, the study of folk art, which is a remarkably accessible aesthetic form, offers significant ways to study cultural traditions and community celebrations. In classrooms across the South, students research and discuss the narrative work of Clementine Hunter and learn about life on a southern plantation. Students learn about cultural heritages and the contexts in which folk art is created, and they are encouraged to tell their own stories and find their own voices to communicate social issues and cultural traditions.

The emergence of folk art in education can be traced to the 1920s, when it was common practice for art education periodicals to feature folk traditions. Educators such as John Dewey embraced a child-centered approach to teaching that emphasized respect for diversity. Although folk art entered the curriculum, it remained a discretionary supplement for many years. In the 1970s, curricula that included folk art became more common as grants allowed state and local agencies to hire folk artists who increasingly served as artists in residence or speakers at whole-school assemblies. In the 1980s many southern art agencies, with support from the National Endowment for the Arts, engaged in an evaluation of art education programs with wide repercussions for the inclusion of folk art in the curriculum. The results demonstrated a strong desire to develop authentic programming that focused on the unique characteristics of individual communities rather than the traditional touring programs that bore no direct

relation to regional cultural heritage. As a result, in Mississippi, for example, a collaborative program called Artists Build Communities was developed in 1993 to provide professional development for artists and educators and the publication of folk art handbooks and Web-based communication tools. Similar collaborative programs began to emerge in other southern states. Folk arts became an integral part of arts education curricula.

Since the turn of the century, programs such as Goals 2000 and the subsequent No Child Left Behind legislation have required art education to focus on academic standards and assessment. Despite this emphasis on assessment and accountability, as well as increased funding challenges, meaningful folk arts education continues to be widespread in the South. For example, the Louisiana Voices Folklife in Education Program and the Georgia Folk Program provide opportunities to explore community traditions through curriculum resources and professional development for teachers. Many southern states, such as Georgia and Alabama, offer apprenticeship programs for preserving southern folk art. The University of Central Florida (UCF) Cultural Heritage Alliance, under the direction of Kristin Congdon and Natalie Underberg, provides projects, research, and networking opportunities for folk arts education. This alliance is supported by the National Endowment for the Arts (NEA) and the UCF College of Arts and Sciences. Folkvine.org is another innovative education-oriented project funded by Florida that utilizes new media technology to build a sense of community. Using video and narrative, participants learn about folk artists in an effort to enhance their understanding of the artists' works. This award-winning, interactive website features local artists and invites visitors to participate rather than function as passive viewers.

Dedicated educators also rely on national networks for support, such as CARTS—Cultural Arts Resources for Teachers and Students, the website for the National Network for Folk Arts in Education. This online clearinghouse for national and regional folklore resources includes virtual folk artist residencies, educational teaching tools, articles, and more.

DONALYN HEISE
University of Memphis

Joyce Cauthen, *Presenting Mississippi's Traditional Artists: A Handbook for Local Arts Agencies* (2006); James S. Lanier, *The Complete Lanier: A Professional Profile* (1998); June K. McFee, *Preparation for Art* (1970); June K. McFee and Rogena M. Degge, *Art, Culture, and Environment: A Catalyst for Teaching* (1980); University of Central Florida, www.folkvine.org.

Baskets, Lowcountry

Travelers along coastal Highway 17 North near Mt. Pleasant, S.C., across the Cooper River from Charleston, cannot fail to notice the coiled baskets displayed on rough wooden stands on the edge of the road. These baskets, made of golden sweet grass, decorated with russet bands of longleaf pine needles, and bound with strips of palmetto frond, have been offered for sale on the highway since the 1930s. Widely recognized as one of the oldest African-inspired crafts in America, Lowcountry baskets are appreciated today not only for their utility and beauty but as symbols of the region and of the people who make them.

The tradition of coiled basketry goes back centuries on both sides of the Atlantic. In the late 1600s, European settlers and the enslaved Africans who worked the land in the new British colony of Carolina began experimenting with rice as a potential export crop. The skills associated with growing rice and processing the grain were familiar to many of the Africans, particularly people from the Upper Guinea Coast, where Europeans saw rice under cultivation as early as 1446, and the inland delta of the Niger River, where rice has been grown for 2000 years. On Lowcountry plantations, one particular basket—a wide-coiled winnowing tray called a "fanner"—was adopted as the essential tool for separating the grain from its chaff. To wrap and stitch rows of bulrush, basket sewers on the mainland used white oak splints, while Sea Islanders fashioned strips from the stem of the saw palmetto.

As plantation agriculture spread across the South, basket makers took with them the tradition of coiled basketry that had taken hold in the Lowcountry. When rice production expanded into Georgia and North Carolina in the early 18th century, South Carolina planters led crews of experienced slaves to break the new ground and plant the crop. By the mid-1840s, rice operations extended down the coast of Georgia and into northern Florida, and the range of the basket followed suit.

With the breakup of the plantation system at the end of the Civil War, many freed people acquired land and began to farm for themselves. Coiled grass baskets remained in use in homes and fields and became a familiar sight on the streets of Charleston. People from rural settlements such as James Island, Johns Island, Edisto Island, and Mt. Pleasant brought farm produce to market in coiled rush baskets balanced on the head.

In the early decades of the 20th century, as agriculture declined and jobs in industry lured tens of thousands of black southerners to the North, Lowcountry baskets could have gone the way of gourd and earthenware vessels, wooden mortars and pestles, palmetto fans and thatching. But the tradition proved to be resilient. Seventy-five miles south of Charleston, the Penn School

on St. Helena Island introduced "native island basketry" as part of its agricultural curriculum for boys and kept bulrush basket making alive.

Meanwhile, around the time of World War I, basket makers in the vicinity of Boone Hall Plantation north of Mt. Pleasant increased their output and expanded their repertory in response to a new wholesale market and a budding tourist trade. Charleston merchant Clarence W. Legerton began commissioning baskets to sell by mail through his Sea Grass Basket catalog and retail from his bookstore on King Street. Sam Coakley from Hamlin Beach acted as an agent for the community of sewers. Every other Saturday basket makers would bring their wares to his house for Legerton's inspection.

These Mt. Pleasant "show" baskets differed from agricultural work baskets in several ways: the sewers tended to be women, not men; sweet grass was the principal foundation material rather than bulrush; palm leaf was used in place of white oak splints or palmetto butt to bind the rows of grass; and new forms were created and pine needles added for decorative effect. With the construction of the Cooper River Bridge in 1929 and the paving of Highway 17, basket makers found a way to reach their market directly. They began selling baskets by the side of the road, displaying them on chairs or overturned crates. As the tourist trade quickened, sewers responded with new, individualized basket shapes displayed on an innovative marketing device—the basket stand.

Today the basket makers' creativity and resilience are being put to the test as rampant development threatens the future of their art and the physical continuity of their community. Since the 1970s, suburban and resort development has drastically diminished the local supply of sweet grass. The highway that once assured the survival of the tradition now threatens to run the basket stands off the road, and subdivisions and gated communities are displacing the very neighborhoods where basket makers live.

In spite of these dangers, Lowcountry basketry continues to thrive. To compensate for the sweet grass shortage, sewers have reintroduced bulrush. Baskets are bigger and bolder. Some pieces are considered collectors' items, with prices reflecting this status. As symbols of the distinct Gullah culture of the south Atlantic Coast and as works of art, coiled baskets carry a lot of weight. Yet they remain what they have always been: vessels made of grass sewn with a flexible stitching element, useful for countless purposes.

DALE ROSENGARTEN
College of Charleston

Joyce V. Coakley, *Sweetgrass Baskets and the Gullah Tradition* (2006); Dale Rosengarten, *Row upon Row: Sea Grass Baskets of the South Carolina Lowcountry* (1994);

Dale Rosengarten, Theodore Rosengarten, and Enid Schildkrout, eds., *Grass Roots: African Origins of an American Art* (2008); John Michael Vlach, *The Afro-American Tradition in Decorative Arts* (1990).

Bottle Trees

Bottle trees are a product of southern black culture with roots in the animistic spiritualism and totemism of several African tribal cultures. Glassblowing and bottle making existed as far back as the ninth century in Africa, as did the practice of hanging found objects from trees or huts as talismans to ward off evil spirits. The bottle tree was a Kongo-derived tradition that conveyed deep religious symbolism.

The bottle tree was once common throughout the rural Southeast. Trees were made by stripping the foliage from a living tree, with upward-pointing branches left intact. Bottles were then slipped over these branch ends. Cedars were a preferred species, because they were common, resistant to decay, and well shaped with all branches pointing upward.

According to folklore, brightly colored bottles attracted and entrapped spirits. When the wind shook bottle trees, spirits could be heard moaning. In some cases, paint was poured into the bottles before hanging them on the trees. This was done ostensibly to help trap spirits, but the addition of color to clear bottles may have been the true motivation.

Today bottle trees are scarce. Those that exist in northeast Mississippi, for example, are produced by rural whites as often as blacks. Like the hex signs of Pennsylvania Dutch barns, they are a vestige of the past, produced more for the sake of art than for protection from the supernatural. They can be beautiful, and even the worst examples are still curiosities.

Southern authors, notably Eudora Welty, have commented on bottle trees, perhaps because they have a primal fascination. Sunlight on and through colored glass has charmed people for centuries; the bottle tree can be considered the poor person's stained glass window.

JIM MARTIN
Yazoo City, Mississippi

Robert Thompson, *Flash of the Spirit: African and Afro-American Art and Philosophy* (1983); John Vlach, *The Afro-American Tradition in Decorative Art* (1978); Eudora Welty, "Livvie," in *The Wide Net* (1943), *One Time, One Place* (1971).

Cajun and Creole Folk Art

Louisiana's Cajuns are descendants of 18th-century Acadians, French-speaking colonists deported from Nova Scotia by the British in 1755. However, today's Cajuns also trace their ancestry and aspects of their culture to various waves of Continental French, Irish, German, Spanish, and other settlers in south Louisiana. Best known for their music, food, and celebrations, Cajuns also produce abundant arts that reflect the region's landscapes, traditional occupations, and recreations. These arts, like most living traditions, constantly adapt to changing times. Some have almost disappeared, others thrive, and still others are being rediscovered and revived.

Life in much of south Louisiana revolves around waterways. Not surprisingly, Cajun folk arts include carved bird decoys and detailed miniature versions of pirogues, skiffs, oyster luggers, and other vernacular boats.

Acadian weaving is one of the culture's oldest and most exquisite folk arts, though it is less common today than in the past. Acadian settlers brought a tradition of spinning and weaving wool to their new home, where homegrown cotton replaced wool. Cajun women once made virtually all the textiles used in their homes—blankets, towels, coverlets, clothing, and other goods—from white cotton and a wild brown cotton (*coton jaune*) woven on two-harness looms. Most Acadian textiles were a plain weave of natural white cotton and the delicate café-au-lait of brown cotton. Cajun women created textural patterns by weaving in heavier yarns (*cordons*), pulling up short weft loops (*boutons*), and adding color with narrow bands of indigo cotton or strips of commercial fabric. Acadian cotton blankets were widely admired for their beauty; with the help of the influential Avery family, they were promoted and marketed nationally in the late 19th and early 20th centuries. By the 1930s weaving had declined in popularity among Cajun women. In the 1940s the Acadian Handicrafts Project (directed by Louise Olivier through Louisiana State University's Extension Service) attempted to revive local interest by hiring traditional weavers to demonstrate and teach the art. The project had limited long-term success, but contemporary weavers have begun weaving in the traditional style for festival and museum demonstrations, sparking a modest revival.

Perhaps the most vibrant Cajun folk art is the creation of colorful disguises for annual Mardi Gras runs (*courirs de Mardi Gras*), held in more than a dozen rural prairie communities. On Mardi Gras day, or the weekend before, masked and costumed men (and in some places women and children) travel the countryside on horseback or in trucks, seeking donations of chickens, rice, and other gumbo ingredients. In exchange for these gifts, they sing, dance, beg,

and clown before inviting their hosts to share a gumbo feast. Each community has its own disguise conventions and aesthetics, but Cajuns typically wear a two-piece, pajamalike *suit de Mardi Gras*, a tall, pointed hat called a *capuchon*, and a handmade mask. Some Mardi Gras suits are made of expensive satins, but most juxtapose vividly colored cotton prints with contrasting solid colors. Layers of fringe line arms and legs, and matching fabric covers the *capuchon*.

Mardi Gras masks may be traditional or innovative. Wire screen masks are the most traditional form, but construction and adornment vary from one place to another. Husband-and-wife team Georgie and Allen Manuel, of Eunice, purposefully re-create an old-fashioned look by painting stylized features on their masks. In other communities, such as Tee Mamou in Acadia Parish, mask makers prefer more elaborately decorated masks covered in fake fur, burlap, Spanish moss, or feathers. Tee Mamou artists feature layers of three-dimensional materials: long fabric noses, protruding tongues, rubber insects and snakes, and toy animals. Cajun women, who now run Mardi Gras in some communities, are among the most prolific and inventive mask makers. Suson Launey, Renée Frugé Douget, Jackie Miller, and other artists have introduced new materials, techniques, and whimsical designs. One popular innovation by Suson Launey is a yarn mask stitched on plastic needlepoint screen, which many women find more comfortable than wire screen. Cajun Mardi Gras masks have become favorites with folk art museums and collectors, folklife festivals, and tourists, as well as with locals.

Creoles in Louisiana have a similar wealth of folk arts. "Creole" has meant various things to different people throughout history, but today it typically refers to people of Afro-European (French and sometimes Spanish) descent, often with some American Indian heritage as well. Like the word "Cajun," Creole implies roots in a French-speaking (or Creole-speaking), Catholic culture that emphasizes strong family ties. Louisiana has rural Creole communities—on the prairies of southwest Louisiana and the Cane River area, for example—and an urban community in New Orleans, each with its own history and traditions.

New Orleans's Creoles are historically some of Louisiana's most skilled building-trades workers as plasterers, bricklayers, and ironworkers. They have brought the same artistry, and some of the same techniques, to the city's festive traditions of second-line parades (featuring elaborately decorated umbrellas, sashes or "ribbons," and baskets) and Mardi Gras Indian processions.

Generations of New Orleans Creoles and African Americans have "masked Indian" on Mardi Gras each year and again on St. Joseph's night. The tradition's origins are contested, but participants say that it began as a tribute to American

Indians who harbored and intermarried with runaway slaves. The first documented black Indian group was the Creole Wild West in the 1880s, led by a Creole man named Becate Battiste. The custom probably predates this reference and has connections to similar Caribbean festivities.

Mardi Gras Indian suits, with their ornate beadwork and brilliantly colored plumes, are some of Louisiana's most dazzling folk arts. In the years before World War II, suits were fairly simple, with decoration improvised from discarded or inexpensive materials. The master Allison "Tootie" Montana recalled his father and other men using glitter-covered egg crates, small pieces of tin and other metal, bottle caps, and pieces of mirror to make their suits shine.

Today's suits are far more intricate, expensive, and time consuming to create. Designing and building a beautiful suit is central to masking Indian; as several participants have remarked, "If you want to mask Indian, you've got to sew." They create a new suit each year, keeping design and colors secret. Competing to make the prettiest suit, makers buy the best beads, ribbons, rhinestones, and ostrich plumes died shades of yellow, purple, blue, red, and other colors. Many say they work all year long on a new suit, between work, Indian practice, and other responsibilities.

Making a truly exceptional suit requires not only a great deal of time and thousands of dollars but also imagination, a talent for design, and an eye for color. The suit begins with an idea, inspired by an existing illustration, a dream, or some other source. This design is sketched on a piece of canvas backing and then painstakingly stitched with hundreds (or thousands) of colored beads, sequins, and rhinestones to make a "patch." The suit will eventually include numerous beaded patches sewn onto a larger satin foundation. Once the suit is complete, some patches are visible only when the wearer raises other pieces to display them. A finished suit can include more than a dozen pieces, including the plumed "crown" or headdress, apron, vest, leggings, and moccasins, all generously jeweled, beaded, and feathered. A suit can weigh well over 100 pounds.

New Orleans is a city of distinctive neighborhoods, and different parts of the city favor certain styles of Mardi Gras Indian suits. Historically, most New Orleans Creoles lived in Downtown neighborhoods (divided from Uptown by Canal Street). Downtown Indians often prefer the abstract, three-dimensional style made famous by Allison "Tootie" Montana. Montana, Big Chief of the Yellow Pocahontas group for 50 years, was a master plasterer who brought his building skills to suit making, creating impressive sculptural effects. One memorable example was an elephant head with its trunk jutting from the front of the suit decorated in pearls, sequins, and small mirrors as well as beads. Uptown Indians create detailed patches—typically depicting 19th-century Plains

Indian life, especially battle scenes—with thousands of beads and small rhinestones. There are also Midtown and "Back of Town" Mardi Gras Indian styles, though crossover is common.

Mardi Gras Indian suits are not only exceptional art; they are material expressions of Creole and African American history, heritage, and pride. They are avidly sought by art collectors and museums, such as the American Folk Art Museum. Most suits are taken apart after St. Joseph's Day. Patches are rearranged in a new suit, sold, or given to another masker. The Backstreet Cultural Museum in the Treme neighborhood, however, now collects and preserves suits that might have been discarded and displays them for a wide audience. Other museums, including the Louisiana State Museum, also exhibit entire costumes. Virtuosic contemporary costume makers, such as Darryl Montana, continue to bring new techniques and materials to Mardi Gras Indian art.

CAROLYN E. WARE
Louisiana State University

Barry Jean Ancelet, Jay Edwards, and Glen Pitre, *Cajun Country* (1991); Maida Bergeron, ed., *Fait à la Main: A Source Book of Louisiana Crafts* (1988); F. A. de Caro and R. A. Jordan, *Louisiana Traditional Crafts* (1980); Michael P. Smith, *Mardi Gras Indians* (1994); Nicholas R. Spitzer, ed., *Louisiana Folklife: A Guide to the State* (1985).

Calligraphy and Penmanship

Begun by people who had little training in the art of writing and were willing to teach themselves by purchasing a book or attending penmanship classes, calligraphy has long been enjoyed for its craftsmanship and its finely drawn images. Before the early 20th century, the art of fine penmanship was understood to include the embellishment of manuscripts with elegant pen-work "flourishes." These flourishes were hand-drawn ornaments that ranged from a few simple arabesques executed beneath a writer's signature to elaborate pictorial drawings that a penman composed using multiples of the same straight and curved lines. The subjects of calligraphic drawings range from simple sketches to large depictions of arresting doves, running deer, roaring lions, and rearing horses.

Execution of these drawings was one of the bona fides of the established penmanship instructor, and mastery of calligraphic drawing was the goal of many of the penmanship students who enrolled in the "writing institutions," "business colleges," and "mercantile academies" of the 19th century. In rural areas, itinerant "writing masters" and "professors of penmanship" promoted their classes with local displays of their calligraphic drawings.

American penmanship is grounded in British writing styles, and into the

early 19th century Americans used English copybooks to teach penmanship. In the young nation, already beginning the change from an agricultural to an industrial economy, however, need arose for a simple, rapid writing style, attractive but also consistently legible. Platt Rogers Spencer, an Ohioan, developed and ably promoted "The Spencerian Handwriting System," which dominated schools for the rest of the century.

The Spencerian System became a veritable industry itself, with Spencer's children, siblings, and students opening schools around the country. The South could claim well-known Spencerian business colleges in Washington, D.C., and Louisville, Ky. Booker T. Washington included a course in "Elements of letters and Spencerian copy-book" in his curriculum at Tuskegee University. Many of Spencer's apostles also produced books and copy sheets that gave models for flourished drawings and offered them for sale by mail order. A practitioner of Spencerian handwriting, a man named Louis Madarasz, who worked in Arkansas and operated a mail-order design business, is the probable creator of Coca-Cola's famous manuscript logo.

The Spencerian method reduced lettering to a group of seven interchangeable elements, or "principles," that could be combined in various ways to form 26 gracefully balanced letters in a regular, repeatable manner. While Spencer may have developed his concept of principles on his own, such a system was not an entirely new idea; earlier penmen had also recognized common elements in calligraphy. None, however, had promoted it so effectively as the key to training new hands. Teaching of the principles and their integration into letters required rote memorization and recitation of the principles needed to form each letter as well as repeated practice in forming each element until the student could produce pages of identical strokes. Spencer's penmanship books remain in print.

The elements used to form letters could also produce pictorial drawings. Indeed, most calligraphic drawings, like Spencerian letters, break down into a series of repeated parallel principles. A typical drawing of the penman's quill, for example, uses a combination of only three basic principles stroked onto the paper one after another in a prescribed manner.

LESLIE SPRAKER MAY
Cranbury, New Jersey

William E. Henning, *The Golden Age of American Penmanship and Calligraphy* (2002); Tamara Plakins Thornton, *Handwriting in America; A Cultural History* (1996).

Canes

Hand-carved canes are both folk art and part of America's cultural history. American folk art canes can be divided into traditional canes and contemporary canes. Traditional folk art canes are generally those made from the early 19th century until around World War II. Contemporary canes are those made in the second half of the 20th century, mostly after 1970, and until today.

During the 19th century, particularly in the second half of the 19th century and the early part of the 20th century, many American men carried or, in the terminology of the times, "wore" a cane as part of their attire. Although most of these canes are plain, others are decorated, for example, with gold-plated, silver, or ivory handles.

The folk art counterparts of these traditional decorative canes are canes made by carvers, some of whom were skilled whittlers or craftsmen. Traditional folk art canes are utilitarian, but generally they were not designed primarily as walking aids. Rather, like today's business cards or T-shirts, they often served as means for the user to communicate his vocation, fraternal affiliation, or other personal interests.

Traditional folk art canes are generally made from tree branches (from almost any kind of tree or shrub) with carvings or decorations on the shaft or the handle or both. The carvings or decorations involve almost every conceivable subject, including the ubiquitous snake, often used, among other reasons, because a snake's body suited the cane's gnarled form. The carvers of the traditional folk art canes were probably men. Historical records, family memories, and characteristic designs have allowed scholars to identify some of the cane makers. In the case of contemporary canes, the names of almost all of the makers are known.

There is little compelling evidence of regional styles, and where (and often when) a traditional cane was made is very difficult to determine. In fact, unless a cane is inscribed with the name of the carver, is made with native wood, or has a special subject or an identifiable history or style, it is difficult to determine whether a traditional cane was even made in the South, North, East, or West, let alone in which state. There are, however, some common regional subjects; for example, alligators combined with snakes are often found on traditional southern folk art canes. The one subject that truly identifies traditional southern canes is the Civil War, which is a common subject among the canes made by Civil War veterans in the United Confederate Veterans, an organization founded in 1889. R. M. Foster (1830–after 1900) from Sparta, Mo., is an example of a prolific maker of canes with southern themes. He incised on one of his canes, "carved by a rebel's hand, who gave his health, his wealth, his

all for Dixie's Sunny South Land." Other known 19th-century southern multi-cane carvers include Virginians Thomas Purkins (1791–1855) and Zachariah S. Robinson (1806–73).

Southern African Americans also made traditional canes. Some canes may be identified as African American by their African-based iconography. However, other American cane makers sometimes used the same iconography. Among the known, and perhaps one of the most important, 19th-century southern African American cane makers was Henry Gudgell (1829–after 1867), who lived in Missouri but was born a slave in Kentucky.

As distinguished from traditional canes, contemporary canes are frequently made as a works of art rather than as utilitarian objects. They tend to be bolder and brightly colored, include fewer details than traditional canes, and reflect the popular culture and interests of the day. Twentieth-century southern carvers include William Rodgers (1865–1952) from Georgia, Denzil Goodpaster (1908–95) from Kentucky, and Luster Willis (1913–90) from Mississippi.

GEORGE H. MEYER
Bloomfield Village, Michigan

Catherine Dike, *Canes in the United States* (1994); George H. Meyer, *American Folk Art Canes* (1992); Kurt Stein, *Canes and Walking Sticks* (1974).

Caribbean American Folk Art

The history of the black self-taught artists of the western Pan-African diaspora is no more and no less than the history of the Pan-African culture itself. Vernacular art is cultural art, and, in the African Atlantic diaspora, it serves as a visual aspect of the oral culture. It encompasses various manifestations of folkways, including storytelling, remembrance, proverbs, acts of spirituality, veneration of and homage to ancestors, moralities, worldviews, and visual traditions.

There are major regional variations in these manifestations, in the same way that there are also regional variations in North American blues styles. Africa is the baseline of commonality; differing local cultures constructed by enslaved Africans, including interactions with the dominant religion, account for the degree of variation within African art in the Caribbean. Santeria and Palo Mayombe in Cuba, Haitian Vodou, and Brazilian Macumba and Candomblé all display French and Spanish Catholic influences. In the United States and Jamaica, the Church of England and other Protestant denominations have exerted considerable influence.

Patterns of immigration from Africa and the dominant class's attitudes

toward African cultural continuities have also played a role in Caribbean American art making. Slaves imported into the United States from Havana or from other points in the Caribbean clearly brought concepts and practices inflected with specific Caribbean local cultures. This pattern of immigration continued even during the postemancipation period, when several waves of legal and/or smuggled indentured servants, mainly from the Congo, arrived in the Americas. These new arrivals reinforced African aesthetic preferences, while workers from China and India contributed their own resources to a Caribbean vernacular. In some locales, slaves could openly express themselves according to their own cultural preferences. In Jamaica and Haiti, for example, masters did not forbid the use of drums. To this day the persistence of more obvious African folkways survive in those countries as well as in Brazil and Cuba, where slaves were also allowed to maintain African beliefs and aesthetics.

Scholars of African Caribbean art have focused their attention on Haiti, Jamaica, Brazil, and the southern United States. The practices of self-taught artists in Cuba still await close examination. While there are major differences among the vernacular visual arts of these countries, the rise of tourism, the bourgeoning civil rights movement in the United States, Negritude, the Harlem Renaissance, and the legacy of Marcus Garvey are all aspects of black self-awareness that these arts have in common. The true impetus for the Caribbean art came from its African legacy, reinvented, expanded, and continued through each culture. Increasing political awareness and cultural resistance have allowed these Caribbean artists to take on the role of culture bearer. In their communities they are often priests, visionaries, or healers. Kapo, Hector Hyppolite, Everald Brown, Elijah Pierce, Sister Gertrude Morgan, and Andre Pierre were all preachers within their religions.

Haiti, with its highly intricate and complex dance between Vodou and Catholicism, became known for its self-taught artists in the mid-1940s through the efforts of Dewitt Peters, an American living in Port-au-Prince. Peters encouraged the work of local artists as a way of attracting those tourists who wanted more than a cursory experience of the island's culture. Long before Peters, however, the culture was deeply impregnated with art. The Vodou temples, or humforts, had elaborate and highly detailed murals on their walls depicting the *lwa*, or the sacred spirits of Vodou. Drums were built on African models, and ceremonial flags had their own sets of symbols based on the families of *lwa*. This rich legacy of visual imagery translated easily to boards of Masonite set on easels. While most Haitian self-taught artists painted narratives with references to Vodou practice and belief, several artists like Georges Liautaud used steel to produce both utilitarian metal sculptures, such as iron crosses for cemeteries,

and idiosyncratic sculptures. Others, like Andre Pierre, Rigaud Benoit, Castera Bazile, and Hector Hyppolite, translated their wall paintings to the easel.

It is important to make a distinction between narrative and sacred art. In Haiti, narrative work such as village scenes, depictions of history, or ceremonies, even if filled with the imagery of Vodou, is not Vodou art. For example, the narrative easel paintings that feature lwa by Andre Pierre may serve a didactic function but not a sacred one. On the other hand, Pierre's depiction of lwa on the walls of his temple or on gourds for his altar assumes a different meaning. Pierrot Barra's sculptures consisting of cast-off dolls encrusted with charms, glitter, sequins, beads, and crosses that were originally intended for altars have been recontextualized within the art world. It is safe to say that most of the art in the Haitian art market is *about* Vodou, not a functional part of the religion itself.

As in the United States and Haiti, the self-taught art of Jamaica was first noticed in the 1940s. Jamaican art draws on a variety of visual resources — the Pre-Columbian cave paintings of the Taino people, the myriad forms of African drums, the banners that decorate the balm yards of folk healers, and the ritual costumes of the African Baptist Revival ceremonies. Among the artists working in Jamaica were John Dunkley, David Miller Sr., David Miller Jr., and Kapo (Mallica Reynolds).

While self-taught Haitian artists attracted an international following during the 1940s, self-taught artists working in the United States and Jamaica have received primarily national acclaim. Jamaica's market for self-taught artists has always remained rather insular; artists' pieces are collected and shown more locally than internationally. That we have seen Jamaican art at all is largely a result of the efforts of David Boxer, director of the National Gallery of Jamaica, founded in 1974. Recognizing the importance of the Jamaican "Intuitives," he made their art an integral part of the museum's collection.

Jamaican artists are more idiosyncratic than the Haitians. It is as if each artist expresses his or her spirituality without being conscious of other artists. The objects in Jamaican yard shows are not accumulations of disparate elements but are fully integrated constructions that may be ephemeral. Similar to the abstract yard shows in the southern United States, Jamaican yard shows are not outdoor galleries of works for sale. Artists in Jamaica, like Lloyd Atherton, make guardian figures and amulets to serve specific and generalized spiritual purposes.

The yard show provides the basis of a language that links most of the work of the Afro-Atlantic diaspora. These yard shows have a syntax that can be interpreted as an encyclopedia of references and symbols shared by members

of a cultural community. Grey Gundaker and Robert Farris Thompson have written exhaustively on yard show complexes in the United States, but to date the Caribbean versions, such as the balm yards or yards by artists such as Lloyd Atherton, Sylvester Stephens, and Errol McKenzie, and various Rastafarian groups in Jamaica, have not received such treatment. The humforts and healing spaces in Haiti have not been adequately contextualized with their North American counterparts. The language of the yard show provides the vocabulary for nearly *all* African American artists.

The yard show is an arena where "place" is contextualized into an immediate visual culture in the subverted or recycled language of the dominant culture. Objects with a specific meaning in one world pick up multiple meanings when used in another. The language of the yard show is often highly symbolic and seemingly cryptic or solipsistic, yet it is based on criteria that are logical and recognizable to their intended audience. Yard shows are places where the tangible world of the present meets the nonmaterial and immanent world of spirits and ancestors.

Another commonality of African Caribbean art is an urge to repair and complete the birth-death-rebirth cycle—the Kalunga cycle—disrupted by slavery. Forcibly removed from home and the essential passage of life, enslaved Africans cannot hope to finish the part of that cycle after death where they meet with the ancestors beneath the waters, assess the life previously lived, receive guidance, and are thus reborn into the next life wiser and more prepared. The yard show re-creates African home ground in the Americas and affords a symbolic chance of positive redemption. For the Rastafarians of Jamaica, this completion of the cycle becomes graphically symbolic, as the intention of a Rasta yard is to re-create an actual piece of Africa within the oppressors' homeland.

The Haitian yard of the Vodou temple also offers a locus for completion of the life cycle. In this yard, the center pole (*poteau mitan*) surrounded by images of the Spirits represents the tree of life that redeemed souls climb to contact Guinee, the true African home ground. With similar purpose, Errol McKenzie in Jamaica has created the symbolic body of a goddess spirit who covers an entire hillside. The buildings on the site, which contain her heart and her spirit, are the places where one can learn to become more African. As we can see in places like Hilton Head, S.C., or New Orleans, La., and in the vast numbers of yard shows all through the North American South, the origins and the philosophies of the Caribbean and the United States are deeply and intricately intertwined. Variations tend to be local but intrinsically contain philosophical universalities. Specifics differ and coincide at the same time. To truly understand

the North American Pan-African complex, one needs to combine the Caribbean and the United States to achieve a true view of black art in America.

RANDALL MORRIS
Brooklyn, New York

Donald J. Cosentino, *Sacred Arts of Haitian Vodou* (1995); Grey Gundaker, *Signs of Diaspora / Diaspora of Signs: Literacies, Creolization, and Vernacular Practice in African America* (1998); Betty M. Kuyk, *African Voices in the African American Heritage* (2003); John W. Pulis, ed., *Religion, Diaspora, and Cultural Identity: A Reader in the Anglophone Caribbean* (1999); Dianne M. Stewart, *Three Eyes for the Journey: African Dimensions of the Jamaican Religious Experience* (2005).

Craft Revival

The southern craft revival—or handicraft revival, as it was often called at the time—was an effort focused on making and selling handmade creative products to provide work for rural families. The movement was centered in the southern Appalachians, the upland sections of Kentucky, North Carolina, Tennessee, and Virginia. Beginning in the late 19th century, the revival continued for 50 years, peaking in the 1930s and dissipating by the mid-20th century. In 1896 William Goodell Frost, president of Berea College, announced "An Educational Program for Appalachian America," in which he identified "a life of survivals . . . [found in the] people of the mountains—independent landholders, sturdy yeomen . . . the bone and sinew of the nation." In May of that same year, the college held its first "homespun fair" to celebrate the culture of these peoples. The year 1896 also marked the death of John Ruskin, an influential English thinker and writer who railed against the abuses of industrialization and proposed that dignity be returned to common labor.

The initial development of the South's craft production centers was organic. Some began as missionary projects; others began as schools. Some were nonprofit; still others were aimed at bringing money into local communities. Under the overarching umbrella of "mountain work," the craft revival continued to evolve. The earliest craft revival endeavors came about after mountain workers became aware of local weaving traditions. Frances Louisa Goodrich, Yale educated and northern born, established a mission station in Madison County, N.C., with support from the Presbyterian Home Mission. Goodrich was motivated by the gift of a locally made coverlet. Farther north in the mountains of eastern Kentucky, Katherine Pettit and May Stone cofounded the Hindman Settlement School in 1902. After learning to weave from a local woman, Pettit

established a weaving program at Hindman. Hands-on educational programs were also established in rural mountain communities. The craft revival also saw several initiatives that sought to reposition Cherokee craft, previously suppressed, within the cultural landscape. In 1914, the Cherokee living on the Qualla Boundary (the federally defined Cherokee reservation) established an annual festival to celebrate traditional culture. By the 1930s the Cherokee were part of the broader craft community. Culturally specific native arts—baskets, beadwork, and arrows—were shown as part of the *Mountain Handicrafts* traveling exhibition in 1933. Throughout the 20th century, the Cherokee have been known for masterful baskets and wood carvings.

In 1926 the independent nature of individual craft revival centers began to change when Allen H. Eaton, a curator and writer with an expertise in crafts, spoke on crafts at the Conference of Southern Mountain Workers, headquartered at Berea. Inspired by Eaton's presentation and subsequent programs on handicrafts, the annual conference provided mountain workers with a forum to discuss production and marketing. In 1928 a handful of craft enthusiasts came together to discuss the formation of a guild to eliminate competition and foster cooperative marketing. At the spring conference in 1930, the guild was formalized as the Southern Mountain Handicraft Guild (later, the Southern Highland Handicraft Guild and today's Southern Highland Craft Guild). The Mountain Craftsmen Cooperative Association was founded in 1932 in an attempt to alleviate the poverty surrounding West Virginia's coalfields region, and in 1946 Cherokee makers banded together to create Qualla Arts and Crafts Mutual, an artisan cooperative.

The promotion of southern crafts, via the craft revival, and increased tourism were successful in bringing regionally made items to the attention of a national audience. In 1933 the *Mountain Handicrafts* exhibition toured the eastern United States. Eleanor Roosevelt purchased Brasstown carvings from the John C. Campbell Folk School entries. In 1935 the Southern Highlanders opened three gift shops, one in New York City's Rockefeller Center. In 1933 and 1934 photographer Doris Ulmann traveled the region taking photographs that were published in 1937 as part of Allen Eaton's study *Handicrafts of the Southern Highlands*, a text that remains a valuable resource to scholars today.

The craft revival was an enigmatic movement in that it combined progressive and conservative elements. Its leaders sought to create a rural and sustainable economic enterprise, while simultaneously preserving and maintaining traditions thought to be in danger of extinction. Woven into the complex tapestry that formed the revival were issues concerning the value of work and the place of country life within an industrializing nation. One legacy of the craft re-

vival was its influence on folk artists who transformed community craft forms into individualistic works of folk art.

M. ANNA FARIELLO
Western Carolina University

Allen H. Eaton, *Handicrafts of the Southern Highlands* (1937).

Decoys

Decoys, or artificial birds used to entice game within gunshot range, are a highly prized genre of American folk art. The word "decoy" is derived from the Dutch *de kooi* (the cage or trap) or possibly from *eende kooi* (duck cage). The original term refers to a method of gathering wildfowl first recorded in 16th-century Europe. In this context, the decoy refers to a long, cone-shaped tunnel of netting arranged over a pond; the ducks were herded in by men in boats or by a small, trained dog. Sometimes semidomesticated ducks, known as "coy ducks," were used to entice the wild waterfowl into the mouth of the tunnel.

In 1924 the earliest known decoys were discovered near Lovelock, Nev., in a cave containing a massive number of artifacts. This cache of 11 canvasback decoys, made of tule reeds and feathers, are between 1,000 and 2,000 years old. As migration patterns, climactic conditions, and food availability made sections of North America—particularly the Atlantic Coast and the Mississippi River—prime hunting grounds for wildfowl, it is not surprising that Native American artifacts are the oldest known examples of bird decoys.

The carving tradition can be mapped along with gunning patterns throughout the country, with distinctive styles emerging to reflect the varying hunting conditions and aesthetic values of their respective communities. In the South, the decoy tradition is most visible in Virginia, the Carolinas, and Louisiana. Chincoteague, Va., on the Eastern Shore of the Chesapeake Bay, has produced some of the finest examples of decoy carving by such legendary carvers as Ira Hudson, Miles Hancock, and Delbert "Cigar" Daisey. Well-known North Carolina carvers include Ned Burgess, Lee and Lem Dudley, Ivey Stevens, and John Williams. South Carolina, thought to be devoid of handmade decoys until the 1980s, was home to the five Caines brothers, whose elegant and distinctive birds from the late 19th century were discovered near Georgetown. Decoys made in the Carolinas are often purposely oversized so that they can be seen on open water.

In contrast, Louisiana's decoys tend to be light and long, made of cypress root and tupelo, now recognized by carvers as superb materials for carving. In Louisiana, which offers plenty of ground cover, hunters do not need large rigs

to attract wild fowl. This decreased requirement for quantity may contribute to the famous quality of so many of the region's decoys. John Bruce, Nicole Vidocavitch, Mark McCool Whipple, the Vizier family, and Reme Ange Roussel are all well-known Louisiana carvers.

Collecting decoys has become a significant hobby for both art collectors and hunters. Since the 1960s, many organizations, specialty books, and magazines have emerged to support the growing trend for collecting decoys, and prices for rare works by well-known carvers have reached record highs, in some cases more than a million dollars.

CYNTHIA BYRD
Ward Museum of Wildfowl Art
Salisbury University

Joel Barber, *Wild Fowl Decoys* (1934); Adele Earnest, *The Art of the Decoy: American Bird Carvings* (1965); Joe Engers, ed., *The Great Book of Wildfowl Decoys* (1990).

Environments

Scattered across the South are dozens of places where remarkable artists have planted unusual gardens, embellished their homes, or built entire environments in response to highly personal urges to create. Environment makers typically work alone on their own property without financial recompense or formal training in art or architecture. Although environments have been called "outsider sites" (after the term coined by Roger Cardinal in his landmark 1972 book *Outsider Art*), "folk art gardens," "visionary yard art," "eccentric spaces," and a variety of other terms, "self-taught artists' environments" now seems the most appropriate term. The term "yard show" refers to an African American vernacular tradition.

Artists' environments are not specific to the South; similar environments can be found elsewhere throughout the United States and in most other countries. Brother Joseph Zoettl's *Ave Maria Grotto*, for example, belongs to a global Catholic tradition of creating artificial and other pilgrimage sites. However, like evangelical religion, snaky backwoods, rejection of conventional taste and good sense, eccentric individuality, and ornery behavior in general, self-taught artists' environments have long been commonly identified associated with the South, not always for complimentary reasons.

Some of the environments, like Howard Finster's *Paradise Garden* in Pennville, Ga., have covered acres. Others take up no more space than a small yard show, while some environments are entirely indoors. All, however, are idiosyncratic expressions of their makers' personalities, needs, and beliefs.

Although the life stories of the artists who made these environments are as varied as their creations, some broad patterns can be established. More often than not, people who suddenly feel motivated to transform their property in inventive ways have been engaged in an occupation that yields tangible results for a day's work. For example, farmers can see the fields they have spent the day plowing; textile workers can look at the bins of towels or count the picks on their pick-clocks to calculate their earnings; loggers can take satisfaction in the piles of logs loaded onto their trucks; and laundresses can see the linens hanging on their clotheslines in the late afternoon breeze. Visible accomplishments can signify the artists' senses of self-worth as contributing members of a community or as fully participating partners in a household.

When something upsets this sense of self-worth — a debilitating accident, an unexpected layoff, a serious illness, a psychologically scarring incident, or the death of a spouse or child — environment builders remake their immediate surroundings to suit their emotional needs. Such needs run the gamut from the need to understand — and express — the meaning of life and one's own place in it (a common motivation behind many religiously inspired environments), to make sense of history, to memorialize lost loved ones, or to demonstrate (or continue to exercise) special skills. Outdoor environments also attract attention, and many environment makers are eager to gain an audience for their insights.

Examples abound for each of these categories. Lonnie Holley began his *Sandman Studio and Square Acre of Art* in Alabama near Birmingham's airport after a fire killed two of his nieces; the environment's original site (the artist later moved it to Harpersville, Ala.) included thousands of sculptures that dealt with the historic suffering and diaspora of African peoples as well as the artist's own personal losses.

Death is not the only way loved ones can be lost, of course. After ill health prevented him from holding a regular job, Edward Leedskalnin began building his *Coral Castle* environment in south Florida to memorialize the 16-year-old fiancée who had many years before backed out on their planned wedding. "Prophet" Royal Robertson's *Artistico* environment in Baldwin, La., was a furious antimemorial aimed at his estranged wife, Adelle, who had left him after many years of marriage.

Often artists seek to place personal losses within a wider historical context. Leedskalnin's castle seems to hark back to some ancient civilization, while Robertson often incorporated futuristic cities and space travel in his diatribes against Adelle (and against women in general). Sam Doyle's *Nationwide Outdoor Art Gallery* on St. Helena Island, S.C., Joe Minter's *African Village in*

America, Rev. George Kornegay's *Art Hill*, and Kenny Hill's *Chauvin Sculpture Garden* are examples of environments that rely heavily on historical references to reestablish a sense of personal equilibrium. Minter's and Kornegay's environments are especially intense recollections of the civil rights movement and powerful examinations of African American history.

The need to use acquired skills is another strong motivator. Minter's steel and metal constructions reflect the years he spent in Alabama's steel industry. Rev. B. F. Perkins built a folk art environment near Bankston, Ala., in large part to prolong his ministry, following a "Judas betrayal petition" that his former church had raised to oust him. Vollis Simpson's *Whirligig Park* near Lucama, N.C., got under way in earnest only when Simpson entered semiretirement yet still felt a strong urge to keep developing the advanced techniques he had acquired as a machinist and farm equipment repairman.

For most environment makers, the primary artistic strategy is accumulation. John Milkovisch, for instance, gradually covered his entire house with flattened beer cans and decorated it with garlands of pull-tabs and can lids to make the *Beer Can House*. At some point the house transitioned from an ordinary Houston, Tex., bungalow with a bit of weird décor attached to a display that visitors would come from some distance away to behold. Howard Finster's *Paradise Garden*, with its immense towers of hubcaps, bicycle frames, bottles, vast mosaics of broken mirrors, and embedded tools demonstrate Finster's deep satisfaction in accomplishing a large quantity of work. Loy Bowlin, who had already adorned his car and clothing to underline a newly minted identity as the Original Rhinestone Cowboy, attached thousands of rhinestones to the interior of his house, the *Beautiful Holy Jewel Home* in McComb, Miss.

The clusters of giant wind-operated mechanisms hulking across the road from Vollis Simpson's workshop, and the acres of trimmed and sculpted living plants that form Pearl Fryar's *Topiary Garden* outside Bishopville, S.C., have almost as much to do with providing proof of industriousness and self-worth as with pursuing any overarching artistic goals. The accumulated sizes and numbers suggest the duration of the efforts involved, though the astounding results were by and large something the artists discovered in hindsight and had likely not predicted at the outset.

Although the majority of environments grow from similar gradual accumulations of objects, a few begin with some kind of revelatory experience that from the outset gives shape to the environment in its entirety. Kenny Hill's millenarian garden in Chauvin, La., is such an environment. Eddie Owens Martin claimed that *Pasaquan* near Buena Vista, Ga., was inspired by an encounter

John Milkovisch's **Beer Can House**, Houston, Tex., 1968–94 (*Photograph courtesy Larry Harris*)

with a being dressed in a futuristic "levitation suit" that he met while walking down a Manhattan street one afternoon. Following directives provided by this being (which apparently only he could see), Martin headed home to Georgia, moved back into his by-then-abandoned family farm, proclaimed himself St. EOM, and founded his own religion, which he called "Pasaquoyanism." With the help of a few assistants the place was gradually transformed to approximate the image revealed in St. EOM's visionary experience, complete with brightly painted pagodalike Pasaquoyan temples, extensive wall murals, dance platforms, freestanding statuary, and consultation rooms. Although local residents undoubtedly regarded St. EOM a peculiar man, they were so willing to pay for St. EOM's advice as a fortune-teller that he made a reasonable living.

Though most visionary encounters are religious in nature, there have been a few exceptions, such as Jeff McKissack's *Orange Show* in Houston, Tex., which began with a stunning realization concerning the key importance of that fruit as a necessary element in maintaining human health and well-being. Despite the secular aims of his environment, McKissack was no less evangelical than others in promoting his vision for improving his fellow citizens.

A growing number of southern self-taught artists' environments have

been actively preserved for the future. Brother Zoettl's *Ave Maria Grotto*, on the grounds of St. Bernard Abbey in Cullman, Ala., has long been both a pilgrimage site and a roadside attraction advertised on highway billboards. After Jeff McKissack's death in 1980, a group of admirers stepped in to preserve the *Orange Show*. This group, now known as the Orange Show Center for Visionary Art, sponsors Houston's Art Car Parade and numerous community arts programs. In 2001 the Orange Show Center took on responsibility for the *Beer Can House*. Thanks to the Kohler Foundation of Sheboygan, Wisc., Kenny Hill's *Chauvin Sculpture Garden* has been preserved in place. The Kohler Foundation gifted the site to Nicholls State University in Thibodeaux, which also sponsors community art programs. With the support of an active community group, Eddie Owens Martin's *Pasaquan* was in 2008 recognized by the National Register of Historic Places for its architectural and historical significance, and Leedskalnin's *Coral Castle* has also been placed on the National Register of Historic Places. The Friends of Pearl Fryar's Topiary Garden seeks to preserve that environment and supports many community programs. With the group's help, the environment has become a preservation project of the Garden Conservancy. Supporters of Loy Bowlin's *Holy Jewel Home* painstakingly disassembled the house's interior. Although no longer in its original site, the environment has found a home at the John Michael Kohler Art Center in Sheboygan. Similarly, the High Museum of Art in Atlanta, Ga., exhibits objects removed from Finster's *Paradise Garden*.

Unfortunately, not all sites have been so lucky. Without well-organized community support, environments rarely survive the deaths of their creators. Most of Enoch Tanner Wickham's *Wickham's Sculpture Park* (also known as the *Wickham Stone Park*) stood forlornly headless near Palmyra, Tenn. In 2006 Wickham's family moved the 14 intact sculptures to nearby family property. The statues continue to be displayed to the public.

Where once such environments were primarily seen as objects of ridicule and their makers as Boo Radley–esque outsiders (years ago, "Everyone throws away their trash but the Finsters" was a common taunt in Pennville). Some communities, though, recognize their artists as local treasures. Summerville, Ga., has created "Howard Finster Day," and *Paradise Garden* was recently purchased by Chattooga County, Georgia, as a tourist attraction. Wilson, N.C., has its annual "Vollis Simpson Whirligig Festival and Parade," and Bishopville, S.C., now proudly proclaims itself the "Home of Pearl Fryar's Topiaries." Kenny Hill's Chauvin garden enjoys much community support, and volunteer docents stand ready to guide tourists through the site. In places like these, self-taught

artists' environments have earned the people who made them a place of respect that is long overdue.

ROGER MANLEY
Gregg Museum of Art and Design
North Carolina State University

John Beardsley, *Gardens of Revelation: Environments by Visionary Artists* (2003); Kelly Ludwig, *Detour Art: Outsider, Folk Art, and Visionary Environments Coast to Coast* (2007); Roger Manley, *Self-Made Worlds: Visionary Folk Art Environments* (2005); Leslie Umberger, *Sublime Spaces and Visionary Worlds: Built Environments of Vernacular Artists* (2007).

Eroticism

Flip through any major exhibition catalog and book dedicated to the work of American self-taught artists, and you will not find very much erotic art. This is especially true of books about the South, which, paradoxically, has produced some of the most accomplished purveyors of aesthetic erotica.

Although eroticism is an important part of many well-known artists' work, it has systematically been hidden away in the back rooms of galleries or in the storage facilities of museums—along with anonymous vernacular erotica such as hand toys and prison flipbooks—thanks to the puritanical nature of American cultural institutions. The result has been a failure to represent the full range of many southern self-taught artists' oeuvres. Such major artists as Edgar Tolson, Miles Carpenter, Sam Doyle, Mose Tolliver, and Thornton Dial celebrated eroticism as an important aspect of the human experience. Tolson, of Trent Fork, Ky., was best known for his wood carvings of Adam and Eve confronting the Serpent, but less so for his wonderfully whimsical, erotic versions of the first couple of the Bible, engaged in compromising positions. Carpenter, a wood carver from Waverly, Va., carved well-endowed, pitchfork-wielding devils. Sam Doyle, of St. Helena Island, S.C., used latex paint on tin to capture randy scenes and portraits, part of the artist's chronicling of his local community.

Mose Tolliver, of Montgomery, Ala., and Thornton Dial, of Bessemer, Ala., have both focused on the erotic allure of the female nude. While Tolliver's paintings of nudes sprawled on exercise equipment bear a slapstick appeal, Dial's monumental nudes are more serious, undeniably powerful celebrations of female sexuality. Dial, in fact, uses depictions of nude women as symbols of freedom, equating the oppression of women with the oppression of all minorities.

Steve Ashby of Delaplane, Va., arguably the master of self-taught southern erotica, has been noticeably underrepresented in the self-taught arena, likely because his larger-than-life, figurative, mixed-media assemblages are almost all explicitly erotic, often utilizing moving parts to create a dynamic effect. Until erotic artwork is integrated into gallery and museum exhibitions, this work will remain largely unknown, except to those who seek it out.

JENIFER BORUM
New York, New York

Milton Simpson, with Jenifer P. Borum, *Folk Erotica: Celebrating Centuries of Erotic Americana* (1994).

Face Jugs

One of the most intriguing products of southern folk potters, past and present, is the face jug. Where did the idea of modeling a human face on a jug (and other vessel types) come from, and what were the meanings of early examples? Emerging knowledge suggests that the answers are far from simple.

A substantial group of face vessels was made in 1863–65 by enslaved African American potters at Thomas Davies's Palmetto Fire Brick Works in South Carolina's Edgefield District. They are distinguished by bared teeth and bulging eyes of white clay set into the wheel-thrown stoneware to contrast with an often dark alkaline glaze. Ceramics historian Edwin Atlee Barber speculated in 1909 that their inspiration came from the "Dark Continent." Portrait pots were indeed made in Africa, perhaps early enough to have influenced the African American potters. Barber, who corresponded with Davies, says that the slaves made face jugs on their own time but offers no motive; it is known, however, that Nigeria's Yungur people made figural vessels to contain ancestral spirits at shrines. Africa, then, is one possible source of the southern face jug tradition.

However, the slave-made examples are not the earliest such pieces. Fragments of a vessel with a European-looking face were excavated from the site of Phoenix Factory, a short-lived Edgefield operation of the early 1840s. A white potter who worked there, Thomas Chandler, then ran his own shop in the district where a jug stamped "CHANDLER / MAKER" was made no later than 1850; its happy face contrasts with the angry-looking ones by slaves. Before coming to South Carolina, Chandler worked in New York State, and on his northern sojourn he may have met potters of the Remmey family, who created the earliest dated Euro-American face vessels (1830s) as an extension of the German *Bartmannkrug* tradition (a jug with a bearded face molded on the neck). However speculative, this connection to Germany via the Mid-Atlantic is not far-

fetched: another potter, German-born Charles Decker, worked at the Remmey Pottery in Philadelphia before establishing Tennessee's Keystone Pottery in 1871, where he and his son William made Remmey-style face jugs. Chandler's example raises the question of influence between him and the slave potters—or were they working in separate traditions with different meanings?

Another possible influence is England, where Toby jugs have been made since the 1760s. Depicting the figure of a jolly drinker with tricorn hat, these molded character mugs differ in spirit from the South's face jugs. Perhaps southern potters drew on all three sources—Africa, Germany, and England. Conversely, it may be that none was an influence, but that the tradition arose from an anthropomorphizing impulse universal in clay-working societies.

The current popularity of face jugs as an icon of southern folk art is due largely to Lanier Meaders of Mossy Creek, Ga. (1917–1998). His father, Cheever, made a small number of face jugs, but they became the cornerstone of Lanier's career, which gained national publicity in the 1960s. Cheever had learned of face jugs from William Hewell of Gillsville; Hewell, in turn, acquired the idea from his Ferguson in-laws, who made the earliest known north Georgia examples. In 1921 Casey Meaders, Cheever's brother, brought the face jug tradition to North Carolina's Catawba Valley, where Harvey Reinhardt made them in the 1930s. Reinhardt's work influenced that area's famed folk potter Burlon Craig, who also visited Lanier Meaders in the late 1970s. Beginning in 1925, brothers Davis and Javan Brown made face jugs at Arden, N.C., like those made by their family back in Atlanta. All this history indicates diffusion of a 19th-century Anglo-southern face jug tradition.

For 19th-century African American potters, face vessels may have been made to place on graves or as nonverbal protests against enslavement. For white potters of the early 1900s, they were occasional whimsies expressing a masculine "aesthetic of the ugly," later to become tourist novelties and, now, a good source of income in the folk art collectors' market.

JOHN A. BURRISON
Georgia State University

Robert Hunter, ed., *Ceramics in America* (2006); Jill Beute Koverman, ed., *Making Faces: Southern Face Vessels from 1840 to 1990* (2001).

Festivals and Fairs

Folk art festivals and fairs constitute only a small number of the thousands of festivals held each year in the South. Some long-standing events showcase local history traditions, foods, and material culture. In general, arts organizations,

historical societies, civic organizations, and community volunteers operate these community events. Other fairs, newly created, are the offspring of entrepreneurs, auction houses, antique businesses, museums, nonprofit organizations, or even groups of artists. These fairs constitute a major marketplace for the sale of folk art; indeed, folk art festivals and fairs generate significant revenues for artists, dealers, and sponsors.

Because "folk art" means so many different things to so many people, folk festivals often take on specific personalities. Events that equate folk art with the traditional material culture of a specific community often feature functional objects—pottery jugs and bowls, fabrics, and baskets. These events often pay homage to craftspeople who have learned their craft from family or other community members. Festivals of this kind, often calling themselves "folklife" festivals, may focus on scholarship and seek to preserve traditional cultures. Folklife festivals in Kentucky and Texas as well as the Smithsonian Folklife Festival produced annually on the National Mall in Washington, D.C., are good examples. These events demonstrate the creative strength of community-based traditions by showcasing food, musicians, and performers, as well as craftspeople and artists. While folklife festivals may offer visitors the opportunity to purchase objects, they emphasize education.

On the other hand, festivals that classify themselves as antique shows are a major marketplace for objects known as traditional folk art—duck decoys, vernacular pie chests, memory paintings, root sculpture, embroidery, quilts, calligraphic drawings, and mixed media pieces. Examples of this kind of festival are Nashville, Tenn.'s Heart of Country Antique Show and Fearrington's Antique Show in North Carolina. For the dealers and collectors who participate in antique fairs, "folk art" refers to handmade, traditional, and sometimes even functional objects but emphasizes aesthetics. At these fairs, dealers play an important role in educating collectors, explaining, for instance, the aesthetic differences between an everyday duck decoy and one crafted by the Ward Brothers.

Other fairs define "folk art" in one of a series of terms, including self-taught, visionary, outsider, vernacular, naive, or even primitive. These fairs showcase 20th- and 21st-century works made outside the academic fine art field and without regard to formal art training or process. This conceptualization is perhaps the most prevalent one in the southern United States, where sculpture made with found objects or carved wood, paintings, assemblages, decorated furniture, and story quilts are often displayed. These objects are often based in traditional community values, and their makers may have learned processes or concepts from family members. The artists, however, transform what they have

learned into a personal aesthetic. Although their purposes may initially have nothing to do with the world of art, the individuality of their creations attracts public interest and creates markets for their work.

Across the South, "folk art" festivals and fairs provide an active marketplace. Driven by the enthusiasm of private collectors as well as an increasing number of artists, the marketplace is a strong force. Visitors seek to purchase the art and meet the artists. Because the enthusiasm for contemporary folk art has been marked by interest in the artists themselves, their presence is significant. Some wear quirky dress and drive outlandishly decorated cars; they give the events a distinctive character. Moreover, in the South, strong bonds of friendship among the artists create an atmosphere of camaraderie and easy informality.

Because precise definitions fail, the inclusion of the term "folk art" in a festival's title offers no firm guarantee of the kind of art it displays. Some artists, such as traditional potters and quilters, can be featured in the Smithsonian Folklife Festival and also in contemporary folk art marketplaces. New artists appear frequently, finding inspiration in the work of more legendary artists and defining themselves in the same genre. "Faux" folk artists, that is, trained artists or hobbyists working in a "folky style," often participate, making art with similar materials and exuding a similar character. Some work is personal, some more contrived and derivative. There is generally a diverse mix of music and food, a wide range of quality and subject—and in some cases traditional objects in the form of antiques. "Craft" and "art" are not clearly defined. Because of its popularity, moreover, "folk art" has also become a component in broader fine art festivals and a small presence at primarily music events.

Among the best-known folk art festivals and fairs in the South is the Kentuck Festival of Art, which began in 1971 as a small sidewalk celebration in downtown Northport, Ala., near Tuscaloosa. In 1973 the festival moved to nearby Kentuck Park nestled on the banks of the Black Warrior River. A two-day, out-door, juried art festival, Kentuck annually hosts more than 30,000 visitors and showcases more than 250 artists. Guest artists have included Jerry Brown, Nora Ezell, Howard Finster, Charlie Lucas, Lonnie Holley, Allie Pettway, Jimmy Lee Sudduth, Mose Tolliver, and Yvonne Wells Myrtice West. Southern basket makers, blacksmiths, furniture makers, quilters, and potters also show their wares. Legendary musicians perform, and there are children's art activities and southern and ethnic foods. The Kentuck Festival of the Arts takes place the third weekend in October every year.

Kentucky is famous for two folk art festivals. A Day in the Country takes place each June in Morehead, Ky. Begun by nationally acclaimed husband-and-

wife folk artists Minnie and Garland Adkins at their mountain home in eastern Kentucky, A Day in the Country was established to showcase the work of regional artists, such as Linvel Barker and Tim Lewis. The festival originated in 1987, when the couple hosted a small picnic that included Museum of American Folk Art Assistant Director (now Director Emeritus) Gerald W. Wertkin. The festival soon attracted art collectors from across the United States. Since 2003 the festival has been hosted by the Kentucky Folk Art Center in nearby Morehead. It features the work of more than 50 southern folk artists and attracts a crowd of more than 1,000 people. Visitors can expect to find wood carvings, stone carvings, paintings, and more. Another Kentucky folk art festival takes place each November when Louisville hosts the Good Folk Festival. Begun in 2006, the festival attracts nearly 1,500 visitors and showcases the work of more than 80 local, regional, and internationally known artists, including southerners C. M. and Kelly Laster, Jim Shores, and Lavon Williams, as well as more than 40 or so "primitive" musicians. Housed within the 14,500 square feet Mellwood Arts and Entertainment Center, a refurbished meat packing plant turned creative environment, the festival features folk artists—visual and musical—of the 21st century. The brainchild of Scott Scarboro, a multimedia artist and entertainer from Louisville, who creates kinetic junk art and electrified homemade instruments, the Good Folk Festival showcases visual art that is characterized as "elegantly raw," "rough," "hand made," and "soul felt," and performance art that is "stripped down," "raw," and "traditional with a contemporary bend." Daniel Johnston, the singer-songwriter-artist and folk-punk hero from Texas who was immortalized in the 2005 film *The Devil and Daniel Johnston*, was the featured artist of Good Folk Fest 2008.

The Fearrington Folk Art Show, founded in 2002, occurs each February in Pittsboro, N.C., located near Chapel Hill. This two-day folk art festival invites a select group of artists to exhibit. These include Missionary Mary Proctor, Benny Carter, Cher Shafer, and Sam "The Dot Man" McMillan. Whimsical, wind-driven whirligigs by Vollis Simpson greet visitors and residents year round. Folk art shows up as well on the walls of the farm's old granary, now transformed into a restaurant and bar. Fearrington also hosts the Antiques Show, begun in 2007. Touted for an outstanding selection of 18th- to 20th-century American and Continental furniture and accessories, the fair also features southern furniture, folk art, silver, jewelry, fine carpets, prints, paintings, early tools, porcelains, and architectural pieces offered by 26 dealers.

The Slotin Folk Fest, a three-day event every third weekend in August, bills itself as the world's largest folk art show and sale. Held in the 80,000 square foot North Atlanta Trade Center, in Norcross, Ga., Folk Fest hosts around 100

galleries or dealers who specialize in self-taught, outsider, and contemporary folk art as well as southern folk pottery. When former Cliffs Notes salesman Steve Slotin and his wife Amy founded Folk Fest in 1994, the fair drew a crowd of 6,000; now it attracts as many as 12,000 visitors each year. Collectors from across the nation as well as local onlookers are attracted by the show's wide selection of artwork, which ranges in cost from $5 to $50,000 and includes starter pieces as well as museum quality masterpieces. The Meet-the-Artist-Opening-Night Party also draws crowds. In earlier years Leroy Almon, Archie Byron, Ned Cartledge, Howard Finster, Woodie Long, C. J. Meaders, Lanier Meaders, R. A. Miller, W. C. Rice, and Mose Tolliver, all now deceased, appeared at the festival. Other artists who attend include Lonnie Holley, Charlie Lucas, Missionary Mary Proctor, and Purvis Young.

The House of Blues Folk Art Festival, scheduled each November, originated in 1999. Located at the House of Blues, Downtown Disney, Walt Disney World Resort, Lake Buena Vista, Fla., the two-day festival, entitled "Where the Art Meets the Soul," is free to the public and features not only the work of folk artists, who often attend, but also musical performances and Delta-inspired cuisine. By 2008 the HOB Festival, then in its 10th year, was a thriving enterprise. Scheduled in conjunction with the 33rd annual Festival of Masters, a nationally recognized and juried fine art fair presented by Sharpie and also located in downtown Disney, the HOB festival showcased 40 artists and attracted more than 150,000 visitors. Activities complementing the fair include children's programs, sidewalk decorations, and paintings by members of the Florida Chalk Artists Association, and performances by members of the Cirque du Soleil La Nouba.

More than 30 years ago, Emma Lee Turney established an antiques and craft fair in Round Top, Tex. (pop. 77), which lies midway between Houston and Austin. Today, the Round Top Antiques Fair and Art Festival has grown into Texas Antiques Weekend, an antiques and art extravaganza that is spread over several neighboring towns near Round Top, including Warrenton, Carmine, and Shelby as well as communities in between; takes up as many as 300 acres of land; and features more than 2,000 dealers. Estimates of visitors attending the shows range from as low as 15,000 to an extraordinary 50,000. Attendees come to see fine patchwork quilts, old farm tables, walnut church pews, folk art, school maps, painted pine cupboards, French trims, and cowboy kitsch galore. The festival traditionally occurs over the first full weekend of April and October, but in the last few years, "antique weekend" has become "antique week" or even "antiques up to three weeks."

Nashville's popular Heart of Country Antiques Show features 150 antique

and folk art dealers from across America held every February at the Gaylord Opryland Hotel (where it has been held since 1982). The show features a wide array of objects from all over the country, including paint-decorated cupboards, dry sinks, cast-iron architectural pieces, mantel clocks, tavern signs, game boards, theorems, miniature paintings, all kinds of textiles, and lots of jewelry. The two-day sale is complemented by such special events as a walking tour and a roundtable discussion conducted by veteran dealers. A fall version of Nashville's Heart of Country occurs in Grapevine, Tex. Once located close by and timed to occur in conjunction with Nashville's Heart of Country, two other huge shows, the Tailgate Antiques Show and the Music Valley Antiques Show, moved to the Tennessee State Fairgrounds in 2009 with perhaps as many as 350 dealers. In 2008 *Country Home* magazine partnered with Jenkins Management, the producer of Music Valley Antiques Show, to develop the Country Home Antiquing Festival.

Folk pottery celebrations and art car events are two specific types of festivals of interest to folk art enthusiasts. The pottery events showcase work that falls strongly in both the defined categories of traditional "folklife" and more contemporary "folk art." The best known of these pottery festivals are held in north Georgia and North Carolina, many in October and November. The events are held at individual pottery locations, and they draw sizable audiences, with collectors arriving at daybreak for the best selections.

Art car events bring artists together to showcase the decorated vehicles they have made. Two such annual southern Art Car Weekends happen in Houston, Tex., in May, organized by the Orange Show Center for Visionary Art, and in Louisville in August, organized by the Kentucky Museum of Art and Craft. These events offer parades and a variety of other activities, bringing the message that art is a part of everyday life.

GEORGINE CLARKE
Alabama State Council on the Arts

Henry Glassie, *The Spirit of Folk Art: The Girard Collection at the Museum of International Folk Art* (1989); Chuck Rosenak and Jan Rosenak, *Contemporary American Folk Art: A Collector's Guide* (1989); Betty-Carol Sellen with Cynthia J. Johanson, *Self Taught, Outsider, and Folk Art: A Guide to American Artists, Locations, and Resources* (2000).

Fraktur

Fraktur is a term used by scholars and collectors to refer to the decorated certificates and drawings produced by German-speaking people in America and

Europe. Originally the term referred to a printer's typeface and to the elaborate manuscript lettering derived from typeface used in German-speaking countries from the Renaissance into the early 20th century. The German term *Fraktur* refers to the broken or "fractured" style of the lettering. In America, fraktur has come to signify an entire genre of Germanic works on paper, applied even to drawings that lack text. The term is also sometimes applied erroneously to folk art drawings and documents that are not of Germanic origin but have similar folk art appeal.

Fraktur was made wherever German-speaking immigrants settled. Though most often associated with Pennsylvania, fraktur was also produced in Ohio, Canada, and the South as immigrants spread far beyond Pennsylvania's borders. Many examples of fraktur are found in southern states with Germanic populations, including Maryland, Virginia, and North and South Carolina; German-speaking settlers migrated to the Shenandoah Valley in the second quarter of the 18th century and into the 19th century and then settled throughout the South. Southern fraktur shares many similar designs, colors, and forms with Pennsylvania fraktur, in part because some Pennsylvania artists moved or traveled to the South. Settlers also brought fraktur with them from Pennsylvania when they moved southward, thus introducing motifs to new areas. Variations among southern fraktur are often the result of the influence of individual artists, a trend that also appears in Pennsylvania as many artists developed a distinctive design vocabulary and style that then influenced a particular region's fraktur.

The earliest known evidence of fraktur production in Pennsylvania dates from the 1740s, while most are dated between the 1780s and mid-1800s. Most frakturs were produced to commemorate special events, in particular births and baptisms (*Geburts und Taufscheine*). Fraktur artists rarely made marriage certificates, though some did produce family registers. The second major category of fraktur was related to the German parochial school system and included *Vorschriften* or writing samples, songbooks, copybooks, and rewards of merit. Many other types of fraktur were produced, including house blessings, New Year's greetings, bookplates, religious texts, and love letters.

The primary reason for the dominance of the *Geburts und Taufscheine* is that most German-speaking immigrants and their descendants were members of the Lutheran or the Reformed denominations and placed high importance on infant baptism. The Plain Germans, including the Amish, Mennonites, and Schwenkfelders, were Anabaptists who did not practice infant baptism and thus largely did not make *Taufscheine*. Some Anabaptists did, however, make birth certificates, or *Geburtsscheine*. Occasionally, they also used a birth and bap-

tismal certificate but left the baptismal information blank, or commissioned a certificate later when the person was baptized as a young adult.

American fraktur is rooted in European traditions, yet there are few, if any, exact counterparts for the most common types of American fraktur, birth and baptismal certificates. Rather, the American form appears to be derived from several related European types of fraktur. One such type is the *Taufzettel*, a baptismal paper that was folded around a coin and given to the child. Another is the *Geburtschein*, an official birth certificate. These documents were issued by the minister, who in Europe was a state-sanctioned official. A third form of related European fraktur is the *Taufpatenbrief*, literally a letter from the godparents to the child. These typically record the names of the godparents and date of the baptism. Frequently decorated with hearts, flowers, angels, and other motifs, these European pieces bearing similarities to American fraktur. The exact manner by which these related European traditions may have provided the inspiration for producing birth and baptismal certificates in America is not altogether clear. Immigrants likely brought records with them to document their age and provide proof of baptism, though few frakturs can be documented as being brought from Europe during the period. Another possibility is that the American Revolution necessitated men to provide proof of age for conscription reasons, for which birth and baptismal certificates could be utilized, but whether this practice actually contributed to the rise in the making of birth and baptismal certificates after the Revolution is difficult to determine. Other factors, including a desire to preserve Germanic identity within the larger American culture, may have encouraged German-speaking people to produce and own ethnically distinctive objects such as fraktur. Eventually, in the 19th century, confirmation became a more important religious right of passage and was accompanied by the production of confirmation certificates in addition to the more traditional birth and baptismal certificates.

Most known fraktur artists were men, typically ministers and schoolmasters, who had the necessary education to produce fraktur as well as access to the materials and clientele. Some were professional scriveners and artists. Fraktur artists made these certificates, drawings, and other documents for extra income or as gifts for their family, friends, parishioners, or students. The materials used in producing fraktur were fairly simple: paper, ink, and watercolors, sometimes assisted by tools like a compass or straightedge, used for laying out designs and text. For many years it was believed that artists made their own inks and pigments using berries, bark, and other ingredients and utilized local cherry tree gum as a binder. Research, however, indicates that many fraktur artists were actually sophisticated consumers of imported materials. Scientific analysis of

numerous frakturs has revealed the use of a wide range of commercial pigments (many of them imported), including Prussian blue, chrome yellow, and vermilion, with gum Arabic used as a binder. Newspaper advertisements from the 18th and 19th centuries also document the availability of a wide range of imported pigments not only in Philadelphia but also in inland market towns and cities.

Today one of the most distinctive and highly prized types of folk art, fraktur began as a largely personal and private art. Few, if any, pieces were originally framed, hung on walls, or otherwise displayed. Frakturs were placed inside books for safekeeping, often folded several times, and occasionally pasted inside furniture, in particular to the underside of the lid to a chest. Frakturs were also rolled up and stored inside chests and boxes. As the popularity of collecting fraktur grew in the early 20th century, pieces were increasingly framed and hung for display.

Fraktur production continued well into the 19th century, although it underwent significant changes. Traditional school-related frakturs such as the *Vorschriften* declined as public education replaced parochial school systems. English-language fraktur became increasingly available, though demand for German fraktur continued as well. More and more print shops continued to make hand-drawn fraktur into the 1900s. Some artists, however, such as the Amish artist Barbara Ebersol of Pennsylvania, established and produced printed fraktur certificates and broadsides by the thousands. In a sense, fraktur never died out but rather evolved and adapted along with the Germanic culture that introduced it to America. To this day, fraktur artists work in traditional and contemporary styles.

LISA M. MINARDI
Winterthur Museum and Country Estate

John Bivins, *Journal of Early Southern Decorative Arts* (November 1975); Russell D. Earnest and Corinne P. Earnest, *Papers for Birth Dayes: Guide to the Fraktur Artists and Scriveners* (1997); Cynthia Elyce Rubin, ed., *Southern Folk Art* (1985); Donald A. Shelley, *The Fraktur-Writings or Illuminated Manuscripts of the Pennsylvania Germans* (1961); Frederick S. Weiser and Howell J. Heaney, *The Pennsylvania German Fraktur of the Free Library of Philadelphia* (1976); Klaus Wust, *Virginia Fraktur: Penmanship as Folk Art* (1972).

Fraternal Societies

Fraternal societies have played an important role in shaping the behavior, beliefs, and personal identities of many southerners. Groups such as the Free-

masons, the Odd Fellows, the Modern Woodmen of America, the Improved Order of Red Men, and hundreds of other voluntary, oath-bound organizations have tutored members in systems of thought and have bestowed symbolic identities and fictive familial relationships on their members. While some fraternal organizations promoted ethnic solidarity and fiscal responsibility through insurance, nativism, or other values, the initiation of new members constituted the central activity of most groups. Fraternalism in the South can be traced to the establishment of Masonic lodges in coastal cities in the first half of the 18th century. The movement reached its greatest popularity and influence in the years between 1865 and 1930.

Fraternalism has appealed to southerners of both European and African descent, although blacks and whites have rarely belonged to the same organizations. Instead, parallel systems of lodges developed in many communities, such as the Independent Order of Odd Fellows and the Grand United Order of Odd Fellows or the Ancient Arabic Order Nobles of the Mystic Shrine and the Ancient Egyptian Arabic Order Nobles of the Mystic Shrine, in which men practiced similar rituals and promoted comparable ethical systems but did not communicate or engage in fraternal brotherhood.

Members of societies have placed fraternal symbols on everything from palatial buildings to personal adornments. Fraternal material culture can be divided broadly into objects created for institutional use and personal items used by individual members to celebrate their affiliation. Altars, ritual paraphernalia, and emblematic paintings fall into the former category, whereas watch fobs, walking sticks, chains carved of wood, and marquetry picture frames are in the latter. Because numerous men held memberships in more than one society, personal objects often combine the symbols and emblems of multiple groups.

A wide range of artists and artisans created fraternal objects. While enthusiastic amateurs have produced numerous items expressing their devotion to fraternal ideals, in other cases creators of the highest training and talent have created extraordinary works of the greatest refinement. The Masonic chair currently owned by the Colonial Williamsburg Foundation and created by Benjamin Bucktrout in Williamsburg, Va., in the 1770s is a notable example. Similarly, as a young man the artist John Gadsby Chapman created a ritualistic painting for the Masonic lodge in Alexandria, Va., in the second quarter of the 19th century. Local milliners, silversmiths, and engravers, like Thomas Coram and Horatio G. Aspinwall, both of Charleston, S.C., often received fraternal commissions. Starting in the 1850s and expanding after the Civil War, a specialized industry, largely based in the Midwest, shipped fraternal goods to groups

across the nation. Although regalia houses produced fraternal goods in large quantities, it can be difficult to differentiate their products from items created locally.

WILLIAM D. MOORE
Boston University

Barbara Franco, *Fraternally Yours: A Decade of Collecting* (1986); John D. Hamilton, *Material Culture of the American Freemasons* (1994); F. Carey Howlett, *American Furniture* (1996); William D. Moore, *Folk Art* (Winter 1999–2000); Mark A. Tabbert, *American Freemasons: Three Centuries of Building Communities* (2005).

Furniture, Decorated and Painted

Painted and decorated furniture of the 17th through the mid-19th century reflects the color choices and artistic vision of individual artisans rather than the published designs for high-styled furniture forms and decorations. Makers of painted furniture were aware of what was being done in more urban areas with fine cabinet woods, yet they chose to incorporate color, religious, cultural, fraternal, or political traditions, and occasionally whimsy, into the furniture they produced. Sometimes they attempted to mimic high-style furniture in their painted designs, and sometimes they decorated pieces following their own artistic vision.

There are three general categories of decorated and painted furniture. The first includes furniture that was painted with one or two colors in order to create a more elaborate and unified appearance than that of unpainted furniture. These pieces were usually made of plain, inexpensive woods like pine or tulip poplar. They might also be made with various woods that would have looked incongruous without a unifying painted surface. When furniture has surface decorations that are of an artistic nature and transmit a cultural or personal aesthetic, these pieces certainly fall under the rubric of folk art. The second category involves the application of grain painting or faux-finishing. The patterns created by dragging glazes over a base coat of a different color with tools such as combs, feathers, or leather rollers provide the effect of richer woods with deeper colors and pleasing grain patterns. Rosewood, mahogany, bird's-eye maple, and even marble were emulated by these faux finishes—both on furniture and in architectural settings. In the early 19th century, this type of graining was commonly found on "fancy" furniture, so called because of the exuberant and often whimsical nature of the pieces and their ornament. Furniture makers had two variations of faux-finishing at their disposal: imitative, which mimicked the natural materials, and imaginative, in which the artisan

allowed his fancy to dictate the grained designs. A third category of decorated furniture includes furniture that was painted with pictorial elements or scenes. Often these pictorial elements may derive from cultural, religious, fraternal, or patriotic traditions or from the maker's idiosyncratic artistic sensibility. The distinctive regional aesthetics and cultural influences on pieces of southern decorated and painted furniture often differentiate them from their northern cousins.

Some of the earliest painted furniture in the South are utilitarian objects that had color added to appeal to a less affluent audience eager to acquire more fashionable furnishings. One early 18th-century cupboard from the Tidewater area of Virginia, composed primarily of yellow pine with tulip, poplar, and walnut components, was originally painted blue with a white interior in order to highlight ceramics stored inside. While many other pine cupboards were left unpainted during this period, the blue paint provided both a unified and pleasing appearance. This type of decorating, which allowed furniture makers to create slightly more expensive and fashionable utilitarian objects, was common throughout the South.

A very distinctive regional approach to painting furniture was found on the Eastern Shore of Virginia and Maryland. The raised-panel cupboards and presses produced by the carpenters in this area were typically painted blue with details including panel outlines, fluted columns, and moldings picked out in white and occasionally green, black, and orange. The Eastern Shore, a peninsula extending south from Delaware on the eastern side of the Chesapeake Bay, was geographically isolated from the rest of the Tidewater region. Because of its physical separation and agricultural economy, finish carpenters made much of the furniture locally. The design and coloration of these cupboards and presses relates quite closely to the architectural paneling found in Eastern Shore houses that were built by these same artisans.

Grain-painted furniture of the South also demonstrates a crossover between the architectural and furniture finishes. Numerous houses with grained and marbleized wainscoting, baseboards, and mantles have been found from Virginia to Georgia, including one painted by Isaac Scott for Colonel and Mrs. Alexander Shaw of Wagram, Scotland County, N.C. In addition to graining the woodwork, Scott painted the pine wall boards with drapery swags in imitation of period wallpaper borders. Southern corner cupboards, chests, boxes, clocks, tables, and trunks were also painted with these faux finishes, sometimes with the feet of the object grained to match a room's baseboard. Some of the graining was done in a naturalistic or imitative manner to replicate the natural material. Other grain patterns, however, were imaginative de-

signs hardly recognizable as any specific wood or stone. The decorators of this furniture were typically not the joiners or cabinetmakers who constructed the furniture. Rather, the decorators often were signboard or coach painters or artisans in other related professions. Nineteenth-century published manuals such as Nathaniel Whittock's *Decorative Painters' and Glaziers' Guide* (1828) taught those interested in the subject the subtleties of the techniques.

The fancy furniture of early 19th-century Baltimore filled the need for fashionable painted furniture both locally and throughout the Chesapeake region. Produced by manufacturers such as John and Hugh Finlay, Thomas S. Renshaw, and John Barnhart, the Baltimore furniture of the first quarter of the 19th century echoed the forms of fashionable urban mahogany and rosewood furniture with an exuberance of faux-graining, gilding, and colorful painted motifs that included flowers, wreaths, anthemia, and musical instruments. Landscape views also adorn some chairs and tables. These pieces demonstrate the confluence of the furniture decorators, found in the grain painters, with artists like Francis Guy. Guy, who immigrated from England without academic training in art, painted landscape scenes and house views, both real and imaginary, on high-style furniture from the Finlay manufactory and in time became one of the most celebrated American landscapists. Affluent Baltimoreans purchased suites of this furniture for their parlors as well as for assembly rooms. While much of the Baltimore furniture was purchased locally, these firms also advertised and shipped their wares across and down the Chesapeake Bay to the Eastern Shore, Norfolk, and beyond.

The southern backcountry was a melting pot of settlers from northern states such as Pennsylvania and Connecticut as well as from Europe. English, Scots-Irish, Irish, German, Swiss, and Welsh immigrants populated the backcountry from the Valley of Virginia down into North Carolina, South Carolina, Tennessee, and Georgia. These immigrant groups brought with them their own distinctive cultural traditions, including the furniture forms and decorations with which they were familiar. The German and Swiss traditions stand out, especially in the work of decorative painters in the Valley of Virginia, where groups of affiliated artists created distinctive local styles. For example, Johannes Spitler (1774–1837), a German immigrant decorator working in Shenandoah County, Va., was instrumental in establishing the distinctive style of Wythe County, Va., painted chests. Wythe County chests, with facades broken into three painted arch-headed panels enclose painted vases of tulips that are the most traditional German American designs. Similar designs and motifs appear on Pennsylvania German chests as well. Johannes Spitler pairs a consistent paint scheme of white, red, and black on a blue background with a consistent

repertoire of motifs: geometric designs, free-hand flowers and animals, stylized hearts and moons, compass-drawn flowers, and abstract fractured designs that are all linked to the decorative German fraktur tradition. While most of Spitler's work diverges from traditional German American chest and clock designs, it may incorporate typical elements such as tulips, birds, and hearts. Not all painted chests and clocks find their ornamental devices in cultural traditions brought to America by German immigrants, however. Furniture decorators, for example, may have employed political imagery. One Greene County, Tenn., chest displays the eagle from the Great Seal of the United States alongside traditional tulips. The imagery on the chest demonstrates the decorator's Germanic ancestry as well as his patriotism. Members of fraternal organizations often purchased furniture and decorative arts ornamented with specific symbols related to their groups or positions. An unusually pedimented and paneled tall case clock found in Edgefield, S.C., is decorated with Masonic imagery both on the clock face and on the case. These are just a few of the many unique objects decorated by southern artisans.

Painted chests, clocks, hunt boards, tables, sugar chests, and other common forms, with either solid colors, faux finishes, or painted decorative motifs, are known from Virginia, North Carolina, South Carolina, Georgia, Tennessee, and Texas. These pieces of painted and decorated furniture reflect distinctive cultural, religious, fraternal, and political influences as well as the decorators' own traditions and personal aesthetics.

TARA GLEASON CHICIRDA
Colonial Williamsburg Foundation

Benjamin H. Caldwell Jr., Robert Hicks, and Mark W. Scala, *Art of Tennessee* (2003); Lance Humphries, in *American Furniture*, ed. Luke Beckerdite (2003); Ronald L. Hurst and Jonathan Prown, *Southern Furniture, 1680–1830: The Colonial Williamsburg Collection* (1997); Deanne D. Levison, *Neat Pieces: The Plain-Style Furniture of Nineteenth-Century Georgia* (1983, 2006); James R. Melchor, N. Gordon Lohr, and Marilyn S. Melchor, *Eastern Shore, Virginia: Raised Panel Furniture, 1730–1830* (1982); J. Roderick Moore and Marshall Goodman, *The Magazine Antiques* (September 2007); Sumpter Priddy, *American Fancy: Exuberance in the Arts, 1790–1840* (2004); Cynthia V. A. Schaffner and Susan Klein, *American Painted Furniture, 1790–1880* (1997); Donald Walters, *The Magazine Antiques* (October 1975); Gregory R. Weidman and Jennifer F. Goldsborough, *Classical Maryland, 1815–1845: Fine and Decorative Arts from the Golden Age* (1993).

Furniture, Vernacular

When used to describe furniture, the term "vernacular" means different things to different people. For some, vernacular furniture is simply the opposite of formal or high-style furniture; in other words, vernacular furniture has no obvious design source that can be traced to formal design books such as Thomas Chippendale's *The Gentleman and Cabinet-Maker's Director*. To others, equally vague terms often used to describe furniture, such as "plain," "country," "common," "folk," "rural," or "provincial," are synonymous with "vernacular." Although no single definition of vernacular furniture will probably ever be completely accepted by all furniture historians, perhaps scholar David Knell comes closest to an inclusive definition in his book *English Country Furniture* (1992). In it he describes the concept of vernacular furniture thus: "The label . . . 'vernacular' [is] an adjective borrowed from architecture and implying a relatively unsophisticated product of ordinary people, normally of a regionally traditional design frequently made of native materials, and usually with connotation of general, utilitarian use. In its widest sense, 'vernacular furniture' is the furniture 'of the people,' as opposed to that of a privileged few."

An example of furniture that strictly adheres to Knell's definition is a cupboard in the collection of the Museum of Early Southern Decorative Arts (MESDA). The cupboard is made of yellow pine, which has been painted dark red with black or green and white used as accent colors. Although the case and drawers are dovetailed, the dovetails are rather large and crude; the doors have heavily fielded panels; and the decorative cornice is composed of three parts—a lunetted band topped by two separate ogee moldings. Most fasteners are fairly large cut nails, and the doors swing on hand-forged pintle hinges, which allow the doors to be removed easily. The door pulls are petite, squared wooden examples. The most likely construction date is 1800–1820. In addition to step-back cupboards like this one, the maker also produced hanging cupboards, corner cupboards, dish dressers, chests, and chests of drawers.

The maker of MESDA's cupboard lived and worked in the north-central part of Montgomery County in the Piedmont of North Carolina. In the 18th and early 19th centuries, this area was relatively isolated, with no large towns and only small farms, gristmills, sawmills, and a few gold mines dotting the hilly landscape of the Uwharrie Forest. An early inhabitant, probably a general carpenter who built houses as well as furniture, was most likely responsible for the MESDA piece.

The cupboard is a perfect example of vernacular furniture because it is a relatively unsophisticated product (at least in comparison to urban examples), was made by an ordinary craftsman probably for an ordinary neighbor, was of a

"Peaked apron" cupboard made by Jacob Sanders, Montgomery County, N.C., ca. 1800 (Old Salem Museums and Gardens/MESDA)

regionally traditional design, was made of native yellow pine, and was made for the utilitarian purpose of storing food and food-related items such as dishes, drinking vessels, cutlery, and textiles. It could have been owned by any of the small farmers who lived in the area and clearly was not a product made for "the privileged few."

The makers of such furniture were almost always of limited means, but that fact in no way limited their creativity. The maker of MESDA's cupboard used a bright polychrome paint scheme, shaped pintle hinges, tiny pulls, and decorative cornice to create an object that surely brightened and cheered the functional space in which it first resided, much as it does its museum setting today. In fact, many contemporary collectors prefer the warmth of vernacular furniture to the high style of more formal examples. To some, the ordinary is extraordinary.

TARA GLEASON CHICIRDA
Colonial Williamsburg Foundation

David Knell, *English Country Furniture* (1992).

Furniture, Vernacular, of Texas

During most of the 19th century, Texans obtained their house furniture from local cabinetmakers. From the extension of the Cotton Kingdom into Texas by Anglo-Americans in the 1820s until the late 1870s, the region's isolation from the rest of the United States meant that factory-made furniture from the East was not generally available. During those years there was at least one cabinet shop in every county in Texas, and most towns had several. By the 1880s most of these shops had disappeared, and Texans started furnishing their homes with mass-produced furniture. In the 18th century Hispanic *carpinteros* undoubtedly made furniture in the Spanish communities in Texas, as they did in New Mexico, but no examples or documentation of their work has survived.

Texas furniture became distinctive within the South. The majority of 19th-century cabinetmakers in Texas were southerners, but a significant minority was German, as a result of the German immigration to Texas that took place in the 1850s and 1860s. In 1860, when only 6 percent of the state's population was German-born, Germans totaled 33 percent of the cabinetmakers listed on the census. The German cabinetmakers, who had passed through formal apprenticeships in Europe, tended to be better trained than their Anglo-American counterparts, and their furniture shows that they were more aware of cosmopolitan styles.

Most rural cabinetmakers in Texas operated one-man shops and also farmed, a pattern that is found all through the rural South in the 19th century. Many also practiced other woodworking trades and built houses, cotton gins, wagons, and coffins as well as furniture. Their shops were equipped with hand tools and foot-powered lathes, and they produced a limited variety of furniture forms: chairs, tables, beds, wardrobes, bureaus, settees, desks, pie safes, and cupboards. They produced little upholstered furniture.

Furniture makers usually obtained wood locally, either from the pine forests of east Texas or from the fluvial hardwood forests along the rivers and creeks of central and north Texas. The primary woods used were pine, cedar, and walnut. However, there was an active lumber trade, and exotic woods such as mahogany and rosewood were imported through Galveston and hauled by wagon to cabinetmakers as far inland as San Antonio and New Braunfels. Pine from Alabama, Florida, and Maine was also imported through Galveston, as was hardware such as hinges and locks. Pine furniture was often painted with oil-based paint or grained in imitation of more expensive woods. Furniture from other woods was finished with a glossy varnish, often made from copal, a tree resin.

Before the Civil War most Texas cabinetmakers worked in the Plain Grecian style, known as "pillar and scroll," that was popular throughout the South. German-born cabinetmakers frequently made furniture derived from the Biedermeier style popular in Germany in the 1840s. By the 1870s, increasingly sophisticated clients were demanding furniture in the Renaissance Revival, Rococo Revival, and Gothic Revival styles; and Texas cabinetmakers responded with furniture that exhibited elements of these styles. In the 1880s a San Antonio furniture factory produced furniture made from animal horns in the Rustic style, which was popular in Europe and the East for furnishing hunting lodges.

As in the rest of the South, some furniture makers in Texas specialized in the production of inexpensive chairs. Chair makers used a turning lathe and a drawknife to make light ladder-backed chairs with rawhide, woven corn-shuck, or split oak bottoms. They usually shaped the parts in the winter and assembled them as needed. According to the 1860 census, Anderson Dorris of Lockhart and his son John made 450 hide-bottomed chairs in that year and sold them for $1.50 each. Some Texas chair makers continued their production well into the 20th century; the Jackson family of Blue in Lee County made chairs there from the 1870s through the 1930s.

After the Civil War the American furniture industry began to be concentrated in the Midwest. Factories with steam-powered machinery produced

large quantities of cheap furniture that could be shipped by railroad to local consumers. As the national railroad net was extended across Texas in the 1870s, some local Texas cabinetmakers struggled unsuccessfully to compete with midwestern factories by employing more workers and by adding horse-powered and steam-powered woodworking machinery to their shops. Mechanization was most intense in east Texas and on the Blackland Prairie of north Texas. William Sheppard's shop in Tyler provides a good example of the process. Sheppard was a Kentuckian who moved to Tyler in the 1850s and opened a one-man cabinet shop equipped with hand tools. By 1860 he was in partnership with J. C. Rogers; they described themselves as "Furniture Merchants and Cabinet Makers." They had a horse-powered lathe and three employees who made bedsteads, wardrobes, and bureaus. Their retail department also carried furniture made by other local cabinetmakers. By 1870 they had moved to a new location several miles from Tyler called Mechanicsville, where they had a 15-horsepower steam engine, four lathes, two boring machines, a tennoning machine, and 10 employees who made $5,500 worth of furniture that year. By 1880 they had gone out of business.

Other Texas cabinetmakers, however, continued to work in one-man shops with hand tools well into the 1870s. This was especially true in the German settlements of the hill country west of Austin, where German-born cabinetmakers worked in relative isolation from Anglo-American society and where some of the most aesthetically pleasing furniture made in 19th-century Texas was produced. The hill country shops in New Braunfels and Fredericksburg operated on a carefully circumscribed basis, none of them employing more than one person and an apprentice and none of them using steam-powered machinery. The best-known hill country cabinetmakers were Johann Jahn of New Braunfels, Franz Stautzenberger of Clear Spring, and Johann Peter Tatsch and William Arhelger of Fredericksburg. Collectors eagerly seek out their furniture. Major collections of 19th-century Texas vernacular furniture can be seen at the University of Texas at Austin's Winedale Historical Center in Round Top, Tex.; the Witte Museum in San Antonio; and the Museum of Texas Handmade Furniture in New Braunfels.

LONN TAYLOR
Fort Davis, Texas

San Antonio Museum Association, *Early Texas Furniture and Decorative Arts* (1973); Donald L. Stover, *Tischlermeister Jahn* (1978); Lonn Taylor and David Warren, *Texas Furniture: The Cabinetmakers and Their Work, 1840–1880* (1975); Tommy Titsworth, *Early Comfort, Texas Cabinet Makers: A History of Hill Country Furniture* (2007).

Gravestone Carving

Southern cemeteries are free outdoor art museums displaying the work of both taught and commercial gravestone carvers. A few graveyards include masterpieces by formally or self-trained artists, but most grave markers are more notable as indicators of the rich cultural and social diversity of the South than as works of art alone. Gravestones also provide an ongoing historical record of the South's self-identity in relationship to other parts of the United States.

In the 18th century, wealthy southerners could afford to employ New England artisans to carve gravestones of slate and other materials, and a few southerners in the Charleston, S.C., area and elsewhere imported gravestones from England. Local Charleston artists such as the Scots immigrant Thomas Walker carved in a manner once associated solely with New England Puritans. The icons on these colonial-era stones reflect the styles promoted by the design books and apprenticeship system of the time. Many display the winged skulls, winged hourglasses, and other memento mori symbols observable in New England graveyards.

In the late 18th century, the winged skulls slowly morphed into winged soul effigies with angelic faces, and more-inspiring icons such as the anchor of hope began to appear in gravestone sculpture. In addition, classical designs such as willow trees and urns suggested that American citizens were eager to align their new republic with those of ancient Greece and Rome. The New Orleans sculptor Jacques Nicolas Bussière de Pouilly used classical and other revival styles in the distinctive aboveground tombs of that city after Louisiana became a state in 1803. Traditional gravestone carvers, such as the Bigham family of the North Carolina Piedmont, also exemplify a growing national consciousness in their iconography as they gradually replaced traditional Scots-Irish designs such as the Scotch thistle and the Dove of Promise with such symbolic references to the new Republic as the seal of the United States.

In some parts of the South during the 18th and early 19th centuries, however, financial necessity and ethnic identity dictated memorial practices—and this pattern continues in some areas well into the 21st century. The Upland South, for example, has many folk cemeteries with features such as mounded graves, wooden grave houses, and "scraped earth" graves free of vegetation. Many gravestone makers represented in these folk cemeteries are self-trained artists who create markers out of materials at hand, such as wood, concrete, and broken glass.

African American graves can also demonstrate a keen sense of ethnic consciousness. Sometimes graves are decorated with shells or with broken household vessels that derive from African practices and from beliefs that the

ancestors lived in a watery realm and that vessels or water symbols aided communication between the worlds of the living and the lives of the dead. Other African American grave markers include symbols of time, like broken clocks and objects or clothing used by the deceased. Concrete markers, sometimes embedded with marbles, by unnamed, self-taught artists are also characteristic of many African American graveyards such as Holt Cemetery in New Orleans. The starkly eloquent grave markers of Nashville's folk sculptor William Edmondson presage the abstracted forms of his later sculptures.

Ethnic identity is a primary defining feature in other graveyards as well. In North Carolina's Davidson County, 19th-century artists such as cabinetmaker Joseph Clodfelter and members of the Swisegood School carved on soapstone distinctive pierced-stone designs of hearts, fylfot crosses, and tulips that derived from their German Protestant heritage. Many southern cities have Jewish cemeteries—sometimes as part of larger municipal cemeteries—and their iconic grave markers reflect both Jewish culture, with stars of David and Hebrew inscriptions, and an investment in the shared secular symbology of wider American culture. Makers of more complexly decorated stones, with flowers, birds, and other symbols found in Jewish folk art, may have been immigrants familiar with Jewish aesthetics and expectations. Recent Jewish immigrants from the former Soviet Union have introduced a 20th-century style of folk carving. Though some American Jews have believed that the elaborate portraits carved into black granite are not consistent with Jewish practice, enameled portraits commonly appear on early 20th-century gravestones. With rabbinical approval, carved portrait stones are now welcome in Jewish cemeteries throughout the United States.

The 19th century introduced a paradigm shift in cemetery and gravestone design. Mt. Auburn Cemetery in Cambridge, Mass., consecrated in 1831 as the first picturesque rural/garden cemetery in America, exerted considerable influence. Large municipal cemeteries in the South such as Hollywood in Richmond, Va., Cave Hill in Louisville, Ky., and Bonaventure in Savannah, Ga., incorporate such rural cemetery elements as winding paths, graves clustered by families, lush natural plantings, iconic gravestones with hopeful symbols such as the opening doors of heaven, and unique marble statuary, sometimes commissioned from European artists. Southern garden cemeteries may contain some particularly southern monuments to the Lost Cause of the Confederacy. Oakland Cemetery's grandiose "Lion of Atlanta," a slumbering lion resting upon the Confederate flag, guards the graves of some 6,000 Confederate and Union soldiers—including 3,000 of unknown identity. Carved by Georgian T. M. Bradley and erected in 1894, the lion was carved from the

largest block of marble yet quarried in Georgia. By the middle of the 20th century, the trend toward memorial parks with flat commercial markers and a few pieces of mass-produced statuary deemphasized the work of individual artists, as does the more recent trend of ecologically friendly cemeteries. In Ramsey Park preserve in Westminster, S.C., founded in 1998 as the first green cemetery in the United States, trees or other plants and natural stones with minimal biographical information, brief epitaphs, and very simple line drawings minimize the carver's artistic presence.

By the turn of the 20th century, middle-class southerners could order relatively inexpensive marble tombstones from Sears Roebuck *Tombstones and Monuments* catalogs. However, while the availability of standardized, mass-produced stones greatly decreased the number of local stone carvers who might have preserved regional styles, these generic stones did not completely displace the folk memorials that some people preferred and that others chose out of necessity.

In working garden cemeteries, churchyards, and folk cemeteries, significant new designs continue to appear. Many mourners prefer memorials and grave decorations like those of their ancestors; many include grave gifts to personalize the grave. Because of advances in computer-assisted engraving, customers can choose fairly inexpensive individualized memorials. Recent stones engraved with footballs, dogs, or men fishing reflect regional interests while others engraved with portraits or prized possessions reflect a cult of the individual or even affirm the notion common to southern gothic fiction that the lines between physical and spiritual dimensions may blur. Although these machine-made recent stones are not folk art, they do reflect a folky, informal sensibility often found in southern folk art.

JUNE HADDEN HOBBS
Gardner-Webb University

Diana Williams Combs, *Early Gravestone Art in Georgia and South Carolina* (1986); D. Gregory Jeane, in *Cemeteries and Gravemarkers: Voices of American Culture*, ed. Richard E. Meyer (1989); M. Ruth Little, *Sticks and Stones: Three Centuries of North Carolina Gravemarkers* (1998); Peggy McDowell, *Cemeteries and Gravemarkers: Voices of American Culture*, ed. Richard E. Meyer (1989); Susan H. McGahee and Mary W. Edmonds, *South Carolina's Historic Cemeteries: A Preservation Handbook* (2007); David Charles Sloane, *The Last Great Necessity: Cemeteries in American History* (1991).

Interior Painting, Decorative

Decorative interior painting is an art form that is integrally tied to architecture. Wood-grained, marbled, sponged, stenciled, trompe l'oeil, and scenic painting have been used historically, as today, to brighten interiors. As with other art forms, the range of creative expression seen in decorative interior painting runs the gamut from the sophisticated academic work of formally trained and highly skilled artists to the more abstract and freewheeling painting executed by lesser-trained or self-taught folk artisans. The entire spectrum contributes to an understanding of southern culture.

Until recent decades, the study of historic decorative interior painting has concentrated on New England, with a particular emphasis on the stenciled walls, scenic walls, and overmantel paintings found there. More recently, regional historians have begun to examine decorative interior painting in the southern states. With the publication of these studies, it is becoming clear that the South also possesses a rich collection of decorative interior painting that is simply waiting to be recorded in full and analyzed. Some of this painting reflects an adaptation of the stenciling and wall painting found in New England. However, decorative interior painting in the South goes well beyond this to establish, as with southern food, its own flavor.

Historical decorative interior painters are an elusive group. While some examples of decorative painting can be tied to specific painters, and while information is known about the lives of some of these, the painters of most decorative painting, by far, remain anonymous. Most decorative painters in the 19th century led itinerant lives. Both painters' advertisements in newspapers and, in some cases, the paintings themselves reveal that some painters traveled a small area, while others covered a much broader territory. The essential mobility of itinerants made their names less memorable than the names of homegrown artists, thereby making the task of identification more difficult and knowledge of painters' backgrounds and training next to impossible. Nineteenth-century trade journals and related publications offered painters instructions in simulating various types of wood and stone with paint. Especially during the last quarter of the 19th century, trade catalogs advertised a variety of tools to assist painters with decorative painting and, at the same time, provided illustrations and instructions for using the tools. Among these devices were graining plates, rollers, brushes, combs, and stencils. Nevertheless, the availability of these publications should not imply that all decorative painters were in a position to use them. Indeed, many painters made their own tools from whatever they had at hand, taking a freehanded rather than a mechanical approach to their painting. Ultimately, in many cases the level of training and influences affecting the work

of a particular painter can be surmised only by the quality and character of the painting itself.

The clientele for decorative interior painting in the South varied greatly. Both wealthy landowners and entrepreneurs who could afford fancy wallpapers and other decorative devices and middling farmers who could acquire the services of a painter in exchange for room and board commissioned painters to decorate their homes.

During the 19th and early 20th centuries, the most popular form of decorative interior painting in the South was wood graining, used primarily on doors, but also on wainscots, mantels, and other architectural features where wood would have been used naturally. Painters imitated different types of wood, with mahogany, bird's-eye and tiger-grain maple, and oak being among the favorite choices. Wood graining allowed homeowners to use common local woods and dress them up to look like fancier or more exotic woods. Yet even when fancier woods were available and could be acquired, wood graining was often chosen instead, primarily because it was fashionable, but also because it could be over-grained later to imitate another type of wood. As with painting in the folk tradition, painters tended to forgo a realistic portrayal of wood from nature in favor of a more imaginative presentation that is exciting in its originality. In the more stylized examples, pattern and color were clearly more important to the painter than the replication of wood from nature.

During the early 19th century, wood graining tended to follow a stylistic formula that was closely tied to period furniture with inlaid wood detailing. This type of graining usually consisted of imitation mahogany with a thin, painted inlay border that created the impression of a raised panel. Doors at the early 19th-century Edwards-Franklin House in Surry County, N.C., illustrate a dramatically stylized version of this. Across the state in Edgecombe County, doors at the Bynum-Sugg House are even more abstract, with panels painted like great feathered plumes.

The use of painted bird's-eye maple panels with tiger-grain maple surrounds was especially popular during the mid-19th century. While some examples could be surprisingly realistic, others were so stylized that their visual associations with maple are tenuous. Two of the most fanciful examples, both in North Carolina, are the wainscoting at the Gardner-Moore House in Pitt County and doors at the Dr. R. H. Riddick House in Gates County. The former consists of tiny, light-colored doughnut shapes against a dark brown ground combined with paisley shapes created by stamping the curled-up side of a hand on wet paint. Six-panel doors at the Riddick House stretch the concept of bird's-eye maple about as far as possible. An extraordinarily lively example of the folk

painter's imagination, these doors feature symmetrically arranged dots and squiggly lines painted in teal blue and burnt orange that look rather like Mardi Gras confetti or serpentine.

Marbling, the painted imitation of various types of marble and other stones, followed closely behind wood graining in popularity during the 19th century. Marbling was used primarily for mantels, baseboards, and stair risers and secondarily for wainscots, door casings, and other trim. Folk-painted marbling tended to be more abstract in color and design than the more true-to-nature academic versions.

Stone-blocked painting was an ambitious subcategory of marbling that was related to the use of ashlar-patterned wallpapers popular in America from the late 18th century through the mid-19th century. Painted on both plastered and flush-boarded walls, stone blocking made use of painted lines to break marbling into neatly arranged, usually rectangular, blocks that covered entire walls. The relative formality of stone blocking dictated its use for hallways, parlors, and dining rooms, where visitors could best appreciate its effect. Although, like other forms of decorative painting, stone-blocked painting could produce academically realistic examples, its folk form tended toward more color and imagination. For example, the Flinchum House parlor, now in storage at the North Carolina Museum of History in Raleigh, exhibits startling rainbow-colored marble blocks with delicate veining in the yellow blocks only, enough to make clear that the painter was, in fact, imitating marble blocks.

Another subcategory of marbling was smoked painting, created by waving a lighted candle, torch, pine knot, or kerosene lamp across wet paint so that the smoke created a marbled effect on the paint surface. This technique appears primarily on ceilings. Good examples can be found at the Johnson-Hubbard House in Wilkesboro, N.C., the Damascus Methodist Church in Lumpkin, Ga., and the Calhoun-Perry House in Cherino, Tex.

Occasionally, spongework was combined with graining and marbling to further brighten woodwork. A particularly good example is the early 19th-century painted parlor at the Plecker-Wise House in Augusta County, Va. Here most of the mantel as well as the door and wainscot panels are painted in brown-over-yellow spongework described locally as "light rolls" and "oysters" because of their appearance. The stiles and rails are sponge-painted in a variety of designs using blue-green paint.

Historic stenciling can be found in the South from two periods, each with its own particular character. The less common of the two forms, featuring a variety of patterns painted over entire walls, dates from the early 19th century and is related in form and style to New England's wall stenciling tradition. In Virginia,

the Brick Tavern in Middlebrook and the Robert Tate House in Greenville provide good examples. Other fine examples include the Colonel James Coleman House in Cynthiana, Ky., and, in Tennessee, Cragfont in Gallatin and the Stencil House near Clifton. The painting in all these houses appears to date from the early part of the second quarter of the 19th century. The other type of stenciling, more complex and used primarily to decorate ceilings and wall cornices, gained popularity during the late 19th century. While stencils could be purchased from catalogs, folk artists often made their own and then combined them with free-hand elements to achieve designs that bore their artistic signatures.

A good example is a group of six houses and one church that all appear to have been painted during the last quarter of the 19th century and that may have shared a common itinerant painter, even though the buildings are widely separated. Of the seven, the Rucker-Eaves House in Rutherfordton, the Edwards-Maxwell House in Alleghany County, and the Blair House in Watauga County, all in North Carolina, the Chesser-Williams House in Gwinnett County, Ga., and the Calhoun-Perry House in Chireno, Tex., have strikingly similar ceiling designs. Decorated with stenciling intermixed with free-hand painting, the ceilings feature a center medallion with central compass rose. The medallion is surrounded by several circular bands, some containing a vine border and some composed of geometric panels. Four radiating paths lead from the center rose to the outer walls of the room. One of the stencils common to all is a border of alternating half circles and diamonds, with two dots dripping from each diamond. The Damascus Methodist Church in Georgia has four similar, but smaller, ceiling medallions, and this church and a house in Chatham County, N.C., share many of the same stencil patterns as the other five properties.

Perhaps the most fascinating form of decorative interior painting in the South is trompe l'oeil painting. Unlike much other painting that imitated a particular building material on existing architectural elements, trompe l'oeil painting created illusionary architectural elements where none existed. Usually found in conjunction with other forms of decorative painting, trompe l'oeil painting created imaginary doors, door panels, windows, wainscots, wall niches and panels, ceiling medallions and cornices, and an array of other architectural features. In the dining room of the John Hart House in Yazoo City, Miss., the flush-boarded walls are ornamented with a fanciful colonnade of Gothic columns. Somewhat more restrained, the Chesser-Williams House and the Damascus Methodist Church, both in Georgia, exhibit painted classical columns in the room corners. The Damascus Methodist Church also has a trompe l'oeil apse that appears to recede into the distance with classical pilasters and a Gothic arch defining the entrance, paneled walls, and a checkerboard tile floor. Very similar

Parlor overmantel, ceiling, and wall painting at Blair Farm, Watauga County, N.C., last quarter 19th century, painter unknown (Photograph by Heather Fearnbach)

to the apse at Damascus Methodist Church, the Blair House in North Carolina and the Calhoun-Perry House in Texas have three-dimensional-looking Gothic arches set on classical pilasters that surround scenic overmantel paintings. Naaman Reich, the owner and decorative painter of the Reich-Strupe-Butner House in Bethania, N.C., painted dramatic windows with deep reveals in the stone-blocked walls of the parlor that appear to open out to an agricultural scene and a rural industrial scene. Over the mantel, Reich painted a niche with an arrangement of flowers and fruit.

The "windows" at the Reich-Strupe-Butner House illustrate another form of decorative interior painting found in the South, scenic painting. Wall murals like those found in New England are rare, at best, in the South. However, the South does have examples of scenic painting in more-confined spaces. Very similar scenic paintings are found in overmantels at the Calhoun-Perry House in Texas, the Chesser-Williams House in Georgia, and the Blair House in North Carolina. The Blair House also possesses an upper-wall frieze with a series of scenes set in trompe-l'oeil frames. Although the scenes themselves are complex—including hills, mountains, bodies of water, boats, houses, castles, fences, and accompanying vegetation—the execution is fairly simple.

In south central Tennessee, former circus painter Fred Swanton included scenic painting in the decorative work he executed at the James G. Carroll House, the Hinkle-Price House, the Maple Dean farmhouse, and the Green-Evans House. Painted on a mantel, overmantels, a wainscot, a ceiling, and a cornice, these are all pastoral scenes. Favorite motifs found in Swanton's work are broken tree limbs and Native American maidens.

Perhaps the liveliest collection of scenic painting in the South is found at the A. J. Miller House in Augusta County, Va. Painted by Green Berry Jones, these large scenes are set within trompe-l'oeil frames on the walls of the center hall and up the stairs to the second floor. Among Green's imaginative scenes are a sleigh ride, nature scenes with birds and animals, hunting scenes, circus scenes, Buffalo Bill, and the Crucifixion.

In the South, historic decorative interior painting dates primarily from the 19th and early 20th centuries and ranges from simple wood graining to marbled, stone-blocked, smoked, sponged, stenciled, trompe-l'oeil, and scenic painting, sometimes in complex compositions. Although hundreds of examples of decorative interior painting have been recorded in the South, undoubtedly countless more await discovery.

LAURA A. W. PHILLIPS
Winston-Salem, North Carolina

Ann Eckert Brown, *American Wall Stenciling, 1790–1840* (2003); Heather Fearnbach, Blair Farm National Register Nomination (2008); Ann-Leslie Owens, *Border States: Journal of the Kentucky-Tennessee American Studies Association* (1997); Laura A. W. Phillips, *North Carolina Preservation* (Winter 1989), *Perspectives in Vernacular Architecture, IV* (1991); Carroll Van West, *Tennessee Historical Quarterly* (Spring 1994).

Jewish Ceremonial and Decorative Arts

As a port of entry for Jewish immigrants in the colonial era, Charleston and Savannah ranked in importance with New York, Newport, and Philadelphia. Attracted by commercial opportunities and the promise of religious tolerance, Jews began settling in the British Province of Carolina as early as the 1690s. By 1749 the Jewish population of Charleston was substantial enough to form a congregation, and by 1800 the bustling port city was home to the largest, wealthiest, and most cultured Jewish community in North America—upwards of 500 individuals, or one-fifth of all Jews in the nation.

In dress and language, ambition and privilege, southern Jews did not stand apart from their neighbors. They pursued the same material goals and status symbols as other white southerners. Those who could afford them owned slaves. The affluent lived in fine houses, traveled abroad, commissioned paintings from leading artists, and bought elaborate silver tea services. Ceremonial objects used in synagogues and in private homes often came from Europe, though notable exceptions include an American-made silver-plated charity box with hinged cover, dated 1820 in Hebrew, and inscribed in English with the words "This Almsboxe belongeth to the Synagogue of Kahal Kadosh of Charleston in South Carolina." For a Jewish community at the height of its prominence and prosperity, the traditional motifs and sentiments expressed on the elegant object were perfectly appropriate. The gilded cartouche on the front features two rampant lions each standing on a scrolled branch, flanking a menorah. "Charity delivers from death" is engraved in Hebrew above the cartouche, and "A gift in secret pacifieth anger" (Prov. 21:14) below.

It was not uncommon for well-traveled, acculturated southern Jews to adapt secular items for religious purposes, which then became sanctified by use. A case in point is a finely wrought silver basket presented to Charleston's K. K. Beth Elohim in 1841 by Joshua Lazarus on the completion of the congregation's second synagogue. Fashioned in 1777 by London silversmith David Bell, the basket began its career as a sugar or sweetmeat bowl with a glass lining. Joshua Lazarus may have purchased it on one of his trips abroad, or inherited it through the family of his English wife Phebe Yates. On the basket's cartouche

he had engraved his name and the date of the gift, 5601, according to the Hebrew calendar. For the next 20 years the basket likely was used by the congregation as an *etrog* container, a receptacle for the *Sukkot* citron. In 1861 the silver basket was sent along with other valuables for safekeeping to the state capital, Columbia, from whence it disappeared in the melee following General Sherman's invasion, possibly looted by a Yankee soldier. A hundred years later the basket was retrieved and returned to Beth Elohim by a Jewish couple from Patterson, N.J. From sugar bowl to *etrog* container to spoils of the Civil War—this is the trajectory by which a domestic object became an icon of southern Jewry.

Some Jewish traditional arts were transplanted from Europe to America. To produce Torah scrolls, *ketubbot* (marriage contracts), and ritual plaques such as *mizrah* and *shivviti* required the services of skilled *soferim*, or scribes. A *ketubbah* dated 1814 was penned in Charleston by an unknown scribe to solemnize the marriage of Abraham Isaacks Jr. and Rebecca Cohen. This *ketubbah* follows the standard Aramaic formula, with the names of the couple and the date written in Hebrew. A meandering vine encircles columns on either side of the calligraphy, referring perhaps to Psalm 128:3, "Thy wife shall be as a fruitful vine."

Other surviving *ketubbot* from the early 19th century, like the 1814 example now in the collection of the Jewish Theological Seminary in New York, are also unattributed. One Hebrew scholar and scribe, however, left an indelible legacy in Charleston. Mordecai Judah Patla (1853–1924), native of Kiev, Russia, arrived in the city in 1880, via Savannah, Ga., and earned a reputation for his highly decorative and inventive *mizrahim*. A *mizrah*, meaning "east," symbolizes hopes for the restoration of the Second Temple and is hung on the east wall of a house indicating the direction in which to pray—toward Jerusalem. A *mizrah* Patla presented to Agnes and Joseph A. Volaski on their wedding day, 6 May 1890, features stylized urns on either side of the central tablets and menorah. On each urn is a "clock" with movable paper hands held by metal clasps. In the lower corners Patla drew a motif common in his work, a circle enclosing a six-petal flower, seen also on the Isaacks/Cohen *ketubbah*. In a *mizrah* Patla made in 1888 for synagogue Brith Sholom, the figure is repeated around the border and looks a great deal like a sand dollar, symbolic perhaps of his South Carolina home. Zelig Abe Goldsmith, who immigrated to Denison, Tex., as a youth, is the maker of another fine *mizrah*, one that demonstrates the artist's knowledge of Hebrew and his familiarity with both Jewish and Masonic symbolism. Goldsmith, who spent most of his adulthood in Troy, N.Y., created the 1896 *mizrah* during a nine-year period in which he had returned to Denison. Goldsmith

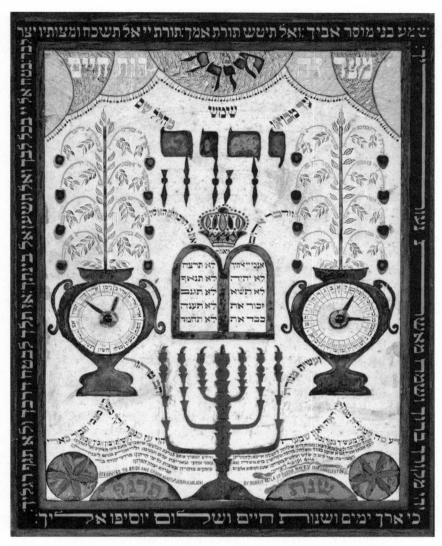

Mordecai Judah Patla, mizrah *presented to Agnes and Joseph A. Volaski on their wedding, 6 May 1890, paper and ink, gold gilt, and metal clasps (Photograph courtesy of Special Collections, College of Charleston Library)*

was not a professional artist but a grocer and waterworks employee. He also served as secretary and president of his synagogue in Troy.

A compelling aspect of the story of Jewish decorative arts is the adoption of American folk traditions, such as album quilts, by Jewish families not only in the South but across the nation. A quilt made between 1851 and 1854 in honor

of Eleanor Israel Solomons, née Joseph (1794–1856), originally of George-town, S. C., for example, is both typical of the genre and particularly southern. The Solomons quilt represents a map of the social circle of a Jewish American woman. Composed of 63 blocks, pieced and appliquéd chintz, and calico on muslin, the handiwork was organized by Eleanor's sister Charlotte Joseph, as Eleanor prepared to move from South Carolina to Savannah, Ga., and sewn by people as far away as Poughkeepsie, N.Y. Inscribed on each block is the name, and sometimes date and place of residence, of its maker. The contributors were women and girls, mostly Jewish but not all, family members and friends, in-cluding one slave of the Solomons family — "my servant Rinah" — whose seven-pointed blue-green calico star testifies to the bonds of affection and servitude that coexisted at times in the antebellum South. Another album quilt from Canton, Miss., documents a once-thriving community that, like many other small town synagogues, had to close when, after World War II, a younger gen-eration went to college, entered professions, and moved to urban areas. While these quilts can be seen as a symbol of the southern Jews' assimilation into so-ciety, other objects of folk art reflect a blended identity. An excellent example of a Jewish tradition reinvented in the American South is a dollhouse *sukkah* con-structed in Charleston, S.C., in 1925 by Harry Sholk for his daughter, Mary. The Sholks lived in a spacious two-story home above the hardware store Harry's father-in-law, Harris Livingstain, operated at 438 King Street. As the family's backyard had no room for a *sukkah*, the temporary structure built to celebrate the fall harvest and to recall the tabernacles of the Exodus during the festival of Sukkot, Sholk erected a miniature one for the dining room. Sholk fashioned gothic windows and rough, wooden rafters hung with fake fruit, and the family outfitted the structure with dollhouse furniture, porcelain figurines, and a tiny tea set complete with candlesticks. After Mary Sholk married Irvin (Dunny) Zalkin, a son of Charleston's kosher butcher, they and their three daughters continued to decorate the *sukkah* each autumn. In place of the palm branches Charlestonians commonly lay on their *sukkot*, the Sholks and Zalkins topped theirs with green pine needles and Christmas tree lights, the only lights avail-able. No longer in use by the family, the Sholk/Zalkin *sukkah* now resides in the Jewish Heritage Collection at the College of Charleston.

Cemeteries also record Jewish life in the South. Although the makers of southern gravestones carved primarily for Christian communities, they also provided markers for Jews. These stones might be engraved with the symbols that appear in other genres of Jewish folk art, but most later stones follow the 20th-century preference for restraint. Frequently a modest Star of David is the only indication of Jewish identity. Recently, however, stone carvers from

the former Soviet Union have introduced new forms. Large stones made of black granite, adorned with life-sized, hand-engraved portraits of the deceased, have embroiled some communities in disputes. Some rabbis and cemeteries have ruled that portrait stones are inconsistent with Jewish law; other rabbis and cemeteries have accepted them as proper expressions of Jewish identity. Although portrait stones carved in computerized factories are far from artful, the dramatic hand-carved stones represent a renewal of Jewish folk art.

Of course, many articles of domestic folk art have remained in the families of their makers. Countless girls and women have embroidered cloths, including challah covers and matzoh covers, that incorporate Jewish motifs. The techniques employed have not, however, been specifically Judaic. "Orphaned" objects—artifacts that, for one reason or another, have been separated from their original owners and that sometimes wind up in pawnshops and yard sales—are signs of the changing demographics of Jewish households and communities in an era of intermarriage, out-migration, and upward mobility. These trends, which the South shares with other regions of the country, have motivated documentation, collection, and cultural reclamation projects and fueled the proliferation of Jewish museums. Researchers interested in Jewish ceremonial and domestic arts in the American South will find rich resources at regional repositories throughout the South.

DALE ROSENGARTEN
College of Charleston

James W. Hagy, *This Happy Land: The Jews of Colonial and Antebellum Charleston* (1993); Norman L. Kleeblatt and Gerard C. Wertkin, *The Jewish Heritage in American Folk Art* (1984); Dale Rosengarten, in *Jewish Roots in Southern Soil: A New History*, ed. Marcie Ferris and Mark I. Greenberg (2006); Theodore Rosengarten and Dale Rosengarten, eds., *A Portion of the People: Three Hundred Years of Southern Jewish Life* (2002).

Landscape Painting (16th–19th Centuries)

Southern landscapes, seascapes, history paintings, and genre paintings from the 16th century through the 19th century reflect the exploration, colonization, and growth of a new nation. Views of the land itself, no matter their dates, support prevailing notions of American identity. They offer images of rich resources, immeasurable economic opportunities, and eventually the nation's manifest destiny to master the continent and become a great world power. Visual representation of the lands that would become the American South began with the travel sketches and drawings of European explorers. The French

Huguenot artist Jacques Le Moyne de Morgues (ca. 1533–87) was the first to record the lives of American peoples during the catastrophic French expedition in Florida. Barely escaping massacre by the Spaniards in 1564, Le Moyne moved to London, where he translated his sketches into a series of watercolors, only one of which survives. Two decades later, in 1585, Sir Walter Raleigh sent John White to Virginia with instructions to document life around the Roanoke colony. White's watercolors depicting the daily life of the native inhabitants, birds, insects, flora, and fauna inspired Theodore de Bry (1528–98) to produce a comprehensive series of engravings. *Les grands voyages* relate to America and *Les petits voyages* encompass Africa and the East Indies. *Les grands voyages*, comprising 14 folio volumes, contains narratives of 35 explorations and 250 engravings that provide extraordinary information about native customs and beliefs. Part I of the tome (published 1590) features engravings based on John White's watercolors that are now in the British Museum; part II (1591) features Jacques Le Moyne de Morgues's engravings.

After the age of exploration and settlement, landscapes, which present views of specific locations and customs, appear most often as telling elements in domestic arts. Between 1750 and 1850, ornamental painters added luster to the homes of their affluent patrons by decorating walls, fireboards, overmantels, and cornices with landscape scenes. A bucolic hunting mural attributed to West Virginian Rev. Daniel Schroth and painted in the 1800s probably honored the marriage of the artist's daughter. A watercolor on velvet by Mary Catherine Noel, perhaps executed in the first half of the 19th century, also depicts a hunting scene. Noel may have created this work in 1833 or 1834 while attending the Salem Female Academy in Winston-Salem, N.C.

As backdrops to portraits, broad vistas often depict the sitters' homes or property and signal the sitters' achievements and affluence. Indeed, commissioning a portrait was very likely a sign that the patron wished to preserve an image of personal success and character. The winding path that Kentucky painter Dupue, also known as the Guilford Limner, includes in his 1820 watercolor portrait of Mr. and Mrs. Raglan indicates the extent of the Raglan property and records the family's social status. Landscape details in many portraits also refer to the sitters' occupations, the means to their success. In Joshua Johnson's portrait of Capt. Thomas Sprigg (ca. 1810), for example, the seated subject holds a sextant in his right hand and rests his left hand on a table topped by a compass and navigational chart; a window view of ships in a harbor further indicates the sitter's occupation. This window view convention also appears in Daniel Welfare's circa 1830 oil portrait of Wilhelm Ludwig Benzien, the business manager and music instructor of the Moravian settlement in Salem, N.C.

In the upper quarter of the portrait, Welfare presents a partial view of a town, probably Salem, through an open window. The window view landscape that occupies the background of Jacob Frymire's 1801 portrait (now in the Museum of Southern Decorative Arts) of Amelia Haskell Lauck of Winchester, Va., however, is merely generic. Similarly, the column and curtains that frame the stylized watercolor portrait of Mrs. Keyser by an unidentified artist from Baltimore are conventions. In this amusing portrait the column and drapery highlight the exaggerated geometries of the fashionable sitter's neck, anatomically impossible sloping shoulders, waist, long arms, and tiny hands.

Of course, many artists created landscapes that stand on their own. Artists often copied prints of such natural wonders as Virginia's Natural Bridge. Others documented specific times and places. The Museum of Early Southern Decorative Art owns the painting *A View of Charles-Town* (1773) by Thomas Leitch (or Leach) and an engraving of Leach's painting made in the same year by Samuel Smith. In this view, the artist surveys Charleston from the harbor, an indication of the importance of maritime trade to the flourishing town. Such landscapes also reveal local pride in the rise of well-ordered prosperous towns; like portraits, they celebrate ideals of American industry.

Baroness Anne Marguerite Hyde de Neuville (ca. 1749–1849), the wife of a French diplomat, was eager to record the development of an independent America. She created more than 200 sketches that document the early days of the republic. Her works *The White House with State, War, Navy, and Treasury Buildings* (ca. 1820) and *St. John's Church* are early sketches of Washington, D.C. Her sketch of *F Street* (1821) demonstrates her interest in people and how they lived. The artist's sketch of *Washington's Tomb at Mt. Vernon* (1818) is the only known work that depicts the original family tomb with stacked coffins.

The Plantation, painted in oil on wood by an unknown artist, ca. 1825, and now housed in the Metropolitan Museum of Art, is one of the masterpieces of American folk art; this highly abstracted landscape documents a plantation's social and historic importance. The central main house at the apex of a steep incline is emblematic of the power and authority of its owner. The owner's material accomplishments are evident in the number of buildings that surround the property and in the broad expanse of the surrounding landscape, thick with trees and lush vegetation. A ship sailing on the river transports plantation goods—cotton, rice, or other crops—while a warehouse and a mill powered by a waterwheel further illustrate the plantation's activities. Oversized grapes and leaves frame the landscape and highlight the land's abundance and the owner's prosperity.

Another emblematic painting is *The Old Plantation*, painted in watercolor

on paper circa 1785–90 by John Rose, a South Carolina plantation owner, is now in the Abbey Aldrich Rockefeller Folk Art Museum. Although it is not known whether the work is a memory painting or a contemporaneous genre scene, it is an invaluable social document of the private lives of slaves. The dancing couples and musicians with African-derived instruments seem to be celebrating a marriage ceremony or performing a secular dance; whatever the case, the painting is a rare depiction of the customs of Africans enslaved in America. Scholars have noted continuities with various African cultures; thus, the painting may record a creative amalgam of social traditions that developed as slaves brought from different regions and cultures became neighbors.

The merchant-class clients who employed Francis Guy (1760–1820) to paint vistas of entire properties or individual houses also sought visual proof of their success and importance during the early decades of the new republic. Guy had worked as an itinerant tailor and silk dyer before emigrating from England, first to New York and then to Baltimore in the late 1790s. Guy first worked as a silk dyer, but after a fire destroyed his business, he found work as a landscape painter, furniture decorator, dentist, and minister. The artist Rembrandt Peale commented that Guy "boldly undertook to become an artist, though he did not know how to draw." Guy, recognizing that Peale's assessment was correct, accomplished accurate renditions by devising an ingenious method. The technique involved the construction of a portable tent with a window set into it the size of his intended painting. Guy covered the opening with black gauze and then, using white chalk on the black gauze, set down the scene in front of him. Lastly, he transferred the chalk drawing by simple pressure of his hand to a canvas on which he painted the final view.

Marie Adrien Persac (1823–73), a surveyor and civil engineer, who immigrated from France in 1851 and reached New Orleans in 1857, first created highly decorated maps and a chart of the Mississippi River and then went on to produce "optimistic and precise" plantation portraits. Persac's training in architecture, civil engineering, and cartography served him well as he worked in gouache on paper to create detailed paintings of Louisiana plantation houses and their grounds, outbuildings, and adjacent fields. Intriguingly, the beautifully dressed ladies and the gentlemen who occupy these paintings are often collages. Made separately and painted, they were glued into the scenes.

Lewis Miller (1796–1882), a chronicler of everyday life, was an extraordinary social historian. He worked for decades as a house carpenter, but zealously pursued sketching and drawing of the people, places, and events he encountered locally and on his many travels in America and abroad. Among thousands of watercolor and ink drawings, he depicted a wide variety of subjects,

including private homes, public buildings, farms, towns, slave auctions, dances, artisans in their daily work, and visits among family and friends. Born in Pennsylvania, in 1831, he took 15 documented trips to Virginia, where his brother Joseph was a prominent physician in Christiansburg and where the artist spent the last 20 years of his life. The sketchbook Miller produced in Virginia, now in the collection of the Abby Aldrich Rockefeller Folk Art Museum, contains views of Richmond and Christiansburg as well as depictions of nearby villages, hunters in the wood, a ferry crossing the James River, slave auctions, and the jubilant *Lynchburg Negro Dance, August 18th, 1853*, comparable in its significance to John Rose's circa 1785–90 depiction of slaves dancing in *The Old Plantation* as a social document of early African American life. Miller added neatly inked text to each drawing and often included himself in his scenic recreations and also the day, month, and year of the event.

Many 19th-century artists documented the growth of towns and cities. Joshua Tucker (1800–71), born in Massachusetts, spent several years in the South, where he practiced dentistry and painted a meticulous watercolor and ink landscape, *South East View of Greenville, S.C.* The scene captures the rolling hills and neat houses of the small town. *View of Savannah* (1837) was painted by Joseph Louis Firman Cerveau (1806–96), who was born in Smyrna (now Izmir, Turkey) and said to reside in Savannah from the 1830s to 1855. Cerveau portrays a thriving city with public buildings, private homes, churches, and monuments of many styles. Charles J. Hamilton (ca. 1832–80), also known for his carvings of wooden cigar-store statues, painted his *Charleston Square* in 1872, now in the Abby Aldrich Rockefeller Folk Art Museum. It presents the city's neoclassical architecture and ships as emblems of permanence, power, and authority.

In his four lively views of San Antonio's main plaza, William G. M. Samuel (1815–1902) documents historic buildings and chronicles the colorful, even exotic, activities of daily life in Texas before it was a state. A stagecoach crosses the square, wood and water vendors mill about, oxen stand ready to pull carts, and cowboys appear on horseback. The paintings, in the collections of Bexar County, can be seen in the Witte Museum in San Antonio, where they are on extended loan. Rudolph Mueller (1859–1929), a boot maker and shoemaker who immigrated from Germany, painted several local Texas landscapes including an ambitious bird's-eye panorama of his town, Castroville, Tex., an Alsatian community founded in 1844. Mueller's paintings can be found in the Witte Museum and San Antonio Museum of Art.

Some artisan and amateur landscapists took up art making to commemorate signal events in a locale's history. French immigrant and architect Jean Hyacinthe de Laclotte (1766–1829) took part in the Battle of New Orleans and

painted a panoramic view of the event. *The Battle of New Orleans* is now in the New Orleans Museum of Art. In vivid watercolor works on paper, Sam Chamberlain (1829–1908), an adventurer and unschooled artist from Massachusetts, recalled a soldier's life and his ribald escapades during the Mexican-American War. Chamberlain's exploits—Sam in a knife fight, Sam seducing two Mexican maidens at once, Sam in house-to-house battles—form the subject of his sketches. However, the diverse southwestern landscape—its mountains, valleys, and plains, its trees and broad skies, its citadels and fortified walls, and its people, their dress and customs—provide the context for his adventures and sometimes usurp the role of Chamberlain's daring acts. The San Jacinto Museum of History houses 147 of Chamberlain's watercolors.

The Civil War also fueled the imaginations of self-taught landscapists. One of many examples, *Howard's Grove Hospital, Richmond, Virginia*, is an oil painting on canvas by an unidentified Confederate soldier. Opened in 1862 in what was once a popular Richmond picnic and recreation area, the hospital consists of several buildings half-hidden in a grove of trees and set within a charming, verdant landscape. Confederate tents can be seen at the lower right, just as a Y-shaped dirt road turns into the complex's main street, dividing the scene vertically as it stretches upward to a high horizon mark. On either side of the road, small cabins seem ready to slide down the steeply pitched terrain.

Perhaps the most prolific documentarian of the Civil War was the Union soldier Robert Knox Sneden (1832–1914), who lived in Manhattan and worked as an engineering surveyor or architectural apprentice. He also tried his hand at making art. In 1861 he joined the 40th New York Volunteer Infantry and served the Union army as a cartographer. More than 300 of his maps are housed today in the Virginia Historical Society, along with a 5,000-page journal, illustrated with watercolors based on his wartime experience. Sneden's eyewitness accounts include the Peninsula campaign at Yorktown and Williamsburg, the battles of Manassas and Antietam, and the Second Battle of Bull Run. Perhaps the most compelling records he left detail his imprisonments at Libby Prison in Richmond, Salisbury Prison in South Carolina, and, most notorious of all, Andersonville Prison in Georgia. Sneden's untutored depictions of the South, which range from cityscapes, battlefields, and burning homes to Union soldiers on the march, city harbors, and all the vagaries of prison life, are not simply documents, however. Although Sneden's tiny depictions are characterized by analytical detachment and immediacy of effect, his selection of subject matter, subtle compositional arrangements, and color choice often betray his feelings. Moreover, Sneden's illustrations, which sometimes situate the minuscule world of humanity within nature's wide expanse or bring the viewer into intimate dia-

logue with his subjects, reveal the artist's ability to manipulate emotion. Hiding his sketches in his shoes and sewing them into his coat, Sneden was determined to avoid the discovery of his drawings by his Confederate guards, to rescue his observations, and preserve them for posterity. Permanently disabled by his prison confinement, Sneden returned north in 1864 and spent the rest of his life making art from his memories of the past.

As drawing was an acceptable polite art for women in the 19th century, girls and women also contributed landscapes. Mrs. A. A. Flotte used a popular medium for amateurs, colored pastels on marble dust paper, and is thought to have drawn *Jackson Square, New Orleans*, which is in the Historic New Orleans Collection. Unlike the space of *Howard's Grove Hospital*, the environment in Flotte's Jackson Square seems more secure and stable: the receding ironwork that frames the square and its centerpiece, the Jackson monument, leads the eye to focus on the low horizontal buildings in the distance and the centrally placed Cathedral of St. Louis.

LEE KOGAN
American Folk Art Museum

Robert Bishop, *Folk Painters of America* (1979); Angela D. Mack and Stephen G. Hoffius, *Landscape of Slavery: The Plantation in American Art* (2008); Cynthia Elyce Rubin, ed., *Southern Folk Art* (1985); Cecilia Steinfeldt, *Texas Folk Art: One Hundred Fifty Years of the Southwestern Tradition* (1981); John Michael Vlach, *The Planter's Prospect: Privilege and Slavery in Plantation Paintings* (2002).

Landscape Painting (20th and 21st Centuries)

Twentieth- and 21st-century self-taught artists, embracing their precursors' fascination with landscape, transform the world of nature into abstract patterns that often occupy a flattened, shallow pictorial space. Unblended colors and generalized light further distance their landscapes from the limits of naturalism. Contemporary self-taught artists approach the subject of landscape from three different perspectives, often blending those perspectives to fit personal taste. Many self-taught artists portray the urban landscape with its towering buildings and crowded streets. Many imagine unreal and fantastic landscapes, and many find beauty in the South's distinctive landscape.

William Lawrence Hawkins (1895–1990), Jimmy Sudduth (1910–2007), and Purvis Young (b. 1943) are among the best-known artists of the urban landscape. Hawkins, who grew up on a Kentucky farm, moved to Columbus, Ohio, as a young man. He spent the rest of his life in Columbus, working at a variety of jobs, ranging from house painter to truck driver. To augment his income, he

salvaged cast-off objects and odds and ends he found in city streets for resale. Cast-offs also became materials for art making. From leftover cans of enamel paint and scavenged photos and magazine illustrations that included depictions of modern art works, he created forceful depictions of animals, religious scenes, historical events, and cityscapes. His architectural paintings, which demonstrate a love of compressed space, abstract form, and intense colors, include views of Columbus's skyline and the city's landmark structures, such as the Columbus City Hall and the Ohio Stadium. Hawkins also painted Chicago's Wrigley Building and New York's Chrysler Building. In almost every case, the buildings are unpopulated, and the city's streets are devoid of human life; the abstract two-dimensional surface pattern suggests perhaps the emptiness of modern life.

Jimmy Sudduth, who lived in Fayette, Ala., also painted scenes of empty buildings and vacant city streets. Famous for his homemade paint of sugar mixed with pigments and other binders, Sudduth often portrayed buildings, especially the mills, covered bridges, and log cabins that dot the southern landscape. Over the years, he added more elaborate structures, imposing houses, and country churches. After visiting Washington, D.C., in 1976, Sudduth painted the capital's familiar monuments and began a series of high-rise buildings, which draw attention to his ability to suggest three-dimensional space. Nonetheless, the solid forms of such buildings embrace the surface of his paintings and create a latticework of abstract designs. Such paintings suggest that Sudduth, like Hawkins, may have been concerned not only to manipulate such formal elements of art as shape, line, and color but also to convey the alienation he saw in urban life.

Unlike Hawkins's and Sudduth's architectural vistas, the city streets and buildings that Purvis Young creates teem with human figures. In his paintings and assemblages made of objects found in city streets, tiny human silhouettes wave their arms in the air. Three large heads loom mysteriously over crowded buildings that spew smoke. Cities blaze, and people riot. Pregnant women and street gangs, children and the homeless, truck convoys and basketball players, looters, and barred churches occupy Young's urban settings. Inspired by Overtown, the impoverished Miami neighborhood where he lived, Young's artworks document the life of poor urban blacks, protest the inequities and injustices they suffer, and castigate the system that oppresses them. Not the city itself but rather the social life of its occupants haunts Young's creative imagination.

Self-taught artists Nellie May Rowe (1900–82), Minnie Evans (1892–1987), Sister Gertrude Morgan (1900–80), Howard Finster (ca. 1916–2001), and Royal Robertson (1936–97) imagine landscapes of another kind. Inspired sometimes

by visions, sometimes by religious texts, and often by both, these artists offer fantastic realms for their viewers' delectation. Although Nellie Mae Rowe's artwork is grounded in dreams and evangelical faith, actual fact, popular culture, and media imagery also inspired her. Just as she transformed her house in Vinings, Ga., into a "playhouse," where her creative imagination flourished, Rowe's chronicles of everyday life become in her crayon, pen, and pencil depictions delightful but imaginary occasions that unite the commonplace with memories and dreams. What should be a more or less ordinary event, *Making It to Church Barefoot*, becomes in Rowe's hands an inexplicable incident set in a magical landscape: a large church, a canine organist, a luxuriant garden, and what must be the imprint of the artist's bare feet with toenails appropriately polished for church. Rowe's *Pig on Expressway* is another subject ingeniously imagined. Undulating bands of bright color crisscross the drawing's surface, creating a dense maze of pattern that traps a pig, isolated and stunned, atop one of the roadway's diagonal bends. Instead of imitating nature, Rowe catches the animal's confusion; her drawing captures the landscape of emotion.

Like Rowe, Minnie Evans was also inspired by dreams, which she had experienced since childhood, and by her Christian faith. Equally important must have been her position as gatekeeper, from 1949 to 1974, at Airlie Gardens, in Wilmington, N.C., the probable source of much of her landscape imagery. Her paintings and drawings take as their primary subject a lush and mysterious garden paradise visualized in bright colors and peopled by fantastic creatures. Solitary, unblinking eyes that emerge from foliate designs, angels, demons, lions, unicorns, and other supernatural beasts populate this magic realm. Often these surreal figures join with more naturalistic flowers, butterflies, and birds to frame a central motif: a human visage adorned with foliate headdress and flowering necklaces and framed by curling leaves and fantastic blossoms.

Among Sister Gertrude Morgan's paintings are several landscapes of the New Jerusalem, the celestial city described in the New Testament book of Revelation. These highly imaginative landscapes feature a large, contemporary apartment building with its facade removed so that its occupants are visible. Several waiters in butler's attire attend a tuxedoed, Caucasian Jesus and his bride, a black woman, Morgan herself, wearing a modern-day wedding dress. Choirs of angels frame the scene. A self-appointed missionary, Morgan imagines Jesus and his bride awaiting the guests of honor in a heavenly world where dark- and light-skinned people live harmoniously.

Like Morgan's depictions, Howard Finster's painted landscapes were also inspired by religious faith. Most of his imagery has a rhetorical purpose. He aimed to bring his religious sermons to as many people as he could. Fin-

ster's visionary landscapes were annotated journeys to heaven and hell. In an enamel-on-Plexiglas painting, *There Were Just Enough*, Finster creates an imaginary heavenly landscape that features a mountainous terrain dotted with some recognizable vernacular architectural forms intermingled with a series of tiered tower structures topped by spires. A few figures and a couple rowing a boat on a midground river people the scene. A painted text reads, "A LITTLE TOWN WHERE SOME HAD MUCH AND GAVE TO THEM WHO HAD LITTLE AND AMONG THEM THERE WERE NONE WHO WERE IN WANT."

Undoubtedly the most eccentric of contemporary landscapists is Louisiana's Royal Robertson, whose art making was provoked by what he perceived to be the perfidy of his wife, Adell Brent, who after 19 years of marriage, walked out on him. From this devastating experience sprang two themes: scenes condemning the duplicity of womankind and architectural drawings of an ideal extraplanetary realm. Trained as a sign painter, Robertson used magic markers, tempera and enamel paint, colored pencils, and ballpoint pen on poster board both to castigate his ex-wife and to create cityscapes bearing the imprint of the science fiction magazines he read. His architectural vistas are reminiscent of comic book designs. They display futuristic cities filled with ultramodern buildings, space needles, broad avenues, aerial tramways, and hovering spaceships. Other times they focus on single constructions—dream houses or temples with onion domes. Robertson often marked his artworks with rambling, ranting texts that reveal his unsettled mental state and, on their reverse, calendars that carry biblical references and apocalyptic notations.

The South's distinctive geography, which includes Louisiana's bayous and the Florida Everglades, the French Quarter's courtyards, Mississippi cotton fields, the plains of eastern Texas, the Gulf Coast's white sands, the Shenandoah Valley, the Appalachian Mountains, and Kentucky's rolling limestone hills, have all appealed to self-taught artists of the 20th and 21st centuries. Charles Woodward Hutson (1840–1936), trained as a lawyer and teacher of Greek, metaphysics, moral philosophy, history, and modern languages, grew up on a South Carolina plantation. He taught in universities throughout the South before moving to New Orleans, where he painted *plein air* watercolors of south Louisiana and the Mississippi Gulf Coast. Hutson balanced his sentient visions of the southern landscape with the abstract shapes he distilled from its trees, foliage, and terrain. Clementine Hunter's (1886/87–1988) memory paintings, wall murals, and quilts chronicle life at Melrose Plantation, near Nachitoches, in northwest Louisiana, where she painted for half a century. Hunter's landscapes include the plantation's main house; Ghana House; and the African House, described by the Historical Building Survey as the only Kongo style structure built by en-

slaved blacks in the United States. Hunter's paintings also feature daily activities such as picking cotton, harvesting pecans, washing laundry in huge outdoor pots, and playing cards. Philo Levi "Chief" Willey, also known as Philip Leroy Willey (1887–1980), was another painter of the southern landscape, rendering exuberant anecdotal works of life in New Orleans, including scenes of Mardi Gras, Jackson Square, and the Mississippi. One of his most engaging landscapes is an oil-on-Masonite triptych, *Three Day Wedding Trip up the Mississippi*, which Willey painted to commemorate his honeymoon. The scene features a paddleboat, the *Bayou Bell*, moving upstream on the Mississippi as it departs New Orleans. Pictured in bright colors, the picture is replete with details—trucks, police cars, a carriage ride, the Café Du Monde, waving children, little houses, ducks, roosters, swimmers, and fishermen. Like many other self-taught artists, Willey abstracts the representational elements and uses flattened perspective and unmixed color.

Further west, half way between Austin and Houston, another self-taught artist made landscape an integral part of his paintings as he chronicled the life of African Americans near Brennan, Tex. Johnnie Swearingen (1908–93), who had made paintings as a child, returned to making art in the 1950s and began to sell his work. Painting with oil on Masonite, Swearingen captures 20th-century life in rural Texas. His rhythmic line both creates movement and unifies compositions. Placing figures within small pockets of shallow space, which he often nestles within an undulating landscape, the artist represented scenes of lively church gatherings, washdays, hog selling, cotton picking, swimming, and fishing. Landscape was for him, however, more than a stage for human action: ranchers, animals, and nature coexist harmoniously in his paintings and demonstrate their mutual, benign relationship. Swearingens's unusual colors and juxtapositions of colors demonstrate his sensitivity to the effects of light and weather on a landscape.

Far from Texas, on the east coast in Richmond, Va., John William "Uncle Jack" Dey (1912–78), a retired policeman, used the rural landscape as a setting for events, some real, some imagined, and some religious. *Adam and Eve Expelled from the Garden of Eden* (now in the Smithsonian American Art Museum) is a good example of Dey's work. The couple and the angel brandishing a flaming sword are based on Michelangelo's depiction of the *Expulsion from the Garden of Eden* in the Sistine Chapel, but the northern Eden with dead fir trees is Dey's own invention. So are the signs posted in the Garden. The angel hands down an "eviction notice." Another sign identifies "The Forbidden Tree," while others express Dey's tongue-in-cheek humor: "Gravy train gone. Adam settled down. Work hard in the barren land. Raise a family. Passed years before Eve."

Other characteristics of Dey's landscape paintings are woodland animals—moose, bears, rabbits, and here, appropriately, a snake. Black crows often populate the sky and enliven it with rhythmic punctuation.

The exotic flora and fauna of Florida have also intrigued self-taught landscapists. Peter Minchell (1889–1982) first painted Louisiana's bayous and New Orleans's buildings, courtyards, and church interiors. After he moved to Palm Beach, he became entranced by the plant and animal life of the Florida Everglades. Minchell's drawings, which feature palm trees, dense foliage, waterfalls, pools of water, reptiles, and exotic birds, demonstrate the artist's strong debt to the Everglades. Dreams and fantasies also inspired his art. In several of his drawings, his imagination moves forward and backward in time and space to recount antediluvian geological narratives and stories of interplanetary space. Like Minchell, Earl Cunningham (1893–1977) also blended fantasy with the real landscapes of his youth in Maine, of his travels, and of his adopted Florida. His deeply saturated palette lends his works an almost surreal quality. Cunningham's landscapes of the Atlantic coast and the Everglades, peopled by tiny humans—dockworkers, fishermen, farmers—are based in fact. The reality of windswept trees and the driving rain of a hurricane in the painting *The Big Storm* is clearly the product of observation. Cunningham, nonetheless, took historical and topographical liberties. In *The Everglades*, a gift to President and Mrs. John F. Kennedy, now in the John F. Kennedy Presidential Library and Museum, a Viking ship sails past flamingos to enter the Everglades.

Landscapes, seascapes, and townscapes take ever-changing forms, styles, and meanings. Southern self-taught landscapists, like all artists, record the world around them, interpret their worlds, and create landscapes of the imagination. They may take pride in place, remember better times, preach, or even locate social criticism within familiar landscapes. They also sometimes idealize the world and offer utopias where humankind and nature peacefully coexist. Altogether, these self-taught artists present a panorama of southern vistas and personal identifications with geography.

CAROL CROWN
University of Memphis

LEE KOGAN
American Folk Art Museum

Lynne Adele, *Spirited Journeys: Self-Taught Texas Artists of the Twentieth Century* (1997); Paul Arnett and William Arnett, eds., *Souls Grown Deep: African American Vernacular Art of the South*, vol. 1 (2000); William Arnett and Paul Arnett, eds., *Souls Grown Deep: African American Vernacular Art*, vol. 2 (2001); Robert Bishop,

Folk Painters of America (1979); Glen C. Davies, *Stranger in Paradise: The Works of Reverent Howard Finster* (2010); William A. Fagaly, *Sister Gertrude Morgan: The Tools of Her Ministry* (2004), "The Gifted Amateur: The Art and Life of Charles Woodward Hutson," *Folk Art* (Fall 1997); Howard Finster and Tom Patterson, *Stranger from Another World: Man of Visions Now on This Earth* (1989); Shelby Gilley, *Painting by Heart: The Life and Art of Clementine Hunter, Louisiana Folk Artist* (1988); Lynda Roscoe Hartigan, *Made with Passion: The Hemphill Folk Art Collection in the National Museum of American Art* (1990); Mitchell D. Kahan, *Heavenly Visions: The Art of Minnie Evans* (1986); Lee Kogan, *The Art of Nellie Mae Rowe: Ninety-Nine and A Half Won't Do* (1988); Art Shriver and Tom Whitehead, *Clementine Hunter: The African House Murals* (2005); Alice Rae Yelen, *Passionate Visions of the American South: Self-Taught Artists from 1940 to the Present* (1993).

Latino Folk Art

To date, almost no published work has focused on southern folk art by Latino/a artists. This omission is partially related to the comparatively recent arrival of Latinos in large areas of the South and may also stem from confusion about what constitutes "Latino folk art." Because "Latino/a" is an umbrella term that refers to any person of Latin American descent living in the United States, "Latino folk art" refers to an expansive body of work made by self-taught artists from a variety of regional and cultural backgrounds. These artists work in urban, suburban, and rural parts of the country and in diverse media. Moreover, folk art forms taught and shared through informal circuits, such as word of mouth, and tied directly to the experiences of local communities may serve both as a means of conservation of culture and as platforms for idiosyncratic interpretation. An artist may fulfill community expectations or transform communal expressions into highly personal ones. In some cases, the visual traditions of a community remain static and unchanging for long periods of time. In other scenarios, community artists take the imagery of their local audiences and re-create it in many different media and personal variations. Even when created by an isolated artist, the art of self-taught Latinos is almost always linked to location and community-based experience, materials, and symbolic imagery.

What unites Latino artists and their respective artistic traditions are connections to local communities that have forged shared visual imagery through community experiences, a common language, and often through collective religious beliefs. While Texas has one of the longest histories of Latino folk art in the country, the recent boom in Latino population across the South has led to new community formations and the development of new folk art traditions that are simultaneously wide ranging, complex, and specific to their local con-

texts. However, Chicanos, U.S. citizens of Mexican descent, have created art forms and symbols shared by immigrants throughout Latin America.

Latino folk art in Texas is predominantly made by Mexican Americans—that is, both immigrants from Mexico who have settled in Texas and Texas-born Mexican Americans ("Tejanos"). Many traditional Latino folk art forms in the state relate to ranching accoutrements and include objects such as personalized cowboy hats and leatherwork on boots and saddles. As with many folk art traditions, these art objects are tied to aspects of daily working life. Folk art historian Francis Edward Abernethy explains that "all people have an artistic impulse, a desire to elaborate, ornament, decorate, and personalize the utilitarian objects that are parts of their lives." Some Tejanos have adopted a Mexican style of cowboy boots so elaborate and individualized that the boots become a vernacular art form. Through the detailed and original embellishment of their gear, ranch hands and leather workers enrich ordinary spaces of labor with creative forms of self-expression and at the same time garner recognition within their local communities.

The most deeply rooted and widespread Latino folk art traditions in Texas—as well as the broader United States—relate to religious worship. The Virgen de Guadalupe is perhaps the most commonly depicted religious figure for Catholic Mexican Americans; said to have appeared to an Aztec farmer, Juan Diego, in 1531, she is the patroness of Mexico and is considered to be the protectress of Mexico and, by extension, of Mexican Americans. A manifestation of the Virgin Mary, la Virgen de Guadalupe has a distinctly *mestiza* appearance—that is, she blends the European Catholic imagery of Mary with that of symbols from Mexican indigenous religious beliefs. Some scholars have considered la Virgen a syncretic blend of Mary and the Mexican deity Tonantzin or the Aztec goddess Coatlicue. In the South and especially in Texas, the Virgin's visage has appeared on all forms of decorated objects, including paintings, wood carvings, devotional paintings, murals, tile designs, rugs, ceramic sculptures, candles, home altars, flags, jewelry, clothing, towels, tattoos, cars, and shop signs. Depending upon her placement, la Virgen evokes different connotations. Within the space of home altars, she is a private figure to whom family members pray for intervention and protection. In her more public manifestations, la Virgen is a symbol of community, identifying the person who displays her image as someone who is proud of his or her Mexican American and Catholic heritages. Additionally, as some border relief agencies have provided T-shirts depicting la Virgen to immigrants, la Virgen may also symbolize protection and safety in the United States.

Other sacred Latino folk art traditions include the creation of *altares* (altars)

that honor local saints, deceased family members, friends, and local celebrities. *Altares* are usually built by community members who construct or use a found devotional image (painting, sculpture, or photograph) and surround it with objects such as candles, printed and handwritten prayers and messages, flowers, and photographs of families and friends. These *altares* range in size from small spaces for prayer in a home to larger sites where community members take offerings and pray for intervention. For instance, just outside Falfurrias, Tex., at Los Olmos visitors can find the altar for folk saint Don Pedro Jaramillo (known by his admirers as Don Pedrito), a local *curandero* (healer). Born in 1829, Don Pedro came to Texas from Mexico in 1881 to work at King Ranch and was soon recognized for his curative powers. Local communities walk in procession to the altar on holy days and festivals. At the shrine, which also serves as his burial site, visitors can light votive candles decorated with a drawn portrait of the healer and place messages in thanks or supplication next to a life-sized sculpture created to memorialize Don Pedro. Crosses and flower arrangements fill the small building that houses the sculpture. People healed from their maladies leave behind crutches; photographs and drivers' licenses accompanied by notes to the saint fill the walls to form an impromptu and ever-changing community collage that becomes a folk art environment.

The tradition of altar building has extended also to the virtual world, where artists have constructed websites that commemorate deceased family members or celebrities. The sites are available internationally, broadening the communities that come together to mourn. Websites honoring Tejana singer Selena Quintanilla Perez (1971–95), for example, combine the *altares* tradition with contemporary modes of visual expression available on the Internet by allowing visitors to purchase and light virtual candles. Handmade painted portrait murals of Selena can be found on the walls of urban buildings throughout the United States.

The aesthetic of Latino *altares*—whether virtual or handmade—suggests their direct connections to Catholic devotional spaces. They are also tied to an aesthetic termed *rasquache*, which art historian Tomás Ybarra-Frausto defines as an "alternative aesthetic . . . rooted in Chicano structures of thinking, feeling, and aesthetic choice." This aesthetic, juxtaposing ugly and beautiful, high and low, good taste and bad, aggressively rejects the aesthetic notions of the dominant culture. He writes, "In an environment always on the edge of coming apart (the car, the job, the toilet), things are held together with spit, grit, and *movidas*. *Movidas* are the coping strategies you use to gain time, to make options, to retain hope. *Rasquachismo* is a compendium of all the *movidas* deployed in immediate, day-to-day living."

Rasquache is evident in Latino yard art, which can be found throughout the South. Comprised of found objects, devotional sculptures, flower pots, cement shrines, painted wood fences, car parts, decorative mailboxes, lawn ornaments, and ornamental and functional gardens, among other things, yard art is the accumulation and intentional arrangement of one's yard to show a personal and often highly idiosyncratic aesthetic not necessarily shared by neighbors. Rufino Loya Rivas, for example, has constructed a "Casa de Azúcar" near El Paso, Texas. His home is surrounded by an elaborate and ornate system of concrete walls covered in decorative floral motifs and shrines dedicated to the Sacred Heart of Jesus and la Virgen de Guadalupe. Sam and Lupe Mirelez have filled their front yard in San Antonio with elaborate, homemade birdhouses in the forms of castles, apartment buildings, and towers. Not only do the individual elements of a yard suggest the artist's tastes and interests, but yard art symbolizes its maker's roots in a place; having a yard show advertises the ownership of land and home, two elements that literally ground the artist in a place, a community, and a region.

Chicana artist and professor Amalia Mesa-Bains has defined a particular type of *rasquache* found in domestic spaces, such as home altars and yard art, as an aesthetic that includes "intimate expressions of sincere decoration in the domestic space." These decorative impulses, central to folk art traditions, take materials available on hand and combine them to create a visual construction that is both "irreverent and spontaneous . . . defiant and inventive." Mesa-Bains writes, "Aesthetic expression comes from discards, fragments, even recycled everyday materials such as tires, broken plates, plastic containers, which are recombined with elaborate and bold display in yard shrines (*capillas*), domestic decor (*altares*), and even embellishment of the car." This aesthetic of found materials cobbled together to create sacred spaces and sites for community pride, resilience, and cultural survival in new communities and environments is central to Latino folk art.

While Texas has one of the longest traditions of Latino folk art in the South, the Latino population is currently experiencing a widespread boom across the region. In the 10-year period from 1990 to 2000, the Latino population in the South went from approximately 6.5 million to 11.5 million, with substantial population increases occurring in North Carolina, Arkansas, Georgia, Tennessee, South Carolina, Alabama, and Texas. Because of this population explosion in the past 20 years, Latino communities in the South are in the process of developing new folk art traditions that are tied to their new contexts. One expression of contemporary experience that has translated into a recurring folk art form can be found in prison communities. Paños, also known as *Pañuelos*,

decorated handkerchiefs, have become an established genre of folk art, sought out by collectors of folk art and Latino art. Images on paños are often stylistically similar to other urban Latino art forms, such as lowrider paint jobs, tattoos, graffiti, and mural painting. Paños are another example of *rasquache*, as artists juxtapose such figures as la Virgen de Guadalupe, self-portraits of the artist kneeling in prayer to la Virgen, voluptuous women, life in the barrio, crime scenes, gang symbols, cartoon characters, Pre-Columbian scenes, religious figures such as Christ in Agony or Saint Martin de Porres, and historical figures such as Pancho Villa and Emiliano Zapata. Artists use ballpoint pens, markers, and colored pencils. Prisoners learn to make art within a form of guild system: one artist designs an image or motif that other artists copy. In some cases, an artist draws the outline of an image and others fill in the colors. Paños have found a museum audience with exhibitions such as the Whitney Museum of American Art's 1981 exhibition *The Prison Show: Realities and Representations* and the Museum of International Folk Art's 1997 exhibition *Paño Art from the "Inside" Out*. The New England Center for Contemporary Art organized a traveling exhibition of paños titled *Art from the Inside: Drawings by Chicano Prisoners*, which toured nationally from 1999 to 2002.

Car art using many of the same images has also found a wide Latino audience and has expanded as a truly contemporary form of folk art that unifies communities around common symbols and an aesthetic language. With roots in East Los Angeles of the 1970s, the custom painting of lowrider cars has developed into a widespread urban phenomenon celebrated with car shows, photographic exhibitions, magazines, and online communities.

Latino artists have also adapted public arts strategies deployed historically by Mexican muralists in the 1930s and Chicano activists in the 1970s and 1980s. Murals and graffiti drawings now appear on public buildings throughout the South. Acceptance of the Mexican muralists Diego Rivera, José Clemente Orozco, and David Alfaro Siqueiros into the art-historical canon has made way for wall paintings by individual artists and the implementation of mural projects by local organizations. Community mural projects commonly have artist coordinators, who may be self-taught or academically trained. Community murals can be found inside restaurants, on billboards, along highway overpasses, and on public institutions, such as schools, universities, and government agencies throughout the South. Artist and educator Valerie Aranda, for example, has worked collaboratively with local artists in Georgia and Texas to develop murals that speak to community experiences and ideals, such as the 2003 mural *Architects of Change* at the School of Education at Georgia College & State University in Milledgeville, Ga., and her 2006 mural *Líderes* in San Antonio, Tex. Because

of the grass-roots nature of mural painting, community mural projects often enlist both Latino and non-Latino artists and therefore contribute to shared southern visual culture influenced by historically Latino art forms.

Many contemporary academically trained Latino artists who have, with great struggle, found acceptance in more formal circuits of art making such as museum exhibitions and university art communities create works that reference Latino folk arts. For example, painter Carmen Lomas Garza depicts community celebrations and daily scenes of life in south Texas, such as cooking, healing, and playing *lotería*. Amalia Mesa-Bains constructs altars to important symbolic and secular figures, such as the actress Dolores del Rio. These altars have been shown in museum exhibitions and are collected by institutions such as the Smithsonian American Art Museum. Delilah Montoya uses photographs to depict contemporary urban Latino life, including figures with tattoos of la Virgen de Guadalupe. John Valadez paints scenes from daily encounters on Los Angeles streets, using them as subject matter for community mural projects. In one work, artist Richard Lou collaboratively ornamented a lawnmower with elaborate (perhaps *rasquache*) decorations, creating what he called a *Low-Mower*, which references the urban decoration of lowrider cars. Sculptor Luis Jiménez created fiberglass sculptures that often depict figures such as the *vaquero* or cowboy. These artists, though not necessarily all southern Latino artists, show the importance of folk art in Latino community life.

The complexity of Latino culture is "always dynamic, and always in the process of becoming," to cite Tomás Ybarra-Frausto. Furthermore, artists inevitably engage with themes of identity, place, community, experience, and exclusion individually and in ways specific to local contexts. Thus, there is no monolithic and homogeneous Latino audience or artistic community. Instead, we find that Latino folk artists in the South engage with richly diverse public and personal experiences. They are creating new forms of art that are simultaneously innovative, critical, complex, controversial, and deeply rooted in their local contexts and communities.

LAURA A. LINDENBERGER WELLEN
University of Texas at Austin

Francis Edward Abernethy, *Folk Art in Texas* (1985); James D. Cockroft, *Latino Visions* (2000); Kathy Moses, *Outsider Art of the South* (1999); Jill Nokes and Pat Jasper, *Yard Art and Handmade Places: Extraordinary Expressions of Home* (2007); Tomás Ybarra-Frausto, in *CARA: Chicano Art: Resistance and Affirmation* (1991); Alice Rae Yelen, *Passionate Visions of the American South: Self-Taught Artists from 1940 to the Present* (1993).

Memory Jugs

The term "memory jug" is a general name used to describe an array of embellished vessels commonly dated from the 1800s to the mid-1900s. In creating the form, the maker covers a vessel with a malleable substance, such as putty, plaster, or cement, which then serves as a three-dimensional canvas for decorative appliqué. While the adhesive remains in its softened state, numerous and varied items such as shells, buttons, pottery shards, and trinkets are pressed into the container's surface to create a highly embellished and textured composition.

Known by a variety of names—mourning vessels, forget-me-not-jugs, spirit jars, what-not jars, or whimsy jugs—these vessels are as individual and varied as their makers. Although historians and material culture specialists have reached no definitive explanation or consensus regarding their origins, uses, or intents, the naming of these idiosyncratic vessels can perhaps offer some clues about their purported significance and utility.

Aligning strongly with African and African American funerary traditions of placing vessels (often cracked or broken) on gravesites, some speculate that "spirit jars" may have been used directly as grave markers or at least in the practice of grave decoration. Grave decoration in Africa, particularly in the West and Central regions, served as an important way to commemorate the dead and was recognized as a viable conduit in linking the spirit world with the world of the living. The decorating of gravesites with vessels, shells, pebbles, mirrors, bits of glass, and other reflective or water-related items visually referenced the watery realm below where spirits were believed to reside. Objects used in this manner were meant to soothe the spirit and offer protective medicine for those left behind. The preponderance of similar items found repeatedly on the surface of African American memory jugs suggests a potent visual connection to age-old African funerary traditions and may very well be a creolization of this custom as it traveled to the New World. While strong affinities may be drawn between grave decoration and memory jugs, as of yet there is no concrete evidence or visual documentation that supports the idea that memory jugs were used specifically as grave markers.

Another viewpoint suggests that, while memory jugs may not have been actual grave markers, they may have functioned as mnemonic devices. Much like the making of quilts, the collection of everyday fragments or personal mementos, as well as the carefully collaged arrangement of these bits and pieces, can be reckoned as an accounting of sorts. Shells, trinkets, stones, and other artifacts placed on the surface of the vessels served as visible markers, signifiers that evoked in the viewer particular memories or associated stories that

helped to recall the past as well as reflect on its meanings within present circumstances. Bearing a striking resemblance to the *lukasa* or memory boards used by the Luba people of southeastern Zaire to recount significant events and tribal histories, memory jugs may have served similar purposes, exploring the ways particular artifacts or personal items such as buttons, keys, coins, or jewelry can serve as links to memory. In this way "mourning vessels" or "forget-me-not" jugs can be thought of as personal memorials or testimonies. They were likely placed in some prominent spot inside the home, such as a mantle or shelf, as a loving reminder of the departed. The embellishment of these containers, though not tied exclusively to African American culture, can be seen as creative expressions highlighting personal stories as well as treasured family histories.

An additional theory notes that these vessels were also part of an elaborate Victorian hobby craft tradition. Practiced by well-to-do women to pass the time, "what-not jars" or "whimsy jugs," as the names imply, were created for no particular purpose and were made just for the fun of it. This craft practice extends into the 21st century. In a sense, these vessels can be thought of as a sort of three-dimensional scrapbook of disposable or throwaway items arranged artistically for the pure pleasure and delight in the aesthetics of creating something from nothing. Given the fact that many women's magazines and publications have from time to time contained instructions for the making of whimsical novelties, it is quite plausible that magazines and newspapers also published recipes for the making of memory jugs.

Regardless of their makers, these beautifully enigmatic vessels seem indelibly tied to memory. With their highly encrusted, mosaiclike surfaces and oddly organic forms, memory jugs are wonderfully mysterious and speculative objects. They are signs, symbols, and metaphors that point to something else beyond their mere physicality or functionality. They hold histories; they are sublime and complicated texts rife with cultural constructs and social meanings. They are carriers as well as containers of memory. Their power and majesty is rooted in their ability to transport us, linking past and present into one time-space continuum.

MARIANETTA PORTER
University of Michigan

Brooke Davis Anderson, Linda Beatrice Brown, and Robert Farris Thompson, *Forget-Me-Not: The Art and Mystery of Memory Jugs* (1996); Aurelia Gomez, *Art Education* (May 1999); Grey Gundaker, *Signs of Diaspora / Diaspora of Signs: Literacies, Creolization, and Vernacular Practice in African America* (1998); Robert Farris Thompson,

Flash of the Spirit: African and Afro-American Art and Philosophy (1983); John Michael Vlach, *The Afro-American Tradition in Decorative Arts* (1978).

Memory Painting

In common usage, memory painting is a 20th- and 21st-century genre, often nostalgic in tone and often the work of artists who begin to paint after the age of 50. Anna Mary Robertson Moses, who as Grandma Moses, was the most celebrated of American memory painters, probably gave the genre its name when she wrote in her 1952 autobiography that "memory is a painter." She later commented, "Painting is memory and hope—one looks backward, the other forward." Robert Bishop and Herbert W. Hemphill Jr., director and curator of the American Folk Art Museum, popularized the term in the 1970s as they introduced contemporary folk art to a wide audience.

The memory painters first celebrated in the 1970s and 1980s were, with a few notable exceptions, primarily white, primarily female, and primarily rural. Their paintings, rooted in community lore and personal reminiscence, often recall daily life in an idyllic past free from the complexities of contemporary society. The simplicity they enshrined was greatly appealing to an audience mindful of Cold War tensions and cultural change. The celebration of the American Bicentennial in 1976, which spurred interest in folk art of all kinds, also helped establish memory painting as a quintessentially American genre of folk art. Indeed, memory artists have frequently seen their own experiences implicitly as emblems of national identity.

Even before the 20th century, self-taught American artists painted memories before the term entered the vocabulary of folk art historians. Certainly, 19th-century artists commemorated events and reported on the American scene as they themselves had experienced it. Remembrance was the core of mourning art that came into vogue following the death of George Washington in 1799. The death of America's celebrated hero, in addition to generating classical motifs from an era of romanticism, allowed individual Americans to cast themselves as mourners for a passing generation of heroes. Other artists, conscious of the United States as a new nation, commemorated historical events and presented personal notions of American identities to a curious audience. French immigrant and assistant engineer in the Louisiana army during the War of 1812, Jean Hyacinthe de Laclotte (1766–1828), painted the panoramic *Battle of New Orleans* in 1815 from sketches he had made on the battlefield. In hundreds of vivid watercolor works on paper, adventurer and artist Sam Chamberlain (1829–1908), from Massachusetts, depicted views of the West and the South in

his recollections of a soldier's life during the Mexican War and the Civil War. While some of the paintings raise questions about authenticity and some imply that Chamberlain's perception may be colored by distasteful attitudes, Chamberlain certainly could speak from experience; he served in the Second Illinois Volunteer Regiment during the Mexican War, was with the First U.S. Dragoons in San Antonio, and saw action in Virginia during the Civil War with the First Massachusetts Cavalry. Discharged after being severely wounded, Chamberlain reenlisted and for a few months commanded the Fifth Massachusetts Cavalry, an all African American unit.

In contrast to these earlier works, memory paintings of the 20th and 21st centuries are almost all personal narratives of typical daily experiences. Self-taught artists often begin to record their experiences in response to retirement, illness, accident, or death of a spouse. Obviously, a fond remembrance lightens feelings of loss. Grandma Moses began to paint after the death of her husband and after her arthritis made household chores and needlework difficult. A few of Grandma Moses's paintings recall her early married years between 1887 and 1905, when she and her husband, Thomas, lived in the Shenandoah Valley of Virginia. *Making Apple Butter* recalls a seasonal activity that she describes in her autobiography, and *The First Auto* commemorates the unexpected arrival of an automobile at a country fair in Gipsy Hill Park near Staunton, Va. *Auction* and *Moving Day* recount the moves the family made within Virginia and finally back to New York.

Georgia's Mattie Lou O'Kelley painted stylized landscapes that are very similar to Grandma Moses's in mood and content; and Robert Bishop, who became the artist's champion after seeing her paintings in the High Museum gift shop in the late 1970s, emphasized this parallel in his 1979 *Folk Painters of America*. While O'Kelley's dour self-portraits show the artist's complex personality, her cheerful pictures of neat patchworklike fields in Banks County, Ga., never suggest discord. Instead, the formal rhythms in her paintings echo the cycle of life—birth, childhood, adolescence, and maturity. Intricate patterning and pointillist brushstrokes form Edenic narratives. At a time when small farms were struggling, these nostalgic landscapes evoked a longing for better times.

African American artist Clementine Hunter (1886/87–1988) chronicled rural life on Melrose Plantation in Natchitoches, La., where she worked for more than half a century as a field hand, maid, and cook. Hunter's pictures are a veritable encyclopedia of work, religious practice, and recreation in northeast Louisiana during her lifetime. Paintings of planting and picking cotton, cooking, washing clothes, and gathering pecans record women's work, while

river baptisms, weddings, funerals, and Saturday night revelry capture the activities that filled hours of rest. Hunter occasionally memorialized specific people and events. *Uncle's Jack's Statue, Called the Good Darkey* (1950) depicts a statue in Nachitoches, La., of Uncle Israel, one of the last former slaves living on Melrose. In *Frenchy Goin' to Heaven*, painted only a week after her son's death, Hunter comforts herself by showing Frenchy rising from his grave. Hunter's paintings, sold to a white audience, show almost no hint of the harsh lives of African Americans in the pre–civil rights era; only her many crucifixions of a black Jesus express the sufferings of her people.

The relentlessly cheerful view of Emma Serena Dillard Stoval (1887–1980), best known as "Queena" Stovall, also provides a cozy view of southern life. In *Fireside in Virginia* (1950), Stovall depicts two women congenially sharing friendship and talking as they informally stand before a fireside warming themselves. In *Hog Killing* (1949) she superimposed details of the past on the present to make for a more colorful and detailed visual presentation. As Stovall recreated community life around Lynchburg, in the piedmont area of Virginia of the 1940s and 1950s, details of the past were commingled in her paintings. Her depiction of an African American funeral, *Swing Low Sweet Chariot* (1953), shows an old-timey draped hearse instead of a sleek modern one. While many of Stovall's works are composites or imagined scenes, others such as *The Baptizing* (1957) and *Baptizing-Pedlar River* (1957) pinpoint specific events. Stovall, a white woman, painted memories of her own family and of her African American neighbors. All are idealized views. Depictions of African Americans, however, can be patronizing.

Minnie Smith Reinhardt (1898–1986), born and raised in southeast Catawba County, N.C., also documented work scenes such as planting cotton, cutting wheat, shucking corn, and making molasses. Reinhardt's paintings such as *Pa's Pottery Shop*, *Dr. Foard Home*, *Hog Hill School*, and *Corinth Baptist Church* document significant buildings. Reinhardt's artistic career did not take off until freedom from family responsibilities, successful eye surgery, and encouragement from her daughter, Arie Taylor, also a painter, rekindled an early interest art. Reinhardt painted every day for the last 12 years of her long life.

Vivid memories of cattle drives remembered from early childhood inspired Aunt Clara McDonald Williamson (1875–1976) to paint *Get Along Little Dogies*. Here, the artist paints herself as a young child observing a cattle drive of Texas longhorn cattle as they cross the Bosque River near her home in Iredell, eastern Texas. Iredell was a stop on the old Chisholm Trail, a dirt cattle-drive trail from southern Texas to Kansas. Other paintings—*Arbor Meeting*, *Chicken for Dinner*, *The Day the Bosque River Froze*, and *Main Street, Iredell*—recall the

frontier town's square dances, harvests, camp meetings, and the building of the town's first railroad. Like Moses, O'Kelly, Stovall, and others, Williamson began painting late in life after her husband died. Her husband had believed that painting was a waste of time.

While memory painters whose families had been able to provide security tend to cast the past as a series of idyllic filtered scenes, less fortunate artists paint unhappy memories. Sarah Albritton (b. 1936), who has lived all her life near Ruston, La., does not idealize the memories of her difficult past. Indeed, many of her works are hellish tableaux. In *Dirty Old Men* numerous men take advantage of women and girls. In *The Killers* a rural community suffers widespread destruction as many men fire guns, and many die. In *We Are Coming* members of the Ku Klux Klan attack with guns. Albritton's memories, however, did not paralyze the artist. She married, capitalized on her talent for cooking by opening a successful restaurant, wrote autobiographical memoirs and poetry, and still paints with gusto, tempering her memories of violence with depictions of guardian angels and expressions of faith.

Although the celebrity of Grandma Moses has focused attention on female memory painters, men have also recalled the past through art making. For more than 50 years, Mario Sanchez recreated the life of El Barrio de Gato, a section of Old Town, Key West, Fla., where many Cuban American cigar makers lived. With an incredible memory for detail, Sanchez carved and painted shallow reliefs that memorialize local characters and neighborhood landmarks—Ernest Hemingway's house, the Convent of Mary Immaculate with its dormered roof and towers, and numerous bars and restaurants. Many polychromed tableaux also depict local street life—funerals, holiday celebrations, cock fights, elegant ladies with parasols, peddlers, boats docked at wharves, and trains that passed through town. *Old Island Days No. 20* is an affectionate view of a cigar factory interior that features a man reading to workers as they sort tobacco and roll cigars. For many years Sanchez's father was a reader in the Key West cigar factory.

Velox Ward also captured the distinctive flavor of a well-loved locale. His hauntingly beautiful pictures of the quiet spare landscape of east Texas reveal the artist's sensitivity to place. Recollections of his boyhood spent on a family farm in Franklin County, Tex., inspired *Mama Blows the Horn*: an open door reveals a set table and a female figure, standing on the porch in red dress and apron, who blows an animal horn to summon her family from the fields. Other works show people in their day-to-day activities: butchering meat, ginning cotton, baling hay, and napping on the porch. Ward began to paint when his three children asked him to paint a picture for each as a Christmas present. He

enjoyed the experience and displayed his pictures on the walls of his shoe repair shop.

Another memory painter was Peter Minchell (Isenberg), who recorded the lush vegetation of the Florida Everglades in numerous watercolor pictures. Luxuriant exotic settings, architectural renderings, fictional worlds in space, and the creation of the earth, all rendered in a pastel palette, were among his varied subjects. Strong elements of fantasy intermingle with the southern landscape in his painted series *Geological Phenomena*; hurricanes, tidal waves, and tornadoes abound in these pictures. In two other series, *Planet Perfection* and *Comet X*, Minchell blends memory and imagination to create fantasy realms. Earl Cunningham, who had worked on a schooner that traveled from Maine to Florida, settled in St. Augustine in 1949. While he certainly drew on memories of seacoasts, flora, and fauna, the idyllic 19th-century world of his paintings is the fruit of a vivid imagination. Schooners, lighthouses, warehouses, wharves, homes, winding paths, numerous species of birds, and cypress swamps coexist in Cunningham's world. Waterways are never far from land; the artist's deeply saturated color palette dramatically presents sunsets, sunrises, and hurricanes.

William O. Golding, like Cunningham, also blended experiences aboard ship and imaginative interpretations of the past. The 60 small pencil and crayon drawings made by this African American artist from Savannah, Ga., depict both imagined ships and vessels of the Confederacy based on print sources. Golding began to draw while a patient at the United States Marine Hospital, where Margaret Stiles, a local artist and hospital recreation director, encouraged him to paint. Golding's work was included in the seminal 1970 Georgia folk art exhibition *Missing Pieces: Georgia Folk Art, 1770–1976*.

Recording experiences is a natural strategy for coping with the swift and inevitable passage of time and a method for establishing and reinforcing identity. As scientists have discovered, memories and emotions are inextricably linked to our limbic system. Memories also help to establish a sense of belonging, integrating an individual into a family or community that can be local, national, or global. Memory painters preserve varieties of personal experiences and offer a kaleidoscopic view of American identities.

LEE KOGAN
American Folk Art Museum

Robert Bishop, *Folk Painters of America* (1979); Samuel E. Chamberlain, *My Confession: Recollections of a Rogue* (1996); Harry De Lorme, *Hard Knocks, Hardship, and a Lot of Experience: The Maritime Art of William O. Golding* (2000); Nance Frank, *Mario Sanchez: Before and After* (1997); Wendell D. Garrett, Virginia M. Mecklen-

burg, and Carolyn J. Weekley, *Earl Cunningham's America* (2007); Shelby R. Gilley, *Painting by Heart: The Life and Art of Clementine Hunter, Louisiana Folk Artist* (2000); Jane Kallir, *Grandma Moses in the 21st Century* (2001); Otto Kallir, ed., *Grandma Moses: My Life's History* (1948); Lee Kogan, *Grandma Moses: Grandmother to the Nation* (1997); Thomas R. Perryman and Barry G. Huffman, *"Mine's My Style"*: *The Paintings of Minnie Reinhardt* (1996); Susan Roach, ed., *On My Way: The Arts of Sarah Albritton* (1998); Barbara Rothermel, *Folk Art* (Fall 1996); Cynthia Elyce Rubin, ed., *Southern Folk Art* (1985); Beatrix T. Rumford, *American Folk Paintings: Paintings and Drawings Other Than Portraits from the Abby Aldrich Rockefeller Folk Art Center* (1988); Art Shiver and Tom Whitehead, *Clementine Hunter: The African House Murals* (2005); Donald Vogel and Margaret Vogel, *Aunt Clara: The Paintings of Clara McDonald Williamson* (1966); Claudine Weatherford, *The Art of Queena Stovall: Images of Country Life* (1986).

Moravian Material Culture

Having come from Europe, the Moravians established their first successful American communities in Pennsylvania. In 1753 they expanded to the South and established three carefully controlled theocratic communities in North Carolina: Bethabara, Bethania, and Salem. Salem was established as a trading community in which the church regulated trades and artisans through a guild system. The Moravian artisans provided goods both to community members and to the surrounding region. The art making of the Moravian artists is a good example of folk art that arises from craft traditions. The Moravian craftsmen did receive training, some in Europe before coming to America and others through a firmly established apprenticeship system, but a distinctive Moravian aesthetic emerged, particularly in pottery, furniture, and textiles, owing in part to the isolated and carefully regulated communities the Moravians established. Moravian material culture reflects German, English, and Scandinavian influences because artisans settling the North Carolina communities came from Moravian towns in all of these places. The most distinctive medium in which the Moravians excelled was the production of slip-decorated lead-glazed earthenware. Master potter Gottfried Aust settled in Bethabara in 1755 and established what was to become one of the longest-lasting and most important distinctive southern ceramic traditions. Aust and his apprentices and journeymen, including Rudolph Christ, who replaced Aust as master in 1788, also experimented with English wares like creamware and white salt-glazed stoneware as well as tin-glazed earthenware. In addition, Rudolph Christ was an innovator who began the tradition of slip-cast bottles in the shapes of animals such as fish, squirrels, turtles, and owls. The earthenware tradition established by Aust

and Christ in the 18th century continued well into the 19th century in the shops of a succession of masters.

The community of Salem also included several cabinetmakers, including Johannes Krause, who served as master of the Single Brothers' joinery for more than 20 years. His conservative style, which changed little in the 18th century and was characterized by broad proportions, baroque styling, and the use of walnut as a primary wood, influenced a generation of apprentices and journeyman. The 19th century saw a gentle shift to a Teutonic interpretation of the neoclassical style, but furniture proportions remained broad, and style remained conservative. By the mid-19th century, shops operated by Danish Moravian Karsten Petersen and his contemporaries were producing vernacular furniture similar to that being made elsewhere in Piedmont North Carolina with the notable exception of upholstered furniture, which had a decidedly Scandinavian flair.

In 1804 the Moravians established a girls' boarding school in which needlework, both plain and fancy, taught by the Moravian Single Sisters led to the establishment of recognizable Moravian sampler and needlework traditions. These traditions were shared by the northern Moravian communities, with which the Salem school frequently exchanged teachers. The Moravians also had distinctive schools of gunsmithing, silversmithing, clockmaking, and portrait and landscape painting. Examples of the arts of many of the Moravian folk artists working in Salem during the 18th and 19th centuries are on exhibit at Old Salem Museums and Gardens in Winston-Salem, N.C., a living history museum that interprets Moravian life and material culture.

JOHANNA METZGAR BROWN
Old Salem Museums and Gardens

John Bivins, *The Moravian Potters in North Carolina* (1972); John Bivins and Paula Welshimer, *Moravian Decorative Arts in North Carolina* (1981); Johanna Metzgar Brown, *Journal of Early Southern Decorative Arts* (Winter 2001), *The Magazine Antiques* (January 2007), *Antiques and Fine Art* (January–February 2007).

Music and Musical Instruments

In the rural southern United States, art and music, visual and aural expressions of Anglo- and African American traditional cultures, often walk hand in hand. Such connectedness between the arts, while not a universal conceit, has been noted in numerous cultures. Erich von Hornbostel was among the earliest scholars to investigate "intersense modalities." Robert Farris Thompson relates this concept to Africa and African continuities in the Americas when he refers

to the *nsibidi* ideograms of the Ejagham as "visual music." Thus, while a dialogue between the visual and aural is hardly unique to the South, both southern musicians and folk artists prize resourcefulness and improvisation.

Southern music often reflects strong localized traditions, and so does southern folk art. Indeed, similar aspects of style, content, and motif in both media are apparent, negating the opinion that the typical self-taught southern artist operates as some kind of outsider or isolate. Instead, an intra-aesthetic emerges between folk music and art in the South, one bound up in but not limited by the autarkic, or self-governing, motivations and cultural preservation of a region, community, family, or, in the case of much African American vernacular art and music, a level of Afrodiasporic continuities and reinterpretation.

The repetitious yet asymmetrical patterns of African American strip and appliqué quilts, for example, correspond to the repeated musical riff of a blues tune, providing structure and variation through circumscribed, economical means. The experiential relationship with God that one hears in the first-person commentary of gospel songs finds counterpart in the Pentecostal-driven works of, say, Sister Gertrude Morgan, who prominently placed herself in her pictures, often as a steadfast Bride of Christ.

In addition to painting and preaching, New Orleans–based Morgan sang and played several instruments. Her one album, *Let's Make a Record* (1971), in which her sole accompaniment is a tambourine, exists within a long-standing tradition of evangelical expression in both repertoire and execution. For jackleg preachers who ministered outside the official sanction and ordination of a church, the tambourine became a street corner necessity, able to inspire religious fervor but also to simply grab one's attention. As extensions of her faith, Morgan's music and paintings share a rapture-poised spontaneity and melismatic motion that physical and musical frame have a hard time containing.

Music and art were but two tools in the same preacher's kit for Georgia legend Howard Finster, who played the banjo, guitar, harmonica, and piano. His music, a mix of traditional and popular material, would have been familiar to any southerner his age—black or white. His music making matches his art in idiosyncratic delivery, in the artist's knack for recycling iconic images such as Coke bottles, and in the goal to proselytize through a blend of secular and sacred. The mixture of elements underlies Finster's likeable, charismatic manner.

Other self-taught artists have also been musicians. West Virginia sculptor Shields Landon "S. L." Jones was an award-winning fiddler in his youth; Rev. Anderson Johnson of Newport News, Va., excelled as a painter and a steel gui-

tarist; and famed east Tennessee fiddler and mandolin player Howard Armstrong painted as well as carved mojolike pendants he called "tikis." In the rural Alabama community of Gee's Bend, women often sing spirituals while they piece together their distinctive quilts; each expressive act is a reflection of solidarity and self-identity. Memphis-based husband-and-wife team Henry and Georgia Speller also made art and music together, playing the blues and creating images in a way that became a playful, self-reflective dance between the two. Speaking to William Arnett, Henry Speller said of his drawings, and he might as well have been talking about the blues: "They consolate me when I'm back here by myself."

Indeed, some of the strongest intra-aesthetic connections between folk music and art are found within the blues, arguably the single most influential musical by-product of the South. For starters, as music of self-reliant, self-referential means, blues mirrors the empowering, maverick images of southern self-taught art. More importantly, the rich vocabulary of the blues—its use of double meaning, ambiguity, contrast, irony, metaphor, and the rhetorical vernacular device of indirect speech, or signifying—finds visual parallel in much black vernacular art of the South. Finally, the philosophy of the blues, a recognition of life's vagaries and a willingness to see a situation or problem from every angle, is on one level the aural equivalent of the synoptic vision so identified with African American self-taught art.

We best see all of the above in the artistic achievements of someone like guitarist-sculptor James "Son" Thomas, the most famous bluesman to also make visual art, and it is in his most striking sculptures, those of skulls, that one sees the tropisms of blues best at work in a visual medium. As roughly hewn as any Delta guitar riff, Thomas's skulls most behave like the blues in that they become an abstraction of the truth—the blues' overriding philosophy of verisimilitude captured in stark realism through formed clay. Built around an aesthetic of the unsentimental, Thomas's bluesy art and artful blues both force the viewer to look inward, to stare into the face of hard reality where the biggest vagary of life, after all, is death. Thomas's son, Raymond "Pat" Thomas, who once collected and worked up the clay for his father, now continues both family traditions, perpetuating the signature guitar blues and clay skulls of his dad while adding his own sense of style, medium, and motif, such as the many cat drawings he produces.

That artists and musicians alike can be viewed as marginal in their own communities, working on the fringe of a mainstream that sometimes barely tolerates such expressions, should not be overlooked. If the self-taught are marginalized through geography, gender, race, personhood, or other factors,

the ability to assert one's self in art or song becomes even more defining. To appropriate William Ferris's term, both music *and* art become "territories of freedom."

Yet the southern experience as a whole has been at times one of marginalization, particularly among African Americans, who, because of the limited options for affirmation, fostered alternative perspectives. Subversive resistance often depends on strategic improvisation. Yet to varying degrees, rural southerners black *and* white have found the strategic means to survive through such adaptive behavior. To that end, music and art in the South have also been bound by the salvage approach found in each medium's materials. Assemblage, a dominant mode of African American artistic strategy, finds its parallel in the making of homemade and ad-hoc instruments by poor and/or regionally isolated musicians who could not afford or obtain commercial instruments. Kentucky sculptor Carl McKenzie, for example, played a saw as well as the banjo. Noah and Charley Kinney, whose rustic paintings and sculptures were reflected in the equally rustic old-time music they played on banjo and fiddle, crafted many of their instruments. The fife and drum tradition of the rural black South was usually practiced on a fife fashioned from river-bottom cane, while all types of modified guitars can be found in the blues, from Bo Diddley's self-made square guitars to the highly decorative "chicantars" of Clarksdale musician James "Super Chikan" Johnson, who has turned gasoline cans into functional works of art. Various gourd instruments and mouth bows were also once familiar among white and black rural southerners.

The makeup of blues-oriented jug bands from the 1920s and 1930s included such reinvented household objects as the jug, washtub bass, and washboard with cheap children's toys such as the kazoo. The earlier spasm bands of New Orleans, 19th-century street ensembles that played a role in the development of jazz, featured a number of makeshift instruments such as jugs for a tuba effect, cigar boxes for fiddles, and suitcases for percussion. The improvisatory use of ordinary, cheap household items in musical performance within rural southern African American culture can also function as a type of initiation, one with African origins. Specifically, the use of the one-string zither among children in the Deep South became a way of learning a musical skill before graduating to "adult" instruments. Better known as the diddley bow, the single-strand instrument was constructed from such commonplace objects as broom wire, bricks, nails, and a medicine bottle and employed the house itself as a resonator. Many professional bluesmen, in fact, have cited the diddley bow as their first instrument, and some luthiers now market commercial variants.

Even for the fiddle and banjo—instruments with long-established craft

traditions in America—individual construction methods have led to unconventional if practical solutions worthy of the self-taught. The handcrafting of banjos, originating with the first slaves refashioning their West African *xalams* in the New World, prevailed well into the 20th century among the South's mountain folk, whose knack for resourcefulness could create a "banjar" with materials at hand. Animal hides became heads, and objects such as gourds and metal cans became bodies. The fashioning of fiddles was even more versatile, with cigar box bodies, purfling from plastic milk jugs, and corn stalks for the fiddle and bow. Howard Armstrong's father carved his son's first fiddle from a crate, and Noah and Charley Kinney's father made a fiddle out of a cigar box. If anything, the crafting of handmade instruments in the southern United States is far from becoming a vanishing art. In Florida, for example, the state's cultural diversity has given rise to an abundance of makers of all types of instruments, often with emblematic ethnic status, from Cuban *batá* drums to Serbian *gusles*, while a cottage industry has even developed around one particular instrument with a homespun pedigree, the Appalachian, or mountain, dulcimer.

WILLIAM L. ELLIS
Saint Michael's College

Kristin G. Congdon and Tina Bucuvalas, *Just above the Water: Florida Folk Art* (2006); David Evans, *River City* (Summer 1995), *Western Folklore* (October 1970); William Ferris, *Local Color: A Sense of Place in Folk Art* (1982), *Afro-American Folk Art and Crafts* (1983); John Rice Irwin, *Musical Instruments of the Southern Appalachian Mountains* (1979); Ramona Lampell, Millard Lampell, and David Larkin, *O, Appalachia: Artists of the Southern Mountains* (1989); Alan P. Merriam, *The Anthropology of Music* (1964); Robert Farris Thompson, *Flash of the Spirit: African and Afro-American Art and Philosophy* (1983); John Michael Vlach, *The Afro-American Tradition in Decorative Arts* (1978); Erich M. von Hornbostel, *Psyche* (April 1927); Eliot Wigginton, ed., *Foxfire 3* (1975); Eliot Wigginton, ed., *Foxfire 4* (1977).

Outsider Art

Outsider art, currently a popular designation of nonmainstream art, has become synonymous with quirky creativity and isolated inspiration. Nonetheless, it is difficult to justify the use of this catchy umbrella term to link varieties of art as disparate as the creations of artists with autism and the backyard environments of retired preachers.

The term *outsider art* has a long, sometimes troublesome history. During the first decades of the 20th century, psychiatrists in Europe such as Walter Morgenthaler of Bern, Switzerland, and Hans Prinzhorn of Heidelberg, Ger-

many, began to recognize that drawings, paintings, and sculptures made by certain asylum inmates could be valued more as significant works of art, affording valuable insights into universal human creativity, than as mere symptoms of illness. When the published studies of these doctors fell into the hands of modern artists in the early 1920s, the notion of mad creativity became quite popular in European art circles; expressionists like Paul Klee and surrealists like Salvador Dali and Andre Breton embraced the works of schizophrenics as untrammeled expressions of authenticity. By midcentury, the French artist Jean Dubuffet had begun to build a collection of so-called schizophrenic art; and he soon added to his collection the spirit-inspired artwork of spiritualist mediums, eccentric isolates, and blue-collar workers. He called all of these works "art brut," or raw art, as a direct challenge to the art supported by mainstream galleries and museums, or what he called *l'art culturel* (cultural art). Although Dubuffet ultimately valued *artistes brut* for their creative purity in comparison to academic artists, the lasting tropes associated with art brut have consistently been psychopathology and social isolation.

In 1972 English art historian Roger Cardinal wrote a book celebrating art brut; and his publishers, in an attempt to reach a wide, English-speaking audience, titled it *Outsider Art*. Cardinal championed Dubuffet's notion of a pure, untainted creativity, celebrating the extremes of psychological and social marginality as ideal creative positions. In 1979 Cardinal, together with Victor Musgrave, organized a major exhibition at London's Hayward Gallery called *Outsiders*. The curators presented canonical *artistes brut* such as European schizophrenics like Adolf Wolfli and Aloise Corbaz and spiritualist mediums like Augustin Lesage and Madge Gill alongside a range of other self-taught American artists, from Henry Darger to Martin Ramirez to Joseph Yoakum. No matter what their backgrounds or intentions, this exhibition used sensationalist language to present the artists with a pathological spin; despite the inaccuracy of this formulation, the international field of outsider art was born.

In the years immediately following the Hayward show, American museum curators and art dealers adopted the catchy outsider art designation, recognizing its dramatic appeal and ostensible usefulness in marketing self-taught artists, heretofore often called folk artists. Curators, dealers, and collectors systematically recast artists across the country, and especially in the South, as outsider artists. At best, the term outsider art created benign chaos; at worst, the term opened the door to regional, racial, and social stereotyping.

No group of artists has been so consistently misrepresented by the category of outsider art than southerners. Southern self-taught artists such as Howard Finster, Sam Doyle, and Minnie Evans—all of whom were valued members of

multigenerational families and tight-knit, local communities—have often been recast as crazy isolates under the rubric of outsider art. Those invested in the concept of otherness implied by the term outsider have taken little interest in the rich web of southern cultural practices that nurture the work of southern self-taught artists. The most egregious misuse of the outsider art label has been its application to the work of southern religious visionary artists—from William Edmondson to J. B. Murray, whose work derives inspiration from the culturally grounded practice of celebrating personal vision; as outsiders, their expressions of vision, even when those expressions articulate Christian faith, have been systematically misconstrued as eccentric.

Today, outsider art has come to include the work of artists flourishing in workshops for people with disabilities, of psychotics in hospitals, of eccentrics of all kinds, and of virtually anybody unable to afford a formal art education. The blockbuster sales fair called the Outsider Art Fair, held annually in New York City since 1991, has become the barometer of the field of outsider art. The South's own version of this event, called Folk Fest and held annually in Atlanta, Ga., has presented the same range of art as its northern counterpart since 1994. The promoters' interchangeable use of the terms "outsider art," "folk art," and "self-taught art" demonstrates the field's hybrid, confused status.

In the 21st century, as the earlier, canonical generation of so-called outsider artists disappears, market and museum establishments invested in the outsider art margin have increasingly opened their doors to include the work of artists with varying degrees of formal art training. Many artists actively market themselves as outsiders, even promoting their work on sophisticated Internet websites. Despite its unhappy connotations and inaccuracy, the outsider art designation remains the most widely recognized descriptor of the full range of art created by artists without academic training. For better or worse, the term "outsider" is probably here to stay. Museum professionals, scholars, dealers, and collectors must continue to qualify the meanings of "outsider" and reject stereotypes that impede the understanding and appreciation of individual artists.

JENIFER BORUM
New York, New York

Roger Cardinal, *Outsider Art* (1972); Michael Hall and Eugene Metcalf, eds., *The Artist Outsider: Creativity and the Boundaries of Culture* (1994); John MacGregor, *The Discovery of the Art of the Insane* (1989); Lucienne Piery, *Art Brut: The Origins of Outsider Art* (2001); Colin Rhodes, *Outsider Art: Spontaneous Alternatives* (2000).

Photography, Vernacular

A vernacular photograph is any photographic image where artistic intent is absent. Yet, despite the lack of intent, the accidental aesthetic qualities of some vernacular photographs invite contextualization as art. Indeed, Susan Sontag, in her seminal 1973 book *On Photography*, places the naive snapshot within the history of artistic photography by saying that "an unassuming functional snapshot may be as visually interesting as the most acclaimed fine art photographs."

Because found vernacular images are almost always anonymous, they are mysterious—yet often oddly familiar. Collectors of vernacular photography now find artful images in photo booth strips, police mugshots, medical and science photos, employee photo identification badges, school pictures, common news photos, and studio photographs. Those who appreciate the work of self-taught artists certainly appreciate vernacular photography's fantastically wrong compositions, serendipitous moments, and "accidental masterpieces." Collectors and dealers who specialize in the work of self-taught artists, in fact, have taken the lead in bringing attention to the potential artfulness of photographs not intended as art. Following the collectors' lead, museums have recently mounted exhibitions, published catalogs, and acquired collections of vernacular photographs.

The history of vernacular photography is part and parcel of the history of photography itself. The equipment available to amateur photographers and the assumption that users of amateur equipment require no training, in fact, invite the mistakes and accidents that define vernacular photography. The making of a photograph, like any artistic endeavor, is a process of making visual choices. John Szarkowski, the director emeritus of the Department of Photography at the Museum of Modern Art in New York, expressed it best when he wrote: "Photography is a system of visual editing. At bottom, it is a matter of surrounding with a frame a portion of one's cone of vision, while standing in the right place at the right time. Like chess, or writing, it is a matter of choosing from among given possibilities, but in the case of photography the number of possibilities is not finite but infinite."

Professionals and art-school-trained photographers go about the process with a mental checklist of technical items to put into place before the shutter is clicked—all the while weighing innumerable choices and editing the subject matter to assure the best image possible. While many photographs by these professionals look easy to accomplish, behind that image are usually years of technical training and a critical artist's eye. Additionally, professionals often use top equipment, multiple lenses, and generous darkroom time, as parts of the creative act.

Though photography was first invented in the late 1830s, its science and understanding remained something of a mystery to the common person. By the middle of the 19th century, however, photography was accessible to the public through professional photographic studios. Itinerant photographers arriving in horse-drawn photography wagons served rural areas. The mid-19th century was the era of daguerreotypes, cabinet cards, and tintypes, and it was during this period of slow films that photography subjects had to remain very still. Smiling for the camera during these early years was quite unusual, especially when exposure times could be 15 to 20 seconds long. Popular from 1856 through the first quarter of the 20th century, the tintype, actually a thin sheet of pressed iron, made photography simpler for experienced photographers. However, tintypes were dark and monochromatic and, if color was desired to enhance realism, had to be hand-tinted.

With the literacy rate in the United States estimated at only 13 to 14 percent by 1890, it is not surprising that the average American left photography to the special few who had the knowledge, wherewithal, and money to practice it. The process of creating a fixed image was complicated, requiring measured amounts of caustic chemicals, light-sensitive papers, emulsions, and printing equipment. Even the requirement for a dark room to produce a photographic picture simply added to its mystery and inaccessibility.

At the turn of the century, however, photography became available to ordinary people. "Making a picture" was not only for the wealthy and the elite. A Kodak camera in the 1880s cost about $25 and came with a roll of film exposing 100 circular images. In order to develop the film, the entire camera had to be sent back to the manufacturer, which developed the pictures and returned the camera with a new roll of film. In 1900, however, the Kodak Brownie "black box" went on the market for just $1; the Kodak company advertised that "we furnish anybody—man, woman or child, who has sufficient intelligence to point a box straight and press a button . . . with an instrument which altogether removes from the practice of photography the necessity for exceptional facilities, or, in fact, any special knowledge of the art."

By the early 1900s, many amateurs were documenting family life, nearby scenes, and special occasions with affordable Brownie cameras. For middle-class folks, picture taking was not a means of personal artistic expression. Indeed, ordinary snapshots through much of the 20th century remained informal records made without much more forethought than "point and shoot." Outdoor portraits and landscapes depended on available light and required only that photographers center their subjects in a viewfinder. Amateur photographers threw away their unsatisfactory shots, so family albums almost always

Anonymous, Princess Warrior, ca. 1935, 3½" x 5¼" (Courtesy John and Teenuh Foster)

represent only flattering, happy, and significant family events—newborn babies, family cars, vacations, birthdays, and graduations. This selective editing of the family photo album usually portrays the family as myth, its viewer seeing only what the "editor" wants the viewer to see. Like travel brochures that show only bright and beautiful places, family albums are skewed to represent the best of home life.

In contrast, many of the most intriguing vernacular photographs are mistakes and discards. Long shadows of the photographer veering into the picture may create an ominous effect, and unusual poses and events may evoke unexpected emotions. Recorders of family events, for example, rarely think of pulling out the camera during a family argument or at the moment someone learns of a tragic event. Vernacular images of such events are exceedingly rare but, removed from context, may become highly collectible. These singular anonymous snapshots remain enigmatic mysteries, probably never to be solved. While digital photography threatens the futures of vernacular photography collecting—many digital images are never printed at all—the study of vernacular photography from the past 100 years has just begun.

JOHN FOSTER
St. Louis, Missouri

Anonymous, *Robert Flynn Johnson* (2004); Stacey McCarroll Cutshaw and Ross Barrett, *In the Vernacular: Photography of the Everyday* (2008); John Foster, *Accidental Mysteries: Extraordinary Vernacular Photographs from the Collection of John and Teenuh Foster* (2005); Susan Sontag, *On Photography* (1973); Mia Fineman, *Other Pictures: Anonymous Photography from the Thomas Walther Collection* (2000); John Turner and Deborah Klochko, *Create and Be Recognized: Photography on the Edge* (2004); Brian Wallis, *African American Vernacular Photography* (2006).

Portraiture, to 1790

The history of early portrait paintings and southern patrons who sought images of self and loved ones is remarkably broad and complex. Skill levels, training, and expectations were diverse. In fact, early Americans made no clear distinction between self-taught, or craft-trained and craft-oriented, folk portrait painters and their academic counterparts who also worked in America, including the South. Some wealthy southern consumers like the Izard, Pinckney, and Manigault families of Charleston, S.C., the Carrolls in Maryland, and the Carters and Byrds in 18th-century Virginia were just as discerning as their counterparts living in the Mid-Atlantic and the North. These wealthy, more sophisticated colonists had learned how to distinguish quality and a well-finished picture

through firsthand knowledge of seeing or owning similar works. They were able to engage some of the finest trained painters to capture their family likenesses. Other consumers, particularly those with middle-class backgrounds and incomes, were simply satisfied with either what was available to them or what they could afford. The Stiths of Williamsburg, Va., for example, could afford portraits by the minimally trained William Dering, while their more learned and wealthy contemporaries, like the Pages of Rosewell Plantation, could hire the London-trained painter Charles Bridges.

Economics and the size of one's purse played a major role in shaping the look of portraits. There were price scales, usually dictated by the artist's reputation and the amount of time invested by an artist to complete a portrait. The artist's time was dictated by the type of portrait commissioned: oil, watercolor, pastel, or cut silhouette; bust length, half length, or full length; the selection of other details such as hands showing or not showing, seated or standing, with or without accessories, and plain or elaborate background options; and the complexity or simplicity of the costume dictated both by what one could afford and by the fashions of the time. At least one mid-19th-century folk painter, William Matthew Prior, who traveled as far south as Baltimore, devised a price option based on whether the portrayal was done with or without shade or shadow.

Many painters in the South, even those with studio or academic training, also worked as ornamental painters by providing signboards, gilding, heraldic devices, and furniture and interior decorations. The 18th-century Charleston, S.C., artist Jeremiah Theus advertised many of these services in addition to portraiture. Some painters settled or were born in the South and traveled for commissions. Before the American Revolution, artists immigrated to the South from other colonies to the north and from abroad, chiefly from England, Germany, Switzerland, and Sweden. By 1785, French artists were arriving in increasingly large numbers and offering the latest styles in silhouettes in various mediums, pastels, and miniature painting. Some painters stayed in the colonies while others returned to Europe. These variables and others often influenced the style and quality of a given artist's work.

The earliest images of people living in the South, and in all of colonial America, are those that chronicle early expeditions by Spanish, French, and English explorers who brought with them cartographers and artists to record the natives, flora, and fauna of the New World. The best of these were probably painted by the French cartographer Jacques Le Moyne around 1564 and by John White, who in 1585 painted watercolors of North Carolina native peoples. He also painted fish, fowl, and plants. Arguably, these were not intended as por-

traits in a traditional way, but they were undoubtedly based on actual persons, their dress, and manner of deportment.

Although the concept of portraiture probably has its roots in prehistoric times, the tradition of portrait painting as we know it did not become popular in Europe until the Renaissance. By the 16th century its practice in England and elsewhere included life- or larger-scale images for royalty, courtiers, and wealthy merchants by a few well-known artists and several distinguished miniaturists like Nicholas Hilliard. The explorer pictures by Le Moyne and White fall within the two categories of miniatures and natural history painting. Philip Georg Friedrich von Reck was another artist whose pictures were executed in a similar manner but likely for personal consumption. He came to Georgia with a group of Salzburgers in 1734 to establish a colony. His likenesses of local Indian leaders are more compelling and sincere. They are devoid of the formulaic poses seen in similar figures in White's and Le Moyne's work.

It was not until about 1700, with the steady strengthening of the South's ports, its plantation system, and small towns, that painters who could provide portraiture and a group of willing patrons emerged. In the South, as well as elsewhere in the colonies, portraiture quickly became the favored format. Only a handful of landscapes and still lifes predating 1775 can be labeled as southern. Portraiture remained the chief artistic expression throughout the 18th century and into the 1840s when the introduction of photography provided clientele with greater realism at less expense. Photography offered cheap, lasting images of family and friends and ruined the careers of many portrait painters.

Portraits served as permanent records of persons. There were both sentimental and practical reasons for having family likenesses painted, particularly in the 18th century when mortality rates were high. Families tended to be more tightly structured than they are today, as the family unit was often vital to social and economic survival. Portraits were emblematic of social status, and they reflected a high degree of worldly wealth and gentility. They also recorded and evoked memories and reminders of an individual or a whole family's life within socially acceptable norms. Relationships were guided by proper conduct in religious, civil, and social life. The relationships between husbands and wives, parents and children, and siblings are clearly defined in these images. Most life-size and large-scale portraits were meant to be displayed and seen by family and visitors to the home. Miniatures and small-scale likenesses were usually considered more intimate and for the pleasure of close loved ones. Thus, portraits could function on both private and public levels as family icons, genealogical records, decorative embellishments, or sentimental reminders. The Jaquelin-

Brodnax portraits, created in the 1720s in coastal Virginia, and family groups of portraits by John Hesselius, John Wollaston, and Jeremiah Theus from Maryland, Virginia, and South Carolina, illustrate many of these points quite well. By the mid-1750s, southern colonies were well served by these artists and others.

On the eve of the American Revolution, an even larger number of artists had either settled in or visited the South, including European-trained painters like Henry Benbridge, Matthew Pratt, and Charles Willson Peale. Folk or minimally trained painters like John Durand were also able to make a living in the region. By 1800 the artist population in the South had quadrupled, and patronage continued to shift more toward America's thriving middle class of tradesmen, farmers, and merchants. This resulted in a number of creative solutions for cheaper portraiture on paper, such as pen-and-ink, graphite, and watercolor versions. These smaller types of portraiture, as well as the traditional sizes in oil, proliferated throughout the South until the mid-19th century.

CAROLYN J. WEEKLEY
Colonial Williamsburg Foundation

Graham Hood, *Charles Bridges and William Dering: Two Virginia Painters, 1735–1750* (1978); Donald B. Kuspit et al., *Painting in the South, 1564–1980* (1983); Margaret Simons Middleton, *Jeremiah Theus: Colonial Artist of Charles Town* (1991); Jessie Poesch, *The Art of the Old South: Painting, Sculpture, Architecture, and the Products of Craftsmen, 1560–1860* (1983); Beatrix T. Rumford, *American Folk Portraits: Paintings and Drawings from the Abby Aldrich Rockefeller Folk Art Center* (1981); Anna Wells Rutledge, in *American Philosophical Society Transactions* (November 1949).

Portraiture, 1790–1850

As in the colonial period, much of the imagery produced in the southern states after the formation of the American Republic was portraiture. The dominance of this subject matter for both academically trained and folk artists did not end in the last decade of the 18th but continued through the first five decades of the 19th century. This period was a time of expansion and territorial growth with regional consolidation, financial development, population increases—as well as displacement of native people—and the emergence of urban centers, albeit with greater distances separating them than was to be found in more northern regions. In the South, towns and cities were accessible through coastal and river trade, and it is along such routes that artists found their way to places such as Baltimore, Washington, D.C., Charleston, Savannah, Richmond, Nashville, Lexington, Natchez, Meridian, and New Orleans. Some of these centers grew to national and even international prominence; Baltimore, Md., by 1800 was one

of the most important ports in the antebellum South, only to be surpassed in the mid-19th century by New Orleans, which was on a par with New York City.

Much was happening. In 1790 Washington, D.C., became the capital of the nation. Louisiana had been purchased from the French. Lewis and Clark had set out on their great cross-continental trek from St. Louis, and Florida had been acquired from the Spanish. The American South was economically booming for much of this period, and in the Deep South "cotton was king," made possible by that attendant evil of human slavery. Furthermore, the despicable practice of land dispossession led to the Trail of Tears—the westward trek of many southern Indian tribal people.

Most of the South remained rural and agrarian, with only a few places where cultural interest and artistic activity could take root, such as Baltimore and New Orleans, which each had their own cultural enlightenment. Local artists came forward but others came as itinerants from the North or abroad. The French especially continued to be drawn to the region. Efforts to provide support for the arts through the establishment of academies, museums, and artists' organizations were sporadic and not always successful, although a few organizations did survive. There were a few well-known local patrons, but most of the portraits painted were for the growing ranks of a more economically sound rising middle class.

The portraits produced by folk artists often shared common elements of style, materials, and technique that usually set their work apart from that of academically trained painters. These stylistic elements frequently included anatomical inaccuracies as well as fanciful inventions; inconsistencies of lighting; little knowledge or utilization of visual perspective; a reliance on the repletion of detail and patterning, as well as a nonrealistic use of color. These stylistic characteristics are a significant part of the attraction folk portraits have for viewers today.

Frequently folk artists had no access to or were unaware of technical changes for pigments and materials. Some painters continued to utilize wooden strainers with fixed joints to support their canvas at a time when academically trained painters were more likely to use commercially prepared canvases or, if needed, to prepare their own canvases. In those situations, they would use wooden stretchers with expandable joints that allowed the canvas to be responsive to climatic changes.

The most significant influence on both folk artists and their patrons came from standards set by those academic painters who visited and worked throughout the South, such as Charles Willson Peale, John Trumbull, Gilbert Stuart, Thomas Sully, and George Peter Alexander Healy. Although none

of these established a permanent residence in the South, their portraits of southern sitters continued to hang in homes and places of business or government, thus providing a visual resource for all to use.

There were also those painters whose names remain unknown and whose works are identified by the name of the family whom they portrayed. One such is the Payne Limner active in Goochland, Va., who depicted 11 members of that family during the 1790s, including a rare portrayal of a slave child. Even though there were numerous African Americans enslaved throughout the region, few were ever painted, and equally few who worked as folk artists have been identified.

One of the finest as well as the earliest known African American painters in the United States, Joshua Johnson, was active during this period in Baltimore. Much has been learned about this important painter including that his mother was enslaved and his father a free white man. As a child Johnson was indentured for training as a blacksmith. Once freed, he turned to portrait painting. How he acquired the necessary skills and training for this profession has not been documented. In his newspaper advertisements, he called himself a "self-taught genius," the earliest use of the label self-taught as applied to his surviving portraits, and newspaper advertisements suggest a diligent course of self-study complimented by the opportunity of looking at portraits by various members of the Peale family, most probably those of Charles Peale Polk. Johnson created an impressive body of work, frequently depicting entire family groups in usually serenely quiet, direct portraits.

Charles Peale Polk, whose works may have inspired Johnson, might even have known him while residing in Baltimore or visiting there. Polk was the nephew of Charles Willson Peale of Philadelphia, who not only raised him but taught him to paint. However, Polk developed his own dynamic style of anatomical exaggerations, lively brushstrokes, and electric highlights. His travels took him through Maryland and the Valley of Virginia before he settled down in Washington, D.C., seeking political patronage and additional portrait commissions. Life was financially hard for even such a well-connected artist as Polk, and he struggled, finally accepting a federal clerkship to support his family. After his marriage to his third wife, the couple moved to Richmond County, Va., where he farmed the final years of his life, while still keeping his painting equipment at hand.

Polk had also supplemented his income copying portraits of such well-known Americans as George Washington, Thomas Jefferson, and Benjamin Franklin. Other folk artists followed suit; William Joseph Williams received a famous commission from the Masonic Lodge in Alexandria, Va., for a portrait

of their most illustrious member, George Washington, in Masonic regalia. Although born in New York City, Williams spent most of his artistic career as an itinerant crossing back and forth in and out of the North and South, finally settling in New Bern, N.C. Another folk painter, Ralph E. W. Earl is probably best known today for the numerous portraits of Andrew Jackson he painted. Earl was born in Connecticut, son of the itinerant painter Ralph Earl, who began his career as a self-taught artist and, even after training in Europe, continued to paint in a folk style. In 1817 the son arrived in Nashville and had come south seeking a chance to paint Jackson. He met and married Jackson's niece, Jane Caffery, and remained in Nashville. Following Jane's death a year later, Earl remained close to Jackson and moved with him to Washington after Jackson was elected president. After Jackson's second term, Earl returned with him to Nashville where he resided at the Hermitage, Jackson's home, until the artist's death.

Other artists, unlike Polk, Earl, and Johnson, did not settle down and live in the South. Most were itinerants from the North, if not from Europe. Many came from France—often to the Deep South. Jacob Frymire, Frederick Kemmelmeyer, and Charles Boudon traveled throughout Maryland and Virginia seeking commissions for their works, which were available in a variety of media. Some artists worked in both a large and a small scale to produce portraits. Frymire painted nearly life-size portraits in oil on canvas, as well as miniatures painted in watercolor on ivory. Kemmelmeyer worked in pastel on paper, and Boudon in graphite on card stock or vellum to execute delicate tiny profile portraits.

The academically trained Raphael Peale turned itinerant to compete with folk artists for a middle-class audience. Using a physiognotrace, a mechanical device, he offered inexpensive cut-paper silhouettes to a middle class audience. Although academically trained artists continued to paint miniatures, folk artists lost their audience to photographers. By the time of the Civil War small photographic portraits were easily available in both the North and the South.

Itinerancy continued to be commonplace up and down the rivers and along the coast throughout the South up to the time of the Civil War. George Cooke, who began his career in his native Maryland, visited many southern locales during his career. He, like others, spent his early years in Washington, D.C., anxiously hoping for federal patronage. He also worked in Georgia before traveling to Italy and France to continue his artistic studies. Back in the United States he resumed his travels through Alabama and then went to New Orleans. His patron, Daniel Pratt, a builder, architect, and industrialist, provided space in a building on Charles Street for Cooke to open his National Gallery of Paintings. There Cooke operated a commercial gallery, exhibiting and selling not only

his own paintings but others by such well-known American artists as Thomas Cole, George P. A. Healy, and Rembrandt Peale. The gallery, which lasted only a few years, was an artistic achievement in New Orleans but a financial failure for Cooke. He was preparing to close it and move to Athens when he died of Asian cholera.

In reviewing this 60-year period of folk art in the American South, a few things appear evident by comparison with the North. Folk artists were active in both regions, and they remained responsive to the public demand for portraits whether they were large or small scale. Of course, in both regions the introduction of photography aided in the decline of miniature painting. What was the number of folk artists active in each region? It is difficult to know. Our knowledge of the high frequency of artists traveling into the South from the North is documented not only by newspaper advertisements but also by manuscript sources such as letters, diaries, and newspaper stories. Very few references have been found indicating a similar current of itinerancy of southern folk artists flowing to the North. Evidence suggests that southern folk painters moved westward, as did the Kentucky-born Thomas Jefferson Wright. We know little about Wright's training. His style of painting provides evidence that he carefully observed portraits by both Thomas Sully and Gilbert Stuart, and his artistic ambitions impelled him in the 1830s to paint portraits of the men forming the Texas Republic. Wright became a friend of Sam Houston and portrayed many figures of early Texas. He remained there for more than a dozen years before he died on a trip home to Kentucky in May 1846. Another self-taught Texas portraitist was the lawman Wm. G. M. Samuels, whose painting of Sam Houston is now housed in the Witte Museum in San Antonio.

During the 60 years from 1790 to 1850 folk artists ranged widely in the South seeking portrait commissions. Occasionally, when possible, these artists exhibited their paintings, and once in a while they were able to sell a portrait of noted figures like George Washington or Andrew Jackson. But long-term sustainability—financially and professionally—was limited for folk artists. Many turned to decorative painting activities as well as other work to support themselves. An art world—commercial galleries, museums, dealers, and collectors—lay in the future. In the middle of the 19th century, however, life for the folk artists of the South remained hard, and success in the art world a challenge.

LINDA CROCKER SIMMONS
Corcoran Gallery of Art

E. Bryding Adams, *The Magazine Antiques* (January 1984); James G. Barber, *Andrew Jackson: A Portrait Study* (1991); Mary Black, *American Naïve Paintings from the*

National Gallery of Art (1985); Robert Bishop, *Folk Painters of America* (1979); Jennifer Bryan and Robert Torchia, *Archives of American Art Journal* (1996); Deborah Chotner, *American Naive Paintings* (1992); Karen M. Jones, *The Magazine Antiques* (July 1981); James C. Kelly, *Tennessee Historical Quarterly* (Summer 1985); Donald D. Keyes, *George Cooke, 1793-1849* (1991); Elizabeth Thompson Lyon, "The Payne Limner" (M.A. thesis, Virginia Commonwealth University, 1981); Jerome R. Macbeth, *The Magazine Antiques* (September 1971); Jessie Poesch, *The Art of the Old South: Painting, Sculpture, and Architecture and the Products of Craftsmen, 1560-1860* (1983); Cynthia Elyce Rubin, ed., *Southern Folk Art* (1985); Linda Crocker Simmons, *Charles Peale Polk, 1767-1822: A Limner and His Likenesses* (1981), *Jacob Frymire: An American Limner* (1974), *The Peale Family: Creation of a Legacy, 1770-1870* (1996), in *Painting in the South* (1983), *Southern Quarterly* (Fall-Winter 1985); University of Maryland, *350 Years of Art and Architecture in Maryland* (1984); Carolyn J. Weekley and Stiles Tuttle Colwill, *Joshua Johnson: Freeman and Early American Portrait Painter* (1987); Jean Woods, *The Germanic Heritage* (1983).

Pottery

Until the second half of the 20th century, most pottery made in the South was relentlessly utilitarian. Using local clays and homemade tools, potters "turned" and "burned" essential forms for use in the home and on the farm: jugs and jars, churns and baking dishes, chamber pots, and chicken waterers. Most were not decorated. At the rate of 10 to 15 cents per gallon, potters had to finish pots as quickly as possible. Burlon Craig, the last of the old utilitarian potters in North Carolina, always recalled the advice he received from his mentor, Floyd Hilton: "'Don't make any difference,' Hilton said, 'Just so they hold what they're supposed to and got a good glaze on it.' Said, 'People's gonna set them in the smokehouse or cellar, and nobody'll ever see them anyway.'"

Makers of southern pottery would certainly have understood Hilton's advice. They knew that the aesthetic qualities of their pots—their formal beauty or decoration—were irrelevant. Pots sold according to their utility; customers wanted watertight pots that held the number of gallons indicated by stamped numbers. Spending extra time to pull up forms, trim walls, or embellish surfaces made little sense. In the eminently practical world of the rural South, pots were tools designed to sustain a rural, self-sufficient people. In such a context, embellishment meant losing money.

At the same time, there were potters all across the South whose talent and ambition transcended the norm. Members of the Fox and Seagle families in North Carolina, the Longs and Bechams of Georgia, and the potters of the

Edgefield District in South Carolina, including the famed African American potter David Drake, were not content to "hog it on up," as one old potter in North Carolina liked to put it. The work of such potters speaks eloquently to their aesthetic intent; their bold, carefully turned forms, neatly balanced rims and handles, and rich, flowing glazes are a delight to the hand and the eye. Such men were true artists in a world that did not recognize their work, yet they persisted in moving beyond necessity to create works of enduring beauty.

Burlon Craig often reflected on the artistry of earlier potters and once explained, "They could turn better than they really did. But I've heard this remark a lot. 'Ah, what's the use to spend a lot of time and try to make a nice shape if it sets in somebody's cellar or springbox. They don't know the difference; people don't know the difference.'" His observation makes the work of a Nicholas Fox or Daniel Seagle all the more remarkable. Unwilling to compromise, these two insisted on the finest work possible. Ironically, they must have lost money in doing so. With their persistent attention to form, texture, and surface, they could not work as fast as their peers, who focused solely on utility. Their large, unembellished, and sculptural forms constitute a major artistic achievement.

Other turners chose to enhance the appeal of their pots through overt surface decoration. In fact, the first southern pottery to attract the attention of museums and collectors was the slip-decorated earthenware made by German potters along the Shenandoah Valley of Virginia and the Moravians in north central North Carolina. Masters like Gottfried Aust and Rudolph Christ of Salem, N.C., and members of the Bell family in the northern Shenandoah Valley produced sophisticated designs equal to any from the Mid-Atlantic or New England regions. Often they dipped their pots in a white engobe to hide the red clay body and then painted or trailed on slips in precise geometric and floral patterns, often in three or four colors. The Virginia potters also used the simpler technique of splattering or sponging the colors in random patterns on the walls of the pot. Granted, the bulk of their work was not decorated, but these earthenware potters did produce a substantial quantity of wares in a wide range of bright colors using white clays along with iron, manganese, and copper oxides.

By the early 19th century, southern potters and their customers were beginning to recognize the toxic nature of the lead glaze used with earthenwares, and so they gradually began shifting to a new clay body, the higher fired and more durable stoneware. This radical change required new clays, glazes, and kilns; and potters quickly discovered that the old coloring oxides would burn out at the high temperatures needed to mature stoneware. In Virginia and the eastern Piedmont of North Carolina, potters turned to salt glaze, which was used to the north as far as Maine. Like their northern counterparts, many pot-

ters in Virginia used dark blue cobalt oxide to paint on floral patterns, abstract designs, and sometimes names or dates. In North Carolina, however, cobalt rarely appears, and, farther south, salt glaze appears only sporadically, notably in Georgia and Alabama.

Southern stoneware coated with thick, runny alkaline glaze occurs from North Carolina south to Florida and west to Texas. A Chinese glaze that dates back 2,000 years to the Han Dynasty, alkaline glaze first appeared in the Edge-field District of South Carolina at the beginning of the 19th century. Edgefield potters devised some of the most original and dramatically embellished stoneware ever made in the South. Collin Rhodes, Thomas Chandler, and others used kaolin and iron to produce light and dark slip designs under a clear, lime-based alkaline glaze. They both trailed and brushed on the slips to create swags, tassels, floral patterns, names, numbers, roosters, snakes, pigs, and even ladies in billowing hoop skirts. Numerous African Americans worked in the Edgfield potteries, which were often quite large plantation enterprises. Some African Americans, women in particular, may have played a role as "painters." At first glance, slip decoration appears indebted to the cobalt blue designs on northern stoneware; however, scholar John Burrison also has also suggested the influence of English earthenwares.

The Edgefield potters were fortunate to have light-burning clays with high kaolin content. Elsewhere in the South, thick and murky alkaline glazes obscured delicate designs. However, potters did find ways to vary the color and texture of their pots. In Georgia and North Carolina, potters added iron in the form of limonite, hematite, or sand to their glazes. Known in Georgia as "iron sand" and "paint rock" glazes, the additives produced colors and textures ranging from a smooth, glossy black to a streaky brown. A second technique widely used in the Catawba Valley of North Carolina involved balancing shards of glass across the mouths or handles of pots that had just been set in the kiln. Once melted, the glass ran down the sides of the pots in grey or milky white streaks, creating a strong contrast to the darker alkaline glaze. Finally, in Alabama some potters double dipped the upper section of their pots in the alkaline glaze, producing a two-tone effect. None of these techniques was very precise or controllable, but they demonstrate the southern potter's interest in aesthetics. Sometimes the great heat of their wood-burning groundhog kilns produced very striking results.

Just as potters painted, they also drew on their pots. Simple incising or rouletting, a process that took only a few seconds before the pot was cut off the wheel, was quite common. Potters accented different sections of the pot by tracing bands or sine waves around the neck, shoulder, or belly. Freehand picto-

rial drawing was extremely rare, but occasionally a potter was moved to sketch a human or animal likeness in the soft clay. One extraordinary example is the two-gallon alkaline glazed jug made by John C. Avera in Crawford County, Ga., in 1871. A harried fox runs around the belly of the jug pursued by two hounds and a hunter bearing his rifle. The inscription indicates that Avera made this presentation piece for a wealthy neighbor who loved foxhunting. Most one-of-a-kind pictorial drawings are crude and cartoonish. Members of the Webster family in North Carolina, however, created a remarkable body of jugs, jars, and pitchers incised with birds, fish, trees, branches, flowers, Masonic emblems, a soldier, and assorted geometric embellishments. These sophisticated works, which are unsigned, bear dates from the 1840s through the 1870s. The Websters had come south from Connecticut around 1820, and Chester Webster, the primary maker, was apparently continuing a decorative tradition that had long since ceased in the North. Such *retardataire* practice is common in folk art, especially when the artists have moved away from the communities where they began their creative careers.

While clay is an ideal material for the sculptor, three-dimensional ornamentation was rare. The earthenware potters of the Shenandoah Valley were among the few who regularly applied three-dimensional ornamentation. These potters were particularly adept at making molds of animals, birds, fish, flowers, leaves, and human figures that they could apply to pitchers, coolers, bowls, vases, and flowerpots. The Bell family was particularly renowned for its grinning, zipper-mouthed lions; the Eberly family modeled log cabins to commemorate a Civil War battle. In like manner, the Moravians produced an extensive line of molded wares, including stove tiles, toys, and bottles in the form of fish, squirrels, chickens, and other animals. Under the bright colors of their lead glaze, these elaborate forms proved extremely appealing.

Stoneware potters, by comparison, were much more restrained and largely limited their sculptural efforts to flowerpots, grave markers, and, most of all, face jugs. The earliest known American face vessels were made in the North in the early 19th century, but there is no question that the South has produced more than its share of these often bizarre, anthropomorphic forms. Southern face jugs probably appeared around the middle of the 19th century in the Edgefield District of South Carolina, where potters—both white and black— applied faces to a small number of alkaline glazed jugs, bottles, jars, and cups. Scholars continue to debate the origins of these rare sculptural forms, and the best answer is that they are a biracial creation. The technology and alkaline glaze were certainly Euro-American, but enslaved Africans may have brought with them a preference for mixed media, including the use of kaolin for eyes

and teeth and the fierce, angry expressions seen on many of these early creations. Despite their obvious aesthetic appeal, however, face vessels were rare until they became popular with folk art collectors during the second half of the 20th century. A potter can turn three or four jugs in the time it takes to apply one face, and few customers looking for a utilitarian jug were willing or able to pay more just to have a face on their water jugs. However, the extra work required to make them and potters' individualistic aesthetic choices suggest that face vessels possessed deeper meanings as presentation pieces, expressions of protest, or possibly even ritual artifacts.

The 19th century was the great age of folk pottery in the South. During the first quarter of the 20th century, demand for the old utilitarian wares sharply declined. The Temperance movement, factory-made metal and glass containers, and improved methods of refrigeration and transportation all combined to put many potters out of business. With greatly reduced competition, some potters continued to sell traditional churns, jars, milk crocks, and flowerpots. Others, however, most notably around Seagrove, N.C., began to innovate, greatly expanding their repertoire of forms and glazes. Seagrove potters paid particular attention to Asian ceramics and adopted new technologies and marketing practices. A much more colorful, carefully finished artistic product, made to be seen as well as used, attracted a new clientele: tourists, collectors, and middle-class housewives.

During the late 1960s and early 1970s, as the nation prepared to celebrate its Bicentennial, Americans sought out authentic, handmade objects. Many turned their gaze southward and discovered southern pottery. Alkaline glazed face jugs, most notably the work of Lanier Meaders of Georgia and Burlon Craig of North Carolina, were the catalysts for almost obsessive collecting of southern ceramics. Without question, Lanier Meaders was the Michelangelo of this movement. He turned the face jug into an art form, modeling his clay heads and pushing the old jug into all manner of humanoid shapes. Craig, for his part, rarely manipulated the basic form but added Catawba Valley decorative techniques like glass runs and swirls—the use of contrasting clays to create a striped body. He started applying faces to almost everything he made; his chamber pots were the most humorous of his productions. In turn, Lanier Meaders and Burlon Craig opened the way for a new generation of potters, who have stretched this genre in all sorts of new directions. Today the southern face jug has a national audience and has become an icon of southern culture.

Although the rage for face jugs has somewhat declined, it has created a broader interest in southern pottery. Over the past decade or two, buyers from within and outside the South have come to appreciate the inherent beauty of

the old forms and glazes. This, in turn, has stimulated the production of traditional pottery by Jerry Brown of Alabama; the Hewell and Meaders families in Georgia; the Coles, Lucks, and Owens around Seagrove, and the numerous younger potters trained by Burlon Craig in the Catawba Valley in North Carolina. At their annual Turning & Burning Festival, held every October in Gillsville, Ga., four generations of the Hewell family sell their handsome, alkaline glazed pitchers, jars, and jugs. In addition, Chester Hewell has revived the old Edgefield decorative tradition and produces slip designs against a clear, olive green glaze.

The most creative use of the old salt and alkaline glazes can be found in North Carolina, where Mark Hewitt of Pittsboro, Ben Owen, Pam and Vernon Owens, and David Stuempfle of Seagrove, and Kim Ellington of the Catawba Valley base their innovations on work of earlier potters. Using wood kilns and blends of local clays, they turn elegant bowls, pitchers, vases, massive bottles, jars, and planters, some of which weigh hundreds of pounds. They continue to enhance their forms with rich streams of salt and wood ash, iron and manganese, and glass runs, ingredients that flow and fuse in unexpected ways in the hot flames of their kilns. Their work is well documented in *The Potter's Eye*, which accompanied a remarkable exhibition of old and contemporary pottery held at the North Carolina Museum of Art. Perhaps 19th-century southern masters like Daniel Seagle and David Drake would have been surprised to see their work presented as fine art in a museum, but there is no question they would have affirmed their kinship with these modern-day potters.

CHARLES G. ZUG III
University of North Carolina at Chapel Hill

Cinda K. Baldwin, *Great and Noble Jar: Traditional Stoneware of South Carolina* (1993); John Bivins Jr., *The Moravian Potters in North Carolina* (1972); Joey Brackner, *Alabama Folk Pottery* (2006); John A. Burrison, *Brothers in Clay: The Story of Georgia Folk Pottery* (1983); H. E. Comstock, *The Pottery of the Shenandoah Valley Region* (1994); Mark Hewitt and Nancy Sweezy, *The Potter's Eye: Art and Tradition in North Carolina Pottery* (2005); Nancy Sweezy, *Raised in Clay: The Southern Pottery Tradition* (1984); Charles G. Zug III, *Turners and Burners: The Folk Potters of North Carolina* (1986).

Prison Art

In contemporary American prisons, the visual arts are flourishing. Almost every incarcerated man and woman is either making art or buying it. The oppressive prison environment, its dearth of resources, and the desperate need of

its residents to activate their natural creative impulses have produced a kind of folk art. Certain forms and traditions, handed down from cellmate to cellmate, instead of generation to generation, are the folk arts of this culture. These arts are usually fashioned from materials and substances that are available only because their primary purpose is functional.

Soap carving is one example. The most popular subjects are three-dimensional initials of the inmate's beloved, treasure chest jewelry boxes, flowers, ships, generic city skylines, and various animals. One nationally known prison soap sculptor, Michael Harms, makes tiny, intricately carved chairs and love seats. Carving tools might be sewing needles, plastic bread ties, paper clips, and fingernails grown long. Toilet paper, pliable when wet, hard and durable when dry, also serves as a sculpture medium in the creation of small art objects — figures, heads, animals, and the ever-popular long-stemmed rose.

Paper weaving is a traditional folk expression practiced around the world. What distinguishes paper weaving by prison artists is the recycled paper that is used — wrappers from potato chips, cupcakes, cigarette packs, and instant noodle soup packages, and other commodities available in the commissary. These materials are torn into strips, folded, and interwoven to produce picture frames, hearts, baby shoes, and purses. Occasionally inmates fashion innovative, personal pieces, such as the elegant jeep woven from Parliament cigarette wrappers and barcode stickers by an inmate exhibitor at the biannual arts and crafts fair held in conjunction with the rodeo at Angola Penitentiary in Louisiana. Two to three hundred inmate artists and artisans exhibit and sell their work at this colorful bustling event. Artists designated as security risks attend to their wares from behind chicken-wire fencing, while the more trusted inmates interact freely with potential buyers. Popular items, in addition to paintings, are carved walking sticks, wood-burned slabs of tree trunks, wishing-well banks, and a wide variety of furniture crafted in the prison wood shop.

Tattoos are another significant body of traditional jailhouse art. Tattooing is forbidden in prison but thrives nevertheless. Tattoo artists have developed a repertoire of motifs and distinctive styles that also inform the designs on handkerchiefs and envelopes. Handkerchief art or *paño arte*, historically a Latino-American art form, illustrates a wide range of cherished imagery such as biker designs, cartoon figures, and religious and romantic symbolism. Paños and envelopes are in great demand because they take up little space and are easily sent home to loved ones.

Certain individual prison artists have gained recognition for their work in the outside art world's "outsider art" arena. John Harvey made his powerful drawings in a Massachusetts prison, but their roots in his Georgia childhood

are unmistakable. His dynamic oilstick interpretations of scripture are fueled by an unrelenting sexual fury coming up against the teachings of his black southern Baptist upbringing.

Texas prisoner Frank Jones was born with a "veil" over his left eye. According to widespread African American folk belief, this endows the afflicted person with the power to see spirits. During the last six years of his life, while still in prison, Jones rummaged through trashcans for paper and pencils to create more than 500 drawings that he called "Devil Houses." The devilish creatures he called "haints" are entrapped in the architecture of the penitentiary. Some, however, with evil grins burst through the prison walls.

Roger Cardinal writes of two well-known southern prison artists, Henry Ray Clark and Welmon Sharlhorne, as authors of bold calligraphic imagery. Clark was incarcerated in Texas, and Sharlhorne is a former Angola Penitentiary inmate. Sharlhorne gained worldwide attention with works such as *The Lady Kissed the Beast That Turned Back into the Prince*, created with colored inks on manila envelopes.

The author of the book *Dead Man Walking*, Helen Prejean, ministered to death-row inmates in Louisiana state prisons. She wrote that, "stripped of freedom, beautiful surroundings, and supportive community, these convicts draw pictures of what their souls see. They sketch their way past despair. They give us insight into what it means to be a thrown-away-one. Their pictures cry out: I, too, can see, I, too, can create, I, too, am a human being."

PHYLLIS KORNFELD
Stockbridge, Massachusetts

Lynne Adele, *Raw Vision* (Spring 2008); Janet Fleisher Gallery, *Devil Houses: Frank Jones Drawings* (1992); Phyllis Kornfeld, *Cellblock Visions: Prison Art in America* (1997).

Quilting, African American

African American quilters have created their quilts in a variety of styles. Some quilts follow the trends of the dominant culture while others follow an African-derived aesthetic characterized by strips, bright colors, large designs, multiple patterns, asymmetry, and improvisation—all design principles with roots in African textile techniques and cultural traditions. The actual links between African and African American textile traditions occurred from 1650 to 1850 when Africans were brought to the United States from areas that are now Senegal, Mali, Ivory Coast, Ghana, Republic of Benin, Nigeria, Cameroon, the Democratic Republic of Congo, and Angola.

While African American quilts and Euro-American quilts share techniques

and design elements, certain design elements have strong affinities with African textile traditions. Indeed, many African American quilts are profoundly different from European or Anglo-American quilts. The dominance of strips may point to roots in West Africa, where most cloth has been constructed from strips woven on small, portable looms and sewn together to make larger fabrics for clothing or wall hangings and banners. The bold colors and large designs in many African American quilts may derive from the communicative function of African textiles that indicate status, wealth, occupation, and history. The strong contrasting colors characteristic of prestigious African textiles ensure a cloth's readability at a distance. African American quilters often speak of "colors hitting each other right." African American quilts are best seen from a distance, in contrast to other American quilts, which are meant to be inspected in intimate settings.

A preference for asymmetry, often the natural result of joining strips, characterizes many African American quilts. Indeed, skilled quilters pride themselves in asymmetrical, improvisational designs. Improvisation also offers quilters the freedom to meld multiple patterns. In African royal and priestly fabrics, the number and complexity of patterns decorating a fabric increase in accordance with the owner's status. While multiple patterns no longer indicate status, they continue to highlight the quilter's skill. Black quilters often begin a quilt with a traditional Euro-American quilt pattern and then improvise upon it in successive squares. These African American quilt squares often change in size, arrangement, and color. Unpredictable rhythms and tensions are similar to those in the blues, jazz, spoken language, and dance.

Appliqué is another sewing technique known in West Africa and remembered in the Americas. With bold appliqués of figures and symbols, African cultures record court histories, religious values, and biographies. African American appliquéd quilts often tell stories and express ideas in the same manner as the appliquéd banners that record royal Fon history in the Republic of Benin. The most famous African American appliquéd textiles, made by Harriet Powers in 1886 and 1896, show scenes from the Bible, local historic events, and symbols from Christian, Fon, Kongo, and Masonic traditions. From Nigeria, Africans remembered the concept of four eyes—for physical and spiritual, or ancestral, vision. The four-eye motif reappears on quilt tops as four circles. In the quilt that Pecolia Warner calls *Four Eyes of the Stove*, the four eyes are a symbol for protection. Diamonds, in quilt patterns, on graves, or on houses, are also associated with protective ancestral powers and can be traced back to Central African religious beliefs in the four moments of the soul: birth, life, death, and rebirth.

Some African American quilts may continue additional protective charm traditions. In West Africa, religious writing is often enclosed in small, square charms, made from red leather, red cloth, or metal. In the United States, a small red charm, called a mojo, or hand, is often kept in a pocket or worn around the neck to protect someone from disease. Red squares, appearing in African American quilts, may refer to African American protective mojos, the helping hands of the ancestors. In Sara Mary Taylor's *Mermaid* quilt, an appliquéd blue hand touches a small, square red charm, perhaps indicating the artist's knowledge of this charm tradition. Some think that complicated multiple patterns and appliquéd symbols repel evil spirits, who have to read them all before they can do any harm. Similar protection is attributed to the newsprint once pasted on the walls of drafty houses as insulation.

African American quilt making is inextricably linked to the thrift and industry that characterize black culture. It fuses African, Euro-American, and other textile traditions. The persistent aesthetic preferences of African American quilters demonstrate the extraordinary tenacity of African American ideas over hundreds of years in the face of major historical obstacles. This vital aspect of our nation's artistic and cultural heritage must be recognized and celebrated now so it can be promoted and preserved in the future.

MAUDE SOUTHWELL WAHLMAN
University of Missouri at Kansas City

Cuesta Benberry, *Always There: The African-American Presence in American Quilts* (1992); William Ferris, ed., *Afro-American Folk Arts and Crafts* (1983); Gladys-Marie Fry, in *Missing Pieces: Georgia Folk Art, 1770–1976*, ed. Anna Wadsworth (1976), *Stitched from the Soul: Slave Quilts from the Ante-Bellum South* (1990); Melville Herskovits, *Cultural Relativism: Perspectives in Cultural Pluralism* (1972); Zora Neale Hurston, *Journal of American Folklore* (October–December 1931); Eli Leon, *Who'd a Thought It: Improvisation in African American Quiltmaking* (1987), *Accidentally on Purpose: The Aesthetic Management of Irregularities in African Textiles and African-American Quilts* (2007); Carolyn Mazloomi and Faith Ringgold, *Spirits of the Cloth: Contemporary African American Quilts* (1998); Robert Farris Thompson, *Four Moments of the Sun: Kongo Art in Two Worlds* (1981), *Flash of the Spirit: African and Afro-American Art and Philosophy* (1983), *Face of the Gods: Art and Altars of Africa and the African Americas* (1993); John Michael Vlach, *The Afro-American Tradition in Decorative Arts* (1978); Maude Southwell Wahlman, *Signs and Symbols: African Images in African American Quilts* (2001), in *Self-Taught Art in America*, ed. Charles Russell (2001).

Quilts, General

For more than 200 years, patchwork quilts have functioned as potent symbols of American identity. Romantic images of frontier women sitting at the fireside to craft warm bedcovers from bits of fabric and images of quilting bees evoke the cooperative spirit of the democratic ideal. Such values as resourcefulness, frugality, self-reliance, and cooperation are so deeply ingrained that, even in the 21st century, Americans hold strong beliefs about quilts that are not always supported by fact. Moreover, such nationalistic views ignore regional meanings, functions, and values, and overlook the complex stories that quilts tell, stories that bring together many strands of southern life.

A quilt is usually defined as a bedcover made from two or three layers of textiles. A quilt may be "whole cloth" (made from whole lengths of fabric) or "patchwork," a term that includes both piecing (sewing small fabric pieces directly to one another) and "appliqué" (sewing fabric pieces onto a larger background). "Quilting" refers both specifically to the stitches that hold the layers of the quilt together and, more generally, to the entire process of making a quilt. Although patchwork and quilting are both ancient processes, the patchwork quilt as we know it developed in the late 18th century.

Early European colonists in the American South used a variety of bedding textiles. Inexpensive woolen blankets imported from English factories supplied the general need for practical bedcovers, supplemented to a small degree by locally woven blankets and, in frontier areas, animal pelts. In prosperous settlements surrounding seaports, the families of wealthy landowners and merchants relied heavily on imported trade goods from Europe and Asia. During the 18th century, these textile imports included fine, hand-quilted, whole cloth bedcovers made from a variety of printed, plain, or textured fabrics of silk, cotton, or wool. By the 1770s, the movement toward independence encouraged local textile production as a means to reduce the colonies' dependence on British goods. Although efforts to establish textile factories in southern states were short-lived, some plantation households established their own spinning and weaving operations to supply clothing and bedding for their slaves.

During the federal period (1790–1830), many ambitious and especially skilled southern women embraced the fashion for all-white quilts and embroideries known as white work. A thriving cotton industry had made white thread and white whole cloth fabric widely available; and the color white complemented the neoclassical designs deemed appropriate for a new nation. Meticulously stitched and often further elaborated with stuffing and cording, white work quilts functioned as proud assertions of both American home industry

and the virtues of "republican womanhood," which included purity, domesticity, and humility. Favorite designs included trees of life, floral arrangements and designs, and neoclassical patriotic symbols such as the eagle that adorned the Great Seal of the United States, adopted in 1790. Some southern women also stitched white work quilts with local references; Virginia Ivey's 1856–57 quilt is a detailed rendering of the fairground near Russellville, Ky. Like many others, this quilt, now in the collection of the Smithsonian National Museum of American History, was not made for warmth but for show.

For the next two centuries, American quilt making continued to be associated with patriotism, home industry, self-sufficiency, and idealized womanhood, even as the appearance of quilts changed. During the early 19th century, well-to-do southern women, along with their European and northern cousins, also made patchwork quilts, using imported cotton fabrics printed with large floral and representational motifs. With fine fabrics and fine stitching, these quilts demonstrated both the needlework proficiency of their makers and the wealth of their fashionable families. The majority of the surviving quilts of this style belonged to coastal families or to prominent families in inland settlements. Oral family traditions sometimes identify certain of these surviving antebellum quilts as the work of enslaved — usually unnamed — African Americans; indeed, such skilled seamstresses were among the most highly valued slaves.

By the 1840s, a new style of patchwork quilting, first developed in the Delaware River valley, near Philadelphia, had spread rapidly throughout the country. The new patterns were typically complex floral designs, constructed in red and green fabrics. Quilters used both fabrics dyed in a single color and small-figured prints. Southern quilt makers acquired patterns by tracing them from finished quilts or by drawing designs from memory or imagination. Over time, some patterns, including Rising Sun (later called Star of Bethlehem), Irish Chain, Caesar's Crown, and various rose motifs, became known widely throughout the south. Although innovations in textile manufacturing resulted in wider availability, a variety of printed fabrics, and lower prices for cotton fabrics — woven in northern mills from southern cotton — quilt making remained an activity practiced by upper- and upper-middle-class women.

During the Civil War, southern women formed service groups to provide clothing, bedding, and other supplies for Confederate soldiers. They collected donations of materials and, in some locations, auctioned quilts to raise money for the war effort. Caught up in the fervor of the cause, some women donated fine family quilts in addition to more practical blankets. The Union blockade resulted in shortages of consumer products, and some women brought old looms out of storage to weave blankets and fabric for the soldiers, for home use, or for

sale. According to stories passed down in families, quilts were among the treasured possessions hidden from Union looters.

After the war ended, fabrics manufactured in New England textile mills from southern-grown cotton were once again available to southern quilt makers, joining imported textiles on the shelves of general stores and in the packs of peddlers serving rural settlements throughout the south. The availability of inexpensive domestic fabric allowed middle-class women to take up quilt making to showcase their skills and taste, in imitation of their wealthy neighbors. Typical quilts from the 1870s and 1880s were carefully constructed from purchased fabrics, and the thicker battings of these quilts indicate that they were made with the potential for practical use as well as for personal satisfaction. Between 1880 and 1900, southern quilt makers also participated in an international pastime of making crazy quilts, sewing small silk remnants in irregular arrangements and embellishing the surface with elaborate embroidery. As fashionable women lost interest in making elaborate crazy quilts from satins and velvets, rural women, both black and white, adopted the style, using remnants from wool and cotton clothing, simplifying the embroidery, and personalizing their work with embroidered names.

Continuing development of the southern textile industry at the end of the 19th century provided an extraordinary range of inexpensive fabrics. For the first time, even women of very modest means could afford to make quilts. The use of sewing remnants and factory mill ends, relatively simple patchwork patterns, heavy cotton battings, and large quilting stitches characterize these surviving utility quilts. Importantly, many quilts of this period demonstrate the wide availability of sewing machines. The sewing machine, patented by Elias Howe in 1846 and popularized by the Singer Sewing Machine Company among others, was often the first appliance that aspiring households acquired. Although special long-arm sewing machines that could stitch through three layers of cloth had appeared in 1871, home seamstresses created patchwork, appliquéd, and topstitched quilts with simple straight-stitch machines. While some quilters dismiss machine-made quilts as inferior to hand-stitched ones, many masterpieces, among them, Harriet Power's Bible quilts, contain machine piecing and stitching.

By 1900, middle-class southern families could order factory-made, relatively inexpensive, washable bedspreads from mail-order catalogs. Quilts were seen as old-fashioned and associated with rural poverty and lack of hygiene. During the 1910s, however, middle-class, urban American women participated in a quilt making revival sparked by the colonial revival movement in architecture and home decorating and fueled by articles in women's magazines that in-

correctly presented patchwork quilts as products of the colonial period. These revivalists purchased stylish fabrics and mail-order patterns or kits for their new hobby. The association of quilts with poverty initially inhibited middle-class southern women from embracing the new quilt styles, but by the 1930s southern quilts incorporated the pastel hues and popular patterns associated with the colonial revival. The most popular new patterns of this era included Double Wedding Ring, Dresden Plate, Dutch Doll, and Grandmother's Flower Garden. At the same time, rural southern women, both black and white, continued to make quilts from inexpensive fabrics in geometric patterns, such as Hole in the Barn Door (also called Churn Dash or Double Monkey Wrench), Bow-Tie, Nine-Patch, and Eight-Pointed Stars.

The economic conditions leading up to the Great Depression intensified the divergence of southern quilt making traditions. Middle-class southern women took comfort in making quilts, as they believed their frugal and resourceful ancestors had done. While they typically purchased new fabric and selected new patterns, they often chose to sew their patchwork by hand. Women in struggling families made utility quilts, constructed simply and quickly from inexpensive or salvaged fabric and sewing remnants. Some women contributed to their families' physical and economic security by making quilts to sell or quilting for hire. Regardless of a family's economic position, quilt making served the personal and emotional needs of Depression-era women.

During World War II and the two decades following, quilt making largely disappeared from the popular imagination. Nonetheless, individual women, including southerners, continued to make quilts, motivated by varying degrees of economic need and desire for personal expression. During the late 1960s and 1970s, quilt making experienced another revival, this time associated with the counterculture's back-to-the-land movement, the American Bicentennial celebration in 1976, and the women's movement's celebration of quilts as emblems of women's art. This revival has continued into the 21st century, maturing into an international subculture that has taken root in Western Europe, Japan, Australia, and elsewhere.

Quilts remain dynamic cultural and individual expressions. Some women make the self-conscious decision to create innovative and individualized works of fabric art. The association of quilts with ordinary women's needlework, however, tends to limit the acceptance of quilts as art by some museums and collectors. In contrast, numerous collectors value quilts as folk art; they look for quilts they perceive as the authentic expression of a premodern aesthetic. During the 1970s, collectors popularized quilts made in Amish communities in Pennsylvania and the Midwest. Quilts made by rural, southern African

American women, long assumed to be poor imitations of mainstream traditions, were discovered by art historians in the 1980s, who theorized that their irregular designs, bright color combinations, and loose technique were derived from African aesthetic traditions.

A series of exhibitions and books during the late 20th century brought public attention to those African American quilts that conformed to a perceived African aesthetic. In the 1990s, a traveling exhibition, *The Quilts of Gee's Bend*, promoted such quilts as a unique folk art tradition resulting from poverty and isolation within a single community, ignoring similar quilts made throughout the South. These exhibitions also ignore or dismiss the large number of quilts made by African American women that do not conform to the perceived authentic aesthetic. Issues of authenticity, African influences, and marketing continue to spark debate among scholars, museum professionals, and collectors; today quilt makers themselves take part in these debates. A controversy involving African American quilts resulted from the 1999 publication of *Hidden in Plain View*, a heavily promoted book suggesting that slaves used quilt patterns as a code to communicate escape plans. Textile experts, historians, and numerous responsible scholars have clearly documented that the quilt-code theory is historically impossible, yet the story proved so appealing that it quickly became immensely popular. Seeking a positive way to address the difficult issue of slavery, teachers readily incorporated the story into their curricula. Belief in the quilt-code legend has become firmly ingrained in the popular imagination. Attempts to present the actual, more complex, and fascinating history of slaves and quilts are largely ineffective.

While the majority of quilts, historic and contemporary, represent the work of an individual maker, Americans continue to cherish the romantic image of the old-fashioned quilting bee. Quilting was one of a number of communal work traditions in the early 19th century, sometimes as an adjunct to house raising, corn shucking, or other activities that combined work and a festive meal. However, most shared quilting involved close friends and family members. By the 20th century, group quilting centered primarily on the fundraising efforts of religious groups. During the quilt revival of the 1970s, many quilters gathered around a quilting frame as a way to connect with the experience of an earlier generation of women. In the early 21st century, quilting groups connected with religious or social institutions continue to raise money by quilting for others. Mennonite quilt auctions are highly successful in raising money for charitable causes.

In 1982 the Kentucky Quilt Project published the results of the first statewide quilt survey. This important pioneering effort launched similar projects

in other states and other countries. The books and exhibitions resulting from quilt projects in most of the southern states have demonstrated the number and variety of the region's quilt making traditions, while offering a wealth of material for further study. While southern quilt makers have shared the same general fashions and trends as the rest of the country, they have also maintained a variety of local traditions, regional patterns and pattern names, geographic color preferences, ethnic influences, and individual innovations, all of which enrich the region's beds, clotheslines, gift shops, and gallery walls.

LAUREL HORTON
Kalmia Research

American Quilt Study Group, *Uncoverings* (1980–); Cuesta Benberry, *Always There: The African-American Presence in American Quilts* (1992); Karoline Bresenhan and Nancy Puentes, *Lone Stars: A Legacy of Texas Quilts, 1836–1936* (1986); Nancy Callahan, *The Freedom Quilting Bee: Folk Art and the Civil Rights Movement in Alabama* (1987, 2005); Roland Freeman, *A Communion of the Spirits: African-American Quilters, Preservers, and Their Stories* (1996); Gladys-Marie Fry, *Stitched from the Soul: Slave Quilts from the Antebellum South* (2002); Laurel Horton, *Mary Black's Family Quilts: Memory and Meaning in Everyday Life* (2005), ed., *Quiltmaking in America: Beyond the Myths* (1994); Laurel Horton and Lynn Robertson Myers, eds., *Social Fabric: South Carolina's Traditional Quilts* (1985); Mary Elizabeth Johnson, *Mississippi Quilts* (2001); Kentucky Quilt Project, *Kentucky Quilts, 1800–1900* (1982); Bets Ramsey and Merikay Waldvogel, *The Quilts of Tennessee: Images of Domestic Life Prior to 1930* (1986); Bets Ramsey and Merikay Waldvogel, *Southern Quilts: Surviving Relics of the Civil War* (1998); Ruth Roberson, *North Carolina Quilts* (1988); Jacqueline Tobin and Raymond Dobard, *Hidden in Plain View: A Secret Story of Quilts and the Underground Railroad* (1999); Patricia A. Turner, *Crafted Lives: Stories and Studies of African American Quilters* (2009); Fawn Valentine, *West Virginia Quilts and Quiltmakers: Echoes from the Hills* (2000); Virginia Consortium of Quilters, *Quilts of Virginia, 1607–1899: The Birth of America through the Eye of a Needle* (2006); Maude Southwell Wahlman, *Signs and Symbols: African Images in African American Quilts* (1993); Anita Weinraub, ed., *Georgia Quilts: Piecing Together a History* (2006); Charlotte Williams, *Florida Quilts* (1992).

Quilts and Embroidery, 20th Century

Although needlework historians continue to search for regional traditions and local idiosyncrasies in quilt and embroidery designs, the similarity of the bedcovers included in the many state surveys that have been conducted in the past 35 years (beginning with *Kentucky Quilts, 1800–1900*, published in 1982 by the

Kentucky Quilt Project) demonstrates how successful American women were in circulating their favorite patterns. Styles, fads, and fabrics specific to a particular area have, of course, been documented; the album quilts of 1850s Baltimore and the "string" quilts made by African American women throughout the South are well-known examples. By the turn of the 20th century, however, the plethora of commercial enterprises, including ladies' magazines and pattern companies, was responsible for the remarkably homogeneous quality in the design and construction of a large number of American quilts and embroidery projects, including those made in the southern states.

The publication of needlework patterns in this country dates back to the second quarter of the 19th century. In 1835 *Godey's Lady's Book* began printing designs for patchwork, a practice that was soon followed by other periodicals. Many of the popular magazines even hired needlework editors (often from England) specifically to find designs that would appeal to their women readers.

The first business to sell quilt designs by mail order, the Ladies' Art Company, was founded in St. Louis in 1889 and continued to supply quilt makers with a wide range of patterns until the 1970s. By the 1920s the Ladies' Art Company had many competitors providing a wide range of services for quilt makers, including printed patterns, stamped quilt tops, complete kits, and even finished quilts. Most of these companies advertised in publications ranging from local newspapers, such as the *Chatham County Record* (North Carolina), to large national magazines, including *Hearth and Home, Needlecraft*, and *McCall's*. Some also sold their designs through syndicated columns that were printed in newspapers around the country, often marketing their designs by inventing fictional "grandmas" or "aunts" to assure their clientele that their patterns were authentically "colonial." In actuality, however, the designs were frequently recycled with new names and sometimes proved as authentic as the pseudonymous aunts and grandmas.

Perhaps the greatest impetus to the revival of interest in American needlework that took place in the first half of the 20th century was the contribution of a talented group of women who provided original designs to a public that was fascinated with the handiwork of the American past, yet eager to have their homes appear up to date. Some of these women were professional designers, although not necessarily quilt makers, who had already succeeded in other areas and who turned their skills to quilts and other home furnishing projects because of the great demand for original patterns. Others were gifted amateurs who began creating their own designs because of their dissatisfaction with the patterns of the past.

One of the most successful of these women (and possibly the most influential among the southern states) was Anne Champe Orr (1875–1946) of

Nashville, Tenn. Orr began her career in 1913 as the needlework columnist for *Southern Woman's Magazine*. At first, her articles included a variety of cross-stitch embroidery designs as well as tatting, filet crochet, and knitting patterns. By the time *Southern Woman's Magazine* ceased publication in 1918, Orr was a well-known needlework designer, and her patterns were sold worldwide.

Orr began writing for *Good Housekeeping* magazine in 1919 and published her first "patchwork" pattern, a bedspread and bureau scarf in a "Mother Goose and Goslings" design, in 1921. Over the years, Orr printed 68 patterns for full-size quilts—including whole cloth, appliqué, and pieced designs—in *Good Housekeeping*. Some of the bedcovers were updated traditional designs, but Orr is best remembered today for her pieced quilt patterns made of one-inch squares of color that look like cross-stitch designs.

Anne Orr was not a needleworker herself, but she was a prolific designer and successful businesswoman. Beginning in 1917 she gathered about her a group of Nashville women she called her "needlework cabinet" to carry out her designs and make sure they were simple enough for her readers. She also employed professional quilters in Kentucky to make the finished quilts she sold through her mail-order business, the Anne Orr Studio. This company marketed her needlework designs, quilt kits, prestamped fabric and basted tops, iron-on transfers, and pattern books. By 1932 Orr was so well known as a quilt designer that she was asked to judge the first national quilt contest at Storrowtown Village in Springfield, Mass., a task she repeated for the Sears, Roebuck Quilt Contest that was part of the Chicago World's Fair of 1933.

The Sears National Quilt Contest, announced in Sears's January 1933 sales catalogs, played a major role in the revival of interest in quilt making in the 20th century, as well as the dissemination of patterns for prize-winning quilts. The $7,500 in prizes offered by Sears undoubtedly led to the record number of entries in the contest—nearly 25,000 quilts competed in a series of heats, beginning at the local store level and progressing through regional competitions. The top 30 quilts were selected for exhibition at the fair, where the grand prize-winner was to be awarded $1,000. A bonus of $200 was offered if the winning quilt was a design commemorating the "Century of Progress" theme of the fair. While this extra incentive inspired many quilt makers to explore the topics of technological change and American history, the judges gave the grand prize to a traditional eight-point feathered star quilt, submitted by Margaret Rogers Caden of Lexington, Ky. Soon after the fair, commercial sources marketed patterns and kits of the prizewinning design.

In recent years, however, it has been discovered that Margaret Rogers Caden, the woman honored as the maker of the quilt, was not the actual seamstress.

Instead, Miss Caden, one of the owners of the A. M. Caden Gift Shop, orchestrated the work of several women, members of a cottage industry of needleworkers who frequently sewed for hire for the shop: one woman sewed the patchwork top, a second did the quilting, and a third stuffed the applique leaves in the plain blocks and borders. Margaret Caden chose the design, signed the contest entry form, and shipped the quilt to Sears.

Caden's was just one of many such cottage industries in the South that were renowned throughout the country for their needlework products. Successful businesses, spurred by the national interest in the colonial revival style of decorating and a newfound appreciation of old-fashioned American handicrafts, also flourished in the southern highlands, Appalachia, and West Virginia. The sewing prowess of the Bluegrass State, however, became so legendary that even firms located in other parts of the country proudly advertised that their quilts were handmade by the women of Kentucky.

In the second half of the 20th century many needleworkers continued to rely on commercial firms and periodicals for their patterns. An entire industry of magazines devoted specifically to quilters' interests and needs has emerged in the past 40 years (as well as a significant number dedicated to embroidery), and a click of a mouse will deliver designs directly to a desktop in seconds (www .freequiltpatterns.info promises links to 1,073 different websites that offer free patterns). But some needleworkers have also traveled in other directions for inspiration; no longer looking to the past, they have preferred to experiment with new materials and new methods for turning fabric and thread into fiber art. And as communication modes increase in number and speed, regional variations among fabric artists will continue to decrease.

ELIZABETH V. WARREN
American Folk Art Museum

Barbara Brackman, *Clues in the Calico: A Guide to Identifying and Dating Antique Quilts* (1989); Merikay Waldvogel, *Soft Covers for Hard Times: Quiltmaking and the Great Depression* (1990); Merikay Waldvogel and Barbara Brackman, *Patchwork Souvenirs of the 1933 World's Fair* (1994); Elizabeth V. Warren, *Quilts: Masterpieces from the American Folk Art Museum* (2010); Elizabeth V. Warren and Sharon L. Eisenstat, *Glorious American Quilts: The Quilt Collection of the Museum of American Folk Art* (1996).

Religious Ephemera

Folk artists in the American South have lived in a society that produced massive amounts of religious ephemera, and those material items have contributed

general stylistic elements and specific iconic detail to their works. Evangelical Protestantism, the religious tradition that has dominated the South since the early 19th century, is a faith that stresses a dynamic of sin and salvation and values religious experience. Believers work to convert others, with the resulting tendency to witness for the faith, to testify, and to proselytize; they encourage the production of religious signs, placards, leaflets, brochures, and other forms used to spread the gospel word.

Religious denominations and interdenominational tract societies produced countless items of text, often illustrated with succinct devotional imagery, whether the burning flames of hell or the doves, angels, and clouds of heaven. Paperback songbooks began appearing in the 1870s, and by 1912 one company alone, the Vaughan Publishing Company in Lawrenceburg, Tenn., was selling 85,000 books a year, with cover art that depicted nostalgic scenes of country revivals, the bright sunrises of heavenly new beginnings, and domestic images of holiness. These popular images became a part of the South's visual culture.

Southern Protestants inherited traditional Protestant suspicions of graven images, but this sentiment did not prevent appreciation of sacred images and artifacts in homes, businesses, and other spaces. Women embroidered biblical scenes, and in the late 19th century lithography and chromolithography resulted in mass-produced engraved prints. Photomechanical processes in the 20th century made inexpensive reproductions of sacred paintings easily available. Printers took popular paintings and reproduced them, or details from them, to sell to religious magazines and companies marketing devotional goods. The close-up portrayals of Christ's head in Heinrich Hoffmann's *Christ and the Rich Young Ruler* (1889) and *Christ in the Temple* (1882) were placed on book covers, plaques, bookends, thermometers, and everyday goods. Warner Press began selling Warner Sallman's *Head of Christ* in 1941, and it became a defining popular image of Jesus for decades in the South. Among the most reproduced items were paintings of a winged guardian angel leading children across a bridge or hovering lovingly over a crib.

Southern homes and businesses have been awash with mottoes displaying religious sentiments, with accompanying devotional imagery. The display of religious words in a popular artistic portrayal has reflected a southern religious aesthetic and been a particularly important source for folk artists. Women in the late 19th century embroidered pious sayings on perforated cardboard, a medium that encouraged modest, clean designs. Aniline dyes made the mottoes more colorful than the original embroidered samplers. These mottoes had special meaning when hung in homes, claiming domestic space as Christian, an environment in which many of the folk artists grew up. These mottoes could

project a generalized proverbial wisdom or be adapted to specific religious traditions in the South, as in such Pentecostal mottoes as "Is Any Afflicted? Let Him Pray," which reflected that tradition's belief in faith healing, or "Without Holiness No Man Shall See the Lord," which evoked Pentecostal belief in a second blessing of grace leading to sanctification. By the early 20th century, mottoes became less sectarian and more simply consoling, with such popular sayings as "Prayer Changes Things," "Jesus Never Fails," and "Abide in Me." The cardboard mottoes were small, but they typically included sacred images on their borders. The Gospel Trumpet company blanketed the South and Midwest with these iconic cardboard mottoes.

Roadside signs convey a straightforward message of the need for salvation, one that folk artists passed often in walking and driving through the southern landscape. Hand-printed leaflets may well have announced the earliest revivals to frontier people. We know that such signs advertised 20th-century revivals in the South. Photographer Margaret Bourke-White captured a sign that said "The Day of Salvation Is at Hand" in rural Georgia in the 1930s. Such signs have long reminded southerners of God's omnipotence and Jesus's open arms. "Jesus Saves," "Get Right with God," and "Prepare to Meet thy God" are typical sentiments on signs. They were usually rough and hand-lettered, as one seen in rural North Carolina in the 1980s: "He Loved You So Much It Hurt" was next to the depiction of a hand with a nail through it and red blood spurting out of it. The symbolism of such a sign nailed to a tree symbolically evoked Christ's suffering in the Crucifixion. More recently, signs are professionally printed and painted, but the messages remain the same, with the cross; with images from Christ's nativity, death, and resurrection; and with Bible quotes all commonly depicted. Such sentiments are portrayed on billboards, on permanent or portable signs in front of churches, and as moveable signs in the form of bumper stickers on cars.

Church fans were once one of the most common forms of religious ephemera, a welcome way to fight the stifling heat of southern churches. Palm fans were the original fans, but in the early 20th century printers began producing inexpensive cardboard fans on wood handles for businesses to purchase and distribute with information on the back. Funeral homes and insurance companies most typically used the fans to get their messages out to congregants hoping of the rewards of an afterlife that would surely be cooler than hot southern Sunday mornings. The front of the fans had religious images, often reproducing popular religious prints. Warner Sallman's *Christ at Heart's Door* (1942) and *The Lord Is My Shepherd* (1943) were two of the most reproduced images, as were prints of Christ praying in the Garden of Gethsemane and at the Last

Supper. This tradition was a biracial one, with printers producing fans with images of black children, black families, the black Jesus, and later depictions of Dr. Martin Luther King Jr., portrayed as a single figure, with his parents, with Coretta Scott King, or with John and Robert Kennedy.

Southern self-taught artists portray biblical scenes that draw from popular religious imagery and also from the pronounced orientation of southern popular religion toward the Word. Kentucky artist Edgar Tolson made hundreds of wooden sculptures portraying Adam and Eve, Mississippian Theora Hamblett painted the Old Testament figure of Daniel, and others portray Creation, Noah's Ark, and scenes from Christ's life using variations on popular prints. Johnnie Swearingen's *Sunday Camp Meeting* evokes the images of revivals that are found on the old-time paperback songbooks. R. A. Miller's *Lord Love You*, most often painted on tin, reflects the simplicity of the older cardboard mottoes, as do such Benjamin Perkins's paintings as *Jesus Is the Light of the World* and *May We All Let Jesus Come into Our Hearts*. Few artists matched Howard Finster for combining the bright colors favored in popular religious ephemera with the extensive use of words on paintings. A photo shows Finster preaching from his car in the late 1940s, a car with the following motto painted on its front door: "The Wages of Sin Is Death. Don't Put God Off." Finster did not draw from the domestic sentimentality of the cardboard mottoes but often preached warnings of apocalypse and doom, with verses from the book of Revelation common. Finster's *Paradise Garden* environment, though, was filled with both warnings and comforting sayings. One sign read "LAST DAY PERLIOUS TIMES SHALL COME," while another quoted Revelation 21:6: "I Will Give Unto Him That Is Athirst of the Foundations of Water of Life Freely." Finster drew from the South's fondness for angels in his series of angel paintings. "*I Am the Angel Flying Low*" (1984), Finster's painted angel on a plywood cutout, carries a sign that reads "I AM THE ANGEL FLYING LOW TO TELL YOU THAT THE BIBLE IS SO. ONLY BELIEVE IN IT AND BE READY TO GO, FOR YOUR LAST DAY YOU NEVER KNOW AND REMEMBER I TOLD YOU SO. BY HOWARD FINSTER." This work calls to mind messages found on numerous roadside signs.

Clementine Hunter's paintings express her singular religious experience. Hunter, a member of a community of Creoles of color in Natchitoches Parish, La., was a lifelong member of St. Augustine's Catholic Church. She also attended St. Matthew's Baptist Church, where she enjoyed singing the Bible-based songs of the African American church. Her paintings draw upon her participation in both Catholic and Protestant worship services. Cheryl Rivers argues that "a specifically Catholic visual culture is the most important source

for Hunter's idiosyncratic aesthetic preferences, particularly her economy of detail and plain ground rendered in startling color." Catholics in the South, as elsewhere, used holy cards, inexpensive religious prints, as devotional artifacts, and these items influenced Hunter's compositional designs and color schemes. The cards include a wide variety of religious images such as the Flight into Egypt, the Nativity, the Crucifixion, and Catholic saints. The cards with grounds of "supernatural pinks and heavenly blues" enclose these sacred figures within symmetrically balanced compositions. Hunter produced thousands of paintings that capture the vibrancy of religious life in her community, using the aesthetics of popular Catholic art to do so. Her paintings of nuns and the Mass convey a particular Catholic spirituality, while other paintings capture the details of Protestant experience, such as revivals, water baptisms, and wakes. Hunter painted more than a hundred black crucifixions that depict a dark-skinned Jesus suffering on the cross. Her *Cotton Field Crucifixion* is particularly compelling as it relates the Crucifixion to black suffering in the American South. Her *Crucifixion with Red Zinnias* (1965) suggests a knowledge of Mexican prints that display a localized black Jesus. Church fans portrayed a black Christ as early as the 1930s, and Hunter likely drew from those prints as well. Other African American artists have painted the black Christ, including Bill Traylor, Mose Tolliver, Elijah Pierce, Mary T. Smith, and William Hawkins.

Popular Catholic spirituality includes home altars, candles, yard shrines, pilgrimage badges, medals honoring saints, and dashboard saints. These are especially popular among Italian and Latino Catholics, and the dramatic growth of the latter in the last 10 years has made these forms of devotion more common in the southern public and private landscape and will surely affect the future religious folk art of the South.

CHARLES REAGAN WILSON
University of Mississippi

Carol Crown, ed., *Coming Home! Self-Taught Artists, the Bible, and the American South* (2004); Colleen McDannell, *Material Christianity: Religion and Popular Culture in America* (1995); David Morgan, *Visual Piety: A History and Theory of Popular Religious Images* (1998); Cheryl Rivers, in *Sacred and Profane in Southern Self-Taught Art*, ed. Carol Crown and Charles Russell (2007).

Roadside Art

Whether claiming to be the biggest, the strangest, or simply one of a kind, roadside attractions aim to entice. Any kind of feature along the side of a road can

be considered a roadside attraction, but roadside art differs from purely commercial endeavors. Most often with nothing to sell, the creators of roadside art make audiences out of passersby.

In the 1930s, long-distance road travel — seeing America — spiked in popularity. Catering to a rising demand, motels, coffee shops, and all manner of businesses sprouted up along the way. Not destinations unto themselves so much as a break between here and there, shops of all kinds increasingly vied for attention. Novelty and programmatic architecture — buildings given the form of animals, household items, or people; giant sculptures such as Paul Bunyan and Babe his Blue Ox or the World's Largest Gopher; unique geological sites or spectacular vistas; and monuments to obscure people and events — became part of the apparatus of grabbing attention and, along with it, the consumer dollar. In the 1950s the building of the United States Interstate Highway System facilitated high-speed travel across the country, and many roadside attractions could no longer stay in business.

While some roadside art is rooted in the entrepreneurial spirit, many roadside artists are motivated to share personal visions with anyone who might happen by. Honing in on personal goals that are as varied as the individuals involved, roadside art ranges from visual evangelism such as Howard Finster's *Paradise Garden* to celebrations of secular life, American popular culture, immigrant success, and local history. Some works of roadside art may have been undertaken initially as an aid to a roadside business, such as Cal and Ruby Black's *Possum Trot* in Yermo, Calif., in the Mojave Desert. In 1953 when California State Highway 15 was constructed along their remote piece of land, the Blacks, rural southerners who had gone to California with dreams of success, opened a rock shop, hoping to earn some income. Not a big attraction on its own, the rock shop increasingly borrowed on the concept of "roadside attraction" to lure customers in. Cal Black began to fabricate a variety of wind-powered carousels and carnival or circus-style amusements, populated with brightly painted wooden dolls elaborately dressed in clothes made or co-opted by Ruby. Cal Black's community of dolls eventually encompassed the Birdcage Theatre, wherein Cal used his mechanical abilities and his own voice to put on the *Fantasy Doll Show* until his death in 1973. As is true for many roadside artists the project became a fulfilling life's work. Many museums, including the Smithsonian American Art Museum and the American Folk Art Museum, have added figures from the environment to their collections.

LESLIE UMBEGRER
Smithsonian American Art Museum

Stacy C. Hollander and Brooke Davis Anderson, *American Anthem* (2001); Tom Patterson, *Contemporary Folk Art* (2001); Leslie Umberger, *Sublime Spaces and Visionary Worlds: Built Environments of Vernacular Artists* (2007).

Rugs, Handsewn and Hooked

Collections of 18th- and 19th-century hand-sewn bed and table rugs contain few southern examples, and the history of early southern bed and table rugs is best documented in wills and inventories from North Carolina, Virginia, and Maryland. It is often unclear in the documentation whether the rugs were made in England or America, as Lord Baltimore and other promoters of American settlement encouraged the new colonizers to bring their bed furnishings with them. Whether American or imported, these labor-intensive rugs and cover-ings—yarn-sewn, shirred, or embroidered—were highly prized by owners and often passed down through families. Owners were certainly conscious of the value of 18th- and early 19th-century textiles; since there was little commercial textile production in America during this time, rug makers and their families raised and sheared sheep, dyed and spun the wool, and then painstakingly cre-ated their coverings on handwoven foundation cloths.

A rare pictorial hand-sewn large bed rug (ca. 1825) in the Henry Francis du Pont Winterthur Museum, Garden, and Library is a spectacular shirred, yarn-sewn, and embroidered example on linen. With a fringed border, this rug features a center medallion comprised of colorful shirred spirals surrounding a central spiral and corner areas filled with multicolored spirals surrounded by shirred stars. Adding to the rug's liveliness are embroidered animals, a few defying naturalistic convention, as they break out of their proscribed borders with improvisatory freedom. Another rare bedcovering is in the collection of the John Marshall House, Richmond, Va. Made between 1770 and 1820, this piece was worked with embroidered wool knots on a natural unbleached wool ground. A bold leaflike border frames two central flowering boughs. A bed rug with a Wytheville, Va., provenance is housed in the Museum of Early Southern Decorative Arts. The rug, on a linen twill weave foundation, is initialed "E.G." and bears a partial date in a corner that suggests 1825 as the date the rug was made. The geometric design is executed with turkey work knots.

After the first quarter of the 19th century, importation of jute led to the pro-duction of burlap, an inexpensive foundation cloth for rugs. With this develop-ment, the hooked rug became the predominant rug form, and rugs moved from beds and tables to the floor. In the 1840s the Shaker community in Pleasant Hill, Ky., hooked, shirred, and sewed rugs for community use. Although knitted and crocheted rugs were common among Shakers in the Northeast, the Kentucky

Shakers preferred hooked and shirred rugs for both warmth and aesthetics. The community also produced "dollar" mats, or scaled rugs consisting of repeated cutout circular forms individually folded or clustered and sewn to a ground fabric of linen, cotton, or burlap. Balance, symmetry, and order characterize the geometric arrangement of circles, rectangles, scallops, and occasional pictorial subjects of Shaker rugs. A few rugs feature a central pictorial element. Two hooked examples feature a central horse motif, not surprising in a state in which horse breeding is a predominant interest. These unsigned, undated rugs often have multiple braided borders.

At the turn of the century, the craft revival movement and a concomitant home fashion trend known as the colonial revival renewed interest in handmade rugs. Cottage industries proliferated all the way from Labrador through the Northeast and southward. Rugs, furniture, toys, baskets, and quilts lent important economic support to rural communities. Frances Louisa Goodrich, who founded the Allanstand Cottage Industries, summarized the multiple aims of the crafts revival, saying that she wished "to bring money to women working in homes and communities too far from the market, to give these women the pleasure of producing beautiful things, and to save the old time crafts from extinction." In shelter and antiques magazines, such as *The Magazine Antiques* and *House Beautiful*, decorators and antiques dealers promoted furnishings incorporating American handmade crafts. Thus, crafts revival organizations found an eager market for braided, hooked, and woven rugs.

Crafts organizations distributed supplies and patterns to rug makers who worked in small groups and to artisans who did piecework. They also opened shops, supplied department stores, and established mail-order businesses. Numerous organizations participated in the revival of rug making. While rugs were a small part of Allanstand's production, rug hooking was an important department in Rosemont Industries, Marion, Va., organized by Laura Lu Scherer Copenhaver in 1918. As director of the Virginia Farm Bureau Federation, Copenhaver was instrumental in developing southwestern Virginia's agricultural economy, and she also organized textile production for women in her home. She hired women to produce coverlets and then expanded the offerings to include a variety of rugs, bed canopies, fringes, and other household articles woven, knitted, or crocheted by hand and, some, by machine. The company issued catalogs and marketed its products in the United States, Asia, Europe, and South America.

The Crossnore School, in Avery County, N.C., founded by Mary Martin Sloop in 1911, created a vocational program for disadvantaged youth. The school promoted handloom weaving and rag rug making. In 1935 the school

constructed a weaving room and invited local women to weave rugs and coverlets, which the school marketed. At the Pine Burr Studio, founded in Apison, Tenn., in 1921, Mrs. F. D. Huckabee trained mountain women to make cotton and wool hooked rugs. This group both designed its own rugs and purchased commercial designs. It also executed table rugs and runners from recycled silk stockings. The Blue Ridge Weavers, in Tryon, N.C., organized by Mr. and Mrs. George Cathay in 1922, sold weavings, quilts, and hooked rugs made by more than 100 mountain women. In 1931 the Forest Community Foundation extended activities of the Shenandoah Community Workers, founded to support women's work in 1927. The foundation constructed a furniture factory that employed men and sold both handicrafts and fine furniture through mail order. In November 1933, *Needlecraft Magazine* featured the Shenandoah Community Workers and published a photograph of an unidentified female worker hooking a *Simple Simon* rug design with a punch needle. The Madison Rug Shop in Mars Hill, N.C., was another rug factory that offered employment to scores of women and some men during a period of economic hardship. Between 1940 and 1942 Jacob Ranklin "Jake" Bruckner and his family supervised all aspects of rug making from acquiring materials from textile and hosiery mills, to dyeing, preparing patterns, setting up frames, hooking, hemming, clipping, pressing, and hauling finished rugs for distribution. Many of the rugs were roughly 2 by 3 feet, but some were as large as 12 by 18 feet. When the factory closed as a result of foreign competition and government regulation of wages and hours, rug hookers continued production at home and took their finished rugs to the Treasure Chest, a cooperative, and to Floor Coverings, Inc., in Asheville. Eventually, hundreds of families were involved in rug making in Madison County. Although aesthetic satisfaction may have been a motivator for some, the primary impetus was economic. Other groups similarly organized to help raise the standard of living while at the same time bring pride to local communities were Wooten Fireside Industries, Wooten, Ky. (1924), Carcasonne Community Center, Gander, Ky. (1925), and Asbury Tennessee Community Industry (1930s), among others.

Some individual rug makers distinguished themselves through original patterns and personalized materials. During the 1930s Joy Kime Benton of Hendersonville, N.C., hooked rugs of exceptional craftsmanship and aesthetic appeal. For Benton rug hooking began as a healing activity following a nervous breakdown and advice from her physician that she change her environment and find a hobby. Observing women in the neighborhood who made rugs, Benton believed that she could make better ones. She made a hook from a bent nail, acquired some rags and canvas, and began to create. She dyed materials

to create an original color palette for her pictures, cut the loops, and brushed yarn ends to blend the colors. In May 1934 Benton's rugs won a North Carolina state artistic achievement award at the Chapel Hill Dogwood Festival. Isadora Duncan (1884–1976) of Pickens County, N.C., who worked as Marketing Specialist with the University of Tennessee Agricultural Extension Service, was also known for her rug hooking. Active from the 1940s at Berea College in Kentucky and at the Penland School of Crafts in North Carolina, Duncan helped launch the Southern Highland Craft Guild.

Closely related to rugs are the wool pictures of Kate Clayton Donaldson of Kentucky, known as Granny Donaldson. Singled out for recognition in Allen H. Eaton's seminal volume *Handicrafts of the Southern Highlands*, Donaldson crocheted and appliqued designs of animals, plants, and people on a wool ground in lively and varied arrangements. Some contemporary makers of wall hangings have appropriated Granny Donaldson's designs.

In recent decades, interest in creating hooked rugs has enjoyed a nationwide grass-roots resurgence. National organizations like the Association for Traditional Hooking Artists encourage individual creativity and organize workshops, contests, and exhibitions.

LEE KOGAN
American Folk Art Museum

Robert S. Brunk, *May We All Remember Well* (1997); Laura Copenhaver, *Rosemont Marion Virginia Hooked Rug Catalog Book* (1930); Allen H. Eaton, *Handicrafts of the Southern Highlands* (1937, 1973); Beverly Gordon, *Shaker Textile Arts* (1980); Joel Kopp and Kate Kopp, *American Hooked and Sewn Rugs: Folk Art Underfoot* (1985); Jessie Armstead Marshall, *Bed Rugs: 18th and Early 19th Century Embroidered Bed Covers* (2000).

Schoolgirl Samplers and Embroidered Pictures

Southern schoolgirl samplers and embroidered pictures are as diverse as the southern geography itself; they reflect the different cultures, religions, and education of the immigrants—both free and enslaved—who settled the South during the 17th, 18th, and early 19th centuries. In general, southern embroidery differs from northern examples in both design and stitching preferences. Of course, another fundamental difference between northern and southern needlework is the African American presence in the South.

Before about 1850, many southern girls learned sewing skills by working a sampling of stitches and patterns. The girls usually stitched in silk embroidery threads on a linen ground—materials generally purchased at a local store. In

addition to teaching sewing skills and patience, sampler making reinforced the learning of alphabets, numbers, and pious verses. The typical age for stitching samplers and embroidered pictures ranged between 9 and 14 years of age, although some schoolgirls as young as 6 were already mastering needlework skills. Family status and economics, kinship ties, and religious associations determined if girls were taught at home, at a local school, or at a boarding school. After completing a sampler, some southern schoolgirls worked more elaborate projects such as pictures consisting of silk embroidery on a silk ground. However, few southern silk pictures have been documented.

Southern schoolgirl embroideries differ among themselves with regional styles often influenced by one needlework teacher. By reusing specific design elements, patterns, and stitching techniques throughout her career, a needlework teacher created a recognizable personal style. Needlework teachers advertised for students in newspapers. For example, Elizabeth Gardner Armston marketed her Norfolk, Va., school in the *Virginia Gazette* from 1766 until at least 1772, where she informed the public that she taught embroidery. It was at this school in the years 1768 and 1769 that Elizabeth Boush of Norfolk stitched a rare silk embroidered picture of the Sacrifice of Isaac, which is now in the collection of the Museum of Early Southern Decorative Arts. The earliest identified American needlework picture to name the school of its origin, the picture is the only colonial southern needlework that identifies a teacher.

Although no extant 17th-century southern schoolgirl needlework has been identified at this time, 18th-century embroideries, primarily from Maryland and Virginia, have been documented. By the 1760s, distinct regional styles in Chesapeake needlework had developed. Many 18th-century Chesapeake samplers demonstrate precise stitching techniques that create a reverse just as neat as the front—a labor-intensive construction feature paralleled in the furniture of a region that favored the "neat and plain" and "English style." The extensive use as late as the 1810s of reversible stitches, such as the marking cross, is a distinct sampler-making characteristic that separates Chesapeake samplers from the North and other regions in the South.

No known Virginia needlework made by African American schoolgirls survives. However, written evidence suggests that these girls may have worked samplers. On the other hand, much is known of the surviving African American needlework from Baltimore. Black children attending schools operated by Saint James First African Protestant Episcopal Church and the Oblate Sisters of Providence created samplers from the late 1820s to the 1860s.

Regional styles for samplers and embroidered pictures may not exist for all areas of the South, especially the Lowcountry. One researcher observes that

of all the surviving Charleston, S.C., samplers made between 1729 and 1840, no two are stylistically similar. No documented Charleston girlhood embroideries associated with an enslaved or free black maker have been identified. Yet public sale notices and teacher advertisements indicate that in Charleston some "misses of colour" were sent to schools by their masters to learn needlework skills. In these cases, the owner paid the school's tuition.

By the second decade of the 19th century, regions of the South's backcountry offered ample opportunities for girls to learn needlework skills. Two almost identical samplers in the collection of Colonial Williamsburg Foundation marked "Lynchburg, Virginia" were probably worked with the same needlework teacher in the years 1815 and 1825. Identical embroidered motifs of double birdcages, fenced houses, and large stylized vases with flowers appear on the samplers, in addition to decorative areas of Irish stitch. These same motifs appear on samplers worked by girls living deeper in the backcountry—in Tennessee and Indiana. Of particular note are backcountry embroideries created by students attending the Young Ladies Seminary operated by a community of Moravians in Salem, N.C. The oval format and use of ribbon and crepe work that appear in these silk pictures typify Moravian needlework.

Other religious associations also influenced the look of samplers produced in the South. For example, samplers created under the influence of a Quaker teacher typically feature bold Roman alphabets, octagons, medallions, half geometric medallions, and motifs such as swans, pairs of birds, wreaths, and sprigs of flowers—usually worked in cross-stitches in a monochromatic color scheme. Vine and leaf borders, Quaker verses or "extracts," and octagons enclosing inscriptions such as "An Emblem of Love" or "An Emblem of Innocence" are also characteristic of Quaker samplers.

The needlework of the antebellum South also added biblical stories to the religious and pious verses that were integral to many southern samplers. Allegorical figures such as Justice, Wisdom, Liberty, and Hope and classical heroes were also subjects for southern needlework. In Virginia, family record samplers that included birth, death, and marriage dates of the sampler maker's family were especially popular. Silk memorial pictures, common in the North, were rare in the South. Boarding students at St. Joseph's Academy in Emmitsburg, Md., made most of the silk memorial embroideries that have been identified.

Samplers depicting precise replicas of printed maps were exacting needlework exercises worked by some southern girls. The earliest group of map samplers stitched in America depicts the state of Maryland, with the earliest dated 1798. An original engraving of Pierre L'Enfant's plan for Washington served as the source for two embroidered and painted maps of the new capitol city.

By the mid-19th century, in the South as well as throughout the nation, sampler making and fine silk embroidery had all but disappeared from the curriculum of instruction offered in female seminaries. The midcentury vogue for painted still lifes and coarse Berlin wool embroideries requiring only minimal needlework skills had replaced the samplers and silk pictures that had previously displayed the accomplishments of educated girls.

KIM IVEY
Colonial Williamsburg Foundation

Gloria Seaman Allen, *A Maryland Sampling: Girlhood Embroidery, 1723–1860* (2007); Jan Hiester and Kathleen Staples, *This Have I Done: Samplers and Embroideries from Charleston and the Lowcountry* (2001); Kimberly Smith Ivey, *In the Neatest Manner: The Making of the Virginia Sampler Tradition* (1997); Betty Ring, *Girlhood Embroidery: American Samplers and Pictorial Needlework, 1650–1850* (1993); Kathleen Staples, *Sampler and Antique Needlework Quarterly* (Spring 2006); Patricia V. Veasey, *Virtue Leads and Grace Reveals: Embroideries and Education in Antebellum South Carolina* (2003).

Silhouettes

Silhouettes, initially known as "shades," became a popular art form in England around 1700. The genre later traveled to France, where such works acquired the name silhouettes. By the late 18th century, silhouettes had begun to appear in the United States. The first silhouettes were painted images of a subject's shadow. Reduced in size, often with a pantograph, the profiles were usually painted with lampblack on glass. It was the later silhouette, created by cutting a person's profile from black paper and mounting it on a white background, that reached widespread popularity in 19th-century America. Families of modest means commissioned portraits, and wealthy families often chose more complex and amusing action scenes, either cut with scissors or traced with a French machine called a physiognotrace.

One of the most acclaimed silhouettists traveling through the South was the Frenchman Auguste Edouart, who arrived in the United States in 1839 and became wildly popular by cutting full-length and head portraits, group portraits, and action scenes. The most popular native-born silhouettist in the South was William Henry Brown of Charleston, S.C. His work was not limited to portraiture but included animals, machines, and objects. He worked on a large scale, "portraying entire family groups, military companies, fire companies with their engines and horse-carriages, sporting scenes, race-courses and marine views." Brown's circa 1842 *Hauling the Whole Week's Picking* is a striking panorama ap-

proximately nine feet in length. Cut for the Vicks family of Vicksburg, Miss., this subtly colored and collaged work documents a common scene of plantation life. Here, Brown has placed silhouettes upon a watercolor background. His collaged figures depict poorly dressed and bare-footed slaves—including small children, an adolescent boy struggling to carry an enormous basket of cotton, and a woman, presumably his mother, who balances another heavy basket upon her head. Silhouetted oxen and mules pull cotton wagons and at the end of the parade Mrs. Sara Pierce Vick appears on horseback.

Today, the academically trained artist, Kara Walker, has created a resurgence in silhouettes. Walker's controversial murals examine black history through the use of large-scale silhouettes. Much of her work has focused on slavery and race relations of the South. Through such pieces as the 1994 mural *Gone: An Historical Romance of a Civil War as It Occurred between the Dusky Thighs of One Young Negress and Her Heart*, she confronts both historical and contemporary prejudices surrounding race. The use of the once genteel silhouette has become a powerful medium of irony.

PATTI CARR BLACK
Jackson, Mississippi

Ariella Budick, *Newsday* (14 October 2007); Andrew Oliver, *Auguste Edouart's Silhouettes of Eminent Americans, 1839–1844* (1977); Jesse Poesch, *The Art of the Old South: Painting, Sculpture, Architecture, and Products of Craftsmen, 1560–1860* (1983).

Soldier Art of the Civil War

Confederate and Union soldiers in the American Civil War chronicled their experiences in camp, battle, and prison not only with words but also with pictures. Soldiers' art represents an often-overlooked source of information about soldiers' lives and activities. Well-known and very familiar to readers of Civil War books and magazines is the artwork of formally trained and, later, commercially successful Confederate soldiers. Most notable were Conrad Wise Chapman, Allen Christian Redwood, and William Ludwell Sheppard. The former executed important wartime paintings of Confederate camp life and defenses. The latter two became prolific postwar illustrators for books and articles about the war.

Contrasting with those artists' works are the sketches and drawings of untrained artists. Untutored artists' typical media were pencil, ink, and occasionally watercolor on paper; they often drew or painted in diaries, in letters, on envelopes, or on the back sides of blank army forms. The typical subject was camp life. Soldiers documented the appearance of their camps for their own

memory or as illustrations to accompany letters to loved ones. "I send you a scetch though Imperfect of the camp of Smith's Brigade I did not have Room on the paper to Draw it full," wrote Corporal John P. Wilson of the 36th Virginia Infantry in a letter. "It will give you some idea of it."

Some of those camp sketches emphasize not the arrangement of huts or the appearance of tents or officers' quarters but the artists' friends and messmates. Cartoons drawn in the style of contemporary political cartoons captured likenesses and the characters or, at least, caricatures of specific men. One of the most prolific soldier cartoonists was also an important chronicler of the Confederate prison experience. Private John J. Omenhausser, a member of Company A, 46th Virginia Infantry, made several pen and watercolor cartoons of his messmates. He also was likely the artist of a sketchbook of watercolors documenting and offering barbed commentaries on life inside the Point Lookout, Md., prison camp between 1863 and 1865.

Federal prison camps were the source of an enormous volume of surviving Confederate soldier art. Although some pieces of POW art were sketches and watercolors similar to soldier camp art, most items were carvings made of wood, animal bone, shell, and gutta percha, a natural latex made from the sap of certain trees. As with camp art, the POW art testifies to how some Confederate soldiers spent their abundant leisure time. POW art also testifies to the economic activity within prison camps. Federal guards often supplied materials and tools to prisoners and marketed the works around and outside the prisons. Although many POW art products were made for loved ones, the majority were made for the marketplace or what the soldiers and guards dubbed the "ring trade." Omenhausser's works may be seen at the Hornbake Library, University of Maryland, and at the New York Historical Society.

JOHN COSKI
Museum of the Confederacy

John M. Coski, *America's Civil War* (January 2007), *North South Trader's Civil War* 31, no. 6 (2006); Ross M. Kimmel, *Civil War Times Illustrated* (May 2002); Lauralee Trent Stevenson, *Confederate Soldier Artists: Painting the South's War* (1998).

Theorem Painting

Theorem painting is a technique in which the artist layers a series of stencils cut out of board or, more commonly, oiled, waxed, or varnished paper to render an image on wooden furniture, velvet, or paper. Most theorem paintings are still lifes, but there are depictions of landscapes, mourning scenes, and portraits. The majority of American theorem paintings are watercolors on velvet.

Young girls and women of 18th-century England adopted the originally Asian technique of stenciling to make still lifes on velvet or paper. Theorem painting became a popular pastime and academic practice for American girls and young women in the first half of the 19th century. Although examples of American theorem paintings are known as early as 1800, the 1830 publication of *Theoremetical System of Painting or Modern Plan, fully explained in Six Lessons; and Illustrated with Eight Engravings, by which a child of tender years can be taught the sublime art in one week*, by Matthew D. Finn, introduced the technique throughout the States. Soon, young girls in many academic institutions were learning to use theorems or stencils to make paintings that, like needlework, displayed their talents and patience. Theorems could also be used to decorate all manner of domestic objects: storage boxes, tinware, tabletops, walls, scarves, bedspreads, and curtains.

The art of theorem painting relies heavily on the artist's ability to compose a work with careful shading of colors, correct dilution of paint, and attention to technical details. Art teachers or drawing schools often provided their students with ready-made stencils, but young women also turned to print sources for models or templates. These could be found in books and lithographic prints, like those published by Currier & Ives, and, by midcentury, in ladies magazines.

The most popular subjects chosen for theorems were baskets or pots filled with fruit and flowers and sometimes shells or birds. One such example, listed in the Smithsonian Institution Art Inventories Catalog as *An American Southern School-Girl Theorem*, is Polly Giles's particularly lovely theorem in which a yellow bird perches upon an urn of yellow and pink flowers. Like Giles's theorem, such paintings often demonstrate an amazing abundance: baskets filled high with fruits and vegetables, plates overflowing with melons, apples, and grapes, translucent dishes brimming with ripe peaches, pears, and berries, and elegant vases filled with tulips, roses, carnations, and lilies. In their profusion the theorems assert Nature's beneficence, in a stylistic language of decorative elegance that inclines toward abstraction and flattening of three-dimensional space. The artist uses stencil after stencil to build up the composition, employing a formulaic technique that embraces linear shapes, rhythmic line, and two-dimensional pattern.

The making of theorems peaked between 1820 and 1840 and remained popular into the 1860s. By the late 19th century, when new technologies introduced quicker and cheaper means of reproduction, they fell out of fashion. Southern theorems have not been well studied. Only a few survive owing to the climate and perhaps to the chaos of the onslaught of the Civil War. Others remain in family collections. Moreover, because theorems are rarely signed,

their provenance is difficult to establish. Examples of theorem painting can be found in the National Gallery of Art, the American Folk Art Museum, the Abby Aldrich Rockefeller Folk Art Museum, High Museum of Art, and the Arkansas Art Center in Little Rock. The technique of theorem painting survives, owing to the efforts of modern practitioners and contemporary organizations, such as the Historical Society of Early American Decoration.

HALLIE MANNING
University of Memphis

Janet S. Byrne, *Metropolitan Museum of Art Bulletin* (Spring 1976); Deborah Chotner, *American Naive Paintings* (1992); Bev Norwood, *New England Antiques Journal* (5 December 2008); Beatrix T. Rumford and Carolyn J. Weekley, *Treasures of American Folk Art from the Abby Aldrich Rockefeller Folk Art Center* (1989).

Toys

Children and their toys have been a part of southern culture since the 17th century. The 1657 estate inventory of George Beach, a Virginian, included "Childrens toys" valued at 100 pounds of tobacco. Toys amused and educated children and reflected the material life that surrounded a child.

For wealthy children, toys came from near and far. Miniature versions of adult objects, like tea sets, came from England, Holland, and China. In the 19th century, German toy manufacturers exported large quantities of toys to the American South. Children in Salem, N.C., owned barnyard animals and miniature furniture from these German workshops. Often, imported toys inspired southern toy makers in their efforts.

Many southern craftsmen made child-scale versions of their larger wares. At age five Alethea Coffin of Guilford County, N.C., received a miniature fish bottle. Made by Rudolph Christ, a potter in Salem, N.C., Alethea's toy bottle closely mimics the larger ones Christ made for adults. Furniture makers also often made miniature versions of their work. A miniature blanket chest was probably made by Salem, N.C., cabinetmaker Friedrich Belo to accessorize the doll of one lucky little girl.

Dolls were popular playthings for southern girls of all socioeconomic levels. Wealthy girls had access to exquisite dolls made in Europe along with fancy furnishings and fashionable clothing. Poorer children made dolls out of natural materials like corncobs, apples, or gourds, and they imaginatively dressed and accessorized them with available materials.

Ingenious southern children and parents also fashioned other creative playthings using everyday materials. The flipperdinger was a hollowed-out wooden

tube with a hole in one end and a smaller hole on top. A child blew in one end and attempted to levitate a ball up off the top hole and through a hoop attached to the far end. Simpler toys included tops and cup-and-ball games. Today, many of these toys are categorized as "folk toys" and are sold at craft fairs and historic sites.

The toys children play with educate them about the adult world and are a reflection of the material life that surrounds them. A southern child with a miniature SUV is not far removed from an 18th-century child whose doll owned a Chippendale tea table like the one in her parents' parlor.

DANIEL ACKERMANN
Museum of Early Southern Decorative Arts

Jane Carson, *Colonial Virginians at Play* (1989); Thomas A. Gray, *The Old Salem Toy Museum* (2005); Dick Schnacke, *American Folk Toys* (1973).

Trade Signs

Trade signs and figures are among the most highly prized and most enduring forms of American folk art. Before the advent of mass-produced advertising signs such as those lithographed on tin, businesses depended on individual makers to paint trade signs on board or canvas and to carve three-dimensional trade figures that could catch the attention of customers. Many signs—like barber poles painted red, white, and blue or cigar store Indians—employed commonly understood symbols; three-dimensional molars and eyeglasses or silhouettes of boots, descriptive rather than symbolic, left no doubt about the goods or services offered. Sign and figures, legible at a distance, did not depend on the literacy of customers. The oversized plate that Moravian potter Gottfried Aust made as a sign for his shop in Salem, N.C., was a particularly successful sign; deeply incised with the words "Gottfried Aust / Anno 1773," the plate both demonstrated the refinement and vibrancy of Aust's wares and directed to Aust's shop those backcountry customers, who traveled as much as 50 or 60 miles to purchase Moravian pottery. This tour de force, now in the collection of the Museum of Early Southern Decorative Arts, is one of the most impressive southern trade signs.

Among the best-loved trade symbols in American folk art are figural signs that advertise the sale of tobacco. Carved figures, such as Moorish maidens, classical figures, and Indians dressed in tobacco leaves, all proffering bundles of cigars, were in use for decades; some stores still displayed their figures into the 20th century. Larger figures of this type often stood on sidewalks; smaller figures adorned tobacconists' counters. However, while the South was the pri-

mary source of American tobacco, agrarian regions could support neither local wood carvers nor stylish shops. Carvers of sophisticated three-dimensional trade figures instead established businesses in Baltimore and in Washington, D.C., where they might serve clients in both northern and southern cities. German immigrant John Philip Yaeger worked as a plain, ornamental, and fancy carver, advertising in the Baltimore business directory from 1853 to 1854. Yaeger's son Charles Philip Yaeger worked with his father, and another son, Louis G. Yaeger, apprenticed as a coach painter. Among the largest carved figures produced in the Yaeger shop is a 76½-inch-tall figure now in the collection of the Maryland Historical Society. Baltimore carver William Teubner Jr. and Charles J. Hamilton, a Washington, D.C., carver also produced figures for southern tobacconists. Urban professional carvers and sign painters most likely provided signs and figures for the 18th- and 19th-century inns and taverns that catered to upper-middle- and middle-class travelers. These signs, which once dotted city streets and post roads, appeal especially to collectors interested in regional history. Another unidentified professional carver from Philadelphia was the maker of the circa 1850 wingspread gilded eagle perching upon a mechanical pencil that advertised a jeweler's business in Danville, Ky. This figure, now in the collection of the Abby Aldrich Rockefeller Folk Art Museum, signaled that the shop offered such luxurious items as gold pencils, to be worn on a gold chain as a piece of jewelry. The eagle and pencil may also link education and financial success to American identity.

Local self-taught artists, with a variety of backgrounds, produced the majority of southern trade signs and figures. Many collectors are drawn to 19th- and early 20th-century three-dimensional trade signs such as outsized boots, hats, mortars and pestles, fish, and teeth that today often strike viewers as charmingly naive. The painted wood lyre (ca. 1900), found in Weaversville, N.C., is a fanciful neoclassical trade sign for a music shop. The 19-foot tall wooden double-barreled revolver formerly attached to the Watkins and Cottrell Company premises in Richmond, Va., is particularly bombastic. At some date, the proprietors of this shop further adorned the premises with more contemporary but just as enormous signage reading "TENNIS, GOLF, PISTOLS, GUNS." Vintage photographs taken in cities and towns throughout the South document a plethora of symbolic and descriptive signs that have not survived.

The brightly painted American flag banner attributed to San Antonio painter Henry C. Freeland, best known for his portrait of Sam Houston, depended on its size and vibrancy to draw attention to a printing business. Comparisons of Freeland's banner, painted in a conventional commercial style, and his portraits demonstrate that his primary income came from sign painting.

Other sign makers, without the benefit of training craft, created more individualistic but still effective signs. Creative spelling did not confuse the viewers of a double-sided painted sign on wood that reads "P R REG. BLUTICK'S," as a lively scene of a blue tick hound in the act of treeing his prey appears on both sides of this advertisement for a Fauquier County, Va., dog breeder. Perhaps some customers could also decipher the breeder's name.

Some advertisers sought out materials they hoped would prove less susceptible than wood to seasonal changes. Signs made of hammered and cast iron, however, also require periodic repainting and repair. Like wooden signs, many iron signs have been lost to weather. Among the most outstanding of surviving Southern trade signs are the life-size cast-iron Vega-Cal men made in Alabama by an unknown local artist who most likely learned his craft in the iron industry. These figures, created sometime after 1913 and probably in Bessemer, advertise a popular patent medicine produced in Bessemer, Ala., a thriving city that from 1890 until the end of the 20th century was a major center of mining and iron and steel fabrication. The W. D. Taylor Chemical Company clearly commissioned the Vega-Cal men as roadside signs. With three-dimensional two-faced heads that share a single brimmed hat, the otherwise flat figures with arms held at almost right angles to the torso offer messages for travelers both coming and going. One side of the men's torsos reads in low relief, "Vega-Cal / FOR / THE / LIVER." Travelers in the opposite direction learn that "VEGA-CAL / GETS / THE / BILE." The abstract form of the Vega-Cal men, especially the long, outstretched arms that extend at almost right angles, have given rise to a theory that the Taylor Company might have given the figures to farmers to use as scarecrows. Although it is possible that farmers may have given a new purpose to some iron figures, no documentation supports this theory. Removing the figures from the roadside and covering them with clothing would certainly have obscured the advertising. At least one Vega-Cal man, still installed on a roadside in Hartselle, Ala., however, has survived the era of patent medicine to take on a life of his own. Known as the Iron Man (or Ironman), he has become a local mascot. He now serves as an informal trade sign for the Ironman Grocery and has given his name to a major thoroughfare, Ironman Road, and to the Ironman Baptist Church. Locals report that the Ironman has become a landmark, frequently cited when giving directions. Local high schools celebrate graduations by dressing the Ironman in cap and gown, and a local civic group maintains the Ironman, periodically giving him a coat of silver or gold paint. One well-preserved Vega-Cal man is in a private collection. Because only a few other examples are documented, it is possible that W. D. Taylor, intending the ironmen for local use, commissioned only a small number of these trade fig-

ures. Some may have been melted down for cash during the Great Depression. An additional eroded and rusted ironman captured in a snapshot has not been located.

Also dating from the early decades of the 20th century, is another important group of figures known as the Buckeye Family. Carved around 1925 by Tennessee grocer Joseph Cumming Lee, known as Joe, these nearly life-size figures represent a family, perhaps Lee's own. Carved from buckeye, a hardwood common in the Great Smoky Mountains of North Carolina and Tennessee, the group consists of a father wearing a military uniform with gold buttons, a mother wearing high heels and a 1920s gray drop waist dress with pleated skirt, a pensive blonde daughter named Shelby Jean dressed in blue and red, and a smiling black woman, perhaps the family's housekeeper or child-minder. Standing in Lee's store, the Buckeye Family became famous in its environs. According to Lee, some 65,000 people from all over the world also visited the tiny town of Beaver Hill to see the figures and sign their names in a visitors' book.

Several well-known 20th-century southern self-taught artists have painted or carved signs to promote their businesses, to express personal and political opinions, or to inspire an audience to follow their religious precepts. Cal and Ruby Black's *Possum Trot* environment was itself an advertisement for the roadside rock and souvenir shop that they operated near Yermo, Calif., and eventually for their Birdcage Theatre, which featured singing and dancing dolls. With the humor and make-do attitude learned during their Appalachian childhoods, the Blacks installed in the front of their property a handmade locomotive, a stagecoach, wind-powered carousels, and life-size dolls as well as folksy painted signs like "We don't know where Ma is But we got Pop on Ice." Miles Burkholder Carpenter of Waverly, Va., carved and painted a wooden watermelon said to weigh 200 pounds; an oversized pumpkin; and a large ICE sign to urge people to buy products from his roadside stand that offered ice, soda pop, and vegetables from his garden. In his 1982 autobiography, *Cutting the Mustard*, Carpenter recalled that the heavy watermelon was unwieldy and required a pushcart to "haul it in and out for display." He also boasted that one potential customer "got mad with me for fooling him to stop and see a fake melon." A carved and painted melon, supported on a hand truck, is now in the collection of the Abby Aldrich Rockefeller Folk Art Museum. Carpenter's sense of humor also enlivened his other advertisements. He sat his carved figure of an Indian Brave in the cab of his truck and delighted in pulling a string to make the figure nod at people who passed. Rev. Howard Finster installed multiple hand-painted signs to attract visitors to *Paradise Garden*, the folk art environment he created in Summerville, Ga. Signs installed within the garden ad-

dressed a variety of topics—religion, social mores, morality, and history. These singular missives, often touched with humor, were intended to sell his spiritual messages. The signage for *Margaret's Grocery* in Vicksburg, Miss., once advertised the cold drinks and snacks that Margaret Rogers sold to travelers; however, after Rogers married Rev. Herman D. Dennis, her husband painted the store in bright colors, now in a checkerboard pattern, and added structures and many hand-painted signs that advertise faith. The grocery, no longer selling snacks, became a much-visited folk art environment. However, with Margaret's passing in 2010 and Reverend Dennis's move to a nursing home (where he died in 2012), the complex has fallen into disarray.

Even though contemporary sign businesses can offer professionally painted signs or signs made in lights, plastic, and a multitude of weather-resistant materials, handmade signs still appear in both cities and rural areas. Some advertisers choose handmade signs through necessity. Others, preferring individualistic signs, make their own trade signs or hire locals known for imaginative advertisements with particular local resonance. Throughout the South, hand-painted and hand-sculpted pigs dressed in all sorts of clothes and engaged in all sorts of activities call attention to barbecue joints. Hairdressers choose to advertise the varied and extravagant styles that they can offer through equally expressionistic paintings on board, in murals, or on the glass of shop windows. The sultry women on the painted signs that advertise the It's All About U Hair Salon in Cusseta, Ga., are memorable trade signs that someday might appear on the walls of a museum. Giant animals made of cement, fiberglass, roofing tin, and cast-off materials, such as the enormous crawfish that sits upon the roof of a Houma, La., restaurant, are fitting and amusing advertisements for down-home products and values. Another well-loved giant animal is the Big Chicken that advertises the Shady Lawn Truck Stop in Elkton, Tenn. A Birmingham mural advertising a car dealership is another apt example of a handmade sign chosen to express old-fashioned homeyness; while signage states that the cars on offer are all Japanese, the mural's central image is a vintage American pick-up, an emblem recalling a southern, rural past. An enormous layered birthday cake made of sheet metal and standing on a tall pole directs customers to a bakery, functioning exactly as did 19th-century three-dimensional signs hung from a pole or affixed to a building. Murals of the Virgin of Guadalupe painted on the exteriors of grocery stores or pizzerias welcome Mexican immigrants not just in Texas but also across the South. As these images of the Virgin of Guadalupe signal that proprietors speak Spanish, they attract the attention of immigrants from all over Latin America. A multitude of car repair shops use cast-off auto parts to create figures known as muffler men; other businesses attract attention

by displaying creations like fanciful dogs made of welded chain or dinosaurs made of whatever materials are at hand. Along older highways, travelers can see such tour de forces as Natchez, Mississippi's Mammy's Cupboard, a giant concrete woman whose pink painted hoop skirt is large enough to house a business. Formerly a restaurant, Mammy's Cupboard is now a gift shop. The once black mammy is now a blonde woman with rosy cheeks. Another vernacular architectural folly is the full story-tall head of a lion through whose toothy jaws diners enter a Wilmington, N.C., restaurant.

The handmade trade sign, though most commonly identified with the pre-industrial past, remains a dynamic folk art genre. Signs with personal touches—abundant in cities, towns, and rural locales—continue to be remarkably effective in grabbing attention and delighting potential customers. Trade signs are also the focus of many fans of folk art—both those who seek out older signs with beautiful patinas and those who collect photos of quirky trade signs and often post them online.

LEE KOGAN
American Folk Art Museum

CHERYL RIVERS
Brooklyn, New York

Robert Bishop, *American Folk Sculpture* (1974); Robert Bishop and Jacqueline Marx Atkins, *Folk Art in American Life* (1995); Russell Bowman, Lucy R. Lippard, Kenneth L. Ames, and Jeffry R. Hayes, *Common Ground / Uncommon Vision: The Michael and Julie Hall Collection American Folk Art* (1993); Benjamin H. Caldwell Jr., Robert Hicks, and Mark W. Scala, *Art of Tennessee* (2003); Miles Carpenter, *Cutting the Mustard* (1982); Fred Fried and Mary Fried, *America's Forgotten Folk Arts* (1978); Herbert W. Hemphill Jr., ed., *Folk Sculpture USA* (1976); Cynthia Elyce Rubin, ed., *Southern Folk Art* (1985); Skinner, Inc., *Catalog #2444* (15 February 2009); Cecilia Steinfeldt, *Texas Folk Art: One Hundred Fifty Years of the Southwestern Tradition* (1981); Nicholas Fox Weber, *Architectural Digest* (March 1993).

Tramp Art

Tramp art is the long-recognized term for three-dimensional objects made from layers of shaped and chip carved wood. The craft was most popular in America around the 1900s and was made by anonymous skilled artisans. Some tramp artists created small objects like jewelry boxes or picture frames; others, ambitious and patient, created desks, tall case clocks, and other imposing pieces of furniture. The wood used by makers of tramp art came primarily from wooden cigar boxes and shipping crates. Such wood was widely available. In 1865 the

first tax revenue law in the United States mandated that all cigars sold had to be offered in wooden boxes of precise dimensions. The law further specified that the boxes could not be reused for the resale of cigars, which remained the most popular tobacco product until the middle 1930s. Not surprisingly, tramp art's golden age was between the 1870s and the 1930s.

Although tramp artists could use any material that could be carved and notched, most tramp artists were purists who used only wood from cigar boxes. The woods for cigar boxes, in fact, were fine woods, mostly cedar and mahogany; the value of the boxes was generally far greater than the tobacco they carried.

The origins of tramp art are obscure. Chip carving was a common northern European decorative technique. It is possible that immigrant craftsmen taught the technique in a person-to-person manner. For the most part, however, tramp artists were amateurs or hobbyists who had spare time and worked in their homes. Tramp art was a time-consuming endeavor; tramp artists had to shape their wood and, with simple tools like pocket knives, decorate edges before completing each layer. Depending on the individual vision of the artist, articles could take days, weeks, or even years to produce.

Although "tramp art" has become the widely accepted name for this genre, there is no evidence that its makers were tramps. Some oral history accounts refer to wandering tramp artists, but dozens of tramp art makers had stable lives, jobs, and family structures. In fact, most pieces of tramp art are domestic and decorative.

Early collectors of American folk art ignored tramp art. The first book on the subject, *Tramp Art: An Itinerant's Folk Art*, by Helaine Fendleman, accompanied a traveling exhibition organized by the American Folk Art Museum in 1975. Today tramp art, firmly established in the folk art world, has entered important museum collections, including those of the Smithsonian American Art Museum and the American Folk Art Museum.

CLIFFORD WALLACH
Manalapan, New Jersey

Helaine Fendleman, *Tramp Art: An Itinerant's Folk Art* (1975); Francis Lichten, *Pennsylvania Folklife* (Spring 1959); Clifford Wallach, *Tramp Art: One Notch at a Time* (1998), *Tramp Art: Another Notch, Folk Art from the Heart* (2009).

Visionary Art

When broadly applied to creative practice, "visionary" might refer to a range of extraordinary, forward-looking modes of expression, not necessarily related in

any way to the supernatural but remaining within the realm of human intellect. A more specific and accurate definition of visionary art, however, describes a creative process in which artists consciously engage a supernatural or divine intelligence and understand themselves to be conduits whose art making translates that intelligence, a spiritual message, into palpable forms. In today's cynical art world, visionary artists are most often presented to the public as insane, eccentric, or simply amusing. Although personal experience of the divine finds widespread acceptance in the South, few religious institutions commission individualistic artistic expressions of the spiritual.

It is impossible to discuss visionary art without mentioning William Blake, who indeed understood his drawing and paintings to be inspired by God. Yet Blake, despite his inspired, maverick persona, was profoundly influenced by the Western canon of art, especially evident in his heroic, Michelangelesque figuration. By contrast, self-taught visionary artists, who derive inspiration to make art not from academic standards but from what they feel to be a "call" to make art, form the core of this category, especially in the American South.

In Europe, best-known visionary artists have had some involvement with the tradition of spiritualism, a grass-roots movement that began in the 19th century. Artists like Augustin Lesage, Raphaël Lonné, and Madge Gill reinvented mediumistic techniques such as spirit writing and spirit drawing—modes of expression used to channel the spirits of the dead. By contrast, southern visionary artists are ostensibly Christian, even though their art making takes place outside the purview of church activities and may involve other spiritual beliefs and practices. Although no two visionary artists are exactly alike, they all share the experience of a dramatic, precipitous moment—often following a personal tragedy such as the loss of a husband, wife, or child—in which they are "called" to create. One example of a dramatic calling is the experience recollected by the late artist and preacher Howard Finster, of Summerville, Ga., who in 1976 saw a face in the paint on his finger as he was patching a bicycle tire and heard a voice commanding him to "make sacred art." The fact that this experience mirrors multiple earlier visions—in which he was "called" to be a Baptist preacher—points to the cultural roots of his artistic identity, an important point that is too often forgotten in the rush to make visionary artists into isolated outsiders. For decades curators have attempted to reinvent southern visionaries to fit different agendas, as evidenced by the consistent attempts by museum curators to recast the visionary stone carver William Edmondson of Nashville, Tenn., as a regionless modernist. The result has been a stripping away of these artists' regional identity and a persistent devaluing of southern culture in the international museum world.

Although visionary artists work in a range of ways, two central groupings help to organize this category. Some visionary artists experience auditory or visual conversion visions that shape their oeuvres. Finster's visions ranged from images of Jesus, Elvis, and even "other worlds," all of which guided him to construct *Paradise Garden* as well as many individual works of art. Edmondson typically experienced visions of his carvings before he brought them into being with a hammer and chisel. Sister Gertrude Morgan was "called" by God twice — once in 1956 to make art and again a year later to tell her that she was the bride of Christ, a vision that led her to construct her Everlasting Gospel Mission in New Orleans. She is known for her paintings that offer her highly personal interpretation of the visionary book of Revelation and yet reveal in their function a didactic tradition that goes back to the 1840s. Anderson Johnson, of Newport News, Va. overcame debilitating paralysis and turned his home into a faith mission filled inside and out with paintings and mixed-media artworks. Two other visionaries, both of whom were guided by communication with the dead, were Frank Jones, of Texas, who painted "haints," and Georgia Blizzard, of Chilhowie, Va., whose unprecedented ceramic works often reflected her clairvoyance, communicated through her reinvention of the Appalachian folk idiom.

Other visionary artists continually channel an external force — whether named God, Holy Spirit, angel, or anything else — and do not work from a priori visions but from an ongoing feeling of being guided through the creative act. Artists who fall under this category include Minnie Evans, of Wilmington, N.C., whose drawings and paintings of heavenly beings surrounded by lush foliage were made in a willing partnership with a divine, guiding energy. The same is true of J. B. Murray of Sandersville, Ga., whose color-coded, abstract drawings and paintings, the visual equivalent of glossolalia, were the artist's manifestation of Holy Spirit, which he believed could be deciphered if viewed through a glass bottle filled with holy well water. Many scholars recognize the visionary art of both Evans and Murray as examples of the cultural syncretism that characterizes much southern self-taught artwork. Both artists produced dynamic hybrid languages that blended Protestant Christianity with African diasporic vernacular practice such as spirit writing.

Another grass-roots diasporic practice known as "yardwork" — or the activation of one's yard through highly coded shapes, forms, and messages designed to keep evil out and good in — have given rise to unique visionary environments, such as that of David Butler, of St. Mary Parish, La. Butler, who believed that his talent was a God-given gift and filled his yard and house with brightly painted tin cutouts, including impressive whirligigs, created an unsurpassed bestiary that both carried forward and reinvented the tradition of yard protection.

To be sure, not all visionary art or environments reflect the constellation of images and ideas associated with Bible Belt diasporic syncretism. Eddie Owens Martin returned to his native Buena Vista, Ga., after years of living in New York City, where he had read tea leaves for a living and learned about Eastern religions. After a vision in which he was visited by three imposing people from the future called "Pasaquoyans," he constructed a four-acre compound of poured concrete and bright paint, calling it *Pasaquan*, and naming himself St. EOM. Martin's work, which included the environment, drawings and paintings, embellished costumes and feathered crowns, and performance to honor his Pasaquoyan visions, was like nothing the locals had ever seen. This site, recently added to the National Register of Historic Places, is, like many other visionary environments, sorely in need of restoration.

JENIFER BORUM
New York, New York

Paul Arnett and William Arnett, eds., *Souls Grown Deep: African American Vernacular Art of the South*, vol. 1 (2000); William Arnett and Paul Arnett, eds., *Souls Grown Deep: African American Vernacular Art*, vol. 2 (2001); Carol Crown, ed., *Coming Home! Self-Taught Artists, the Bible, and the American South* (2004); Carol Crown and Charles Russell, eds., *Sacred and Profane: Voice and Vision in Southern Self-Taught Art* (2007); Grey Gundaker, ed., *Keep Your Head to the Sky: Interpreting African-American Home Ground* (1998); Roger Manley, *Signs and Wonders: Outsider Art inside North Carolina* (1989); Roger Manley and Mark Sloan, eds., *Self-Made Worlds: Visionary Folk Art Environments* (1997).

Weathervanes, Whirligigs, and Whimseys

Weathervanes have long served the important function of showing wind direction—always a useful indication of upcoming weather conditions. The vane's body usually consists of a flat surface cut or carved into a shape such as a religious symbol, an animal, or any decorative object that pleases its maker. The maker then connects the body asymmetrically to a post, with the larger area to one side of the center so that, sitting on a bearing, the vane can move freely, pointing into the direction of the oncoming wind. Commercially produced weathervanes were eventually fabricated from sheet or cast metal and even recontextualized as folk sculpture, but the quirkier, more primitive, handmade wooden and metal vanes that preceded them were no less effective as weather forecasters—and offered the bonus of individual expressiveness.

Unlike weathervanes, whirligigs and whimseys were created more for amusement than necessity. Whirligigs, like weathervanes, are kinetic. Their

basic components might be as simple as an object or shape with an attached propeller, like a pinwheel, but they have often included gears and bearings that allow articulated pieces to make complex movements. A small whirligig might consist of nothing more than a soldier flailing his arms. The large weathervanes, some 40 feet tall, made by Vollis Simpson of Lucama, N.C., create a virtual circus of whirling color that takes up an entire field. Impressive in any circumstance, these whirligigs are particularly magical at night when the headlights of cars illuminate the discarded reflective highway signs that Simpson cuts ups and attaches to his creations.

Whereas whirligigs might be made by a carver interested in creating a delightful visual experience, whimseys provide a different sort of challenge, one that almost always invites the observer to ask, "How did you do that?" A ship constructed in a bottle or a long chain of wood carved from one solid piece is a delightful example of folk art that tests the limits of a craftsman's engineering and carving skills. Other examples of whimseys include balls-in-cages or crown-of-thorns work. While not functional in the same sense as weathervanes, whirligigs and whimseys do serve to sharpen an artist's skills while allowing him to pass the hours constructively and happily.

MEG SMEAL
Allendale, New Jersey

Robert Bishop, *American Folk Sculpture* (1974); Elinor Robinson Bradshaw, *American Folk Sculpture: The Work of Eighteenth- and Nineteenth-Century Craftsmen* (1931); Stacy C. Hollander and Brooke Davis Anderson, *American Anthem: Masterworks from the American Folk Art Museum* (2001); Roger Ricco and Frank Maresca, *American Primitive: Discoveries in Folk Sculpture* (1988), *American Vernacular: New Discoveries in Folk, Self-Taught, and Outsider Sculptures* (2002).

Aaron, Jesse James

(1887–1979)

At 3:00 A.M. on 16 July 1968, Jesse James Aaron was awakened by a voice saying "Carve wood!" He immediately went outside and, as he put it, "I found a piece of wood from the woodpile and started carving." Two or three days later he had completed his first face. "Now I see faces in any wood and just start carving," he said. Aaron always declared his newfound talent "a gift from the Lord."

Aaron, born in Lake City, Fla., had no formal education and spent most of his early years doing farm work because his family had "hired him out" after his first grade at school. He was proud of his unusual heritage, always sharing a love of the "Geechee ways" that his mother, a Seminole Indian, had taught him. His father's ancestors were slaves. In 1908 he began work at a bakery, eventually baking and cooking at the local Hotel Thomas. Between 1909 and 1933 he got married, did farm work, and was in the "stump and wood" business, which meant he prepared and sold firewood, split kindling, and gathered turpentine stumps. In 1931 he moved 30 miles south to Gainesville, where he spent his later years working for local kitchens and running a small nursery. He sold the nursery in 1968 to help pay for his wife's cataract surgery. Soon after, Aaron, then unemployed at 81, had his helpful directive from above.

Aaron's yard-based sculptural environment was often full of fresh works for sale, but some work was not for sale. Aaron practiced the art of scarification on his large dogwood trees. He cut faces into the bark of his trees, adding eyes and sometimes horns. Over time the faces grew larger and more integrated into the tree, giving an eerie feeling to his already somewhat shrouded yard, which was covered from spring to fall with coyote squash vines that grew on fence wire stretched above head level. In addition to these faces, his early work included carvings, some of which were low-relief totems, paintings, and drawings. He created low reliefs, carving cypress wood when he could get it, using cedar and juniper when he could not. He painted on or added marbles for eyes. Aaron fashioned "wolfagators" made from cypress knees with their bark to simulate alligator hide. He gave them chainsaw-cut mouths and eye sockets and affixed shiny eyes. Over time the pieces got larger, more complex, and less carved. As Aaron's hands gave out, he began to use an electric chainsaw to make the primary cuts of mouths, eyebrows, and ears. He used a hand auger to cut the nostrils and eye sockets and used a mixture of white glue and sawdust to make the "body putty" used to fill in around arms, legs, and horns.

Aaron was particularly proud of his homemade eyes and always assured collectors they could come back and exchange the eyes if they "got tired of their color." To make his "invention," as he called it, he used castable acrylic to mold his two-tone eyes by pouring it into round-bottomed ice cube trays and then sticking a roofing nail into the congealing acrylic. When set, the eye was ready to nail into place. Sometimes he put shark teeth in the mouths of ani-

mals, and other times he added horns or bones. He often combined a human body with the face of an animal. His totems were in low relief, and, although rarely, he did drawings.

Aaron's first big exhibition was the Corcoran Gallery's seminal *Black Folk Art in America, 1930–1980*. His work is in the collection of the Mnello Museum of American Art and the Mary Brogan Museum of Art and Science.

JIM ROCHE
Florida State University

Jane Livingston and John Beardsley, *Black Folk Art in America, 1930–1980* (1981).

Adkins, Minnie

(b. 1934)

Minnie Adkins began carving as a young girl after seeing the carving and whittling of the men who lived near her family's home in rural Elliott County, Ky. Her early carvings, made with a knife her father had given her, were heavily influenced by the utilitarian carving practices and recreational whittling of Appalachian Kentucky, where most men carried a knife for practical use on a daily basis.

From the mid-1940s until the early 1980s, Adkins made small birds and animals, occasionally accented with paint. The artist gave away most of her early carvings and sold a few in flea markets while living in Fairborn, Ohio, from 1968 to 1983. After a 1984 exhibition of her work in a local gallery in Morehead, Ky., the artist attracted the attention of dealers, collectors, and galleries beyond Kentucky.

Adkins increased the scale of her work in the mid-1980s, from objects that would fit into the palm of a hand to pieces up to four feet in length. To meet growing demand for her work she made many versions of characteristic forms—foxes, tigers, bears, opossums, and horses. She is best known for her roosters that are crafted with rudimentary carving from a forked stick and mounted upright on a flat wooden base. For these roosters, Adkins debarks part of one fork, splits it several times vertically, and flares it out to suggest tail feathers. She then uses paint to accent comb and beak. Adkins has also produced paintings and commissioned quilts that feature her animals.

Adkins's husband, Garland, whom she married in 1952, assisted Minnie from 1984 until his death in 1997. He procured the wood and roughed out the pieces, leaving Minnie to carve, assemble, sand, and paint them as she chose. Garland also carved on his own and is best known for his horses. All works completed by either of them from 1984 to 1997 are signed "G & M Adkins." In 1999, Adkins married Herman Peters, a retired pipe fitter, who has replicated Minnie's animals in welded pipe.

Minnie Adkins is widely recognized for her support, encouragement, and promotion of fellow folk artists. Beginning in the late 1980s, when her own work blossomed, Minnie Adkins mentored other self-taught artists, particularly those living nearby in northeast Kentucky. In 1989 the Adkinses staged a folk art sale in the Isonville Elementary School gymnasium that evolved into an annual event known as A Day in the Country. The fair featured many

artists and attracted collectors from numerous states. It was held for more than 10 years in the couple's front yard until 1993 when, at Minnie's request, it was moved to the Kentucky Folk Art Center at Morehead State University.

Adkins has received significant public acknowledgment for her work, including Centre College's Jane Morton Norton Award, 1992; the Award for Leadership in Arts and Culture from the Eastern Kentucky Leadership Foundation, 1993; the Folk Art Society of America's Distinguished Artist Award, 1993; the Appalachian Treasure Award, Morehead State University, 1994; and the Artist Award, honoring lifetime achievement, Governor's Awards in the Arts, Kentucky Arts Council, 1997. In 1998 she and Garland (posthumously) received an Honorary Doctorate of Humanities from Morehead State University. The Kentucky Folk Art Center, the Owensboro Museum of Art, the Huntington Museum of Art, and the Longwood Center for the Arts are among the museums that hold works by Minnie Adkins.

ADRIAN SWAIN
Kentucky Folk Art Center

Julie Ardery and Tom Patterson, *Generations of Kentucky* (1994); Kentucky Folk Art Center, *Against the Grain: Minnie Adkins, Kentucky Folk Carver* (2007); Millard Lampell and Ramona Lampell, *O Appalachia: Artists of the Southern Mountains* (1989); Morehead State University, *Local Visions: Folk Art from Northeast Kentucky* (1990); Kathy Moses, *Outsider Art of the South* (1999); Betty-Carol Sellen with Cynthia J. Johanson, *Twentieth-Century American Folk, Self-Taught, and Outsider Art* (1993); Adrian Swain, *Against the Grain: The Works of Minnie Adkins* (2006); Alice Rae Yelen, *Passionate Visions of the American South: Self-Taught Artists from 1940 to the Present* (1993).

Albritton, Sarah

(b. 1936)

Born Sarah Drayton in Arcadia in Bienville Parish, La., on 6 February 1936, self-taught artist Sarah Albritton is known for painting her life in rural north Louisiana. From 1987 to 1999, when she had heart bypass surgery, Albritton owned Sarah's Kitchen, a restaurant in Rushton, La., specializing in southern home-style soul food. The restaurant received extensive press attention, thanks in part to the kitchen corner where she began painting her memories and visions. She continues to paint in her home behind the kitchen and also bottles jellies, cans, and caters occasionally.

As a child Albritton was shuttled from her single mother's home in Ruston to her mother's relatives on small farms in the country, where she learned about farm life. She graduated from Lincoln High School and later attended the American Baptist Theological Seminary. In 1954 she married Robert Albritton. In addition to their own three children, the couple raised six of her uncle's children.

Two constant themes running through Albritton's life and art are work and religion. At the age of 9 she began her first job washing dishes at a restaurant, where she learned to short-order cook; by 12, she became head cook. She also worked as a nutritional aide for the

Louisiana State University Cooperative Extension Service. Later Albritton developed catering and cottage canning businesses and helped organize the North Central Farmer's Market Association. These skills in traditional southern cooking and farming led to her participation in state, regional, and national folklife festivals.

Albritton's painting career began in 1993, when she was invited to participate in a fundraiser hosted by the North Central Louisiana Arts Council. Albritton joined other celebrities to create artwork while the audience watched and bid on paintings. Afterward, she began painting stories from her life. These memory paintings led to her first exhibition in 1996, a traveling exhibition, and a catalog, *On My Way: The Arts of Sarah Albritton*.

Albritton's paintings represent childhood memories and symbolic statements of her religious and spiritual vision. Instead of idealizing the past in the nostalgic manner of many memory painters, Albritton's paintings depict painful memories of hardships, abuse, and racism. So bitter were these memories that Albritton describes her childhood experience as a literal hell. Paintings such as *Mama, Don't Send Me Away*, *Lonely Road*, and *Bridge over Troubled Water* show the young girl in her blue skirt struggling to make her way through the poverty and precariousness of southern African American family life in the post-Depression years. Written and transcribed stories that often accompany her paintings reveal complex narratives.

Although Albritton does not consciously pattern her work after other artists, she is familiar with Clementine Hunter and Grandma Moses (Anna Mary Robertson Moses). Like Clementine Hunter, Albritton paints her regional landscape and folk traditions such as baptisms, funerals, homecomings, cotton picking, hog killing, fishing, picnics, and clothes washing. Albritton often includes herself as a protagonist accompanied by hovering angels among the numerous figures in her complicated landscapes, even in visionary works such as *Hell* and *Pay Day*, which depicts Judgment Day. A devout Baptist, poet, and lay preacher, she considers her creative arts to be God-given gifts.

Albritton's work can be found in the Louisiana State Museum.

SUSAN ROACH
Louisiana Tech University

Carol Crown, ed., *Coming Home! Self-Taught Artists, the Bible, and the American South* (2004); Susan Roach, ed., *On My Way: The Arts of Sarah Albritton* (1998).

Almon, Leroy, Sr.

(1938–1997)

Leroy Almon Sr. was born in 1938, in Tallapoosa, Ga., and grew up in Ohio. After finishing high school, he sold shoes and worked for Coca-Cola in Columbus. A devout Christian, Almon attended the Gay Tabernacle Baptist Church, where he met the renowned, self-taught wood-carver Elijah Pierce. Almon became friends with Pierce, assisting the older artist with the art gallery in his barbershop and with his wood carvings. Starting as apprentice and collaborator, Almon became

Pierce's respected colleague, deserving recognition in his own right for his signature sermons in the form of brightly painted, wooden relief carvings that mix fire-and-brimstone warnings about the world's evils with a playful sense of humor.

It would be a mistake to let the didactic nature of Almon's relief tableaux overshadow the subtlety and brilliance of his carving, paint handling, and overall compositional solutions. A consummate storyteller, Almon dedicated his work to recounting African American history, the civil rights movement, and the battle between good and evil, all with his own maverick evangelistic language in which Satan is ever present. Almon was a master of balancing narrative with form, in some cases inventing multipanel compositions to cover events unfolding in time and, in other cases, condensing a complex message into one dynamic frame.

One of the most commonly recurring themes in Almon's work is that of the corruption to be found in organized religion. A nondenominational evangelical minister himself, he nevertheless railed against what he saw to be the hypocrisy of churchgoers who do not practice what they preach. These indictments of false piety often take the form of comic scenes, revealing human nature and, more often than not, Satan's triumph on earth. Although he might be best known for his mode of comic moralism, one finds more serious, quite moving expressions of a powerful faith well matched by a formidable talent. Almon's work can be found in the collections of the Smithsonian American

Folk Art Museum, American Folk Art Museum, and the High Museum of Art.

JENIFER BORUM
New York, New York

Paul Arnett and William Arnett, eds., *Souls Grown Deep: African American Vernacular Art of the South*, vol. 1 (2000); Carol Crown, ed., *Coming Home! Self-Taught Artists, the Bible, and the American South* (2004); Kinshasha Conwill and Arthur C. Danto, *Testimony: Vernacular Art of the African-American South* (2001); Sal Scalora, *Gifted Visions: Black American Folk Art* (1988).

Amézcua, Consuelo González (Chelo)

(1903–1975)

Consuelo González Amézcua was born in Piedras Negras, Mexico, on 13 June 1903. On 27 November 1913 (Thanksgiving Day, she often noted), she moved with her family to Del Rio, Tex. This small town was home for the rest of her life. Speaking only Spanish, she attended a school that taught Spanish-speaking children English. While Amézcua's sisters and brothers flourished in this environment, she resisted schooling and attended school for only six years. By the time she was through with her short-lived formal education, Amézcua was already writing poetry.

Before Amézcua began creating the drawings for which she is known, she carved river stones. She continued this activity, which involved what she called the beautiful, serene, and solitary task of finding the stones by the water's edge, until 1964 when the physical work became too much for her. She then focused her prodigious creativity on her drawings and her poetry. She compiled

Consuelo González Amézcua, La Cubierta de mi Libro, 1974,
ink on matboard, 28″ x 22″ (Courtesy of Cavin-Morris Gallery)

Cantares y Poemas, a book of songs and poems, and often wrote poetry on the back of her drawings.

Amézcua's religious faith and her family's clear love for her, despite their incapacity to encourage her art making, sustained her desire to make art. She referred to her drawings as "filigree art," and the subject matter was as individualistic as her technique. Her poetic nature rarely focused on the mundane; she was interested in the confluence of creativity and beauty. Her subjects included biblical figures (usually

women), philosophers, architects, gardens, music, her Mexican heritage, and—in and among these themes—free and beautiful birds and human hands in the act of creation. A list of her titles for drawings reveals her focus on mystery, magic, and mysticism: *Miriam the Prophetess, Lola Punales, Queen of Sheba, Winged Hands, Mano y Cerebro,* and *Amor Divino.* Her most autobiographical drawing, *The Legend of the Seed,* tells of a seed lying unattended by the side of the road. An inspiration from God sends a little breeze to cover the seed with dirt, and rain provides succor to the thirsty sprout. With the abundant sunshine and the ever-present protective spirit of the creator, the tree grows strong and healthy, providing shade and comfort to passersby.

According to Amézcua's niece, Livia Fernandez, Amézcua rarely sketched a drawing before she started it. She began in one corner and continued the drawing, often taking up to a month to complete it to her satisfaction. Densely filled intricate patterns overlap and dovetail, creating mass. The drawings then open with a path of loose lines or empty space, directing the viewer to the next tableau of dense patterning and imagery. Her preferred medium was an inexpensive ballpoint pen because it produced a dependable line of consistent thickness. She later added colored pen, and finally marker, to her repertoire.

As an artist Chelo Amézcua was unassuming. She worked in a Kress department store selling candy and lived a simple life with her sister. Her gentle compassion for humankind is evident in all of her oeuvre, a quality that Rolando Hinojosa-Smith refers to as *bondad,* Spanish for goodness, excellence, kindness, and kindliness. That being said, she was able to make her sublimely carved river stones, her elaborate drawings, and her poetry and song because of her ferocious and tenacious dedication to her personal vision.

Her drawings are in the collection of the Smithsonian Museum of American Art, the American Folk Art Museum, the Marion Koogler McNay Art Institute in San Antonio, Tex., the Menil Collection, and abcd, Paris, France.

SHARI CAVIN
Brooklyn, New York

Jacinto Quirarte and Rolando Hinojosa-Smith, *Mystical Elements / Lyrical Imagery: Consuelo Gonzalez Amézcua, 1903–1975* (1993).

Andrews, George Cleveland
(1911–1996)

George Andrews, known as "The Dot Man" to residents of rural Morgan County, Ga., began to draw and paint as a very young child. Many years later, his son, the prominent artist Benny Andrews, who received a B.F.A. degree from the Art Institute of Chicago and was director of Visual Arts at the National Endowment for the Arts during the early 1980s, would say, "He's like a brush filled with dripping paint walking around looking for some place to place a drop."

In fact, the elder Andrews covered every imaginable sort of surface—from lampshades and handbags to ceramic household objects and assorted furniture—with his signature dots and squiggles of flat, bright color. His lively

imagination was kindled by memories of tenant farming in the rural South, childhood, nature, animals, politics, and religion. During the last three decades of his life, he transformed multitudes of small-scale canvas boards, pieces of cardboard, wood, plastic, and Styrofoam trays into compact, narrative paintings framed and enlivened by his characteristic decorative dots, stripes, and circle patterns. The body of his work also includes a series of larger family portraits produced in 1991. The figures in these paintings are likewise engulfed by flying and whirling dots of color along with descriptive texts. The artist placed boldly written titles across the bottom of most of his paintings. In *The Pig Tree*, the title shares pictorial space with a pair of cookie-cutter pigs as large as the tree's entire expanse of foliage. His titles and texts were meant to assure that the viewer would comprehend his subjects, whether a singing duck or *My Dear Mother Flowers Bed*.

Occasionally Andrews would paint a directly moralizing subject such as *On Dope Talk 1989*, in which he declared his disdain for illegal drug use with three talking heads—a Caucasian, an African American, and an Asian. Overhead is the critical message that drug abuse knows neither racial nor ethnic barriers. He also treated universal themes like life and death. These are symbolically represented in compositions such as *Peace in the Valley for All*, with happy blue birds framed by festive blue dots, and *The Valley of Dry Bones*, in which red X marks form the border around predator birds on the horizon. More typical is a painting titled *2 Cane Snakes Doing the*

Buggy, presented in the artist's witty and optimistic way with the striped serpents cast as hilarious dance partners. Even though most of Andrews's subjects are readily perceptible, he sometimes added a personal *O Boy Ha Ha* to a title to assure that the audience would fully understand his humor.

George Andrews and his wife, Viola, a published writer and poet, reared 10 children in a sharecropper cabin on the same land where George's parents had lived. Several of their offspring, like Benny, continued George and Viola's artistic and creative legacy. During the 1990s critics and curators began to recognize this family's contributions to the culture of the South. Numerous museum exhibitions and publications featured Andrews's inherently authentic art, whether a dot-covered pair of lady's shoes or a painting of a rocket-like planter with exploding posies and swirling space gizmos.

The Morris Museum of Art, the Tubman African American Museum, and the Ogden Museum of Southern Art hold works by Andrews.

PATRICIA BLADON
University of Memphis

Armstrong, Zebedee B.
(1911–1993)
Born in 1911, in Thompson, Ga., Zebedee B. Armstrong attended school through the eighth grade and picked cotton for most of his life on the Mack MacCormick farm, where his father had also worked. He married Ulamay Demmons in 1929, and together they raised two daughters. When his wife died in 1969, Armstrong went to work as a

foreman at the Thomson Box Factory and built furniture to supplement his income. He retired in 1982.

In 1972 Armstrong experienced an apocalyptic vision in which an angel told him: "You have to stop wasting your time because the end of the world is coming." He responded by beginning to create a range of timekeeping devices—ledgers, calendars, and innovative end-time "clocks"—intended to calculate the Second Coming. Art historian Grey Gundaker has fruitfully grounded Armstrong's experience and artwork within African diasporic vernacular culture, specifically grass-roots creative responses to interpreting passages in the New Testament that speak to the unknown hour of the apocalypse.

Often taking the form of wrapped and taped box constructions, Armstrong's calendars and clocks bear the mark of his work in the box factory. Yet his works cannot be pinned down to this form alone. Following the make-do ethic shared by many southern self-taught artists, he has used all kinds of found objects (fans, mailboxes, clocks, and even vending machines) and materials (paper, cardboard, and wood) to create his inventive devices articulated with black, red, white, and blue paint. From flat calendars with dates running on grids to clocks with moving hands, these eschatological calculators invite viewers—Christian or not—to meditate on the passage of time. It is estimated that Armstrong made approximately 1,500 works. His oeuvre, reaching far beyond standard Christian interpretations of end-time prophecy, reveals the hand of a true mystic.

Zebedee B. Armstrong's work can be seen in the Birmingham Museum of Art, Morris Museum of Art, and the Baron and Ellin Gordon Art Galleries at Old Dominion University.

JENIFER BORUM
New York, New York

Grey Gundaker, *Signs of Diaspora / Diaspora of Signs: Literacies, Creolization, and Vernacular Practice in African America* (1998); Roger Manley, ed., *The End Is Near: Visions of Apocalypse, Millennium, and Utopia* (1998); Kimberly Nichols, in *Passionate Visions of the American South: Self-Taught Artists from 1940 to the Present*, ed. Alice Rae Yelen (1993); Betty-Carol Sellen with Cynthia J. Johanson, *Twentieth-Century American Folk, Self-Taught, and Outsider Art* (1993).

Arning, Eddie

(1898–1993)

Raised on a farm in east Texas by German immigrant parents, Eddie Arning, born Carl Wilhelm Edward Arning, was diagnosed as schizophrenic and committed to the Austin State Hospital in 1934. When he no longer displayed symptoms of the disease, he was transferred in 1950 to the Texas Confederate Home for Men, an annex of the hospital. Helen Mayfield, an artist who volunteered at the state nursing home in the summer of 1964, introduced Arning to drawing with crayons. Impressed by his sureness of color and form, Helen and her husband, Martin Mayfield, began exhibiting Arning's drawings at local venues. After meeting him in 1965, Alexander Sackton, professor of English at the University of Texas, Austin, began promoting Arning's art. Within three

Eddie Arning, Farm Scene, *1960–70, oilstick and pencil on paper, 32" x 22" (Courtesy John and Susan Jerit)*

years, Arning's work had been shown in galleries from Austin to Boston, and four of his drawings were included in Herbert W. Hemphill Jr.'s landmark 1970 Museum of American Folk Art exhibition *Twentieth-Century American Folk Art and Artists.*

Sackton's interest in Arning was both professional and personal. From strikingly different backgrounds but similarly quiet and reflective, the two friends visited often. Sackton fostered the artist's pride in himself and his work by encouraging him to explore new subjects and compositions and by purchasing professional materials with money that Arning had earned from the sale of his drawings. In 1967 Sackton arranged for Arning to move to a private nursing home in Austin; he resided there until 1973, when he moved to McGregor, Tex., to live with his recently widowed sister,

Ida Buck. In declining health, he again moved into a nursing home in 1986, where he remained until his death from natural causes seven years later at the age of 95.

Arning created more than 2,000 crayon and oil pastel drawings between 1964 and 1974. He also made a dozen or more postage stamp collages. Most of the nearly 500 drawings he created from 1964 to 1966 contain creatures or objects against a solid background. Arning based his pictures of animals and implements, flowers and fish, musical instruments and game boards on memories of life on his family's farm.

Without explanation, in 1966 Arning began using illustrations and advertisements he tore from popular magazines such as *Life, Woman's Day, Sports Illustrated,* and *Reader's Digest* as the models for his drawings. The artist delighted

in the opportunities offered by these photographs and drawings to create increasingly complex compositions, involved narratives, dynamic patterning, and rich color combinations. Arning's stylized profile figures and boldly abstracted settings remained striking characteristics of his work through his transition to oil pastels in 1969. After moving from Austin in 1973, however, the artist's compositions quickly diminished in number and strength. Although his small circle of friends visited him in McGregor, without their regular company and support Arning lost interest in his art. He stopped drawing and briefly took up constructing furniture and storage boxes from scrap lumber. Discouraged that passersby showed no interest in the pieces he displayed for sale in his yard, Arning soon abandoned that artistic effort as well.

Until his death in 1992, Sackton remained a tireless and effective champion of Arning and his art. Working with curator Barbara Luck, he arranged a major exhibition and catalog of Arning's drawings at the Abby Aldrich Rockefeller Folk Art Center in 1985. In addition, between 1985 and 1987 Sackton donated more than 100 of Arning's drawings to 17 museums nationwide, solidifying the artist's place as a major 20th-century folk artist. Today works by Arning can be found in numerous prominent galleries that deal in self-taught art as well as private collections throughout the United States.

PAMELA SACHANT
North Georgia College and State University

Eddie Arning, *Selected Drawings, 1964–1973*, catalog for an exhibition organized by the Abby Aldrich Rockefeller Art Center (now Museum), Colonial Williamsburg Foundation (1985); Pamela Jane Sachant, "The Art and Life of Eddie Arning" (Ph.D. dissertation, University of Delaware, 2003), *An International Journal of Intuitive and Visionary Art, Outsider Art, Art Brut, Contemporary Folk Art, Self Taught Art* (Fall 1999).

Arnold, Edward Everard

(b. ca. 1816–1824; d. 1866)
A native of the town of Heilbronn in Württemberg, Germany, Edward Everard Arnold arrived in New Orleans sometime between 1846 and 1850 and remained there until his death in 1866. Like many artists-craftsmen of the era, he divided his time as a sign painter, lithographer, genre and history painter, portraitist, and marine painter. Arnold probably learned the lithography trade as an apprentice in Germany, but he appears to have been a self-taught painter. Today, he is best known for the ship portraits that he presumably painted for New Orleans commission merchants, cotton factors, and masters of visiting ships.

The format and composition of his ship portraits demonstrate an intimate familiarity with the established tradition of English and American ship portraiture of the era, although Arnold's technique is, with a few exceptions, decidedly naive. Vessels in Arnold's paintings typically appear in profile to best illustrate specific attributes. Although sometimes integrated into their environment, they are treated in a glyptic fashion that emphasizes details significant to

the mariner, such as the configuration of sails and location of lines. He signed nearly all of his ship portraits and painted the name and other particulars of many in black borders along the canvas's lower edge. As Estill Curtis Pennington has noted, Arnold's black borders probably derive from *verre églomisé* legends that frequently appear on China trade reverse-glass paintings. At any rate, Arnold's use of the black border demonstrates the vital exchange of artistic conventions between Europe, Asia, and the United States made possible by the thriving international mercantile economy.

Arnold was described in the New Orleans press shortly after his arrival as a "talented young German artist" without equal in the branches of portraiture and marine painting. Although he may have been New Orleans's leading ship portraitist, claims about his skills as a portraitist are probably hyperbole. However, precise assessment is difficult, as public collections currently exhibit none of Arnold's portraits. Arnold entered into a short-lived partnership with James Guy Evans in September 1850 to produce a panoramic view of the city from Marigny, but the project apparently did not materialize. However, both Evans and Arnold signed several paintings such as *Levi Woodbury of New Orleans* (1850). Evans's reportedly erratic behavior and religious fervor may have contributed to the rapid dissolution of the partnership. The same year, Arnold collaborated with R. W. Fishbourne on an ill-fated attempt to secure subscriptions for a lithograph of New Orleans. Arnold married Caroline Mary

O'Reilly of Ireland in April 1851. A press notice suggests that he was now offering portraits at a price so attractive that "no family should be without them."

Toward the end of his career Arnold painted several views featuring Civil War naval engagements such as *The Battle of Port Hudson, Louisiana, July 9, 1862* (1864). He died in New Orleans on 14 October 1866, a few days after his three-year-old son, Charles Edward Arnold. Arnold has the distinction of being the only antebellum artist in Louisiana to list his profession as marine painter in city directories, though not until 1860. Surprisingly, he is also one of the few 19th-century artists to have specialized in ship portraits in the thriving port of New Orleans.

Arnold's works can be found in the Historic New Orleans Collection, the Louisiana State Museum, the Mariner's Museum in Newport News, Va., the Peabody Essex Museum, the Shelburne Museum, and the Smithsonian American Art Museum.

RICHARD A. LEWIS
Louisiana State Museum,
New Orleans

Alberta Collier, *Times Picayune* (20 July 1975); William H. Gerdts, *Art across America: Two Centuries of Regional Painting, 1710–1920* (1990); Historic New Orleans Collection, *Encyclopedia of New Orleans Artists, 1718–1918* (1987); Louisiana State Museum, *250 Years of Life in New Orleans: The Rosemonde E. and Emile Kuntz Collection and the Felix H. Kuntz Collection* (1968); Estil Curtis Pennington: *Down River: Currents in Style in Louisiana Painting, 1800–1950*; Roulhac B. Toledano, *The Magazine Antiques* (December 1968).

Arnold, John James Trumbull

(1812–ca. 1865)

Working at mid-19th century, John James Trumbull Arnold promoted himself as a "Professor of Penmanship" as well as a portrait and miniature painter. The fine linear skills associated with pen and ink are reflected in the clean, simple outlines of his figures, and they also lend a touch of elegance to his distinctive style. The hallmarks of his work include soft gray-brown shading round the eyes, minutely painted eyelashes, and simple arched eyebrows. Arnold also painted his sitters with minimal modeling. The flat, two-dimensional rendering of their hands, set in a frontal position with fingers straight or awkwardly bent, is another distinguishing characteristic of his portraits.

There is little information about the life of this painter, aside from that fact that he was born in 1812—one of the eight children of Dr. John B. and Rachel Arnold of York County, Pa. According to an advertisement, it appears that Arnold had begun working at least by 1841. Approximately 35 portraits have been attributed to Arnold, most of them executed in Pennsylvania, although a number have also been found in Washington, D.C., West Virginia, and western Virginia. Although it is possible that sitters traveled to Washington to have portraits painted, it is more likely that Arnold was an itinerant painter. Like most itinerants, he left no diary or account book. It is believed that Arnold died as a result of alcohol consumption shortly after the Civil War. His work is included in the collections of the Abby Aldrich Rockefeller Folk Art Center and the New York State Historical Association.

MARILYN MASLER
Memphis Brooks Museum of Art

Paul D'Ambrosio and Charlotte M. Emans, *Folk Art's Many Faces* (1987); Beatrix T. Rumford, *American Folk Portraits: Paintings and Drawings from the Abby Aldrich Rockefeller Folk Art Center* (1981).

Artists with Disabilities

Inspired by the activism of the civil rights movement of the 1960s and 1970s, many minority groups organized their own campaigns for recognition and justice. People with disabilities, their families, and health professionals demanded services, including education and deinstutionalization. The disability rights movement and deinstutionalization of many former inmates of psychiatric institutions led to the establishment of programs where former patients might participate in vocational training, life skills education, and recreation. The 1970s thus saw the founding of art centers that allowed people with disabilities a new freedom of expression. The various centers encouraged people with disabilities to enjoy poetry, literature, music, visual arts, drama, and dance.

Today, visual artists with disabilities engage with an art world that includes collectors, galleries, and museums. Some of the visual arts studios have grown out of large mental health or social services programs; these studios may offer art therapy along with independent art making. Other studios take as their model the freestanding Creative Growth Art Center, founded in Oakland, Calif., by Elias Katz and Florence

Ludins-Katz in 1974. The Katzes, while understanding that art is often as therapeutic for the observer as for the creator, did not offer art therapy but rather a means for people with disabilities to express themselves independently. According to Elias Katz, the mission of art centers for people with disabilities is to provide an art program that promotes creativity, independence, dignity, and acceptance within the community. Today, most studios, no matter what their founding principles may have been, have embraced the Katzes' ideals, offering public exhibitions, projects with community participation, and marketing that allows artists both to earn money and to enjoy new identities as artists.

In the South, the studios established by J. Iverson Riddle and his wife, Martha Riddle, and by the Enola Group, which has partnered with the J. Iverson Riddle Developmental Center, in Morganton, N.C., are perhaps the best-known studios. The original center was opened in 1979, after staff at the Western Carolina Center (now known as the J. Iverson Riddle Developmental Center) recognized that one of the center's residents, Harold Crowell, was trying to communicate by drawing on virtually anything he could get his hands on. In 1993 the Enola Group partnered with Riddle Institute to open Signature, the only studio in the United States where artists with developmental disabilities both lived and worked. In 1994 Riddle opened Studio XI, an art co-op and gallery that provides art activities and studio space, mounts exhibitions, and markets the work of artists

associated with the Enola Group and the Riddle Institute.

Other southern art studios include LifeSpan in Charlotte, N.C., the Enrichment Center in Winston-Salem, N.C., Studio by the Tracks in Irondale, Ala., Imagine Art in Austin, Tex., and Very Special Arts (VSA). VSA, established by Ambassador Jean Kennedy Smith in 1974, is an umbrella organization with chapters in many states, including states in the South, and in other countries. Regional and national exhibitions mounted by VSA have contributed to awareness of the value of the art and the art making by people with disabilities.

Southern artists with disabilities who have received attention in the self-taught and, indeed, contemporary art worlds include Gene Merritt, Harold Crowell, and Laura Craig McNellis. Merritt's work, better known in Europe than in the United States, is in the Collection de l'Art Brut in Lausanne and the abcd collection in Paris, and the South Carolina State Museum. McNellis's work is in the permanent collections of the Collection de l'Art Brut, abcd, and Intuit: The Center for Intuitive and Outsider Art. Many southern artists with disabilities have exhibited at New York's annual Outsider Art Fair. Others have not yet received recognition in the art world.

MICHELLE WILLIAMS
University of Memphis

Anne Allen and George Allen, *Everyone Can Win: Opportunities and Programs in the Arts for the Disabled* (1988); Elias Katz and Florence Ludins-Katz, *Art and Disabilities: Establishing the Creative Art Center for*

People with Disabilities (1990); Elias Katz, *Art Centers for Adults with Disabilities.*

Ashby, Steve

(1904–1980)

After the death of his wife in 1950, retired farmer and gardener Steve Ashby began to craft the sculptures he called "fixing ups." These assemblages, made of odd pieces of lumber, logs, branches, roots, broken children's toys, bits of hardware, hickory nuts, fabric, and photographs cut from magazines included small works that could be displayed on a table as well as life-size male and female figures. The large female figures wear Ashby's late wife's clothing and jewelry, even bras and panties. Beneath their clothing, Ashby's figures, including those displayed in his yard, are anatomically complete. Ashby liked to tell visitors, "She's all woman" or "He's all man." The sly eroticism of these clothed figures, however, pales next to the salacious but humorous pairs of figures whose moving parts, activated by the wind, by pushing levers, or by pulling strings, perform elemental acts. While Ashby kept the most graphic sculptures under his bed and showed them only reluctantly to female visitors, he also delighted in sharing his naughty jokes: he added breasts made of acorn caps to photographs cut from men's magazines, applied bits of fur to articulated figures, and indicated the virility of male figures with salvaged metal springs.

While the catalog of the groundbreaking exhibition *Black Folk Art in America, 1930–1980* discussed Ashby's erotic works, the examples illustrated are rather tame. Indeed, for many early collectors, the erotic works were simply too challenging. Thus, many early collections, including those later acquired by institutions like the Smithsonian American Art Museum, focus on tamer examples. These works nonetheless demonstrate Ashby's wit and desire to entertain. A gaily dressed woman plays a piano when a string is pulled, animals full of personality wear ambiguous expressions, a jaunty woman clutches her handbag, a snappily dressed gentleman struts. Later exhibitions such as *Self-Taught Artists of the 20th Century*, organized by the American Folk Art Museum, presented the full range of Ashby's work. Ashby's works appear in the collections of the American Folk Art Museum, the Smithsonian American Art Museum, and the Roger Brown Study Collection at the School of the Art Institute of Chicago.

CHERYL RIVERS
Brooklyn, New York

Paul Arnett and William Arnett, eds., *Souls Grown Deep: African American Vernacular Art of the South*, vol. 1 (2000); Stacy C. Hollander and Brooke Davis Anderson, *American Anthem: Masterworks from the American Folk Art Museum* (2001); Mason Klein, in *Self-Taught Artists of the 20th Century: An American Anthology*, ed. Elsa Longhauser and Harald Szeemann (1998); Jane Livingston and John Beardsley, *Black Folk Art in America, 1930–1980* (1982).

Audubon, John James

(1785–1851)

John James Audubon was a self-taught artist whose work art historians virtually ignored until the middle of the

20th century. Audubon claimed that he had "studied drawing for a short time in youth under good masters." He once claimed an early relationship with no less a master than Jacques-Louis David. However, this claim was probably an attempt to establish an artistic pedigree after the fact. Theodore Stebbins wrote that Audubon may have "only admired [David] from a distance," and biographer Richard Rhodes declared that Audubon maintained this fiction to "pad his credentials." Like Davy Crockett, with whom he seems to have shared several personality traits, Audubon was the creator of his own myth. Audubon's paintings are not always considered folk art, but the world of folk art has as much right as the world of "high art" to claim him as its own.

Born out of wedlock in Haiti, Audubon was more at home in the American wilderness than in Europe. He depended on his charm, colorful image, and ability to spin a yarn. Audubon's writings reveal his core identity as a romantic artist. His combined genius as both a naturalist and an artist allowed him to interpret his observations as a woodsman within subtly manipulated compositions by superimposing anthropomorphic dramas onto his representations of "each [bird] family as if employed in their most constant and natural avocations." The most obvious of these avian dramas are those involving fathers, mothers, and either eggs or hatchlings threatened by an evil outsider. For example, in one painting male and female brown thrashers protect their nest from an invading blacksnake.

When Audubon presented these idiosyncratic groupings, he sought a visual parallel to the moral allegories and fables of La Fontaine, a volume of which was among his dearest possessions. Like contemporary folk artists who find inspiration in the Bible, Audubon, grounded in this folkloric moral structure, found constant inspiration in the behavior of the birds he painted. Just as the author of a fable defines symbolic characters, he gave birds, such as the blue jay, fish hawk, and osprey, distinctly archetypal personalities. The blue jays were, to him, a "beautiful species—rogues though they be," and fish hawks were "of a mild disposition. These birds live in perfect harmony together."

Audubon's idiosyncratic visual interpretations of bird personalities are a natural reflection of his folkloric interpretations of bird behavior. For example, his painting of the peregrine falcon depicts two of these aggressive "pirates . . . congratulating each other on the savouriness of the food in their grasp. Their appetites are equal to their reckless daring." The falcon on the left confronts the viewer with a direct stare, beak wide open, hunched full length over the duck it has killed, as if to protect it from being stolen. Its mate pauses in the midst of tearing apart another duck to give the viewer a wary one-eyed glance, blood dripping from its beak. As a woodsman and expert hunter, Audubon undoubtedly identified with these predators and enjoyed positioning the specimens he collected in highly expressive poses. His method of pinning their bodies, wings, and limbs allowed

him to create expressionistic paintings of birds in dancelike positions, such as the group of "Virginian partridges" (Northern bobwhites) being "attacked by a hawk. The different attitudes exhibited by the former cannot fail to give you a lively idea of the terror and confusion" of the prey.

Audubon's genius is revealed most clearly in his ability to maintain the attitude and idiosyncratic message of the folk artist, while veiling his work in the scientific accuracy of an Enlightenment naturalist. Audubon's original watercolors can be found in collection of the New York Historical Society Museum and Library.

JAY WILLIAMS
Vero Beach Museum of Art

John James Audubon, *Ornithological Biography* (1999), *Writings and Drawings* (1999); Annette Blaugrund and Theodore E. Stebbins Jr., eds., *John James Audubon: The Watercolors for "The Birds of America"* (1993); Alice Ford, *John James Audubon: A Biography* (1988); Waldemar H. Fries, *The Double Elephant Folio: The Story of Audubon's Birds of America* (1973, 2005); Christoph Irmscher, ed., *Writings and Drawings* (1999); Richard Rhodes, *John James Audubon: The Making of an American* (2004).

Aust, Gottfried

(1722–1788)
Gottfried Aust was the first master potter in the church-governed Moravian communities of Bethabara and Salem, N.C. Born in Heidersdorf in Silesia, now Saxony, Germany, Aust trained with his father as a weaver. At the age of 19, he left his family and moved to the Moravian community of Herrnhut, Germany, where he was eventually apprenticed to Andreas Dober to learn the potter's craft. In 1754 he immigrated to the Moravian settlement of Bethlehem, Pa., where he worked briefly with the potter Michael Odenwald.

In 1755 Aust traveled with other Moravians to the newly settled community of Bethabara, N.C., where he established the first Moravian earthenware pottery in the South. The pottery was one of several church-owned businesses in which the church shared profits with the managing master. Aust worked primarily in a central European style, but he also produced some forms based on English precedents. Although utilitarian wares were the bread and butter of the pottery, Aust is known for the lively and colorful trailed, slip-decorated plates and dishes produced in his shop. The most ambitious example of Aust's work that survives is an elaborately slip-decorated plate made as his shop sign, complete with the potter's name and the date of manufacture on the front, and lugs on the verso for hanging. The shop sign serves as an index of the trailed-slip motifs and techniques Aust is known to have used.

In 1771 the pottery operation moved seven miles from Bethabara to Salem, N.C. Although the Moravian records indicate that Aust was most adept at producing both utilitarian and decorated earthenware made from "unwashed" clay or less refined locally mined clay, Aust apparently opened his Salem shop to two traveling English creamware potters visiting at different times in the 1770s. Though unidentified by name, the

first came in 1771. The second, William Ellis, came in 1773. Both had seemingly been associated with experiments in the failed attempt to establish a creamware pottery in South Carolina, and each of these potters instructed Aust in the techniques of creamware manufacture. Although the production of utilitarian wares, including slip-trailed decorative earthenwares, remained the focus of the Salem pottery run by Aust, archaeological evidence of this experiment with creamware suggests that the Moravian potters achieved at least some success in the production of fine wares.

As the founder of the North Carolina Moravian pottery tradition, one of the earliest and most important earthenware traditions in the South, Aust was pivotal in the development of a North Carolina Moravian style of earthenware that persisted to some degree through several generations of potters into the late 19th century. His best-known apprentice and journeyman, Rudolph Christ, took over the pottery operation after Aust's death in 1788.

The most comprehensive collection of earthenware made by the North Carolina Moravian potters is in the collection of Old Salem Museums and Gardens, Winston-Salem, N.C.

JOHANNA METZGAR BROWN
Old Salem Museums and Gardens

John Bivins Jr., *The Moravian Potters in North Carolina* (1972); John Bivins Jr. and Paula Welshimer, *Moravian Decorative Arts in North Carolina* (1981); Adelaide Fries, ed., *The Records of the Moravians in North Carolina* (1970); Bradford Rauschenberg, *Journal of Early Southern Decorative Arts* (Summer 2005).

Barker, Linvel
(1929–2004)

Linvel Barker, who began carving wood late in life, was born and raised in rural Morgan County, in northeast Kentucky. As a young man he married and relocated to northern Indiana, where he raised a family and worked for 30 years as a skilled maintenance technician at a steel mill. In the late 1980s he retired and returned with his wife to Isonville, Ky., where he preached at a small independent church.

Encouraged by his folk-artist neighbor Minnie Adkins, Barker began carving in 1988 to help pass time in retirement. His first carvings were roosters. He gradually expanded his range of subjects to include cats, dogs, horses, mules, cows, pigs, and buffalo. Most notable are his carvings of giraffes, which have long, upward-reaching necks and stand up to 30 inches high.

Although there were other active folk artists close by, Barker's carvings exhibit no influence from other artists. He worked in blond-colored basswood known locally as linn wood. Barker's sculptures are easily recognizable, with satin-smooth, sanded surfaces, elegant fluid lines, slender legs, and delicate feet. Even his bulky pig carvings, which have distinctive rolls of fat around the neck, have legs that taper dramatically to tiny feet. Barker did not paint his carvings, except a few early cats made in the late 1980s, on which he painted yellow-green eyes.

From early on, Linvel Barker was assisted in his work by his wife, Lillian Faye. She roughed out the basic shape with a band saw and helped with the

final sanding that gave the carvings their unique identity. Lillian Barker became a folk artist in her own right, depicting scenes from the Bible in paintings executed in acrylics on canvas board.

Soon after he began carving, Barker's work attracted the attention of collectors and dealers and demand for them escalated. By the mid-1990s his work was included in exhibitions of regional folk art and offered for sale in folk art galleries around the United States.

Linvel Barker's career as an artist ended abruptly on 12 January 1997, when his wife died in an accident in which the car Barker was driving ran off the road. He was profoundly affected by his wife's death and never produced another carving. He experienced deep depression, and his family eventually placed him in a nursing home in nearby Sandy Hook, Ky., where his health gradually deteriorated. He died there in 2004.

Although he was active as an artist for fewer than 10 years, Barker gained wide recognition for the elegance of his carvings, which are a significant contribution to the larger body of contemporary Appalachian Kentucky folk art. Barker's sculptures can be found in the Kentucky Folk Art Center, the Huntington Museum of Art, and Philip and Muriel Berman Museum of Art, and the Longwood Center for the Visual Arts.

ADRIAN SWAIN
Kentucky Folk Art Center

Julie Ardery and Tom Patterson, *Generations of Kentucky* (1994); Morehead State University, *Local Visions: Folk Art from Northeast Kentucky* (1990); Betty-Carol Sellen with Cynthia J. Johanson, *Twentieth-Century American Folk, Self-Taught, and Outsider Art* (1993); Alice Rae Yelen, *Passionate Visions of the American South: Self-Taught Artists from 1940 to the Present* (1993).

Bell, Solomon
(1817–1882)

Solomon Bell, a potter who worked in the Shenandoah Valley, was born in Hagerstown, Md., the third and youngest son of Peter Bell Jr., whose father had emigrated from Wiesbaden, Germany, in the 18th century. Peter Bell, who had been apprenticed as a potter and who followed the conventions of German utilitarian ware as practiced in Hagerstown, became the head of a long-lived dynasty of potters. The Bell family of potters flourished throughout the 19th century and included not only Solomon but also his two brothers, John and Samuel.

In 1824, when Solomon was six years old, Peter Bell moved his pottery to Winchester, Va. The boy worked alongside his older brother, Samuel, and watched his eldest brother, John, experiment with such techniques as tin glazing. Solomon worked for his father from around 1838 until 1845, except during the early 1840s, when he joined John, who had established a thriving pottery in Waynesboro, Pa. After returning to Winchester, Solomon marketed his own ware and then decided in 1845, perhaps because of his father's retirement, to work for Samuel in Strasburg, Va., where he ultimately became

his brother's business partner. Samuel, who according to tradition was the most businesslike member of the Bell family, dealt with marketing. He supervised the production side of the pottery for nearly 40 years. He never married.

Throughout his career, Solomon Bell produced stoneware sometimes modeled on earthenware prototypes and almost always decorated in traditional cobalt blue. Whether stoneware or earthenware, his crocks, jars, pans, jugs, pitchers, flowerpots, vases, cups, and water coolers were primarily utilitarian. He threw much of his work on a wheel but also used molds, a technique he likely learned from his brother John in Waynesboro. Solomon employed molds to make bottles and animals, including whippets, Staffordshire dogs, and a ewe lying with a lamb, probably inspired by chalkware models. He chose to coat his earthenware with glazed metallic oxides of manganese dioxide (brown), copper oxide (green), cobalt oxides (blue), and lead-oxide superglazes. He also ornamented earthenware dishes and pans with slip decoration that clearly recalls the Germanic traditions of Hagerstown.

Solomon Bell was not afraid to experiment, and he sometimes borrowed forms and decorating techniques from local potters. Bell's cobalt blue paintings, glazing techniques, pottery forms, and handles clearly demonstrate a distinctive versatility of approach and freshness of imagination. Undoubtedly, Bell's most original contributions were hand-modeled animals, his most famous being the lion figure of circa 1850, now in the collection of the Museum of Early Southern Decorative Art. Although the lion's torso was probably thrown on the wheel, Bell hand-modeled its four legs and head. The tail was pulled—just like the handle of a pitcher—to circle over the lion's back. The mane, whiskers, and tail tip are made of hundreds of small, clay filaments extruded through a pierced template. Using a sharp instrument, Bell carved the details of the lion's oval eyes, claws, nostrils, and teeth. Bell covered the body with a slip wash to produce the lion's characteristic buff color, used manganese dioxide for the darker parts of the animal's body, copper oxide for its green eyes, and a clear lead glaze to cover the animal's entire body.

Bell's lion, copied by his brother John, may have been inspired by the sign of the Red Lion Tavern, located near the family pottery in Winchester. The most obvious three-dimensional prototype for Bell's lion, however, must have originated among the aquamaniles (aqua + manos) of medieval Europe. Essentially ewers in anthropomorphic and zoomorphic shapes, aquamaniles were made for washing hands in liturgical or secular settings. In stance, pose, and demeanor, the aquamaniles most similar to Bell's terracotta lion are bronze ones made in Germany from the 12th century onward and revived in the 19th century, when there was a revival of interest in the medieval period. Plaster casts of a lion aquamanile acquired in 1852 by the Germanisches National-museum in Nuremberg bear a striking resemblance to Bell's lion, which dates to about the same time.

Bell's production of hand-modeled animals did not end with his lion door-

stop. Other attributions include a bear standing on its hind legs, two cats, and a seated dog with a basket in its mouth. Bell's exquisitely modeled, fiercely energetic lion doorstop, however, is his most celebrated creation and has rightly been called an icon of southern folk art.

CAROL CROWN
University of Memphis

Peter Barnett and Pete Dandridge, *Lions, Dragons, and Other Beasts: Aquamanilia of the Middle Ages, Vessels for Church and Table* (2006); Luke Beckerdite and Robert Hunter, *The Magazine Antiques* (January 2007); C. E. Comstock, *The Pottery of the Shenandoah Valley Region* (1994); George Manger and Connie Manger, *Pottery from the Shenandoah and Cumberland Valleys* (2003).

Benavides, Hector Alonzo

(1952–2005)
Hector Alonzo Benavides was born in Laredo, Tex., on 2 September 1952, the youngest of three children of a rancher in Hebbronville. The Benavides family had been ranching for more than 100 years near Laredo. Hector Benavides grew up in Hebbronville and moved to Laredo with his mother after his father's death in 1970. He became an optician and also worked for the Catholic Diocese radio station in Laredo for a short while.

As a child, Benavides was never without a pen, and he drew and doodled constantly. He first drew portraits, but his work became more abstract as he grew older. In the early 1980s, determined to take his art more seriously, he enrolled in a class in still-life drawing. He was called unteachable, because he refused to give up what would become his trademark style of dense areas of tiny abstract patterns made up of lines, dots, and triangles.

Benavides, a devout Catholic, referred to triangles as representing the Holy Trinity, squares as the cage of the obsessive-compulsive disorder from which he suffered, and circles as his escape from his illness through his art. He often worked 10 to 15 hours a day, drawing lines with a straight edge, making intricate patterns by rotating the paper as he worked, and adding small areas of colored ink. Though mainly abstract, a bird or animal might appear occasionally in his drawings.

The drawings were so tightly conceived that from a distance many have perceived them to be woven. In fact, the designs Benavides made with his ultrafine-point, rolling-ball, black-ink pens were extremely varied. He added colored ink in many hues, limiting colors to particular parts of a drawing, often applying touches of gold and/ or silver ink. His pieces shimmer with these hints of metal and color against the patterns and solid areas of deep blacks he so deftly applied.

Benavides worked at home with only his family as an audience for 10 years before showing his drawings in a gallery. In addition to obsessive-compulsive disorder, he suffered from a rare disease that shortened his tendons and forced him to suffer depression and walk with crutches.

When Benavides's mother died in 1996, he dedicated all his work to her memory. Severely depressed, he moved to San Antonio, becoming a part-time

security guard. Later, he moved to the family farm that his older brother ran. He died in his sleep there at 53 years of age.

Benavides was proud about putting his obsessive-compulsive disorder to use in making art. He once said: "Through my art, I have taken a negative and turned it into a positive." The America Folk Art Museum and the Blanton Museum of Art at the University of Texas at Austin contain works by Benavides.

N. F. KARLINS
New York, New York

Lynne Adele, *Spirited Journeys: Self-Taught Texas Artists of the 20th Century* (1997); Bruce Webb, *Raw Vision* (Summer 1999); Julie Webb, *Folk Art Messenger* (Summer–Fall 2005).

Benson, Mozell
(b. 1934)

Mozell Benson was born and raised on a farm with nine brothers and sisters. She was taught to quilt by her mother but was not interested in sewing until later in her life. She married in 1952 and again in 1955 but was widowed in 1968. She lived briefly in southern Alabama and in Chicago, but she spent most of her life supporting her family in rural central Alabama. She drove the local school bus from 1969 to 1995.

Having begun quilting out of necessity in the 1960s, Benson now creates about 20 quilts a year, piecing them during the spring, summer, and fall and tacking the tops and linings together in the winter. Brown makes quilts for her family's use and to give away. She allows a quilt top design to evolve while she

sews the pieces together. Many people give scraps of cloth to Benson because they admire her quilts. Her wide strips, somewhat wider than typical African American quilt strips, are characteristic of her designs. She explains that less time is needed for sewing, but the wide strips also delineate colors and designs particularly well. Her multicolored patterns often look like modern art. In another generation, she might have gone to art school and become a painter, as her quilts often come across as paintings in cloth. Her quilts are the visual equivalent of jazz or blues, for she often takes a basic pattern and then does variations on it as jazz musicians do.

To save time, Benson tacks the quilt layers together with evenly spaced single stitches of yarn or heavy thread. This tacking gives her quilts a feeling of openness; the single yarn color pulls together the quilt top design. The quilter's use of strips and the boldness of her designs link her art to African textile traditions. Her quilts also reflect the African aesthetic of multiple patterning and African traditions of small, square red protective charms, called mojos in African American culture. Benson comments, "Black families inherited this tradition. We forget where it came from because nobody continues to teach us. I think we hold to that even though we're not aware of it."

Quilting contributes to Mozell Benson's sense of self-worth by providing an outlet for both her creativity and her industriousness. In 1982, when discussing her future, Benson mentioned the significance quilting had come to have in

her life: "I always felt that if I got so I couldn't use part of my body, as long as I had eyes to see and hands I could still find something to do. When I can't do anything else but just sit around, I'll get back to all those little bitty pieces."

In 2001, the National Endowment for the Arts awarded Benson a National Heritage Fellowship. Her quilts are in the permanent collections of the Montgomery Museum of Fine Arts and the American Folk Art Museum.

MAUDE SOUTHWELL WAHLMAN
University of Missouri at Kansas City

Margo Jefferson, *New York Times* (22 March 2005); Anne Kimzey and Joyce Cauthen, *Tributaries* (2002); Maude Southwell Wahlman, *Signs and Symbols: African Images in African American Quilts* (2001).

Bernhart, Peter

(birth and death dates unknown)
Peter Bernhart, one of the most prolific and best known of all southern fraktur artists, lived in Keezletown, near Harrisonburg, Va. He produced fraktur for families primarily in Rockingham County, Va., as well as in Shenandoah and Augusta counties. Bernhart may have been influenced by the Pennsylvania fraktur artist Friedrich Krebs; a certificate decorated by Krebs was filled out in what appears to be Bernhart's hand for a child born in Keezletown. In addition to working at least briefly as a schoolmaster, Bernhart was a post rider who delivered German- and English-language newspapers between Winchester and Staunton, Va. Travel may have provided him with opportunities to peddle his fraktur to families

he encountered along the way. Although details of Bernhardt's early years remain obscure, the artist's residence in Virginia and documented fraktur production span an almost 30-year period, from 1789 to 1819. During the first half of his career, Bernhart produced frakturs that were written and decorated entirely by hand. Around 1810 he began using printed forms from the Henkel print shop in New Market, Va., which he then embellished with hand-drawn decoration. Later forms were printed for Bernhart by Laurentz Wartmann in Harrisonburg.

Bernhart's fraktur production was sizable, as evidenced by a surviving letter he sent in 1813 to the printer Solomon Henkel, in which he requested 100 blank certificates, along with two dozen hymn sheets. Apparently his clients had complained about the quality of previous certificates, as Bernhart specified that Henkel should take care to use only good paper so the ink would not run and the paper not be full of holes. Unlike most fraktur artists, Bernhart frequently signed and dated his work. His color palette usually consisted of a distinctive combination of bright blue, orange, pea green, and yellow. Motifs used by Bernhart include a highly characteristic long, skinny leaf with scalloped or dashed borders resembling a pea pod or caterpillar. He also frequently enclosed the certificates' central printed text with a hand-drawn double- or triple-line border. In addition to the typical birth and baptismal certificates that he produced, Bernhart also made birth records for Menno-

nite families that omitted any baptismal information. The artist's work can be found in the Winterthur Museum and Country Estate.

LISA M. MINARDI
Winterthur Museum and Country Estate

Russell D. Earnest and Corinne P. Earnest, *Papers for Birth Dayes: Guide to the Fraktur Artists and Scriveners* (1997); Bonnie Lineweaver Paul, *Bernhart and Company: Shenandoah Valley Folk Art Fraktur, 1774–1850* (2011); Klaus Stopp, *The Printed Birth and Baptismal Certificates of the German Americans* (1999); Klaus Wust, *Virginia Fraktur: Penmanship as Folk Art* (1972).

Black, Calvin and Ruby

(Calvin, 1903–1972; Ruby, 1913–1980) Calvin and Ruby Black's environment *Possum Trot*, created between 1953 or 1954 and 1972, was one of the most important vernacular art environments of the 20th century. Although situated in California's Mojave Desert near the town of Yermo, *Possum Trot* recalled the vernacular musical and carving traditions of Appalachia, where both Blacks had been born and raised.

In his teens, Cal Black left his family's home in Tennessee and joined a carnival, where he was introduced to puppetry and ventriloquism. He enjoyed performing and moved to Hollywood to work in the movie industry. A magazine advertisement brought Cal and Ruby, who lived in Georgia, together as pen pals, and in 1933 they married. After Cal was released from prison, having been jailed on charges of sedition, the couple left the South for Redding, Calif., to pan for gold. They later ran a small tourist resort near Los Angeles. Around 1950 the Blacks bought a 10-acre plot of Mojave Desert land in hopes that the dry climate would relieve Cal's suffering from diabetes.

Calling their new home Possum Trot—highland slang for a remote and backward settlement, the shortest route between two farms, or a style of house with a central breezeway also known as a dog trot—Ruby opened a rock and souvenir shop, and Cal built a fanciful locomotive, a stagecoach, and several wind-powered carousels to attract customers traveling the newly opened Highway 15. Inspired by the corncob carvings of his childhood and his interest in puppets, Cal enhanced this display by incorporating more than a dozen life-size dolls. With heads and bodies carved from redwood posts scavenged from the highway and limbs made of softer pine, each doll was given a distinct identity, including a unique costume that Ruby made from materials taken from the local dump. "He'd have the dress before he'd start carving the doll," Ruby recalled. "He always knew the color of their eyes, their hair and name, everything, before he even started."

The Blacks also created more than 50 "indoor" dolls of various sizes, and by 1969 Cal had built the Birdcage Theatre to hold his *Fantasy Doll Show*. This all-girl revue included an introductory monologue and ensemble concert with Cal providing guitar accompaniment and all the dolls' voices—in falsetto— through a system of battery-powered tape recorders and speakers embedded in the dolls. Several dolls, including

a can-can dancer and bicyclist, also moved via connections to roof-mounted whirligigs. Accessories included musical instruments, hand-painted signs and portraits, and "kitty boxes" for tipping dolls for exceptional individual performances. Cal called the show "artist's work," and without a family of his own, he came to regard the dolls as "his children."

After Cal's death the theatre closed, but Ruby refused his plea to destroy the dolls rather than see them dispersed. Today a substantial remnant of the *Fantasy Doll Show* survives in the Milwaukee Art Museum's Hall Collection of American Folk Art. Other museums, including the Smithsonian American Art Museum, the American Folk Art Museum, and the High Museum of Art also hold works by the Blacks.

JEFFREY R. HAYES
University of Wisconsin at Milwaukee

Susan L. Brown, *Connoisseur* (September 1982); Ann Japenga, "From Out of the Desert, Wooden Dolls Carved a Niche in Folk Art World," *Los Angeles Times* (7 December 1986); Allie Light and Irving Saraf, *Possum Trot: The Life and Work of Calvin Black, 1903–1972* (film) (1976); Milwaukee Art Museum, *Common Ground / Uncommon Vision: The Michael and Julie Hall Collection of American Folk Art* (1993).

Blizzard, Georgia
(1919–2002)

Georgia Blizzard, one of the South's preeminent ceramic artists, was born in Saltville, Va., on 7 May 1919. Clay became a part of her life at an early age. As children, Georgia and her sister dug in deposits from a nearby cave and river-

bank to form small toys and dishes for their own amusement. Their mother showed them how to pit-fire the pieces to make them hard, as had been done by the Native Americans whose ancestry they partially shared.

Blizzard's life was one of struggle and tragedy: she lost a lung to black lung disease contracted through her job in a textile mill. Her husband was crippled in a coal mining accident, her marriage failed, and she eventually slid into paranoid schizophrenia. However, these experiences fed Blizzard's creative impulses, which were expressed in her complex clay work. "I can get rid of taunting, unknowing things by bringing them out where I can see them," she said. "I feel the need to do it. It's all I have left." She died near her lifelong home of Glade Springs, Va., on 2 June 2002.

Clay portraits sculpted around her pottery vessels are the works for which Blizzard is celebrated. These portraits depict people she had known or imagined. Her work should not be confused with southern face jugs or "grotesques," more often associated with southern clay traditions. In fact, Blizzard might not have been aware of face jugs or other southern pottery traditions.

Blizzard's pieces are burnished and unglazed; and while she later used an electric kiln to first harden the clay, the distinctive black-to-brown flashing of her pots is the result of her refiring them in her coal kiln. Many of her pots incorporate poetically expressed sayings or sentiments. The base of one of her portrait pots of an anguished woman bears the legend, "When I'm Moaning

Time Comes Who Will Weep for Edith." The surfaces of other pots were adorned by images created in bas-relief that were then highlighted by a pertinent phrase or saying. Georgia Blizzard's ceramic work endures because she brought an artistic sensibility to a medium known more for its functionality. Many museums, including the American Folk Art Museum, the Asheville Art Museum, the High Museum, the Abby Aldrich Rockefeller Museum, and the Smithsonian American Art Museum, hold works by Blizzard in their collections.

MEG SMEAL
Allendale, New Jersey

Stacy C. Hollander and Brooke Davis Anderson, *American Anthem: Masterworks from the American Folk Art Museum* (2001); Kelly Ludwig, *Detour Art* (2007); Roger Manley, in *In Search of Elvis: Music, Race, Art, Religion*, ed. Vernon Chadwick (1995); Tom Patterson, *Not by Luck: Self-Taught Artists in the American South* (1993); Jonathan Williams, *The Independent* (12 June 2002).

Bolden, Hawkins

(1914–2005)

A blind sculptor known for representational if highly abstract objects he called "scarecrows," Hawkins Bolden displayed strong vernacular African American traditions in his art and yet stood distinctly apart from his southern self-taught peers.

Born in 1914 to parents of Creole and Native American descent, Bolden, who never married, lived his entire life in poverty in Memphis, Tenn., first in Bailey's Bottom and then from 1930 in one of two small adjacent houses shared

with relatives in the city's Midtown district. At age seven, while playing baseball, he was struck in the head with a bat by his twin brother, Monroe. Bolden developed seizures and a year later one such episode left him staring into the sun, causing his blindness. It was only in 1965 after a niece suggested he make scarecrows to keep birds out of his backyard garden that Bolden began to create his fanciful sculptures. These utilitarian constructions teem with metal-drilled holes that act as eyes. Scraps of carpet, rubber hosing, and shoe soles that become tongues. Typically Bolden fashioned his art from discarded and found objects—pots, buckets, hubcaps, tin cans, milk bottles, wiring, and wood—that were stored in a crawl space under his house.

Anthropomorphic, often in name only, Bolden's "scarecrows" have been likened to modern abstractionism. They can be approached from a number of contexts including craft (he made his own radios among other things), yard shows, bricolage and the salvage process, religion (the crosslike forms of many pieces can also be read as an expression of his Christian faith), and blindness (his body of work is distinguished by its profusion of "eyes"). Scholars have further noted Africanisms in Bolden's art. Indeed, one finds a remnant of the spiritually charged *minkisi* (Central African objects considered to contain spiritual powers or spirits) in his sentrylike totems, as well as in the motion emblems, reflective surfaces, and cosmogram-suggesting shapes that survived in such New World expressions as yard and grave art, although

care should be given in placing too much emphasis on such African continuities.

Bolden's work is in the permanent collection of the Smithsonian Institution's National Museum of American Art and has been featured in many exhibitions including 2004's *Coming Home!* at the University of Memphis, the only showing of his art Bolden ever attended.

WILLIAM L. ELLIS
Saint Michael's College

William Arnett and Paul Arnett, eds., *Souls Grown Deep: African American Vernacular Art*, vol. 2 (2001); Carol Crown, *Number* (Spring 2005); Grey Gundaker, *Keep Your Head to the Sky: Interpreting African American Home Ground* (1998); Grey Gundaker and Judith McWillie, *No Space Hidden: The Spirit of African American Yard Work* (2005); Robert L. Henningsen, *Envision* (July 1999); Judith McWillie, in *Testimony: Vernacular Art of the African-American South*, ed. Kinshasha Conwill and Arthur C. Danto (2001); Charles Russell, *Raw Vision* (Fall 2003).

Bowlin, Loy Allen

(1909–1995)

In the late 1970s Loy Allen Bowlin appeared in the town square of McComb, Miss., clad in the flamboyant attire he fashioned to fit his adopted persona: "The Original Rhinestone Cowboy." Bowlin admitted that his sobriquet was inspired by singer Glen Campbell and his 1974 anthem "Like a Rhinestone Cowboy."

At the time Bowlin had recently retired, but life had never been easy. He grew up with eight brothers and four sisters on a hardscrabble stock ranch in Franklin County, Miss. His childhood was defined by the family's struggle to stay fed, clothed, and sheltered; and his adulthood brought more of the same. In 1933 Bowlin married and started a family. Low-paying jobs and the loss of two of three children kept life's challenges in the fore. Divorce and his grown son's moving away left Bowlin struggling with isolation and depression. "I was layin' on my bedside just as lonesome as I could be," Bowlin explained. "I was by myself and so lonesome the tears just come in my eyes. I prayed and said, 'Lord, give me something to make me happy.'" It was then that Campbell's refrain seemed like a revelation.

Although Bowlin had no sewing experience, he was familiar with the Nashville-style "cowboy" outfits donned by glamorous performers such as Roy Rogers, Buck Owens, and Merle Haggard. He purchased suits in orange, red, yellow, black, and blue and adorned them with glued-on bric-a-brac and plastic rhinestones. A friend helped by painting on the back of several of the jackets an iconic image of Bowlin waving from astride a pale palomino. Bowlin coated boots, hats, and his eyeglasses in gold and colored glitter, wore a bolo tie bearing his own image, and even had his dentist inlay his dentures with rhinestones for an unforgettable smile. "I'll never forget that first time I came walking into town in that suit," he later recalled. "Everybody started calling to me, 'Hey, Rhinestone Cowboy!'"

Routinely, Bowlin drove to McComb's Sunshine Square, the shopping mall, or to regional festivals to play

his harmonica, dance, and tell jokes. He signed photographs of himself on a borrowed horse, for $1.50 apiece. His display drew attention, and crowds gathered to watch his act, precisely as he had hoped. A slate blue 1967 Cadillac crowned with a glittering set of longhorns and colorfully painted doors further announced his identity wherever he went.

In the mid-1980s, growing weary of dancing in the hot sun but wanting to retain his celebrity status and draw crowds, Bowlin commenced transforming his small home into a backdrop for his over-the-top Rhinestone persona. The small five-room house became a three-dimensional canvas on which Bowlin painted and wallpapered with sparkling collages of colored paper, photographs, tin foil, and glitter. Light fixtures, floorboards, and even the front porch received the shimmering treatment. Silver garlands and a ceiling hung with Christmas tree ornaments lent the scene a saturated and celebratory atmosphere; a professionally painted sign on the porch invited visitors into "The Beautiful Holy Jewel Home of the Original Rhinestone Cowboy."

Many visited Bowlin in his astonishing home, but after the artist's death in 1995 the home faced demolition. Efforts by some locals to preserve the home failed. Just before the slated razing of the house, Katy Emde, a Houston, Tex., artist and collector, learned of its fate. She agreed to purchase the house with the stipulation that it be entirely removed from the property. Emde carefully documented and subsequently dismantled the house, bit by bit, so it could be preserved and later reassembled. Kohler Foundation, Inc., of Kohler, Wis., acquired the dismantled house from Emde in 1998 and spent four years conserving individual works of art that covered the interior of the house. Today, the *Beautiful Holy Jewel Home*, embellished suits, donated by the artist's son, and additional works of art are part of the John Michael Kohler Arts Center collection in Sheboygan, Wis.

LESLIE UMBERGER
Smithsonian American Art Museum

Murphy Givens, *Jackson (Miss.) Clarion-Ledger* (3 November 1979); Leslie Umberger, *Sublime Spaces and Visionary Worlds: Built Environments of Vernacular Artists* (2007); Lonnie Wheeler, *McComb (Miss.) Enterprise Journal* (May 1976).

Brown, Jerry Dolyn

(b. 1942)

Jerry Brown is a traditional potter from Hamilton, Ala., and member of, arguably, the most prolific southern pottery-making family. He is known for the manufacture of a wide range of pottery forms, including the face jug, and for old-fashioned technology, such as ash glazing and grinding clay with mule power. He was awarded the National Heritage Fellowship in 1992 by the National Endowment for the Arts.

Brown and his older brother, Jack, trained in their father's shop in Sulligent, Ala., during the 1950s. Their father, Horace Vincent "Jug" Brown, was an older-than-average father, having been born in 1889 to U. Adolphus Brown of the famous Georgia pottery-making clan. Horace passed on to Jerry and Jack a turn-of-the-century pottery style. Jerry's mother, Hettie Mae Stewart, was

from a family of traditional potters from Louisville, Miss.

The deaths of his brother and father in the mid-1960s prompted Jerry to leave the pottery business. Jerry became a logger and moved to Hamilton, Ala. Though successful at logging, he yearned to return to the pottery business. Jerry met and married Sandra Wilburn in 1979. With her help, he re-entered the pottery business in 1982, converting his barn into a pottery shop.

Jerry Brown's pottery operated much like that of his father, using a wood-fired groundhog kiln and a mule-powered clay mill. In 1985 and 1986, a film crew documented this technology in *Unbroken Tradition*, produced by the Alabama State Council on the Arts and Appalshop and funded by the National Endowment for the Arts. Around 1990, Jerry converted his wood-firing kiln into a gas-firing unit. This conversion simplified the firing process, eliminating the need to tend overnight wood firings. Mules continued to grind the clay and served as picturesque marketing tools.

Initially, Jerry Brown made utilitarian forms such as flue thimbles, churns, and flowerpots much like those of his father. In 1984, Jerry took part in the Smithsonian's Festival of American Folklife and came to appreciate the heritage market for folk pottery. Afterward, he started signing his pottery and added new pottery forms and glazes to his repertoire. Inspired by the Meaders family of Georgia, Jerry and Sandra began to make chicken pottery jugs. In the late 1980s they revived the family tradition of making face jugs. Produced in many sizes, glazes, and variations, the face jug is now Brown's flagship form. Their showroom now also contains canister sets, soup bowls, coffee mugs, and many other forms. Brown glazes such as the Albany and Alberta slips and the white Bristol glaze remain important. With the help of maternal uncle Gerald Stewart, Brown added the older ash glaze to his repertoire in the early 1990s. Jerry Brown's greatest experimentation involved cobalt decoration, which he began applying randomly in a "splatter" glaze or by "feathering" it with a chicken feather.

Jerry and Sandra have trained a number of younger people in their shop, including Jeff Brown and Jeff and Tammy Wilburn, children by first marriages. Jerry Brown's Pottery is open for business near Highway 78 in Hamilton, Ala.

JOEY BRACKNER
Alabama Center for Traditional Culture

Joey Brackner, *Alabama Folk Pottery* (2006); John A. Burrison, *Brothers in Clay: The Story of Georgia Folk Pottery* (1983).

Brown, William Henry

(1803–1883)
William Henry Brown, born in Charleston, S.C., in 1803, was the most accomplished southern silhouettist of the 19th century. As a teenager he moved to Philadelphia where he spent at least 20 years. Although Brown made his artistic debut at age 16 with a full-length silhouette of Lafayette, he first turned to engineering as a profession. By the 1830s, he was working as a silhouettist in New England. In the 1840s

Brown traveled through the South. He described his talent as a "rare and peculiar," ability to execute "with wonderful facility and accuracy the outlines or form of any person or object from a single glance of the eye, and without any machinery whatever but with a pair of common scissors and a piece of black paper." He published lithographs of his work in *Portrait Gallery of Distinguished American Citizens* (1845), but almost the entire edition was lost by fire. Individual lithographs from Brown's book, however, survive. In addition to portraits, Brown's legacy of silhouettes includes scenes of military and fire companies, sporting events, and marine views. His six-foot silhouette of the *De Witt Clinton*, a locomotive, is on view at the Connecticut Historical Society. His 1842 *Hauling the Whole Week's Picking*, now in the Historic New Orleans Collection, is a striking panorama consisting of four panels and measuring approximately nine feet. This work, with subtly colored collaged figures, is one of Brown's most celebrated works. Brown also created "pasties," collages of cutout watercolor sketches pasted on lithographed backgrounds. Examples of these are also in the Historic New Orleans Collection. Brown pursued his career as an artist until at least 1859, when he resumed his work as an engineer. He died in Charleston in 1883.

PATTI CARR BLACK
Jackson, Mississippi

Penley Knipe, *Journal of the American Institute for Conservation* 41, no. 3 (2002); Jessie Poesch, *The Art of the Old South: Painting, Sculpture, Architecture, and the Products of Craftsmen, 1560–1860* (1983); Anna Wells Rutledge, *The Magazine Antiques* (December 1951).

Brown Family

The Brown family is arguably the most prolific pottery-making family in the history of the American South. Associated primarily with the state of Georgia, members of the Brown family have also worked in most of the other southern states, including Alabama, Florida, Mississippi, North Carolina, South Carolina, and Texas. They mastered all of the glazes and forms known to southern folk potters and for at least the past century have been associated with the manufacture of the iconic southern face jug.

The identity of the first Brown potter has eluded researchers and genealogists. Family tradition suggests an 18th-century English immigrant by the name of John Henry Brown was the first potter in the family to work in America. His descendants came to Georgia from Virginia in the early 19th century. As devotees of the newly developed alkaline glaze, the Browns became agents for the westward diffusion of this shiny green stoneware glaze, along with other features of southern folk pottery, such as the use of the groundhog kiln and the manufacture of face jugs.

Taylor Brown (1800–1883) was among the throng of southern pioneers to file west to Alabama's newly acquired Creek lands in 1836. In 1837 he applied for two land patents in Talladega County, Ala., where, according to family historians, he had at least three children. The family moved to Rusk County, Tex., by April 1839 and received

a 640-acre land grant from the Republic of Texas. There Brown worked as a surveyor, farmer, and potter. Brown is widely credited with being the first southern potter to bring the alkaline glaze into the Republic of Texas.

The Browns who remained east were instrumental in establishing two of Georgia's best-known pottery-making communities. Bowling Brown (1806–92) was the first documented potter in the famous Jugtown community on the Upson/Pike County line. Brown and his pottery-making brood then helped establish the pottery industry in mid-19th century Atlanta.

Starting in the late 19th century, grandsons and great-grandsons of Bowling Brown left the Atlanta area to work at various potteries throughout the South, including the Alabama jugtown of Rock Mills in Randolph County. Grandson Charles Thomas "Charley" Brown (1869–1934) was one of the most prolific potters in Rock Mills and a renowned fiddler and singing school instructor. He was one of several sons of Thomas O. "Boss" Brown (1833–75) to come to Rock Mills at the dawn of the 20th century. Boss's brothers U. Adolphus (1858–1933), James O. (1866–1929), and Theodore (1872/74–?) also became Rock Mills potters during the years before World War I, along with James's sons Bobby (1889–1959), Javan (1897–1980), Willie (1887–1966), and Davis P. (1895–1967), the great-grandsons of Bowling. Of these men, Charley and Theodore were the only ones who stayed in east Alabama. They also worked in nearby Oak Level in Cleburne County. The others wandered to other jug-

towns in Alabama, Georgia, and the Carolinas.

As the relative value of locally made pottery decreased, an economic system akin to sharecropping evolved in the pottery industry. Between the World Wars, some traveling potters worked shares for established potteries. Others built shops and shared profits with landowners who had access to good clay deposits. The Browns built more than 30 such kilns throughout the South. After this period of mobility, Otto, Davis, Willie, and Javan Brown established the Brown Brothers Pottery in Arden, N.C.

Several members of the Brown Pottery are still making pottery today. The Brown Pottery in Arden, N.C., and Jerry Brown's Pottery in Hamilton, Ala., carry on a centuries-old family tradition. The Arden shop, established in 1924, is the most long-lived Brown pottery. Here the family association with the face jug was firmly established as a tourist item in the early and mid-20th century. Charles Brown (b. 1949), the grandson of Davis, currently operates this pottery. Jerry Brown (b. 1942), great-great-grandson of Bowling Brown and 1992 National Heritage Fellow, has made face jugs popular with tourists and collectors. These and other wares can be seen at his pottery shop, established in 1982, near Highway 78 in Hamilton. Pottery made by the Browns can be seen in the Abbey Aldrich Rockefeller Folk Art Museum, the American Folk Art Museum, and the Mint Museum.

JOEY BRACKNER
Alabama Center for Traditional Culture

Cinda Baldwin, *Great and Noble Jar: Traditional Stoneware of South Carolina* (1993); Joey Brackner, *Alabama Folk Pottery* (2006); John A. Burrison, *Brothers in Clay: The Story of Georgia Folk Pottery* (1983); Charles G. Zug III, *Turners and Burners: The Folk Potters of North Carolina* (1986).

Burleson, Thomas Monroe

(1914–1997)

Born in 1914 Waxahatchie, Tex., Thomas Monroe Burleson died in Fort Worth, Tex., in 1997, leaving behind thousands of small drawings. His ballpoint and colored ink abstractions, crammed with drawings of machine parts and multiple abstract designs, were saved from oblivion by Burleson's son Bill.

As a young man, Tom Burleson dropped out of teacher's college in Texas to play minor league baseball. Facing sometimes-rowdy crowds, he was noted for going into the bleachers with fists raised, possibly an early sign of mood swings. After several short-term jobs, Burleson became a Navy seaman on a minesweeper in the South Pacific during World War II. It seems likely that Burleson's time below deck provided much of the mechanical imagery that appears in his work. His son Bill suggests that it also fueled some sort of mental breakdown. Burleson was released from service because of malaria and mental instability.

Burleson, who could be quite charming, then authoritarian, became a shipping inspector at Bell Helicopter in Fort Worth, Tex., where he worked for five years. He then moved to San Jose, Calif., to be a shipping inspector with Lockheed Missile and Space.

After working there 18 years, he retired to Fort Worth. Burleson, self-taught, began making his drawings during night shifts at Lockheed. An abusive father, Burleson spent much of his time alone and, especially later in life, drank heavily. At the same time, he was drawing obsessively, completing one work and immediately starting the next.

Burleson's earliest dated work is from 1967. He began by making drawings of nonsensical mechanical contraptions in pencil or pen on paper only a few inches in height and width. In 1970 he began to make larger works, often on the backs of shipping forms, adding vivid hues from marker pens, employing a few undiluted shades. His bright colors were influenced perhaps by art of the psychedelic 1960s. A natural colorist, Burleson employed an ever-changing palette with mastery.

Burleson's drawings are dense, emanating from the center of the page, sometimes pressing against the arbitrary boundaries that he had set for them and other times menacing the edges of the paper. His abstractions interweave a variety of patterns with mechanical gizmos. Occasionally Burleson outlined real objects—perhaps to jumpstart his imagination. He also drew abstracted versions of dogs, chickens, and birds. Many of Burleson's more mechanical amalgams read as human figures, possibly self-portraits. He put his self-portrait into several works, usually in combination with cinder-block walls and other motifs of entrapment. In tension with the claustrophobic density of the pieces and entrapment motifs are propellers and landing gear that suggest

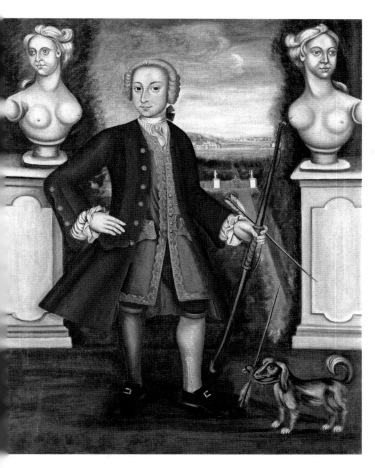

William Dering, Portrait of George Booth, *Virginia, 1748–50, oil on canvas, 50¼" x 39½" (The Colonial Williamsburg Foundation)*

Gottfried Aust, shop sign in the form of a large deep dish, Salem, N.C., ca. 1773, slip-decorated earthenware, diameter 22" (Collection of Old Salem Museums and Gardens, Winston-Salem, N.C.)

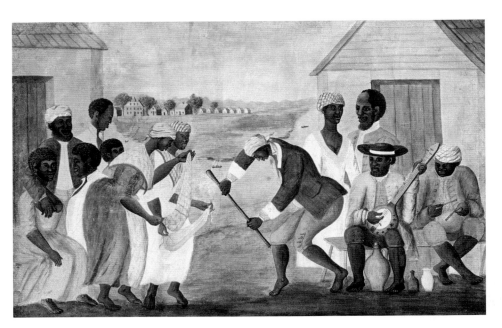

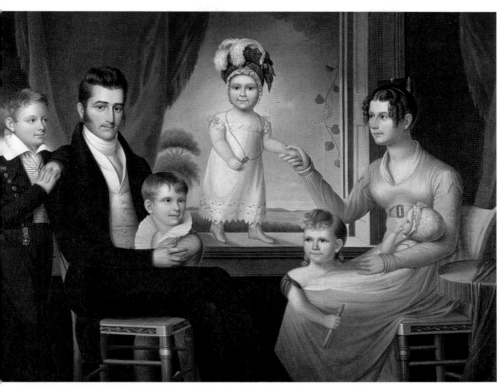

Ralph E. W. Earl Jr., The Ephraim Hubbard Foster Family, *ca. 1824, oil on mattress ticking* (*Collection of Cheekwood Botanical Garden and Museum of Art*)

(opposite)

(top) John Rose, The Old Plantation, *probably South Carolina, ca. 1795, watercolor on laid paper,* 11¹¹⁄₁₆″ x 17⅞″ (*Abby Aldrich Rockefeller Folk Art Museum, The Colonial Williamsburg Foundation, gift of Abby Aldrich Rockefeller*)

(bottom) Unknown artist, attributed to Lee Spencer, Jean Baptiste Wiltz, *ca. 1815, oil on canvas,* 43⅛″ x 36⅞″ (*Louisiana State Museum, 07326*)

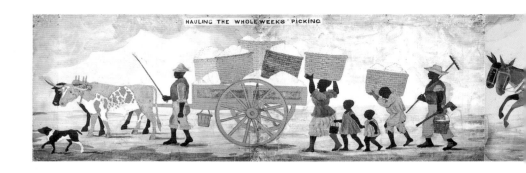

HAULING THE WHOLE WEEKS PICKING

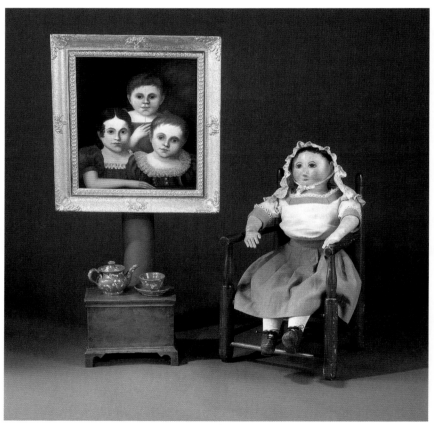

A collection of children's toys. The doll is "Miss Chitty," made by Emma Chitty (1848–1919), Salem, N.C., late 19th or early 20th century; the painting is by Daniel Welfare of the Samuel Schultz children, Salem, N.C., ca. 1831; the teapot, cup, and saucer are attributed to Henry Shaffner, Salem, N.C., ca. 1825; the miniature blanket chest is attributed to Friedrich Belo, Salem, N.C., cherry and tulip poplar, ca. 1820 (Collection of the Toy Museum at Old Salem Museums and Gardens, Accs. D-191, 2069.1, T-182, and 234)

William Henry Brown, Hauling the Whole Weeks Picking and Sara Pierce Vick on Horseback, ca. 1842, paper collage with watercolor mounted on board in five parts, 1975.93.1: 19¼″ x 28⅛″, 1975.93.2: 19⅜″ x 24⅞″, 1975.93.3: 19⅜″ x 27⅝″, 1975.93.4: 19⅜″ x 27⁹⁄₁₆″, 1975.93.5: 16¹¹⁄₁₆″ x 20⅛″ (The Historic New Orleans Collection, 1975.93.1–5)

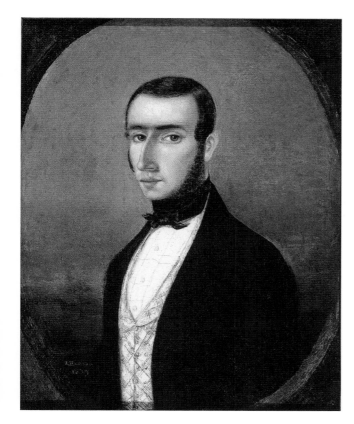

Julien Hudson, Self Portrait, 1839, oil on canvas, 8¾″ x 7″ (Louisiana State Museum, 07526 B)

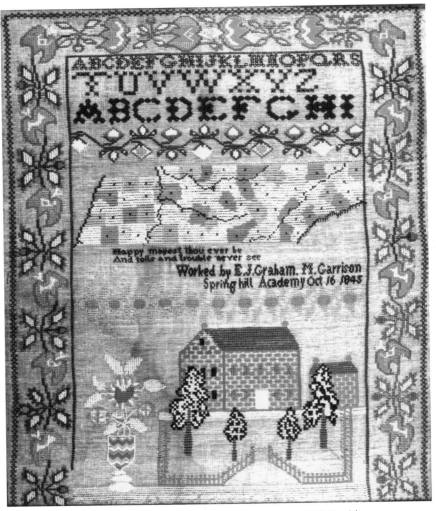

Sampler by Eliza Jane Graham, 1845, wool on linen, 14″ x 20″ (Image courtesy Rick Warwick, previously published in Williamson County: More Than a Good Place to Live)

(opposite)
(top) Edward Everard Arnold and James Guy Evans, Tugboat Panther Towing the Cotton Ships Sea King, Themis, and Columbia Up the River to New Orleans, 1850, oil on canvas, 50½″ x 40″ (Louisiana State Museum, 11430)

(bottom) Solomon Bell, ceramic lion doorstop, Strasburg, Va., ca. 1850 (Collection of the Museum of Early Southern Decorative Arts at Old Salem Museums and Gardens, Acc. 2024.95)

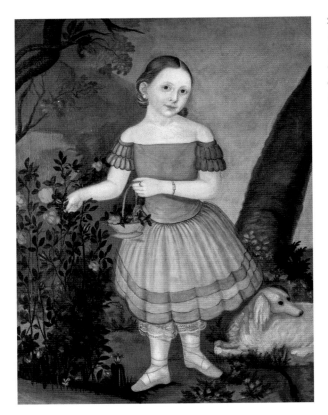

Susan Fauntleroy Quarles Nicholson, Laura Jane Harris (Mrs. James Blake) (1846–1892), ca. 1853, oil on canvas, 48¹¹/₃₂″ x 35⁶³/₆₄″ (Maryland Historical Society, 1944.17.1)

William Traylor, untitled, ca. 1939–40, mixed media on cardboard, 13″ x 7.5″ (Collection of Gordon W. Bailey)

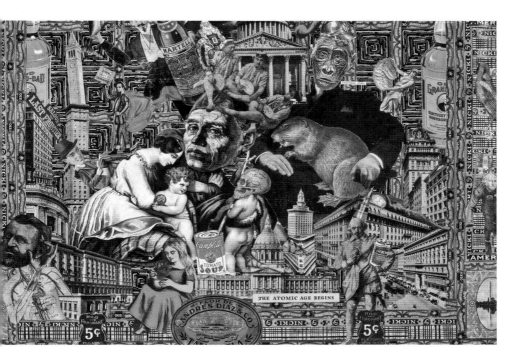

(top) Felipe Jesus Consalvos, detail of It's Not Nationality Ev'ry Time, n.d., collage on paper, 29" x 44" (Courtesy John and Susan Jerit)

(bottom) The Vega-Cal trade-sign advertisement in Hartsdale, Ala., n.d. (Photograph by Ginger Ann Brook)

Jessie T. Pettway, Gee's Bend quilt, 1950s, cotton, 95″ x 75″ (Courtesy the Souls Grown Deep Foundation, from The Quilts of Gees Bend)

Theora Hamblett, Walking, Meditating in the Woods, *1963, oil on canvas, 31″ x 43″ (Collection of Mississippi Museum of Art, Jackson, Gift of First National Bank [Trustmark])*

(top) Clementine Hunter,
Cotton Crucifixion, 1970,
oil on Masonite, 27" x 20½"
(Collection of Gordon W.
Bailey)

(bottom) David Butler,
Wiseman on Camel,
1970s, paint on metal,
28" x 26½" (Collection of
Gordon W. Bailey)

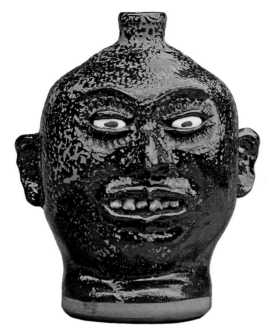

(top) Quillian Lanier Meaders, untitled, 1970s, red clay face jug with tobacco spit glaze, 11″ x 8½″ x 22″ (Collection of Gordon W. Bailey)

(bottom) Nellie Mae Rowe, Cow Jump over the Mone, 1978, colored pencil, crayon, and pencil on paper, 19½″ x 25¼″ (American Folk Art Museum 1997.10.1)

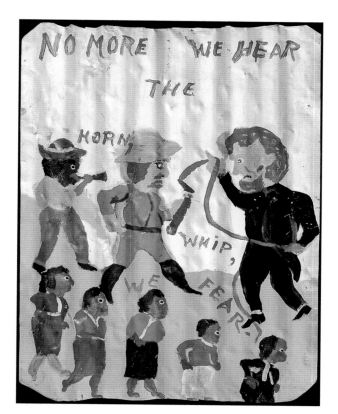

Sam Doyle, No More, *1980–85, paint on metal, 38" x 27½" (Collection of Gordon W. Bailey)*

Lonnie Holley, Family, *1985, sandstone sculpture, 23" x 28" x 11" (Collection of Gordon W. Bailey)*

Sulton Rogers, Devil Family, 1980s, paint on wood, from 12″ x 5″ x 4″ to 6½″ x 3½″ x 3″ (Collection of Gordon W. Bailey)

Hawkins Bolden, Untitled, 1987, metal pot, blanket strips, found metal, twine, nails, wood, 48½″ x 23″ x 8″ (Courtesy the Souls Grown Deep Foundation)

Edwin Jeffery Jr., The Last Supper, 1990s, paint on wood relief,
27″ x 54″ x 2″ (Collection of the University of Mississippi Museum)

Joe Wade Minter Sr., Mass Graves of Two Cultures, 1995, mixed-media environment
(Courtesy the Souls Grown Deep Foundation)

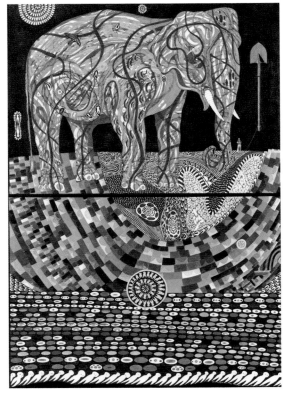

(top) Thornton Dial Sr., Don't Matter How Raggly the Flag, It Sill Got to Hold Us Together, 2003, Mixed Media, 71″ x 114″ x 8″ (Courtesy Indianapolis Museum of Art)

(bottom) John James Cromer, The Way We Dig Keeps Them Floating, 2008, mixed media on two sheets of paper, 43.5″ x 29.75″ (Courtesy J J Cromer)

a desire to flee. In the 1990s Burleson's compositions loosened with more negative space appearing, suggesting that whatever his demons, their hold on him may have partially dissipated. His work is in the collections of numerous museums, including Collection de l'Art Brut and the Museum of Fine Arts, Houston.

N. F. KARLINS
New York, New York

Edward M. Goméz, ed., *Thomas Burleson: Lone Star* (2007); N. F. Karlins, "Folk Art Notebook," www.artnet.com (15 February 2007).

Butler, David

(1898–1997)

African American artist David Butler transformed his yard and home in Patterson, La., into an art environment defined by form, color, sounds, and motion. From the late 1960s through the 1980s, Butler created a domestic environment with shapes and imagery drawn from his dreams and religious beliefs. The eldest of eight children, Butler left school as a youth to help care for his siblings and earn wages in the sugarcane fields. As a young adult, he moved to Patterson, in the bayou country of Atchafalaya Bay on the Gulf of Mexico. Butler labored at various menial jobs. Always artistic, he began to put most of his time and energy into creative efforts in 1962, after a serious head injury prevented him from returning to work.

In the early 20th century, life in Louisiana was especially challenging for African Americans. Racist attitudes prevailed, and poverty was widespread. Butler's mother, a Baptist missionary, instilled in her son a deep respect for scripture, but he was also aware of the Afro-Caribbean religion of Vodou, which was firmly rooted in the New Orleans region. Like many African Americans artists across the South, Butler fashioned a creative expression founded on an African American and Christian religious framework.

After Butler's accident, and the death of his wife soon after, the artist described his condition as chronically "nervous." Failing at conventional gardening, he began to fashion a more durable garden from cut and painted roofing tin. Using hand tools to excise his characters, he brought to life fanciful silhouettes of creatures real and imagined. Butler affixed his array of sculptures to the fence posts in his yard, onto stakes stuck in the ground, all over his bicycle, and directly onto the exterior of his house. In addition to shape and color, the sound and motion created by windmills, mobiles, and whirligigs filled the environment.

Butler's garden served multiple functions. It kept him busy, brought interested children and passersby into his life, and, like all gardens, infused his home with life. His bas-relief window screens kept the harsh sun out of his house. Arguably, however, what Butler had created was a comprehensive protective charm, wherein color, sounds, and movement held mischief at bay.

By the 1970s Butler's dynamic art environment was receiving widespread attention and acclaim. Known widely as a kind and generous person, Butler was nevertheless unwilling to sell the individual elements from his home space to

eager patrons. In the end, Butler had not the will to stave off the increasingly relentless approach of people who wanted his art. By 1982, when Butler was included in the now-famous exhibition at the Corcoran Gallery of Art in Washington, D.C., *Black Folk Art in America, 1930–1980*, most of the art from his home and yard had been removed. Butler's work is in the collections of many museums including the American Folk Art Museum, the Georgia Museum of Art, and the John Michael Kohler Arts Center.

LESLIE UMBEGRER
Smithsonian American Art Museum

Stacy C. Hollander and Brooke Davis Anderson, *American Anthem: Masterworks from the American Folk Art Museum* (2001); Charles Russell, *Self-Taught Art: The Culture and Aesthetics of American Vernacular Art* (2001); Leslie Umberger, *Sublime Spaces and Visionary Worlds: Built Environments of Vernacular Artists* (2007).

Byron, Archie

(1928–2005)

A native Atlantan, Archie Byron was a self-taught artist who created religious and secular art using a medium of his own invention. Born in 1928 to parents of mixed ancestry, Byron was raised by his maternal grandmother in the Buttermilk Bottom neighborhood of Atlanta. Byron's father, a music instructor, performed at the church attended by the Martin Luther King family, and Byron and Martin Luther King Jr. were childhood friends. Later, Byron would march with King and eventually provide security to the King family after Martin Luther King's assassination.

Dropping out of Catholic school to join the navy, Byron fought in World War II on Okinawa. Upon his return in 1949, he enrolled in a vocational school where he studied architectural drawing and masonry. After a 16-year career as a mason, Byron went on to work at a number of other occupations. He worked for the Fulton County Sheriff's Department and operated "the first black-owned detective agency in the United States," a bait shop, a firing range, a security guard training school, and a gun-repair shop. He served for a decade on the Atlanta City Council.

In 1975, while working at a construction site, Byron found a tree root resembling a gun. His wife Joyce suggested that he carve something out of it, thus launching a new career for her husband. Byron's subsequent creation of a new medium distinguishes his art. As the story goes, Byron was sweeping his gun-repair shop when he noticed the sawdust on the floor and exclaimed, "I could make something with this." Combining sawdust and small pieces of wood with white glue, he created a unique vehicle for his art. Byron's sawdust amalgam, coated onto wood, allowed him to work much like a mason, layering and building up forms. Byron's bas-reliefs and freestanding sculptures, painted with an airbrush, include biblical tableaux, portraits, self-portraits, landscapes, and still lifes. Byron's portraits of African American heroes and depictions of "ghetto life" reflect the social issues that concerned the artist during his terms as a councilman.

Most celebrated, however, are Byron's abstracted figurative compo-

sitions. Adopting a contemporary aesthetic, Byron generalizes male and female forms and exaggerates their commonalities by giving them similar features, such as eyes, noses, and ears. Byron's limited neutral palette and the rough tooth of his sawdust composite mimic soil and give the sculptures an archaic quality. Byron highlights essences and deemphasizes race and gender. Bill Arnett, a collector of Byron's art, notes that "Archie's work exhibits a universal aesthetic that doesn't limit in terms of its place and times. I think qualitatively it equals the best of the work of most of the civilizations of the world."

MELISSA CROWN
University of Memphis

Paul Arnett and William Arnett, eds., *Souls Grown Deep: African American Vernacular Art of the South*, vol. 1 (2000); Kinshasha Conwill and Arthur C. Danto, *Testimony: Vernacular Art of the African-American South* (2001); Gail Andrews Trechsel, ed., *Pictured in My Mind: Contemporary American Self-Taught Art from the Collection of Dr. Kurt Gitter and Alice Rae Yelen* (1955).

Calloway, Frank
(b. ca. 1896)
Frank Calloway, born in Montgomery, Ala., has been a resident at Bryce Hospital in Tuscaloosa, Ala., since 1952. He currently lives at the hospital's Alice M. Kidd Nursing Facility. For many years, Calloway was required to work on the farm and gardens of the hospital's 200-acre grounds. In 1970, Hal Martin, the editor of the *Montgomery Advertiser*, compared the hospital to a concentra-

tion camp, and a class-action suit demanding reforms drew attention to the notorious institution. The suit, *Wyatt v. Stickney*, emulated across the nation, was instrumental in establishing rehabilitation, freedom from physical restraints, and individual treatment plans as basic rights of institutionalized people. Since 1972, when hospital residents were first offered classes in arts and crafts, Calloway has drawn almost every day. Working from seven to nine hours each day, he says, he likes to "take his time to do the job right."

Calloway's drawings, rendered in crayon, ballpoint pen, and marker on rolls of butcher paper and painstakingly delineated with the use of straight edges and templates for circles, are memory drawings that capture a century of experiences. Calloway, who worked in the Alabama mines and in cotton mills, also dug wells and worked on the railroad. His drawings, some measuring more than 30 feet long, recall not only these work experiences but also societal changes. He is particularly fond of brightly colored vehicles. His lovingly drawn horses, farm wagons, steamboats, trolleys, trucks, farm equipment, and steam-powered trains record the progression of vehicles he has witnessed. For Calloway, all these vehicles animate scenes of daily life. Farmers drive pickups loaded with produce and animals. Well-dressed citizens wearing wide-brimmed hats ride in trolleys. Train engines and the coal cars that follow spurt plumes of smoke. Some train drawings depict trains with dozens of cars. In the Deep South, many African American homes had no elec-

tricity until the 1970s, and some of his drawings, which make a record of technological developments in the South, contain such telling details as electric poles and wires leading into buildings.

CHERYL RIVERS
Brooklyn, New York

Desiree Hunter, "Tuscaloosa Resident May Be Oldest Man in Nation," *Tuscaloosa News* (30 December 2008).

Cartledge, William Ned
(1916–2001)

A political liberal and freethinker, Ned Cartledge combined social criticism with satirical humor in his painted bas-relief wood carvings. Cartledge modestly commented, "Some writers and critics call me a folk artist. I call myself a wood carver." Although his calling card proclaimed him a "woodcarver specializing in political and social commentary," art historian Peter Morrin called him, more poetically, "a southern Hogarth."

Born in Canon, Ga., on 1 October 1916, Cartledge moved with his family to Austell, Ga., in 1925 and to Atlanta in 1930. He graduated from Boys High School in 1935. Son of a small-town bank cashier, Cartledge was influenced by the Universalist views of his grandmother and mother. As a young man, he reacted against the cruel racism that surrounded him and developed an attraction to the labor movement. Just before the onset of World War II, he found a job classifying cotton. After returning from overseas service he continued his career in the cotton industry as a cotton broker and, later, as manager of a cotton

industry arbitration service, settling pricing disputes.

From an early age, Cartledge whittled toy swords and pistols from wood salvaged from produce crates. After marrying in 1947, he began to carve boxes and plaques. In the mid-1960s he exhibited a panoramic piece, *The Story of Cotton*, at the Piedmont Arts Festival, and before the end of the decade he began to create narrative "wood constructions" as a response to the Vietnam War. He created painted bas-relief carvings such as *Under the Cloak of Justice* (1969) and *The Flag Waver* (1970) as commentaries on government wiretapping and racism. His later work in this style addressed a wide variety of social and political topics, including the nuclear arms race, the My Lai massacre, religious extremism, the rehabilitation of Richard Nixon, televangelists, and Reagan-era trickle-down economics. "I do these carvings to make statements on issues and situations which I believe are of importance to the average American," he explained.

Cartledge's painted carvings stand out from the work of many self-taught artists because their moralizing subject matter is often expressed in secular rather than religious imagery. His powerful images are complemented by confident carving, saturated color, and vivid shapes and outlines.

Atlanta gallery owner Judith Alexander gave Cartledge his first solo exhibition in 1979. In 1987 the Georgia Museum of Art of the University of Georgia at Athens organized a major one-person show of Cartledge's work, *Ned Cartledge: Comment and Satire.*

Virginia Commonwealth University's Anderson Gallery presented a third solo show, *Under the Cloak of Justice*, in 1994. His work is included in the permanent collection of the High Museum of Art. Cartledge received the Folk Art Society of America's Award of Distinction in 1995. He died on 21 September 2001, having just completed his book *The World War II Memoirs of Ned Cartledge* (2001).

JAY WILLIAMS
Vero Beach Museum of Art

Lynn Browne, *Folk Art Messenger* (Fall–Winter 2001–2); Ned Cartledge, *Ned Cartledge* (1986), *The World War II Memoirs of Ned Cartledge* (2001); High Museum of Art, *Let It Shine: Self-Taught Art from the T. Marshall Hahn Collection* (2001); Joan Muller, *Folk Art Messenger* (Fall 1993); Ann Oppenheimer, *Raw Vision* (Winter 1995–96).

Catesby, Mark

(1683–1749)

Mark Catesby, an English naturalist and self-taught artist, came to North America in order to document the South's "birds, beasts, fishes, serpents, insects, and plants." After exploring the fauna and flora along the James River between 1712 and 1719, Catesby returned to England to secure sponsorships from members of the Royal Society so that he could pursue a more comprehensive documentary project. Having secured the sponsorship of prominent backers, including the governor of colonial South Carolina, Catesby sailed to Charleston in 1722 and embarked upon four years of extensive outdoor sketching and note making. Painting from life whenever practical, he concentrated on the birds, snakes, reptiles, and amphibians that were least like European animals.

Depicting animals beside the plant forms with which they were naturally associated was one of Catesby's most notable innovations. Catesby's approach to his subject matter was guided by the spirit of British empiricism—an expression of Enlightenment values—as advocated by John Locke and George Berkeley. The empiricism evident in the drawings and descriptions in *The Natural History* was careful and in many ways systematic, but Catesby's intuitively expressive art retains a delightful sense of the irrational. Though empiricism and irrationality seem contradictory, Catesby's visual information—based upon his individual grasp of "truth"—was naturally and fortunately irrational. His illustrations for *The Little Owl, The Goat-Sucker of Carolina*, and *The Rice Bird* combine a strong sense of personality conveyed by pose and facial expression with an intuitive sense of linear design and two-dimensional composition. When Catesby depicted snakes, he used their forms and colors as part of an overall decorative design. His *Corn Snake, Green Snake*, and *Wampum Snake* are beautifully arranged in flowing linear patterns on, over, or around plant forms. Because his flora are shown as isolated cuttings or lab specimens, they often have the formality of an arrangement of pressed flowers.

One of Catesby's most amusing illustrations is *The Alligator*, "soon after breaking out of its shell," shown with mangrove seed pods and branches of

the mangrove tree that seem gigantic by comparison. The combination of a very small alligator with very large mangrove stems and leaves may be close to lifelike scale, but this work projects a strange sense of the disproportionate. "As I was not bred a painter," Catesby apologized, "I hope some faults in perspective, and other niceties, may be more readily excused."

In 1726 Catesby returned to London to seek subscriptions to support the publication of *The Natural History of Carolina, Florida, and the Bahama Islands*. Volume 1 of this important work was published in installments between 1729 and 1732, and volume 2 from 1734 to 1743. Later editions were published after Catesby's death. In the introduction to volume 1, he described his 220 examples of southern fauna and flora as "a Sample of the hitherto unregarded, tho' beneficial and beautiful Productions of Your Majesty's Dominions." Until recently, this description might have applied equally to Catesby's creative work, as his contribution to the history of southern art has been overshadowed by the illustrations of the more flamboyant Audubon. Even though some writers, such as Joyce E. Chaplin, insist that Catesby's standing as an "illustrator" has diminished his reputation as a naturalist, Catesby has not received art world attention either. His etchings and the watercolors deserve recognition as significant southern folk art. The Royal Library, Windsor, is the repository for Catesby's watercolors.

JAY WILLIAMS
Vero Beach Museum of Art

Kristin Sullivan Amacker, *Mark Catesby's The Natural History of Carolina, Florida and the Bahama Islands* (2003); Alan Feduccia, *Catesby's Birds of Colonial America* (1985); Gail Fishman, *Journeys through Paradise: Pioneering Naturalists of the Southeast* (2000); George Frederick Frick and Raymond Phineas Stearns, *Mark Catesby: The Colonial Audubon* (1961); Amy R. W. Meyers and Margaret Beck Pritchard, *Empire's Nature: Mark Catesby's New World Vision* (1998); Henrietta McBurney, *Mark Catesby's Natural History of America: The Watercolors from the Royal Library, Windsor Castle* (1997).

Christ, Rudolph

(1750–1833)

Rudolph Christ was the master potter in the Moravian communities of Bethabara and Salem, N.C. Trained by the first North Carolina Moravian potter, Gottfried Aust, Christ produced earthenware vessels in a central European style, making plain utilitarian wares; vibrant, slip-decorated plates and dishes; convincing imitations of English creamware; and press-molded figural bottles. In 18th- and early 19th-century Moravian communities, pottery operations were among several businesses owned by the church in which managing masters shared the profits.

Born in Württemberg, Germany, Christ immigrated with his family to the Moravian settlement of Nazareth, Pa., as an infant. In 1764 Christ moved to Bethabara, N.C., and by 1766 he was working as an apprentice in the shop of master potter Gottfried Aust. Christ left the pottery around 1770 and worked briefly with a gunsmith, Valentine Beck. By 1773 Christ was working again with

Aust in the potter's shop, which had moved to Salem, N.C. After the death of Gottfried Aust in 1788, Christ replaced Aust as the master potter in Salem.

Although Aust deserves the credit for establishing the Moravian earthenware tradition in North Carolina, Rudolph Christ can be credited with embracing change and experimentation within the pottery operation. Christ experimented with creamware in the mid-1770s and developed it into a profitable arm of the pottery business, using techniques learned from traveling English creamware potters. It was also Christ who in 1793 welcomed German potter Carl Eisenberg from whom he learned techniques of tin glazing. Finally, Christ introduced what has become one of the most collectable forms of North Carolina Moravian pottery, the press-molded figural bottle.

The pottery inventory taken in 1800 is the first Salem pottery inventory to list animal bottles of any kind. This new form was launched with the introduction of the turtle bottle, the mold for which was taken using an actual turtle. Over the next couple of years, the available bottle menagerie grew to include fish, squirrels, crayfish, owls, and foxes, just to name a few. Although some of the bottles functioned as casters and others may have served as flasks, most were probably purely decorative and collectable in the 19th century just as they are today. Several of the press-molded forms are reminiscent of Staffordshire antecedents. Others seem to be whimsical creations from the modeler's own imagination.

At the age of 71, Rudolph Christ re-quested that he be relieved of the management of the pottery. The church asked a journeyman in Christ's shop, John Holland, to take over the pottery operation at that time. Rudolph Christ died in 1833.

The most comprehensive collection of earthenware made by the North Carolina Moravian potters is in the collection of Old Salem Museums and Gardens, Winston-Salem, N.C. Other museums with works by Christ are the Metropolitan Museum of Art and the Mint Museum.

JOHANNA METZGAR BROWN
Old Salem Museums and Gardens

John Bivins Jr., *The Moravian Potters in North Carolina* (1972); John Bivins Jr. and Paula Welshimer, *Moravian Decorative Arts in North Carolina* (1981); Adelaide Fries, ed., *The Records of the Moravians in North Carolina* (1970); Bradford Rauschenberg, *Journal of Early Southern Decorative Arts* (Summer 2005).

Clark, Henry Ray

(1936–2006)

Henry Ray Clark was born 12 October 1936, in Bartlett, Tex. His family relocated to Houston when he was three years old, and his parents separated when Henry was 12. His father was a general contractor, and his mother, with whom Henry lived, worked as a housekeeper. Clark dropped out of school after completing the sixth grade and picked up odd jobs in the construction industry. However, he found street life more appealing and quickly slipped into a lifestyle that included gambling and drug dealing. He assumed a street name, "Pretty Boy," which he even-

tually changed to "The Magnificent Pretty Boy."

Clark's first criminal conviction, for attempted murder related to a gambling dispute, came in 1977. While in prison, he made his first drawing. Using manila envelopes, prison forms, the backs of letters, or whatever materials were accessible to him, he drew with pens and pencils, designing intricate and colorful geometric patterns that formed elaborate borders around central figures. Although he suffered partial paralysis of his drawing hand from a previous gunshot wound, his ability to draw was unimpeded. He explained that an outside force inspired him and helped him draw the pictures. He felt that "something or somebody" guided him as he drew. Clark's drawings were first discovered in a prison art show, and from there he began to receive attention in the outside world.

Released from prison after serving 13 months, Clark returned to the Houston streets, stopped drawing, and resumed his old activities. Making art only when incarcerated was a pattern he would repeat throughout the rest of his life. Five years later, Clark was sent back to prison for possession of a controlled substance. Again he began drawing to pass the time. After a second 13-month stint behind bars, he returned to Houston and quit drawing. Five years later, he was charged with possession of narcotics. Under Texas's habitual criminal statute, as a repeat offender Clark was handed a 30-year sentence and returned to prison. Once again, he found the structure of prison life conducive to making

art. Clark was released on parole in 1991 and returned to Houston. In 1994 he opened a fast-food stand, the Magnificent Burger. However, he was arrested later that year after failing to report to his parole officer as scheduled and was sent back to prison. Once again, Clark turned to drawing to pass the time. In 2001 he was released and returned to Houston. Altogether, he spent more than 15 years behind bars.

Making art offered Clark a means of transcendence from the harsh realities of incarceration. Many of his drawings allude to the mystical powers of the universe, refer to extraterrestrial life forms, or depict sexualized female figures. Images are frequently accompanied by text or by calligraphic shapes that suggest unknown alphabets. Clark's drawings represent a world far beyond the physical confines of the prison where he was transported in his imagination. He once explained, "I have my own private galaxy out there, and it has nothing to do with you-all's world."

Henry Ray Clark was shot by intruders in his Houston home on 13 July 2006. He spent the following 16 days in a coma and on life support in a Houston hospital, where he died 29 July 2006, at the age of 69.

LYNNE ADELE
Austin, Texas

Lynne Adele, *Spirited Journeys: Self-taught Texas Artists of the Twentieth Century* (1997); Henry Ray Clark, interview by William Steen, *Artlies* (Spring 2001); Patricia C. Johnson, *Houston Chronicle* (2 August 2006).

Cobb Family

The Cobb family carvers were among the most important Chesapeake Bay decoy makers. Around 1833, Nathan F. Cobb Sr. (1797–1890) moved his family from Cape Cod, Mass., to Virginia, where he was able in 1839 to acquire Sand Shoal Island, a barrier island off Chesapeake Bay's Eastern Shore. On this island, renamed Cobb Island, Nathan Sr. and his three sons operated a lucrative salvage business, hunted and fished for the market, and eventually operated one of America's most celebrated hunting resorts. In addition to the hotel, the Cobb family resort offered a Methodist chapel, a ballroom, a bowling alley, and a billiards room. The resort, which functioned from 1860 until 1896, supplied visitors with tackle, guides, and decoys.

When the Cobb family first opened its hunting retreat, the flocks of small brant geese, which remained on the island all year, and the flocks of birds migrating through the region were so vast that hunters did not need decoys. Only after the birds decreased sometime around 1870 did the family begin producing decoys. It is not certain that Nathan Cobb Sr. produced decoys. Experts ascribe a majority of the decoys signed on the bottom with a serifed *N* to Nathan Jr. (ca. 1825–1905). Nathan Jr.'s son Elkanah (1852–?) incised his decoys with a serifed *E*. Decoys marked with an *A* are possibly the creations of Albert (1836–1890), another son of Nathan Sr., or of Arthur Cobb, a nephew of Nathan Jr.

For their decoys, the Cobb family exploited all sorts of wood at hand. They used broken spars and masts that had washed up on shore after the frequent shipwrecks on nearby shoals, waste lumber, salvaged driftwood, and roots. The sturdy driftwood and roots made for particularly outstanding decoys. These hard woods stood up well in the field, and their twisted shapes inspired expressivity and creativity. The Cobbs' ability to suggest the birds' movements and their use of naturally curved wood to echo the curving necks of geese became the signature of the influential Cobb Island style. The style, however, did not derive entirely from local sources. The Cobbs' geese, ducks, and other shorebird decoys adopt and transform the characteristics of earlier New England decoys.

Cobb family decoys are among the items celebrated by the early collectors of American folk art. They are also among the most prized American decoys. With their elegant shapes and naturalistic painting, decoys made by Nathan Jr. fetch auction prices in the hundreds of thousands. Museums with Cobb family decoys include the Chesapeake Bay Maritime Museum, the Shelburne Museum, the American Folk Art Museum, and the Milwaukee Art Museum.

CHERYL RIVERS
Brooklyn, New York

Adele Earnest, *The Art of the Decoy: American Bird Carving* (1965); Joe Engers, ed., *The Great Book of Wildfowl Decoys* (2001); Henry A. Fleckenstein Jr., *Southern Decoys of Virginia and the Carolinas* (1983); John M. Levinson and Somers G. Headley,

Shorebirds: The Birds, the Hunters, the Decoys (1991); William J. Mackey, *American Bird Decoys* (1965), *The Magazine Antiques* (August 1964).

Coins, Raymond Willie

(1904–1998)

Raymond Willie Coins was born into a family of white subsistence farmers in Stuart, Va., in 1904. After moving the family to Stokes County in 1911, his father moved the family again in 1914 to Winston-Salem, N.C. Coins dropped out of school after only a few years to help on the family farm. Records of his birth date and subsequent dates of events in his life are questionable; the Coins children have told researchers that their mother set her sons' birth dates back two years so they would not have to go to war.

Married in 1925, Coins hired out as a farmer until around 1950, when he and his wife, Ruby, bought a small farm northwest of Winston-Salem. In the summer they grew tobacco and various grains. During the winter Coins worked at a tobacco warehouse, eventually becoming a floor manager during auctions. He found additional work in a sawmill and a furniture factory. After Coins retired from farming, well into his sixties, he began to carve sculptures based on visionary experiences that had occurred as early as the 1930s. A long-time member and deacon of the Rock House Primitive Baptist Church, Coins believed strongly in the spiritual messages revealed through his dreams. He stated that people and animals, such as turtles, frogs, and birds, revealed themselves to him through cedar wood,

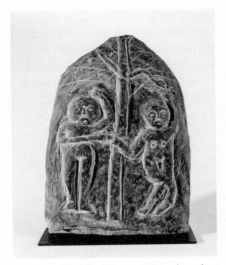

Raymond Willie Coins, Adam and Eve, n.d., carving on stone (Image from the Collection of Ellin and Baron Gordon, photograph by Tom Green)

soapstone, and river rock found near his home. He created many little soapstone figures called "doll babies," three-dimensional angels and other figures, sculptures resembling Indian artifacts, bas-reliefs of such subjects as the Statue of Liberty, and traditional Christian themes, such as the Crucifixion and Adam and Eve in the Garden of Eden.

In 1990, at age 86, Coins was forced to give up his carving because of physical limitations. Coins is one of the finest folk carvers of his time, and his wooden and stone carvings have been exhibited in major museum exhibitions nationwide. Coins's work is included in nearly every important collection in the field, including the American Folk Art Museum, the Asheville Art Museum, and the Anthony Petullo Collection of Self-Taught and Outsider Art. Coins received a North Carolina Folk Heritage Lifetime Achievement Award in 1995.

He died in 1998 at the age of 94 at his home in Westfield, N.C.

KATHERINE HUNTOON
Santa Ana, California

Rosemary Gabriel, *Folk Art* (Spring 1998); Grace Glueck, *New York Times* (19 July 2002); Vivien Raynor, *New York Times* (2 January 1994); Lowery Stokes Sims, *American Visions* (1994); Sarah Vowell, *ArtForum* (May 1994).

Consalvos, Felipe Jesus

(1891–ca. 1960)

To speak of mysterious Cuban American collage artist Felipe Jesus Consalvos is to invoke context and *constancia* (material evidence) and to speculate beyond scant biographical details. An inscription on his collaged typewriter provides an apt epitaph: "FELIPE JESUS CONSALVO * BORN IN HAVANA * 1891 * CIGARMAKER, CREATOR, HEALER, & MAN." Even the final "s" of "Consalvos" is unstable; it is an uncommon surname, possibly a corruption of a Castilian or Italian analog. His great-niece Helena Martí—who sold her "Uncle Lipe's" oeuvre to a collector/ curator in 1980 at a West Philadelphia garage sale—furnished a few further clues in a brief letter, but the artist's life remains enigmatic. Consalvos apparently grew up on his mother's farm outside Havana and immigrated to Miami (likely through Key West) in 1920 (the year of a devastating economic depression) with his wife, Eriquita, and their young son José, who later collaborated on his father's collages. Felipe worked as a *rolero* (a cigar roller) in Miami and Panama City, Fla.—unpopular locations at that early date, compared to Tampa—

and in New York before finally settling in Philadelphia. Every collage incorporates branded U.S.-manufactured cigar box labels, at least as a frame. Many of Consalvos's works on paper are double-sided. The artist's sculptures, decorated found objects, such as musical instrument cases or dressmaker's forms, also incorporate collaged images and text. We can assume that all extant artwork dates to a postimmigration period.

Cigar rolling offered both material and conceptual sources for Consalvos's art, a means of reconfiguring and reconciling the conservative visual idiom of *tabaqueros*—the glut of nostalgic chromolithographic advertising and the hobbyist tradition of cigar-band collage—with their radical politics of unionized resistance. Cigar makers were renowned for the ferocity and frequency of their strikes and for their funding of Cuba Libre. When they paid *lectores* (readers) to relieve the monotony of their repetitive, meticulous work, their preferred texts included socialist tracts, leftist and labor newspapers, and works of literature.

Consalvos's work—approximately 750 surviving collages of cigar box wraps, found (and family) photographs, dead letters, maps, sheet music, books, musical instruments, furniture, and other unexpected surfaces—extrapolates that spirit of critique into a subversive articulation of vernacular modernism. Bitingly satirical, often humorous, and provocatively engaged with imperialism, race, and sexuality— Hitler, blackface minstrels, gruesome anatomical illustrations, and grinning pin-ups (both beefcake and cheese-

cake) all make ironic appearances—his work parallels and prefigures trends in Dada, surrealist, and pop collage and modernist visual poetry. Staccato headlines and stagy compositions at once celebrate and eviscerate the icons of American history, betraying a deep skepticism of American milk-and-honey mythology, particularly the vaunted deeds of presidents. George Washington's head appears decapitated from dollar bills and dressed in drag; Abraham Lincoln is lobotomized. Beneath the political and pop-cultural sedimentation of Consalvos's practice lies another stratum. This self-described "healer," who his great-niece claimed "made medicine with the help of God," with his *chaveta* (the *rolero*'s knife) was perhaps attempting to conjure or cure (via Santeria, spiritualism, or herbalism) as well as to lacerate and layer American cultural tropes.

BRENDAN GREAVES
University of North Carolina at Chapel Hill

Edward Gomez, *Folk Art* (Fall 2006); Brendan Greaves, *Cigarmaker, Creator, Healer, and Man: The Artwork of Felipe Jesus Consalvos* (2005); Tom Mackie, *Cigar Magazine* (Spring 2006); Roberta Smith, *New York Times* (20 January 2006); Edward J. Sozanski, *Philadelphia Inquirer* (5 November 2004).

Cooke, George E.

(1793–1849)

Born in Saint Mary's County in eastern Maryland on 13 March 1793, George Cooke was the second son of seven children. After working as a clerk in a store, he began his artistic career as a self-taught itinerant painter in the area of the District of Columbia and northern Virginia. By the early 1820s, he was executing portraits in Washington, D.C., and northern Virginia. His first formal training was with Charles Bird King, a respected portraitist and a painter of Native Americans.

In 1826 Cooke and his wife, Maria Heath, left America and spent six years in Italy, England, and France. There he studied classical sculpture, prints after Greek and Roman art, and Renaissance, baroque, neoclassical, and romantic paintings. Back in the United States, Cooke made his living depicting local people and landscapes, mainly in Virginia, Georgia, Louisiana, and Alabama. He also developed a unique friendship and relationship with the Alabama manufacturer Daniel Pratt, who created an entire gallery dedicated to Cooke's work.

Cooke traveled from place to place, often staying with friends while visiting nearby communities to execute his portraits. Among his most well-known portraits are *Mrs. Robert Donaldson* (1832), *Mary Anee Foxall McKenney and Samuel McKenney* (1837), and *Henry Clay* (ca. 1839). He attained great success with these portraits and, by the time of his death from cholera in New Orleans in 1849, was one of the South's best-known painters. Cooke's other important images include *Patrick Henry Arguing the Parson's Cause at Hanover Court House* (ca. 1834), *Tallulah Falls* (1841), a sublime view of the "Niagara of the South," and *The Interior of St. Peter's* (1847), a gigantic canvas mounted on panel in the Chapel at the University of

Georgia. Today his works can be found in institutions such as the Georgia Museum of Art, the Brooklyn Museum, the Corcoran Gallery of Art, and even the Hanover County Courthouse in Virginia.

PAUL MANOGUERRA
Georgia Museum of Art
University of Georgia

Donald D. Keyes, *George Cooke, 1793–1849* (1991); Jessie Poesch, *The Art of the Old South: Painting, Sculpture, and Architecture and the Products of Craftsmen, 1560–1860* (1983).

Cooper, Ronald E. and Jessie F.

(Ronald E., 1932–2012; Jessie F., b. 1931)

Ronald and Jessie Cooper met as teenagers at a camp meeting in Fleming County, Ky., and married shortly thereafter on 8 January 1949. They worked in grocery stores in their hometown and in southern Ohio before returning to Kentucky in 1953. Here, in the early 1960s, they fulfilled their dream of owning their own grocery store. Unfortunately, after eight years they were forced to close the store and return to Ohio. Ronald worked for Frigidaire, and Jessie worked at a peanut factory and then at Kroger. The Coopers' lives were forever altered in 1984 when they were involved in a car accident in Wilmington, Ohio. Ronald, severely injured, was bedridden for months and thereafter confined to wheelchairs, walkers, and crutches during his long recovery. This accident and the couple's subsequent return to the South began the story of Ronald and Jessie Cooper as folk artists.

Ronald had always carved craft objects such as dolls and animals. After the accident, art was his salvation. Unable to get around well and plagued by nightmares, Ronald began to carve with a band saw that his children had given him. The snakes that stood upright and chased him in his nightmares became real through saw, wood, and paint. His nightmares stopped, and Ronald realized the curative properties of art. He associated snakes with the devil, and figures of the devil leading unfortunate souls to hell became a theme that continues throughout his work. Even humorous images such as *Hell in a Handbasket*, *Hell Airlines*, and *Wheeling to Hell* carry a serious message: you may not go to hell in a hand basket, an airplane, or a furniture dolly, but if you are not living your life for God, you will get there somehow.

Jessie Cooper, who began drawing at the age of six, has throughout her life created drawings and paintings for her own pleasure. Jessie's penchant for painting on found objects began as a young child, when she used pebbles to draw on rocks. She and her husband now spend many Saturdays scouring flea markets, where she chooses objects that speak to her. Just as the Holy Spirit fills the faithful in the Coopers' Christian Holiness church, so the spirit seems to imbue these objects with artistic inspiration. Jessie paints on cabinets, cow skulls, shoes, and—as always— on rocks. Her subject matter is usually lighter than her husband's. In contrast to her husband's devils, snakes, and painted texts urging viewers to get ready for the Last Judgment, she prefers heavenly scenes and idealized earthly

scenes of weddings and baptisms. She usually paints her cow skulls with Native American and animal themes. Jessie also collaborated with her husband, painting her ethereal yet earthly images on his carvings.

Like a true self-taught artist, and with genuine humility, Jessie states that she never thought of what she and her husband were making as art. She also denies gaining inspiration from other artists or works of art. In fact, the Coopers' influences ran much deeper. These artists were true to their southern roots; God and family were both the center of their world and the inspiration for their art making. Ronald insisted that his art was not a ministry, but he spoke proudly of a young man who testified in a local church and of the fact that the Coopers' work led the young man to God. Ronald's hope was that those purchasers of his work who had never given much thought to heaven and hell would contemplate the messages intrinsic to his and his wife's art. Among the museums displaying works by the Coopers are Morehead State University's Kentucky Folk Art Center and the Owensboro Museum of Fine Art.

MARGARET NORVILLE
University of Memphis

Ronald Cooper and Jessie Cooper, interview by Julia Ardery, tape recording, 2 May 1994, Kentucky Folk Art Oral History Project, Lexington; Carol Crown, ed., *Coming Home! Self-Taught Artists, the Bible, and the American South* (2004); Ellin Gordon, Barbara L. Luck, and Tom Patterson, *Flying Free: Twentieth-Century Self-Taught Art from the Collection of Ellin and Baron Gordon* (1997); Kentucky Educa-

tional Television, *Mixed Media*, first shown 19 April 2005; Adrian Swain, *Raw Vision* (Autumn–Fall 2008).

Cornett, Chester
(1913–1981)

Born in Poor Fork and raised on Pine Mountain in southeastern Kentucky, Chester Cornett learned traditional chair making from his maternal uncle, grandfather, and great uncle. The techniques involved working with green wood, allowing the unseasoned "posts" or legs in a chair to dry around the cured slats and "rounds" or stretchers. No glue or nails were required, only a small wooden peg in the back of each post to secure the top slat. Preferred materials, cut in the hills by the craftsman, included hickory and sassafras for durability and, in Cornett's case, walnut for its beauty. Seats were woven of strips of the inner bark of a hickory tree.

Small rocking chairs and simple, unadorned "settin'" chairs typified the tradition. Cornett soon innovated by increasing the size of chairs and bending the back posts outward and backward at the top, producing curving lines that please the eye as well as contribute to comfort. By the mid-1950s he gave up the foot-powered turning lathe, opting to shape each post and round by hand using a drawing knife. Intrigued by the possibilities of eight-sided pieces, he created several side chairs with seven, then eight legs and octagon seats. In the early 1960s, after his wife Ruth left him for a second time, Cornett produced tall sculptural rocking chairs with seven slats, eight legs, and four rockers that

created a feeling, he later said, "just like somebody huggin' you." These chairs stand at the beginning of a long line of ingenious constructions inspired by Cornett's fertile imagination.

Intellectual challenge on the one hand, and emotional states on the other, often determined what Cornett created. Thrilled to be reunited with his daughter Brenda upon his wife's return, he constructed a chair for her of fragile and expensive walnut. In the middle of each slat he carved a heart. He had to sell it for a few dollars, however, to buy Brenda a pair of shoes for winter. In July 1967 he dreamed of a chair, inspired by a desire to use discarded pieces of sassafras and walnut, which consists of alternating light and dark wood. The undulating arms, with a light colored peg in each side, resemble a snake. He said he would like to make a snake chair some day. He did so eight years later. The chair's seven slats are wavy, the posts ripple, each finial or knob at the top ends in a tail, and rockers and armrests look like serpents in motion. The chair appeared on the Columbus, Ohio, episode of *Antiques Road Show* in 2003.

Despite his brilliant creativity, Cornett suffered obscurity, poverty, abuse, and depression most of his life. Illiterate and shuttled between relatives as an unwanted child, he grew up isolated and withdrawn. His first and second wives deserted him. Drafted into the army and stationed in the frozen Aleutian Islands for two years, he returned with numerous physical impairments and "a nervous condition." His male children deteriorated physically and mentally through a congenital disease upon reaching puberty. At his wife's insistence, he attempted to work as a janitor, handyman, and even coal miner but failed, finally moving to a secluded hollow where he resumed making chairs that he was forced to sell cheaply. As he says in the film *Hand Carved* (released after his death), "I've traded a chair many a time for groceries."

Local attention finally came to him in 1965 through an article in the *Hazard Herald*, then regional awareness in the *Louisville Courier-Journal Magazine*, and at last broader acclaim in the *National Observer*. His life improved briefly, but in 1969 his wife left him for the last time, taking the children. He fell into a deep despondency that lasted for months. A tornado destroyed his home. He sculpted a wooden crucifix (now in the American Folk Art Museum); beneath the suffering figure of Christ, with long human hair and beard like Cornett's, is an inscription proclaiming his return. Cornett moved to Cincinnati, where eventually he took up chair making again. Chester Cornett's style, techniques, and chairs inspired numerous craftsmen, such as furniture maker Brian Boggs of Berea, Ky.

MICHAEL OWEN JONES
University of California at Los Angeles

Wendell Berry, *The Nation* (27 September 1965); Chris Beyers, *College Literature* (Fall 2003); Michael Owen Jones, *The Hand Made Object and Its Maker* (1975), *Craftsman of the Cumberlands: Tradition and Creativity* (1989); Jim Wayne Miller, *Appalachian Journal* (Summer 1978); Herb E. Smith and Elizabeth Barret, *Hand Carved* (1981); Louis Zukovsky, *"A"* (1967).

Craig, Burlon B.

(1914–2002)

Burlon B. Craig of Vale, N.C., continued the 19th-century Catawba River Valley alkaline-glazed, stoneware-pottery tradition through the 20th century. He created thousands of pieces of pottery and influenced a still-thriving community of young potters.

At the age of 14, Craig went to work for local potter Jim Lynn, who wanted the use of Burlon's mule to turn the clay grinder. Over the next few years, Craig learned every process of making pottery, including digging clay on the banks of the south fork of the Catawba River, preparing the clay and glaze, turning the ware on a foot-powered wheel, glazing, and loading and firing the wood-burning groundhog kiln. He mastered turning storage vessels needed to preserve food for farm families and jugs to transport the corn crop to market. Like the previous generation of potter/farmers, he worked for other potters who needed help. He sometimes traded his ware for food and supplies.

After serving in the Navy in World War II, Craig returned to Lincoln County to buy a farm, shop, and kiln from Harvey Reinhardt. From this location Craig continued his life as a potter, although he was forced to work at a furniture factory for nearly 20 years to support his family. Craig supplied his neighbors with pottery for preserves and sauerkraut and also provided flowerpots, vases, strawberry jars, and birdhouses. He made jars, jugs, pitchers, and bowls in many sizes. His swirl ware was always in demand. When a customer requested a wig stand, Craig added this form to the traditional shapes he produced.

The country's bicentennial in 1976 sparked interest in handmade crafts, and Craig began attracting crowds at his periodic kiln sales. He turned to making jugs and jars decorated with faces, following the work done earlier in the century by Harvey Reinhardt and the Brown family of Buncombe County. At the suggestion of a friend, he also put snakes on vessels. Folk art collectors came from distant states to acquire his pottery. His sales were local events, often attended by more than 200 people, including historians, media professionals, arts and crafts dealers, collectors, neighbors, and the curious. As interest grew, young men who wanted to become potters knocked at Craig's door. In his unpretentious way, he shared his knowledge with them, allowing them to use his experience to create new directions for an old tradition.

Craig was faithful to his craft, making alkaline-glazed stoneware the same way it had been made for generations. He was unfazed by fad and fashion, allowing only small additions of decoration to shapes that had served his community so well. Craig served as a bridge to a new generation of potters that would carry his craft into the 21st century, and perhaps longer. In 1984 Craig was named a National Heritage Fellow by the National Endowment for the Arts, and his works are at the Mint Museum, the American Folk Art Museum, and Smithsonian American Art Museum.

BARRY G. HUFFMAN
Hickory, North Carolina

Mark Hewitt and Nancy Sweezy, *The Potter's Eye: Art and Tradition in North Carolina Pottery* (2005); Charles R. Mack, *Talking with the Turners: Conversations with Southern Folk Potters* (2006); Nancy Sweezy, *Raised in Clay: The Southern Pottery Tradition* (1994).

Cromer, John James (J J)
(b. 1967)

J J Cromer grew up in Tazewell, Va., where both his parents were science teachers, a fact he credits with giving him an early interest in nature. He recalls drawing "creatures real and not" as well as writing stories from an early age. However, he had no intention of becoming an artist. Cromer earned his B.A. in history at the University of Wyoming in 1990, an M.A. in English at the University of Western Kentucky in 1994, and a Master's of Library and Information Science at the University of Southern Mississippi in 1996. He met his future wife, Mary, a fellow librarian, on the first day of his job as a reference librarian at Clinch Valley College (now the University of Virginia's College at Wise). In 1998 they married and began living on her family farm.

Cromer picked up an old art set belonging to his wife and began making drawings while the couple watched television in the evenings. Soon he was covering reams of paper with his nightly drawings. At first the Cromers hung his work in their house, and then gave some to friends. Nonetheless, Cromer eventually had boxes full of drawings. He showed some to a gallery in Bluefield, W.Va., and to his amazement, the gallery took a group and sold them. On a modest budget, Cromer also began collecting self-taught artists' work. It was in the course of buying a painting by Malcolm McKesson from dealer Grey Carter that Cromer first asked Carter if he would look at his work. Carter was impressed and became Cromer's exclusive dealer.

Mary Cromer practices environmental law, and J J draws all day, every day. He says he "has to do" his drawings and cannot imagine not making art as "a way to filter the world." He describes himself as "self taught," but, as many have noted, he is not unsophisticated. He appreciates contemporary art, but he claims that what he is doing is different from contemporary art making. "When I work as a reference librarian, it's my responsibility to provide answers. When I work on my drawings, I'm less interested in certainty. I sit in isolation, directing myself to ambiguity and exploration, skepticism and play." His method of working involves listening to music or books on tape that distract a certain level of his attention so his hand is free to create. He often starts with what he calls a "letter," ghostlike little people, or with the elongated, open oval he calls a cowry shell. He then multiplies this form until another "letter" appears. The process is intuitive, and the results are meticulously detailed, brightly colored, repetitive forms that are linked by rhythmic, two-dimensional patterns. His mixed-media works start with pen and ink and colored pencil and then add collage, paint, and scratching.

Cromer's work is in public collections of Intuit: The Center of Intuitive

and Outsider Art, the Taubman Museum of Art in Roanoke, Va., the University of Virginia at Wise, and the High Museum of Art.

PAMELA H. SIMPSON
Washington and Lee University

Brooke Davis Anderson et al., *Life in the South: Self-Taught Artists from the Huffman Collection*, catalog for Lindenau-Museum Altenburg (2004); Cara Zimmerman Campbell, "Visual Vocabularies of J J Cromer," *Raw Vision* (Fall 2010); Pamela H. Simpson, *The Outsider* (Spring 2007); *Our Stampedes are Compatible: A Selection of Works by J J Cromer*, brochure for Staniar Gallery, Washington and Lee University (2008).

Crowell, Harold

(b. 1952)
Harold Crowell is an untrained artist who lives and works in Morganton, N.C. His career as an artist began in 1975, after he became a resident of the Western Carolina Center (WCC) in Morganton, which serves clients with developmental disabilities. Dr. Ivor Riddle, who developed the art program at WCC, encouraged Crowell to continue with the art making he had done since childhood.

Crowell came to the attention of the art world during the 1990s, when his work was included in exhibitions like the New Orleans Museum of Art's *Passionate Visions* (1993). Since then, his paintings and drawings have been widely collected.

Although Crowell, like many untrained artists, is not aware of the precepts of contemporary art, he seems to be a painter in the tradition of 20th-century modernism. Crowell's use of color and form are independent of the experienced visual world. His powerful abstractions depend on color and form to create a variety of visual impressions of individuals and places and to generate spatial and three-dimensional sensations of joy, pleasure, humor, or delight for the viewer. Crowell never compromises the flat surface of paper or canvas, another hallmark of modernism.

Crowell's palette is usually limited to three or four colors that enhance the "scene" he paints. He applies his colors with a range of gestures that give his works the improvisation and immediacy associated with 20th-century painting. His colors are usually thinly layered, and they frequently overlap and intermingle, creating forms that can be uneven, rough edged, and spiky as well as smooth. His shapes reference individuals, objects, and events, and his contrasting colored forms balance each other to give his paintings an energetic equilibrium. Crowell's subjects may be friends or familiars, local scenes of the mountains, or scenes observed in books or magazines. His father was a Methodist minister who had also served as a Seabee, and Crowell frequently explores biblical and nautical scenes. The artist's references are sometimes very clear to the viewer while at other times the intense colors or unusual juxtaposition of forms seem whimsical and capricious. Recently Crowell has begun to make wire figures that he fashions from a single strand, which he twists, turns, reverses, and overlaps until the figure emerges from the tangle. These fresh, spontaneous forms recall Alexander Calder's circus figures.

For a number of years, Crowell lived in Morganton N.C. at Signature Home, a group home for artists with developmental disabilities supported by the Enola Group. He and other artists share studio space at Signature Studio, where his interaction with its larger group of gifted untrained artists stimulates and encourages him. Examples of Crowell's art are featured in the Watson School Art Collection, University of North Carolina Wilmington.

CHARLOTTE VESTAL BROWN
Gregg Museum of Art and Design

Charlotte Vestal Brown, *Homegrown and Handmade II: The Natural World*, Hickory Museum of Art, Hickory, North Carolina (2006); Roger Manley, *Signs and Wonders: Outsider Art Inside North Carolina*, North Carolina Museum of Art, Raleigh (1989); Alice Rae Yelen, *Passionate Visions of the American South: Self-Taught Artists from 1940 to the Present* (1993).

Culver, John
(b. 1960)

John Culver is an African American self-taught visionary artist from Sparta in an area known in Georgia as the Historic South. Born on 13 July 1960, he is the son of Clifford Moody and Julia Culver of Hancock County. Culver's sharecropper grandparents raised him on a large plantation called Beaver Dam, now a hunting reserve. As a youth, Culver enjoyed living with his grandparents. Culver said his grandmother was his "soul teacher" and took great care of him.

When Culver reached the 11th grade, he dropped out of high school to attend a trade school. In 1979, after a year in trade school, Culver moved from a bucolic existence in middle Georgia to Atlanta to look for work. He obtained a job as a cook. Far from home and not accustomed to an urban setting, Culver fell into deep depression and returned to Sparta in 1980. Culver remembers, "In the effort to understand life, love, and myself, I began to place my thoughts on paper in the form of art. Most important, I had to learn to love myself and recognize my own self-value. I prayed to God for a good job. Instead, he opened my mind to something greater than anything I've ever had before." The act of drawing was the epiphany that brought Culver out of his melancholic slump.

Although Culver is not a churchgoer, he attributes his drawing abilities to God and sees his paintings as signifying God's profound love. Culver's works relate to a spiritual realm, where after death the human soul exists in infinite space. Culver communicates through a personal symbolism: "Eyes represent the soul of a man, circles [a prominent shape in his drawings] expressing that there is no ending," he said. "In my work are vessels, flowing energy, space, arks [spacecrafts] booster-powered by all forms of energy. Examples: the wind, heat, love, and telepathic powers are all symbols of time and travel." He adds that his work is about "love and understanding life that has no death," and "that time, is time. Time is now."

Culver has been drawing for 28 years. His ongoing series, *Traveling through Time Trying to Find Paradise*, sees life as a journey and death as traveling to another dimension.

Traveling through Time Trying to Find Paradise was also the title of his debut exhibition in September 2006 at Georgia College and State University in Milledgeville, Ga.

Culver uses drafting tools, rulers, and a compass to draw the symbols and intricate geometric shapes that make up his mosaiclike compositions. He then fills the delineated shapes with deeply saturated inks. Culver also finds symbolism in his color choices, saying that colors "represent power and knowledge—ancient knowledge as well as present and future knowledge." Culver's mesmerizing, complex, and colorful drawings are in the permanent collection of the American Folk Art Museum.

CARLOS M. HERRERA
Georgia College and State University

John Culver, *Traveling through Time Trying to Find Paradise* (exhibition catalog) (18 September 2006).

Cunningham, Earl
(1893–1977)

Earl Cunningham (1893–1977) was born in Edgecomb, Me., near Boothbay Harbor. He was exposed at an early age to sailors' art and sailing ships. Leaving home at age 13, he made his living as a peddler and tinker. After joining the Merchant Marines, he traveled the East Coast from Maine to Florida on a series of four- and five-masted sailing ships that carried coal and other cargo. During World War II, Cunningham gave up sailing and bought a farm in Walterboro, S.C., where he raised chickens for Walterboro Army Air Field.

Cunningham's early paintings, created during the late 1920s and early 1930s, center on the harbors of New England. These are safe harbors where the ships are protected from the elements. Perhaps the artist was trying to project his desire for a personal safe harbor from hardship. Strong colors first appear in these early works—brilliant orange skies hover over a landscape painted in varying shades of bright to dark green. Cunningham sometimes finished his early paintings with handmade frames in which painted surfaces repeat the palette of the painting.

Upon moving to St. Augustine in 1949, Cunningham continued to paint harbors, but he also turned his attention to vivid scenes of Seminole Indian life in the Florida Everglades. The skies become lemon yellow, orange, green, coral, or bright blue. Cunningham's Indians wear elaborate headgear and paddle unlikely birch bark canoes on brown water. Occasionally, a Norse ship inserted into a Florida scene reveals Cunningham's idiosyncratic point of view. Cunningham's personal goal was to complete 1,000 paintings. At the time of his death in 1977, he had completed approximately 450 works. With their naive figurations and vivid, unmodulated colors, his paintings serve as a link between 19th-century American folk art and 20th-century modernism. The Mennello Museum of Art, the American Folk Art Museum, and the Smithsonian American Art Museum contain works by Cunningham.

FRANK HOLT
The Mennello Museum of Art

Robert Hobbs, *Earl Cunningham: Painting an American Eden* (1994); Wendell D. Garrett, Virginia M. Mecklenburg, and Carolyn J. Weekley, *Earl Cunningham's America* (2007); H. Barbara Weinberg, *From Sea to Shining Sea: The American Dream World of Earl Cunningham* (1998).

Davis, Ulysses

(1913–1990)

Ulysses Davis was a Savannah, Ga., barber and wood-carver who created a diverse but unified body of highly refined sculptures that reflected his deep faith, humor, and dignity.

Davis was born in Fitzgerald, Ga., in 1913 and began to carve wood as a child. After leaving high school to help support his family, he worked as a blacksmith's assistant for the railroad until he was laid off in the early 1950s. He then opened a barbershop in Savannah, "whittling," as he called it, during the intervals between customers. Davis first gained national recognition when his sculpture was included in the Corcoran Gallery's groundbreaking 1982 exhibition of work by African American self-taught artists, *Black Folk Art in America, 1930–1980*. Since then, his carvings have appeared in many group exhibitions. He appeared on the *CBS Evening News* in 1984 and received a Georgia Governor's Award in the Arts in 1988. In 1989 he was the subject of *Wooden Souls*, a slide documentary photographed by Roland Freeman and sponsored by the Georgia Humanities Council and the National Endowment for the Humanities.

Davis sold his work reluctantly because he longed for his oeuvre to remain largely intact and accessible to the public. After he died in 1990, the King-Tisdell Cottage Foundation, a Savannah institution devoted to promoting knowledge of African American culture and history, purchased his remaining work from his heirs after a major fundraising effort. Davis's dream was realized, with more than 250 of his sculptures residing today at the foundation's Beach Institute in Savannah.

Ranging from outlandish to decorous, Davis's subject matter includes biblical personages, tributes to American national and civil rights leaders, African rulers, inventive anthropomorphic or animal forms inspired by African sculpture or science fiction, humorous depictions of pop culture, offerings of love to his wife, and abstract decorative objects. His most famous work is a group of 40 busts of the presidents from George Washington to George H. W. Bush. As Davis's sculpture varies in mood from wild whimsy to quiet devotion, it also varies in style from fantastic, decorative elaboration to near-modernist simplification.

Davis carved wood he salvaged, bought at lumberyards, or received from friends, including longshoremen who had access to discarded exotic timber such as mahogany. Although his primary tools were his penknives, he was not averse to using mechanical aids for certain steps in his process, including having a friend reduce the bulk of a block with a saw or mill surface details using a bit Davis had made.

Largely because most of Davis's sculpture resides permanently in

Savannah, it is familiar outside Georgia primarily to scholars, collectors, and enthusiasts. A collection containing many Davis works is extremely rare. Nonetheless, his carvings are included in the collections of the High Museum of Art in Atlanta, the Abby Aldrich Rockefeller Folk Art Museum, and the Smithsonian American Art Museum. A few private collections also contain fine examples of his works.

SUSAN CRAWLEY
High Museum of Art, Atlanta

Susan Mitchell Crawley, *The Treasure of Ulysses Davis: Sculpture from a Savannah Barbershop* (2008); Carroll Greene, *Ulysses Davis: American Folk Artist*, King-Tisdell Cottage Foundation (1996); Lynne E. Spriggs, Joanne Cubbs, Lynda Roscoe Hartigan, and Susan Mitchell Crawley, *Let It Shine: Self-Taught Art from the T. Marshall Hahn Collection* (2001).

De Batz, Alexandre

(b. unknown; d. 1759)
Alexandre de Batz, engineer, architect, draftsman, and artist, was active in America from 1730 to 1759. He arrived in the Louisiana Territory around 1727, when French engineer-architects Ignace François Broutin and Pierre Baron arrived to build government structures in New Orleans. Referred to as "Engineer for the King," de Batz produced numerous maps and drawings of French Louisiana and plans for structures in Mobile, Natchez, and New Orleans. He worked for the Company of the Indies, located across the river from New Orleans. He also worked with Le Page du Pratz when Le Page took over the Indies property and ran it as the "King's

Plantation." De Batz was sent to Natchez in 1732 to help reconstruct Fort Rosalie after it was burned to the ground by the Natchez Indians. For three years he remained in the area, traveling around the countryside. Because of his personal interest in the Native American tribes of the area—specifically the Colapissas, Tunica, Natchez, Illinois, Fox, Attakapa, Chickasaw, and Choctaw—his legacy includes watercolors and drawings of warriors, women, and children, with carefully observed detail. Alexandre de Batz is best remembered as the architect responsible for the Ursuline Convent in New Orleans, built in 1745. In 1757, de Batz left Louisiana for Illinois to supervise completion of Fort de Chartres. He died there in 1759. His drawings and plans are in the Library of Congress, the Peabody Museum at Harvard University, and the Archives Nationales in Paris.

PATTI CARR BLACK
Jackson, Mississippi

David I. Busnell Jr., *Drawings by A. De Batz in Louisiana, 1732-1735*, Smithsonian Miscellaneous Collections 80, no. 5, publication 2925 (1927); Samuel Wilson Jr., *The Architecture of Colonial Louisiana, Collected Essays* (1987).

Dellschau, Charles August Albert

(1830-1923)
Charles August Albert Dellschau was born 4 June 1830 in Brandenburg, Prussia. Little is known about his childhood. In 1850, like many other Germans, Dellschau immigrated to Texas, entering through the port of Galveston, Tex. Six years later he applied for U.S. citizenship in Harris County, Tex. He married in 1861 and fathered three chil-

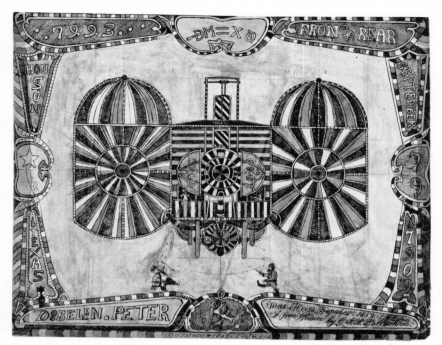

Charles August Albert Dellschau, Doblin Peter #1993, 16 September 1909, 18" x 16"
(Courtesy John and Susan Jerit)

dren. The family lived for a number of years in Richmond, Tex., where Dellschau worked as a butcher.

In 1877 the Dellschau family was struck by a double tragedy. Dellschau's wife, Antonia, and their six-year-old son, Edward, died within a two-week period. Dellschau and his younger daughter then joined his eldest daughter and her husband in Houston, where Dellschau went to work as a clerk in his son-in-law's business, the Stelzig Saddlery. He continued working there until retiring in 1900 at the age of 70.

Around the time of his retirement, Dellschau began to create mixed-media drawings of primitive flying machines, or "aeros," and to place them in scrapbooks he constructed. Dellschau first drew grids onto paper and then drew the aeros in ink and watercolor. In many of the drawings he also collaged newspaper clippings of the day. These clippings were articles about aeronautics and scientific discoveries that he collected from numerous sources, including the *Houston Chronicle*, the *New York Times*, and *Scientific American*, as well as from German-language newspapers. He called the drawings "*press blumen*" or "press blooms." Each aero was identified by name, and often specific designs were attributed to an original designer along with notes written by Dellschau in both German and English regarding their history. He also added symbols that composed a secret code.

Dellschau constructed his scrapbooks from heavy cardboard sewn together with heavy thread and bound with shoelace material. He lined the covers with purple or green cheesecloth. Some of the books had laces inserted for use as handles, and others were tied together. Dellschau numbered and dated each drawing, with the earliest extant drawings dated 1908 and the latest dated 1921, two years before his death.

Charles Dellschau died on 20 April 1923. His scrapbooks remained unknown until 1967, when they were found in a trash pile along with letters, canceled checks, and other discarded material. They ended up in a junk shop in Houston, where they remained for two more years, covered by a tarp to protect them from a leaking roof. In 1969 students from Houston's University of St. Thomas discovered them. Later that year, some of the drawings were included in an exhibition held at St. Thomas focusing on the theme of flight.

Later in 1969 four of Dellschau's volumes were purchased for the Menil Collection. The remaining eight were purchased by P. G. Navarro, a Houston UFOlogist who had visited the exhibition. Ten years later the San Antonio Museum Association purchased four of the books in Navarro's possession. These drawings are now divided between the Witte Museum and the San Antonio Museum of Art. The work has since been included in several exhibits featuring Texas folk art, but it remained relatively unknown outside of the Texas museum community and a small group of amateur scientists interested in drawings related to reported 19th-century UFO sightings. Dellschau's work was first shown outside Texas in 1996 when it was included in the American Visionary Art Museum's exhibition *The Wind in My Hair*. Shortly thereafter, a number of Dellschau's works came onto the market through a New York gallery. They became instantly collectible.

Navarro, in the meantime, had cracked Dellschau's secret code. He translated the deciphered code from German to English, unfolding an incredible story of flying machines that were built and flown by the secret Sonora Aero Club operating in California in the 1850s. Dellschau claimed that his aeros had flown with the aid of a secret antigravity substance in the form of green crystals created in a process known only to a single member of the group. Whether they depict craft that actually once existed or are the fanciful creations of Dellschau's imagination, the scrapbooks and their contents represent an artistic achievement of great vision and serve as valuable artifacts relating to man's obsession with flight. In addition to Texas museums, Dellschau's watercolors can be seen in American Folk Art Museum, abcd, the High Museum of Art, and the Philadelphia Museum of Art.

LYNNE ADELE
Austin, Texas

Lynne Adele, *Spirited Journeys: Self-taught Texas Artists of the Twentieth Century* (1997); Kathryn Davidson and Elizabeth Glassman, "C. A. A. Dellschau, A Visual Journal," Menil Collection Archives (1977); P. G. Navarro, *Visions*, vol. 2, American Visionary Art Museum (1996).

Dennis, Herman D.

(1919–2012)

Born in Rolling Fork, Miss., in 1919, Rev. Herman D. Dennis—artist, self-styled preacher, World War II veteran, and devoted husband—led a charmed life. It is hard to disagree with his claim that he had been spared for a purpose, considering what he lived through: his mother's death during childbirth (which left him alone with her for six days until someone discovered him), a deadly tornado, and a wound sustained during his tour of duty as a GI in the South Pacific during World War II. Margaret Rogers Dennis of Vicksburg, Miss., gave in to his charm when Reverend Dennis promised, at age 63, to transform her humble grocery store into something truly extraordinary if she'd marry him. In 1979 she did, and he kept his promise. The result is a remarkable art environment, titled *Margaret's Grocery and Market, the Home of the Double-Headed Eagle*, or *Margaret's Grocery* for short, located on Highway 61, just five miles from the center of Vicksburg. Margaret Dennis died in 2009. Reverend Dennis continued to live in Vicksburg, at a nursing home, until his death in 2012.

The brightly colored, geometric hodgepodge of structures and bold signage that compose *Margaret's Grocery* adds up to much more than the sum of individual parts. Reverend Dennis's message is a highly personal hybrid that mixes quotes from the New Testament with Masonic symbols, none of which seem to contradict each other but are instead unified by the overall aesthetic. To create the exterior, including a number of impressive towers,

Dennis added cinder blocks, sheet metal, and found objects to the original grocery store, painting everything predominantly bright red, white, pink, and yellow, with some blues and greens as well, mainly in a dynamic checkerboard motif. The interior, densely filled with Mardi Gras beads, Christmas lights, newspaper clippings, and additional mystical signs and images, is in its rich incrustation of surfaces a mysterious contrast to its vibrantly colored cinder block exterior.

As do many self-taught visionary artists in the South who are also ordained ministers—the best-known example being Howard Finster of Summerville, Ga.—Reverend Dennis does not "shun the nonbeliever." Just like Finster, who constructed a full-fledged chapel as part of his environment at *Paradise Garden*, so Reverend Dennis constructed a chapel in a brightly painted bus located at the side of the central structure, complete with pews, pulpit, and King James Bible, and rendered impressively shiny with silver paint, duct tape, and aluminum foil. Multiple signs welcome all people, promising "All is Welcome / Jews and Gentiles."

At once an art installation and a devotional environment, *Margaret's Grocery* bears witness to the nature of the man who created it, who was both artist and preacher, and who never distinguished between his two callings.

JENIFER BORUM
New York, New York

Carol Crown, ed., *Coming Home! Self-Taught Artists, the Bible, and the American South* (2004); Chris Thompson, Chad

Chisolm, and Dorothy-Dean Thomas, *Mississippi Folklife* (1999); Bruce West, *Arkansas Review: A Journal of Delta Studies* (2001); Stephen Young, *Southern Quarterly* (Fall–Winter 2000–2001).

Dering, William

(birth and death dates unknown)
William Dering was not a well-known painter in the 18th-century, and little is documented about him or his work. Only a few portraits have been attributed to Dering, and all are stylistically linked to his hand by one signed likeness of Mrs. Drury Stith of Williamsburg.

On 10 April 1735 Dering advertised as a dancing master in Philadelphia, Pa. He continued to advertise dancing lessons and his wife's teaching of needlework and other skills the next year. The artist was probably still in Philadelphia as late as May 1736, when local papers advertised that his horse had strayed away.

The next year Dering advertised that he had opened a dancing school at the College of William and Mary in Williamsburg. He may have traveled to Williamsburg once or twice a week for these sessions because he seems to have established a residence in nearby Gloucester County, Va. On 8 October 1738 William Dering and his wife, Sarah, were present at the baptism of their son, William, at Abingdon Parish Church in Gloucester. Dering probably painted the portraits of George Booth and his mother, Mrs. Mordecai Booth of Gloucester, during this period.

By 1739 or perhaps before, Dering encountered financial trouble and the first of many suits from various citizens in Williamsburg, York, and Gloucester counties were filed against him. Inventories of his heavily mortgaged house in Williamsburg, where he was living by the early 1740s, indicate a somewhat lavish lifestyle for a person of Dering's occupation. The artist painted several portraits in Williamsburg and also continued to teach dancing. He was acquainted with William Byrd II, whose 1674–1744 diary mentions the artist's visiting on 20 different occasions; on one of these visits, Byrd showed Dering his print collection and, on another, Dering played the French horn.

By 1749 Dering had departed Virginia and was advertising his sponsorship of a ball in Charleston, S.C., with "Mr. Scanlan." Dering was still there in 1751 when John Blair in Virginia mentioned his whereabouts in correspondence.

Judging from his surviving artwork, Dering received little or no formal training. He imitated the baroque portrait style as practiced in England and by various artists visiting the colonies. Bold in line and color, most of his paintings are linear and flat and reveal a modest understanding of painting techniques. Dering's portraits may be seen in the Abby Aldrich Rockefeller Art Museum.

CAROLYN J. WEEKLEY
Colonial Williamsburg Foundation

Graham S. Hood, *Charles Bridges and William Dering: Two Virginia Painters, 1735–1750* (1978); J. Hall Pleasants, *Virginia Magazine of History and Biography* (January 1952); Carolyn J. Weekley, *Journal of Early Southern Decorative Arts* (1975).

Dey, John William (Uncle Jack)

(1912–1978)

Ex-policeman John William Dey, who signed his paintings "Uncle Jack," probably spent the happiest time of his life in an isolated cabin in the Maine woods, where he worked briefly as a lumberjack. But it was not until psychological problems caused his early retirement from the Richmond, Va., police department that he began to explore his idyllic memories in paint.

A high school dropout, untrained in art, Dey was born in Norfolk, Va., in 1912 and raised in the nearby town of Phoebus. After his parents separated, he began at the age of 11 a series of odd jobs to help his mother. Dey's restless nature prompted him, at 20, to travel to a Maine lumber camp in search of adventure, but he soon abandoned this pursuit and returned to Virginia in 1934, settling in Richmond. There he began an ordinary working-class life, marrying and learning the barber's trade before donning a policeman's uniform in 1942.

Already known to neighborhood children as "Uncle Jack," the childless officer had long devoted his spare time to repainting their scratched toys. He also decorated objects, such as doorstops for use in his home in the historic Fan District. In 1955 Dey, only 43 years old, began to produce landscapes that recall his youthful stint trapping and felling trees in snowbound mountains. The denizens of these densely populated paintings are often unlikely; for example, Charlie Chaplin, Dey's self-proclaimed alter ego, is joined by kangaroos and elephants in surreal juxtapositions. The works' high horizon lines provide more than overarching memory fields. Their jumble of animals and Native American artifacts serve as fanciful narratives. Dey usually elaborated on these visual stories in a written description he enclosed in envelopes affixed on the paintings' reversed sides. Dey's wife, Margaret, who preferred his landscapes to other subjects, was the artist's first critic. She wanted "just scenery—don't put in all those animals."

Dey's chosen medium, airplane-model enamel, was likely a staple on his toy-laden workbench, and it served him well for the more than 650 works he produced in retirement. The enamel's bright opacity, built up in many layers—at times to a bas-relief effect—satisfied Dey's own brand of compositional concision. He liked to level his works, painting in a rabbit or plant to fix a lopsided scene, a problem he identified after going over each piece with a bright light. Satisfied with the final, often humorous narratives worked up on cardboard in thrift-store frames, "Uncle Jack" then gave away most of his early paintings. In the 1970s, however, when Dey became a topic of attention in a world he barely knew, collectors began to seek out his works.

The dark, ominous subtext of some works, indicated by huge black crows that swoop across the sky in *White Crow* or by the titles he bestowed, such as *Hiroshima, Atom Bomb*, surely generated interest in Dey's work as the art world turned its attention to self-taught, visionary, and Sunday painters. He soon met other newly celebrated folk artists including fellow Virginian Miles Carpenter. Dey's admiring portrait of Car-

penter places this small-town southern sculptor in the midst of the northeast woods. Because Richmond was a center for collectors, Dey enjoyed his last years as a successful artist. He died of heart problems in 1978. Dey's art can be found at the Smithsonian American Art Museum, the Akron Museum of Art, and the Longwood Center for the Visual Arts.

LINDA F. MCGREEVY
Old Dominion University

Chris Gregson, *Life and Legend: Folk Paintings of "Uncle Jack" Dey* (1986); Elinor Lander Horowitz, *Contemporary American Folk Artists* (1975); R. Lewis Wright, Jeffrey T. Camp, and Chris Gregson, *Clarion* (Spring 1992).

Dial, Richard
(b. 1955)
The second son of renowned self-taught artist Thornton Dial Sr., Richard Dial was born and currently resides in Bessemer, Ala. As a young man he worked as a machinist for the Pullman Standard Company, where his father was also employed, until leaving to start his own business making metal patio furniture. In 1984, with assistance from his father and brother Dan, he founded Dial Metal Patterns. From its humble beginnings in a tin shed in his father's backyard, the business grew into a successful enterprise during the late 1980s and 1990s.

Working with the same basic steel framework used for his line of functional patio furniture, known as "Shade Tree Comfort," Dial incorporates additional materials, including wood and hemp, to create sculptural chairs that play with the theme of comfort in relation to religion, family, and community. With titles such as *The Comfort of Prayer*, *The Comfort of the First Born*, and *The Comfort and Service My Daddy Brings to Our Household*, Dial's works maintain the association with utilitarian forms that have endured within the realm of folk art for generations while simultaneously revealing his individual sense of humor and playful interpretation of the human form. The 1988 piece *The Comfort of Moses and the Ten Commandments* features a stylized, hemp-bearded face, attached to the back support, and two large, incised wood panels, serving as the tablets of law, that are propped against the arms of the blue enamel-painted chair that acts as Moses's body. With an economy of detail, Dial creates a visual tension between the form as "chair" and the form as "figurative sculpture." The work asks the viewer to consider how one's sense of "support" may take shape in a variety of ways: sometimes physically, sometimes spiritually, and often as an expression of familial continuity. Dial's art is represented in the American Folk Art Museum.

WENDY KOENIG
Middle Tennessee State University

Paul Arnett, in *Encyclopedia of American Folk Art*, ed. Gerard C. Wertkin (2004); William Arnett and Paul Arnett, eds., *Souls Grown Deep: African American Vernacular Art*, vol. 2 (2001); Chuck Rosenak and Jan Rosenak, *Museum of American Folk Art Encyclopedia of Twentieth-Century American Folk Art and Artists* (1990).

Dial, Thornton, Sr.

(b. 1928)

An African American self-taught artist who began producing art late in life, Thornton Dial Sr. rapidly distinguished himself as an ambitious and prolific painter and sculptor of national renown. His works express an at once intensely personal and historically informed response to African American life in the 20th- and 21st-century South and comment broadly on contemporary American life and culture.

Dial was born in Emelle, Ala., in 1928. Raised primarily by his great-grandmother, in 1941 he moved to Bessemer to live with his great-aunt and her family. Having received very little schooling, Dial supported himself and his family through many manual labor jobs before working for 30 years at the Pullman-Standard boxcar factory. Laid off at the age of 55 when the factory closed, he started a small steel garden furniture shop with his sons. He also began creating art works, shown to only a few family members and acquaintances. By the late 1980s, however, his works had come to the attention of the art world, and in 1993 he received recognition in both the folk art and mainstream art worlds with simultaneous solo exhibitions at the New Museum of Contemporary Art and the Museum of American Folk Art in New York. Although most consistently embraced by the self-taught and outsider art world, his work has been exhibited in the 2000 Whitney Biennial and was the subject of a 2005 solo show at the Museum of Fine Arts in Houston. Product of a vernacular artist with a global vision,

Dial's work consistently challenges the aesthetic and institutional premises of these presumably distinctive art worlds.

Dial's paintings are ambitious personal responses to his times and his culture. Rooted in a strong figurative vision and expressive impulse, they depict his interpretation of historical, political, and personal experience. Many address recognizable contemporary events and the broad historical dynamics of cultural change. His early works encompassed the distant past, the civil rights struggle, the daily personal and collective struggles of rural sharecroppers, industrial workers, miners, and African Americans in the cities. As he explored new artistic media and aesthetic vocabulary, his subject matter expanded significantly, while remaining inherently political. His late works increasingly have embraced the collective experience of Americans within a global context, treating subjects as diverse as the culture's response to the O. J. Simpson trial, the death of Princess Diana, the events of 9/11 and its aftermath, the politics of oil, Katrina, and the wars in Iraq.

A balance of expansive gesture and lyrical touch is evident throughout Dial's artworks. Dial employs many styles, from pure abstraction to patently allegorical representationalism and evocative figurative expressionism, and moves with remarkable ease among a variety of media: wood or steel sculpture; large-scale, thickly built up paintings and assemblages; and deceptively simple, lyrical works on paper in charcoal, pastel, water color, and acrylic. His works demonstrate significant artistic assurance through his mastery of ma-

terials and his comfort with the personal voice he has achieved through nearly 30 years of creating. Indeed, in recent years, Dial has embraced the role of a mature artist deeply rooted in African American regional culture who creates a fully contemporary American art. The High Museum of Art, the American Folk Art Museum, the Indianapolis Museum of Art, and the Birmingham Museum of Art own examples of Dial's art.

CHARLES RUSSELL
Rutgers University at Newark

Paul Arnett, ed., *Thornton Dial in the 21st Century* (2005); William Arnett and Paul Arnett, eds., *Souls Grown Deep: African American Vernacular Art*, vol. 2 (2001); Amiri Baraka, Thomas McEvilley, Paul Arnett, and William Arnett, eds., *Thornton Dial: Image of the Tiger* (1993); Carol Crown and Charles Russell, eds., *Sacred and Profane: Voice and Vision in Southern Self-Taught Art* (2007); Joanne Cubbs, David C. Driskell, Eugene W. Metcalf, and Greg Tate, *Hard Truths: The Art of Thornton Dial* (2011); Bernard L. Herman, ed., *Thornton Dial: Thoughts on Paper* (2012).

Doyle, Sam
(1906–1985)

St. Helena Island native Sam Doyle lived all of his 79 years in the Lowcountry of South Carolina where Gullah culture teeming with Afro-Caribbean influences emerged from the diasporic firmament of slavery. As a child, he absorbed ancestral lore from his elders and attended Penn School, established by northern missionaries during the early days of the Civil War to provide educational and vocational training to those newly liberated. Though family hardship forced his withdrawal, at Penn he learned the value of history and first received encouragement for his artistry.

By 1927, bridges linked St. Helena to Beaufort and the islanders to mainland employment opportunities. Doyle found work there himself and commuted for several years before relocating. During his off-island residency, he met his wife-to-be, Maude, married, and parented three children. In 1943, much to the disfavor of his more cultured spouse but heeding Gullah tradition, Doyle moved his family to St. Helena. They settled into a modest two-story house nestled on a few acres of ancestral farmland. World War II was then at full flame, and his marriage was failing. (Because of a childhood foot injury, Doyle was classified "unfit" for military service, which he later confided was the low point of his life.) Hoping to unify his family, he built Maude's Shop adjacent to their house. His wife and children sold refreshments to youngsters who played sports at the nearby sandlot field. He painted a roofing-tin portrait of a bald eagle, the mascot of the community's baseball team, the Wallace Eagles, and placed it in his front yard.

After the couple's tempestuous marriage was officially dissolved, Doyle moved into a ramshackle structure behind the family home and lived there quite uncomfortably until his children graduated from high school. Perhaps to atone for his lack of military service, he took a job in the laundry at the Marine Corps Recruit Training Depot on Parris Island. Arrangements were made with relatives so the children could attend

college elsewhere in the state, and his wife, following the lead of many of the Lowcountry's African Americans, resettled in the Northeast.

Doyle's outdoor gallery was in its embryonic stage. A portrait of boxer Joe Lewis joined the Wallace eagle, and with no particular plan Doyle added more artworks to his display. "You know," he told National Public Radio in 1983, "I'll be in my bed and I just say I want to paint something, like people I've known a long time ago and stories that I have been told." Though not yet signified, themes emerged: patriotism, faith, history, and achievement.

Doyle was fond of saying "That's natural, man!" St. Helena was a "natural" place, a peaceful place filled with mystery and intrigue where one's imagination was encouraged to contribute. The painter immortalized many of the island's legendary denizens in paintings such as *Dr. Crow* and *Rocking Mary* and gave shape to the unseen phenomena of his youth in *Old Hag* (who sheds her epidermis and rides her victims to misery) and *Jack O Lanton*, the fabled nocturnal angler, who with spear in hand fishes in ditches and stuns his unsuspecting prey by shining a light from his derriere.

After his retirement, Doyle evangelically committed to "painting history." With bold strokes and vibrant colors, he blended ancestral Gullah lore and his devout Baptist faith into a rich multicultural impasto. Two series, *Penn* (school) and *First* (achievement or event), commingled with his folkloric works and clearly established Doyle's mission to honor Gullah culture and, more gener-

ally, African American advancement. Through the years, the museumlike display that overflowed the yard of his small, two-story house and adjacent workshop evolved into the St. Helena Out Door Art Gallery.

Doyle created art on all manner of surfaces but much preferred the smooth surface of metal, and his long fluid strokes reveal his affinity for the tactile nature of his craft. Often, he painted the background around his subject, contouring the figure as he worked. This overlaying of paint created a discernible aura that added considerably to its presence. He resolutely defended the works in his outdoor gallery from the harsh climatic extremes of the Lowcountry. Virtually all of the artist's older works show signs of rejuvenation, some were nearly rebirthed by their imaginative creator.

Doyle's uniquely styled personal portraits and tributes brought him much acclaim, particularly after his inclusion in the Corcoran Gallery of Art's seminal 1982 exhibition *Black Folk Art in America, 1930–1980*. Aficionados traveled from around the world to view his outdoor history lesson. He commemorated many of their visits by painting their hometowns or countries of origin on a 4 x 8 foot plywood *Visitors* panel, and he amended his gallery sign, adding "Nation Wide" parenthetically to emphasize its broad appeal.

The Washington, D.C., event was Doyle's only excursion away from his home state. He had the sublime pleasure of seeing his artworks formally presented and shaking the hand of First Lady Nancy Reagan. Flush with patri-

otism, upon his return he refreshed a number of his artworks with red, white, and blue house paint, bathing some of his favorites, *Rambling Rose*, *First Black Midwife*, and *Penn Roser House*, in the patriotic hues.

As evidenced by his *Visitors* sign, Doyle's influence is far and wide. The late neoexpressionist Jean Michel-Basquiat once traded some of his own artworks to a gallery owner for a few of Doyle's, and noted contemporary master Ed Ruscha, who has cited Doyle's "strong effect on me," paid posthumous tribute to the artist with his painting *Where Are You Going, Man? (For Sam Doyle), 1985*. The work now resides in the collection of Eli Broad. Public collections include the High Museum of Art in Atlanta, the American Museum of Folk Art, the Dallas Museum of Art, the New Orleans Museum of Art, the South Carolina State Museum, and the Smithsonian American Art Museum in Washington, D.C.

GORDON W. BAILEY
Los Angeles, California

Paul Arnett and William Arnett, eds., *Souls Grown Deep: African American Vernacular Art of the South*, vol. 1 (2000); Gordon W. Bailey, *Raw Vision #61* (Winter 2007); Philip L. Bishop, *Orlando Sentinel* (30 April 2003); Edith M. Dabbs, *Face of an Island* (1970); Beryl Dakers, *Conversations with Artists: Sam Doyle*, South Carolina Educational TV (1983); Vertamae Grosvenor, *Horizons: Sam Doyle*, National Public Radio (1983); Jane Livingston and John Beardsley, *Black Folk Art in America 1930–1980* (1982); Regenia Perry, *Raw Vision #23* (Summer 1998); Ed Ruscha, *The Museum of Everything: #1* (exhibition) (2010); Lynne E.

Spriggs, *Local Heroes: Paintings and Sculpture by Sam Doyle* (2000); Charissa N. Terranova, Interview: Ed Ruscha, . . . , fluentcollab.org/mbg/index.php/interview/index/164/94 (2011); Jay Tobler, ed., *The American Art Book* (1999).

Drake, David (Dave the Potter)
(1800–ca. 1870)

David Drake, also known as Dave, was an African American potter and poet born into slavery in 1800. He lived in the Edgefield District of South Carolina until his death sometime after 1870. As a young slave, Drake learned how to turn pots from various members of the Landrum family, including Harvey Drake. The Landrum family established the alkaline-glazed stoneware tradition in South Carolina and operated several stoneware manufactures during the antebellum period. Drake is especially well known because he was not only a potter but also a poet. By 1832 he was writing poetry on the sides of the utilitarian vessels he created. Although researchers have not discovered how Drake learned to read or write, his inscriptions indicate that he was aware of current events and had knowledge of the Bible. At this point in his life, Dave was a master potter working for Lewis Miles, a man 10 years his junior. Among Drake's most celebrated lines are "I wonder where is all my relations / Friendship to all and every nation" (16 August 1857) and "The fourth of July is surely come / to blow the fife and beat the drum" (4 July 1859).

Drake produced thousands of pots, hundreds of which survive to this day. Indeed, working seven days a week

and every month of the year, he was the most prolific of the potters who worked in Edgefield. Scholars believe that Drake produced the largest handmade pots in the United States during the 19th century. In 1859 the artist made two 40-gallon jars, each bearing a verse, with the assistance of "Baddler," perhaps another slave working at the Lewis Miles pottery. One of these jars carries the famous rhyming couplet "Great and Noble Jar / hold sheep, goat and bear" (13 May 1859). Drake continued to work during the Civil War; the latest known pot he made dates to 31 March 1864. The 1870 Federal Census lists David Drake as a turner. Drake's works are in numerous museums: the Philadelphia Museum of Art, the McKissick Museum at the University of South Carolina, the Charleston Museum, the Atlanta History Center, the Museum of Early Southern Decorative Arts, the High Museum, the Museum of Fine Arts, Boston, and the Smithsonian National Museum of American History.

JILL BEUTE KOVERMAN
McKissick Museum

Cinda Baldwin, *Great and Noble Jar: Traditional Stoneware of South Carolina* (1993); Orville Vernon Burton, *In My Father's House Are Many Mansions: Family and Community in Edgefield, South Carolina* (1985); Jill Beute Koverman, ed., *"I made this jar . . .": The Life and Works of the Enslaved African American Potter, Dave* (1998).

Drgac, Peter Paul

(1883–1976)

Peter Paul Drgac was born 21 July 1883 in New Tabor, a Czech farming community in Burleson County, Tex.

His parents, Czech immigrants, were among the area's first white settlers. Peter was the youngest of their nine children. After completing the seventh grade, Peter left school to work on the family farm; he also worked as a carpenter and house painter. He joined the New Tabor Brethren Church, a congregation of the Texas-based Czech Protestant denomination, the Unity of the Brethren. Drgac was proud of his Czech heritage and spoke the language fluently.

Drgac married in 1905, and he and his wife, Frances, ran a grocery store and bakery for many years. Although they had no children of their own, Drgac loved children, and "Uncle Pete" was beloved by his nieces and nephews. After retiring in 1955, Drgac and his wife settled in Caldwell, Tex., where Drgac became known for his spectacular fruit trees, flowers, and vegetables. In 1962 Frances, his wife of 62 years, died. Drgac consoled himself with gardening, church work, and reading.

In the late 1960s, the 85-year-old Drgac found a new passion. After building a flower box, he decided it needed painting. He painted some flowers on it but was not satisfied with the results. That night as he lay in bed, he worried over how to improve his painting, mentioned it in his prayers, and reached a conclusion: with practice, he would be able to draw flowers and any other subject he desired. He began painting on every available surface—furniture, light bulbs, soda bottles, egg cartons, and flowerpots—until his house was nearly filled with decorated objects. During the following eight

Peter Paul Drgac, Drgac Ranch, n.d., paint and mud on wood, 20" x 14.5" (Collection of David B. Bean)

years, he also produced hundreds of paintings on poster board.

Working rapidly, Drgac could complete several paintings each day. He typically drew designs on drafting paper, traced them onto the poster board, and then applied enamel paint. Sometimes, however, he applied the paint directly. His distinctive paintings appear to be visual inventories, perhaps inspired by many years spent arranging objects on display shelves in his store. Objects, animals, figures, and plants appear as flat, stylized shapes placed in seemingly

random groups on the page, without concern for three-dimensional representation. These elements, along with the disproportionate scale of the objects, result in mysterious spatial relationships, as objects relate to each other in unexpected ways.

"Uncle Pete" Drgac enjoyed giving his paintings to friends and relatives. While he welcomed visitors into his home to see the paintings, he showed no interest in selling them. When he did accept payment, the charge was based on the estimated cost of materials.

Drgac died 12 November 1976 in Caldwell, Tex., at the age of 93. After his death, some of his several hundred paintings were distributed among his surviving relatives. Since his death, his work has been included in numerous group and solo exhibitions and is found in the Blanton Art Museum's permanent collection at the University of Texas.

LYNNE ADELE
Austin, Texas

Lynne Adele, *Spirited Journeys: Self-taught Texas Artists of the Twentieth Century* (1997); Clinton Machann, in *Folk Art in Texas*, ed. Francis Edward Abernethy (1985); American Visionary Art Museum, *Tree of Life* (1996).

Dulaney, Burgess

(1914–2001)

The creations of Burgess Dulaney, fashioned of unfired Mississippi mud, leave one wondering whether his hands were guided by otherworldly forces. The act of transforming a simple earthen mass into what others would later call artwork seemed intuitive for Burgess. Led by an inner voice or a vivid imagina-

tion—and a true love of the feel of wet clay on his hands—Burgess spent his life choosing the mud carefully, familiarizing himself with its qualities and its limits, and using this knowledge to produce astonishingly powerful raw works of art. He used store-bought marbles for eyes and occasional bits of broken china for teeth. He also added horsehair to some of his more unusual and whimsical mud creations.

Dulaney, the youngest of 12 children, was born in Itawamba County, Miss., on 16 December 1914. He never traveled more than a few miles from his birthplace. He spent his childhood working on the family farm to help his family survive difficult times. He never attended school and never learned to read or write.

In the mid- to late 1970s, he began to create solid mud sculptures made of clay dug from pits behind the family home. Made without interior support, some of the solid pieces weigh nearly 50 pounds. Most are similar in size to a soccer ball or bowling pin. In addition to the solid pieces, Dulaney also built thin-walled and hollow vessel-like works that refer to utilitarian-style pottery and classic southern face jugs. Dulaney's gift of several pieces to local merchants led to the discovery of his talent. The endless supply of locally dug clay allowed him to create fascinating creatures, unusual human forms, animal caricatures, and vessels, many of which have stunning similarities to Pre-Columbian and American Indian artifacts. Some of the clay, rich in iron oxide, darkens over time, adding an almost eerie effect to these amazing unfired works.

Dulaney experimented with fashioning some pieces from cement but found that he much preferred the feel of natural clay to the harshness of concrete mix. He spent hours working on each piece, removing impurities, forming the clay by hand, and seeing to it that it did not dry too quickly.

A small man with the twinkling eyes of a gentle soul, Dulaney welcomed visitors to his home and with whimsy and awe told tales of local legends, especially mysterious visions of night visitors, and of life he had witnessed for over 80 years. The artist occasionally ended a phrase with his soft and singsong "Whoo-eee!"

Dulaney passed away 27 June 2001, leaving behind a body of fascinating art. His work is held in numerous private collections and in a variety of institutions including the Mississippi Museum of Art, the Mississippi Department of Archives and History, the Art Museum of Southeast Texas, and the American Visionary Art Museum.

TERRY NOWELL
Austin, Texas

Karekin Goekjian and Robert Peacock, *Light of the Spirit: Portraits of Southern Outsider Artists* (1998); University of Southwestern Louisiana, *Baking in the Sun: Visionary Images from the South,* (1987); Wilfred Wood, *Raw Vision* (summer 1997).

Earl, Ralph E. W., Jr.

(ca. 1785–1838)

The successful career of painter Ralph E. W. Earl Jr. can be largely attributed to his lifelong association with Andrew Jackson. Son of Ralph Earl, who had begun his career as a self-

taught artist and whose art retained folk qualities, Ralph E. W. Earl had initially taken lessons from his father before traveling to England in 1809. In London, Earl studied for a year with Benjamin West and John Trumbull. Afterward, he lived with relatives in Norwich before traveling to Paris in 1814. The following year he returned to the United States and began working as an itinerant portrait painter in the Southeast. Despite his professional training, Earl painted portraits with folk characteristics, such as proportionally incorrect figures, exaggerated anatomical features, and shallow picture planes.

In 1817 Earl arrived in Nashville, intent on painting a portrait of General Jackson. As a result of his ensuing friendship with the general and his subsequent marriage to Mrs. Jackson's niece, Earl remained in Nashville, where he established a studio. Considered the first of Tennessee's resident portrait painters, Earl created many likenesses of Jackson's relatives and friends, including his military comrades Colonel Isaac Shelby and Brigadier Generals James Winchester and John Coffee. In 1818 Earl established the Nashville Museum, which displayed a variety of "natural and artificial curiosities" and also housed a group of Earl's portraits. Earl's reputation throughout the South—from Nashville and Memphis to Natchez and New Orleans—was built upon his images of Andrew Jackson. More than three dozen were completed over the course of their 20-year friendship. A few of these works, which were reproduced as engravings, were circulated in Tennessee and nearby states, where Jackson

was celebrated as the great hero of the Battle of New Orleans.

When Jackson was elected president in 1829, Earl joined him in Washington, continuing to fill requests for portraits of the popular statesman from Tennessee. Whether depicting Jackson as a military hero, a country gentleman, or a national leader, the artist accentuated Jackson's gallantry and strength through his subject's stance and facial features. Earl typically portrayed Jackson with his head at three-quarter view, highlighting the contours of his strong chin and nose and high forehead. Topped with thick billowy white hair, this stylized image of Jackson was replicated by Earl numerous times. Because of the inordinate time he spent painting canvases of Jackson, he gained the nickname "the King's painter."

In 1836, near the end of Jackson's second term in the White House, Earl returned to the Hermitage; the general joined him a year later. He spent the last few years of his life designing the gardens on Jackson's estate. Earl died on 15 September 1938 and was buried on the grounds of the Hermitage. Many museums, including the North Carolina Museum of Art, the Tennessee State Museum, the Cheekwood Botanical Garden and Museum of Art, the Metropolitan Museum of Art, and the National Gallery of Art, have collected Earl's work.

MARILYN MASLER
Memphis Brooks Museum of Art

American Naïve Paintings from the National Gallery of Art National Gallery of Art (1985); James G. Barber, *Andrew Jackson: A Portrait Study* (1991); Deborah Chotner, *American Naive Paintings* (1992); Earl Papers, Tennessee State Library and Archives, Nashville; James C. Kelly, *Tennessee Historical Quarterly* (Summer 1985); Jerome R. Macbeth, *The Magazine Antiques* (September 1971); Jessie Poesch, *Art of the Old South* (1983).

Edmondson, William

(1874–1951)

Not long after the end of the Civil War, when former slaves from the South were struggling to define themselves as free men and women, former slaves Orange and Jane Brown Edmondson delivered five children into freedom. One child, William, was destined to become an artist with recognition in the annals of art history. Sometime in midlife, William found the spark of creativity. He emerged as one of the greatest sculptors of the 20th century, trained or untrained.

William Edmondson never knew exactly how old he was. "How old I is got burnt up," he once said, referring to a house fire that destroyed the family Bible. He was thought to have been born about 1883 until the research of Bobby Lee Lovett, a historian at Tennessee State University in Nashville, found the definitive record of Edmondson's birth in a census that revealed he was actually born nine years earlier. To view a large group of Edmondson's extraordinary limestone sculptures is a powerful and somewhat rare experience; the last full-scale retrospective of his work was organized by the Cheekwood Museum of Art in Nashville in 2000. Photographs of Edmondson's

working life reveal a short man, barely five feet tall, with large, powerful hands. The photographs also show Edmondson's yard and sculpture shed, with perhaps a hundred or so white limestone carvings just sitting there waiting for purchase. Many masterworks that can be seen in the photographs have been lost over time.

After many years working at various jobs on the Nashville, Chattanooga, and St. Louis Railway and as a janitor at the Nashville Woman's Hospital, Edmondson went through a period of unemployment. He received most of his stone from black quarry workers who dropped off odd shapes of stone that could not be used for building or street projects. Using only railroad spikes for chisels, Edmondson began simply—by making tombstones for the local black community. "I was out in the driveway with some old pieces of stone when I heard a voice telling me to pick up my tools and start to work on a tombstone. I looked up in the sky and right there in the noon daylight He hung a tombstone out there for me to make."

William Edmondson was destined for far more than just making tombstones and utilitarian objects such as birdbaths. He was a keen observer of nature, of people, of traditions, and of his community. Edmondson's observations informed his treatment of subjects that otherwise came straight from his imagination. Edmondson's sculptures may address religious themes; his angels, crucifixions, Noah's Ark, and Adam and Eve are masterful. This intuitive artist also released from their stone rectangles mermaids, telling in-

terpretations of black heroes such as Jack Johnson, preachers, nurses, rabbits, birds, lions, horses, frogs, and various animals. Some sculptures depict local folks whose poses Edmondson captures with affection; some offer gentle social criticism.

Edmondson's first one-man show was held from 20 October to 31 December 1937 at the Museum of Modern Art in New York. This exhibition was the museum's first one-person show of a black artist and of a self-taught artist. Edmondson passed away 7 February 1951. His reputation was revived during the 1960s, and numerous museums have collected his works. Among them are the Cheekwood Tennessee Botanical Garden and Museum of Art, the Philadelphia Museum of Art, the Brooklyn Museum of Art, the Memphis Brooks Museum of Art, the Smithsonian American Art Museum, and the American Folk Art Museum.

JOHN FOSTER
St. Louis, Missouri

Cheekwood Museum of Art, *The Art of William Edmondson* (2000); Edmund L. Fuller, *Visions in Stone: The Sculpture of William Edmondson* (1973); Josef Helfenstein and Roxanne Stanullis, *Bill Traylor, William Edmondson, and the Modernist Impulse* (2004); Georganne Fletcher and Jym Knight, *William Edmondson: A Retrospective* (1981).

Ehre Vater Artist

(birth and death dates unknown)
The Ehre Vater Artist was active from circa 1782 to 1828 and produced fraktur in Pennsylvania and the South, including Virginia, western North Caro-

lina, and South Carolina. Although it has been claimed that he produced fraktur in Canada as well, the evidence of this is based on a fraktur made for a child born in Pennsylvania, who later moved to Canada and may have taken the certificate along. Over 50 examples of his work are known, consisting primarily of birth and baptismal certificates, in addition to religious texts and drawings.

The artist's nickname comes from his periodic use of the phrase "Ehre Vater und Mutter" (Honor Father and Mother), written as a bold title at the top of some certificates. Other artists used this phrase as well, so not every fraktur containing this line can be attributed to the Ehre Vater Artist. This artist is believed to have been an itinerant schoolmaster within the German Lutheran or Reformed parochial school systems, although he did produce several frakturs for families belonging to the Moravian and Mennonite faiths. Among the approximately 20 known examples of fraktur that the Ehre Vater Artist made for southern families are certificates for children born in the Moravian settlement of Bethania, as well as Rowan and Stokes Counties, N.C.; Lexington and Newberry Counties, S.C.; and Berkeley County, Va.

Most of the artist's frakturs are entirely hand drawn, but he did decorate several printed certificates from the Allentown, Pa., printshop of Joseph Ehrenfried. These printed certificates, of which both German- and English-language examples survive, were vertically oriented with the text in the upper portion, leaving a blank space at the bottom in which the artist typically drew a large bird perched on a flowering branch. The Ehre Vater Artist decorated these printed certificates and sold some of them blank to other scriveners, who in turn filled in the personal information. His hand-drawn frakturs are colorful and well organized, with motifs that include large birds, flowers, vines, compass stars, and columns. He used shading techniques on flowers and foliage to impart a greater sense of realism than many fraktur artists attempted. Frakturs by Ehre Vater Artist belong to the Museum of Early Southern Decorative Arts and the Henry Francis DuPont Winterthur Museum, Garden, and Library.

LISA M. MINARDI
Winterthur Museum and Country Estate

Cory M. Amsler, ed., *Bucks County Fraktur* (1999); John Bivins, *Journal of Early Southern Decorative Arts* (November 1975); Russell D. Earnest and Corinne P. Earnest, *Papers for Birth Dayes: Guide to the Fraktur Artists and Scriveners* (1997); Christian Kolbe and Brent Holcomb, *Journal of Early Southern Decorative Arts* (November 1979); Cynthia Elyce Rubin, ed., *Southern Folk Art* (1985); Klaus Stopp, *The Printed Birth and Baptismal Certificates of the German Americans*, vol. 1 (1997).

Ellis, Milton
(1915–2008)
In January 2007, after a freak tornado had destroyed his central Florida residence, Milton Ellis became homeless. After the storm the 91-year-old artist's personal possessions filled only two grocery bags. Yet, somehow, his large

reverse paintings on Mylar, which had been rolled-up and stowed away for 30 years, remained unscathed by nature's wrath. In these paintings, Ellis had expressed his vision of a pending apocalypse.

Throughout his long life, Milton Ellis had always gone his own way. One of four children, he was born on 3 June 1915 to Romanian Jewish immigrants living in Brooklyn, N.Y. By his mid-teens, deeply engrossed in the world of art, Ellis had dropped out of high school to enroll in the National Academy of Art. Ellis took only employment that would not be too time constraining; he needed intermissions in which to think, travel, and paint. As often as possible he frequented art museums. Inspired, he told himself, "I am going to become a great artist."

Ellis's dreams of being a noted artist gradually faded during the decades in which he worked at a variety of jobs. While his stint as a screen printer may account for his use of bold shapes and color, other experiences undoubtedly have contributed to his fatalistic outlook and imagery. Eventually he stopped painting, returning to art making only after his retirement. With single-minded devotion, he then created some 50 mural-sized works that have only recently been discovered.

Ellis holds fast to two credos when he talks about his artwork: God formed these images through him, and these creations speak for themselves. His air of indifference does not come from artistic arrogance or an inability to express himself. He is sure of the messages conveyed, but he will not discuss any of them. Drawing from the South's pronounced evangelical religious culture, he explains that "these don't belong to me; they're God's paintings." According to Ellis, the images in his paintings came to his mind without any deliberation on his part: "God blessed me and put the creativity in my mind. I'm the intermediary to do it for Him." He added, "It's not what He says. It's what He instructs me to do."

Behind its cartoonish veneer, Ellis's art is moralistic, unleashing visions of dreams and fears. In a didactic manuscript Ellis wrote, called *The Drama of Man in the Universe*, he describes his search for goodness but finds only moral decay, concluding, "The world is nothing short of a 'Lunatic Asylum.'" Ellis was convinced that any escape from this world, which will be destroyed by nuclear war, will be to another planet.

Ellis was always independent and self-directed. An impassioned man, carrying the weight of the world, he traveled along his own path—a path taken regardless of aesthetic canons, criticisms, and trends. Milton Ellis perpetually and consistently answered to a higher authority.

GARY MONROE
Daytona State College

Evans, James Guy

(b. ca. 1808–1809; fl. 1853–1859)
Surviving biographical details suggest that James Guy Evans was a colorful figure. Born in New York City about 1809, he worked as a shoemaker before enlisting as a private in the U.S. Marine Corps at Philadelphia in 1829. He sailed

with the Mediterranean Squadron to Constantinople in 1832.

Evans probably began painting watercolors about 1833. He appears to have been self-taught, relying on the example of American and European ship portraitists, such as members of the Roux family. Evans's earliest marine painting depicts the uss *Constellation* and suggests that he may have been assigned to this vessel. Between 1832 and 1835, he painted portraits of the uss *Constitution* and the uss *Delaware*. He also painted a view of several vessels in the Mediterranean fleet at Port Mahon in 1837. Evans appears to have left the Marine Corps shortly afterward.

Evans submitted two sketches of the Battle of Lake Erie and two of the uss *Constitution* at Malta to the *U.S. Military Magazine*. These were lithographed by T. S. Wagner, J. Queen, and P. S. Duval and were published in Philadelphia by Huddy and Duval in 1840. Evans next appeared in 1844 in New Orleans, where he remained until disappearing from the historical record about 1859. In addition to marine subjects, he painted *The Second United State Customs House, New Orleans*, shortly before its demolition in 1848. He also painted *The Arrival of Genl. Z. Taylor & Staff at Balize on the U.S. Steam Ship Monmouth, B. T. Willse Commander, November 30th, 1847*.

In about 1849, Evans established a partnership with Edward Everard Arnold. The collaborative effort was short-lived but produced a number of fine marine paintings. Evans and Arnold announced plans to produce a large panoramic view of New Orleans, but the project never materialized. Evans seems to have been something of a religious firebrand. According to news accounts, he identified himself as a Methodist minister, or a "Sinner Pardoned and Missionary of the True Faith." In 1850 *The Daily Orleanian* noted that he was "today a painter; tomorrow a preacher," and that he "dubs himself a 'pardoned sinner' when it ought to be a 'good painter.'" About 1854, Evans painted a scene entitled *Commodore Perry Carrying the "Gospel of God" to the Heathen in 1853* (Chicago Historical Society). At some point, Evans caused a riot at the "Love Street" Tabernacle after spontaneously usurping the duties of the preacher until being restrained by an alderman.

At about this time, his association with Arnold dissolved, and Evans seems to have taken up with a man named Johnson. The two advertised "house, ship and sign painting also historical, marine and ornamental painting with studio on corner of Enghein and Poet Streets, New Orleans." After this, nothing about Evans's life is known. Evans may have traveled to San Francisco, perhaps as a sailor, but this suggestion is probably based on Evans's painting of the San Francisco fire, adapted from a lithograph and executed about 1850. Several authors have proposed that he took to circuit preaching; again, this is a matter of speculation. His work has been conflated with an otherwise unidentified watercolor portraitist active in New England between 1827 and 1834 by the name of J. Evans.

Works by James Guy Evans can be found in the collections of the Louisiana State Museum, New Orleans, the Metro-

politan Museum of Art, the New York Historical Society, the Peabody Essex Museum, and the Wadsworth Athenaeum Museum of Art.

RICHARD A. LEWIS
Louisiana State Museum,
New Orleans

Alberta Collier, New Orleans *Times Picayune* [ca. July 1975]; *Daily Orleanian* (22 September 1850); Historic New Orleans Collection, *Encyclopedia of New Orleans Artists, 1718–1918* (1987); *Kennedy Quarterly* (December 1969); Homer Eaton Keyes, *The Magazine Antiques* (January 1935); Louisiana State Museum, *250 Years of Life in New Orleans: The Rosemonde E. and Emile Kuntz Collection and the Felix H. Kuntz Collection* (1968); Norbert and Gail Savage, *The Magazine Antiques* (November 1971); John Wilmerding, *A History of American Marine Painting* (1968).

Evans, Minnie

(1892–1987)

Born Minnie Eva Jones in Long Creek, Pender County, N.C., Minnie Evans sustained a 40-year career drawing and painting highly symbolic and surreal spaces in which repeating faces, mythological beasts, insects, and eyes emerge from lush forests and flowers. Working as a domestic at Pembroke Park Estate in Wrightsville Beach, outside Wilmington, N.C., Evans composed her first drawings on Good Friday in 1935, when divine inspiration took her hand. She produced two small 5 x 7 inch drawings but did not return to art making until five years later, when, at the age of 48, she found these two works while cleaning. From that day forward, Evans devoted herself to her artistic career.

The artist married Julius Evans in 1908 and raised three sons before she found time for drawing and painting. Evans's skills grew quickly, and the job she took in 1948 as gatekeeper at Airlie Gardens only encouraged her artistic development. The estate's statuary, verdant plantings, and neoclassical architecture all appear in Evans's work.

Scholars have categorized Evans's artistic production into distinct phases. From 1940 until approximately 1943 she composed a group of 141 7 x 5 inch, semiabstract drawings in pencil and crayon that were composed of symmetrically ordered dots, circles, triangles, and faces. Around 1943 she started working on larger 12 x 9 inch pieces of paper and began to use oil paints. During this period, Evans also developed the imagery that characterizes much of her work: faces, eyes, insects, butterflies, and a sun rising above a horizon that demarcates air from water. In 1945 Evans worked briefly on U.S. Coast Guard paper that her son had given her. Between the mid-1940s and early 1960s, Evans developed two equally important styles: semiabstract works with a central face or design surrounded by symmetrical, radiating wings, eyes, horns, or floral patterns and renderings of three-dimensional spaces that contain lions, winged griffins, castles, crucifixions, images of Jesus, or praying angels. From approximately 1966 to 1969 Evans also drew repetitions of eyes and faces framed by composites of earlier semiabstract works that she collaged and mounted onto canvas board.

Evans's 1935 visionary experience was one of a constant stream of visions or

dreams that, throughout her life, provided glimpses of angels and heaven and, in one instance, advised her to "draw or die." Explaining that her work came from God, Minnie Evans believed her drawings and paintings brought back into the world glimpses of "nations destroyed before the flood." Because the artist often asserted that her work was revealed to her, scholars have often aligned her work with surrealism. Yet the notion that Evans had tapped into a collective unconscious obscures the significance of Evans's surroundings and Christian faith. The artist delicately intermingled her visions of past nations with the lush gardens inspired by Airlie Gardens; Bible verses; and, as some scholars have shown, Yoruba ideographs or Kongo cosmograms that "map the ideal [or] spiritually guided world." In 1962 Evans stated that the "whole entire horizon all the way across the whole earth was put together like this with pictures. All over my yard, all up the side of trees and everywhere were pictures." Among the many institutions that include Evans's work in their collections are the American Folk Art Museum, the North Carolina Museum of Art, the Cameron Art Museum, the Gibbes Museum of Art, the High Museum of Art, and the Smithsonian American Art Museum.

EDWARD M. PUCHNER
Indiana University

Sharon D. Koota, *The Clarion* (Summer 1991); Mitchell D. Kahan, *Heavenly Visions: The Art of Minnie Evans* (1986); Allie Light and Irving Saraf, *The Angel That Stands by Me: Minnie Evans' Art* (film, 1983); Nina Howell Starr, *Minnie Evans* (1975).

Ezell, Nora

(1917–2007)

Nora Lee McKeown Ezell of Mantua, Ala., was a nationally recognized quilter known especially for her distinctive story quilts. Some of her most celebrated story quilts are those depicting the histories of the University of Alabama and Stillman College, the life of Martin Luther King Jr., and the civil rights movement in Alabama. When Ezell was a child, the family moved near Fairfield, west of Birmingham, where her father went to work for the Tennessee Coal and Iron Company. The artist said she learned how to sew in a home economics class but taught herself to quilt by watching her mother and her aunt. Required to stand and fan her mother while she sewed, Nora had plenty of opportunities to observe her mother's stitching.

Throughout her adult life, Ezell made pieced and appliquéd quilts. One of her best-selling designs was the donkey quilt, a popular pattern among African American quilters in rural west Alabama and elsewhere. Ezell's creative improvisation is equally obvious in her patchwork quilts, perhaps most notably in her Star Puzzle quilts in which she fractures and recombines a variety of traditional eight-point-star patterns in explosions of color and shifts in scale.

Ezell began making pictorial quilts in the early 1980s. Her first was the University of Alabama quilt inspired by a visit to a craft show where she and her daughter, Annie Ruth Phillips, saw a University of Alabama quilt with a football theme. "If you're going to make a quilt about the University of Alabama,"

she later said, "why are you going to just put Paul Bryant's hat and his football? We know the man made history and we can't take that away from him, but we wanted to show he didn't make ALL the history." Ezell and her daughter included appliquéd images of Lillie Leatherwood's track shoes, books representing academic disciplines, and the doorway where Gov. George Wallace stood to block integration of the campus.

In 1984 Ezell and Phillips began a second collaborative quilt about the life of Martin Luther King Jr., but Phillips died of cancer before the quilt was finished, and Ezell completed it alone. Both story quilts attracted attention, and the Birmingham Civil Rights Institute commissioned "Tribute to the Civil Righters of Alabama," perhaps Ezell's best-known work. During the 1980s and 1990s, recognition of Ezell's distinctive quilt making grew, and Stillman College, the Birmingham Public Library, and the Alabama Artists' Gallery in Montgomery featured her work. She demonstrated her artmaking and sold quilts at many regional craft fairs, including the annual Kentucky Festival in Northport, Ala. Ezell received the Alabama Folk Heritage Award from the Alabama State Council on the Arts in 1990 and a National Heritage Fellowship from the National Endowment for the Arts in 1992. As a master artist in the Alabama State Council on the Arts' Folk Arts Apprenticeship Program, Ezell instructed other quilters for 12 years.

A confident, meticulous artist who took pride in her creations, Ezell was conscious of her legacy. She said, "I like to put a little bit of me in my quilts, because I think this is one thing that lives on after us. Maybe you've forgotten my name, but you'll remember that I always used certain colors that went together so well." Works by Ezell can be found in the collections of the American Folk Art Museum, the Birmingham Civil Rights Institute, the Birmingham Museum of Art, the Montgomery Museum of Art, and the International Quilt Study Center and Museum.

ANNE KIMZEY
Alabama State Council on the Arts

Nora Ezell, *My Quilts and Me: The Diary of an American Quilter* (1999); Mary Elizabeth Johnson Huff, *Just How I Picture It in My Mind: Contemporary African American Quilts from the Montgomery Museum of Fine Arts* (2006); Maude Southwell Wahlman, *Signs and Symbols: African Images in African-American Quilts* (1993).

Farmer, Josephus

(1894–1989)
Rev. Josephus Farmer described his art-making ability as "a gift from God." From the late 1960s until his death in 1989, he created an impressive body of painted wood reliefs and carved three-dimensional assemblages that drew inspiration from a rich interplay of southern history, Christian evangelism, and African American cultural expression.

Farmer was born in 1894 in a rural area outside the town of Trenton, Tenn. His grandfather was a slave, and his father was born into slavery shortly before the Civil War. Like many children within the impoverished rural black communities of the South, Farmer spent

much of his youth laboring in the fields and attended school only sporadically. By the age of 12 he had already assumed full-time employment picking strawberries and cotton. Toward the end of World War I, Farmer joined many other African Americans in the Great Migration from the rural agrarian South to cities farther north. Settling first in Missouri, then in Illinois, and later in Wisconsin, he pursued several occupations over the next four decades, including jobs as a chauffer, mechanic, domestic, construction worker, and hotel porter.

Farmer classified his carvings as either historical or biblical. Many of his historical works recount memories of his early life in the South and feature scenes of riverboats, cotton farming, blacksmith shops, log houses, and banjo playing. Sometimes he combined his recollections with imagery from popular sources. For instance, his repeated renditions of "The Village Blacksmith" reference both his own experiences and the famous poem by Henry Wadsworth Longfellow. In other historical depictions, Farmer paid tribute to United States presidents whom he regarded as champions of the oppressed. Examples include an homage to Abraham Lincoln juxtaposed with images of a slave auction, a portrait of Eleanor and Franklin D. Roosevelt during the Depression, and a memorial to John F. Kennedy with eerie renderings of the president's flag-covered casket and assassin Lee Harvey Oswald portrayed as a blue serpent winding around a pole. The snake staff figure, repeated in various guises throughout Farmer's work, recalls imagery common to African American walking sticks, a carving tradition that Farmer himself practiced as a young man.

Farmer's biblical carvings are among his most powerful expressions. While some capture events from the life of Christ, the majority depict Old Testament themes and figures — Samson wrestling a lion, Abraham's sacrifice of his son Isaac, Daniel in the lions' den, and countless narratives from the life of Moses, including scenes of the Passover and the Exodus. Often inserting small emblems of the United States into his compositions, Farmer clearly intended his scriptural stories of subjugation and liberation to be metaphors for the history of African American slavery and suffering. His biblical works were also a critical facet of his religious calling. Farmer attests that he was beckoned by God to be a preacher in 1922, when he began his lifelong work as a Christian evangelist. Over the years he delivered sermons on street corners, held tent revival meetings, and ministered to many different church congregations. In the end, Farmer viewed his carvings as a way to inspire unbelievers to deep faith or, in his words, "to touch the people's heart." Farmer was included in the Corcoran Gallery's seminal exhibition, *Black Folk Art in America, 1930–1980*. His work is in the permanent collections of numerous museums including the American Folk Art Museum, the Milwaukee Art Museum, and the Smithsonian American Art Museum.

JOANNE CUBBS
Indianapolis Museum of Art

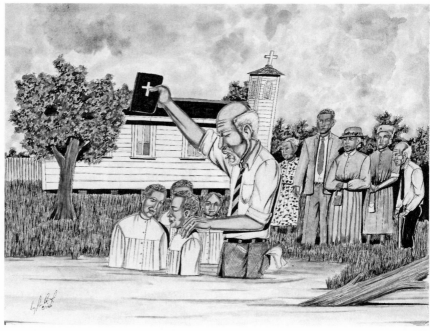

Roy Ferdinand Jr., Baptism, *ca. 2000, mixed media on posterboard, 22" x 28" (Collection of Gordon W. Bailey)*

Joanne Cubbs, *The Gift of Josephus Farmer* (1982); Columbus Museum of Art, *Elijah Pierce: Woodcarver* (1992); Jane Livingston and John Beardsley, *Black Folk Art in America, 1930–1980* (1982); Carol Crown, ed., *Coming Home! Self-Taught Artists, the Bible, and the American South* (2004).

Ferdinand, Roy, Jr.

(1959–2004)

Dubbed a "Goya of the Ghetto," self-taught African American artist Roy Ferdinand Jr. captured the culture, traditions, and societal ills of his native New Orleans. Although Ferdinand battled addiction and homelessness, he was driven as an artist, and before his death from cancer he produced thousands of works. He created most of his paintings with materials he purchased at the drug store: poster board, markers, colored pencils, and watercolors. He began drawing in high school, depicting comic book and science fiction heroes in his notebooks. After dropping out and spending time in a gang, in the army, and in such odd jobs as sign painter, morgue assistant, and bodyguard to French Quarter voodoo personality Prince Keeyama, aka Chicken Man, Ferdinand befriended local art dealer Andy Antippas and shifted the focus in his drawings to life on the streets of Gert Town, an impoverished neighborhood.

Calling his style "urban realism," Ferdinand drew from memory, recalling the harsh realities of an inner-city life he had witnessed firsthand: drugs, gangs, crime, and prostitution. The art-

ist's work—unflinching and at times graphic—has been likened to the stark news images of photographer Weegee. The vivid pop-art immediacy and confrontational stance of Ferdinand's paintings have also led to comparisons to gangsta rap, especially as Ferdinand was unwilling to moralize or take sides. Ferdinand explained this overt lack of sentimentality as coming from a culture "where to show kindness is weakness, to show feeling beyond indifference is weakness." Portraits and self-portraits about the "black urban warrior myth" reimagine the artist as outlaw or revolutionary and relate to a long-standing folk tradition in African American culture that can interpret the outlaw as clever trickster. A practitioner of Santeria, Ferdinand further explored realities of his neighborhood unseen by outsiders. Numerous works portray Baron Samedi/Ghede, a spirit of death and sexuality, or celebrated New Orleans voodoo priestess Marie Laveau. Ferdinand's work is held by the Mississippi Museum of Art, the Ogden Museum of Southern Art, the Louisiana State Museum, and the House of Blues.

WILLIAM L. ELLIS
Saint Michael's College

D. Eric Bookhardt, *Gambit Weekly* (26 February 2002); Randolph Delehanty, *Art in the American South* (1996); Bill Sasser, *Raw Vision* (Spring 2004), *Gambit Weekly* (8 February 2005); Marcus Whittman, dir., *Life and Death at Barrister's* (2001).

Finster, Howard

(1916–2001)
Howard Finster's distinctive style, idiosyncratic formal vocabulary, and fervent Christian belief make him one of the South's most celebrated folk artists. Perhaps best known for *Paradise Garden*, which he began in the early 1960s, and the *Worlds Folk Art Church*, started in 1982, both constructed in Pennville, Ga., Finster is widely acclaimed. His ingenious creations continue to be featured in galleries and museums across the United States.

Born in the Appalachian foothills of northern Alabama, Finster grew up on his father's 40-acre farm. The artist described working for pennies by husking corn, sheathing hay, and digging and clearing fields. Finster, who made it only through the sixth grade, was called to be a preacher at the age of 15. In 1935 he married Pauline Freeman, with whom he had five children. A Missionary Baptist, Finster preached his first tent revival in 1940 and became pastor of his first church in 1941. From the family's home in north Georgia, Finster often served several churches simultaneously and preached tent revivals during the week—sometimes nearby but also in southern Tennessee, Alabama, and Florida. To support his family, he found work as a janitor, a mechanic, and a handyman.

In the late 1940s, Finster began construction of his first environment at his home in Trion, Ga. After he moved to nearby Summerville, he began to construct a far larger environment that he called *Plant Farm Museum*. Using concrete and found objects such as mirrors, bicycle parts, old tires, and even Coca-Cola bottles, Finster intended to honor the inventions of humankind. Finster soon attracted visitors, who became his

audience for impromptu sermons. In 1975 Barbara Damrosch featured Finster's *Plant Farm Museum* in an article entitled "Backyards: The Garden of Paradise" in *Esquire* magazine. The article attracted national publicity, and crowds of sightseers, collectors, curators, and dealers arrived in Pennville to visit the environment, now called *Paradise Garden*. In 1976 Finster's work was featured in *Missing Pieces: Georgia Folk Art, 1770–1970*, an exhibition with accompanying catalog and film, which opened at the Atlanta Historical Society. Finster's engaging personality and his willingness to entertain led to an article in *Life* magazine and exhibitions in San Francisco and New York. In 1984 he was invited to participate in the Venice Biennale. In the following year, *Rolling Stone* chose Finster's album design for *Little Creatures* by the Talking Heads as cover of the year.

Finster loved to tell visitors about the origin of his painting career. In 1976 he espied a portrait of himself in a daub of paint on his thumb. A feeling of warmth that Finster readily identified as a holy feeling came over him, and he knew God was telling him to paint sacred art. From that moment on he painted around the clock. He slept only when he was tired, anywhere from 15 minutes to a few hours at a time. He claimed that he was so busy that he had time to shower only once a month. Finster's enormous output engendered a cast of thousands: George Washington, John Kennedy, Ronald Reagan, and other U.S. presidents; a series of American inventors, such as Henry Ford and Eli

Whitney; portraits of patrons and collectors; Elvis at all stages of life; Mona Lisa; animals of endless kinds; pictures of Jesus and Bible prophets; scenes of hellfire and damnation; thousands of angels; rocket ships; and untold numbers of smiling faces. Bearing aphorisms, prophecies, proselytizing urgings, patriotic proclamations, and Bible verses, all handwritten, Finster's art work was intimately enmeshed with his religious beliefs. Besides the thousands of paintings he created using materials such as tractor paint, chalk, wax, and graphite, Finster also worked in mixed media. His painted Plexiglas constructions might contain mirrors, glass, roots, metal, wood, tiny plastic toys, and beads.

Finster did not number his first works, but soon he began numbering, signing, and dating each work, even telling the time of day it was finished and, frequently, the amount of time taken to do it. For some in the art world, Finster's numbering is all-important, as the numbers allow critics to follow the developmental expansion of Finster's visual powers. Critics debate when or at which number the quality of the work precipitously falls. It is certain, however, that at the close of his prodigious production, he was hampered by arthritis. He became less and less attentive and allowed children and grandchildren to produce many of the later works.

The motivation for Finster's art was his zeal for Christianity and his determination to preach to the unconverted. His art was, in fact, a by-product of his ministry. Calling himself a Man of

Visions, Finster was sure of his divine mandate. No matter how relentlessly he preached, Finster always enhanced his sermons with charm, personal stories, and humorous asides. Finster implored people to be good, and his own goodness was manifest to all people. His words were as important as his images, and in them were the rhyme and humor of his ministerial power. He knew that "hell is a hell of a place to be" and that "heaven is worth it all." The nearly 50,000 works that he created during his lifetime testify to his ardent faith. His works can be found in museums throughout the United States and abroad.

CAROL CROWN
University of Memphis

Howard Finster and Tom Patterson, *Howard Finster, Stranger from Another World: Man of Visions Now on This Earth* (1989); Thelma Bradshaw Finster, *Howard Finster: The Early Years* (2004); John Turner, *Howard Finster: Man of Visions* (1989).

Folk Art Society of America

The Folk Art Society of America (FASA) was founded in 1987 in Richmond, Va., by a group of folk art collectors, university professors, and museum personnel, under the leadership of William and Ann Oppenhimer. The mission statement—to advocate the discovery, study, preservation and documentation of folk art, folk artists, and folk art environments—has remained unchanged. The society currently publishes a full-color, 40-page magazine three times a year. The *Folk Art Messenger* features articles about folk artists, environments, exhibitions, auctions, fairs, symposiums and also includes book reviews, obituaries, and a comprehensive calendar of related events.

The Folk Art Society's annual conference, held in different cities, features a symposium, tours of private and public collections, an art auction, and social events. The National Advisory Board and the Board of Directors meet annually at the conference. Past conferences have been in Richmond (1988), Waverly (1989), Washington (1990), Chicago (1991), Los Angeles (1992), New Orleans (1993), Santa Fe (1994), Atlanta (1995), Birmingham (1996), Milwaukee (1997), Houston (1998), Lexington/Morehead, Ky. (1999), San Diego (2000), Richmond (2001), Savannah (2002), St. Louis (2003), Oakland (2004), Chicago (2005), Phoenix (2006), Louisville (2007), Washington, D.C. (2008), St. Petersburg (2009), Santa Fe (2010), and Richmond (2011).

At each conference, FASA presents Awards of Distinction to artists and scholars. From 1988 to 2007 the following received awards: Howard Finster, Herbert W. Hemphill Jr., Robert Bishop, Seymour Rosen, Minnie Adkins, Dorothy and Sterling Strauser, Felipe and Leroy Archuleta, Warren and Sylvia Lowe, Ned Cartledge, Jan and Chuck Rosenak, Clyde Jones, Gerard Wertkin, Gregory Warmack (Mr. Imagination), Flo and Jules Laffal, Rev. Johnnie Hunter, Lynda Roscoe Hartigan, Marilyn Oshman, Linvel and Lillian Barker, Alan Jabbour, Ted Gordon, Bud Goldstone, Georgia Blizzard, Shirley Yancey, Peggy Baggett, Lorenzo Scott,

Betty-Carol Sellen, John and Stephanie Smither, Ralph N. Lanning, Maude Southwell Wahlman, Artists of Creative Growth Art Center, Irene Ward Brydon, John Foster, Lee Kogan, Stanley Szwarc, Russell Bowman, Peter Cecere, Nicholas Herrera, Marvin Finn, Tim Lewis, Mary Bryan Hood, and Bill Glennon. In memory of one of the original members of the National Advisory Board, Herbert W. Hemphill Jr., the society annually donates a work by a living folk artist to a museum.

Plaques have been given to recognize outstanding folk art environmental sites, such as Howard Finster's *Paradise Garden* in Summerville, Ga.; Grandma Prisbrey's *Bottle Village* in Simi Valley, Calif.; Simon Rodia's *Watts Tower* in Los Angeles, Calif.; Leonard Knight's *Salvation Mountain* in Niland, Calif.; Miles Carpenter's home in Waverly, Va.; and Nek Chand's *Rock Garden* in Chandigarh, India.

The Folk Art Society's website, www.folkart.org, contains hundreds of pages, including reprints of articles, news, and information about the society and the annual conference.

ANN OPPENHIMER
Folk Art Society of America

Ann Oppenhimer, *Folk Art Messenger* (Spring 2003).

Freeland, Henry C.

(1821–1903)

Henry C. Freeland was a native of New York who relocated to Texas in the 1870s. In 1874 he was listed in the Galveston city directory under "Painters—House and Signs," and by 1881 he ap-

peared under the heading "Painter." The following year Freeland moved to San Antonio, married a widow with small children, and built a two-story house that contained a bakery on the first floor and living quarters above. The San Antonio directory for 1889–90 listed Freeland as a grocer and a sign painter, a fact that would indicate that painting alone did not provide sufficient income.

Among the few works by Freeland that survive are painted signs—including an advertisement for the Lone Star Brewing Company in San Antonio—and several small-scale paintings on wooden panels or on cardboard. The latter reveal the efforts of an imaginative self-taught artist who painted from archival sources such as photographs or fine art prints as much as from observation or memory. Two paintings of houses—one reminiscent of Thomas Jefferson's Monticello and the other a fair likeness of George Washington's Mount Vernon—may have been inspired by prints.

One particularly curious painting by Freeland depicts the Alamo set among vegetation more typical of the Northeast. Additional paintings by the artist, such as a whaling scene, a ship scene, and a mountain scene, bear further proof of the artist's interests beyond the specifics of Texas subject matter. In painting these non-Texas scenes peopled with small, ghostlike figures, Freeland produced fantastical interpretations of place that offer an alternative to the documentary-style paintings produced by Texas artist contemporaries more interested in visual and historical accuracy. Works by Freeland can be

found in the Witte Museum and the San Antonio Museum of Art.

A. KATE SHEERIN
Witte Museum

John Powers and Deborah Powers, *Texas Painters, Sculptors, and Graphic Artists* (2000); Cynthia Elyce Rubin, ed., *Southern Folk Art* (1985); Cecilia Steinfeldt, *Art for History's Sake: The Texas Collection of the Witte Museum* (1993).

Fryar, Pearl

(b. 1939)

Pearl Fryar grew up in Clinton, N.C., and subsequently lived in New York for a decade, where he worked as an assembly-line serviceman for American National Can Company. In 1975 Fryar moved to Bishopville, S.C., where he continued to work for the can company. At that time, Fryar had little interest in gardening or landscaping. Indeed, when he began sculpting trees and shrubs in 1984 he valued them primarily as a medium for artistic self-expression.

Fryar had always kept his yard meticulously groomed, but it was his desire to win the Bishopville Yard of the Month competition that instigated his career in topiary design. The competition, however, was open only to town residents, so Fryar, who lived just beyond the city limits in a black neighborhood, set out to design a yard so extraordinary that the judges would have to make an exception.

In 1985, Fryar went to a local nursery and purchased a malnourished juniper that was destined for the garbage. With a few instructions from the owner, Fryar learned the basics of topiary design. He has continued to obtain unwanted plants, and at least 25 percent of the trees in his three-acre yard were once discarded plants. Fryar never repeats a design, nor does he plan the shape of a piece in advance, but he does consider how a work relates to the rest of his yard. He pursues balance without symmetry and endeavors to create unprecedented designs. If he is particularly satisfied with a design, he simply maintains the shape. More often, however, he considers his pieces perennial works in progress.

Fryar's topiaries, almost all abstract in form, often contain hidden representations of people, places, or events that Fryar wishes to honor. While the concept of hidden meaning is in concert with the philosophies of many African American vernacular artists, Fryar's approach to his natural medium is his own. Unlike artists who believe that natural materials dictate form, Fryar believes that he alone is in control of his process.

Pearl Fryar has received both local and national attention. The town of Bishopsville has installed his topiaries in the median of Main Street. The Lee County Chamber of Commerce offers tours of Fryar's Garden, and state tourist guides highlight the garden. Fryar's participation in an exhibition at the South Carolina State Museum in Columbia led to speaking engagements at the Museum of Fine Arts in Boston and at schools throughout South Carolina. In 1996 the South Carolina State Museum commissioned Fryar to create on-site topiaries, which are now works in progress maintained by the artist. In Charleston, Fryar has installed topiaries

at the home of self-taught artist Philip Simmons.

In 2006, Winthrop University awarded Fryar a Medal in the Arts for his work as a self-taught topiary artist and for his impact on his community. A community group, the Friends of Pearl Fryar's Topiary Garden, helps care for the garden and coordinates educational programs and special events. Fryar's *Topiary Garden*, open to visitors, has been designated a Preservation Project of the Garden Conservancy, a national nonprofit organization dedicated to preserving small private gardens. Numerous television programs have featured Fryar's work. *A Man Named Pearl*, a 2008 full-length film, directed by Scott Galloway and Brent Pierson, has appeared in theaters and on HGTV.

WILLIAM ARNETT
Souls Grown Deep Foundation
STEPHANIE BURAK
Atlanta, Georgia

William Arnett and Paul Arnett, eds., *Souls Grown Deep: African American Vernacular Art*, vol. 2 (2001); Scott Galloway and Brett Pierson, *A Man Named Pearl*, DVD (2008); Mark Kane, *Fine Gardening* (September–October 1991); www. pearlfryar.com.

Frymire, Jacob

(b. 1765–1777; d. 1822)

Details about Jacob Frymire's place and date of birth have not been found, but he is known to have been the son of Henry Frymire living in Lancaster, Pa., during the 1760s to 1770s. Also not known is when and from whom he received his training as a painter. More details emerge in the 1790s when his father moved to Hamilton Town-

ship, Franklin County, near Chambersburg in the Cumberland Valley. The next year in May, at the same time his father bought 200 acres of farmland, Frymire had begun work as an itinerant painter in New Jersey where he executed portraits of the Clark family of Cumberland County. The compositions and stylistic elements he utilized throughout his career are seen in these portraits: architectural settings, furniture, and objects specifically associated with the sitter surround the figure—all painted in thin layers of oil pigment on canvas. The description of the portrait of young medical student Charles Clark, unlocated in recent decades, sounds like many of Frymire's other works: a young man stands beside a table with eagle-patterned inlay holding medical books and instruments. In like fashion, the portrait of Clark's half-brother Daniel shows a young man seated in front of a curtain and column before a house in a landscape. The half drop-leaf table beside him holds an inkwell and note reading: "Virtue and Industry are the springs of happiness." Both brothers are depicted as active young men industriously making themselves part of the new postrevolutionary American middle class.

Equally industrious as a painter, Frymire's subsequent career as an itinerant took him to communities in Pennsylvania, Maryland, Virginia, and Kentucky seeking work. His sitters include merchants, sea captains, and landowners, who frequently commissioned portraits of more than one family member. Groups of family portraits have survived for the McKnights

and Marstellers of Alexandria, Va., the Laucks of Winchester, Ky., and the Calmes of Woodford County, Ky. The artist frequently signs on the reverse with the phrase "Painted by" utilizing one of three spellings of his last name: Frymeier, Frymier, or Frymire (using the last most frequently), followed by a date and often the location where he painted the work. By the early 19th century, he was also working in watercolor on ivory creating miniature portraits. One notable example signed and dated "J. Frymire 12th Octbr 1801" is of Peter Lauck, a prominent Winchester innkeeper. Frymire painted his wife, Amelia Heiskell Frymire, in oil on canvas about two months later, adding credence to the frequent speculation that itinerant artists bartered for their room and board.

Frymire is of considerable interest as a painter whose career and style can be linked to other nonacademic or folk artists active at the same time and places such as Charles Peale Polk (1767–1822) and Philippe Abraham Peticolas (1760–1841). Both Frymire and Polk painted members of the Lauck family. Frymire's delightfully perceptive portrayals of children with pet animals link him to a late 18th- to early 19th-century interest in childhood found also in the work of painters such as the African American portrait painter Joshua Johnson.

Frymire maintained a residence in Pennsylvania during the first two decades of the 19th century. He owned land in Shippensburg, where the Federal Census of 1810 listed him living with his second wife, Rachel, and two young children, and it is there between 1807

and 1820 that he was taxed a number of times as a both a limner—a contemporary term for a portrait painter—and a freedman. After his father's death in 1816 he inherited land in Hamilton Township where he lived and apparently worked as a farmer for the rest of his life. Frymire wrote his will 22 May, a few months before his death in July 1822. He provided for his wife and eight children (soon to be nine) to inherit the farm, but he made no mention of his career as an itinerant portrait painter.

LINDA CROCKER SIMMONS
Corcoran Gallery of Art

Linda Crocker Simmons, *Jacob Frymire: An American Limner* (1974), *Winchester-Frederick County (Virginia) Historical Society Journal* 4 (1989), *Southern Quarterly* 24, no. 1 (1985).

Gee's Bend

In antebellum times, the area tucked within a hairpin curve of the Alabama River southwest of Selma contained several cotton plantations and acquired its name—Gee's Bend—from the best known of those estates. After the Civil War, ex-slaves in "the Bend" took the names of the Gee's Bend plantation's later owners. For example, the Pettways stayed on the land as tenant farmers. Geographically isolated, with little day-to-day influence from the surrounding world, the African American residents of Gee's Bend created a distinctive island of culture replete with its own customs, religious traditions, and—incubating for several generations—patchwork-quilt aesthetic.

The Gee's Benders' pioneer-style existence—with its hand-built log

cabins, mule-driven wagons, and nearly self-sufficient economy—was not insulated from fluctuations in the price of cotton, and during the Great Depression the Gee's Benders were thrown into cataclysm. Their goods were repossessed along with their food stores and livestock; the population was on the brink of starvation when the federal government intervened, eventually establishing Gee's Bend as a New Deal experiment that enabled locals to purchase land and acquire new homes and that founded an agricultural cooperative, a school, and a clinic. A long-term effect of these government programs (besides the famous photographs that Farm Security Administration photographers Arnold Rothstein and Marion Post Wolcott took of Gee's Bend in the late 1930s) was that many townspeople left behind their status as tenants; the presence of so many homeowners allowed Gee's Bend to endure mostly intact through the second half of the 20th century, when many other southern rural communities and their traditions dissipated or disappeared.

Among the cultural survivals in Gee's Bend was its quilt tradition. Quilt making had long been a part of young girls' preparations for womanhood, and children frequently apprenticed at the feet of mothers and other female relatives and friends. Eventually a girl would make her own quilt, incorporating skills of cloth salvage, design, and sewing. Gee's Bend quilts were traditionally made from recycled clothing, primarily denims and cotton twills. A reliance on archetypal patterns, especially variations of the "Log Cabin"

or "Housetop" designs of concentric squares, fed into the use of heavy, resistant fabrics and Gee's Benders fundamental thrift to create an aesthetic reminiscent of minimalism—spare, austere meditations on elemental geometric forms. At the same time, many Gee's Bend women measured themselves by their originality and flair as quilt designers, so the Gee's Bend aesthetic brims as well with surprising juxtapositions and shifts of scale, color, and visual rhythm. The distinctive qualities of Gee's Bend quilts—minimalism in tension with dynamism—fit into the spectrum of African American patchwork quilts: the loose "Gee's Bend style" seems a fusion of the individual, the family, the community, and ethnicity considered more broadly—as well as including patterns and techniques that are shared with or borrowed from Anglo-American quilts.

In 2002 Gee's Bend quilts found international prominence when they were the subject of a major exhibition, *The Quilts of Gee's Bend*, that traveled to 12 American museums. A second traveling exhibition, *Gee's Bend: The Architecture of the Quilt*, premiered in 2006.

PAUL ARNETT
Lafayette, California

Paul Arnett, William Arnett, Bernard Herman, and Maggi Gordon, *Gee's Bend: The Architecture of the Quilt* (2006); William Arnett and Paul Arnett, eds., *Gee's Bend: The Women and Their Quilts* (2002); William Arnett et al., *The Quilts of Gee's Bend: Masterpieces from a Lost Place* (2002).

Gibson, Sybil

(1908–1995)

Sybil Gibson said that her sweet and colorful paintings of flowers and children were childhood memories. The sad and haunted portraits of women's faces seem to portray the fears and anxieties of her tumultuous adult life.

Born Sybil Aaron in Dora, Ala., on 18 February 1908 to a well-to-do family, she was educated in Alabama, eventually receiving a B.S. degree in elementary education from Jacksonville State Teachers College. She married her high school sweetheart, Hugh Gibson, in 1929 and had a daughter, Theresa, in 1932. The couple divorced in 1935, and Gibson left her daughter in the care of her parents. She taught school in Alabama and then in Florida, where she married David DeYarmon, who later moved to Ohio without her and died in 1958. Gibson's painting career began in Miami in 1963, after she had seen some striking gift-wrapping paper. She soon became so prolific that she painted up to 100 paintings a day. Many of the thousands of works she produced, however, were lost as she moved from place to place.

Gibson often said that she preferred to paint on paper she took out of the trash bin rather than on good art paper. Considering the volume of her output and the sometimes precarious state of her finances, her approach is understandable. Although Gibson painted on any paper at hand, including newspapers, she preferred to use tempera paints on damp grocery bags. Her delicate wet-on-wet technique stands in contrast to the bold painting often seen in the works of southern folk artists. In addition to tempera, Gibson also used oils, house paint, acrylics, and watercolors. Her subjects included still lifes, landscapes, flowers, birds, cats, children, groups of figures, and striking portraits of women. She also painted a number of abstracts. Her impressionistic work has been praised by art critics as lyrical and tender, and it has been compared to that of Milton Avery and Odilon Redon. Believing that art could not be taught but must come forth intuitively, Gibson did not make sketches of her proposed subject. She said that she let the paintbrush dictate both subject and technique.

In 1971 the Miami Museum of Art organized a one-woman show of Gibson's work. The artist, however, never saw the exhibition. She had returned to Alabama to "study weeds." Over 20 years, Gibson's circumstances continued to deteriorate. She lived in a seedy hotel in Birmingham, in a trailer with her cousin in Florida, and then in a facility for the elderly in Jasper, Ala., which expelled her because of disruptive behavior. By 1981, when she moved into the home for the elderly, Gibson had stopped painting because of poor eyesight. In 1991 Gibson's daughter, Theresa, rescued her and arranged for a cataract operation. Gibson then moved to a nursing facility in Dunedin, Fla., near her daughter. With her eyesight restored, she was soon back at work on new paintings. She died on 2 January 1995. Gibson's work has been included in many exhibitions and is in the permanent collections of such museums as the American Folk Art Museum, the Birmingham Museum of Art, the Mont-

gomery Museum of Fine Art, the Mennello Museum of American Art, and the New Orleans Museum of Art.

JOHN HOOD
New York, New York

John Hood, *Folk Art* (Winter 1998–99); Kathy Kemp and Keith Boyer, *Alabama's Visionary Artists* (1994); Alice Rae Yelen, *Passionate Visions of the American South: Self-Taught Artists from 1940 to the Present* (1993).

Golding, William O.

(1874–1943)

William O. Golding, an African American seaman, created nearly 70 lively drawings of sailing vessels and ports of call while a patient in the Marine Hospital in Savannah, Ga., during the 1930s. Golding recounted that as a boy he was shanghaied, tricked aboard a ship, at the port of Savannah in 1882 and did not see his home again until 1904. After close to 50 years at sea and visits to far-off corners of the globe on a variety of vessels, Golding began making art in 1932. Glimpses of Golding's life and experiences are found in two letters written to Margaret Stiles, a Savannah artist who organized recreational activities at the hospital. Stiles encouraged Golding to draw; provided him with pencils, crayons, and paper; purchased drawings; and sold them on his behalf.

Golding's detailed, fanciful drawings largely depict exotic ports and sailing ships, many of which he apparently had seen or served on. His depictions of specific vessels include the USS *Constitution*, which visited Savannah in 1931, and the USS *Nourmahal*, once owned by John Jacob Astor. Occasional works, for example, a drawing of the *Alabama*, a Confederate vessel, commemorate craft that he could not have seen. Golding's drawings usually include drawn frames and nameplates complete with screws, details suggesting that he was familiar with framed nautical paintings or reproductions.

Stylistically, Golding reinvents the marine painting tradition in personal terms. Like professionally trained marine painters, he is concerned with identifying details such as rigging and signal flags. Golding also relies on individualized conventions, however, such as lighthouses, buoys, and his signature detail, a vibrant sun resembling a compass rose bursting forth from clouds. In his images of ports, Golding captures the flavor of a place by exaggerating landmarks, labeling sites of interest to a seaman, and populating these scenes with tiny human figures. Golding depicts ports of call, including his hometown of Savannah and ports in China, the Philippines, Java, Newfoundland, Trinidad, Cape Horn, the Rock of Gibraltar, and England. Golding claimed to have visited many of these spots and wrote to Stiles that he could not draw Hawaii or Bali because he had not seen them.

Golding died in the Marine Hospital in 1943 during surgery, after which public interest in his work continued intermittently. A 1947 photograph in *Town and Country* magazine shows numerous works by Golding decorating the Manhattan apartment of socialite Margaret Screven Duke, a professionally trained artist and niece of Golding's

mentor, Stiles. Golding's work surfaced again in a 1969 exhibition at the Miami Art Center, in a 1970 article in *Art in America*, and in the traveling exhibition *Missing Pieces: Georgia Folk Art, 1776–1976*. The artist has since been the subject of solo exhibitions at Georgia museums including the Telfair Museum of Art (Savannah) and the Morris Museum of Art (Augusta). His work is also included in the collection of the Smithsonian American Art Museum.

HARRY H. DELORME
Telfair Museum of Art

Pamela King and Harry DeLorme, *Looking Back: Art in Savannah, 1900–1950* (1996); Anna Wadsworth, *Missing Pieces: Georgia Folk Art, 1776–1976* (1976).

Gudgell, Henry

(1829–1895)
Kentucky-born Henry Gudgell was a mulatto slave who spent most of his life in Livingston County, Mo., where he became a blacksmith and wainwright and sometimes worked as a silversmith and coppersmith. Gudgell is best known, however, as the skilled wood-carver of two beautiful walking sticks, one now in the Yale University Art Gallery and the other in a private collection in Kentucky. The cane at Yale is the best documented of the two works. Writing in a seminal 1969 essay titled "African Influence on the Art of the United States" in *Black Studies at the University: A Symposium*, Robert Farris Thompson, a scholar of the arts of the African diaspora, suggested that Gudgell probably made the cane in 1867 for John Bryan, an army officer from Livingston County. Fighting on the side of the South, Bryan

was shot in the leg and crippled in the early years of the Civil War, at the siege of Lexington, Mo., in 1861. Handed down in the Bryan family from one generation to the next, the cane was cataloged and illustrated in 1940 for the Index of American Design, housed at the National Gallery of Art, and then sold to Yale in 1968. The provenance of the second walking stick, which was discovered in 1982 and attributed to Gudgell on the basis of style, subject matter, and technique, is unknown.

Both of Gudgell's canes, approximately 3 feet in height, carry similar abstract and figurative motifs. The designs carved in low relief near the handles of each cane consist of serpentine grooves, circular bands, and diamond-shaped patterns. Crawling up the shaft of each is a tiny caravan of reptiles: a lizard leads the procession, and a tortoise follows. Both are portrayed from above. Bringing up the rear of the convoy is a coiled serpent that glides effortlessly upward. The cane in the Yale collection carries two additional motifs: a branch with a single leaf and the tiny figure of a man. Both are placed just below the turtle and across from each other on opposing sides of the cane's shaft. The man is viewed from behind and positioned just above the snake's head. Dressed in a short-sleeve shirt, trousers, and shoes, the figure grasps the cane's shaft with his arms and bended knees.

The peculiar combination of reptilian motifs and the human figure on the cane at Yale led Thompson to consider the role of canes and walking sticks and the meaning of turtles, lizards, and serpents in African and

African American art, folklore, and folk belief. Thompson established the African roots of Gudgell's cane, situating it as the earliest known example of an African-derived visual tradition best known in the carved canes of coastal Georgia. In *The Afro-American Tradition in Decorative Arts* (1978), John Michael Vlach further explored this connection, discussing similar works not only along the coast of Georgia but also in the Georgia Piedmont and in Mississippi. Referring to Gudgell's cane in the Yale collection, Vlach observed, "It is ironic, although not incomprehensible that the greatest piece of Afro-American walking stick sculpture should have been made in north-central Missouri, in Livingston County, over a thousand miles from the geographic focus of a black carving tradition."

In "An Odyssey: Finding the Other Henry Gudgell Walking Stick," published in *Folk Art* (Fall 2008), Alan Weiss, the owner of Gudgell's second cane, updated and expanded Thompson's findings. Weiss discovered that Gudgell was born in 1829 in Anderson County, Ky., that his 15- or 16-year-old mother was named Rachael, and that his owner and probable father was Samuel Arbuckle, a wealthy white Kentuckian. In 1830 Arbuckle left in trust to his daughter Elizabeth Arbuckle several slaves, including Rachael and her infant son. In the same year Elizabeth and her husband Jacob Gudgell Jr. moved their household to Missouri, where they ultimately settled in Livingston County. In the coming years Henry Gudgell became the property of various members of his extended white family. He married, raised his own family, obtained his freedom after the Civil War, purchased 22 acres of land in 1870, and apparently flourished as a master of the metal arts and a maker of carved wooden canes.

Perhaps the most intriguing aspect of Gudgell's work is its connection with the healing arts of West Africa that survived in the traditions of the African American South. Thompson associated the conspicuous presence of lizards, snakes, and turtles on African American walking sticks, such as Gudgell's, to the prevalent role of reptiles in African American folk medicine or what is known as conjure. He noted, for example, the existence in Charleston, S.C., of a carved walking stick embellished with an entwined serpent that was called a "conjure stick." He also observed that, in the folk beliefs of African Americans in early 20th-century Georgia, reptiles carried a negative connotation, and he concluded that the presence of such animals on a cane may "constitute a coded visual declaration of the power of the healer." Writing in an essay titled "Defining the African-American Cane," in *American Folk Art Canes: Personal Sculpture*, Ramona Austin, art historian and curator of African and African American art, defined two major forms of African American canes, conjuring canes and walking sticks. "Conjurer and root or hoodoo doctor are names for a ritual specialist. This specialist manipulates canes to cure, protect, or afflict." Austin went on to say that Africans and African Americans recognized reptiles, which are able to live in water and on earth, as mediators between

the spirit and the living worlds. Conjuring canes are "mediums of contact to a spirit world that can affect the psychic and physical disposition of people and things in the nonspirit world." Gudgell's canes, which exemplify this tradition, may have been intended and understood as objects that invoked the power to heal.

CAROL CROWN
University of Memphis

Ramona Austin, in *American Folk Art Canes: Personal Sculpture*, ed. George H. Meyer, with Kay White Meyer (1992); Betty J. Crouther, *SECAC Review* (1993); Georgia Writer's Project, *Drums and Shadows* (1940); Betty Kuyk, *African Voices in the African American Heritage* (2003); Regenia Perry, in *Black Art Ancestral Legacy: The African Impulse in African-American Art*, ed. Robert V. Roselle (1989); Robert Farris Thompson, in *Black Studies in the University: A Symposium*, ed. Armstead L. Robinson, Craig C. Foster, and Donald H. Ogilvie (1969); John Michael Vlach, *The Afro-American Tradition in Decorative Arts* (1978); Allan Weiss, *Folk Art* (Fall 2008).

Guilford Limner (Dupue)

(fl. 1820s)

Although records show that itinerant portraitists worked in North Carolina and Kentucky between the 1770s and the mid-19th century, scholars have not yet discovered the name of the artist known as the Guilford Limner. This artist, active during the 1820s in the vicinity of Greensboro, Guilford County, N.C., and also in Kentucky, signed none of the watercolor portraits attributed to him. The artist did not advertise services in local newspapers as did many itinerants, and because newspapers did not report the visit of a female painter, it is unlikely that the Guilford Limner was a woman. Indeed, the only hints at the artist's identity come from a letter by the granddaughter of a North Carolina client referring to "a traveling French artist" and a note on the back of the portrait of Mr. and Mrs. James Ragland of Clark County, Ky., that reads "taken August 1820 on Clark Co., Kentucky by Dupue." The stylistic similarities between the North Carolina portraits and the Kentucky works are sufficient to attribute the portraits to a single artist or perhaps to an artist and a close follower.

The Guilford Limner's watercolor portraits, more affordable than oil paintings, depict middle-class patrons who lived in a time of community growth and increasing prosperity. Whether the sitters were men, women, or children, the limner paid close attention to the subject's faces, and even though almost all have rounded eyes, well-defined eyebrows, short straight noses, diminutive cherub lips, and contained expressions, the artist manages to differentiate subjects from one another. Sometimes the artist also personalizes the portraits by painting the patrons' names within a cartouche or within the composition as though the name were a wall decoration. The number of commissions the artist received in Guilford County—some 30—implies that patrons were pleased with their likenesses.

The conventional settings of the portraits undoubtedly fulfilled the desires of relatively affluent middle-class patrons to document their worldly and

spiritual successes. Just as the artist re-
peated a limited repertoire of stylistic
devices to render faces, he also placed
most of his sitters within conventional
and well-furnished 19th-century in-
teriors that may not reflect the actual
possessions of the sitters or the décor of
their individual homes but suggest their
affluence. Wainscoted walls, Windsor
chairs, faux-painted decorations, and
carpets with exuberant designs all dis-
play middle-class comforts. The sitters'
dress likewise indicates social status,
age, and gender roles. Men wear white
stocks, waistcoats, and cutaway jackets,
while women wear modest but fashion-
able clothing. The portraits of members
of the four generations of the Gillespie
family are excellent representations of
social identities. Colonel Gillespie, "Gi-
laspi" in the artists' spelling, has chosen
to present himself in the uniform and
high-feathered hat of a Revolutionary
War officer. Margaret, Daniel's wife,
wears a ruffled cap, wide scarf, and
dark dress to display the modesty and
rectitude of a grandmother. The Gil-
lespie daughters, Nancy and Thankful,
wearing jewelry and slightly less con-
cealing clothes and sewing or knitting,
advertise their industry and piety. In
the portrait of Robert Gillespie, the
married son of Daniel and Margaret,
the limner indicates the young man's
success as a farmer through an un-
likely display of corncobs that lie upon
a sitting room's paint-grained table.
Robert's wife, Nancy Hanner Gillespie,
sits beside an abundant arrangement of
flowers. The youngest member of the
family, John Patterson Gillespie, wears a
dark suit and carries a book, both con-
ventional emblems of a boy's prepa-
ration for adulthood. Other portraits
contain additional emblems of attain-
ment and virtue. Men may sit at desks
and review their account books. Women
holding bouquets and children standing
in gardens are conventional depictions
that represent the children's flourishing
and their parents' careful nurture. The
Raglan portrait places the couple out of
doors; a winding road leading into the
distance may represent the extent of
their property.

Works by the Guilford Limner, or
Dupue, are held in the Greensboro His-
torical Museum and in private collec-
tions.

CHERYL RIVERS
Brooklyn, New York

Karen Cobb Carroll, *Windows to the Past:
Primitive Watercolors from Guilford County,
North Carolina from the 1820s* (1983); Nina
Fletcher Little, *The Magazine Antiques*
(November 1968), *Little by Little* (1984); Mc-
Kissick Museum, *Carolina Folk: The Cradle
of a Southern Tradition* (1985).

Hall, Dilmus
(1900–1987)
Dilmus Hall, an African American self-
taught artist from Athens, Ga., is best
known for his small- and large-scale
sculptures created out of concrete and
found or scrap pieces of wood and for
his drawings executed in colored pencil
and crayon. His subject matter includes
simple, charming depictions of animals
and humans, ambitious allegorical and
religious narrative scenes, and impor-
tant figures from local history.

Hall grew up in rural Georgia, born
into a farming and blacksmithing

family, one of more than a dozen children. During his childhood he sculpted birds and other animals, often out of flour mixed with sweet gum sap. Hall's mother encouraged her son's early artistic pursuits, but his hardworking father found little merit in them. Hall left the family home and found work on a road gang and in a coal mine. In 1917 he joined the United States Army Medical Corps and transported injured soldiers across the battlefields of France. This experience allowed Hall to view European art, memories of which inspired later sculptures.

After leaving the army, Hall lived in Athens, Ga., where he worked as a hotel captain, a waiter, a sorority house busboy on the local University of Georgia campus, and a fabricator of concrete blocks for a construction company. Hall was a deep thinker, a philosopher, and a man of fierce faith. He believed that the teachings and happenings in the Bible were never far from contemporary life. In the book *O, Appalachia*, Ramona Lampelle describes Hall's speaking style as that of a back-country revival preacher and quotes Hall's Old Testament inspired insights on art making and daily life. Many works reflect Hall's interest in exemplary heroes whose virtues reflect biblical precepts. The artist's small concrete tableau entitled *Dr. Crawford Dying*, for example, is a tribute to the Athens-based 19th-century surgeon Dr. Crawford W. Long (1815–78), who first discovered the effect of ether and used it during surgery. Long was also one of the few white doctors of the time who cared for African Americans.

In the 1950s Hall began to gain local attention for his architectural adornments and "yard art" outside his small cinder block home. The work entitled *The Devil and the Drunk Man* depicts two life-size drunkards and the devil in an allegorical environment. Hall believed that the devil was everywhere, encouraging people to commit sins. Hall saw these sculptures as protections from the devil. Much comparison has been made between Hall's art and the African American conjuring culture, a vernacular religion that mixes aspects of Christianity with African traditions of empowering objects. Hall was drawn to, and believed in, the power of objects and symbols, although he was unaware of their African cultural allusions. To illustrate this point, Hall's oeuvre includes sensitive and powerful depictions of the Crucifixion, many of which use a simplified, tripartite, y-shaped cross. This symbolic shape closely relates to a root sculpture constructed of a twisted branch, scraps of wood, metal, nails, and paint (ca. 1940), which Hall always referred to as his personal emblem.

In the 1980s, Hall's work began to receive wider recognition when its originality and iconographic content became better understood. The High Museum and the American Folk Art Museum include Hall's work in their collections.

JENINE CULLIGAN
Huntington Museum of Art

Paul Arnett and William Arnett, eds., *Souls Grown Deep: African American Vernacular Art of the South*, vol. 1 (2000); Chris Hatten, *Huntington Museum of Art: Fifty Years of Collecting* (2001); Ramona Lampell and Millard Lampell, *O, Appa-*

lachia: *Artists of the Southern Mountains* (1989); Frank Maresca and Roger Ricco, *American Vernacular: New Discoveries in Folk, Self-Taught, and Outsider Sculptures* (2002); Lynne E. Spriggs, Joanne Cubbs, Lynda Roscoe Hartigan, and Susan Mitchell Crawley, *Let It Shine: Self-Taught Art from the T. Marshall Hahn Collection* (2001).

Hamblett, Theora

(1895–1977)

Theora Hamblett was born 15 January 1895 in the small community of Paris, Miss. Hamblett lived the first half of her life on her family's modest farm in Paris. Her experience as a white woman growing up and living in the impoverished rural South was typical of her times, with the exception that she never married or had children. From 1915 to 1936 Hamblett taught school intermittently in the counties near her family home. In 1939 she moved to the nearby town of Oxford, where she supported herself as a professional seamstress and converted her home into a boardinghouse.

Hamblett began painting in the early 1950s, fulfilling an interest in art that had begun in her youth. Although she enrolled in several informal art classes and a correspondence course during her later life, Hamblett was largely self-taught. Her first paintings depict memories of her childhood, and she painted scenes of southern country life for the next two decades, culminating in a series of paintings about children's games. Hamblett's most unusual works are the over 300 religious paintings representing biblical subjects and Hamblett's own dreams and visions. These

paintings began in 1954 with *The Golden Gate*, later renamed *The Vision*. Today, this first painting is owned by the Museum of Modern Art in New York; most of Hamblett's religious paintings and many memory paintings were never available for sale and were bequeathed by the artist to the University of Mississippi Museum in Oxford.

Hamblett's religious paintings and interpretations of her dreams and visions were firmly rooted in her personal religious history. The popular, transdenominational southern Protestantism practiced in the churches, revival meetings, and hymn sings Hamblett attended in and around Paris, Miss., all emphasized the possibility of unmediated encounters between God and communicants, usually taking the form of visionary or dreamlike experiences. Church services were often structured around testimonies in which the worshipers described these experiences, and hymn lyrics regularly referred to them. Hamblett's vision and dream paintings bear structural similarities to traditional testimonies, and many of her paintings employ images from the popular southern hymnody.

Hamblett's aesthetics and working methods were also largely products of her background. The needlework skills she learned as a southern rural woman are evident in her art. Hamblett's characteristic tiny brushstrokes of unmixed color resemble embroidery stitches, and many of her images suggest lacework and tatting. Her work provides a record of a vanishing regional history, and the complex associations of her religious paintings raise Hamblett from the status

of an amateur to that of a significant artist of popular southern traditions.

ELLA KING TORREY
Philadelphia, Pennsylvania

William Ferris, *Local Color: A Sense of Place in Folk Art* (1983), *Four Women Artists* (1977); Theora Hamblett, in collaboration with Ed Meek and William S. Haynie, *Theora Hamblett Paintings* (1975); Ella King Torrey, "The Religious Art of Theora Hamblett, Sources of Attitude and Imagery" (M.A. thesis, University of Mississippi, 1984).

Hampton, James

(1909–1964)

Working in an unheated, dimly lit garage in a run-down neighborhood in Washington, D.C., James Hampton, a janitor employed by the General Services Administration, crafted a dazzling, shrinelike sculpture: a huge altar radiant in gold and silver and touched in colors of wine red and green. Styling himself Director for Special Projects for the State of Eternity, Hampton fashioned *The Throne of the Third Heaven of the Nations Millennium General Assembly*, a huge 180-piece construction. Made of cast-off objects such as old furniture, desk blotters, cardboard, jelly jars, and burned-out light bulbs, the Throne is ingeniously wrapped in gold and silver foil scavenged from store displays, wine bottles, cigarette boxes, and rolls of kitchen foil. From discarded junk, Hampton created a shimmering vision of dazzling light and color.

Born the son of a vagabond preacher or gospel singer, Hampton, who was raised a Baptist, claimed he had experienced religious visions throughout his life. He believed Moses had appeared in Washington, D.C., in 1931. Another vision in 1950 centered on the "Virgin Mary descending into heaven." Drawing inspiration from his visions, he set to work on the *Throne*, which he may have intended to install one day in a storefront church. Today, however, Hampton's creation is housed in the Smithsonian American Art Museum. It has been described by art critic Robert Hughes, writing in *Time* magazine, as perhaps "the finest work of visionary religious art produced by an American."

Little is known about James Hampton. He grew up in Elloree, S.C., a small rural community just south of Columbia. Sometime in the late 1920s, Hampton moved to Washington, D.C., to join his elder brother. He worked at a variety of odd jobs and in 1942 was inducted into the army, where he served in a noncombatant unit as a carpenter. Returning to the nation's capital in 1945, he rented a room in a boardinghouse. A year later, the General Services Administration hired him as a janitor. A quiet, soft-spoken, and unassuming man, Hampton never married, had few close friends, and maintained the same address and job until his death in 1964.

Sometime in 1950, saying he wanted a large work space, Hampton rented a garage in the northwest Washington neighborhood known as "Fourteenth and U," near Howard University, the center of black business, religious activities, and nightlife. There, after his evening shift ended at midnight, Hampton worked on his astonishing liturgical assembly. As the focus of his symmetrical and bilateral design, Hampton erected on a 3-foot-high wooden plat-

form an elaborate winged throne with a burgundy cushion and 7-foot-tall back panel crowned by the command "Fear Not." Other furnishings, flanking it to left and right and situated in three parallel rows, recall the pulpits, altars, pedestals, offertory tables, and plaques of contemporary storefront churches. Hampton labeled many of the objects. Those on the viewer's right of the throne refer to the Old Testament, while those on the viewer's left relate to the New Testament. Other labels reference the millennium and the book of Revelation, the Bible's most important prophetic book.

Hampton's fabrication of *The Throne of the Third Heaven of the Nations Millennium General Assembly* relates not only to the book of Revelation but also to early 20th-century fundamentalist beliefs known as dispensationalism. Teaching that the Bible is the literal word of God, this religious teaching divides history into ages or dispensations and promises the fulfillment of God's prophecies in Christ's return to earth, the millennium (a thousand years of bliss), and, ultimately, the New Jerusalem where God will reign forever. Calling himself St. James, Hampton may have seen himself as a modern-day counterpart to St. John, Revelation's purported author. Like St. John, Hampton left behind a written text, which he entitled the *Book of the 7 Dispensation of St. James.* Each page is marked with the word "Revelation," but the rest of the text is written in a script of Hampton's own making that has not been deciphered. Even so, there is enough evidence to suggest that, like St. John's text, *The Throne of the Third Heaven of the Nations Millennium General Assembly* is intended to function as a visual prophecy of Christ's return and God Almighty's eternal reign.

CAROL CROWN
University of Memphis

Linda Roscoe Hartigan, *The Throne of the Third Heaven of the Nations Millennium General Assembly*, Montgomery Museum of Fine Arts (1997), *American Art* (Summer 2000).

Harding, Chester

(1792–1866)
Born into poverty, Chester Harding was truly a self-made man. He worked as a chair painter, housepainter, sign painter, cabinetmaker, and tavern keeper before he took up portrait painting. At that time Harding had seen only the work of an obscure itinerant painter. By the end of his career, he had become an academic society painter in Boston hailed as a "marvel from the backwoods of America." His success has been attributed not only to his inherent talent but also to his charming personality, confidence, and steadfast determination.

Born in Conway, Mass., in 1792, Harding began making "truthful likenesses" when he and his wife joined his brother in Paris, Kentucky, in 1815. After attempting his first portrait with sign paint, Harding was eager to leave behind his former careers. During this early period he learned by copying the portraits of itinerant but esteemed painters and attempting to replicate their techniques. Aware of his shortcomings, Harding managed to spend a few months during 1819 and 1820 at

the Pennsylvania Academy of Fine Arts "studying the best pictures, practicing at the same time with a brush." Although Harding was dismayed to see that his portraits were greatly inferior to the polished works he had seen in Philadelphia, he commenced his career as an itinerant artist. Over the next thirty years he traveled extensively, visiting and revisiting cities such as St. Louis, New Orleans, Washington D.C., and Philadelphia to generate business. He also made two trips to Great Britain (1823–26 and 1846–1847) receiving many important commissions during these years that reflect the influence of Sir Thomas Lawrence. In 1830 Harding settled his wife and nine children in Springfield, Mass. He maintained a studio and gallery in Boston but also continued to travel in search of commissions. Harding's gallery hosted many art exhibitions and was also home to the school founded by the Boston Artists' Association. The artist died in 1866, leaving behind a lively personal memoir and numerous portraits of many prominent men and women that demonstrate his popularity and his natural talent.

From the fabled Daniel Boone, who sat for him in 1820, to Gen. William T. Sherman, whom he painted in 1865–66, Harding strove to accumulate a notable list of clients during his lifetime. No American painter of his generation could boast a more impressive list of patrons. They included three American presidents (Adams, Madison, and Harrison); statesmen John Calhoun and Daniel Webster; numerous governors, senators, and their wives; and fellow artist and close friend, Washington

Allston. Regardless of their professions or positions, Harding chose to render his sitters with the truthful clarity that commonly characterizes the work of self-taught portraitists; in most of his paintings, a simplified plain background or drapery assures that the subject's face is the center of attention. Harding's full-length portraits again reveal his beginnings as a self-taught painter. Although these portraits may distort perspective and proportions, Harding had honed his skills to produce paintings that were accepted into annual exhibitions at London's prestigious Royal Academy and at the Pennsylvania Academy of Fine Arts.

CAROL CROWN
University of Memphis

CHERYL RIVERS
Brooklyn, New York

Chester Harding, Margaret E. White, and W. P. G. Harding, *A Sketch of Chester Harding, Artist, Drawn by His Own Hand* (1970); Leah Lipton, *A Truthful Likeness: Chester Harding and His Portraits* (1985).

Harris, Felix "Fox"
(1905–1985)

Felix "Fox" Harris was born in 1905 in Trinity, Tex., a small east Texas sawmill town. As an adult, Harris lived in Beaumont, where he worked at various lumbering and railroad jobs, all hard physical labor. Like many other self-taught artists, Harris began art making late in life.

Harris's inspiration for his dense, fantastic forest of shining metal sculptures and 20-foot-high totems came one night as he lay in bed. According to Harris, God appeared to him in a vision,

holding in one hand a sheet of brown paper and in the other hand a sheet of white paper. God spoke to him of the sorrows and struggles of his life, which were symbolized by the brown paper. Laying that paper aside, He told Harris that his old life would also be laid aside and that he would receive the gift of new life symbolized by the white paper. As Harris put it, "God took nothing and made something."

That phrase, "Take nothing and make something," became the theme of Harris's work. For more than 20 years, the artist took the broken and discarded objects of everyday life and transformed them into an environment alive with color and movement. He worked intuitively and confidently; and although the individual pieces are singular, the work as a whole conforms to a strong and consistent vision. His environment displays aesthetic preferences associated with other African American yard shows: flashing metal, circular objects like hubcaps, diamond shapes, and kinetic elements that indicate spirit and potentiality.

Although Harris was certainly familiar with implements that could have speeded his work, his tools were few and handmade. For his metal cutouts, the artist preferred to use what looked like an ordinary table knife that he had modified by flattening the handle with a ball-peen hammer and by sharpening the tip of the blade. He customarily made a stencil with pencil and paper, traced it onto the metal, and then painstakingly cut out the design by placing the sharpened knife tip along the drawn line and gently tap-

ping out the figure with the hammer. He also fashioned a pair of wooden stilts and used them when working on the tall totems. He called them his "tom-walkers." To see him, nine feet tall, striding through his forest on those tom-walkers was a heart-stopping, indelible sight.

Harris continued to work until his death in 1985. After his death, family, friends, and art collectors preserved a portion of the environment, moving it and installing it on the grounds of the Art Museum of Southeast Texas. Because of concerns about hurricane damage and deterioration, the environment was reinstalled inside the museum, where it is on semipermanent display.

PATRICIA CARTER
Beaumont, Texas

Ray Daniel (introduction), Patricia Carter, and Lynn P. Castle, *Felix Fox Harris* (2008).

Harvey, Bessie Ruth White

(1929–1994)
Using little more than roots, shells, and paint, visionary artist Bessie Harvey assembled a diverse cast of figures that appeared vividly before her mind's eye. Biblical characters, African ancestors, mythological creatures, and episodes from African American history materialized under her touch with equal intensity. Each reveals the richness of her imagination, the depth of her spirituality, and her extraordinary gifts as a storyteller.

Born Bessie Ruth White on 11 October 1929, Harvey was the seventh of 13 children born to Homer and Rosie

Mae White in Dallas, Ga. In her early 20s, she moved to Tennessee, briefly living in Knoxville and then permanently in nearby Alcoa, where she secured a job with Blount Memorial Hospital in order to help provide for her children and grandchildren. Although aware of her own creative gifts as a child, Harvey did not devote her full-time energies to making art until her late 40s. Seeking solace from life's challenges, she found strength and comfort in her faith and also began to discern spirits in seemingly ordinary pieces of gnarled wood. Whorls and knots might indicate the eyes or a mouth of a biblical character just as an attenuated branch might suggest a serpent. In her makeshift basement studio, Harvey added paint, wood putty, shells, hair, cloth, and other items to each piece of wood in order to give vivid physical form to the spirit she perceived within. Her earliest creations tended to be small, simple figures decorated only with black paint, human hair, and shells or beads. Collectors began to recognize the raw expressive power of her strange, dark figures, and Harvey's reputation soared by the early 1980s.

Troubled by local rumors that her work was the product of voodoo, Harvey, one day in 1983, burned the contents of her studio. After a few weeks of self-reflection, however, she went back to work with the newfound realization that her sculptures were important messages from God to a troubled world. Her works became increasingly large, colorful, and elaborate and enriched by glitter, cloth, beads, and jewelry. She also embarked on a loosely auto-biographical series, *Africa in America*, which she intended as a teaching tool for children in her community. By the time of her death in 1994, the series included more than 20 sculptural dioramas depicting the African American experience and race relations during and after the era of slavery. Unlike Harvey's earlier spirit sculptures, the works in *Africa in America* are highly descriptive and can be seen as carefully planned episodes in an epic narrative. However, they too reflect the artist's ability to transform ordinary materials into objects of uncommon aesthetic power infused with moral concepts of universal relevance.

In 1995 Harvey's work was chosen for inclusion in the Whitney Museum's Biennial. Museums that hold Harvey's works in their collections include the Whitney Museum, the Milwaukee Museum of Art, the American Folk Art Museum, the Knoxville Museum of Art, and the Smithsonian American Art Museum.

STEPHEN C. WICKS
Knoxville Museum of Art

Paul Arnett and William Arnett, eds., *Souls Grown Deep: African American Vernacular Art of the South*, vol. 1 (2000); Alvia J. Wardlaw, *Black Art, Ancestral Legacy: The African Impulse in African American Art* (1989); Stephen C. Wicks, *Awakening the Spirits: Art by Bessie Harvey* (1997).

Hawkins, William Lawrence
(1895–1990)
William Hawkins, one of America's most important African American artists, was a short, stocky man and a great talker. He was supremely confident and

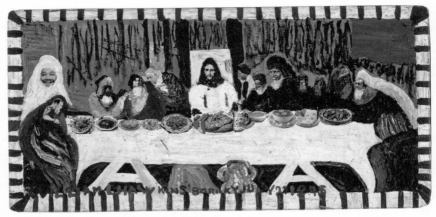

William Lawrence Hawkins, Last Supper #6, 1986, enamel on Masonite with collage, 24" x 48" (Collection of Robert A. Roth)

as exuberant as his monumental paintings and his lesser-known drawings. His principal subjects were animals, architecture, and narratives.

Hawkins was born in rural Kentucky. After his mother's death when he was two years old, he, along with his brother, was raised on the farm of his affluent maternal grandparents. He learned all the skills necessary for farming and was especially good with animals, claiming he could break the wildest horses. He drew constantly from at least seven or eight years of age, often copying pictures of horses his grandfather saved, thus using printed source materials as compositional models, just as he would later in life.

Hawkins moved to Columbus, Ohio, at the age of 21. Thrust into city life with only a third-grade education, he took on many different jobs to support himself. He married and divorced twice and supported numerous children and grandchildren during his long, vigorous life. His most steady early employment was as a truck driver for building contractors. The changing skyline he saw while driving constantly intrigued him and contributed to the urban settings of his paintings.

In the 1930s and 1940s Hawkins occasionally sold a few paintings for small sums. An inveterate scavenger, he collected cast-off materials, which he used for many of his later works. His earliest surviving paintings date from the late 1970s to 1981. Landmark buildings and the American Wild West were his usual subjects. The latter may be accounted for by Hawkins's claiming American Indian and white blood, a mix that he proudly said made him special.

Hawkins's early paintings had unmixed colors, limited to black, white, and gray for the most part. Their scale was small, and their compositions were freely adapted from pictures in magazines and newspapers. Because he could not afford frames, he often painted one around the edges of his paintings,

adding his name, birthday, and often his place of birth—("William L. Hawkins born KY July 23, 1895")—as an elaborate signature.

In 1981 Lee Garrett, a trained artist, discovered the works of William Hawkins and shortly thereafter a New York Gallery introduced his work to the public. With Garrett's encouragement, Hawkins began experimenting. He used a range of bright colors, larger surfaces, and applied paint more freely, sometimes adding a paste of corn meal and enamels. Variations on the printed letters of his signature became larger, and bolder, to form integral parts of his compositions. Around 1986, Hawkins added collage and three-dimensional elements to his works. By this time, Hawkins's average paintings ranged from four to six feet or more in height and width. His preferred support was Masonite, which he worked with a single brush. Hawkins wanted to give each of his clients something distinctive; he never copied his work even if he returned to a subject more than once. He once said, "There are a million artists out there and I try to be the greatest of them all." Today his works can be found in the Smithsonian American Art Museum, the High Museum, and the New Orleans Museum of Art.

N. F. KARLINS
New York, New York

Columbus Museum of Art, *Popular Images, Personal Visions: The Art of William Hawkins, 1895–1990* (1990); Frank Maresca and Roger Ricco, *William Hawkins: Paintings* (1997); Riffe Gallery, *William Hawkins: Drawings in Context* (2000).

Heltzel, Henry (Stony Creek Artist)

(birth and death dates unknown)
Henry Heltzel, formerly known only as the Stony Creek artist, produced fraktur for members of the German Lutheran and Reformed Zion Church at Stony Creek in Shenandoah County, Va. H. E. Comstock identified the artist in 2005 while examining a copybook made for George Peter Dobson of Shenandoah County. This copybook, now in the collection of the Museum of the Shenandoah Valley, contains the signature "H. Heltzel" and the date 16 February 1826. The 40 works attributed to this artist date from 1805 to 1824 and include both German- and English-language examples. Most of the artist's frakturs were made for children in Shenandoah County, Va., although at least six are from the area of Shepherdstown, W.Va. Scholars such as Klaus Wust have suggested that the artist may have been the schoolmaster at the parochial school associated with Zion Church on the Schwaben Creek, located near Stony Creek. Fraktur attributed to Heltzel include birth and baptismal certificates as well as bookplates.

Scholars have based attributions to Heltzel on several distinctive motifs: hand-drawn curtains at the top and sides of the certificate that often flank a central large heart containing the text; winged angels' heads drawn above the heart; floral borders that frame the text; and devices such as four- or five-petaled blooms, either roses or pansies, and fleurs-de-lis that occupy the corners of floral borders. However, as other southern fraktur artists, such as the Virginia Record Book Artist, also

drew curtains and fleur-de-lis, attributions cannot be made on these elements alone. The Winterthur Museum, Garden, and Library hold examples of Heltzel's fraktur.

LISA M. MINARDI
Winterthur Museum and Country Estate

H. E. Comstock, *Journal of Early Southern Decorative Arts* (Winter 2005–Winter 2006); Russell D. Earnest and Corinne P. Earnest, *Papers for Birth Dayes: Guide to the Fraktur Artists and Scriveners* (1997); Cynthia Elyce Rubin, ed., *Southern Folk Art* (1985); Klaus Wust, *Virginia Fraktur: Penmanship as Folk Art* (1972).

Hesselius, John

(ca. 1726–1778)
Around 1711 Gustavus Hesselius, a Swedish artist, and his wife, Lydia, were among a large number of Swedes who settled in the Christiana-Wilmington area of Delaware. Others in the family went first to Pennsylvania. Gustavus moved to St. George's County, Md., at an undetermined date and sold his land there in 1726. John Hesselius, his son, was probably born that year, presumably in Philadelphia, Pa., where his parents had moved and would live until their deaths.

John's father, Gustavus, painted portraits in Maryland, Pennsylvania, and possibly Virginia, because one work from that colony is attributed to his hand. In Philadelphia he advertised that he was from Stockholm and that, in addition to painting portraits, he painted landscapes, coats of arms, signs, and showboards. He was also skilled in ship and house painting, gilding, and restoring pictures. John learned how to do all of these branches of painting, decorative and utilitarian, from his father. John's earliest likenesses, however, show the strong influence of another artist, Robert Feke, who visited Philadelphia in the 1740s. Feke's rich colors and more fashionable compositions impressed the younger, ambitious painter, who quickly adopted them in some of his earliest portraits.

Hesselius may have painted in Virginia as early as 1748. As many as 12 portraits have been identified as his work for the 1748–49 period in Virginia; many others were painted after this. His father's death in 1755 seems to have provided a greater opportunity for the young Hesselius to make painting trips to Virginia and Maryland. By 1759 he had moved his residence to Maryland. On 30 January 1763 he married Mary Young Woodward, the widow of Henry Woodward of Anne Arundel County. The couple raised eight children, including a son named Gustavus. Either this year or the previous one, Hesselius traded painting lessons to Charles Willson Peale for a saddle.

Sometime around 1756, Hesselius's portrait compositions and painting style changed dramatically and became based on the highly successful work of the London-trained painter John Wollaston. The latter worked in the Mid-Atlantic region from about 1755 to 1758. Hesselius softened his colors to more pastel shades and switched to more graceful, flowing poses for sitters in imitation of the rococo style that Wollaston practiced.

Hesselius continued to work in this fashion until the last years of his life,

changing his approach to one of greater realism and eliminating the opulent and mannerist characteristics associated with the rococo. The artist's late work was probably influenced by neoclassicism, first introduced in America by studio-trained painters like Henry Benbridge and Hesselius's former pupil Charles Willson Peale.

At the time of his death on 9 April 1778, Hesselius left an impressive estate of household furnishings, cash, and land holdings. Many museums, including the Baltimore Museum of Art, the Metropolitan Museum of Art, the National Gallery of Art, the Corcoran Gallery of Art, and the Abby Aldrich Rockefeller Folk Art Museum, hold Hesselius's works.

CAROLYN J. WEEKLEY
Colonial Williamsburg Foundation

Richard K. Doud, "John Hesselius: His Life and Work" (M.A. thesis, University of Delaware, 1963); *Virginia Magazine of History and Biography* (April 1967).

Highwaymen

The story of the Highwaymen is an unlikely one. This group of young African American artists living near Fort Pierce, Fla., during the early years of the civil rights movement rose above existing societal expectations and produced a large body of oil paintings that document the mid-20th century landscape of the Sunshine State. For most of their careers, the artists worked anonymously, remaining unrecognized and uncelebrated until they were given the name "Highwaymen" in a magazine article in 1994, some 30 years after the beginning of their loose association.

Alfred Hair, who had begun painting on his own in 1955, enlisted and encouraged friends and family members to join him, so that they might escape their likely destinies working in Florida's orange groves and packinghouses. They painted in their yards, often collectively through the night, and then took their still-wet creations to the streets to sell. These self-taught painters were entrepreneurs who became artists by default. Creating fine art was never their objective; acquiring wealth was their goal.

The artists worked feverishly for more than a decade. To them, time was money. The haste with which they painted each picture, often less than an hour, resulted in a distinct style that was misunderstood by many art fanciers. Characterized by early critics as "motel art," the wind-swept palm trees, billowing cumulus clouds, moody seas, and intensely colored sunsets seemed to idealize Florida in archetypal tropical scenes meant to appeal to the masses. Nonetheless, the paintings became popular representations of how residents and tourists alike viewed the state.

Through their practice of fast painting, the Highwaymen created, or at least contributed to, a fresh approach to the tradition of American landscape portrayal. Their images are not generally detailed or treated in a grand manner; rather, they reveal temporal places in the process of becoming fully formed. The gesturally painted images, stripped of artifice, encourage viewers to lend their own inspirational meanings to these works of art.

Today the story of the Highwaymen is a significant part of Florida's folk life

and history. Even larger, perhaps, is the contribution that this tale makes to our national story. After all, the accomplishment of the Highwaymen is a saga about American dreams realized by a disenfranchised group of young people during a most oppressive time. Their visual legacy of Florida, depicted in as many as 200,000 paintings, has come to symbolize not only the beauty of the area but also the hopes and aspirations of its inhabitants. Works by the Highwaymen appear in the collection of the Museum of Florida History.

GARY MONROE
Daytona State College

Gary Monroe, *Extraordinary Interpretations: Florida's Self-Taught Artists* (2003), *Harold Newton: The Original Highwayman* (2007), *The Highwaymen: Florida's African-American Artists* (2001).

Hill, Kenny

(b. 1950)
In 1990 Kenny Hill of Chauvin, La., began to transform his property on the Bayou Petit Cailou into a complex art environment. Having moved to the undeveloped lot in 1988, Hill camped while building himself a small but unusual home. Little is known about the reclusive Hill, but he insisted to neighbors that his work was a personal endeavor not meant for an audience; he regularly declined requests from would-be visitors and photographers. He stated, simply, that the project was "a story of salvation."

Indeed, Hill's project, envisioned and executed in the final decade of the millennium, is devoted to the artist's complex apocalyptic vision. Some one hundred concrete figures and architectural features, baroquely posed and brightly painted, populate a series of tableaux describing an eternal fight between good and evil. Hill's vision is both personal and prophetic. Representing his own visage repeatedly throughout the site, he casts himself as the penitent seeking redemption.

The overall atmosphere Hill created is one of drama and action, intensified by Hill's bold colors and the lush bayou landscape. Angels are omnipresent, guarding, flying, uplifting, some benevolent, others condemning. On one path, tarry black figures of the damned writhe in agony. Other pathways lead to nine circular platforms, each of which features nine spheres relating to a radiating orb, generally read as the nine planets that revolve around one shared sun. Much of Hill's symbolism is arcane, but throughout the site it is possible to discern an intentional layering of the patriotic, the spiritual, and the cosmic.

The central feature of the site is a 45-foot-tall brick lighthouse in which Hill's expertise in the trade of masonry is evident. The tower, ostensibly referencing the Tower of Babel, is covered with figures both heavenly and earthbound. American history is referenced through Christopher Columbus's ship the *Santa Maria*, cowboys, Native Americans, World War II soldiers at Iwo Jima, and even a jazz funeral. Angels hoist mortals—Hill among them—toward the heavens as God surveys the scene. The tower itself is topped by a flying eagle, an emblem not just of the United States but—and perhaps more significantly here—a symbol for St.

John the Evangelist, author of the book of Revelation (or Apocalypse of John) in the Bible's New Testament.

In January 2000 Hill abandoned the site and fell away from the church that had once been central in his life. Perhaps disillusioned when the Apocalypse did not arrive, Hill never returned to his remarkable environment. By the time the artist left, parts of the site were already decomposing. The Kohler Foundation undertook the site's preservation and built a bulkhead to stave off the encroaching bayou. In 2001 the Kohler Foundation gave the conserved site to Nicholls State University in Thibodaux, La., which agreed to see to the art environment's ongoing care. The site features a studio building and art gallery and is open to the public. From the artist's family, the Kohler Foundation has acquired in 2010 a recent sculptural self-portrait and donated it to the John Michael Kohler Arts Center.

LESLIE UMBERGER
Smithsonian American Art Museum

Deborah H. Cibelli, *Raw Vision* (Winter 2008); Leslie Umberger, *Sublime Spaces and Visionary Worlds: Built Environments of Vernacular Artists* (2007).

Holley, Lonnie
(b. 1950)

The works of Alabama-bred artist Lonnie Holley ably demonstrate how African American vernacular traditions adapt to sociological and technological change. Rooted in the cultural practices of yard shows and yard art, Holley has, since he began to make art in 1979, expanded his creative vision to embrace media as diverse as sandstone carving, found-object assemblage, oil and acrylic paintings, photography, computer-based art, and music. Holley has also worked in a range of scales, from miniature to monumental. When in the company of admirers, Holley further vitalizes his art with brilliant spoken-word performances that situate his work—so concerned with current events and societal wounds—within black American customs of preaching and storytelling.

The seventh of 27 children, Holley was born in Birmingham, Ala., which has remained his center of operations for six decades. Holley grew up in a series of foster homes and reform schools, lived his teenage years on the edge of the law, and ultimately worked as, among a series of jobs, a short-order cook at Disney World. In the late 1970s he drifted back to Birmingham, where, tormented by the deaths of two nieces, he made his first carvings, small grave monuments for the girls. He then moved onto ancestral property, then used as a communal dump, close to the Birmingham airport. There he continued making commemorative carvings from a sandstonelike slag cast off by Birmingham's industrial foundries.

Holley's carvings honoring the dead soon sought to understand death in the context of the deceased's social and personal situations, interlacing biographies with critiques of racial and economic injustice, examinations of family responsibilities, the family unit, and the paradoxes of human nature. By the early 1990s, Holley's site had grown to more than an acre, sprawling beyond his property lines to interact with its neighborhood, a stereotypically poor,

crime-encumbered, and nearly all-black quarter of Greater Birmingham. Numerous works erected in half-seen or abandoned spaces connected the most local of stories—friends', neighbors', and family members' lives—to grander cultural narratives. Scavenging not just debris but significant remnants of the stories of people he knew, the artist created, on a scale perhaps unparalleled in American art, a conceptual tapestry of seemingly infinite intricacy. His yard and surroundings dehisced thousands of artworks whose overarching theme was degradation—of peoples, of the earth, of history, of gender, of race, and of class—and the inexplicable will to endure. Perhaps nowhere else has the rupture of the civil rights movement been so lyrically inscribed on the physical world.

Holley's site finally found itself, in the mid-1990s, fatally and tragically entangled with the very social forces it had documented: the local government targeted Holley's neighborhood for demolition in preparation for a planned expansion of the municipal airport. After a long holdout and legal struggle, during which his site was continually vandalized, in 1997 Holley relocated what portions of his work he could to the rural community of Harpersville, Ala. His new locale never embraced his presence or his art, and while the artist set about making a yard show there in the vein of his earlier one, by the 2000s he was spending most of his time in a rented studio in Birmingham. In 2011 he moved to Atlanta, where he continues to create visual art in many mediums and has developed a following

for his genre-bending music. Holley's work is in the collections of many institutions, including the American Folk Art Museum, the Birmingham Museum of Art, the High Museum of Art, the Milwaukee Museum of Fine Arts, the Philadelphia Museum of Art, the Smithsonian American Art Museum, the Museum of Fine Arts Houston, and the New Jersey State Museum.

PAUL ARNETT
Lafayette, California

Paul Arnett and William Arnett, eds., *Souls Grown Deep: African American Vernacular Art of the South*, vol. 1 (2000); Andrew Dietz, *The Last Folk Hero: A True Story of Race and Art, Power and Profit* (2006).

Hoppe, Louis

(b. 1812; d. unknown)
Louis Hoppe is little known in the field of Texas art. Biographical information is scant, and Hoppe's paintings are scarce. Only four paintings—all watercolors currently in the collection of the Witte Museum in San Antonio, Tex.—are known. Images of these paintings, along with a handful of facts about Hoppe's life and career, were first presented in Cecilia Steinfeldt's landmark *Art for History's Sake: The Texas Collection of the Witte Museum*. Steinhardt's research revealed that Hoppe was a German immigrant who worked as a laborer on the east Texas farms of Johann Leyendecker and Julius Meyenberg.

Although Hoppe is often described as an "itinerant" laborer, additional information about Hoppe, including a very thoughtful letter he sent back to his hometown of Koblenz, Germany, after his arrival in the United States, presents

the image of a man who was well educated and well spoken. Hoppe was born the son of a soldier in the Prussian army in 1812, and in 1851 he was married. Just two months later his wife passed away. Hoppe left Germany the following year, arriving in 1852 in New York, where he decided to become a painter.

Shortly after his arrival in the United States, Hoppe traveled to Texas, where in the early 1860s he painted all of his known works. One of the watercolors, *Julius Meyenberg's Farm*, includes on its front a painted caption, which, in English, reveals that the farm is located on a bluff over William Creek in a settlement by La Grange. A more important function of this, and indeed all of Hoppe's paintings, is the wealth of pictorial information on a place and time neither frequently depicted by artists nor readily captured by camera.

The main elements of the painting— the farmhouse, garden, animals, and family members—are executed in the simple, linear style and frontal perspective typical of the work of self-taught artists. While the house, the center of family and farm life, is the largest element in Hoppe's painting, the elements of nature, most notably the garden, surrounding trees, and family horse predominate. The supremacy of nature is further underscored by the representation of Meyenberg's family as dwarfed by his property and the many natural blessings of Texas.

Whereas Hoppe obscured the farmhouse in the Meyenberg painting, in his depiction of the Leyendecker farm the farmhouse is given a much more prominent role. In *Art for His-*

tory's Sake, Steinfeldt describes in detail the architectural and historic importance of the house, and Hoppe himself was clearly aware of the importance of this building, as it is the house and cleared land around it that dominate the painting. Nature is lushly displayed on the perimeter, but on center stage are the industrious efforts of humans.

The two other paintings by Hoppe— still lifes of bunches of wildflowers—reflect Hoppe's German heritage. These two watercolor and ink works, one entitled *Zur Errinerung*, or *In Memory*, belong to a Germanic tradition of commemorating life events with small works on paper. These works, which may have been made as personal commemorations or given as gifts, draw on the same precedents as frakturs. Like his landscapes, these still lifes return to a celebration of nature. Though not as dense with detail as the two farm paintings, Hoppe's still lifes reflect his commitment to an earnest pictorial description of the world he inhabited. When combined with his farmhouse paintings, the work of Hoppe may be seen as perpetuating a myth of the West where on the frontier Mother Nature meets the taming efforts of human nature.

A. KATE SHEERIN
Witte Museum

Pauline A. Pinckney, *Painting in Texas: The Nineteenth Century* (1967); Cecilia Steinfeldt, *Art for History's Sake: The Texas Collection of the Witte Museum* (1993).

Hudson, Julien
(ca. 1811–1844)
Most likely the son of London-born John Thomas Hudson, a ship chandler

and ironmonger, and Suzanne Dé-sirée Marcos, a free quadroon, Julien Hudson is thought to have been a free man of color. However, he is not listed as such, as was the custom, in the 1838 New Orleans City Directory. Like his racial identity, the date of his birth has been a matter of intense scrutiny for many years, but scholars have recently determined his birth date as 9 January 1811. Hudson's father apparently did not live with the family after about 1820, but his mother maintained a comfortable standard of living, owing to presumed support from her husband in addition to her and her mother's real estate investments. Julien probably studied grammar, mathematics, and other subjects with a private tutor in the French Quarter at their home on Bienville Street near Bourbon. In 1826–27 he studied art with itinerant Antonio Meucci, a drawing instructor, restorer, and painter of miniatures and opera scenery. Upon his grandmother's death, Hudson inherited part of Françoise Leclerc's $7,000 estate in 1829, which allowed him to pursue further study in Paris. When he returned in 1831, Hudson advertised his services as a portrait painter, noting both his training with Meucci and a "complete course of study . . . as a miniature painter" in Paris.

Hudson remained in New Orleans until at least 1832. He may have traveled to other cities in the United States before returning to Paris in 1837 to study with Alexandre-Denis Abel de Pujol, a student of Jacques-Louis David. The second trip was cut short, perhaps because of the death of his sisters and legal difficulties incurred by his mother, and Hudson returned to New Orleans. He maintained a residence at 120 Bienville Street, though he appears in the City Directory as an artist only in the years 1837–38. All of the surviving paintings with secure attributions date to the late period. George David Coulon studied, at least briefly, with Hudson in 1840. Hudson died in 1844.

Only two works can be securely attributed to Hudson; one portrait has been identified since the 1930s as a self-portrait, and the other is a verified likeness of Jean Michel Fortier III. Two additional paintings have recently been discovered with plausible attributions to Hudson's hand. Hudson's portraits possess a stasis and rigidity that betray an intractable connection to folk painting. Strikingly absent is any sign of Parisian academic training. The *Self Portrait* in particular, given its tiny scale and cut-off oval format, suggests Hudson's training as an artisan maker of miniatures. Minute wisps of paint delineate each hair with the rigorous precision of one accustomed to working on a very small scale. Hudson's crisp modeling and the unflinching gaze of his sitters imbue his polished, gemlike compositions with an undeniable power and make compelling statements about self-perception, identity, and social status.

RICHARD A. LEWIS
Louisiana State Museum,
New Orleans

Patricia Brady, *International Review of African American Art* (1995); *New Orleans Bee* (6 June 1831); David C. Driskell, *Two Centuries of Black American Art* (1976); Robert Glenck, *Handbook and Guide to*

the *Louisiana State Museum* (1934); John Burton Harter and Mary Louise Tucker, *The Louisiana Portrait Gallery: The Louisiana State Museum*, vol. 1, *To 1870* (1979); Historic New Orleans Collection, *Encyclopedia of New Orleans Artists* (1987); Regina A. Perry, *Selections of 19th Century Afro-American Artists* (1976); James Amos Porter, *Ten Afro-American Artists of the Nineteenth Century* (1967); William Keyse Rudolph, Patricia Brady, and Erin Greenwauld, *In Search of Julien Hudson: Free Artist of Color in Pre-Civil War New Orleans* (2011); Anne C. Van Denvanter and Alfred V. Frankenstein, *American Self-Portraits, 1670–1973* (1974).

Hunter, Clementine

(1886 or 1887–1988)

The granddaughter of slaves, Clementine Hunter was born Clemence Reuben in late 1886 or early 1887. When she was a teenager, she moved with her family to Melrose Plantation, near Natchitoches, La. Working as a field hand, as a domestic servant, and finally as an artist, Hunter remained at Melrose for most of her life. She married twice and gave birth to seven children. As a domestic worker, Hunter came to know the writers and artists that Cammie Henry, the mistress of the plantation, welcomed to Melrose. Hunter's observations of the artwork of Henry's guests undoubtedly inspired Hunter to try her hand at painting. Regular guests, writer James Register and François Mignon, who had been born Frank Mineah in New York but reinvented himself as a French art critic, became early patrons. These supporters helped with finances, collected art supplies, and encouraged Hunter to paint the farming scenes, river baptisms, wakes, and funerals that they knew would appeal to collectors. Mignon also suggested that Hunter paint the 1955 panoramic murals of farming, worship, and social life that decorate the African House, described by the Historical Building Survey as the only Kongo-style structure built by enslaved blacks in the United States. Scholars have also noticed possible influences from France and creolized Caribbean architecture.

Hunter's primary inspiration was her appreciation of African American life. Clementine Hunter summed up her four-decade long career: "I paint the history of my people. My paintings tell how we worked, played, and prayed." With bold stokes of saturated color, Hunter remembers the work performed by African Americans at Melrose: washing clothes in huge iron pots, shaking pecan trees and gathering the nuts, slaughtering hogs, and, of course, working in the cotton fields. Quilts that depict the main house and other plantation buildings demonstrate aesthetic preferences identified as African: large sections of solid, contrasting colors, irregular but rhythmic sashing, and appliqué. Equally vibrant are paintings of favorite pastimes such as fishing, playing cards, and dancing.

The remaining works, like much of southern folk art, address religious life. Hunter, however, does not share the evangelical fervor of the many Protestant preacher-artists. With French, Irish, American Indian, and African American ancestry, Hunter belonged to a distinctive community of Creoles of color who have lived in Natchi-

toches Parish for more than 250 years. Hunter, who spoke only French until she married Emanuel Hunter when she was in her thirties, was proud of her Creole heritage, defined not only by ethnicity but also by Catholic faith. Hunter had received her brief education from French-speaking nuns, and until her death she was a member of St. Augustine's Catholic Church, the first Catholic parish in the United States founded by and for persons of color. Hunter's paintings of religious life reflect her Catholic background and familiarity with Catholic sacred art.

Unlike the creations of southern Protestants, Hunter's works are not Bible based. While Hunter certainly knew Bible stories from her attendance at the Baptist Church, where she enjoyed singing, her only biblical scenes are nativities and crucifixions. All adopt aesthetic preferences often associated with Catholic art—centrality of important figures, symmetry as shown in pairs of candles and urns, and hazy pink and blue backgrounds that emphasize the otherworldliness of the sacred figures. Holy cards, inexpensive devotional prints that have long disseminated Catholic visual culture, are likely sources. The more than 100 crucifixions Hunter painted of a black Jesus are clearly based on Catholic prints. Her masterful *Cotton Crucifixion* (1970) is a particularly powerful adaptation of holy cards that depict a reciprocal relationship between a localized suffering black Jesus and a community of color.

Hunter's Catholic faith, however, did not deny her the expressive worship of Protestant neighbors. Her paintings of river baptisms and revivals attest to her familiarity with those most Protestant of services. Her paintings of wakes and funerals record shared community values. Hunter's many wedding paintings, in which solemn brides tower over both grooms and diminutive peripheral ministers, show Hunter's feelings toward marriage.

Hunter's memory paintings, estimated in the thousands, are a nuanced history of a place on the verge of change. Before her death in 1988, at the age of 100 or 101, Hunter had witnessed the mechanization of farming and the migration of African Americans to urban centers. Most importantly, African Americans had become outspoken about racial injustice. In 1955 Hunter had not been allowed to attend the opening of her exhibition at a "white" college but had had to sneak in on Sunday with a professor who had keys to the locked gallery. By 1988 Clementine Hunter was a celebrated artist featured in seminal books on folk art, profiled in magazines, and collected by important museums. Hunter's works can be seen at the American Folk Art Museum, the Ogden Museum of Southern Art, the Smithsonian American Art Museum, the Louisiana State Museum, the New Orleans Museum of Art, the High Museum of Art, the Morris Museum, and the Dallas Museum of Art. The Association for the Preservation of Historic Natchitoches maintains the Melrose Historic Plantation Complex, which is a National Historic Landmark.

CHERYL RIVERS
Brooklyn, New York

Robert Bishop, *Folk Painters of America* (1979); Carol Crown and Charles Russell, eds., *Sacred and Profane: Voice and Vision in Southern Self-Taught Art* (2007); David C. Driskell, *Two Centuries of Black American Art* (1976); Shelby R. Gilley, *Painting by Heart: The Life and Art of Clementine Hunter, Louisiana Folk Artist* (2000); Herbert W. Hemphill Jr. and Julia Weissman, *Twentieth-Century American Folk Art and Artists* (1974); François Mignon, *Plantation Memo: Plantation Life in Louisiana, 1750–1970, and Other Matter* (1972); Art Shiver and Tom Whitehead, *Clementine Hunter: The African House Murals* (2005); James L. Wilson, *Clementine Hunter, American Folk Artist* (1990).

Hussey, Billy Ray

(b. 1955)

Billy Ray Hussey was born in Moore County, in central North Carolina, in 1955. The great-grandson of traditional potter J. H. Owens and grandnephew of potter Melvin L. Owens, Hussey grew up steeped in the rich heritage of 19th-century utilitarian ware. By the age of 10 he was working in M. L. Owens's shop, learning every aspect of making ware from preparing the clay to turning vessels, glazing, and firing. By age 20, he was working on his own for M. L. and for his cousin, Vernon Owens, at Jugtown Pottery. Hussey turned pottery and hand-sculpted figural pieces.

In 1979 a customer ordered several small, unsigned pottery lions based on images from William Wiltshire's book *Folk Pottery of the Shenandoah Valley*, published in 1975. Some of these lions had made their way from southwestern Virginia into the marketplace, causing a stir because of their resemblance to

lions made by the famous Bell potters of the Shenandoah. Once collectors discovered that Hussey was the lions' maker, Hussey received considerable attention. He began signing his work "BH" and "Owens Pottery." After acquiring his own kiln, Hussey dropped the "Owens Pottery" designation.

By the 1980s, Hussey was working as a full-time potter. Although it was 1988 before he completed his own operational shop and kiln, by 1986 he had begun to have kiln openings once or twice a year. Hussey began numbering the sale on each piece. In recent years he has been signing his work with a recumbent B, with the kiln sale number inscribed in the curves of the letter. Thus, pieces can be roughly dated by number and signature. In 2007, when he completed kiln no. 54, Hussey estimated that he had produced nearly 3,000 pieces.

Around 1990, Hussey began working with entrepreneurs who had established a company, the Southern Folk Pottery Collectors Society, to sell traditional southern pottery and to promote and sell Hussey's pottery. By 1994, Hussey and his wife, Susan, were owners of the company. Twice a year they conduct sales of consigned traditional pottery, producing a catalog with information about each piece. Hussey markets his own work through events sponsored by the Southern Folk Pottery Collectors Society.

Billy Ray Hussey's early work reflected images created by English Staffordshire potters: small animals of every kind, some on bases, some free-standing. With considerable imagination and wit, he also began to introduce

new forms of turned pieces and figurals. A quirky human head serves as a bank; a wall pocket sports a grinning, bearded face; a small jug takes the shape of a toothy boar.

While Hussey works within the tradition of southern utilitarian pottery, his remarkable creativity establishes him as a major contemporary folk artist. His work may be seen at the McKissick Museum, the American Folk Art Museum, the Chrysler Museum, and the Mint Museum.

BARRY G. HUFFMAN
Hickory, North Carolina

Ellin Gordon, Barbara Luck, and Tom Patterson, *Flying Free: Twentieth Century Self-Taught Art from the Collection of Ellin and Baron Gordon* (1998); Stacy C. Hollander and Brooke Davis Anderson, *American Anthem: Masterworks from the American Folk Art Museum* (2001); Billy Ray Hussey, *North Carolina Visionary Potter* (1997); Chuck Rosenak and Jan Rosenak, *Contemporary American Folk Art: A Collector's Guide* (1996).

Hutson, Charles Woodward

(1840–1936)

Charles Woodward Hutson was born 23 September 1840 into the genteel antebellum culture of Southern aristocracy in McPhersonville, S.C., only to enlist as a soldier in the Confederate effort for independence. He later studied and, after passing his bar exams, practiced law. The majority of his early adult years, however, were spent at his beloved occupation as an itinerant scholar and professor teaching a remarkable variety of subjects with erudition at mostly private schools, colleges, and universities throughout the South. He taught languages including Greek, German, French, Italian, and Spanish. His boyhood absorption of classical literature including Homer, Virgil, Shakespeare, and Sir Walter Scott led to his offering courses in literature. In addition he taught metaphysics, moral philosophy, and history.

It was only after he retired at 68 and moved his family of 10 children to New Orleans that his eldest child, daughter Ethel, an artist and later administrator at the Isaac Delgado Museum of Art, encouraged him to pursue yet another career as a practicing artist. For the next thirty years, without any formal training, he engaged in this field of endeavor with remarkably successful results.

The first phase of his work focused mainly on pastel drawings, executed *en plein air*, of scenes of New Orleans and its City Park as well as the landscape of south Louisiana, the Mississippi Gulf Coast, and recollections of the southern countryside where he had previously lived. While faithful to the view, his artwork took on elements of reduction and abstraction. His landscapes effectively captured the environment, its light and atmosphere, with a deftness of stroke and highly inventive and beautiful color sense. Later having gained confidence as a creator, he ventured into different media, primarily watercolor and oils, with more ambitious compositions and subject matter. Mining his vast knowledge of literature, mythology, and history, he chose to illustrate scenes from those sources while seemingly making the images with their obscure iconog-

raphy a deliberate test for the viewer. He worked at his art daily until the time of his death in New Orleans on 27 May 1936 at the age of 95.

The career of this self-taught artist did not go unnoticed in the art world but was lauded in the press and by the public. First presented publicly in 1917 at the Society of Independent Artists in New York and again there in 1925, Hutson was awarded his first solo exhibition in 1931 at his hometown's museum, the Isaac Delgado Museum of Art (now the New Orleans Museum of Art), where 46 of his oils were displayed. There were two subsequent solo exhibitions presented posthumously at that institution in 1948 and 1965, the latter with a color-illustrated catalog. In 1945 Hutson was featured in an exhibition of the work of self-taught artists at the Phillips Memorial Gallery (now the Phillips Collection) where Washington, D.C., collector Duncan Phillips purchased three of Hutson's works for his personal collection. New York art dealer and scholar Sidney Janis included Charles Hutson in his milestone book of 1942, *They Taught Themselves*. In 2008 the Ogden Museum of Southern Art in New Orleans presented a two-person exhibition pairing the work of father and daughter.

WILLIAM A. FAGALY
New Orleans Museum of Art

William A. Fagaly, *Folk Art* (Fall 1997); Sidney Janis, *They Taught Themselves* (1942).

Jaquelin-Brodnax Limner

(birth and death dates unknown)
The most important paintings to survive for the first quarter of the 18th century in Virginia include 11 oil-on-canvas portraits created for the Jaquelin and Brodnax families living in Jamestown and Yorktown. Although the Virginia Museum of Fine Arts attributes these portraits to Nehemiah Partridge, the identity of the artist remains speculative. The pseudonym for the unidentified artist is based in these family names, although the same hand may have created one portrait for the Custis family. There may have been at least three painters present in Virginia during the period—Peter Wagener from London, an unidentified artist mentioned by Robert "King" Carter in 1727, and a York County resident named Robert Dowsing, whose inventory at the time of his death in 1737 contained a large number of portrait-painting materials.

Whoever the artist was, it is evident that his or her skill probably focused more on utilitarian work than easel painting. The dearth of artists in Virginia during the time surely served as an inducement to some house and ornamental painters to try their hands by creating these and perhaps other, now-lost likenesses. As a whole, the pictures are flat and linear in quality but bold in their coloration and brushwork. The manner in which the sitters are posed and some aspects of their costumes were inspired by printed images of British royalty; prints of this type were inexpensive and commonly owned in the colonies.

Large groups of family portraits executed at or about the same time and usually by one artist were especially

common in the colonial South. Like these extraordinary survivals, they illustrate the cultural importance of patriarchal and dynastic relationships in colonial America.

CAROLYN J. WEEKLEY
Colonial Williamsburg Foundation

Mary Black, *American Art Journal* (1980); Graham Hood, *Charles Bridges and William Dering: Two Virginia Painters, 1735–1750* (1978).

Jeffery, Edwin, Jr.
(b. 1949)
Self-taught sculptor Edwin Wendell Jeffery Jr. is among a short list of noted African American vernacular artists from Memphis, Tenn., including Joe Light, Hawkins Bolden, Henry and Georgia Speller, and Frank "Preacher" Boyle. Jeffery creates wooden, mostly bas-relief works that often invite controversy while embracing religious, social, and historical themes relevant to his life as an African American who came of age during the civil rights struggle (joining Martin Luther King Jr. in a march once left Jeffery tear-gassed and beaten).

Raised by his paternal grandparents and father, Jeffery was instilled with a strong sense of faith and community from a young age; he serves as a steward at the same Methodist church he has attended from infancy. Although he was the son of a carpenter, Jeffery became a firefighter in 1973, noting with pride that he was 1 of only 39 African Americans on the force at the time. He made the rank of lieutenant before retiring.

In 1975 Jeffery saw a publication on hand-carved gunstocks and became intrigued. He read some books on the subject, bought $100 worth of tools, and spent $70 on a carving seminar, the only training he ever received. His first piece was a small pine plaque of a Case knife. Since then, he has created hundreds, if not thousands, of pieces and continues to carve almost daily.

Jeffery, who works with both prepared and found wood, says the grain often tells him what to carve. Working on his back porch, he eschews industrial tools such as band saws and mechanical sanders and instead bows, carves, and sands entirely by hand. He then paints his sculptures in acrylic and coats the finished piece in polyurethane. Jeffery prefers exotic woods, especially those from Africa including wenge, zebrawood, padauk, and his favorite, African mahogany. Symbolic connections of African wood to the African American themes in his sculptures are not lost on the artist.

Jeffery rejects the label "folk artist" and considers himself a storyteller. Acting as a witness to history, he operates not unlike Sam Doyle as a modern equivalent to the West African *griot* or *djeli* and says he feels an obligation to remember what is in danger of being forgotten. As a result, his themes are often ripe with a sense of social and moral justice, black pride, and black pain. Subjects include startling images of lynching and the Ku Klux Klan as well as iconic cultural figures from James Brown and Isaac Hayes to many that feature Dr. King and, recently, President Barack Obama. Most of his subject matter, however, is religious — an acknowledgment, he says, of his

God-given talent. Sacred motifs include wooden Bibles and a variety of Old and New Testament subjects.

Jeffery admits the need for recognition as a motivating factor in his work, and he has given away many pieces to museums, churches, hospitals, and the like in an effort to become better known. Some of his more topically charged pieces are a result of this desire, of which he has said, "Maybe somebody'll get mad enough to remember my name!" Among such pieces are an African American in KKK garb, a vision of heaven with a "colored only" sign, and a reverse image of vaudeville-era blackface entertainer Al Jolson done up in white face. Yet others have been unfairly maligned, he says, noting an effigy of Memphis's first black mayor, W. W. Herenton, called *City Boss*, that was banned from a city exhibition for Black History Month because of a mistaken correlation to infamous Memphis politico E. H. "Boss" Crump.

Jeffery's work has been likened to that of African American vernacular sculptors Elijah Pierce, Leroy Almon, and Herbert Singleton. His work can be found in the collections of the Memphis Brooks Museum of Art.

WILLIAM L. ELLIS
Saint Michael's College

"Banned in Bluff City," *Oxford American* (October–November 1996); Jennifer Hambrick, *Short North Gazette* (July 2005).

Jennings, James Harold
(1931–1999)

James Harold Jennings lived in Pinnacle, N.C., a rural crossroads not far from Winston-Salem. He was a familiar figure often seen bicycling to the nearest convenience store. A loner, a recluse, an eccentric figure in appearance and behavior, Jennings was soft-spoken but intense. After his mother died, he moved into an old bus, the first of the five decommissioned school and church buses he eventually acquired. Jennings used one bus for sleeping, one for making art, and the others for storage. The comfortable brick house he inherited became uninhabitable because it was "too full of junk."

The death of Jennings's mother was an impetus for his art making. He began making art from cast-off lumber and house paint and marked the front of his property with a fence embellished with wooden figures and designs. Additions to the original fence became tall structures, and Jennings wore an assortment of tool belts that held everything he needed as he leaped from one structure to another, adding an Indian here, a Ferris wheel there, a jumble of whirligigs, and his trademark symbols: the moon, sun, and stars.

Home-schooled through the sixth grade, Jennings had a love of old dictionaries; he collected and often presented an unusual word to a visitor as if he were offering a magical talisman — "metempsychosis" was one of his favorites. Other sculptures, especially his "Bad Girl" series, utilized sayings such as "School Girl Sits on a Bully" and "Bad Girl Beats Hell Out of the Devil." Many depict so-called Amazon women beating or wrestling with men. Perhaps Jennings found his subjects during a brief job as a projectionist for an out-

door movie theater that showed pornographic films.

In the early 1980s, Jennings's colors were limited to red, yellow, blue, and white. The wood he used was rough and splintery. Animals, Indians, angels, birds, and a few self-portraits were his main themes. In the late 1980s, he started using a wider variety of colors, and his cuts were more calculated. The Amazon women appeared at that time, and he began to paint in what became his characteristic style—an all-over, optical-dot pattern, applied with the end of a stick.

Over time, Jennings became increasingly paranoid, building a fortress-like fence and occasionally shooting over visitors' heads when they approached. He took his own life on his 69th birthday, the day of the Columbine school shootings, apparently too disturbed to continue.

Jennings's work is in the collection of the American Visionary Art Museum in Baltimore and the Art Museum of Western Virginia in Roanoke.

ANN OPPENHIMER
Folk Art Society of America

David J. Brown, *Folk Art Messenger* (Spring 2002); Ann Oppenhimer, *Intuitive Art: Three Folk Artists: Abe Criss, Howard Finster, and James Harold Jennings* (1986); Ann Oppenhimer and George Jacobs, *Folk Art Messenger* (Spring 1999).

Jiménez, Nicario
(b. 1957)
Known as the "Artist of the Andes," Nicario Jiménez now lives in Naples, Fla., where he creates traditional *retablos* (altars) that take as their subjects biblical stories, scenes of wooden boxes like in his native Peru, and political and humorous commentaries on life in the United States. Born in a small village near Ayacucho in the high Peruvian mountains, he comes from a family of retablo makers. He attended the University of San Cristobal de Huamanga in Ayacucho, where he says he began learning about his identity, a theme that inspired his art making.

Retablos in the form of wooden boxes that open to reveal figures in elaborately composed environments date to the 16th century, when Spanish priests carried them throughout the mountains to teach village people about Catholic saints. Indigenous people later adapted the genre to communicate their own beliefs and experiences. In Jiménez's hometown, retablos were used to respond to the presence of the Shining Path, the military group that terrorized much of Peru from the 1970s through the 1990s. Retablos dealt with violence, destruction, and flight for survival. Dealers began purchasing Jiménez's retablos when he lived in Lima. For fear of reprisal, the artist hid his work that commented on the Shining Path's destruction. However, visitors who saw these political retablos encouraged him to address contemporary subjects. Unrest in the Andes eventually resulted in Jiménez's moving with his family to Lima and, later, to the United States.

Inspired by his great-grandfather, who made retablos of St. Mark, Jiménez began making his own retablos at the age of five or six. He also learned from his father, whose retablos mostly de-

picted scenes of everyday life. Jiménez continues to make traditional retablos that depict the history, religion, and everyday life of the Andean people in Peru. These retablos include bar scenes, hat shops, and the Amazon jungle.

However, Jiménez also incorporated scenes from big cities such as New York and commentary on the segregated South and life under Jim Crow. More humorous retablos detail experiences such as getting a tooth pulled in a dentist's office or giving birth to a baby. Jiménez makes his figures with a mixture of boiled potatoes and gypsum powder. The artist makes dozens of figures at a time and then selects individual pieces from his collection to tell a narrative. He fashions the figures with his hands, using only one wooden tool that looks like a large toothpick. After he dries the small sculptures for at least three to four hours, he carefully paints them.

Nicario Jiménez is now internationally known for his exuberant work. He has exhibited in Ecuador, Venezuela, Canada, Korea, the United States.

KRISTIN G. CONGDON
University of Central Florida

Kristin G. Congdon and Tina Bucuvalas, *Just above the Water: Florida Folk Art* (2006); Carol Damian and Steve Stein, eds., *Popular Art and Social Change in the Retablos of Nicario Jiménez Quispe* (2004).

Johnson, Anderson
(1916–1998)
While playing in his father's cornfield in Lunenburg County, Va., eight-year-old Anderson Johnson had a vision of Jesus that changed his life and directed him on a path of preaching the Lord's Gospel—first as a chosen child, later as a street preacher who gathered a crowd by drawing with either hand and even with his toes. Johnson joined the famous Daddy Grace (Charles Manuel Grace), founder of the United Church of Prayer for All People. Johnson preached with him in such places as Miami, Savannah, and New York. By then Johnson was incorporating music into his ministry. In the 1950s Johnson made recordings of old-time Gospel favorites such as "God Don't Like It," "Let That Liar Pass on By," and "If I Could Hear My Mother Pray Again."

After settling in Newport News, Va., in the early 1980s, Johnson opened Faith Mission, a storefront church where he regularly conducted church services and inspired his tiny congregation with his slide guitar and rowdy piano playing, accompanied by his inimitable, raspy singing. When questioned, he often said, "I don't play the blues, I plays the Gospel."

The exterior of the ramshackle church proclaimed God's message in painted images and biblical texts. Interior walls were covered three- or four-deep with paintings of Jesus, U.S. presidents and their wives, and women in fancy dresses and matching hats. Abraham Lincoln, Martin Luther King, and George Washington were his favorite subjects. The prolific artist claimed to have at least 2,000 paintings on display. He painted with house paint on cardboard, canvas board, and whatever surfaces he could find, including Formica counter tops and asbestos stove mats.

Johnson's second-floor living quarters were painted with life-size figures of men in fedoras and stylish suits, standing beside women with transparent dresses (later painted over). These murals were conserved by a grant from the Department of Housing and Urban Development and are in Newsome House, an African American history museum in Newport News. Faith Mission was demolished in 1997, despite efforts of local folk art preservationists. Johnson decorated a second home where he preached, but it never achieved the aesthetic quality or density level of his first church.

Johnson's work is in the collections of Hampton University, the Baron and Ellin Art Galleries, Old Dominion University, and the Longwood Center for the Visual Arts.

ANN OPPENHIMER
Folk Art Society of America

Carol Crown and Charles Russell, eds., *Sacred and Profane: Voice and Vision in Self-Taught Art* (2007); David Levinson, *Folk Art Messenger* (Winter 1997); Ann Oppenhimer, *Folk Art Messenger* (Summer 1998).

Johnson, Joshua

(b. ca. 1762; d. unknown)
Joshua Johnson was born in Baltimore County, Md., around 1762, the son of an unidentified slave woman owned by William Wheeler Sr. Joshua's white father, George Johnson, about whom very little is known, purchased the boy from Wheeler on 6 October 1764 for £25 current money of Maryland. On 15 July 1782 George Johnson manumitted his son, who was in the process of completing his apprenticeship to Baltimore blacksmith William Forepaugh.

Nothing is known of Joshua Johnson's activities in the years between his manumission and the appearance of his name in the first Baltimore city directory, published in 1796. In 1798 Johnson placed an advertisement in the *Baltimore Intelligencer* in which he referred to himself as a "self-taught genius, deriving from nature and industry his knowledge of the Art; and having experienced many insuperable obstacles in the pursuit of his studies." This is the earliest known use of the term "self-taught" in reference to an untrained American artist. His only signed work, *Sarah Ogden Gustin*, is generally believed to have been painted sometime between 1798 and 1802 in Berkeley Springs, W.Va., where Sarah Gustin lived. As a free man, Johnson could have traveled as an itinerant artist, although it is also possible that Sarah and her husband, Robert Gustin, traveled to Baltimore, where Johnson painted the portrait.

Johnson lived in Fells Point, a shipbuilding and commercial center on Baltimore's waterfront. Many of the portraits attributed to him are of local merchants, mariners, or prosperous tradesmen. The only painting linked to him through documentary evidence is *Rebecca Myring Everett and Her Children* (1818). In a list of legacies made September 1831 and revised 22 August 1833, Rebecca Everett left "the large Family Painting of my self & 5 children Painted by J Johnson in 1818" to her eldest daughter.

Approximately 83 portraits are attributed to Johnson, none of them dating beyond 1825. His style is similar to that of other self-taught painters active in the Mid-Atlantic region in the early years of the Republic. These artists include Charles Peale Polk, John Drinker, Jacob Frymire, Frederick Kemmelmyer, and Caleb Boyle. Johnson's family group portraits also show similarities with those of Ralph E. W. Earl.

Joshua Johnson last appears in the Baltimore city directory for 1824. It is unknown when and where he died. Numerous institutions hold portraits that Johnson painted; among them are the Abby Aldrich Rockefeller Folk Art Museum, Metropolitan Museum of Art, the National Gallery of Art, the Maryland Historical Society, the Museum of Early Southern Decorative Arts, the Baltimore Museum of Art, and the Chrysler Museum of Art.

JENNIFER BRYAN
Nimitz Library
U.S. Naval Academy

Jennifer Bryan and Robert Torchia, *Archives of American Art Journal* (1996); Deborah Chotner, *American Naive Painting* (1992); Carolyn J. Weekley and Stiles Tuttle Colwill, *Joshua Johnson: Freeman and Early American Portrait Painter* (1987).

Johnston, Daniel

(b. 1961)

Daniel Dale Johnston was born 22 January 1961 in Sacramento, Calif., the fifth child of Mabel and Bill Johnston. After a move to Utah, the family settled in New Cumberland, W.Va. Fascinated with comic books, Johnston began drawing his own comics when he was eight years old. His influences included both comic superheroes and the tenets of Christian fundamentalism.

By the time Johnston entered high school, he was exhibiting signs of depression. He spent much of his time alone drawing and playing the piano. He briefly attended Abilene Christian University in Texas and then returned to his parents' home in West Virginia. He subsequently enrolled in the East Liverpool branch of Kent State University, where he studied art and fell in love with a woman who was engaged to someone else. His personal isolation and the pain of this unrequited love resulted in a creative period of drawing, filmmaking, songwriting, and recording cassettes that he released himself. Johnston became obsessed with achieving fame and suffered bouts of depression and mania that were eventually diagnosed as bipolar disorder.

After dropping out of college in 1982, Johnston first moved to Houston and then to San Marcos, Tex., where he lived with siblings and continued his creative activities while working odd jobs. He suffered a nervous breakdown. Fearing that his family was plotting to have him institutionalized, he joined a traveling carnival, ended up in Austin, and eventually took up residence in a back room of a church. He got a job at a McDonald's restaurant and became a regular fixture on the section of Guadalupe Street near the University of Texas known as the Drag, where he peddled his recorded cassettes. The local press took note of Johnston's music, and he

became a favorite in the Austin music scene. However, he also dabbled in marijuana and LSD, which, combined with the bipolar disorder, resulted in paranoia and delusions and led to a series of stays in psychiatric hospitals. His condition is now under control through medications.

Johnston creates his works of art on paper using felt-tip markers, ballpoint pens, pencils, and watercolor. Many of the cartoonlike drawings seem to represent hallucinatory visions populated by the comic-book characters of his youth, especially Captain America and Casper the Friendly Ghost, and those of his own invention. Bizarre hybrid figures, female nudes, and decapitated torsos interact with one another in unusual and sometimes difficult to decipher tableaux. Much of the work includes social commentary, and the devil appears frequently. Other pieces refer to Johnston's personal struggles. He often depicts himself as a figure with the top of its head sliced off. His most recognized character is undoubtedly a froglike creature, Jeremiah the Innocent. The subject of a mural he created in 1992, now an Austin landmark, Jeremiah has reached iconic status, appearing on commercial items, including T-shirts, and has been reproduced as a collectible toy available in several colors.

Johnston has emerged as an international cult figure. He maintains an extensive tour schedule as a musician. Numerous recording artists have covered his songs, and his visual art has received widespread recognition. The year 2006 saw the release of an acclaimed documentary about his life, *The Devil and Daniel Johnston*, the winner of the Director's Award at the 2005 Sundance Film Festival. Johnston's drawings were included in the 2006 Whitney Biennial and in the 2008 Liverpool Biennial. Johnston resides in Waller, Tex.

LYNNE ADELE
Austin, Texas

Irwin Chusid, *Songs in the Key of Z: The Curious Universe of Outsider Music* (2002); Jeff Feuerzeig, dir., *The Devil and Daniel Johnston* (2005); Michael Hall, *Texas Monthly* (February 2005); Randy Kennedy, "Man-Child in the Promised Land," *New York Times* (19 February 2006).

Johnston, Henrietta
(ca. 1674–1729)

Henrietta Johnston was the first known pastellist and professional female artist to work in the American colonies. She was born Henrietta de Beaulieu in France to French Huguenots Cezar de Beaulieu and his wife, Susannah. Cezar was a Calvinist pastor who fled to England from Quentin, France (near St. Brieuc) about 1685. Although the sophistication of her pastel drawings suggests that she may have had some formal training, nothing is known of Johnston's education. Her work has been compared to the work of Irish-born artists Edmund Ashfield and Edward Luttrell, either of whom may have taught or influenced her.

In 1694 she married Robert Dering and moved to Ireland. The artist produced her earliest known works in Ireland after the death of her husband, about 1700. One of the most poignant of these is a recently discovered posthumous portrait of her daughter, Helena,

drawn about 1704. In 1705 Henrietta married Gideon Johnston, who in 1708 became commissary for the bishop of London at St. Philip's Church in Charleston, S.C. Evidence suggests that, once in Charleston, Johnston contributed significantly to the family income by drawing portraits of many of Charleston's French Huguenot residents and prominent members of St. Philip's Church. Disheartened by debt and misfortune in colonial South Carolina, Gideon acknowledged this support in a 1709 letter written to the bishop of London: "Were it not for the Assistance my wife gives me by drawing of Pictures (which can last but a little time in a place so ill peopled) I shou'd not have been able to live."

Johnston's work can be divided into three periods: the Irish period (ca. 1704–5), the period in Charleston prior to Gideon's death (1708–15), and the period between Gideon's death in 1716 and Henrietta's own death in 1729, during which time she worked in Charleston and briefly in New York before returning to Charleston, where she lived until her death. The extant Irish works are all waist-length portraits and show the most attention to detail with well-defined facial features, careful attention to the apparel of the sitters, and dramatic background shading. Some of the Charleston portraits retain the characteristics of these earlier works, but most are bust-length and show less attention to physical features and clothing details, becoming almost ethereal in the period immediately after Johnston's husband's death. In the final period the portraits vary in the quality of detail.

The New York portraits are waist-length. The only landscapes attributed to Johnston are those used as backgrounds in her portraits of children. Johnston is not known to have used any medium other than pastels.

Examples of her work are in the collections of the Museum of Early Southern Decorative Arts, the Carolina Art Association / Gibbes Museum of Art, the Greenville County Museum of Art, the Abby Aldrich Rockefeller Folk Art Museum, and the Metropolitan Museum of Art.

JOHANNA METZGAR BROWN
Old Salem Museums and Gardens

Whaley Batson, *Henrietta Johnston: "Who greatly helped . . . by drawing pictures"* (1991); John A. Herdeg, *Antiques and Fine Art* (Spring 2005); Frank J. Klingberg, ed., *Carolina Chronicle: The Papers of Commissary Gideon Johnston, 1707–1716* (1946); Margaret Simmons Middleton, *Henrietta Johnston of Charles Town, South Carolina: America's First Pastellist* (1966); Martha Severens, *The Magazine Antiques* (November 1995).

Jones, Frank
(ca. 1900–1969)
Frank Jones was born around 1900 in Clarksville, Tex., a descendant of slaves brought by Anglo settlers to Texas from other regions of the American South to labor on cotton plantations. Abandoned by his mother as a small child, Jones was raised mostly by an aunt. He received no formal education and never learned to read or write. Jones made his living performing farm labor and yard work, occasionally traveling to nearby towns to pick up odd jobs.

As a child Jones was told that he was born with a veil over his left eye and that this veil would enable him to see spirits. According to this well-documented and widespread African American folk belief, people born with the veil or caul, a part of the fetal membrane, over their eyes can see and communicate with spirits. Their gift is known as second sight. Jones, who was around the age of nine when he saw his first spirit, described his visionary ability as "looking through a hole" into the spirit world. Throughout his life Jones continued to see supernatural entities, which he interchangeably called "haints" or "devils." Jones lived quietly for the first 40 years of his life, but a series of disastrous events beginning in 1941 resulted in his spending the rest of his life in and out of prison. In the early 1960s, while serving a life sentence in the Texas Department of Corrections Huntsville Unit known as "the Walls," Jones began salvaging paper and stubs of red and blue colored pencils discarded by prison bookkeepers. He began to draw pictures of images he visualized as the result of his veil. He called the drawings "devil houses."

The prison in Huntsville both inspired the concept of devil houses and provided the visual source for Jones's structures, always shown in cross section. Jones divided his structures into compartments, cells, or rooms, and bordered each compartment with "devils' horns," protruding claw shapes that made the compartments impenetrable. Thus, the grinning haint figures that populated the compartments were at once confined and sheltered. By cap-turing the haints on paper and containing them in the devil houses, Jones kept them from doing harm. Although Jones's haints appear friendly and playful, their benign expressions disguise their true objectives. Jones indicated that they smile because "they're happy, waiting for your soul." He also explained that they smile "to get you to come closer . . . to drag you down and make you do bad things. They laugh when they do that."

Jones's color choices were originally determined by the discarded red and blue bookkeeping pencils available to him. Although he experimented with other colors, he never strayed far from his original scheme of blue and red, which he said represented smoke and fire. The alternation of these contrasting colors and the repetition of shapes create visual tension in the work and allude to the coexistence of the dual, opposing forces of good and evil.

In early 1969, Jones, suffering from advanced liver disease, was admitted to the Wall's prison infirmary, where he died on 15 February 1969. Today, Jones's drawings remain among the foremost examples of intuitive art and continue to serve as unique portals into our understanding of African American visionary traditions. Drawings by Jones are in the collections of the Smithsonian American Art Museum, the High Museum of Art, and the American Folk Art Museum.

LYNNE ADELE
Austin, Texas

Lynne Adele, "Frank Jones: The Psychology and Belief System of a Black Folk Artist"

(M.A. thesis, University of Texas at Austin, 1987), *Spirited Journeys: Self-Taught Texas Artists of the Twentieth Century* (1997); Newbell Niles Puckett, *Folk Beliefs of the Southern Negro* (1926).

Jones, Shields Landon (S. L.)

(1901–1997)

Born in 1901, Shields Landon "S. L." Jones grew up in a family of 13 children headed by sharecropper parents on a small rural farm in Indian Mills, Summers County, W.Va. Despite the remote and rugged terrain of the Appalachian Mountains, where subsistence farming was the norm, Jones thrived: he loved the outdoors. During hunting expeditions as he waited for his dog to catch scent, the young hunter taught himself to whittle small carvings of forest creatures. He also loved music and taught himself to play the banjo and fiddle. He won his first fiddling contest before he was a teenager. After attending school for eight years, Jones quit at the age of 17, giving up his dream to become a veterinarian. He went to work for the Chesapeake and Ohio Railroad as a laborer and carpenter. He later became a shop foreman. Only after he retired in 1967, nearly 50 years later, did Jones return to his boyhood hobby of carving, spurred in part by the death in 1969 of his wife of 45 years. In 1972 Jones remarried and moved to Pine Hill, W.Va., where he constructed a studio behind his house and began to carve in earnest. Making statues of the animals he had loved since childhood and using native woods such as black maple, walnut, or poplar, Jones took his carvings to county fairs. In 1972 his work caught the eye of the legendary art collector Herbert W. Hemphill Jr., a founder of the American Folk Art Museum.

From the small, unpainted carvings of his early years, Jones moved in the mid-1970s to larger figures, sometimes two to three feet tall, with flourishes of paint. Broadening his repertoire to include human subjects, Jones whittled standing figures, such as a preacher holding his Bible or a hunter with his quarry. Among his most celebrated works are figural groups that form a tableau, such as a band of three musicians, each with a fiddle, banjo, or guitar; farming couples; and a man driving his horse-drawn sleigh. Jones also portrayed John Henry, the legendary steel driver, tunneling through nearby Big Bend Mountain, the site where, according to tradition, the former slave tunneled faster than the newly introduced steam-powered driving machine, prevailing against the much-loathed modern device. Jones also made a dapper, almost five-foot statue of himself in his courting days. The artist's most widely recognized carvings, however, are his life-size and larger portraits that represent "no one in particular" but everyone in general and also include such celebrities as John Henry and Christ. Frontal in pose, abstract in style, and blunt in presentation, such portraits bear a strong familial resemblance, yet each is distinct in appearance and unique in attitude: a woman with a red bow in her hair, a jaunty man with a pipe in his mouth, a series of men with Jones's characteristic bow ties, a black woman wearing an orange necklace, a stylish white woman with a scarf at

her neck. Perhaps most evocative is the torso of the red-robed figure of Jesus, now in the Milwaukee Art Museum. To make such large-sized carvings, Jones roughed out their forms with a chain saw, then shaped them with chisels and rasp, refined them with a knife, and finished by applying various shades of opaque house paint.

For more than 25 years, Jones enjoyed a successful career as an artist. In his later years, he fell ill and was forced to make drawings rather than sculptures. Described as belonging to the first generation of 20th-century self-taught wood-carvers, Jones made extraordinary works of art, which are now found in numerous public and private collections, including the Abby Aldrich Rockefeller Folk Art Museum, the American Folk Art Museum, the Huntington Museum of Art, the Milwaukee Art Museum, and the Smithsonian American Art Museum.

CAROL CROWN
University of Memphis

John Drury, *Raw Vision* (Spring 2008); Ramonal Lambell and Millard Lampell, with David Larkin, *O Appalachia: Artists of the Southern Mountains* (1989); Charles B. Rosenak, *Goldenseal: A Quarterly Forum for Documenting West Virginia's Traditional Life* (Spring 1982); Chuck Rosenak and Jan Rosenak, *Museum of American Folk Art Encyclopedia of Twentieth-Century American Folk Art and Artists* (1990).

Kemmelmeyer, Frederick
(ca. 1755–ca. 1821)
A self-taught artist, Frederick Kemmelmeyer was born in Germany and came to America sometime in the last quarter of the 18th century. He advertised his services in Baltimore in the *Maryland Gazette* through the years 1788 to 1803 as evening drawing school instructor, limner, sign painter, portrait miniaturist, and portrait painter. Kemmelmeyer also painted military insignia and transparencies used in celebrations, decorated cornices for beds and windows, and gilded mirrors and picture frames. Scholars believed he died in Shepherdstown, W.Va., in 1821.

Portraits and signs of George Washington as military general are Kemmelmeyer's best-known works. Washington sat for Kemmelmeyer on 2 October 1794. The artist is among the few who depicted Washington's smallpox scars. Examples of Kemmelmeyer's various versions of *General George Washington Reviewing the Western Army at Fort Cumberland* during the Whiskey Rebellion riots of 1794 are held by the Henry Francis du Pont Winterthur Museum, Garden, and Library and the Metropolitan Museum of Art. Other historical paintings include the *First Landing of Christopher Columbus* (ca. 1800–1805); at the National Gallery of Art; General Wayne's victory over the Miami Indians in Ohio (ca. 1800), at the Winterthur; and the *Battle of Cowpens 17th of January, 1781* (1809), at the Yale University Art Gallery. These works were executed using oil paints on canvas, cardboard, or paper.

Kemmelmeyer's history paintings possess characteristics traditionally associated with a folk style: stylized forms, such as his rendering of horses with

perfectly C-shaped necks; attention to minute details; and a flat picture plane. Elements common in his work include gold gilt lettering to describe the scene he depicts, a tree in the right of his compositions, and a rocky foreground with low vegetation.

After 1803 Kemmelmeyer worked as an itinerant portraitist throughout western Maryland, from Chambersburg to Hagerstown and into the Upper Shenandoah region. He also worked in Winchester and Alexandria, Va., in Washington, D.C., and in Chambersburg, Pa. As an itinerant, Kemmelmeyer created many pastel portraits, much less expensive than oil paintings. In 1790 in a Baltimore newspaper, the artist advertised that his half-length portraits, created for a middle-class audience, were "as large as life." Two such portraits, dated circa 1810 and circa 1815, are held by the Maryland Historical Society. These likenesses, which capture idiosyncratic features such as dimpled and double chins and graying temples, show greater naturalism than his earlier military paintings. Additional examples of Kemmelmeyer's work can be found in the Museum of Early Southern Decorative Arts and the Corcoran Gallery of Art.

JACQUELYN GOURLEY
Downingtown, Pennsylvania

Ann Uhry Abrams, *American Art Journal* (1993); E. Bryding Adams, *The Magazine Antiques* (January 1984); Robert Bishop, *Folk Painters of America* (1979); Deborah Chotner, *American Naive Paintings* (1992); Elizabeth Johns, in *350 Years of Art and Architecture in Maryland*, ed. Mary Dean (1984); Karen M. Jones, *The Magazine Antiques* (July 1981); Cynthia Elyce Rubin, ed., *Southern Folk Art* (1985); Jean Woods, *The Germanic Heritage* (1983).

Kendrick, Eddie Lee

(1928–1992)

Eddie Lee Kendrick was born on a farm near Stephens, Ark. He lived most of his adult years in rural African American communities near Little Rock, where he was a butcher for a meat packing company. Though he created art throughout his life, the work that survives was created between 1977 and 1992.

Kendrick was an artistic child who drew on grocery sacks and box lids. In his adult years, he drew on cardboard, paper, and fabric with ballpoint pen, pencil, markers, and colored pencils, with which he was especially skilled. During the 1970s and 1980s he combined acrylic paints with drawing media before switching to oil in the 1990s.

Kendrick was inspired by dreams, the landscape of Arkansas, the Bible, and gospel music. "I draw what I dream," he explained in an interview. "When it comes to me real plain I'm gonna draw it." Kendrick often awakened in the middle of the night to sketch dream images that then became the bases of his works.

In his earliest extant pictures, Kendrick divided the composition between earthly and heavenly homes. The sky is dominated by large figures of Christ often set amid expressive storm clouds. Below the heavens are neat landscapes dotted with small rural cottages, churches, and urban buildings.

Kendrick included brief texts in earlier works and in the early 1990s began to replace the Christ figure with sizable texts dominating the sky. In one such drawing, Kendrick quoted the opening words of Psalm 121, a favorite biblical passage: "I WILL LIFT UP MY EYES TO THE HILL." By the mid-1980s the artist also began to replace literal images with visual metaphors. Boats, trains, and planes, all familiar elements in Kendrick's landscape, now showed the way to eternal life. Most often they flew along a diagonal path toward heaven or toward earth to pick up believers. Kendrick continued to use these visual metaphors until his death in 1992.

The use of heavenly vehicles was possibly inspired by a gospel song he sang, "I'm Going Home on the Morning Train." Kendrick explained that he often created art in response to the music he loved to sing at church and as a member of gospel groups like Hearts of Joy: "When you get some good music, you can draw about anything."

In most of Kendrick's works, guardian angels, set amid storm clouds, observe the scene from a corner of the sky. The artist once explained that he included a guardian angel to watch over the recipient of his art both in good times and in bad times, symbolized by dark clouds.

Eddie Kendrick's work was unknown outside Arkansas until 1993, when it was included in *Passionate Visions of the American South: Self-Taught Artists from 1940 to the Present*. In 1998 a retrospective of his work, *Eddie Lee Kendrick: A Spiritual Journey*, was organized by the New Orleans Museum of Art

in cooperation with the Arkansas Arts Center, which holds six of his works in its collection. Works by Kendrick may also be found in the San Diego Museum of Art and the New Orleans Museum of Art.

SUSAN TURNER PURVIS
Little Rock, Arkansas

Beti Gunter, *Arkansas Gazette* (1977); Gary Schwindler, *Pictured in My Mind* (1995); Alice Rae Yelen, *Passionate Visions of the American South: Self-Taught Artists from 1940 to the Present* (1993), *A Spiritual Journey: The Art of Eddie Lee Kendrick* (1998).

Kennedy, William W.
(1818–ca. 1870)
William W. Kennedy is included among the small group of artists known informally as the "Prior-Hamblin school." William Matthew Prior, Sturtevant J. Hamblin, and George G. Hartwell were Maine-born artists working in a stylistically related manner. Their work consisted of two modes of portraiture. Academic portraits included modeling of facial features and drapery and cost as much as $25, whereas paintings in a modified approach of "flat portraits without shade" were advertised for under $3, including the frame, and could be completed in around an hour.

Kennedy's status within this group of artists has not been conclusively established, although advertisements, inscriptions, and city directories situate his activities near William Prior in both Boston and Baltimore. Despite a growing number of signed and attributed portraits, little biographical information about Kennedy has emerged. He

was married to Julia Sarah Richardson in Lowell, Mass., on 21 October 1843. Their three children, Fred, Walter, and Julia, were born in Massachusetts. In 1844 Kennedy was painting in Bridgewater, where he signed and dated portraits of Sally T. (Gardner) Clark and Swallow Clark, whom she had married the year before. In 1845 Kennedy is documented in New Bedford, where he painted the family of rope maker Josiah Bliss. Later that year he advertised a "New Style of Portrait" in the *Nantucket Inquirer and Mirror* (7 July 1845). The signed and dated portrait of Captain David Worth gives compelling visual evidence that this "new style" was in fact strikingly similar to the flat portraits innovated by the Prior-Hamblin School. The advertisement also stated that he was "of Boston," lending further credence to an early association with the Prior-Hamblin circle of artists. Kennedy continued to move along the seafaring coastal towns of Massachusetts, primarily painting sea captains and other members of the maritime trades, until 1846 when he worked in Ledyard, Conn., and then in Berwick, Me., in 1847.

It is not known why the artist moved to Baltimore during the winter of 1849–50. The 1850 Maryland census lists Kennedy as a 32-year-old portrait painter, a native of New Hampshire, and married with three children. He lived at various addresses between 1853 and 1871. A series of Virginian portraits suggests that Kennedy traveled to eastern Virginia, but patrons could also have traveled to the artist's studio in Baltimore. At least 14 signed examples of Kennedy's work have provided the basis for the attribution of a growing number of portraits. An examination of his oeuvre reveals specific characteristics that distinguish his hand from other artists of the Prior-Hamblin School: in particular, the outlining of brows and blunt-tipped noses in a smooth, continuous stroke with uniform white highlights; thick fingers, sometimes curved, with heavy outlining; and a dark line between the upper and lower lips with T-shaped creases at the corners. Portraits attributed to Kennedy can be found in the collections of the Abbey Aldrich Rockefeller Folk Art Museum and the New York State Historical Society.

STACY C. HOLLANDER
American Folk Art Museum

Paul S. D'Ambrosio and Charlotte M. Emans, *Folk Art's Many Faces: Portraits in the New York State Historical Association* (1987); Nina Fletcher Little, *Maine Antiques Digest* (April 1976); Beatrix T. Rumford, *American Folk Portraits: Paintings and Drawings from the Abby Aldrich Rockefeller Folk Art Center* (1981).

Kinney Family

The Kinney family lived on a small farm in northeast Kentucky near Vanceburg, in rural Lewis County. Collectively, members of the family became well known for their accomplishments as self-taught visual artists. The two Kinney brothers were also widely recognized for their music and their role in maintaining the musical traditions of the region.

Charley Kinney (1906–91) was born with a birth defect that limited his capacity for manual labor. He made oak

splint baskets as a young man and used local clay to model a variety of animals and some human busts, including Abraham Lincoln and Moses holding the Ten Commandment tablets. The artist dried his clay pieces on a wood stove, painted these objects, and sold many of them. In the 1950s he took up painting, which became his central occupation from around 1970 until his death. Charley Kinney's style was rugged and gestural. He made no attempts at strict realism but instead gave way to a bold sense of design. His subject matter was wide ranging, including events of interest to him, scenes from traditional life such as animal-powered farming methods, wonders of nature, emerging technologies such as hot-air balloons, and local lore including numerous depictions of "haints," "wild boogers," and "knocking spirits" of the night.

Noah Oliver Kinney (1912–91) worked the family farm where he had been born, growing tobacco and corn and raising livestock. He liked to draw and produced many drawings during his early life. In 1960 he married Hazel Bateman. In 1970, when he retired from farming because of failing health, he began working with wood. Between 1970 and 1990 he created a variety of objects, including detailed models of early machines and equipment such as a steam-driven sawmill, tractors, figures of U.S. presidents, and animals—both local and exotic, the latter inspired by a 1980s visit to the Cincinnati Zoo.

Hazel Dee (Bateman) Kinney (b. 1929) was born in Robertson County, Ky. After marrying Noah Kinney, moving to the Kinney farm, and seeing the artwork produced by the two brothers, Hazel began painting rocks and pieces of coal that she used to decorate the outside of their house. In time, she began making paintings on scraps of wood left over from her husband's work, typically portraying scenes from the Bible such as Noah's Ark. In the 1980s she began painting on paper. In addition to biblical scenes, Hazel's subjects include nursery rhymes, scenes from traditional life, and idealized images of family.

The Kinney brothers' art attracted the attention of formally trained artists as early as the 1970s, when their work was included in *Kentucky Folk Art*, organized by the University of Kentucky as the first exhibition to focus on local self-taught artists. By the 1980s interest in the Kinneys' art had grown, and collectors frequently visited to meet the brothers and make purchases. Paintings by Charley and sculptures by Noah were integral parts of the original collection at Morehead State University that eventually became the Kentucky Folk Art Center. Works by both Charley and Noah Kinney have since been acquired by many American museums.

The Kinney farm was also a popular destination for string musicians and individuals with an interest in traditional Appalachian fiddle music. Charley and Noah were both enthusiastic musicians, and the frequent musical gatherings they held in their tobacco barn attracted musicians from their area and beyond. The Kinneys helped sustain musical traditions peculiar to northeast Kentucky. They were

particularly instrumental in preserving fiddle tunes that had originated in the Scots-Irish musical tradition brought in by early settlers as well as those that had absorbed elements of other traditions brought in by musicians traveling on the nearby Ohio River. Until Charley and Noah Kinney died in 1991, the Kinney homeplace was the single most significant venue for the perpetuation of a local style of fiddle playing and of a bow style specific to western Lewis and adjoining eastern Fleming counties in Kentucky.

The Kinneys lived through a period of social, economic, and technological change. They utilized their diverse creative skills to record their reactions and give context to the changes taking place around them. Through music and art, the Kinney brothers documented their lives and asserted their cultural identity. Charley and Noah Kinney still remain important figures in 20th-century Kentucky folk art and music. Works by the Kinney brothers can also be seen at the Huntington Museum of Art, the Owensboro Museum of Fine Art, the Birmingham Museum of Art, and the New Orleans Museum of Art.

ADRIAN SWAIN
Kentucky Folk Art Center

John Harrodd and Lee Kogan, *Slow Time: The Works of Charley, Noah, and Hazel Kinney* (2006); Morehead State University, *Local Visions: Folk Art from Northeast Kentucky* (1990); Museum of American Folk Art, *Encyclopedia of American Folk Art* (2004); Chuck Rosenak and Jan Rosenak, *Museum of American Folk Art Encyclopedia of Twentieth-Century American Folk Art and Artists* (1990); University of Kentucky, *Folk Art of Kentucky* (1976); Alice Rae Yelen, *Passionate Visions of the American South* (1993).

Kornegay, George
(b. 1917)

Like many southern self-taught artists, Rev. George Kornegay, an African Methodist Episcopal Zion minister, who also worked in Alabama's mills and foundries, took up art making after a visionary experience. Preparing to carve into a rock he had found on his property, he heard a voice saying, "Upon this rock I will build my Church." Kornegay decided to leave the rock as it was and follow his calling to create works that would glorify God. Kornegay's environment, which he has variously named *The New Jerusalem*, *The Seven Holy Mountains*, *The Sacred Mountains*, and *Art Hill*, was a sacred space encoded with the creolized African emblems of the American South and with numerous references to biblical stories and sacred music. Kornegay required that visitors take the time to decode the environment for themselves, warning that some of the symbols are "secrets" between him and God. Of his art, he says, "This is God's stuff. He's my teacher. It all comes from God."

Kornegay's sizable garden, which sloped from his house to a well-traveled road demarcating the property, adopted and transformed the traditional artistic practice of Atlantic Africa. Wrapped structures that recalled the medicated charms known as *minkisi*, bottle trees that attracted and trapped evil spirits, and large guardian figures and faces dotted the garden. Painted roots,

thought to be the domain of powerful spirits, stood affixed to posts that abut a depiction of the Crucifixion made from wheels and other cast-off materials. Throughout the garden, wheels, tires, fans, hubcaps, and discarded electric fans with four blades all suggested the Kongo cosmogram, a circle or diamond divided by two axes that symbolize the four cardinal directions of the universe and the soul's progress from birth, to maturity, to death, and to rebirth. A large assemblage of circular found objects, including chrome hubcaps, may refer to Ezekiel's "wheels within wheels" and encodes the belief that shiny surfaces repel evil and embody *ashé*, the flash of the spirit that denotes the power to make things happen.

Many of Kornegay's constructions blend African-derived emblems with Christian emblems. Kornegay's *Jacob's Ladder* combines wheels, stairs, and a television antenna with gleaming cross bars to illustrate, in the words of the spiritual, that "every rung goes higher, higher." Another multivalent work, a large sculpture of *Jonah in the Belly of the Whale* attached to a bridgelike structure, alluded both to the Edmund E. Pettis Bridge in nearby Selma, where marchers were attacked by police and segregationists, and to the promise of a trans-Jordan land of milk and honey. Kornegay's *Last Supper*, a long table topped with stones and crockery and surrounded with chair frames topped with bottles, audaciously conflated conventional European Last Suppers with bottle trees, African American protective charms that have become a southern vernacular recognized by both whites and blacks. Perhaps influenced by Joe Minter, whom Kornegay met through their inclusion in the same arts events, Kornegay also created numerous figures for an African village and planned to address his American Indian heritage as well.

Although Kornegay's family has stored some of the artist's constructions, the environment has largely disappeared. The esoteric nature of Kornegay's creation—his secrets with God—and his suspicion of admirers certainly discouraged preservation of his "message to the world." Kornegay has moved away from Brent. Photographs recording the site and its development, though they cannot describe the experiential framework of the site, do record some of the site's importance.

CHERYL RIVERS
Brooklyn, New York

William Arnett and Paul Arnett, *Souls Grown Deep: African American Vernacular Art*, vol. 2 (2001); Carol Crown, ed., *Coming Home! Self-Taught Artists, the Bible, and the American South* (2004); Grey Gundaker, ed., *Keep Your Head to the Sky: Interpreting African American Home Ground* (1998), *Signs of Diaspora / Diaspora of Signs: Literacies, Creolization, and Vernacular Practice in African America* (1998); Grey Gundaker and Judith McWillie, *No Space Hidden: The Spirit of African American Yard Work* (2005); Robert Farris Thompson, *Flash of the Spirit: African and Afro-American Art and Philosophy* (1983).

Kühn, Justus Engelhardt

(b. unknown; d. 1717)
Justus Engelhardt Kühn, the South's earliest recorded professional portrait

artist, listed himself as a German, a Protestant, and a painter when he applied for naturalization in 1708 at the courthouse in Annapolis, Md., where he had settled. He soon married and became a father. In 1717 Kühn was named a churchwarden at the Episcopal Church of St. Anne's. He died six months later. Among his possessions at death were 39 books, a flute, and a personal wardrobe of some worth—suggesting the painter's fondness for reading, music, and fine clothes. Besides paintings, Kühn also left an unfinished coat of arms, the latter demonstrating that Kühn, like most colonial painters, augmented his income through a variety of jobs, including sign painting. Even so, he died a debtor.

The portraits attributed to Kühn, all of which date around 1710, depict members of three related Roman Catholic families, the Darnalls, Carrolls, and Diggeses, who ranked among Maryland's most privileged class. Much like court painters of the day, Kühn fashioned portraits for these families that showcase their aristocratic pretensions. Among Kühn's most celebrated paintings, now in the collections of the Maryland Historical Society, are two children, Henry Darnall III and his sister Eleanor, each sumptuously dressed and each the subject of a full-length portrait. Henry wears a yellow-gold brocade coat with silver buttons and a lace jabot as well as high-heeled black shoes with ornate silver buckles. Eleanor, looking much like a princess, wears a necklace of large pearls, a dark red dress with a black velvet train, and a white stomacher with bands of lace.

Equally imposing are the palatial settings in which each child stands. Both are posed in front of an ornate balustrade framed by large curtains that open onto a formal garden with fountains, statues, and manor houses, the likes of which had no parallels in colonial America. Just like the children's costly attire, most likely derived from print sources, these make-believe landscapes serve to communicate the Darnalls' patrician way of life. Further highlighting the family's wealth and status is an attendant figure pictured at Henry's right side. A young African American slave offers the boy, who holds a bow and arrow, a dead game bird, apparently shot by his young master. Around the servant's neck is a metal collar, a symbol of the black youth's low status and a chilling reminder that slavery was already a thriving system in the South. Kühn's painting is one of the earliest depictions of a slave in American art.

Although Kühn's biographical information sheds no light on his artistic training, he clearly admired baroque portraiture as handed down from Flemish artists Peter Paul Rubens and Anthony Van Dyke. Not only does he employ familiar baroque formulas to emphasize his sitters' place in society, but he also makes use of a painterly style that is rich in color and lush in brushstrokes. However, while artists schooled in the baroque style typically envision robust and strongly modeled figures existing within three-dimensional space, Kühn portrayed his figures in a much more two-dimensional and doll-like manner. He also flattened the subjects' surroundings; the enclosed gar-

dens that frame his youthful sitters seem to embrace the canvas rather than extend it. Sometimes described as a provincial baroque painter, Kühn is most comfortable with the two-dimensional. His art fits into a folk art idiom that favors abstraction and emblems like lavish, ornate costumes and richly decorated architectural settings as means to convey power and wealth.

CAROL CROWN
University of Memphis

Wayne Cravens, *Colonial American Portraiture* (1986); J. Hall Pleasants, *Justus Engelhardt Kühn* (1937); Elisabeth L. Roark, *Artists of Colonial America* (2003).

Lancaster, Paul
(b. 1939)
Although sophisticated in technique and composition, the paintings of Tennessee native Paul Lancaster embody the innocence of a childlike imagination. Indeed, Lancaster claims that the birds, flowers, and insects he creates are invented, even when the woods and meadows in which he sets them bear a good deal of resemblance to the west and middle Tennessee landscape where Lancaster, whose grandfather was Cherokee, grew up. Lancaster now works indoors and in complete isolation, drawing not only on childhood memories but also on art history. Well familiar with the work of artists such as Renoir, Matisse, and Rousseau, he pushes beyond their influence into a distinctive intermingling of fantasy and reality. Fireflies, fairies, and bathing or reclining female figures appear in wooded settings in which the textures of leaves, tree bark, and vegetation come

alive. Lancaster's paintings glow with deeply shadowed areas and illuminated textures. His color tonalities evoke sunset skies or luminous aquariums.

Lancaster, who has been painting since 1959, says that drawing and writing preceded his painting. By the time Lancaster was 20, he had created and illustrated a volume of his own poetry. While at an army training camp in Colorado, he was inspired to draw the spectacular western landscape and was promised a promotion if he would enroll in a medical illustration program. Lancaster declined, convinced that such training would squander his artistic gifts. Once out of the service, Lancaster worked for nearly 30 years as a framer at Lyzon, Nashville's first fine art gallery. Gallery owner Myron King was a skillful promoter who has been credited with the rediscovery of self-taught sculptor William Edmondson and the introduction of a high-school-aged Red Grooms. Although King also attempted to promote Lancaster, he merely pushed the artist to create hand-colored etchings of Easter eggs and butterflies that would appeal to the tastes of a local clientele. Lancaster's complex and inventive works languished in the back room of the gallery, and Lancaster was almost unknown to fellow artists in Nashville.

Since his retirement in 1995, however, Lancaster has reconnected with the unfettered world of his imagination. The result has been a prolific outpouring of imaginative paintings of a vibrant fantasy world. Lancaster's work was first presented at New York's Outsider Art Fair in 2001, and curator Marcus Schubert included Lancaster's

work in the exhibition *Treasures of the Soul: Who Is Rich?* at the American Visionary Art Museum in 2000–2001.

SUSAN W. KNOWLES
Nashville, Tennessee

Benjamin H. Caldwell, Robert Hicks, and Mark W. Scala, *The Art of Tennessee* (2003); Grey Carter, *Paul Lancaster: Immersed in Nature* (2009); Susan Knowles, *Raw Vision* (Winter 2002); Paul Lancaster, *The Painted Woods* (1992); Patrick D. Lester, *The Biographical Directory of Native American Painters* (1995).

Landry, Pierre Joseph

(1770–1843)

Pierre Joseph Landry, born in the French village of St. Servan on the Brittany coast on 16 January 1770, became Louisiana's first known self-taught sculptor of consequence. In anticipation of the impending French Revolution, he immigrated to the Louisiana Territory with his family in 1785. His father, Colonel Pierre Joseph Landry, was a French military commander and member of the nobility. The Landry family settled in St. Gabriel, received a land grant, and became distinguished sugar planters in a region that was to become Louisiana's Iberville Parish. Young Landry married Scholastique Breaux in 1790 and then, following her death, remarried several times. He served as a captain under General Andrew Jackson in the 1812 Battle of New Orleans and subsequently became a personal friend of the general.

In 1820 Landry was stricken with tuberculosis of the knee. Because of this illness, he was confined to a wheelchair for the remainder of his life. This debilitating event resulted in Landry's new interest in carving small, wood figures from beech and magnolia. After his death at Bayou Goula, La., in March 1843, his small collections of figures, sculpted with a pocket knife, were distributed to his descendants. Later a majority of the carvings were reassembled as a group, along with other personal memorabilia, and presented to the Louisiana State Museum in New Orleans, where they remain.

Landry became celebrated for small carvings, which were, for the most part, single, or groupings of figures in a suggested environment. His largest and most elaborate creation, *The Wheel of Life*, is a circular wreathlike composition with nine groupings of figures that represent the ages of man from cradle to grave. Landry presented to President Jackson one of his sculptures, a double portrait of General Jackson and the French King Louis Phillipe, now displayed at the Hermitage in Nashville. Another tableau carving, which displays a bit of the artist's wit, *Self Portrait Observing an Indian Maiden at Her Bath*, is in the permanent collection of the New Orleans Museum of Art.

WILLIAM A. FAGALY
New Orleans Museum of Art

Julia Truitt Bishop, [New Orleans] *Times-Democrat* (9 February 1913); *Louisiana Folk Art*, Anglo-American Art Museum, Louisiana State University, Baton Rouge (1972); Robert Morton, *Southern Antiques and Folk Art* (1976); Louisiana State Museum, *250 Years of Life in New Orleans: The Rosemonde E. and Emile Kuntz Collection and the Felix H. Kuntz Collection* (1968).

Leedskalnin, Edward

(1887–1951)

Born in Riga, Latvia, on 10 August 1887, Edward Leedskalnin attended school through the fourth grade before taking a job in a sawmill. Fifteen years later, he had little to show for his efforts. After his 16-year-old fiancée, Agnes Scuffs, jilted him, the 26-year-old Leedskalnin immigrated, first to Canada and then to the United States. He worked in lumber camps until tuberculosis forced him to move to a warmer climate. He settled in Florida City, Fla., and within a year or two began work on the project that occupied him for decades.

At first Leedskalnin hoped that *Rock Gate Park* would lure Agnes Scuffs to Florida. In time, however, the park, carved of huge, roughhewn coral limestone that Leedskalnin quarried himself, evolved into a roadside attraction that locals called the *Coral Castle*. Some neighbors, however, were perplexed by the complex, which resembled a Pre-Columbian or Polynesian temple, and by its esoteric sculptures. Some reasoned that a small man, only five feet tall and weighing less than 100 pounds, could have assembled such enormous blocks of stone only with satanic assistance.

Disputes with neighbors and encroaching development led Leedskalnin in 1936 to relocate the environment block by block to a 10-acre property in Homestead, Fla. Some sources state that Leedskalnin kept his techniques secret by insisting that the mover vacate the premises while the stones were loaded or unloaded. Although extant photographs document complex block and tackle rigs suspended from huge wooden tripods, the artist's techniques remain obscure. Pamphlets Leedskalnin distributed during his lifetime fail to shed light on his obvious accomplishments. Fringe science websites claim that Leedskalnin levitated his stones into place through knowledge of the secrets of the pyramid builders, ancient Babylonian magicians, and space aliens. Increasingly impressive creations, such as a massive stone rocking chair, a nine-ton gate that could be opened by the push of a finger, and carvings of planets, the sun, and several crescent moons that perhaps encode secret meanings further encourage an aura of mystery.

Like many physicists, theologians, philosophers, and self-taught artists, Leedskalnin sought a unified theory that could account for everything in the universe. Magnetism, he believed, explained the movements of the sun and stars, the behavior of light, the workings of gravity, and the attraction or repulsion between males and females. Leedskalnin also dabbled in moral philosophy. His longest pamphlet, *A Book in Every Home: Containing Three Subjects: Ed's Sweet Sixteen, Domestic, and Political Views* (1936), claims that girls reach their peaks at 16 while men take a decade longer to season into maturity; this assertion, of course, conveniently recalls his lost fiancée. He warned that "any girl who associates with a fellow only five years older is headed for a bad disappointment. . . . Girls below sixteen should not be allowed to associate with the boys. . . . Lovemaking should be reserved for their permanent partners. With every lovemaking affair,

their hearts get bruised and by the time they grow up, their hearts are so badly bruised that they are no more good." To avoid such an outcome, he provided one solution: "In case the girl's mamma thinks that there is a boy somewhere who needs experience, then she, herself, could pose as an experimental station for that fresh boy to practice on and so save the girl. Nothing can hurt her any more. She has already gone through all the experience that can be gone through and so in her case, it would be all right."

Edward Leedskalnin, who had never sought the love of another woman, died at the age of 64 in 1951. The Coral Castle, listed on the National Register of Historic Places, is privately owned but open for visitors. The official website, www.coralcastle.com, offers Leedskalnin's published writings.

ROGER MANLEY
Gregg Museum of Art and Design
North Carolina State University

Edward Leedskalnin, *A Book in Every Home: Containing Three Subjects: Ed's Sweet Sixteen, Domestic, and Political Views* (1936), *Magnetic Current: Mineral, Vegetable and Animal Life* (1980); Roger Manley and Mark Sloan, *Self-Made Worlds: Visionary Environments* (1997); Deidi Von Schaewen and John Maizels, *Fantasy Worlds* (1999).

Light, Joe Louis
(1934–2005)

Joe Louis Light, born in Dyersburg, Tenn., was named for the African American boxer who was just beginning his career when Light was born and who later became a hero for black Americans in the era of Jim Crow. Light considered himself a fighter whose opponents were ignorance, jealousy, injustice, hypocrisy, and other human shortcomings. He hoped to provide spiritual guidance for his family, neighborhood, and race, using his art and words as primary vehicles for communicating his messages.

Light searched for ways to make God comprehensible. First, Light wrote biblical-sounding pronouncements on sidewalks and on walls beneath expressway bridges. Then he began painting challenging (and sometimes threatening) signs in his Memphis yard, expressing his thoughts as a social critic, spokesman, and evangelist for minority races and religions.

Although his signs were meant to communicate with uninitiated audiences, many of his most profound visual expressions were directed principally toward himself. To guide his personal journey, Light compressed his worldview and next-world view into a complex visual language, put forth in brightly colored paintings on and around his house. These paintings combined iconic and often autobiographical human and animal figures, strange glyphs and calligraphy-like symbols, and metaphorical "cartoons." Though Light intended his art to communicate to himself and appear enigmatic to outsiders, he put many works on his porch and in his yard, hoping to draw the interest of passersby. He imagined that if they approached the house because of the amusing art, they might be inclined to read the signs and, in response, straighten out their lives.

Joe Light was raised Baptist by his father, but he was highly resentful of

fundamentalist Christianity, considering it a vehicle for the false promises whites had made to blacks. The stern, severe, Old Testament God ideally suited Light's psychological and philosophical desires; in 1960, while serving a second prison sentence, Light heard a prison chaplain read from the Old Testament and decided to convert to Judaism. Theologically, he was not actually Jewish and was the first to admit it. Indeed, Light's art relies heavily on Christian theology and iconography. His paintings are about salvation and personal transformation, imperatives important to Christianity because of its belief in the inherent wickedness of humankind.

Light's art was born of his weekend routine. He sold miscellany in the flea markets of Memphis and then returned home to watch documentaries, cartoons, and cowboy movies on television. The flea market environment surrounded Light with society's kitsch and bric-a-brac, the de facto pop art of the underclass. Perhaps it was Western movies, with their indelible panoramas of Monument Valley that instilled in Light the great American sense of landscape. He enjoyed adding metaphorical found objects to his paintings, calling the result "attachment art."

Through his art and signs, Joe Light developed and communicated a private and personal code of ethics that does not fit any culture's established rule of order. Unfortunately, in the 1990s, Light lost his house to indebtedness. When the house was confiscated, Light's art was whitewashed away. Fortunately, the remarkable paintings on the outside and the inside walls of his house survive in photographs.

Joe Light died in 1995 at the age of 61. Light's works are in the collections of the Georgia Museum of Art, the High Museum of Art, the Morris Museum of Art, and the Smithsonian American Art Museum.

WILLIAM ARNETT
Souls Grown Deep Foundation

STEPHANIE BURAK
Atlanta, Georgia

Paul Arnett and William Arnett, eds., *Souls Grown Deep: African American Vernacular Art of the South*, vol. 1 (2000); William Arnett and Paul Arnett, eds., *Souls Grown Deep: African American Vernacular Art*, vol. 2 (2001); Paul Manoguerra, ed., *Amazing Grace: Self-Taught Artists from the Mullis Collection* (2007); Phyllis Kornfield, *Cellblock Visions: Prison Art in America* (1997); Lynne E. Spriggs, Joanne Cubbs, Lynda Roscoe Hartigan, and Susan Mitchell Crawley, *Let It Shine: Self-Taught Art from the T. Marshall Hahn Collection* (2001).

Limners

The term "limner," commonly used in English as a synonym of "illustrator," derives from the word "illuminator," an artist who decorated or illuminated medieval manuscripts with ornate details and strong color. In the 17th, 18th, and 19th centuries the word "limner" was applied to itinerant portrait painters who traveled throughout the North American colonies. Limners were generally self-taught artists who periodically supplemented their incomes by working as decorative artists. Although most female artists were charged with domestic duties and therefore painted

only friends and family, a few women did enjoy careers as itinerant artists.

Portraiture was an important and necessary part of life for the families of colonial towns in the New World. During the 18th and 19th centuries, portraiture continued to thrive, and the demand for family and individual portraiture offered opportunities to self-taught painters who traveled from town to town to receive commissions. Local landowners and a growing mercantile class often marked their worldly success through portraits of themselves and sometimes of their entire families. From the 18th century, limners offered their services in New England, where commerce and wealth were abundant. As southern communities flourished, New England limners traveled South, painting the portraits that provided models for aspiring southern limners. The first recorded professional portrait painter in the South is Justus Englehardt Kühn (d. 1711), an immigrant from Germany who settled in Annapolis, Md.

Most limner painters portray their figures in a flat manner. Anatomy and placement in space are often awkward, and perspective is often unrealistic. Painting primarily on canvas and wood panels, painters depicted their subjects in frontal positions wearing clothes meant to imply the sitter's prosperity and education. While clothing and background furnishings may have been the real possessions of the sitter, artists also drew on print sources or repeated conventional emblems of material success and refinement. Should the lady of the house be lacking in appropriate finery, the painter could provide lace collars, earrings, or brooches, or stylish furniture.

Few limners could support themselves on portrait commissions alone. In addition to portraiture, limners also adorned fireplace screens, clock faces, signs, fire buckets, carriages, and interior spaces. Such decoration required that the limner be skilled in various techniques, such as striping, wood graining, drawing family crests, stenciling, and painting landscape vignettes. Itinerant painters did not always sign their works; the identification of many artists depends on intensive research into probate records, account books, and other local documents. Some limners, such as the Payne Limner or the Guilford Limner, are identified simply by their sitters' names or by the locale in which they worked. Scholarship has not yet identified many southern itinerants, particularly those who worked in the Deep South, the trans-Appalachian region, and in other areas that developed years after coastal towns with established cultural institutions. Groups of portraits apparently painted by the same hands invite further investigation.

KATHERINE TAYLOR-MCBROOM
Shelburne Museum

Robert Bishop and Jacqueline M. Atkins, *Folk Art in American Life* (1995); Henry Joyce and Sloane Stephens, *American Folk Art at the Shelburne Museum* (2001); Nina Fletcher Little, *Country Art in New England, 1790–1840* (1960).

Line, Marion Forgey

(1919–1999)
Folk artist Marion Line was born Marion Louise Forgey in Morristown,

Tenn. There she received a public-school education and music lessons. She attended Carson-Newman College in Jefferson City, Tenn., earning a bachelor of arts degree in English and a diploma in violin. While attending college, she met her future husband, Lloyd E. Line Jr. In 1952 they settled in Richmond, Va., and raised their family. Although Line had always loved to draw, it was not until the 1970s that she focused on painting. As a violinist who could no longer play because of arthritis, she felt compelled to express her sense of beauty, joy, and spirituality.

Line's paintings depict brightly colored, nostalgic visions of spring flowers, harvests, and wintry wonderlands as well as stories from the Bible. In the more than 300 paintings she produced, rural life in the mountains of Tennessee and Virginia plays heavily — raking leaves, harvesting apples or pears, quilts on a clothesline. A little black poodle, Sadi, serves as a signature element in a majority of the works. Perhaps for Line, Sadi was both talisman and comic relief.

Line was a memory painter like Grandma Moses (Anna Mary Robertson Moses). Her devotion to storytelling, color harmony, unyielding inventiveness in depicting subject matter, and innate sense of balance are all striking. That she did not use linear perspective is a positive attribute rather than a shortcoming. Her lack of linear perspective, which one reviewer called "delightfully cockeyed," supports the notion that these images come from the mind's eye. Indeed, Line's rejection of rigid perspective is a conscious choice. She once said, "I sketch right on the canvas with a light wash of turpentine and yellow ochre. I go by shapes — I don't have to worry about depth." A critic noted the results of Line's multiple perspectives: "Line's ability to extract details from different eras and weave them into single frames results in a slightly distorted reality."

Line also wrote poetry that provides insight into her drive to create. The poems often reflect the artist's bouts with depression as she faced arthritis. Obviously, Line found great comfort in producing pictures of her childhood. The places she painted were her own symbolic safe havens, places where she did not feel pain.

Line's discovery as a painter is the stuff of legends. When Anne Gray, owner of the Eric Schindler Gallery in Richmond, was delivering a cabinet Line had purchased, she saw a painting hanging in the hallway and inquired about the artist. Line was surprised that Gray was interested in her work. In 1983 Gray displayed several of Line's works in the gallery. Then in 1984, at the age of 65, Line had her first solo exhibition.

Longwood Center for the Visual Arts in Farmville, Va., holds 31 of Line's works in its permanent collection, the largest single collection of Marion Line paintings.

K. JOHNSON BOWLES
Longwood Center for the Visual Arts

K. Johnson Bowles, *Fertile Visions: Paintings by Marion Forgey Line, 1919–1998* (2002); Jerry Lewis, *Style Magazine* (Richmond, Va.) (July 1986); Lloyd Line and Roy Proctor, *Richmond News Leader* (17 March

1984); Judith Snyderman, *Richmond's Visual Arts Magazine Gallery* (July–August 1989).

Lockett, Ronald
(1965–1998)

Years after Ronald Lockett's death from AIDS-related pneumonia in 1998, pencil drawings of horses and sports idols—evidence of his childhood desire to be an artist—could still be found on a few walls and houses in the Bessemer, Ala., neighborhood, known as Pipe Shop, where he spent his entire life. Lockett was born into an extended family that included Thornton Dial, a neighbor, mentor, and "cousin" or "uncle"—the family lineages are complex—who later became a renowned self-taught artist. Lockett's parents divorced when he was young, and Dial became a kind of surrogate parent to Lockett, who spent many hours at Dial's home.

After high school, Lockett continued to live in his mother's house, two doors from the Dials. When Dial began to receive art-world attention in the late 1980s, Lockett, who had been making dreamlike paintings on found wood, suddenly found himself at a crossroads; too young (and worldly) to fit the existing paradigm of the folk artist, and yet removed from dialogues about contemporary art, he faced a choice between going to art school or remaining "at home" with his mother, whom he took care of, and his mentor.

Although different in temperament and style from Thornton Dial, Lockett carefully learned from the older artist's syncretic attitude toward media and influences. Lockett's grand theme—an irreducibly autobiographical one he applied to every subject he tackled—was displacement, most notably his generation of urban black males' distance from earlier epics: the civil rights movement, the struggles against fascism and race oppression, and the decline of the industrial economy that had attracted Lockett's ancestors to the steel- and iron-producing Birmingham region. Lockett's storytelling genius was to see this theme, with all its melancholy personal and social implications, through the lens of embattled nature. He often made his protagonists threatened species, such as the whitetail deer that somehow managed to survive in the vacant lots and backyard thickets of Bessemer. His aesthetic genius was to find these issues and narratives embedded in a material—snipped and collaged corroded tin—that gradually replaced easel painting as his chosen expressive medium.

Lockett had always freely mixed materials—incorporating pieces of wire fencing, for example, into a painting of a deer to make his "Traps" series about the tragedy of the deer/black male. By the early 1990s, however, he had begun to believe that African American vernacular artistic traditions, of which Dial was Lockett's exemplar, were themselves as embattled as any other aspect of black experience. Lockett gradually moved away from painting; when he found a decrepit tin barn that the Dials had once owned, Lockett acquired the materials for a breakthrough form of pictorial representation that would occupy his remaining years.

Oxidized tin was the DNA of the story Lockett's art had always told. The

tin embodied the conflict between old and new, between human desires and needs and the effects of time and nature, between the hardness and obduracy of the material and its gorgeous surfaces, and—most rapturously—between death and the promise of rebirth through the act of recycling.

Coinciding with his battles against HIV, Lockett's metal collages—on themes such as the Oklahoma City bombing, the deaths of Princess Diana and Lockett's great aunt Sarah, culture heroes such as Jesse Owens, and iconic deer, wolves, and bison—stand as testaments to the remarkable vision of a budding master. The High Museum of Art and the Tubman African-American Museum are among the museums that hold works by Lockett.

PAUL ARNETT
Lafayette, California

Paul Arnett and William Arnett, eds., *Souls Grown Deep: African American Vernacular Art of the South*, vol. 1 (2000); William Arnett and Paul Arnett, eds., *Souls Grown Deep: African American Vernacular Art*, vol. 2 (2001); Kinshasha Conwill and Arthur C. Danto, *Testimony: Vernacular Art of the African-American South* (2001); Frank Maresca and Roger Ricco, *American Self-Taught: Paintings and Drawings by Outsider Artists* (1993).

Long, Woodie

(1942–2009)
Woodie Long, one of 12 siblings, was a sharecropper's son. "Daddy had us for a reason, that was to be field hands," he said. Kept out of school to harvest crops, Long learned math by rearranging the boxes of fruit he peddled to create an extra box to sell. When Long was 13, his parents moved the family to a housing project in Tampa, Fla.; two years later his father abandoned the family.

Long began his art making while working as a tile setter in a shipyard. His first works, carefree scenes of fishermen and cavorting animals painted on the ships' gunnels, were sandblasted away the following day. Becoming a house painter, Long continued painting on surfaces that would be covered by the next coat. In the 1970s Long worked in Saudi Arabia with a construction firm, where he met his future wife, Dot. Long continued to work as a house painter after the two returned to the United States in 1980. In 1988 Dot Long enrolled in an art class at a local junior college, and for the first time Long had access to art supplies. He began to paint every day and soon had enough works for a successful exhibition. Dot Long became her husband's dealer, and after the couple settled in Santa Rosa Beach, Fla., they opened a gallery dedicated to Long's work. Long estimated that, by the year 2000, he had made nearly 14,000 paintings.

Works that held special meaning for the artist are memory paintings of the lives of sharecroppers and a series called *Moma's Flowers*, which memorializes his mother. Long also painted angels, chicken fights ("I tell people they're just kissing"), children jumping rope and flying kites, women quilting, and men gambling. After visiting New Orleans and New York, he began to paint musicians and Manhattan's skyline. The tenor of his work, however, is defined

less by subject than by his elongated expressive figures. Long's bright palette adds further whimsy to the abstracted portrayals of his recollections. Among the museums that have collected Long's paintings are the High Museum of Art and the Mennello Museum of American Art.

GARY MONROE
Daytona State College

Kristin G. Congdon and Tina Bucavalas, *Just above the Water: Florida Folk Art* (2006); Kathy Kemp, *Revelations: Alabama's Visionary Folk Artists* (1994); Gary Monroe and Mallory M. O'Connor, *Extraordinary Interpretations: Florida's Self-Taught Artists* (2003).

Lucas, Charlie
(b. 1951)
Born in Birmingham, Ala., in 1951, Charlie Lucas grew up in a family of exceptional craftsmen and women. His grandmother and mother were both noted for their quilt making, needlepoint, and ceramic work, and his great-grandfather and grandfather were both blacksmiths. Although Lucas initially seemed to follow in his father's footsteps, working as a mechanic as an adolescent, his mature oeuvre is evidence that he has inherited the scope of his family's talent.

As a child, Lucas used his great-grandfather's welding equipment to create metal objects. Lucas did not take up art making, however, until after he had traveled and lived on his own. Lucas left home at age 14 to work as a truck driver and construction worker and by 1968 was living in Florida, where he tried his hand at breeding shrimp.

His childhood sweetheart, Annie, joined him there. The couple returned to Alabama and in 1975 settled on property in Pink Lily, near Prattville. The couple later divorced, and although Charlie Lucas lives in Selma, he maintains a studio on the property in Pink Lily, where Annie, also a folk artist, still lives.

With the make-do attitude that would come to define his sculptural oeuvre, Lucas built his house entirely from scrap metal and cast-off materials. Lucas worked as a hospital maintenance worker until he was laid off and in 1984 sustained a devastating back injury while clearing his land. During his convalescence, Lucas began to make wire sculptures. He experienced a profound spiritual transformation at this time, during which he decided to dedicate himself to his artwork. Lucas understands his artistic talent to be a gift from God.

After his recovery, Lucas began to make large, spot-welded sculptures on his property. Using scrap metal, favoring the relatively flexible metal bands typically used to pack lumber, Lucas became known as the "Tin Man." As his nickname suggests, Lucas also uses scrap roofing tin as well as a wide range of found objects and materials discovered in local roadside ditches and dumps or brought to him by friends. A walk through his yard is a fantastic tour of a landscape populated by larger-than-life horses, dinosaurs, birds, human figures, and even an airplane. Lucas also makes small figures out of wire and paints abstracted whimsical scenes of people and animals.

The scholar Babatunde Lawal sees

Lucas's metal weaving as a novel reinvention of the African diasporic tradition of braiding, an activity that activates a symbolic connection to ancestors. Lucas has indeed noted that his weaving links him to his talented family elders. More often, however, he refers to his artwork as "toys" and asserts that art making is a form of play. Also significant is the artist's identification with his process of recycling—giving a new life and value to materials that have been cast off or deemed worthless. This multifaceted understanding of his work allows Lucas to create richly allegorical and formally dynamic art that resonates powerfully with the creations of his mainstream contemporaries. Lucas's work is included in, among others, the collections of the High Museum of Art, the Birmingham Museum of Art, and the Montgomery Museum of Fine Art.

JENIFER BORUM
New York, New York

Paul Arnett and William Arnett, eds., *Souls Grown Deep: African American Vernacular Art of the South*, vol. 1 (2000); William Arnett and Paul Arnett, eds., *Souls Grown Deep: African American Vernacular Art*, vol. 2 (2001); Carol Crown, ed., *Coming Home: Self-Taught Artists, the Bible, and the American South* (2004); Kinshasha Conwill and Arthur C. Danto, *Testimony: Vernacular Art of the African-American South* (2001); Kathy Kemp, *Revelations: Alabama's Visionary Folk Artists* (1994); Charlie Lucas and Ben Windham, *Tin Man* (2009); Tom Patterson, *Ashe: Improvisation and Recycling in African-American Visionary Art* (1993).

Marling, Jacob
(ca. 1773–1833)

For 40 years Jacob Marling worked primarily in Virginia and North Carolina painting genre and historical works, portraits, miniatures, landscapes, and still lifes; he also worked as an art teacher and museum director. In addition to his portrait of North Carolina governor Montfort Stokes (ca. 1830), Marling is best known today for an important federal period painting now in the Chrysler Museum entitled the *Crowning of Flora* (ca. 1816) and a scene of the first North Carolina State House (ca. 1820). A still-life composition of a bowl of cherries is the only known work of art signed "Marling."

Marling claimed to have studied in Philadelphia, with drawing master James Cox for seven years from 1788 to 1795. He spent a brief time in New York City in 1795, before relocating to Virginia, where he advertised his services as a drawing and painting instructor in Fredericksburg, Richmond, and Petersburg. By 1805 the artist was living in Southampton County, Va., where he married Louisa Simmons, who also subsequently taught art to young ladies. During this period Marling painted quarter- to full-length portraits of local residents, executed historical scenes after engravings by John Trumbull depicting the battle of Bunker Hill and the death of General Montgomery at Quebec, and probably decorated at least one Masonic apron.

In about 1812 Marling and his wife moved to Raleigh, N.C., where, except for a brief sojourn to Charleston, S.C., in 1819, the artist remained until

his death in 1833. Chartered in 1792, Raleigh was the state's recently established capital and a thriving southern city when Marling moved to the region to teach art and become director of the newly founded North Carolina Museum. For the daily admission price of 25 cents, or $5 for the year, visitors, according to Marling's 1818 entrepreneurial advertisement for this burgeoning institution, frequented an "agreeable and useful place of resort" that maintained a reading room containing newspapers, maps, and curiosities, as well as drawings and paintings, including some by the artist. During this period, Mrs. Marling taught drawing and painting at the Raleigh Academy, where her husband occasionally assisted. It was at this time that Jacob Marling executed the scene entitled the *Crowning of Flora*, depicting young female students and faculty from the Raleigh Academy, all gathered outdoors at Burke's Square to crown the queen of their May Day celebration. Mrs. Marling, and possibly the artist himself, are included in this composition.

By 1825 Marling was renting rooms from John Goneke, who maintained an establishment comprising a concert hall, theater, musical-instrument shop, reading room, dancing school, and liquor shop, in addition to letting rooms for the North Carolina legislature. In this location, Marling advertised that he painted portraits and miniatures, hoping for the business of government officials. Marling stated that if they called early upon him, he would complete their likenesses by the close of session. Marling's works are in the collections of the Chrysler Museum of Art and the North Carolina Museum of Art.

CHARLOTTE EMANS MOORE
Wilmington, North Carolina

Davida Deutsch, *The Luminary, Newsletter of the Museum of Early Southern Decorative Arts, Winston-Salem, N.C.* (Summer 1988); J. Christian Kolbe and Lyndon H. Hart III, *Journal of Early Southern Decorative Arts* (Summer 1996).

Martin, Eddie Owens (St. EOM)
(1908–1986)
Born to poor sharecroppers in southwest Georgia, Eddie Owens Martin was forced as a child to work in the fields, rewarded only with savage beatings by an abusive father. Finding solace with the African Americans with whom he worked, the boy adopted their speech patterns, more relaxed bearing, and predilection for bright colors. Less "uptight," he remembered, they could "laugh and talk." A precocious sexuality also relieved his bitter existence. Vaunting that he was "born ready to go," Martin claimed to have been seduced at three by Tessie, "a hot little baby." Leaving home at 14, he hitchhiked to New York City, his peregrinations financed by homosexual encounters. In 1945, Martin happened upon fortune telling, a profession that earned him enough money to paint.

His art was inseparable from his mystical proclivities, and Martin credited his creativity in part to marijuana, which, he said, broke down "all my inhibitions." A second pivotal influence was a vision experienced during a life-threatening illness in 1935. He recalled

leaving his body and seeing "this big character sittin' there like some kinda god, with arms big around as watermelons." Following the spirit's admonitions, Martin regained his health and began to "reach for the occult" and "man's lost rituals," frequenting New York's libraries and museums in his search.

Martin returned to Georgia in the 1950s and began building *Pasaquan*, the architectural complex for which he is best known. He began by ornamenting the two-room frame house located on the four acres that he inherited from his mother. Though denying an "overall plan," Martin nonetheless revealed an idiosyncratic and sophisticated sense of architectonics, accommodating structure and decoration to purpose. He added rooms to the front and back of the original dwelling, integrating the buildings with the grounds and defining areas for specific "ritual" functions.

Martin assumed the acronym St. EOM (pronounced like the Hindu "Om") and was given the name Pasaquan by spirit guides. He claimed later to have learned that *pasa* in Spanish means "pass" and *quoyan* in an Asian language refers to a bridging of the past and the future. He therefore saw his efforts as interpreting the knowledge of the past for subsequent generations. In addition to his directives from spirits, Martin drew upon his extensive readings about other cultures, both present and historical: Africa, Easter Island, Pre-Columbian Mexico, and Guatemala, together with the legendary continents, Mu and Atlantis.

Having crafted an ambience where he could commune with his spirits, Martin danced on his circular sand pit, chanted endlessly into a tape recorder, told fortunes for the desperate and the curious, at the same time that he continued to build. "Here I can be in my own world with my temples and designs and the spirit of God," he said. In the 1980s, however, repeated illnesses plunged him into depression. He committed suicide in 1986 with a single bullet to his temple. Martin is buried in the town's Baptist cemetery. He had had the granite slab inscribed beforehand with his birthday, his acronym St. EOM, and the name of his compound: Pa-sa-quan. He scribbled a final note: "No one is to blame but me and my past." With the support of The Pasaquan Preservation Society, Eddie Owens Martin's *Pasaquan* was recognized in 2008 by the National Register of Historic Places for its architectural and historical significance. The active community group sponsors events open to the public. The Marion County Society, to which Martin had willed his work, donated some pieces to the Smithsonian American Art Museum, the American Folk Art Museum, and the Los Angeles County Museum of Art. The Albany Museum of Art and the High Museum of Art also have works in their permanent collections.

DOROTHY M. JOINER
LaGrange College

Carol Crown and Charles Russell, eds., *Sacred and Profane: Voice and Vision in Southern Self-Taught Art* (2007); Dorothy M. Joiner, *Southern Quarterly* (Fall–Winter 2000–2001); Tom Patterson, *St. EOM in the Land of Pasaquan: The*

Life and Times and Art of Eddie Owens Martin (1987).

Mayfield, Helen Burkhart

(1939–1997)

Helen Kay Burkhart was born 11 March 1939, in Houston, Tex., the first of six children. When Helen was in junior high school, her family relocated to a ranch near the town of Blanco, in the Texas hill country. Helen was a creative and independent child and was especially drawn to dance and performance.

Following high school, Helen entered Southwest Texas State Teachers College (now Texas State University) in San Marcos, where she studied drama and dance. But her college career ended because of "continual intense disagreements" with her instructors. In 1958, while attending college, Helen became romantically involved with fellow student, Martin Mayfield, and the two were married in 1961. They relocated to Greenwich Village in New York City, and Helen occupied herself with drawing, painting, collage, interpretive dance, and street performance.

After a year and a half in New York, Helen and Martin returned to Texas, settling in Austin in early 1964. Helen volunteered as an arts-and-crafts counselor at the Austin State Hospital, where she befriended patient Eddie Arning and played an influential role in his art career, encouraging him, providing him with supplies, and arranging the first public showing of his work. Arning went on to become one of Texas's most recognized self-taught artists.

In 1970 the Mayfields moved to 20 acres of land outside Austin, where Martin grew marijuana and began to build a house. Helen, who found the isolation of the farm unbearable, began to suffer from severe phobias and extreme mood swings that were exacerbated by drinking binges. She returned to Austin and eventually divorced Martin. Helen's behavior became increasingly erratic, and in fall 1985 she was evicted from her last permanent address.

During the next decade, the now homeless Mayfield was arrested more than a hundred times on various misdemeanor charges and had several stays in the Austin State Hospital. She enlisted friends to store her artwork and became a well-known fixture in the university area, recognized by colorful costumes that included hats made from discarded Styrofoam cups, twigs, paper plates, and whatever other cast-off materials attracted her, and by bizarre behavior that included casting spells on cars in rush-hour traffic with wands of her own making.

Helen Mayfield was arrested for the last time in November 1997 for swinging a fence post at a woman. Twenty-three days later, on 11 December 1997, the 58-year-old Mayfield was found unresponsive in her jail cell and was pronounced dead at an Austin hospital less than an hour later.

Mayfield's artwork, including approximately 300 drawings and a handful of collages, stitched pieces, and masks, resurfaced after her tragic death. Her powerful and disturbing drawings in particular reveal a turbulent psychological landscape and express the artist's growing sense of personal isolation

and alienation. Haunting self-portraits expose her sadness and inner torment, while other drawings depict terrifying hallucinations, threatening storms, and bizarre creatures and document Mayfield's intense personal struggle with internal demons. Trembling lines capture a sense of anxiety; some of the drawings are characterized by a claustrophobic *horror vacui*. Her powerful body of work gave physical form to the creative force that governed her life and illuminated the dark, inner recesses of her imagination.

LYNNE ADELE
Austin, Texas

Lynne Adele, *Art Lies* (Spring 2001).

McKillop, Edgar Alexander

(1879–1950)

Edgar A. McKillop was born in rural Henderson County, N.C., on 8 June 1879, one of four sons of Henry and Lena Allen McKillop. McKillop remained on the family farm and worked odd jobs in agriculture, lumber, blacksmithing, and coopering until his marriage to Lula Moore at age 27. The couple had two daughters and moved often, following jobs in the local mountain communities. In 1926 Edgar found work at the cotton mill in Balfour, N.C., and soon became known in the community as a capable machinist, carpenter, repairman, and jack-of-all-trades. Although he worked only briefly at the cotton mill, while there he patented a bobbin-cleaning device he called a "quill-skinner."

Soon after he left the mill job, a neighbor offered McKillop the wood from several large black walnut trees in exchange for cutting them down and removing them from his property. Thus began a decade of concentrated wood-carving activity. Soon, he was working at home in his yard, night and day, making all of his own tools (mallet, chisel, and knife) and learning how to coax the chunks of walnut into expressive, lifelike sculptures.

The majority of McKillop's carvings are animals, including eagles, a gorilla, a kangaroo, an owl, a lion, a bear, a cougar, frogs, squirrels, and a seven-headed, 10-horned dragon inspired by the New Testament book of Revelation. He also carved at least five human figures, ranging in size from two to four feet high. His subjects came from the natural world, dreams, the Bible, his patriotic feelings, and popular illustrated periodicals. Black walnut was his preferred wood, and he incorporated found materials such as bone, horn, teeth, and claws into his carvings. To attain small detailed flourishes, he often employed a wood-burning tool.

One intricate, ambitious work circa 1928–29 is *Man Holding an Eagle* (52 x 13 x 18 inches),now in the Collection of the Henry Ford Museum and Greenfield Village. It shows an alert, seated man, who, with frogs flanking his boots, grasps a post with both his knees and hands. On top of the post is perched a large, stately eagle with its wings outspread. It is undetermined whether the man is actively struggling to hold the post upright or is holding on for dear life as the eagle takes flight. Another of his best-known carvings is in the collection of the Abby Aldrich Rockefeller

Museum at Colonial Williamsburg. McKillop titled this piece the *Hippocerus*, a cross between a hippopotamus and a rhinoceros. The sculpture, which is almost five-feet long, is carved of black walnut wood and also features leather, glass, bone, horn, iron, copper, and a phonograph. A Victrola mechanism placed in the creature's belly plays a recording as the leather tongue moves back and forth, saying "E. A. McKillop, a born carving man."

McKillop was a bit of a showman. He took great pride in his work and liked to share his creations with his neighbors and visitors. He outfitted an old pickup truck with shelves and curtains and took his sculptures on the road and also set them up in a tent along the main highway in Balfour. It is possible that he regarded his carvings as a cohesive collection, a type of "environment." Just before the death of his wife in 1938, McKillop traded, sold, and dispersed most of his sculptures and stopped carving. He bought a small farm, where he spent his remaining years. Many of his works are now lost.

His surviving works are in important collections such as the Abby Aldrich Rockefeller Museum, Milwaukee Art Museum, Ackland Art Museum, Henry Ford Museum and Greenfield Village, and the Philadelphia Museum of Art. His works bear a bold signature or inscription, usually in carved or burnt letters: "MADE BY /E. A. MCKILLOP / BALFOUR — N. C. / HAND-CARVED."

JENINE CULLIGAN
Huntington Museum of Art

Pat H. Johnson, *Antiques Journal* (November 1978); Elsa Longhauser and Harald Szeemann, eds., *Self-Taught Artists of the 20th Century: An American Anthology* (1998).

McKissack, Jefferson Davis

(1902–1980)

Jeff McKissack, a postman in Houston, Tex., created the *Orange Show* as a monument to the orange, which he considered to be the perfect food, and to illustrate his belief that longevity results from hard work and good nutrition. Working alone from 1956 until his death in 1980, McKissack used common building materials and found objects—bricks, tiles, fencing, and farm implements—to transform a lot in the east end of Houston into an architectural maze of walkways, balconies, arenas, and exhibits decorated with colored mosaics and brightly painted iron figures. When he was finished he had built a two-level structure of over 6,000 square feet. He expected 300,000 people to come and visit his tribute to the orange and declared it to be "the most beautiful show on earth, the most colorful show on earth, the most unique show on earth." He also claimed that "everyone is interested in the orange from the cradle to the grave. But if it had not been for me, Jeff McKissack, the orange industry and the American people would probably have gone another two hundred years without an Orange Show."

The *Orange Show* opened to the public in May 1979. After the waning of initial interest, McKissack became saddened by the lack of attendance. After

McKissack's death in 1980, Marilyn Oshman and a group of Houston art patrons purchased the *Orange Show*. Today, not only does the Orange Show Center for Visionary Art preserve the monument, it also offers many community programs including lectures, workshops, musical and art performances, and films. In 2001 the Orange Show Center took over John Milkovisch's *Beer Can House*. The Center also sponsors Houston's Art Car Parade. The *Orange Show* draws thousands of visitors each year, just as McKissack had envisioned.

STEPHANIE SMITHER
Houston, Texas

Roger Manley and Mark Sloan, *Self-Made Worlds: Visionary Environments* (1997); Chuck Rosenak and Jan Rosenak, *Contemporary American Folk Art: A Collector's Guide* (1996); Betty-Carol Sellen with Cynthia J. Johanson, *Twentieth-Century American Folk, Self-Taught, and Outsider Art* (1993).

McNellis, Laura Craig

(b. 1957)
Birthday cakes, ice cream cones, lollipops, and personal items such as clothing, sunglasses, and hot-water bottles fill the multicolored compositions of Laura Craig McNellis. Her paintings might be mistaken at first for a child's presentation of her favorite things, but a closer study reveals an analytical consciousness at work. Indeed, for McNellis, art may be a way of reporting on her life. Classified as severely mentally retarded at an early age and often frustrated by her inability to communicate, McNellis was not diagnosed

with autism until her adulthood when researchers had refined understanding of the condition. Travis Thompson, the former director of Vanderbilt University's Kennedy Center for Research on Human Development, who organized a 1997 exhibition of McNellis's work, believes that for some on the autism spectrum, art serves as a substitute for words. Author Temple Grandin, who calls herself a "recovered autistic," says that she herself "thinks in pictures" and believes that a large number of people with autism are visual thinkers.

McNellis observes and describes her surroundings in a running monologue of tempera paint on paper. Small objects might take on a large scale or float in rows across the paper's surface. Many objects jostle for space, filling large sheets of paper with their bold black outlines. No matter what captures McNellis's fancy—from a pair of red pajamas to the contents of the medicine cabinet—she first draws it completely with a pen or pencil and then paints over it with water-based paint. During the painting process, she nearly always places a sun with rays projecting in the upper right corner; then, working from right to left, she adds an irregular line of capital letters along the bottom edge. The presence of letters may signify recognition of the importance of the words that lie beyond her grasp. It may also indicate that McNellis wants her work to be a means of communication. Although she writes from right to left, she only rarely draws a letter backwards. She sometimes copies words put before her, such as her own name or a

list, but she still draws them like the objects in the paintings, with no spaces in between.

McNellis often uses the experience of coming in and going out in her work. She depicts staircase banister posts as tall as the whole row of steps—an unusual receding perspective but a real point of view for someone looking up a flight of stairs. In another stairway image, an oblong hole on the left indicates the stairwell. The huge rectangular object next to it turns out to be a light switch—critical for going up and down stairs at night.

McNellis is also careful to provide the visual information necessary to show how an object is used. She shows both front and back of a garment, for example, or a hot-water bottle with its stopper next to it, or an electric fan complete with cord. A cutout image of two gray circles depicts an open tin can seen from above. The hole in the center of one shows it is empty; the circles of the other are the ridges of the still-attached lid.

The Ricco-Maresca Gallery introduced McNellis's work at New York's Outsider Art Fair in 1993; Frank Maresca and Roger Ricco's book *American Self-Taught* (1993) introduced the work to a larger audience. A career survey of 100 pieces, organized by Vanderbilt University's Kennedy Center for Research on Human Development and the Ricco-Maresca Gallery, was presented by the Nashville Public Library in 2003 and by Chicago's Intuit Gallery in 2004. McNellis has worked at Studio XI, a Morganton, N.C., studio for creative adults with developmental disabilities. McNellis's work is in the collection of Intuit: The Center for Intuitive and Outsider Art and in the Collection de L'Art Brut.

SUSAN W. KNOWLES
Nashville, Tennessee

Joseph Jacobs, Vajra Kilgour, and Rena Zurofsky, *A World of Their Own* (1995); Frank Maresca and Roger Ricco, *American Self-Taught: Paintings and Drawings by Outsider Artists* (1993); Laura Craig McNellis, *Laura Craig McNellis: Internal Conversations* (2001); Colin Rhodes, *Outsider Art: Spontaneous Alternatives* (2000).

Meaders, Quillian Lanier
(1917–1998)

Quillian Lanier Meaders of Cleveland, White County, Ga., played a major role in the 20th-century domestic ceramics industry of the rural South. Loosely organized in cottage-industry fashion, southern potters settled near their clay sources, combining craftwork with farming. Potters generally transferred skills informally through the male line, resulting in the formation of potter dynasties spanning several generations. The Meaders family began making pottery during the winter months of late 1892 and early 1893. Lanier's grandfather, John Milton Meaders (1850–1942), who had freighted ceramic ware, along with farm produce, for several artisans in clay-rich White County, evidently saw financial benefit in the work. He therefore directed his six sons—Wiley, Caulder, Cleater, Casey, Lewis Quillian, and Cheever—to build a ware shop and kiln on the family prop-

erty where, with assistance from their neighbors, they began manufacturing stoneware preserve jars, dairy crocks, and sorghum syrup or whiskey jugs. A distinctive feature of the local product, one confined in the main to ware made in Georgia and contiguous parts of the Carolinas and Alabama, was the application of lime and wood-ash (alkaline) glazes. The family's "face jugs"—sometimes grotesque—are striking examples of how a potter can give a simple jug an arresting human face.

Though demand for ceramic vessels subsided after 1910, as glass and metal containers penetrated local farm kitchens, the Meaders family sustained a limited market for its ware. Their persistence in this regard was first noted in Allen H. Eaton's seminal *Handicrafts of the Southern Highlands* (1937). For three more decades, Cheever Meaders, the youngest of the original Meaders potters, derived a marginal livelihood from the production of alkaline-glazed stoneware, which he sold to local customers and to a new audience of tourists.

Lanier, Cheever's son, continued to manufacture the same traditional ware, employing a similar repertoire of tools and techniques as his forebears. His preservation efforts won for him not only a devoted following of folk art collectors and crafts enthusiasts, but encouraged a brother, Edwin, and a cousin, Cleater Jr., to resume the work as well. In recognition of such efforts and the assistance he has provided folklife researchers in their attempts to reconstruct the history of southern industry, the National Endowment for the Arts awarded Lanier Meaders a

National Heritage Fellowship in 1983. Meaders's work can be found in many museums, including the Brooklyn Museum, the American Folk Art Museum, the Folk Pottery Museum of Northeast Georgia, the Atlanta History Center, and the Smithsonian American Art Museum.

ROBERT SAYERS
California Academy of Sciences

John A. Burrison, *Brothers in Clay: The Story of Georgia Folk Pottery* (1983), *From Mud to Jug: The Folk Potters and Pottery of Northeast Georgia* (2010); Ralph Rinzler and Robert Sayers, *The Meaders Family: North Georgia Potters* (1980); Nancy Sweezy, *Raised in Clay: The Southern Pottery Tradition* (1984).

Meaders Family

John Milton Meaders founded the Meaders family folk-pottery operation in the Georgia foothills pottery center of Mossy Creek, White County, in 1892–93. He worked alongside his sons Wiley, Caulder, Cleater, Casey, Lewis Quillian, and Cheever and also hired two members of established local "clay clans," Marion Davidson and Williams Dorsey, to work in the new log shop and teach his older boys. Cheever, the youngest, who learned from his brothers, took over the shop in 1920. With declining demand for food-related farm wares, crafts enthusiasts became Cheever's main customers, as indicated by the inclusion of Meaders family pottery in Allen H. Eaton's seminal *Handicrafts of the Southern Highlands*. In the 1960s Cleeter's wife, Arie, began to work in the pottery, producing a line of ingenious and colorful decorative wares,

including wheel-thrown birds and animals. Cleeter and Arie's sons—John, Lanier, Reggie, and Edwin—all learned the craft.

When Cheever Meaders became too ill in 1967 to participate in the making of a 1967 Smithsonian Institution film, Lanier, who had not been active in the family business, stood in for his father. When Cheever died soon thereafter, Lanier took over the workshop. Combining his father's stubborn adherence to the old ways and his mother's artistic vision, Lanier (1917–98) revitalized the tradition of face jugs, on which his fame was largely based, and was awarded a National Heritage Fellowship by the National Endowment for the Arts in 1983. In carrying on and refining the craft of alkaline-glazed stoneware, he was a crucial link between the past and future of southern folk pottery, and his success encouraged others, including members of the family, to keep that tradition alive today. Among the museums with Meaders family pottery are the Atlanta History Center, the Folk Pottery Museum of Northeast Georgia, the Smithsonian American Art Museum, the Arizona State University Art Museum, the Brooklyn Museum, and the American Folk Art Museum.

JOHN A. BURRISON
Georgia State University

John A. Burrison, *Brothers in Clay: The Story of Georgia Folk Pottery* (1983), *From Mud to Jug: The Folk Potters and Pottery of Northeast Georgia* (2010); Ralph Rinzler and Robert Sayers, *The Meaders Family: North Georgia Potters* (1980).

Merritt, Clyde Eugene (Gene)
(b. 1936)

Clyde Eugene Merritt was born 30 November 1936, in Columbia, S.C., to working-class parents. As an infant he suffered brain damage because of an extended fever. When Merritt was 12 years old, his mother committed suicide in the family's kitchen.

After his mother's death, young Merritt and his father moved to Fort Mill, S.C. Upon his father's death in 1972, Merritt was placed under the care of the Department of Social Services. He has lived in a series of difficult adult foster care environments in Rock Hill, S.C., but currently lives in an assisted-living complex where he makes his art.

It is not clear why Merritt began to draw. For most of his adult life, he had been a musician, playing the guitar in small local bands. However, in 1993, he pawned his guitar and turned to art making. Merritt made his earliest drawings either in his temporary trailer home or at Watkins Grill in downtown Rock Hill. Merritt attempted to sell his work on the street and at Watkins Grill, where he was able to store drawing tablets and supplies. For many years, Merritt's table at Watkins was his impromptu studio. Merritt drew his first works, which he called "cartoons," with ballpoint pen on napkins, lined writing paper, or the occasional piece of drawing paper. Like most of his later work, these early efforts were often head profiles of popular culture celebrities. In these finely delineated drawings, Merritt constructs facial features as though they are pieces in a puzzle. The drawings often possess a cubistlike perspective.

Merritt makes most of his work from memory or, as he says, "from my head." Merritt's drawings are inspired in part by the movies he saw as a young man working as a custodian in a movie theater and from hours of television watching. Travel, fashion, and celebrity magazines also provide source material for his work. However, the visual complexity of his adaptations of source material cannot be underestimated. The artist's ability to recall details from the past plays a consistent role in his work, as does his ability to abstract and transform magazine images. Merritt's contourlike drawings both reflect and amplify specific facial qualities and full-figure gestures. He further transforms images in fashion publications by adorning his drawings of models with colored pencil to represent eyeliner and fingernail polish.

In his mature work, Merritt identifies each drawn profile with distinct labeling that includes the date the work was completed. What he calls his autograph, [-"Gene,'s - Art,'s - Inc,'s,"-], typically appears underlined and bracketed at the bottom of the drawing. In later drawings his autograph has evolved to [-"Gene,'s – Art,'s – Muzieam's – Inc,'s"-]. He refers to his drawings as "paperwork," partly because they have served as both products and business cards.

Gene Merritt's work is in the collections of Winthrop University Galleries, the Museum of York County, the South Carolina State Museum, the Collection de l'Art Brut, L'Aracine, the Outsider Collection and Archives, and abcd.

TOM STANLEY
Winthrop University

Mario Del Curto, *The Outlanders: Forcing Ahead with Art Brut* (April 2000); Bruno Decharme, dir., *Art Brut: Portrait* (film, 2005); Tom Stanley, *Raw Vision* (Fall 1999).

Meucci, Antonio and Nina

(Antonio, active 1818–1847/52; Nina, active 1818–ca. 1834)

Despite their extended itinerancy, the historical record is surprisingly detailed regarding Antonio and Nina Meucci, a husband-and-wife team of miniaturists and portrait painters. Although many miniaturists learned their trade as apprentices to craftsmen, Antonio claimed to have been a member of several academies in his native Italy. Newspaper advertisements state that his Spanish wife, Nina, learned to paint from her husband. The couple's surviving miniatures are charming though unremarkable portraits stylistically indistinguishable from the work of their contemporaries. The Meuccis first appeared in New Orleans in 1818, having arrived from Rome. The earliest advertisement states that each paints portraits and miniatures "of every dimension" and that they operated an "academy for young ladies & gentleman, at [their] dwelling in Bourbon St., in the house belonging to Mr. Honoré Landreaux, near the Orleans Theatre, No. 92." Because of the proximity, it is tempting to speculate that Antonio also may have worked as a set designer.

From 1821 to 1822, the Meuccis lived in Charleston, where the couple offered to teach young ladies and gentlemen to paint landscapes, portraits, and miniatures in 15 weeks at their private drawing academy. Antonio also adver-

tised his ability to "repair any miniatures damaged by weather, etc." and exhibited a panoramic canvas entitled *The Death of Hias* (1822). Thus began the Meuccis' careers as itinerant miniaturists, landscape painters, portraitists, restorers, and drawing instructors. In 1823 they appear in New York City but move to Salem in 1825, returning to New York in 1826. Family records indicate that they also worked in Richmond and Portland, Me.

The Meuccis reappeared in New Orleans in 1826, after a seven-year hiatus, announcing that they have "a great variety of specimens in miniature and other style" that were to be exhibited at Hewlett's Exchange Coffee House and Davis's Coffee House at the Orleans Theatre. The Meuccis also offered to repair "all likenesses painted by themselves, which may be injured by the weather, damp or otherwise."

Antonio is listed in the city directory as a scenery painter for the Théâtre de Orleans. A review of Antonio's "full scenery & entirely new decorations" in February 1827, including a "Scottish view," was praised in the press as presenting "the most agreeable perspective." During the couple's last visit to New Orleans, Antonio Meucci gave painting lessons to Julien Hudson, a free man of color.

Records suggest that the Meuccis traveled to Havana, Cuba, and Kingston, Jamaica. By 1830 they were in Cartegena, Colombia, though they may have visited Bogotá as early as 1828. It seems likely that their daughter, Sabina Meucci (ca. 1805–84), and her husband, Richard Souter, a diplomat or merchant in

Colombia, encouraged the move. However, it is unclear if Nina accompanied her husband or continued working after this. She is not mentioned in subsequent advertisements. In Cartegena, Antonio painted a portrait of Simón Bolivar and made at least a dozen copies.

Antonio was in Rionegro in 1831, possibly in Medellín, and in Popayán in 1832. He advertised his skills as a miniaturist and portrait painter in Lima, Peru, on 27 February 1834. Except for occasional trips to Ecuador, Meucci seems to have spent his remaining years in Peru. No evidence of his artistic activity after 1837 has surfaced. According to family records compiled by Jorge Bianchi Souter, Antonio Meucci died in Lima or Guayaquil between 1847 and 1852. Art works by the Meucci can be found in the New York Historical Society, the Historic New Orleans Collection, and the Louisiana State Museum.

RICHARD A. LEWIS
Louisiana State Museum,
New Orleans

Beatriz González, *Catálogo de Miniaturas,* Museo Nacional de Colombia (1993); John Burton Harter and Mary Louise Tucker, *The Louisiana Portrait Gallery: The Louisiana State Museum,* vol. 1, *To 1870* (1979); Historic New Orleans Collection, *Encyclopedia of New Orleans Artists* (1987); Louisiana State Museum, *250 Years of Life in New Orleans: The Rosemonde E. and Emile Kuntz Collection and the Felix H. Kuntz Collection* (1968); Carmen Ortega Ricaurte, *Diccionario de artistas en Columbia* (1965); Anna Wells Rutledge, *Artists in the Life of Charleston* (1949).

Milestone, Mark Casey
(b. 1958)

As a child, Mark Casey Milestone did yardwork for his grandfather in exchange for a nickel to purchase candy at a nearby country store. He says, "I remember walking across the bridge with my little bag of candy and how totally happy I was. I've always wanted my work to hold that same total happiness for me and hopefully for other people." At the age of six, Milestone realized his purpose to create art, and he often reflects on this moment when he begins a new work. Born in Jacksonville, Fla., on 28 January 1958, Milestone began drawing while in elementary school, copying the masters from one of his sister's library books on Italian Renaissance art. At 12, he amused himself and his sisters by creating sculptures of robots. Nonetheless, Milestone's family did not support his art, and Milestone dropped out of school in the 10th grade to earn the money to sustain his art making. He worked a slew of jobs, including busboy, line cook, and automobile airbrush artist. He even wore a bull costume to attract customers to a parking lot. In 1982 he took a job at a printing company, where he worked as a prepress graphics specialist for many years.

Early in his career Milestone was known primarily for his whirligigs and robots, but at present he focuses on painting, working in both watercolor and oil. His watercolors are typically 10 x 12 inches and his oil paintings range from 24 x 32 inches to 5 x 6 feet. His watercolors are "poetic, lyrical, and whimsical," whereas his oils tend to be more naturalistic. The subjects of his works are usually female figures, often shown with wings. Milestone also incorporates otherworldly creatures that appear to be hybrids of animal and human forms. His work displays the strong influence of symbolists such as Redon and Rousseau. Indeed, Milestone's work includes hallmarks of symbolism: emotion, spirituality, and imagination. The artist draws inspiration both from dreams and from emotions evoked by everyday events. His palette of cool colors and earth tones adds to the moodiness of his work. He often represents himself as a cat and uses the female form to convey mysticism. Milestone begins an open-ended story with each work, leaving the viewer to draw conclusions. The artwork is completed when the painting is sent "into the world and finds a home."

Milestone has been exhibited in *Holy H2O* at the American Visionary Art Museum. He currently resides in Winston-Salem with his wife, Paula, and son, Casey.

MELISSA CROWN
University of Memphis

For more information about Milestone, go to www.markcaseymilestone.com.

Milkovisch, John
(1912–1988)

The *Beer Can House*, 222 Malone St., Houston, Tex., is one of the great examples of folk art environments in the United States. John Milkovisch began to create his environment in 1968, when he started covering his yard, patio, and driveway with concrete embedded with

marbles. He said that he was "sick of cutting the grass." When Milkovisch retired from Southern Pacific Railroad as an upholsterer in 1976, he began to work on his project in earnest. Milkovisch had always enjoyed drinking beer with his friends while he worked on his yard, and he had been saving beer cans for 17 years. Over the next 18 years the artist's suburban house disappeared under aluminum siding of his own design—flattened beer cans. It has been estimated that Milkovisch used more than 50,000 beer cans in this monument to recycling. Sometimes Milkovisch enhanced his allover design by choosing beer cans for their color. Most frequently, however, he used "whatever was on sale." Milkovisch exploited all of the aesthetic possibilities of beer cans; garlands and curtains made of beer can tops and pull tabs hanging from the roof edges make the house sing in the wind.

While Milkovisch considered his work an enjoyable pastime, he took special pleasure in people's reactions to his house. He once said, "It tickles me to watch people screech to a halt. They get embarrassed. Sometimes they drive around the block a couple of times. Later they come back with a carload of friends." Although he did not consider himself an artist, he was aware that he had created something unusual when he stated, "They say every man should always leave something to be remembered by. At least I accomplished that goal."

In 2001, the Orange Show Center for Visionary Art purchased the *Beer Can House* from the Milkovisch family. This group is preserving the house according to the artist's plan.

STEPHANIE SMITHER
Houston, Texas

John Beardsley, *Gardens of Revelation: Environments by Visionary Artists* (1995); Roger Manley and Mark Sloan, *Self-Made Worlds: Visionary Environments* (1997); Leslie Umberger, *Sublime Spaces and Visionary Worlds: Built Environments of Vernacular Artists* (2007); Deidi Von Schaewen and John Maizels, *Fantasy Worlds* (1999).

Miller, Reuben Aaron (R. A.)
(1912–2006)
Reuben Aaron "R. A." Miller, a former minister and resident of the Rabbittown community near Gainesville, Ga., is best remembered for his hilltop installation of figurative whirligigs and his animated cutouts and paintings.

A minister of the Free Will Baptist Church and former cotton mill worker, Miller began making art late in life after glaucoma curtailed his vision. His earliest whirligigs included mechanical figures, but he soon arrived at his signature style of flat cutout figures in gestural poses. The cutouts, made from roofing or gutter tin, were often attached to scrap wood or salvaged furniture parts and finished with tin paddles attached to bicycle wheels to catch the breeze. Miller's whirligigs and cut tin images include church buildings, American flags, and a menagerie of animals from typical barnyard animals—pigs, chickens, and rabbits—to long-necked and carnivorous dinosaurs. His most repeated human and humanlike figures consist of red devils, angels, Uncle Sam, and a character (often

sporting a hat in silhouette) inscribed with the exhortation "Blow Oscar." The latter figure was an encouragement to the artist's cousin to honk while driving by Miller's hilltop environment.

Miller's oeuvre also includes lively, sparely executed paintings on wood or Masonite panels. Like his whirligigs, these works often incorporated seemingly incongruous combinations, such as images of dinosaurs with the blessing "Lord love you" inscribed in the borders.

Folk art enthusiasts in Athens and Atlanta began to visit Miller by the early 1980s. In 1984 Athens rock band R.E.M, working with director James Herbert, filmed the video *Harborcoat* at Miller's hilltop and workshop. As folk art ascended in popularity during the late 1980s, Miller's hilltop was frequently denuded as collectors and dealers bought Miller's inexpensive works in volume.

Later in life, Miller's eyesight worsened to the point that he enlisted others to help paint his cutout figures. Eventually the cutouts once used to adorn his whirligigs made up the bulk of his production. Recognition from the art world came to Miller in the late 1980s. R. A. Miller's work can be found in the Telfair Museums.

HARRY H. DELORME
Telfair Museum of Art

Jerry Cullum, *Raw Vision* (Fall 2001); Georgia Museum of Art, *Lord Love You: Works by R. A. Miller in the Mullis Collection* (2009); Paul Manoguerra, ed., *Amazing Grace: Self-Taught Artists from the Mullis Collection* (2007); Wilfrid Wood, *Raw Vision* (Fall 2006); Alice Rae Yelen, *Passionate Visions of the American South:*

Self-Taught Artists from 1940 to the Present (1993).

Minchell (Isenberg), Peter James
(1889–1982)

Born Peter James Isenberg in Treves (now Trier), Germany, Minchell immigrated to Louisiana to live with his brother in 1906. There he studied at a Catholic seminary and planned to become a priest. Instead, just a few weeks before he was to be ordained, he left the seminary. Eventually he married. Minchell, hoping to become an architect, builder, or engineer, taught himself drafting skills. He also changed his name from Isenberg to Minchell, believing that his German name might hinder his success. The chronology is unclear, but Minchell is said to have left Louisiana, moving to Florida, either in 1911 or after World War II. In Florida he worked for a company that made tile, patio stone, brick, and decorative pottery. Visits to museums inspired Minchell to take up making art sometime during the 1960s. Minchell made most of his paintings after 1960, when he retired. The artist died in 1982.

Minchell's early works draw on his knowledge of mechanical design. As his skills grew, he created drawings of lush vegetation, birds, and reptiles familiar either from his early years living near a Louisiana bayou or from his later years in Florida. Between Minchell's retirement and death, he created three major series of paintings that take as their subjects exotic landscapes, architectural settings, space travel, and the creation of the earth. Minchell said that many of his images, such as those in *Geo-*

logical *Phenomena* (ca. 1972), *Comet X*, and *Planet Perfection* came to him in dreams. Although Minchell grounded his landscapes in the natural world, he distanced them from reality with odd colors—pale yellows, soft greens, and brownish tans—and strange plants and trees with twisted branches hung with Spanish moss. Painted in watercolor, these landscapes evoke a realm of primordial wonder. Equally mysterious are Minchell's religious scenes, ranging in topic from the story of Judith and Holofernes to the fall of Jerusalem in A.D. 70. *He Turned the Water to Blood* pictures Moses and his brother, Aaron, situated within a setting that juxtaposes an exterior view—the Nile—to an architectural interior decorated with Egyptian motifs, including a richly ornamented column. One writer suggests that the image may show the impact of a popular source on Minchell's image making: Cecil B. DeMille's classic film *The Ten Commandments*. Sometimes Minchell added commentary across the lower margin.

At first, Minchell gave away his artworks as presents; later he peddled them at local shopping centers. Lewis Alquist, who exhibited in Chicago and later became chair of the art department at the University of Arizona at Tucson, introduced Minchell's work to Michael and Julie Hall, influential early collectors of contemporary folk art. Robert Bishop, director of the Museum of American Folk Art (now the American Folk Art Museum), also recognized the artist's talent and included his work in *Folk Painters of America*. Minchell's work can be found in the Milwaukee Art Museum and the Smithsonian American Art Museum.

LEE KOGAN
American Folk Art Museum

Robert Bishop, *Folk Painters of America* (1979); Linda Hartigan, *Made with Passion: The Hemphill Folk Art Collection in the National Museum of American Art* (1991); Jay Johnson and William C. Ketchum, *American Folk Art of the Twentieth Century* (1983); Milwaukee Art Museum, *Common Ground / Uncommon Vision: The Michael and Julie Hall Collection of American Folk Art in the Milwaukee Art Museum* (1993).

Minter, Joe Wade, Sr.

(b. 1943)

Joe Minter, a self-taught African American artist, is the creator of *African Village in America*, a quarter-acre, densely packed environment in Birmingham, Ala. Comprised of rough-hewn sculptures, the environment commemorates 400 years of African American history. While one section recalls an ancestral African village before the onslaught of the slave trade and another invokes a slave ship and the horrors of the middle passage, most of the site documents the history of the civil rights movement and contemporary life in America and the world. As a whole, the site expresses at once an epic historic and cultural vision and an intensely personal artistic vision.

Joe Wade Minter Sr., born to Lawrence Dunbar Minter and Rosie McAlpin Minter in 1943 in Birmingham, Ala., was the eighth of 10 children. After graduating from high school and serving in the army from 1965 until 1967, Minter worked for 28 years

in a series of trades, including metal-working, painting, construction, and road building. In 1995 he retired for health reasons. During the 1980s, as Birmingham struggled to develop the Birmingham Civil Rights Institute, Minter became concerned that history would not recognize the contributions of the thousands of ordinary citizens who took part in the battle for human rights—the "foot soldiers" of the movement, as he called them. Thus, in 1989 he began his own testimonial to the civil rights movement by carving trees that would become the core of an envisioned ancestral African village. Concerned about the durability of the work, Minter soon switched to metalwork constructions.

Using found objects, Minter creates individual sculptures and environmental constructions commemorating the middle passage, African American soldiers who have died fighting for America, generations of enslaved and freed black laborers, and such historic moments as the 1965 Selma to Montgomery march over Selma's Edmund Pettus Bridge, Dr. Martin Luther King's 1963 incarceration in Birmingham Jail, the 1963 bombing of Birmingham's 16th Street Baptist Church, the first Iraq War, and the attack on the World Trade Center. Recent works have responded to global concerns such as the 2004 Indian Ocean tsunami. Throughout the yard and often incorporated into the specific sculptures, political and religious messages painted on boards affirm the site's pedagogic and healing functions. Minter proclaims that he has built his environment "to show how we lived and how we live now," to tell "part of

the story that's never been told," and to reconnect people with "the motherland and culture that has been taken away."

African Village in America as an extensive environment serves as a public testimonial to collective history and an act of cross-cultural understanding. For Minter, art is an instrument through which we see, hence understand, how other people see the world we share, however painful or inspiring that vision may be. While exceptionally expansive in size and conception, Minter's environment can also be seen as a manifestation of the broad cultural tradition of southern, African American yard shows—altered landscapes that reveal a complex interaction of personal, aesthetic, and spiritual expression with the cultural, historical conditions out of which they emerge.

CHARLES RUSSELL
Rutgers University at Newark

William Arnett and Paul Arnett, eds., *Souls Grown Deep: African American Vernacular Art*, vol. 2 (2001); Joe Minter, *To You through Me: The Beginning of a Link of a Journey of 400 Years* (2005); Carol Crown, ed., *Coming Home: Self-Taught Artists, the Bible, and the American South* (2004).

Mr. Feuille

(fl. ca. 1834–1841)
The portrait painter Feuille, whose first name is unknown, is said to have been frequently conflated with his brother, Jean-François Feuille, a copperplate engraver who was active in New Orleans at the same time. Scholars have speculated that the Feuille brothers emigrated to the United States from France, although there is no solid evidence

to support this contention. The name
Feuille first appears in the records of the
National Academy of Design in New
York, where one of the two men was
an associate member in 1832. The first
record of Feuille in New Orleans is an
advertisement taken out in the *Bee* on
5 March 1835. The last notice appears in
the *Courier* on 4 April 1841. Although
his name does not appear in directo-
ries, Feuille apparently lived with his
brother at various addresses on Chartres
Street near Canal Street in what is today
the French Quarter. It is also possible
that J. F. Feuille and the artist identified
as "Mr. Feuille" are one and the same
person.

The handful of portraits and minia-
tures signed by or attributed to Feuille
are marked by the tendency, charac-
teristic of plain or folk portraiture, to
reduce volume to a series of flattened
planes. There is a decided emphasis on
the precise delineation of detail and pat-
tern. The representation of fabric sug-
gests a stiff, almost metallic appearance
that readily marks the artist's work. Fig-
ures are set against a dark background
in most portraits. Where suggested,
linear perspective is skewed, and there
is little evidence of atmospheric per-
spective. Nevertheless, Feuille's portraits
are individualized likenesses of specific
individuals executed with a high degree
of competency and charm. Perhaps the
best known of Feuille's portraits is the
likeness of Nicolas Augustin Metoyer,
the patriarch of the prominent Creole of
color community near Nachitoches, La.

RICHARD A. LEWIS
Louisiana State Museum,
New Orleans

John Burton Harter and Mary Louise
Tucker, *The Louisiana Portrait Gallery:*
The Louisiana State Museum, vol. 1, *To*
1870 (1979); Historic New Orleans Collec-
tion, *Encyclopedia of New Orleans Artists,*
1718–1918 (1987); Louisiana State Museum,
250 Years of Life in New Orleans: The Rose-
monde E. and Emile Kuntz Collection and
the Felix H. Kuntz Collection (1968); Martin
Wiesendanger and Margaret Wiesen-
danger, *19th-Century Louisiana Painters*
and Paintings from the Collection of W. E.
Groves (1971).

Mohamed, Ethel Wright
(1906–1992)

At the age of 60, Ethel Wright Mo-
hamed of Belzoni, Miss., began to create
pictures in embroidery, and by age 75
she had created more than 125 extraor-
dinary memory pictures. The Smith-
sonian Center for Folklife and Cultural
Heritage invited Mohamed to partici-
pate in its 1974 Folklife Festival, which
featured artists from Mississippi, and
exhibited her work in its 1976 bicenten-
nial festival. Mohamed's work was dis-
played at both the 1982 and 1984 World's
Fairs.

Ethel Wright was born in 1906 and
grew up near Eupora, Miss. Working
at a local bakery at age 16, she met
32-year-old Hassan Mohamed, owner of
the local dry goods store. The two mar-
ried in 1924 and after a few years moved
to Belzoni, where they opened the
H. Mohamed general merchandise store
and reared eight children.

After her husband died in 1965, Ethel
Mohamed continued to run the family
store but was lonely: "I was a successful
businesswoman. I had brought up eight
wonderful children. I had been married

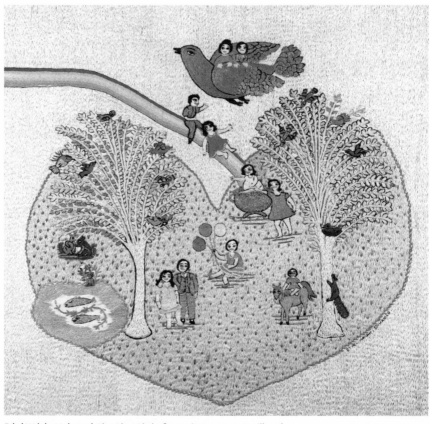

Ethel Wright Mohamed, The Blue Bird of Happiness, *ca. 1979, silk and cotton, 25″ x 25″ (sight) (Collection of Mississippi Museum of Art, Jackson)*

to a marvelous man for 41 years. Now here I was coming home at night to this big empty house. I needed a hobby." First Mohamed tried painting, but one of her grandchildren was embarrassed about his grandmother's art. "People will think you're weird," he said. Young Ethel Wright had been encouraged by her mother to draw and to embroider, to take scraps of cloth and make her own "coloring books." So Mohamed decided to take up embroidery instead. "That way I could fold up the work and put it

away quickly when people came by." She kept her stitchery hidden in a closet.

Her secret art brought her great happiness; she said of her "hobby," "I began to stitch pictures, a family album of sorts, of my family's history. Of graduations, of family stories, of pets and trees and flowers in our yard. I felt a great joy when I was stitching, as if this was what I was meant to do. The needle sang to me." When Mohamed was persuaded to show her pictures to a local artist, she found a waiting audience for her work.

Mohamed created miniature worlds in her pictures of family and community events: births, holidays, scenes at home, and at the store. Twelve pictures tell sequentially the story of the Mohamed family farm. Some pictures are imaginative re-creations of local events; in one scene, an ancestor leaves home to fight for the Confederacy. A Sacred Harp singing group is the subject of another. *The Beautiful Horse* illustrates a favorite story that Hassan Mohamed brought from his native Lebanon.

The joy and the intimacy of Mohamed's memories show in the animation, the brilliant colors, and the fanciful detail of each child, animal, plant, tree. In many of the works, the trees and plants are truly animated—each leaf with a smiling face. As Mohamed stitched, all parts of the needlework came to life to her, each tiny part of the picture with its own story. Mohamed never took out a stitch. If a face turned out ugly, she would tell it, "That's too bad; you were just born that way." She never sold her pictures, considering each a member of the family.

In 1991 the Mississippi Arts Commission presented Ethel Mohamed with the Governor's Lifetime Achievement Award for Excellence in the Arts. Mohamed's work is included in the permanent collections of the Smithsonian American Art Museum, the Ethel Wright Mohamed Stitchery Museum, and the Sarah Ellen Gillespie Museum of Art at William Carey University.

CHRISTINE WILSON
Mississippi Department of Archives and History

William Ferris, *Local Color: A Sense of Place in Folk Art* (1982); William Ferris and Judy Peiser, *Four Women Artists*, video, Center for Southern Folklore (1978); Ethel Wright Mohamed, *My Life in Pictures*, ed. Charlotte Capers and Olivia P. Collins (1976); Emily Wagster, *Clarion-Ledger* (7 February 1992); Christine Wilson, ed., *Ethel Wright Mohamed*, Mississippi Department of Archives and History (1984).

Morgan, Sister Gertrude

(1900–1980)

Between 1956 and 1974, Sister Gertrude Morgan executed approximately 800 drawings, paintings, and sculptures. A self-appointed missionary, Morgan utilized her artwork as tools of her ministry in New Orleans, her adopted city. Morgan also used her talents as a musician, poet, and writer to spread the Gospel and to beseech her audience to live a good Christian life or suffer the consequences. Two major themes dominate her work: self-portraits and biblical subjects, with an emphasis on the apocalyptic warnings of the New Testament book of Revelation.

Gertrude was born to Frances and Edward Williams in Lafayette, Ala., on 7 April 1900. She grew up in various communities in Alabama and Georgia and as a young adult worked as a domestic and nursemaid. In the late 1910s and early 1920s she became affiliated with James Berry Miller's Rose Hill Memorial Baptist Church in Columbus, Ga., where she sensed that God had called her to dedicate her life to him and had sanctified her to a life of faith. She married Will Morgan on 12 February

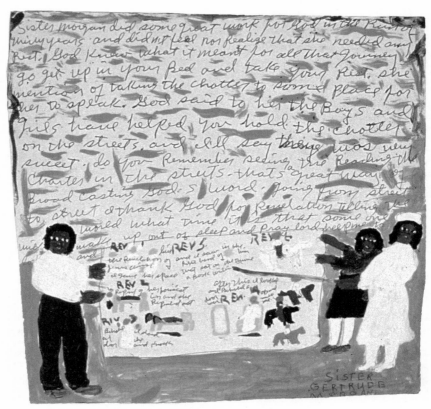

Sister Gertrude Morgan, Sister Morgan Did Some Great Work, 1970, *gouache and ballpoint pen on cardboard, 12″ x 11½″ (Collection of Robert A. Roth)*

1928, but the union did not last, and in 1929 she relocated to New Orleans. There Morgan met Mother Margaret Parker and Sister Cora Williams and, with them, began a new life, first as a cofounder of an uncertified orphanage/daycare center, then as a sometimes-homeless prophetess and street preacher, and, finally, as the sole proprietor of the Everlasting Gospel Mission, which she established in her small house in New Orleans's Lower Ninth Ward.

Around 1956 or 1957 Morgan received a second revelation from the Lord: she was to be the bride of Christ.

From this point, she discarded the black robes she had worn while preaching and put on white garments, in keeping with her new relationship with Christ and God the Father. Abandoning her colleagues at the orphanage and striking out on her own, Morgan began to make art that preached the Gospel and especially the book of Revelation. Around 1960, while preaching and singing in the French Quarter, Morgan came to the attention of art dealer Larry Borenstein. He invited her to show her work and perform her music at his gallery. Through Borenstein's efforts, Sister

Morgan became nationally known through two exhibitions at New York's Museum of American Folk Art, through *God's Greatest Hits*, an illustrated book by poet Rod McKuen, and through a recording of her singing entitled *Let's Make a Record*.

Early in 1974 Morgan suddenly stopped making art but continued to write poetry. She died at her mission on 8 July 1980 and was interred in an unmarked grave in the potter's field in Metairie, La., outside New Orleans.

Morgan's brightly colored designs employ a conceptual mode of representation, showing what the artist knows to be rather than what is actually seen. Figures and architectural forms are highly simplified yet infused with an intense expressive energy. Her works can be found in major institutions across the United States, including the American Folk Art Museum, the Smithsonian American Art Museum, the High Museum of Art, the New Orleans Museum of Art, and the Ogden Museum of Southern Art.

WILLIAM A. FAGALY
New Orleans Museum of Art

William A. Fagaly, *Tools of Her Ministry: The Art of Sister Gertrude Morgan* (2003); Lynda Roscoe Hartigan, *Made with Passion: The Hemphill Folk Art Collection* (1990); Herbert W. Hemphill Jr. and Julia Weissman, *Twentieth-Century American Folk Art and Artists* (1974); Elsa Longhauser and Harald Szeemann, eds., *Self-Taught Artists of the 20th Century: An American Anthology* (1998); Chuck Rosenak and Jan Rosenak, *Museum of American Folk Art Encyclopedia of Twentieth-Century American Folk Art* (1990).

Moses, Anna Mary Robertson (Grandma Moses)

(1860–1961)

Anna Mary Robertson Moses, known as Grandma Moses, is perhaps the most famous self-taught artist of the 20th century. The charismatic artist attained celebrity and achieved unprecedented media attention during her lifetime, and her art still maintains wide appeal. Her art embodies values Americans revere: courage, energy, respect for past, devotion to family and community, and a reverence for nature. Moses lived in rural Virginia for 18 years. Her paintings in later life contain memories of her southern experience.

Anna Mary Robertson was born 7 September 1860 in Greenwich, N.Y., to Mary Shanahan and Russell King Robertson, a farmer. She demonstrated an early interest in art, delighting her father, who also was interested in art. From the age of 12, she spent 15 years as a "hired girl" in area farms. In 1887 she married a "hired man," Thomas Salmon Moses, and the young couple moved to Staunton, Va., to seek a better life. Anna and Thomas worked as tenant farmers for a number of years before they had saved enough money to buy their own farm. Anna sold butter and homemade potato chips to neighboring farmers in order to bolster the family income. By 1905 when the couple decided to move back to New York State, Moses had given birth to 10 children, five of whom did not reach adulthood. Upon their return, the family settled in Eagle Bridge, N.Y., where Thomas Moses died in 1927.

In 1918 at the age of 58, Moses painted her first large picture. During

the 1920s she painted landscapes on panels and occasional small pictures for family and friends. In 1932, at her daughter Anna's request, Moses embroidered a "worsted yarn" picture for her granddaughter, Zoan. She enjoyed the experience and made many more when she moved to Bennington to tend to her daughter during a long illness. When she developed arthritis, yarn pictures became too difficult to execute. Encouraged by her sister Celestia, she gradually switched from yarn back to paint. As she grew older and her farm chores and family responsibilities lessened, she devoted her full attention to art. Her memory painting, *The First Auto*, painted in 1939 at the age of 79, was inspired by one of her visits with Thomas and four children to a fair in Gypsyhill Park, near Staunton, where she had seen her first automobile. *Apple Butter Making* (1947) is another among the relatively small number of memory pictures related to years spent in Virginia with Thomas.

An exhibition of Moses's paintings in a woman's exchange competition organized by Thomas Drug Store in Hoosick Falls in 1938 caught the interest and attention of New York collector Louis J. Caldor. He purchased all of Moses's paintings, met the artist, purchased more, and sought to obtain exhibitions and representation for her in New York City. In 1939 Sydney Janis selected three paintings for a modest exhibition in the Member's Room of the Museum of Modern Art. Otto Kallir, director of the newly formed Galerie St. Etienne, New York, gave Moses her first one-person exhibition, *What a Farm Wife Painted*

(1940). Three paintings sold; the exhibition garnered several reviews, including one in the *New York Herald* on 8 October 1940 that named the artist "Grandma Moses," as she had long been called in her own community.

With an intuitive compositional ability and talent as a colorist, Moses painted an idyllic world through the changing seasons, recording the holidays, especially Thanksgiving and Christmas. She borrowed images from Currier and Ives and other popular sources—greeting cards, magazine and newspaper illustrations, and leaflets, often tracing motifs for anecdotal details for landscapes and interior narratives. She frequently painted more than one rendition of a subject, but always varied details or changed the mood so that her pictures never appear as mimeographed copies. Her mature landscape painting style combined detailed foregrounds with stunning panoramic backgrounds. In her later years, looser brushwork resulted in an expressionistic painterly style. Moses sets many of her subjects in a shallow picture plane; her pictures combine simultaneous perspectives, flattened, abstract forms, and deep illusionistic vistas. Her paintings nostalgically recall earlier times, and her universal messages are imbued with both serenity and spirited optimism.

Moses painted more than 1,500 pictures from 1935 until 1961, the year she died. Hundreds of national and international exhibitions followed, along with a significant body of scholarly articles and books. Virtually every book or catalog that surveys 20th-century self-taught

artists includes an entry on Grandma Moses.

Moses was awarded honorary doctorates from Russell Sage College, Troy, N.Y. (1949), and Moore College of Art, Philadelphia, Pa. (1951). The artist met President Harry Truman in 1949, when she traveled to Washington to receive the Woman's National Press Club Award. Moses took part in an insightful televised conversation with Edward R. Murrow's *See It Now* in 1955 and appeared on the covers of *Time* (28 December 1953) and *Life* (19 September 1960). Moses was a celebrity and a national icon who painted against stylistic trends. During an era of Cold War, her optimistic messages delighted a vast number of people, and many works were reproduced on calendars and greeting cards.

On 13 December 1961 Moses died. Her legacy continues to draw interest from new and committed audiences as well as debate within the art community. Recent reappraisals have analyzed the artist's process and recognized her significance in the history of American art. Moses's paintings are in the collection of many museums and public and private collections. In 1969, eight years after her death, the United States Postal Service issued a commemorative six-cent stamp in her honor, a detail of the painting *July Fourth*.

LEE KOGAN
American Folk Art Museum

Sidney Janis, *They Taught Themselves: American Primitive Painters of the 20th Century* (1942); Jane Kallir, *Grandma Moses* (1973), *Grandma Moses: The Artist behind the Myth* (1948), *Grandma Moses in the 21st Century* (2001); Lee Kogan, *Grandma Moses: Grandmother to the Nation* (2007); Karal Ann Marling, *Designs of the Heart: The Homemade Art of Grandma Moses* (2006).

Mulligan, Mark Anthony
(b. 1963)

A true Louisville original, Mark Anthony Mulligan is an important Kentucky artist. Despite mental and physical disabilities, and no formal art instruction, Mulligan has created a mostly joyous vision of Louisville's urban environment that transcends his personal circumstances.

Mulligan, who is African American, was born into a working-class family and neighborhood in Louisville's west end. In the 1970s, several petroleum refineries operated in an area called Rubbertown near his home. This unlikely place was Mulligan's first inspiration. Rubbertown's large fuel storage tanks with giant trademarked logos became a lifelong obsession that the artist celebrated in numerous pictures and songs.

To Mulligan, who considers himself a "sign and logo artist," these corporate petroleum signs are full of spiritual meaning—manifested in acronyms. For example, Gulf becomes "God's Unique Love Forever," Chevron morphs into "Charity Ever On," and, his personal favorite, Ashland, stands for "Ask Him Love and Never Doubt." That Mulligan is able to find spiritual meaning in the most commercial of ventures is one of the highlights of his remarkable art. In Mulligan's worldview, everything in the urban environment is redeemed

by being an obvious extension of the Creator's plan. Mulligan has a talent for choosing aspects of contemporary life that most artists would find unappealing as subject matter, and yet are omnipresent parts of our culture. For example, Mulligan has celebrated the fast-food industry through his still-life drawings, paintings, and songs about their products.

Mark Anthony Mulligan is at heart a draftsman. Mulligan's use of line is his most expressive quality. He usually fills the page completely, and he has an intuitive sense of how to take advantage of the formal elements of art. Introduced to acrylic painting by a Louisville gallery at his request, Mulligan's use of color is pure and usually straight out of the tube or marker. In a typical Mulligan cityscape, the composition is divided into a patchwork of tall buildings, roads, and highways. Signage is everywhere in the form of real streets and businesses integrated with imaginary places named for friends and pop culture references. Mulligan uses simple perspective and implies depth by reducing the scale of objects as the eye moves from foreground to background. The artist also uses a bird's-eye vantage point. You sense he is floating over the world he creates. Mulligan completes a piece by signing his name, giving the work a title, dating it, and recording how long it took him to finish his composition.

Mulligan's works are fantastic imaginary maps filled with hundreds of named and intersecting roadways. He has produced seek-and-find and connect-the-dot images that underscore the difficulty of finding easy meaning in

life. For fans of mail art, Mulligan has created hundreds of letters with profusely illustrated envelopes. He has also experimented with multiples made on commercial photocopy machines.

Despite being widely exhibited and collected, Mulligan retired from art in 2000. Today, he occasionally produces art, which he prefers to sell or barter on the streets. Years of instability and homelessness have taken their toll. In 2005, the Kentucky Folk Art Center in Morehead, Ky., honored Mulligan with a traveling retrospective exhibition entitled *You Must Withstand the Wind: Transformation of the Urban Landscape*. Mulligan's work is in the collections of the Kentucky Folk Art Center and the New Orleans Museum of Art. In 2003, the Kenyan filmmaker Andrew Thuita directed *Looking for Mark*, an 80-minute documentary about Mulligan.

ALBERTUS GORMAN
Louisville, Kentucky

Kentucky Folk Art Center, Morehead, *African-American Folk Art in Kentucky* (1998); Gail Andrews Trechsel, ed., *Pictured in My Mind: Contemporary American Self-Taught Art from the Collection of Dr. Kurt Gitter and Alice Rae Yelen* (1995); Kentucky Folk Art Center, *You Must Withstand the Wind: Transformation of the Urban Landscape* (2005).

Murray, John Bunion (J. B.)
(1908–1988)

John Bunion (J. B.) Murray, a former tenant farmer from Glascock County, Ga., gained notice in exhibitions of folk and so-called outsider art in the early 1980s. Unlike most artists introduced

in these contexts, he painted abstractly, marking two-dimensional surfaces and found objects with a chantlike asemic script that he called "the language of the Holy Spirit direct from God." Murray cited the origins of his "spiritual work" in a 1978 visionary experience. "When I started I prayed and I prayed and the Lord sent a vision from the sun. Everything I see is from the sun. He came to me slowly, over a period of time, came in a vision and a likeness. It was then I began to write these letters." Murray's first works were inscribed on rolls of adding machine tape and blank stationery. They were sealed in envelopes that he distributed for free at his church and on street corners in the towns of Mitchell and Sparta near his home. "Different writing represents different languages and folks," he explained, "It's like He uses different verses and prayers and psalms—the same."

A year after Murray's initial visionary experience, William Rawlings, his physician, introduced him to watercolor, polychrome inks, and fine art boards and papers. Murray immediately expanded the size and complexity of his work and produced his first autonomous paintings. Among the fields of script he now added ghostly human figures that he described as "people that are dry tongued; they don't know God." He marked found objects such as stovetops, television cabinets, and picture tubes—all objects associated with fire and light—with fluid strokes of blue, yellow, and red enamel. He filled sketchbook pages with vertical syncopated strokes of watercolor and, in larger works, applied dense fields of color in columns. He made geometric compositions with meandering lines and script fields and, when asked about his work, gave lengthy verbal meditations on God and nature.

As a result of the advocacy of Rawlings and the ceramic sculptor Andy Nasisse, Murray's work began to appear in regional exhibitions of self-taught artists. Almost immediately he was invited to exhibit in folk art venues and museums throughout the United States and soon entered important collections in New York, Europe, and Japan. Murray's work is included in the collections of many museums, including abcd, the Birmingham Museum of Art, the High Museum of Art, and the Smithsonian American Art Museum.

JUDITH MCWILLIE
University of Georgia

Grey Gundaker, *Signs of Diaspora / Diaspora of Signs: Literacies, Creolization, and Vernacular Practice in African America* (1998); Judith McWillie, in *Cultural Perspectives on the American South*, vol. 5, *Religion*, ed. Charles Reagan Wilson (1991); Judith McWillie and Grey Gundaker, *No Space Hidden: The Spirit of African American Yard Work* (2005); Mary Padgelek, *In the Hand of the Holy Spirit: The Visionary Art of J. B. Murray* (2000).

National Heritage Fellowships

The National Endowment for the Arts, established in 1965 by an act of Congress, created the National Heritage Fellowships to recognize and preserve the United States' rich and diverse cultural heritage. These fellowships are the highest honor this country bestows upon master folk and traditional artists.

The National Endowment for the Arts' Folk Art Program, which awarded its first Fellowship awards in 1982, follows a folkloristic definition of folk art; honorees are more likely to be practitioners of local craft traditions than artists whose art making is distinguished by idiosyncrasy or aesthetic value.

The number of awardees per year has varied between 11 and 17. As of 2007 more than 325 artists and groups have been recognized for their roles in practicing, conserving, reviving, innovating, and teaching their art forms. One of the fellowships awarded each year is named for Bess Lomax Hawes, the National Endowment for the Arts director of the Folk Arts Program who initiated the National Heritage Fellowship program. This particular honor is given specifically to recognize those who foster and promote folk and traditional arts in the public arena. Recipients of the National Heritage Fellowships have included musicians, dancers, storytellers, boat builders, quilters, basket makers, and many others.

RHONDA L. REYMOND
College of Creative Arts
West Virginia University

Robert Atkinson, *Journal of American Folklore* (Fall–Winter 1993); Steve Siporin, *American Folk Masters: The National Heritage Fellows* (1992).

National Society of the Colonial Dames of America

The National Society of the Colonial Dames of America (NSCDA), a voluntary organization for women, was established in 1891 to foster a national appreciation for America's early history and culture through patriotic service, educational projects, and historic preservation. An unincorporated association of 44 corporate societies with more than 15,000 members, the society maintains its headquarters at Dumbarton House in Washington, D.C. Membership is limited to women whose ancestors lived in the colonies before the American Revolution.

With more than 70 affiliated properties nationwide ranging in date from 1680 to 1930, the NSCDA owns or manages 42; others receive financial assistance, volunteer services, donations of furnishings, or archaeology funding. In the South, the Dames are involved with approximately 25 properties in 14 states, documenting America's development from its pioneer settlements to westward migration. The Dames' interest in museums in the South extends to structures and their furnishings dating from the 18th and 19th centuries, including the Ximenez-Fatio House (1798) in St. Augustine, Fla., Liberty Hall (1796) in Frankfort, Ky., Greek-Revival Craik-Patton House (1834) in Charleston, W.Va., and the Neill-Cochran House (1855) in Austin, Tex. Within these sites, the NSCDA maintains collections of American pictorial and decorative arts. Among these are a double portrait of Frankfort, Ky., residents Mason Preston Brown and his brother Orlando by the itinerant artist Trevor Thomas Fowler (1800–1881) from about 1849; a graphite drawing by an unidentified artist depicting Fort DeRussy, La., during the Civil War; and a dirt dish, an earthenware plate sealed with a clear lead glaze, made in Randolph County, N.C.,

from about 1750 to 1800. Following up on its landmark publication *American Samplers* (Ethel Stanwood Bolton and Eve Johnston Coe, 1921), the society currently is conducting a survey of samplers and pictorial embroideries, building upon more than 2,500 descriptions previously recorded. Again, this survey is an invaluable resource for scholars of southern art, which has often been ignored.

Other NSCDA endeavors include maintaining genealogical records, conducting oral histories, installing plaques and historic markers of local and national interest, and sponsoring an inventory of American paintings and sculpture. This inventory is an important repository for scholars, aiding genealogical, historical, population, and art-historical research. Beginning in 2003, the Tennessee NSCDA chapter began a project documenting Tennessee portraits, in public and private collections including significant portraits in collections out of state. The project has documented more than 2,400 portraits and maintains a website (www.tnportraits.org) that serves as a repository that welcomes new additions and as a resource for future research. Because many southern works, such as portraits, remain in family hands, the NSCDA inventories help scholars locate specific works. Furthermore, as the identities of many southern portraitists remain unknown, the inventories, with images of portraits apparently made by the same hand, serve as an impetus for new research on southern art.

CHARLOTTE EMANS MOORE
Wilmington, North Carolina

Clarinda Huntington Pendleton Lamar, *A History of the National Society of the Colonial Dames of America, from 1891 to 1933* (1934); "National Society of the Colonial Dames of America," special edition, *The Magazine Antiques* (July 2007); National Society of the Colonial Dames of America, *The National Society of the Colonial Dames of America: Its Beginnings, Its Purpose, and a Record of Its Work, 1891–1913* (1913); *Summary of the Histories of the National Society of the Colonial Dames of America and of the Corporate Societies, 1891–1962* (1962); William Seale and Erik Kvalsvik, *Domestic Views: Historic Properties Owned or Supported by the National Society of the Colonial Dames of America* (1992).

New Market, Virginia, Painted Boxes

A unique group of more than 30 paint-decorated miniature boxes and miniature blanket chests has been found and documented in the Shenandoah Valley of Virginia, in the area surrounding the town of New Market in Shenandoah County. The miniature boxes come in two basic sizes. The larger ones have heights ranging from 6⅞ to 7⅝ inches, widths from 9¾ to 10⅜ inches, and depths from 5½ to 6 inches. The smaller ones range from 5⅜ inches high, 6¾ to 8¾ inches wide, and 4¼ to 5 inches deep. In this group, 95 percent of the wood used is yellow pine; the remaining 5 percent is made from poplar. Corners are constructed with either dovetailed joints (60 percent) or nailed together (40 percent). The bottoms of all examples are nailed to the sides, and the tops are attached with leather hinges. The boxes' feet are turned and fitted into holes drilled into the bottoms of the boxes. The turnings used for the feet

vary from box to box, and even sometimes on the same box.

The miniature blanket chests, all made from yellow pine, range from heights of 13½ to 19½ inches, widths of 15 to 28 inches, and depths of 10¼ to 16 inches. These chests have dovetailed corners, bottoms nailed to the sides, and tops affixed with commercial butt hinges. The feet are turned and fitted into holes drilled into the bottom boards of the boxes.

The makers of these miniature boxes and chests applied decorations in paints of two or three colors over a base coat. These decorations usually combine freehand painting and stenciling patterns that include eagles, doves, stylized leaves, stars, snowflakes, and leaves on a stem. Several of the constructions have only freehand decoration. Except for one example, the makers treated all legs with black paint. Most of the "Newmarket" boxes have been found in Shenandoah County, which in the 19th century had the Shenandoah Valley's largest German population. The handing down of boxes and chests in Virginia-German families and their location are evidence of German cultural connection. An inscription under the lid of one box that reads "Maid by Mr. Stiawalt in Shennadoh Co., 1835 bought by Isaac Bull" is further evidence of Germanic origin. At that time there were only two male members of the Stirewalt (or Stiawalt) family living in New Market or anywhere in Shenandoah County. They were brothers who were Lutheran ministers both married to members of the Henkel family. Both lived in New Market, Va., and in North Carolina, traveling back and forth to serve congregations in both places. Information about Jacob Stirewalt, suggests that he was the maker of this Newmarket box.

Jacob Stirewalt, born in Rowan County, N.C., in 1805, was the younger brother of John Stirewalt. In 1833 he married Henrietta Henkel of New Market, Va.; he and his wife had six children. In 1837 he became a licensed deacon in the Lutheran Church, and in 1838 he was ordained as a minister. He owned a farm one mile south of New Market, and family tradition says that he always farmed, even during the time that he was a minister. His son, Jerome Paul, described his father as "an industrious and practical man." An inventor, he was skilled in working wood, leather, and metal. Jacob also taught at the New Market Academy from 1837 to 1838 and became principal of the New Market Female Seminary in 1854.

The variety of Jacob Stirewalt's activities may indicate how he might have marketed his miniatures. He might have made and decorated the boxes in New Market and offered them for sale at his brother-in-law Solomon's store; he might have made and peddled them during his travels to churches he served; or because oral traditions in families from the New Market region associate the miniature chests and boxes with girls who attended school in New Market, he might have made, decorated, and sold them to students at the academies.

Regardless of who made and decorated these boxes, they represent an important regional distinctive folk art tra-

dition that stands apart from the body of painted furniture associated with the Shenandoah Valley of Virginia.

RODDY MOORE
SALLY MOORE
*Blue Ridge Institute and Museum
Ferrum College (Virginia)*

Nicholson, Susannah Fauntleroy Quarles (Susan)

(1804–1858)

A member of a prominent Lynchburg, Va., family, Susan Quarles Nicholson is a self-taught artist best known for her family portraits. After she married Jacob Cannon Nicholson, apparently an artist himself, the couple advertised in the *Lynchburg Virginian* that they both were "prepared to Paint Miniatures and Portraits."

Nicholson and other women artists of the period rarely received commissions; the portraits painted by women are often likenesses of their own family members. Nicholson painted most members of her extended family. Nicholson's circa 1853 full-length portrait of Laura Jane "Jennie" Harris, held by the Maryland Historical Society, is a fine example of the artist's sensitive work. In this portrait, Nicholson depicts Jennie, a girl of about seven years of age, in a romantic landscape suffused with a pink sky. The girl's slight smile and graceful tilt of her head lend an innocent, sweet air. Nicholson complements the girl's blue eyes and light blue dress with the blended alabaster and rose tones of the girl's skin and by her delicate pink slippers with ribbons. The pink reoccurs in the rose bush from which the child plucks a rose and in the pink ribbon worn by a white spaniel, perhaps a symbol of faithfulness. However, while the artist pays attention to some naturalistic details such as the flowers and the girl's expression, the stylization of the pleats of the girl's dress and the shallow picture plane reveal the artist's position as a self-taught artist less concerned with photographic realism. As a whole, the work strikes the viewer with its directness, simplicity, and intimacy, characteristics commonly found in folk art.

Only one painting among Susan Quarles Nicholson's known works is not a portrait but a genre painting. The woman in *Woman Reading Book* is unidentified, though she is probably a member of the Nicholson family. This work is now in the Abby Aldrich Rockefeller Folk Art Center collection in Williamsburg, Va. The permanent collection of the Huntington Museum of Art also includes work by Nicholson.

JACQUELYN GOURLEY
Downingtown, Pennsylvania

John Cuthbert, *Early Art and Artists in West Virginia* (2000); Mary Dean, *350 Years of Art and Architecture in Maryland* (1984); Maryland Art Source, www.marylandart-source.org/artists; Cynthia Elyce Rubin, ed., *Southern Folk Art* (1985).

Ohr, George Edgar

(1857–1918)

George Edgar Ohr, the self-proclaimed Mad Potter of Biloxi, was a ceramic artist active in Biloxi, Miss., from 1882 to 1907. Born on 12 July 1857 to eastern European immigrants, he trained in his father's blacksmith shop but left it for the New Orleans potter Joseph Meyer.

There Ohr learned the mechanics of the pottery trade. In 1881 Ohr left New Orleans and began a two-year trip across the eastern United States visiting a variety of established folk potteries. In 1883 Ohr returned to Biloxi and opened his first pottery studio selling utilitarian and folk pottery. Ohr dug and processed his own clay, built and stoked his wood-burning kiln, and prepared his own glazes.

Ohr opened the Biloxi Art and Novelty Pottery in 1890, establishing himself as a craftsman of utilitarian pottery and a clay artist. In October 1894 Ohr's studio and an estimated 1,000 pieces of pottery were destroyed in a fire. Following the destruction of his life's work and coping with the loss of family income, Ohr produced the most innovative work of his career. In 1894 he began creating a variety of paper-thin vessels known for their undulating pinches, folds, and twists. The curling ribbon handles of his vases, teapots, and mugs reflect the artist's early training as a blacksmith. Contemporaries noted the intensity and brilliant color of Ohr's glazes. Ohr exhibited at many fairs and expositions, including the World's Columbian Exposition in Chicago (1893) and the St. Louis World's Fair (1904), where he received a Silver Medal for his work.

Around 1905 George Ohr stopped glazing his pottery, leaving it in the bisque form. The pottery of this period represents the most abstract, sculptural ceramic objects he ever created. Soon after, however, Ohr stopped potting all together; and by 1910 his studio was disassembled. Ohr spent the remainder of his life in Biloxi experimenting with motorcycles and automobiles. He died in Biloxi on 7 April 1918. Ohr's work stayed packed away on his family property until the 1970s. In 1972 Ohr's surviving children sold the entire collection of his pottery to antique dealer James Carpenter, who introduced Ohr's work to the New York art world. Ohr's creations are featured in the Ohr-O'Keefe Museum of Art, the Mississippi Museum of Art, the Detroit Institute of Arts Museum, the Columbus Museum, the Smithsonian's National Museum of American History, and the Metropolitan Museum of Art.

ANNA STANFIELD HARRIS
Ohr-O'Keefe Museum of Art

Garth Clark, Robert A. Ellison Jr., and Eugene Hecht, *The Mad Potter of Biloxi: The Art and Life of George E. Ohr* (1989); Robert Ellison with Martin Edelburg, *George Ohr, Art Potter: The Apostle of Individuality* (2006); Eugene Hecht, *After the Fire, George Ohr: An American Genius* (1994); Richard D. Mohr, *Pottery, Politics, Art: George Ohr and the Brothers Kirkpatrick* (2003).

O'Kelley, Emily (Mattie Lou)
(1908–1997)

Mattie Lou O'Kelley depicted memories of her childhood, youth, and early adulthood. Her idyllic panoramas of life around the farm where she grew up in rural Banks County, Ga., convey a sense of well-being in a self-sufficient utopia.

O'Kelley was born the seventh of eight children into a farming family. She lived on the family farm for 70 years. Her parents, Augustus Franklin O'Kelley and Mary Bell Cox O'Kelley,

named her Emily Mattie Lou. She attended school through the ninth grade and then worked on the family's corn and cotton farm. After her father died in 1943 O'Kelley became the caretaker for her mother. She remained at home long after her siblings had grown up and left to raise their own families. After her mother's death in 1955, O'Kelley continued to support herself working as a housekeeper, seamstress, school cafeteria cook, and millworker.

Following her 1968 retirement from a yarn mop plant in Mayville, O'Kelley ordered paints and canvas from the Sears, Roebuck and Company catalog and began to create. She said, "I had always wanted to paint. Now I had the time." In the beginning of her career O'Kelley promoted herself, offering paintings for sale at local art shows in Maysville. In 1975, seeking a wider audience, she took paintings to Gudmund Vigtel, then director of the High Museum of Art in Atlanta. Impressed with her work, Vigtel purchased *Spring Vegetables* for the museum and arranged for some of O'Kelley's paintings to be placed for sale at the museum gift shop.

Robert Bishop, editor of publications for the Henry Ford Museum and later director of the American Folk Art Museum (then called the Museum of American Folk Art), saw O'Kelley's paintings in the High Museum gift shop in the late 1970s. Taken with their clarity of expression and their optimistic point of view, Bishop sought out the artist and began to champion her work. When Bishop wrote his seminal book, *Folk Painters of America* (1979), he placed O'Kelley's work firmly in the memory

painting genre along with the painting of Anna Mary Robertson Moses (Grandma Moses). In 1976 O'Kelley won the Georgia Governor's Award in the Arts, the same year that she was included in an influential traveling exhibition, *Missing Pieces: Georgia Folk Art, 1770–1976*, which was sponsored by the Georgia Council for the Arts. In 1977, at the urging of Bishop, O'Kelley left Banks County and moved to New York City. However, urban life was too hectic and the climate proved too harsh for her. O'Kelley relocated first to Palm Beach, Fla., and then to Decatur, Ga., where she spent her final years.

O'Kelley's style is marked by highly stylized landscapes, richly detailed anecdotal genre scenes, still lifes, and portraits. She often uses pointillist brushstrokes, a technique in which small distinct daubs of pure color are applied to a canvas. When seen from a distance their optical blending creates a myriad of shapes, hues, and tones. Manicured trees and shrubs vibrate from O'Kelley's staccato brushstrokes. Bishop called O'Kelley "an exquisite recorder of time and place." Nostalgia and longing for a disappearing lifestyle were at the core of O'Kelley's landscapes, genre scenes, and still-life paintings. The artist used a naturalistic representation for some of her penetrating and honest self-portraits.

Paintings by O'Kelley are in the permanent collections of the American Folk Art Museum, the High Museum of Art, the Abby Aldrich Rockefeller Folk Art Museum, the Fenimore Art Museum, the International Folk Art Museum, and the Smithsonian American

Art Museum. An O'Kelley painting of a yellow cat appeared on the June 1980 cover of *Life* magazine, and O'Kelley was both illustrator and author of *From the Hills of Georgia: An Autobiography in Paintings* (1983).

LEE KOGAN
American Folk Art Museum

Barbara R. Luck, *Moving with Mattie Lou O'Kelley* (1995); Mattie Lou O'Kelley, *Mattie Lou O'Kelley: Folk Artist* (1989); Tom Patterson, *Contemporary Folk Art: Treasures from the Smithsonian American Art Museum* (2001); Betty-Carol Sellen with Cynthia J. Johanson, *Twentieth-Century American Folk, Self-Taught, and Outsider Art* (1993).

Payne Limner

(fl. ca. 1780–1803)
The Payne Limner is an unidentified portrait painter, who worked in the Virginia counties of Henrico and Goochland in the late 18th and early 19th centuries. The artist's distinct style and method of canvas preparation have allowed for the identification of at least 13 portraits by the same hand. The artist's name derives from the 10 surviving portraits of the Payne family completed circa 1791. The nine single portraits and one triple portrait were likely painted at the family's estate, New Market, in Goochland County.

None of the extant paintings bears a signature or date, and the attributions are based primarily on strong stylistic similarities and the idiosyncratic application of ground and paint to the canvas. It is unlikely that the Payne Limner received any formal training as a portrait painter. Instead, he likely worked as an itinerant painter of por-

traits as well as of more mundane items such as coaches and signs. Many of the paintings display a knowledge of 18th-century British portrait conventions, such as the inclusion of flowers or domesticated animals alongside young girls and hunting paraphernalia with boys. The Payne Limner would certainly have had the opportunity to view such compositions in circulated engravings or perhaps in the work of other portrait painters working in Virginia at the time.

The extant works of the Payne Limner serve as an excellent record of contemporary society. The triple portrait *Alexander Spotswood Payne and His Brother, John Robert Dandridge Payne, with Their Nurse* (c. 1791), at the Virginia Museum of Fine Arts, is one of only a handful of paintings from the period that include a full-length enslaved nurse. The work synthesizes British and Colonial American portrait conventions into a work appropriate for the setting at New Market. Another of the Payne Limner's most noteworthy is his *Ege-Galt Family Portrait* (c. 1802–3) in the collection of the Abby Aldrich Rockefeller Folk Art Museum, which includes four figures from four generations of the family.

CHRISTOPHER C. OLIVER
University of Virginia

Elizabeth Thompson Lyon, "The Payne Limner" (M.A. thesis, Virginia Commonwealth University, 1981).

Perkins, Benjamin Franklin (B. F.)

(1904–1993)
By most accounts, B. F. Perkins lived a colorful life. Perkins was born and grew

up in Alabama in rural Lamar County. His mother died when he was only a boy, and he left the area when he was just a teenager. At age 17, he joined the U.S. Marines and, when his tour of duty was over, settled in Virginia. There he became a preacher, then married, and had two daughters. By the time he returned to Alabama sometime in the 1960s, he was divorced, his daughters had married, and he was alone. Perkins built a house and a church, decorating the exterior of his house in red, white, and blue and building other structures on his land, including replicas of Christ's sepulcher and the three crosses of Calvary.

Perkins began painting sometime in the 1970s and took art classes at the nearby Albert Brewer Jr. Community College. He decorated gourds and made paintings that feature patriotic and religious themes. These include in red, white, and blue the Statue of Liberty, the American flag, prophecy charts, and houses and churches, which are almost always accompanied by biblical verses and patriotic sentiments. His other favorite subjects were peacocks, which he sometimes labeled "A KING TUT TREASURE," and the other, Cherokee love birds, a motif depicting two birds with glorious plumage gazing lovingly into each other's eyes. A 1987 newspaper article brought Perkins to the attention of Joe Tartt, a folk art dealer, who promoted his work.

Although the broad outline of Perkins's life is fairly well known, the details of his life are sketchy and sometimes contradictory. One source reports that his mother was part Cherokee, and

another that his father was a farmer and holiness preacher. The elder Perkins is also said to have worked at a sawmill, where the young Perkins joined him at age nine. Perkins later told the story of how his boss bought two huge unbroken horses and gave them to the nine-year old to train: "They fought me every inch of the way. If one of their kicks had ever landed, I'd have gone to heaven." Apparently Perkins attended public schools in Lamar and Fayette counties, but when or if he graduated is uncertain. He is also said to have worked at a cotton mill for 12 hours a day. At age 16 he became a coal miner: "I had to load fifteen tons a day to make five dollars." He is said to have worked picking oranges and strawberries in Florida and on a construction crew in Atlanta.

Perkins served in the Marines from 1921 to 1925. He guarded prisoners on Parris Island and President Calvin Coolidge on the presidential yacht the USS *Mayflower* and at the White House. Perkins volunteered to learn karate in Japan and then returned to the states to teach it. He went on secret missions to Latin America and visited more than 28 countries. After serving in the marines, he enrolled at the University of Virginia, where he studied engineering and religion. He also worked on and off between 1926 and 1966 for the Federal Aviation Administration in Washington, D.C., went undercover for the FBI, and worked as a commercial fisherman, a taxi driver, and a brick mason's helper.

On the way to a Friday night poker game in Washington, D.C., Perkins "saw a big sign with a cross on it and just two

words: *Jesus Saves*. It kept flashing, *Jesus Saves, Jesus Saves*. I answered the call, and that's the happiest day of my life." He put himself through divinity school as a brick mason's helper. In 1929 he became a minister in the Assembly of God. He married in 1936, settled in Virginia, and had two daughters. In 1940 he joined and was ordained in the Church of God, saying later that he "went to the top" as a bishop. He and his wife divorced, he raised his children without her, and by 1964, 1966, or 1969 (the dates vary) returned to Alabama, where he built his new home on a 5-, 15-, or 16-acre wooded lot. Here he also built his church, first naming it the Original Church of God and then renaming it Hartline Assembly Church of God after an old-time radio program. He took up painting in the mid-1970s, had open-heart surgery in 1977, and then decided to enroll in art classes. Another source, however, indicates he first attended art classes in 1969. After Perkins's death in 1993, his two daughters, for unknown reasons, had the Fayette fire department burn Perkins's house/studio to the ground.

Like many self-taught artists, Perkins painted on unorthodox surfaces. In addition to prestretched canvas board, Perkins painted gourds, trays, and mailboxes that he bought from government surplus for five dollars. His work ranges from small paintings to large ones, measuring up to 4 x 7 feet. Perkins's house is best known through photographs of his environment and through his paintings. Perkins's works can be found in the collections of the Birmingham Museum of Art, the Morris Museum, and the Fayette Art Museum.

GEORGE AND SUE VIENER
Wyomissing, Pennsylvania

Georgine Clark, *Raw Vision* (Winter 2008–9); Carol Crown, ed., *Coming Home! Self-Taught Artists, the Bible, and the American South* (2004); Kathy Kemp, *Revelations: Alabama's Visionary Folk Artists* (1997); Ramona Lampbell and Millard Lampbell, *O, Appalachia: Artists of the Southern Mountains* (1989).

Person, Leroy

(1907–1985)

Leroy Person was a sculptor of root wood, an assembler of eccentric furniture, and an experienced woodworker who embellished his environment, both house and yard, in Occhineechee Neck, a small swamp area in northeastern North Carolina. Born the second of five children, Person spent roughly the first 30 years of his life as a sharecropper, starting work while still a boy. Moving to Occhineechee Neck around 1960, he developed an expertise with wood as a result of his own experimentation and his later job grading lumber for W. P. Morris Lumber Company in nearby Jackson, N.C. In the early 1970s, the artist's failing health from breathing sawdust, a leg injury, and arthritis forced him to retire. At about this time, Person started building a yard show of carved sculptures that mixed natural root forms and irregularly shaped, found plywood scraps. He hung his sculptures from trees, applied them to his family home, and affixed them to a self-fashioned fence. Person, however,

scrapped this original configuration after he and his family grew dissatisfied with it.

Nonetheless, remains of Person's work did reach the attention of local collector Robert Lynch, in the mid-1970s. Lynch's attraction to the work renewed Person's interest in carving. The artist created various types of sculpture and received commissions from Lynch for pieces of furniture, including thronelike chairs complete with footstools. The most ambitious of Person's creations, the chairs incorporate root wood as front posts or vertical slats of the backing and plywood for the seats and back posts. Some chairs cleverly recycle fragments of factory-made or antique chairs that the artist found or that others gave him. Person transformed almost every surface of his chairs, root wood sculptures, house fragments, and scrap lumber with chip carving, a glossy coat of melted crayon, or bright house paint. Person's root wood sculptures take the form of birds, snakes, fish, or peacocks. Person sometimes fashioned tableaux of these animal forms, surrounding them with vegetal forms carved or drawn on plywood scraps. In addition, Person also made small baskets out of telephone wire. Later, when his health prevented him from carving, he drew patterned, abstract, or scenic images that repeat the motifs that decorate his sculpture and furniture.

Person developed an individualistic vocabulary of symbols, the form and configuration consonant with recent scholarship on the protective, ancestral, and communal metalanguage of African American yard shows. Indeed, Person's belief that God had called him to carve suggests that his original configuration had been a functional, spiritual, and culturally embedded space, extending perhaps to the next-door Baptist church he attended. Work by Person is in the collections of the Lynch Collection of Outsider Art at North Carolina Wesleyan College, the Mennello Museum of American Folk Art, Intuit: The Center for Intuitive and Outsider Art, and the American Folk Art Museum.

EDWARD M. PUCHNER
Indiana University

Everett Mayo Adelman, *Folk Art* (Fall 1994); Paul Arnett and William Arnett, eds., *Souls Grown Deep: African American Vernacular Art of the South*, vol. 1 (2000); William Arnett and Paul Arnett, eds., *Souls Grown Deep: African American Vernacular Art*, vol. 2 (2001); Elsa Longhauser and Harald Szeemann, eds., *Self-Taught Artists of the 20th Century: An American Anthology* (1998); Roger Manley, *Signs and Wonders: Outsider Art inside North Carolina* (1989).

Pettway, Plummer T.

(1918–1993)

"I been quilting ever since a long time," said Plummer T. Pettway, a quilter from Gee's Bend, Ala. "If I don't quilt, I don't know what I'd be doing—sitting down, doing nothing. I have to make quilts." Plummer T. was Martha Jane Pettway's third child and eldest daughter. Plummer T. and her husband, Famous Pettway, had seven children and lived near the house in Gee's Bend that was shared by her mother and her sister, Joanna. Plummer T., Martha Jane, and

Joanna pieced quilt tops separately in the winters and quilted them together in the summers using Martha Jane's old family quilting frames. While quilting, the women maintained a lively verbal interchange. Plummer T. described their quilting parties: "Talk about talk! I don't know what all we don't talk about! Oh, that's fun."

Pettway also worked at the Rehobeth, Ala., sewing cooperative, called the Freedom Quilting Bee. She saved scraps from the Quilting Bee and combined them with her own scraps when piecing her quilt tops. She preferred to do the piecing with a sewing machine, although she occasionally did hand piecing. She did not consider herself a "fancy" quilter, maintaining that her mother and her daughter were better quilters. Her attitude toward quilts, rather, emphasized their utility: "Quilting keeps you warm. I don't quilt for pretty—quilt them to cover up with." But Pettway's children and grandchildren appreciated her skills and encouraged her to quilt. Pleased with her family's support, she was happy to repay it by making quilts for relatives, making many more quilts than were necessary for her family's warmth. Quilting provided Plummer T. with a means to express affection for her family, be creative, and pass along encoded patterns to others. Her well-developed personal style was best seen in her complex designs. She said that multiple patterns and shapes made the best quilts: "You can't match them. No. It takes all kind of pieces to piece a quilt." She was very careful when combining her pieces, cau-

tioning, "You have to think about the next color."

Pettway varied the colors and shapes in her quilt squares so often that she created multiple patterns in her quilt-top designs. In West Africa multiple-patterned textiles are an indication of status, for only the most literate can name all the desired patterns and only the wealthy can afford to pay a master weaver. The unpredictable innovative rhythms in Plummer T.'s quilts are similar to those found in West African textiles and other African American arts, such as blues, jazz, break dancing, and rap. Her *Bear's Paw Quilt* was made with 25 squares, all variations on the theme of the Bear's Paw.

In Africa, messages are often encoded in multiple-patterned textiles. In African American quilts one finds vestiges of this tradition. Protective symbols cut from printed fabrics and appliquéd onto cloth squares in Pettway's *Appliquéd Quilt* are one example. The patterns are similar to those made by women in Nigeria. Large white diamonds, small printed diamonds, and dominant crosses in squares, also seen in African American graves and houses, are symbols derived from a Central African Kongo cosmogram. The large light and dark circles are reminiscent of the Kongo sun of life and the midnight sun of the ancestral world. The four round black circles are similar to the Ejagham (Nigerian) sign for physical and spiritual vision.

The black and white geometric cloth in Plummer T.'s *Appliquéd Quilt* came from commercial fabric used by the

Freedom Quilting Bee for geometric quilts. But Plummer T.'s use of it, in combination with a protective "hand," produced a seeming index to African religious symbols remembered in the Americas. The hand is a reference to a mojo—a charm, or, in other words, a helping hand. The Montgomery Museum of Art, the American Folk Art Museum, and the Quilt Study Center at the University of Nebraska, Lincoln, own examples of Plummer T. Pettway's quilts.

MAUDE SOUTHWELL WAHLMAN
University of Missouri at Kansas City

William Arnett and Paul Arnett, *The Quilts of Gee's Bend: Masterpiece from a Lost Place* (2002); John Beardsley, *Gee's Bend: The Women and Their Quilts* (2002); Maude Southwell Wahlman, *Signs and Symbols: African Images in African American Quilts* (2001).

Phillips, Samuel David

(1890–1973)
Ordained an evangelist of the Gospel by the Association of Pentecostal Assemblies of Atlanta in 1934, Samuel David Phillips is one of the self-taught artists who carried the South with them when they moved to other regions of the country. Phillips, wishing to escape limited opportunities and the threat of violence toward blacks, left Georgia during the Great Migration to Chicago. His fundamentalist beliefs—salvation through Jesus Christ, an imperative to turn from sin, and a conviction that the world will one day come to an end—were at home in both North and South.

Using crayons, colored pencil, and tempera, often on the backs of oilcloth tablecloths and other supports close at hand, Phillips created more than 70 teaching charts that illustrate biblical accounts and explicate theological principles. Many, often as large as 5 x 6 feet, are retellings of Bible stories that sometimes include scenes of contemporary life. In *Jonah and the Whale*, for example, the boat from which Jonah falls is a modern steamship. Simpler charts explore such themes as "Money is the root of all evil."

Among the most artful and elaborated works of Phillips's are the prophecy charts common to a popular strand of end-time Christian theology. Followers of William Miller, a Baptist lay preacher who preached the Second Coming through illustrated charts, were instrumental in establishing this widespread method of teaching and preaching. The Millerite *Chart of 1843*, which calculated the date of the Second Coming through correlation of the prophecies contained in the books of Daniel and Revelation and eras of human history, is still a model for publishing houses and for self-taught artists like Phillips. Phillips, a pastor of the Progressive Pentecostal Mission in Chicago as well as an artist, preached rousing sermons on end-time prophecies until his death in 1973.

CHERYL RIVERS
Brooklyn, New York

Carol Crown, *The Outsider* (Winter 2002); Carol Crown, ed., *Coming Home! Self-Taught Artists, the Bible, and the American South* (2004); Cleo Wilson, *The Outsider* (Summer 1998).

Pierce, Elijah

(1892–1984)

Elijah Pierce was one of the most significant self-taught artists of the 20th century. He is known for his narrative relief panels and sculptural tableaux carved in wood and embellished with colorful enamel paints. Pierce's subjects encompass biblical stories, moral lessons, autobiographical tales, animals, and portraits of figures distinguished for their roles in history, politics, sports, or entertainment.

Pierce was born in Baldwyn, Miss., to farmer and former slave Richard Pierce and his second wife, Nellie Wallace. While a teen, Pierce became a barber, a trade he practiced for the rest of his life. In 1911 he fathered a son, Arthur, who was raised by maternal grandparents. Four years later he married Zetta Palm. They had a child, Willie Aaron, who, following the death of his mother shortly after childbirth, was also raised by grandparents. From about 1917 to 1920 Pierce was an itinerant laborer, working primarily on railroad bridge gangs. In 1920 the Mt. Zion Baptist Church in Baldwyn issued Pierce a preacher's license. In 1923 he met Cornelia West Houeston in Illinois and followed her to Columbus, Ohio, where they married and where for 60 years he practiced barbering at a number of shops.

Pierce carved from childhood. In 1923 he produced *The Little Elephant* for Cornelia. Many works, including the *Book of Wood*, were used in his ministry. During the 1930s and 1940s he and his wife took summer trips, preaching at various venues and employing his carvings as visual texts for lessons.

In Columbus, Pierce was a well-known, respected member of the African American community, active in his church and Masonic lodge. In 1951 he opened his own barbershop. There a steady stream of patrons exchanged news, jokes, and opinions with the shop's proprietor. Cornelia died in 1948, and, in 1952, Pierce married Estelle Greene, who survived him.

Around 1970 collectors and scholars of American folk art "discovered" Pierce. The initial presentation of his carvings as folk art took place in 1971 at the Ohio State University art gallery. During the next decade, Pierce's work was exhibited in university and museum venues throughout the Midwest and East. He received numerous honors and recognitions, including a National Heritage Fellowship. This recognition stimulated Pierce to produce a new outpouring of work. In 1982 his carvings were included in the seminal traveling exhibition *Black Folk Art in America, 1930–1980*. At age 90, Elijah Pierce proudly attended the opening of this exhibition at the Corcoran Gallery in Washington, D.C. Two years later, he died of a heart attack in Columbus.

Pierce's carvings are held in many important public and private collections. Among his notable works are *Crucifixion* (mid-1930s), *Book of Wood* (ca. 1932), *Obey God and Live* (1956), all in the Columbus Museum of Art; *The Wise and Foolish Virgins* (n.d.) in the Akron Art Museum; *Pearl Harbor and the African Queen* (1941) in the Mil-

waukee Art Museum; and *Abraham Lincoln* (ca. 1975) in the American Folk Art Museum.

NANETTE MACIEJUNES
Columbus (Ohio) Museum of Art

Elsa Longhauser and Harald Szeemann, eds., *Self-Taught Artists of the 20th Century: An American Anthology* (1998); Norma J. Roberts, *Elijah Pierce: Woodcarver* (1992).

Polhamus, Melissa
(b. 1957)

Melissa Polhamus was born 23 August 1957 in Ludwigsburg, Germany. As an infant she was adopted by a U.S. military serviceman's family, which returned to the States when Polhamus was only 18 months old. Polhamus's family continued to relocate frequently as a result of her father's military career. After graduating from high school, Polhamus attended Virginia Polytechnic University, earning a degree in history. She held many jobs, ranging from librarian to golf course groundskeeper to information analyst for a United States defense contractor. In 1989 Polhamus was injured in an automobile accident and suffered from deep depression. During this time she began to draw. Polhamus explains that making art "is a compulsion, all I have going for me right now. I have trouble paying my rent, but I can't stop doing [the drawings]."

Initially Polhamus used pen and ink. In later works she employs colored ink, crayon, and watercolor on high-quality paper. Impulsive and instinctual, Polhamus creates vivid two-dimensional works that are dizzying visual tugs-of-war that push and pull the subjects contained within them. Vertical, horizontal, diagonal, and zigzag lines divide space and force figures to bend over, under, and around the fractured, unsteady architecture. Her figures, red-lipped with gnashing teeth, appear to perform inane and inexplicable tasks among the flora and fauna. Machines, musical instruments, weaponry, and other objects whir throughout compositions. Geometric shapes and symbols, such as crosses and hearts, occupy whatever space is available and often radiate from the subjects, surrounding them within a ripplelike frame. The overall result is a tight, pressured environment that evokes nervous agitation. The viewer who witnesses the tormented subjects of Polhamus's vivid imagination can feel voyeuristic.

Polhamus was named the recipient of the 2001 artist in residence at the Virginia Center for the Creative Arts and received the 1998–99 individual artists' fellowship from the Virginia Commission for the Arts. Examples of Polhamus's work can be found in the Baron and Ellin Gordon Art Galleries, Old Dominion University, the Daura Gallery at Lynchburg College, and the Linda Lee Alter Collection of Art by Women at the Pennsylvania Academy of the Fine Arts.

MELISSA CROWN
University of Memphis

Jenifer Borum, *Raw Vision* (Spring 2002); Ellin Gordon, Barbara L. Luck, and Tom Patterson, *Flying Free: Twentieth-Century Self-Taught Art from the Collection of Ellin and Baron Gordon*, the Abby Aldrich Rockefeller Folk Art Center (1997); Paul Manoguerra, *Amazing Grace: Self-Taught*

Artists from the Mullis Collection; Tom Patterson, *Raw Vision* (Spring 2004); Betty-Carol Sellen with Cynthia J. Johanson, *Self Taught, Outsider, and Folk Art: A Guide to American Artists, Locations, and Resources* (2000), *Twentieth-Century American Folk, Self-Taught, and Outsider Art* (1993).

Polk, Charles Peale

(1767–1822)

Charles Peale Polk was born 1767 in Annapolis, Md., son of Elizabeth Digby Peale and Robert Polk. An orphan by the time of the Revolution, Polk was taken in by his uncle, the noted American artist Charles Willson Peale, and raised to become a painter. He was trained to use the materials, techniques, and stylistic elements of late 18th-century portraiture.

As a youth in Philadelphia Polk became a Baptist, the faith that he followed throughout his life. He married Ruth Ellison about 1785, and the first of his 12 children was born soon after. Following a brief attempt to paint portraits in Baltimore, he returned to Philadelphia and advertised himself as a "house, ship and sign painter." However, he soon resumed work, offering portraits of President George Washington to the public. Although Polk's letter to Washington requesting him to sit for a portrait survives, no acknowledgment has been found. Examination of the many Washington portraits Polk subsequently painted indicates that he derived his image from a portrait painted by his uncle, Charles Willson Peale. Polk's portrait alludes to the battle of Princeton: Washington looms in the foreground. In the background is Nassau Hall, the oldest building on the Princeton campus, and an encampment of soldiers. Polk advertised this "Princeton" type and painted replicas of it throughout his career. More than 57 have been identified by the artist's name and numbered inscriptions on the reverse.

In 1791 after a few years of itinerancy in Maryland and Virginia, Polk settled in Baltimore where he enjoyed some artistic success. The next five years were fruitful ones during which he produced at least 35 portraits, offered his services as a drawing teacher, and operated a dry goods store.

Polk then moved in 1796 to Frederick, Md., where his growing family resided while he traveled through the western reaches of that state and Virginia seeking portrait commissions. During this time his style matured. His brushstroke became fluid, seeming to sparkle with electric highlights. He employed a heightened palette and attenuated the human form as evidenced in his masterpieces of James Madison Sr. and Eleanor Conway Madison (parents of James Madison Jr., who would become the fourth president of the United States) and Isaac Hite and his wife, Eleanor Madison Hite (the daughter of James Madison Sr. and sister of James Madison Jr.). The Hites and their in-laws, the Madisons, were painted in Polk's mature style during 1799 at Belle Grove Plantation in Frederick County, Va. Polk establishes their high place in society though the figures' clothing and possessions.

Polk presents Isaac Hite, a builder, an educated landowner, and man of

intelligence in a manner that demonstrates both his wealth and political involvement. With a dewy complexion, Hite sits at the very edge of his chair ready to spring into action. The newspaper and book, which lie on the table at his side, are emblems of his intelligence and learning. The refined plainness of his clothing and his upright posture demonstrate the rectitude of a citizen supporting the republic movement behind Thomas Jefferson, then running for president. Emblems of republican rectitude are equally evident in the Thomas Jefferson portrait that Hite commissioned from Polk in 1799. In it, a weatherworn Jefferson dressed in plain clothing appears to be the common man. As soon as the portrait was completed, Polk advertised in Richmond that he would produce replicas. Five are known today.

Soon after the election in February 1801, Polk used his political contacts to find employment with the federal government. He moved his family to Washington, received financial assistance from Thomas Jefferson, and received a clerkship in the Treasury Department. Polk became active in the community, playing a major role in founding the first Baptist church in the District of Columbia and recording the minutes of its first meetings. During these years he began working in a new medium, *verre églomisé*—a reverse painting using gold leaf on glass, made popular in France at the end of the 18th century. He made portraits of James Madison Jr., secretary of state, and Albert Gallatin, secretary of the treasury.

Polk continued to work as an itinerant painter. He married two more times. With Ellen Ball Downman, his third wife, and their daughter, Ellen, his 12th and last child, he moved to Richmond County, Va., to farm land left to his wife. His final years were spent there near Warsaw, Va., presumably farming, but his records listing painting equipment hint that he painted until the end of his life.

Polk's family connections and training set him on a career path in the arts with access to sitters and technical training not readily available to many of his contemporaries. Polk faced, however, the same challenges that confronted all 18th- and 19th-century painters. The American society in which he lived and worked did little to encourage, support, or value the arts. There were virtually no schools for training, no museums or artists' associations, no dealers and little if any government support available. Polk creatively turned to other avenues to find the income needed to support his large family. He considered following his uncle's example of opening a museum in Washington. He was prolific in painting portraits of notable men including sitters like George Washington, Benjamin Franklin, Lafayette, and Thomas Jefferson throughout his career. His artistic style had an influence on other artists working in the western regions of Maryland and Virginia, adding to the richness of their images. He, like they, was financially challenged throughout his career, and it is only near the end of his life that he found financial security. Polk's portraits capture elements of time and places long vanished. Charles Peale

Polk's paintings are held in the collections of the Abbey Aldrich Rockefeller Folk Art Museum, the Museum of Early Southern Decorative Arts, the Baltimore Museum of Art, the Smithsonian National History Museum, and the Metropolitan Museum of Art.

LINDA CROCKER SIMMONS
Corcoran Gallery of Art

Linda Crocker Simmons, *Charles Peale Polk, 1767–1822: A Limner and His Likenesses* (1981), *The Peale Family: Creation of a Legacy, 1770–1870* (1996), in *Painting in the South, 1564–1980,* ed. Donald B. Kuspit et al. (1983), *Southern Quarterly* 24, no. 1 (1985).

Powers, Harriet
(1837–1910)

Harriet Powers's two Bible quilts are among the most important and revered works of American folk art. The creations of a former slave, the quilts demonstrate African American aesthetic and folkloric traditions as well as the influence of religious beliefs common among southern Evangelicals. In these masterpieces, Powers transforms a traditional communal art into a remarkably free and creative expression.

Powers was born 29 October 1837. She was likely the unnamed 12-year-old girl listed in the 1850 Madison County, Ga., slave census as owned by Nancy Lester, a 65-year-old widow. In 1855, Powers married Armstead Powers, a farmer. According to the 1900 United States Census, the couple lived in the Athens, Ga., area and had nine children. Only three survived to adulthood. In her lifetime, Powers was grandmother to at least 20.

About 1885 or 1886, Powers stitched a vividly colored, appliquéd pictorial quilt, housed today in the Smithsonian National Museum of American History. The *Bible Quilt* is composed of eleven cotton blocks, each depicting a different Bible story. According to Powers, whose descriptions were recorded, they represent Adam and Eve in the Garden of Eden, continuation of Paradise with Eve and a son, Satan amid the seven stars, Cain killing his brother Abel, Cain goes into the land of Nod to get him a wife, Jacob's dream, the Baptism of Christ, the Crucifixion, Judas Iscariot and the 30 pieces of silver, the Last Supper, and the Holy Family.

Powers exhibited her quilt at the Northeast Georgia Fair in Athens in November 1886. A local art teacher, Onieta "Jennie" Smith, was mesmerized by the quilt and sought to purchase it for 10 dollars. Powers refused to sell. But, in 1891, Powers was in need of funds and sought out Smith to see if the offer was still open. It was. However, Smith could pay only five dollars. In her desperation, Powers accepted.

Powers extracted a promise from Smith that she could visit her "offspring." Smith, in turn, gave Powers scrap fabric. Smith wrote down Powers's description and interpretation of each of the quilt's squares. Jennie Smith exhibited the *Bible Quilt* at the 1895 Cotton States and International Exposition in Atlanta. Representatives of Atlanta University saw the quilt and later either purchased or commissioned another quilt by Powers. Smith passed away in 1946. Her executor held the quilt and documentation for 20 years

before offering them as a gift to the Smithsonian Museum of History and Technology, known today as the Smithsonian National Museum of American History.

Powers's second quilt, sometimes called the *Pictorial Quilt*, is now in the Museum of Fine Arts, Boston. This is the quilt that associates of Atlanta University commissioned or purchased as a gift for Charles Cuthbert Hall, a member of the Atlanta University Board of Trustees and a staunch supporter of Negro education, presumably on his becoming the sixth president of the Union Theological Seminary in New York.

Powers combined machine and hand sewing to create a vivid narration of Bible stories, Bible prophecies, and folkloric tales of celestial events. The quilt's 15 cotton blocks feature both Old and New Testament events, such as the stories of Jonah and the whale and the Crucifixion of Christ. Powers also represents actual events, such as the falling stars of 13 November 1833, when 10,000 meteors fell across the eastern seaboard of the United States. This event had become folklore before Harriet Powers was born and was associated with the end of time. "The people were fright and thought that the end of time had come. God's hand stayed the stars."

The *Pictorial Quilt* stayed in the Hall family for two generations adorning a wall on the second floor of the family's summer home. One of the great-grandchildren confessed publicly that as a child he used a Bic ballpoint pen to draw eyes onto some of the animals and birds. Hall's son, Rev. Basil Douglas Hall, decided to sell the quilt in 1960;

he took it to the Museum of Fine Arts, Boston. The museum benefactor and folk art enthusiast Maxim Karolik immediately made an offer of $500 for the "charming" quilt and bequeathed it to the museum.

Power's quilts show a close association with the appliquéd cotton cloths made by the Fon people of the Republic of Benin. Their large wall hangings, which were created in honor of their kings, feature two kinds of appliquéd images. There are animals, such as lions, buffalo, birds, and sharks, which symbolize the king's identity, and pictorial scenes portraying events in a ruler's life. Powers's quilts contain similar images: animals-elephants, whales, pigs, and birds—and scenes illustrating specific event. Such parallels suggest that her quilts owe a strong debt to African traditions.

Some scholars have assumed Powers was illiterate because she had been a slave. In 2009 a copy of a letter from Harriet Powers to Lorene Curtis Diver of Keokuk, Ia., was discovered. Diver had photographed Powers's *Bible Quilt* at the Cotton Exposition and wrote Powers's that she wanted to purchase it. In her reply Powers wrote that she had learned to read at age 11 and read the Bible frequently. She wrote about making five different quilts, although only the two Bible quilts are known.

KYRA E. HICKS
Arlington, Virginia

Marie J. Adams, *Black Art: An International Quarterly* (1979); Gladys-Marie Fry, *Missing Pieces: Georgia Folk Art* (1976); Kyra E. Hicks, *This I Accomplish: Harriet Powers' Bible Quilt and Other Pieces* (2009);

Catherine L. Holmes, in *Georgia Quits: Piecing Together a History*, ed. Anita Zaleski Weinraub (2006); Regenia A. Perry, *Harriet Powers's Bible Quilts* (1994).

Proctor, Mary

(b. 1960)

Mary Proctor took up art making after the deaths of her grandmother, aunt, and uncle in a 1994 house fire. The loss of the relatives who had raised her threw her into a depression. She "didn't know which way to go" and resorted to fasting and prayer. Her pleas for guidance were answered during February 1995, when "the Lord gave me a vision. He told me to paint on a door. He gave me words." The words were "Can anyone imagine how broken hearted God must be because of the sins of we?"

Proctor, who belongs to a Holiness Church of God, quotes John 10:9: "Jesus said, 'I am the door, by me if any man enter in, he shall be saved.'" When God spoke to Proctor and told her to paint, she grabbed the two cans of blue and white car paint that were on hand and went to work. "Blue like the sky," she muses, adding, "it's like walking outdoors and being overwhelmed. Awesome." Proctor has continued to paint on garage doors, old windows and their wooden frames, and small squares of wood.

Maneuvering through a sea of blue paintings, sometimes enhanced by shards of mirrored glass, buttons, and fabric that fill her house, Proctor paints few themes but varies expressions and interpretation slightly each time. This repetition is her way to "go deeper." She explains, "The message needs to be out there." Another message comes from her childhood. She recalls, "When I was a child I broke my grandmother's old Blue Willow plate. I thought she would whip me. Instead she held my hand and said I forgive you because just yesterday God forgave me. She said God said one must forgive to be forgiven."

Proctor had never painted before her vision, but now she cannot stop, claiming that God uses her to communicate his love for humankind. In his service, she signs her paintings Missionary Mary Proctor. On the outskirts of Tallahassee, Proctor has converted a house into a gallery that contains thousands of her paintings and assemblage paintings. She stacks her garage door paintings in the fenced yard, and the site—looking like the used car lots that dot the old southern highways—can hardly be overlooked. Now Mary Proctor charges admission to her museum shrine.

GARY MONROE
Daytona State College

William Arnett and Paul Arnett, eds., *Souls Grown Deep: African American Vernacular Art*, vol. 2 (2001); Abby M. Contrat, *Modern Maturity* (May–June 1998); Clendinen Dudley, *New York Times* (4 April 2004); Steve Kistulentz, *Raw Vision* (Winter 1999).

Reinhardt, Minnie Smith

(1898–1986)

Minnie Smith Reinhardt shared her rural experience in southeast Catawba County, N.C., by painting familiar scenes of harvestings, plantings, banjo pickings, laundry days, and holiday celebrations. Her art reveals her sensitive eye for detail and familiarity with her subjects.

Minnie was born on a farm to Wade and Emmeline Smith. Her father raised most of the crops necessary to sustain his wife and 11 children. He sold or bartered cotton, sweet potatoes, molasses, and pottery. As a child, Minnie participated in farm chores—plowing, planting, and harvesting. At age six or seven, she began her formal education at the Hog Hill School, a one-teacher, one-room schoolhouse located more than three miles from her home. Her school year was abbreviated, lasting only about four months of the year. Despite the long, daily trek, Minnie enjoyed school as the opportunity to spend time with other children in the community and as a relief from work chores. School was also a place where she could draw, something she was immensely interested in doing.

Reinhardt quit school around age 16 and a few years later married Melton Reinhardt, a farmer. Over the next 60 years, she farmed, raised six children, and continued the activities she had learned from childhood. Her life was so demanding that she did not think about drawing and painting. Her main creative outlets were flower arranging and sewing, women's traditional domestic pursuits.

In late 1975 Reinhardt's eyesight began to fail, and distinguishing colors and shapes became increasingly difficult. Successful cataract surgery gave her renewed spirit. Her daughter Arie Taylor presented her with a gift of oil paints, brushes, and instruction manuals that reinvigorated her yearning to paint. From 1975 to 1986, Reinhardt painted nearly every day. She painted on plywood she found and on rocks from the fields. The subjects of her paintings were people, events, and places—the sum total of her life experience.

Reinhardt preferred painting in oil on canvas. Many of her paintings measure 18 x 24 inches. Reinhardt organized her compositions by drawing a grid on her canvasses. She commonly sketched buildings and trees before painting sky and ground. She used her brush spontaneously to add fine details. Hog Hill School, pottery shops, wheat harvests, cotton fields, corn shucking, molasses making, and the Corinth Baptist Church provided inspiration for many genre scenes. She often repeated the same general subject but varied the details, placement, figures, color, and seasonal setting.

Reinhardt enjoyed attention from her many visitors, recorded in sales in an account book. Her strong desire to create lasted through her final years, and she enjoyed the one-person exhibition, *Mine's My Style: The Paintings of Minnie Smith Reinhardt*, that was organized by the North Carolina Hickory Museum of Art in 1996. Many of her painting are in the Hickory's permanent collection. Work can also be found at the Ackland Art Museum, University of North Carolina.

LEE KOGAN
American Folk Art Museum

Roger Cardinal, in *Self-Taught Art: The Culture and Aesthetics of American Vernacular Art*, ed. Charles Russell (2001); Mary Smith Reinhardt, *Mine's My Style: The Paintings of Minnie Smith Reinhardt* (1996).

Roberg, Robert

(b. 1944)

When preaching on street corners in Nashville, Tenn., Robert Roberg, an unimposing, gentle man, was abused more often than heard. One day he picked up chalk and drew references to the scriptures on the sidewalk. After people stopped, looked, and listened, his previous interest in painting was rekindled. Roberg had painted years before but had destroyed all of his creations because he viewed them as sacrilegious, but now he embarked on what would become a second career as an artist.

Most of Roberg's imagery expresses his view about socially abhorrent behavior. A written message, akin to a commandment, completes each piece. Religion and religious tales inspire many outsider artists, but Robert Roberg's paintings portray Christian tenets of morality with a vengeance. Although always a dutiful soldier of the Lord, as he matured he criticized the hypocrisies of the Christian church, feeling that "the true Gospel has been usurped by Greek Philosophy and Roman militant paganism." His recent paintings challenge the deity of Christ and the Trinity and attack a Christian war ethic as un-Christian.

Having moved from Palmetto, a depressed town on Florida's Gulf Coast, to Gainesville, Roberg now spreads the Word to university students. As he paints on his easel in public places, the young and curious come to him. He points out that the pierced and tattooed residents of this college town are especially intrigued by his work, finding him to be a refreshing change from the typical art scene. When a gallery director censored his work, saying his imagery might offend, Roberg replied, "I hope so. If my art doesn't offend someone then I am off message."

Roberg still fears that recognition, and the financial rewards that may follow, might undermine his conviction to paint, without compromise, in the Lord's service. "I've wasted too much money and time on this solitary art form with too few results." He says, "The problem with preaching through painting is that you are dependent upon good weather, if you paint out on a street corner. Next you are sending a mixed message: people perceive you as a painter and maybe even are attracted to your art, but when they discover you are trying to convert them, they feel a little deceived. The next problem is part of the Gospel message that a man should not put his affections on the things of this world, and yet I am creating an art object that someone will likely covet and treasure. It's kind of like a woman dressed as a whore standing on a street corner condemning sex. I may be creating objects that will not promote a simple nonattachment to the world, but objects that anchor people to this world."

Roberg's vibrant colors, occasional use of glitter, and ornately crafted frames do indeed underline the tension between message and expression. Signing his name in the shape of the cross and noting "Talent by Y'Shua" on each painting, he takes no credit for his vision. While completing 101 Revelation paintings, he discovered a technique to portray his images three-dimensionally

with the use of special glasses; under black light they ascend to yet another level. "It was very popular in my studio but I had to stop because the medium was overwhelming the message. People's reaction was 'Wow, how do you do that?'" Roberg still wants his message to be central, not peripheral.

GARY MONROE
Daytona State College

Kristin G. Congdon and Tina Bucu-valas, *Just above the Water: Florida Folk Art* (2005); Carol Crown, ed., *Coming Home! Self-Taught Artists, the Bible, and the American South* (2004); Gary Monroe, *Extraordinary Interpretations: Florida's Self-Taught Artists* (2003); Chuck Rosenak, *Contemporary American Folk Art: A Collector's Guide* (1995); Betty-Carol Sellen and Cynthia J. Johanson, *Twentieth-Century American Folk, Self-Taught, and Outsider Art* (1993); Amy Namowitz Worthen, *Apocalypse Prophecies and Visions* (2001).

Robertson, Royal

(1936–1997)

Royal Robertson was born 21 October 1936 in Baldwin, La. A field hand and sign painter by trade, he married Adell Brent in 1955. The couple had 11 children. Adell left her husband in 1975, and her departure prompted the paranoia that is at the heart of Robertson's two-sided cartoons and divinatory calendars.

Adell's supposed unfaithfulness sparked erotic, sometimes pornographic imagery in Robertson's work, depicting women's inconstant natures. Robertson's copious writing from this period teems with epithets such as "harlot" and "whore" intermingled with biblical references to adultery and to the figure of Jezebel, who was, for the artist, Adell's biblical parallel. Robertson further perceived himself as prophet and patriarch, calling himself an apostle, a saint, and a psychic. He located the drama of his existence in a mythical time in which he could play a major role. Robertson's obsession with dating minute details of his personal life along with his systematic inclusion of "A.D." clarifies his view of himself as one in a long line of biblical characters.

While Robertson remained convinced that he had been chosen to carry out God's command to condemn the perversity of women and their male followers, he was unable to defend himself from the forces he believed were conspiring against him. Although the many weapons he drew had the potential to harm, they could not match the tidal waves, cyclones, earthquakes, and other devastating forces he predicted in images and words as the logical conclusion for a depraved world.

Robertson, however, also dreamed of better worlds and even visited some of them during his frequent hallucinatory journeys into outer space. His visionary work is filled with spaceships, aliens, and futuristic cities. These utopian projects reveal a postapocalyptic era in which he is recognized as a genuine and charismatic leader.

Until that time could come to pass, Robertson felt he had to take refuge in a protective structure designed to repel malevolent forces. An avalanche of misogynistic signs faced the street and promised unwelcome visitors a well-deserved apocalyptic experience should they choose to trespass on his land. In-

side his house, a profusion of words and images sealed his inner space while an ongoing restructuring of the interior architecture was meant to disorient potential intruders. This marvel of architectural thinking vanished in August 1992 when Hurricane Andrew struck southern Louisiana and destroyed the house. Against great odds, Robertson eventually rebuilt his house and even reconciled with several of his children. Seemingly on the way to a more comfortable life, he died of a heart attack on 5 July 1997. Robertson's work is in the permanent collection of the Smithsonian American Art Museum and the Ogden Museum of Southern Art.

FRÉDÉRIC ALLAMEL
Indianapolis, Indiana

Frédéric Allamel, *Raw Vision* (Winter 1996), *Southern Quarterly* (2001); Roger Manley, *The End Is Near! Visions of Apocalypse, Millennium, and Utopia* (1998); Frank Marescam and Roger Ricco, *American Self-Taught: Paintings and Drawings by Outsider Artists* (1993); Andy Nasisse and Maude Southwell Wahlman, *Baking in the Sun: Visionary Images from the South* (1987).

Rodriguez, Dionicio

(1891–1955)

Dionicio Rodriguez, Mexican *trabajo rustico* (rustic work) or *faux bois* (false wood) sculptor, born in Toluca, Mexico, in 1891, captured nature in cement by mimicking the forms, textures, and colors of wood and rocks. Metal rebar forms, wired together by assistants, were covered with metal lathe and a coat of concrete. Rodriguez then applied a final layer of pure Portland cement with startlingly realistic imitations of smooth and peeling bark, knot holes, lichen patches, split logs, and surfaces of smooth and craggy rock. Oral tradition reveals that he learned the technique from Robles Gil in Mexico City, who possibly had developed the skill in Europe.

Rodriguez's first work in the United States was in San Antonio in 1924, where many of his works have become beloved landmarks. His reputation spread by word of mouth, resulting in commissions throughout Texas and seven additional states. Early work for clients in east Texas included a landscape environment with bridges spanning an artificial lake for Beaumont oilman John Henry Phelan, a conch shell fence and "Cave of Sounds" made of 5,000 conch shells for sea captain Ambrose Eddingston in Port Arthur, and a fountain and bare trees for the aviary in the Houston Zoo.

In 1932 North Little Rock real estate developer Justin Matthews hired Rodriguez to embellish three parks in his residential areas. Rodriguez considered Pugh Memorial Park, a fantasy land of twisted branch bridges, benches, fences, walkways, and a 10,000-pound working cement water wheel, his greatest achievement. Commissions in Dallas and Michigan followed.

By 1935 Rodriguez returned to the South, where Clovis Hinds of Memphis was developing Memorial Park Cemetery. Hinds commissioned Rodriguez to build biblically themed sculptures: the Pool of Hebron, Abraham's Oak (a hollow tree sculpture), the Cave of Machpelah, and the Crystal Shrine Grotto, decorated with five tons of Arkansas crystals. Rodriguez continued

to work periodically for Hinds, with whom he had a nine-year correspondence, until 1939. In 1935 he traveled to Michigan and Brentwood, Md., where he sculpted a vaulted ceiling in Lincoln Park Cemetery.

Owner of Cedar Hill Cemetery in Suitland, Md., farmer-merchant William H. Harrison, commissioned bridges, a tree house, a fallen log bench, and other pieces in 1936 and 1937. In 1938 Rodriguez sculpted work almost identical to that in Cedar Hill—a fallen tree bench, a bridge, and a thatched roof shelter—for the owner of Birmingham's Elmwood Cemetery, investment banker John Jamison.

Rodriguez created sculptures for six memorial park cemeteries in the 1930s, and the largest body of his work was executed during the lean years of the Great Depression, because cement was cheap and the artist worked quickly. In 1939 Rodriguez worked in two cemeteries in Chicago and for Arkansas railroad owner Harvey Couch, at Couch's vacation homes. By 1940 he had returned to Texas, with later trips to New Mexico and back to Arkansas.

Rodriguez taught many others his technique, but his work is considered the most organic of those who worked in the genre. Twenty-three of his projects are listed on the National Register of Historic Places. In the early 1950s, after a lifelong struggle with diabetes, Rodriguez returned to San Antonio, where he lived until his death in 1955 in a tree house that he had built for himself.

PATSY PITTMAN LIGHT
San Antonio, Texas

Patsy Pittman Light, *The Cement Sculpture of Dionicio Rodriguez* (2008); Julie Vosmik, "The Arkansas Sculptures of Dionicio Rodriguez," National Register of Historic Places (4 December 1986), "The Sculptures of Dionicio Rodriguez at Memorial Park Cemetery," National Register of Historic Places (31 January 1991).

Rogers, Sulton
(1922–2003)

Born in Lafayette County, Miss., in 1922, Sulton Rogers was the creator of uncanny, sometimes satirical, sculptures and canes. Rogers drew much inspiration from the preaching of his father, a minister at the North Hopewell Missionary Baptist Church. Rogers began to carve with a jackknife while working as a night watchman in a chemical plant in Syracuse, N.Y. Rogers continued carving after his return to the Oxford, Miss., area in 1995 to live out his retirement. He created his carved and painted figures until his death in 2003.

Although Rogers carved crucifixions and other biblical subjects, many of his carvings are tableaux that satirize preachers who stand behind their pulpits and lead congregations of varied hellish figures. Rogers returned to this theme throughout his career and also created single figures, foot-tall animal-headed figures, half-human ladies of the night, coffin-bound figures, and erotic characters who appear to live out their hellish existence with exaggerated manifestations of their earthly sins. Peeping Toms may have six-eyes and agonizingly short legs, neighborhood gossips have ears the size of coyotes, and sexual perverts are manifest as hermaphro-

dites trapped in a world of ambiguous sexuality. All kinds of imaginary figures emerge from other works—nightmarish three-headed men with bulging eyes, sultry women in high heels with snakelike red tongues, dog-headed men, and hosts of other imaginary humanlike creatures. Roger's described these figures as "haints"—a familiar term used in the South to describe ghostlike apparitions. Other works reflect southern life more affectionately. Rogers's bird dogs point, and men may be treed by a pack of dogs. Rogers's world was seldom pretty—and if all the figures and haints he carved over the years could be seen in one gathering, its scope would rival the imaginative and surrealistic figurative works of 15th-century Dutch painter Hieronymus Bosch.

Rogers often built what he called "haint houses" for his creatures to inhabit. These multitiered buildings often became lamps, with doorways and balconies in which his figures appear. Rogers's work was first seen in the late 1980s and is in many public collections, including the Ogden Museum of Southern Art, the University of Mississippi Museum, the Mississippi Museum of Art, and the Georgia Museum of Art.

JOHN FOSTER
St. Louis, Missouri

Carol Crown, ed., *Coming Home! Self-Taught Artists, the Bible, and the American South* (2004); Kelly Ludwig, *Detour Art: Outsider, Folk Art, and Visionary Environments Coast to Coast* (2007); Alice Rae Yelen, *Passionate Visions of the American South: Self-Taught Artists from 1940 to the Present* (1993).

Rose, John
(ca. 1753–1820)

John Rose was a career court clerk and farmer in Beaufort District and Dorchester County, S.C., who painted in watercolors and oils for personal enjoyment. Although his life details are lost to the public, his most important work, now known as *The Old Plantation*, rose to iconic folk art status. *The Old Plantation*, a watercolor depicting a dozen enslaved men and women engaged in dancing, playing musical instruments, and conversation, has now become one of the best-known depictions of slavery in 18th-century America. Holger Cahill, the early advocate of American folk art, discovered the painting in Columbia, S.C., in the 1930s while seeking southern additions to the growing collection of folk art owned by Abby Aldrich Rockefeller. Rockefeller placed the painting with the Colonial Williamsburg Foundation in 1939, along with the rest of her collection, and it has remained there ever since, earning the admiration of viewers for its early, detailed, and sensitive portrayal of southern slaves.

Rose was appointed clerk of the court of common pleas for Beaufort District in 1775, a position he held until 1795, when he moved to St. George's Parish, Dorchester. While living in the town of Beaufort, he was active in helping start a free school and served on the vestry and as a churchwarden for St. Helena's Parish Church. He also owned nearby rural property on the Coosaw River, and it was there, sometime between 1785 and 1790, that he likely painted the celebrated watercolors of his slaves. Rose married twice, first prob-

ably to a Miss Jones, and second to a young widow, Mary Capers Ladson. He had children from both marriages and also raised a stepson.

After his move to Dorchester, John Rose continued to farm and paint. He also became involved with the local Congregational Church, then going through a revival of membership, and served as a deacon and as the musical director. Rose's interest in religion was evident in his choice of reading material, and when he wrote his will he left each of his heirs specific titles from his large library of books on Christian theology and behavior. His legacy of paintings and art supplies was divided between his widow and his children. Rose died in Charleston in 1820 as the result of a fall from his horse. Forty years after his death, an acquaintance described him as "a man who, in his conversation, was easy and innocent, and whose whole life was exemplary" and "who sang by note, painted in water-colors, and played upon the hand-organ—rare accomplishments in those times."

Rose was also a large slave owner, with documented ownership of more than 50 slaves during his lifetime, which sets him apart from other 18th-century American artists. Most of his slaves can be identified by name and gender, and in some cases by approximate dates of birth and family relationships. Although he regarded his slaves as chattel property and as a valuable labor force, there is evidence that he also saw their human side as well, deliberately choosing to keep mothers and children together when he willed them to his heirs and caring for his very elderly slaves.

Even though his surviving works of art are minimal, John Rose left a visual representation of his known world that cannot be overestimated for its value to historians of art, slavery, music, and southern culture.

SUSAN P. SHAMES
Colonial Williamsburg Foundation

Elizabeth Anne Poyas, *The Olden Time of Carolina* (1855), *Our Forefathers, Their Homes, and Their Churches* (1860); Susan P. Shames, *The Old Plantation: The Artist Revealed* (2010).

Rowe, Nellie Mae
(1900–1982)
Nellie Mae Rowe's dolls, chewing gum sculptures, and works on paper demonstrate a vivid imagination, a strong power of observation, a sense of humor, a deep spiritual faith, and a rootedness in her African American heritage. Rowe created thousands of works that embellished the interior of her home, and its exterior environment she called her "playhouse."

Rowe was born in Fayetteville, Ga., to Sam Williams, an expert basket maker, and Luella Swanson, a gospel singer and quilt maker. As a young child Rowe used fabric she found in the house to fashion dolls, marking their features with pencil or crayon. She showed talent in art as a child but, in her words, she "did not have the opportunity to study." Soon after her marriage to Ben Wheat, the young couple moved to Vinings, Ga., to seek a better life. They farmed, and her young husband died after being kicked by a horse. After a year as a widow, the artist married Henry Rowe, many years her senior. After Henry

Rowe died in 1948, Rowe concentrated on making her art. She had no children and believed that she was meant to develop her God-given talent in art.

Rowe painted on a variety of surfaces, including paper, plastic refrigerator trays, discarded wallpaper, books, discarded bits of cardboard, wood, and shaped forms made of chewing gum. She used pencil, crayon, felt-tip markers, and tempera paint on paper and cardboard. Rowe favored bright colors and rhythmical shapes in her compositions. Recurring motifs ranged from fish, dogs, hybrid creatures (such as half cow / half human or half owl / half human), and, occasionally, "haints." Self-portraits abound in Rowe's pictures, often several in one composition. In her last year, with knowledge of her impending death from multiple melanoma, the artist appeared in many pictures in the guise of a dog, accompanied by revealing text that underscored her anxiety, then resignation, and finally her abiding faith as she approached death.

Rowe's first important public exhibition was *Missing Pieces: Georgia Folk Art, 1770–1976* (1976). She has been included in virtually every important exhibition of 20th-century self-taught artists. Among these exhibitions are *Black Folk Art in America, 1930–1980* at the Corcoran Museum of Art (1980–83), *The Cutting Edge: Contemporary American Folk Art* (1990), *Passionate Visions of the American South: Self-Taught Artists from 1940 to the Present* (1993–95), and *Self-Taught Artists of the Twentieth Century: An American Anthology* (1998). A one-person exhibition, *Ninety-Nine and a Half Won't Do:*

The Art of Nellie Mae Rowe, opened at the American Folk Art Museum in 1999. Rowe's art is in the permanent collections of the High Museum of Art, the Morris Museum of Art, the Smithsonian American Art Museum, the Ogden Museum of Southern Art, and the American Folk Art Museum. Rowe was fortunate in having a sensitive representative and friend, contemporary gallery owner Judith Alexander. Alexander worked tirelessly on Rowe's behalf to gain recognition for the artist through exhibitions and publications.

LEE KOGAN
American Folk Art Museum

Linda Connelly Armstrong, *Nellie's Playhouse* (film, 1983); J. Richard Gruber, *Nellie Mae Rowe* (1996); Lee Kogan, ed., *The Art of Nellie Mae Rowe: Ninety-Nine and a Half Won't Do* (1998).

Salazar y Mendoza, José Francisco Xavier de

(b. mid-1700s; d. 1802)
José Francisco Xavier de Salazar y Mendoza was the foremost painter in Louisiana during the Spanish colonial period. Arriving in New Orleans in 1782 from Mérida in the Yucatán, Salazar painted portraits in the city for 20 years and produced a visual record of its civic and religious leaders, including Andrés Almonester y Roxas (1796), Dr. Joseph Montegut (ca. 1797), Padre Antonio de Sedella (ca. 1800), and Bishop Luís de Peñalver y Cárdenas (1801).

Inconsistencies in Salazar's painting style and drawing problems often suggest joint artistic ventures with his daughter, Francisca de Salazar y Magaña. Salazar's early life and artistic

training are unknown; he arrived in Louisiana as a mature artist. His portraits underscore awareness of Mexican provincial styles and European painting traditions. Shimmering transparent glazes in his portraits bear similarities to those of Goya. Salazar arranged his subjects frontally or in three-quarter view against a dark monochromatic ground. His portraits are characterized by even lighting, limited palette, warm accents in skin tones, upholstery, flowers, or symbolic attributes.

The son of Salvador de Salazar and Feliciana Ojeda y Bazquez, he married Maria Antonia Magaña while living in Yucatán. Maria was the daughter of Antonio Magaña y La Cerda and Francisca Xaviera del Hollós Conejo, an islaña. His daughter Francisca was born in Yucatán. José, the second child, was born in 1781. In 1782 the couple relocated to New Orleans. José Casiano was born in 1784, the first child born to an artist in the colony. Francisca, under her father's tutelage, was the first artist to study in Louisiana. The fire of 1788, which destroyed most of the city, left the Salazar family homeless. The 1791 Patrón, or Census, gives their address as St. Philip Street, where the couple's youngest child, Ramon Rafael de la Crus, was born. Both boys were baptized in St. Louis Church. Maria died on 24 June 1793; nine-year-old José Casiano died the next day. This close death date for mother and child suggests that the cause of death was probably yellow fever, which historically plagued the city.

In 1796 Francisca married Pedro Gordillo, a sergeant in a Spanish colo-

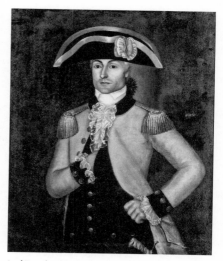

José Francisco Xavier de Salazar y Mendoza, Captain Don Joseph Bernard Vallière d'Hauterive, 1787–90, oil on canvas, 47" x 39¾" (Gift of Mr. and Mrs. A. Howard Stebbins III, from the Collection of the Historical Arkansas Museum)

nial cavalry regiment. On 4 March 1801, evidently being in ill health, Salazar made out his will. He died 17 months later on 15 August 1802. That same year Francisca painted a copy of her father's portrait of the bishop, intended for St. Louis Cathedral. Though married, Francisca signed herself "Franca Salazar." This portrait, Francisca's only signed painting, was destroyed in the 1988 Cabildo fire. With about 70 extant paintings attributed to Salazar, a collaborative effort with his daughter is probable.

In his will Salazar named Gordillo as guardian and referred to José and Ramon as his "minor sons." The appearance of Francisca's name in court records during the probate of her father's will is the last mention of the Salazar family in any Louisiana archive; thus, the fate of surviving family mem-

bers after the Louisiana Purchase is unknown.

Salazar survived at a time when few artists ventured toward Louisiana. The 1791 Census records only two other painters in the city along with Salazar, Joseph Furcoty and Joseph Herrara, of whom nothing is known. Salazar's paintings provide a unique historic glimpse into life in this difficult colony.

JUDITH H. BONNER
The Historic New Orleans Collection

Mrs. Thomas Nelson Carter Bruns, *Louisiana Portraits* (1975); Donald B. Kuspit et al., *Painting in the South, 1564–1980* (1983); John A. Mahé and Roseanne McCaffrey, eds., *Encyclopaedia of New Orleans Artists, 1718–1918* (1987); Jessie Poesch, *The Art of the Old South: Painting, Sculpture, Architecture, and the Products of Craftsmen, 1560–1860* (1983).

Samuel, William Giles Martin

(1815–1902)

William G. M. Samuel, a rugged adventurer and Bexar County, Tex., lawman, was also a self-taught artist who painted large portraits of men important to Texas history. Samuel's spirited town scenes of mid-19th-century San Antonio are also invaluable historical and social documents.

Among Samuel's large historical portraits, several of which he presented to Bexar County, are those of Sam Houston, president of the Republic of Texas, United States senator, and Texas governor; William "Big Foot" Wallace, the Indian fighter and Republic of Texas legislator; Pascual Leo Buquor, mayor of San Antonio; José Antonio Men-

chaca, a descendant of the first Spanish settlers who fought in the Battle of San Jacinto and politician; and John Salmon "Rip" Ford, congressman of the Republic of Texas, state senator, and mayor of Brownsville, Tex. Also attributed to Samuel is *Man on Horseback*, based on the well-known painting *The Trapper* by Charles Deas. The black-bearded subject of this work, in buckskins, confidently sits astride his horse, gun in hand. As Samuel, in his later years, dyed his hair and beard black, some scholars have suggested that this painting is a self-portrait.

A keen observer of life, Samuel made four oil paintings on canvas depicting different views of San Antonio's Main Plaza, the city center. The titles of the four paintings bear the date 1849; Samuel, however, may have painted from memory. Important as social documents, the paintings are also vigorous artworks. Each highlights important buildings and depicts people engaged in day-to-day business: transporting goods, vending merchandise, or chatting among themselves.

Samuel, born in Missouri, moved to Texas in the 1830s shortly after the fall of the Alamo. He took part in Indian wars and, during the Mexican War (1846–48), fought in the Battle of Chihuahua. He joined the Confederate army as an artillery officer during the Civil War. After the war Samuel was elected justice of the peace and lived at Garza Crossing, an Indian battle site. Active in city affairs, he served as marshal, as Bexar County notary public, and as deputy sheriff. He was an excellent marksman

and a fearless law enforcement officer, reputedly one of the bravest men of his time. In his later years, Samuel suffered from spinal disease but continued to work in a cement plant. He died in the St. Francis Home for the Aged and was buried in the Confederate Cemetery of San Antonio.

His paintings can be seen at the San Antonio Museum of Art and the Witte Museum.

LEE KOGAN
American Folk Art Museum

Pauline A. Pinckney, *Painting in Texas: The Nineteenth Century* (1967); Cecilia Steinfeldt, *Texas Folk Art: One Hundred Fifty Years of the Southwestern Tradition* (1981).

Samuels, Ossie Lee (O. L.)
(b. 1931)
Born on 18 November 1931, O. L (Ossie Lee) Samuels is a self-taught woodcarver. Samuels became a Baptist minister in the 1970s. He sometimes uses his sermons as a venue to reflect on difficult times in his youth. For example, while preaching from the pulpit, Samuels has been known to hold a long leather whip that he decorated with African colors and dotted patterns to tell the story of an abusive aunt. Her punishments were so unbearable that Samuels left his southern Georgia home when he was eight years old. As a result, he never received a school education and survived by tree work, prize fighting, and hauling nickel ore.

At the age of 50, while working as a tree surgeon, Samuels was crushed by a large limb. Samuels could not walk and became despondent. He remembered the words of his great-grandmother, a former slave, who had advised him to carve on a wooden spool whenever he felt depressed. Samuels heeded her words of wisdom and picked up a two-by-four piece of wood and a blade knife.

Carving had a curative effect on Samuels, who surrounds himself with his carvings and believes each piece has a distinctive spirit. He maintains that he can never re-create the same piece of art because the work itself dictates what it wants to become. Samuels, who lives in Tallahassee, Fla., combines miscellaneous objects such as tree barks, roots, and discarded wooden furniture to form his sculptures of hybrid animals, horses, dogs, snakes, religious characters, and political figures. Although he is color-blind, Samuels paints his sculptures with an array of colors and a "secret mixture" of sawdust, glitter, and glue, which he calls "skin." He decorates sections of his work with a base coat of spray paint and layers it with dotted patterns of T-shirt paint. Sometimes Samuels decorates his figures, with wigs, jewelry, buttons, beads, and glass, for added character.

Samuels's message is that art soothes the soul. He has seen art's power, and it has enabled him to overcome life's difficulties. Art has brought him joy. With a charming chuckle, Samuels openly describes how proud he is to know about the positive effects his work has had on people who have come into contact with it: "[The thought] that I was making them happy . . . made me happy some more!" The Arkansas Arts Center, the Smithsonian American Art Museum,

the Tubman African American Museum, and the Menello Museum all hold work by Samuels in their permanent collections.

DEBRAH C. SICKLER-VOIGT
Middle Tennessee State University

Kristin G. Congdon and Tina Bucuvalas, *Just above the Water: Florida Folk Art* (2006); Kathy Moses, *Outsider Art of the South* (1999); Jim Roche, *Unsigned, Unsung . . . Whereabouts Unknown: Make-Do Art of the American Outlands* (1993); Debrah C. Sickler-Voigt, *Journal of Cultural Research in Art Education* (2003 and 2006), *Art Education* (2006).

Sanchez, Mario

(1908–2005)

A Florida memory artist of Cuban descent, Mario Sanchez is known for his painted relief wood carvings of Key West. In these images, he portrayed cigar factories, street vendors, parades, children playing games, rumba bands, and other scenes that characterized everyday life in his neighborhood in the early to mid-20th century.

Sanchez was born in 1908 in the small apartment above his family's bodega at the corner of Duval and Louisa Streets in Key West. His family had emigrated from Cuba in 1869 at the beginning of the war for independence from Spain. Both his father and his grandfather were employed in the cigar factories. His father, Pedro Sanchez, who was bilingual, was a reader (*el lector*) in the factories. Sanchez's neighborhood, now known as Old Town, was called El Barrio de Gato after Eduardo Hidalgo Gato, who ran a successful cigar factory. Most of the members of Sanchez's extended family lived near El Barrio de Gato. Sanchez's carved relief paintings depicting the neighborhood events that he joyfully experienced are now valued for both their artistic and historical value.

Blessed with a remarkable memory, Sanchez skillfully captures minute details in the neighborhood places of his early childhood, a time before the island became a destination for tourists and developers. Many of the people in his carved scenes are individuals he knew, such as Little Sprinkle, Bad Body, Monkey Man, and Chicken Thief. Sanchez presents them engaged in activities that reflect their characters. In one painted relief, his father, as *El Lecto*, reads to factory workers as they roll cigars. The position lector was one of great honor, as the factory workers were able to get an education by listening to the reader. The name of the factory hangs above the tables and another sign advertises "1871," a popular brand of cigar. Men roll the cigars while women sit together separating tobacco into large tubs.

In his carvings, Sanchez also remembers his own youthful activities. He flew kites; played marbles, baseball, and pocket billiards; watched parades; spun tops; and wrote and performed plays. He was active in the Cuban Club, where he first performed as a comedian at age 12. Sanchez learned to form images in wood by whittling the pieces of driftwood he had found along the beach.

Sanchez, however, did not plan a full-time artistic career. In 1925 he

earned a degree from the Otto L. Schultz Business Institute in Key West. He worked for a while in real estate and then moved to Ybor City, a section of Tampa where the cigar industry had migrated. Here, Sanchez was employed as an office clerk and met Rosa De Armas, whom he married in 1929.

In 1947 a gallery owner became acquainted with carvings Sanchez had made in his spare time. Soon after this recognition, Sanchez was able to devote his time and energy to his carvings. His first relief carvings were made from the well-cured boxes that were used to ship tobacco to Florida from Cuba. He used Pennsylvania white pine whenever it became available and found cypress and cedar board at the local lumberyards. His tools were simple: a few chisels, a piece of broken glass, and a razor blade. In his early years, he worked in the back yard of his mother's house. He sketched a scene on a piece of brown paper and then traced it on wood. After the carving was done, he painted the wood with bright colors that imbue the image with celebratory feeling.

Sanchez's work continues to delight audiences with its scenes of Cuban life and landmarks, such as the Fourth of July Café, City Hall, La Brisa amusement center, and the Caroline Lowe house. Many of these places no longer exist. Mario Sanchez's work can be found in the Tampa Museum of Art, the Museum of Art in Fort Lauderdale, and the Key West Art and Historical Society.

KRISTIN G. CONGDON
University of Central Florida

Kristin G. Congdon and Tina Bucuvalas, *Just above the Water: Florida Folk Art* (2006); Kristin G. Congdon and Kara Kelley Hallmark, *Artists from Latin American Cultures* (2002); Nance Frank, *Mario Sanchez: Better than Ever* (2010); Elinor Lander Horwitz, *Contemporary American Artists* (1975); Kathryn Hall Proby, *Mario Sanchez: Painter of Key West Memories* (1981); Barbara Rothermel, *Folk Art* (1996).

Scott, James P. (J. P.)
(1922–2003)

To create his fanciful constructions, J. P. Scott called upon his childhood pastime of making things out of the cypress logs he had found on walks in swamps near his home in rural Plaquemines Parish, La. Scott went to work at age 14 and spent the following five decades working in a factory, on construction projects in New Orleans, on commercial fishing trawlers, and in a crab processing plant. Upon retiring in 1984, he began to create signature, imaginative mixed-media assemblages inspired by his work experiences, which had made him equally familiar with the waterways of southeastern Louisiana and the French Quarter of New Orleans.

Scott is best known for his reimagined fishing trawlers of the sort he knew as a fisherman. Scott constructed these boats from cypress, scrap metal, linoleum, car parts, children's toys, Mardi Gras doubloons, and myriad other cast-off materials and objects and then used marine paint—typically red, blue, black green, orange, yellow, white, and black—to enliven them. Scott's boats, ranging from one or two feet in length,

width, and height, to as much as five times larger, appear to belong to the same ingeniously ragtag fleet.

In addition to his signature boats, Scott also created airplanes, oil rigs, and reimagined houses inspired by his years working construction in the French Quarter. Like many self-taught artists, he displayed his work in his house and in his yard.

Scott may be counted among a relatively small, scattered brotherhood of self-taught artists devoted to celebrating modes of travel—most often boats and airplanes—the significance of which far exceeds the practice of model making. Like Scott, artists such as Leslie Payne, who built nearly life-size airplane replicas, and Walter "Captain" Flax, who built a fleet of mixed-media boats, deserve recognition as profound allegorists whose work celebrates freedom, adventure, and journeys taken in this life and the next. (Both men lived and worked, interestingly enough, in Tidewater Virginia.) Scott's work is in the collections of many museums, including the Ogden Museum of Southern Art and the Smithsonian American Art Museum.

JENIFER BORUM
New York, New York

Ted Degener, in *Souls Grown Deep: African American Vernacular Art of the South*, vol. 1, ed. Paul Arnett and William Arnett (2000); Fisk University, *The Afro American Collection* (1976); Kimberly Nichols, in *Passionate Visions of the American South: Self-Taught Artists from 1940 to the Present* (1993); Robert Farris Thompson, *Flash of the Spirit: African-American Art and Philosophy* (1983).

Scott, Lorenzo
(b. 1934)

Lorenzo Scott was born in rural West Point, Ga., on 23 July 1934, one of 11 children. He moved to Atlanta with his family when still a child and grew up across the street from a Baptist church. He quit school after completing the 10th grade. As a young man he found work in carpentry and construction, and also worked as a sign and house painter, but during a bus trip to New York with fellow Baptist church members in 1968, Scott was inspired by the sidewalk artists and by the works in the Metropolitan Museum of Art. Soon afterward, he moved to New York City, returning to Atlanta in the mid-1970s.

Scott's nascent passion for art, and his trips to the High Museum of Art after he returned to Atlanta, led him to oil painting. He began selling his art on an Atlanta street corner in 1983. His work was included in the exhibition *Revelations: Visionary Content in the Work of Southern Self-Trained Artists* at the Atlanta College of Art in 1986. In imitation of the historic frames that museums use for Old Masters, Scott creates his picture frames using Bondo, the automobile body compound. He supplements his continual trips to the High Museum with the personal study of reproductions of masterpieces in art books, periodicals, and postcards.

In 2002 Scott was honored with an Artist of Distinction award from the Folk Art Society of America. He had his first solo exhibition in 1993 at the Springfield Museum of Art in Ohio. His paintings can be found in the collections of the High Museum

of Art, the Georgia Museum of Art, the Morris Museum of Art, the Smithsonian American Art Museum, and the Tubman African American Museum.

PAUL MANOGUERRA
Georgia Museum of Art

Carol Crown, ed., *Coming Home! Self-Taught Artists, the Bible, and the American South* (2004); Stacy C. Hollander and Brooke Davis Anderson, *American Anthem: Masterworks from the American Folk Art Museum* (2001); Paul Manoguerra, *Amazing Grace: Self-Taught Artists from the Mullis Collection* (2007).

Shackelford, William Stamms
(ca. 1814–ca. 1878)
Born in Kentucky circa 1814, William Stamms Shackelford began his painting career during the 1830s in Lexington, where it is believed he received some initial art instruction from sculptor Joel T. Hart. In 1833–34 he took on one of his first commissions, assisting painter Oliver Frazer with a portrait of George Washington destined for the Kentucky statehouse, known today as the Old State Capital. Within the next year he relocated to Athens, Tenn. From this point on, Shackelford divided his time between the two states, living and painting intermittently in various cities and towns until the late 1870s. He worked primarily in Clarksville while in Tennessee in the 1850s and 1860s, but in Kentucky he sought work in numerous locales: Flemingsburg, Winchester, Versailles, Cynthiana, Danville, Bowling Green, and Paris.

Shackelford's more significant Kentucky commissions include portraits of two former governors, Thomas Metcalf

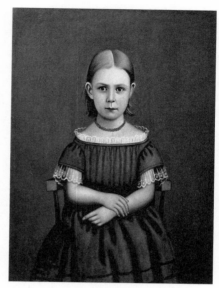

William Stamms Shackelford, *Unknown Girl*, ca. 1850, oil on canvas, 24¾" x 29½" (Collection of Gertrude and Ben Caldwell)

and James Clark. But some of the most distinctive examples of his work are found in the series of likenesses he produced of his relatives, the Shackleford family of Clarksville, around 1857–60. These paintings display the characteristics of a competent but unschooled artisan: figures rendered with clear contours and softly modeled edges and nearly expressionless faces that have a doll-like quality. Yet his pictures of the Shackelford children, with the inclusion of animals and delicate landscapes, which appear as theatrical backdrops behind the sitters, evoke an almost surreal, dreamlike quality.

Aside from his painting career, Shackelford's other pursuits included that of an inventor. He spent years building a perpetual motion machine and also made claims as to having in-

vented the revolver before Samuel Colt did. He died among relatives in Missouri sometime after 1878.

Besides the Kentucky Old State Capital, portraits by Shackelford can be found in the Tennessee State Museum.

MARILYN MASLER
Memphis Brooks Museum of Art

Ann Goodpasture, n.d., typescript, Tennessee State Museum; James C. Kelly, *Tennessee Historical Quarterly* (Winter 1987).

Shakers, United Society of

Widely celebrated for their contributions to American architecture, crafts, and design, the Shakers established two communities in Kentucky: Pleasant Hill, near Harrodsburg in Mercer County, and South Union, near Bowling Green in Logan County. By the 1820s the 4,000-acre Pleasant Hill reached its peak membership of approximately 500, while South Union, with about 6,000 acres of land, consisted of about 350 members at its height.

Shaker origins in Kentucky may be traced to a frontier religious revival that swept through the countryside of central and western Kentucky and neighboring Tennessee and Ohio in the last few years of the 18th century and the first few years of the 19th century. Whether at great outdoor camp meetings or in humble one-room log buildings, the revival was characterized by bold and powerful preaching and ecstatic worship. By August 1801 as many as 20,000 people gathered for a communion service on the grounds of the Cane Ridge meetinghouse, which served a Presbyterian congregation in Bourbon County, resulting in widespread religious fervor among Protestants of several denominations.

At their headquarters in New Lebanon, N.Y., the leaders of the Shaker Society became aware of the revival in Kentucky. Their founder, Ann Lee, who had arrived in North America from Lancashire, England, with eight followers in 1774, had prophesied that the Shaker faith would take root in the southwest, after establishing itself in New York and New England. Three Shaker brethren, Benjamin Seth Youngs, Issachar Bates, and John Meacham, were chosen to travel to Kentucky as missionaries. Preaching at Cane Ridge and other places in Kentucky and Ohio that had been affected by the revival, they were successful in drawing converts to their faith. By the spring of 1806 several local families joined together on the Shawnee Run farm of Elisha Thomas to form the first Shaker communal home in Kentucky, which was later to become the Pleasant Hill community. South Union had its beginnings in a gathering of converts at the Gasper River in 1807.

In its self-sufficient villages, the United Society of Believers in Christ's Second Appearing, as the Shakers became formally known, practiced celibacy, separation from the world, communal ownership of property, pacifism, and confession of sin, all of which were based on the New Testament accounts of the life and teachings of Jesus. A distinctive folk hymnody, which was at once hauntingly beautiful and quick and spirited, gave special character to Shaker religious services, as did the

elaborate dance forms, marches, and unprogrammed movements in worship from which the Shakers took their name. As a distinctive Shaker theology developed, the Believers came to understand the Deity in both female and male terms, as Mother and Father. The equality that Shaker sisters and brethren enjoyed in the various departments of community life and leadership was a practical application of this idea. Moreover, Shaker ideology had an important impact on the planning and organization of the villages.

At Pleasant Hill, the development of the largely agrarian community, its systems, and structures was principally the work of Micajah Burnett, a self-taught architect, village planner, engineer, master carpenter, and widely admired Shaker. Fortunately, many of the buildings that he designed, in an imposing but simplified Georgian style, remain extant. They are often distinguished by dual entrance doors and stairways to reflect the equal-but-separate status of men and women in the celibate society, spacious interiors, arched doorways and fanlights, and characteristic pegboards and built-in cupboards. Constructed of locally quarried Kentucky limestone, the handsome Center Family Dwelling was intended to house 100 brethren and sisters. The Pleasant Hill Trustees' Office is notable for Burnett's exquisite twin spiral staircase, an icon of American design. At South Union, only a few buildings survive. Its brick dwelling house includes such impressive features as arched hallways throughout the building.

Like their brethren and sisters in other Shaker communities, the Shakers of Kentucky exhibited an innovative spirit and a genius for invention. At Pleasant Hill, for example, an especially well-designed wooden sconce was developed to make use of the pegboards that were part of the interior architecture of most rooms. Designed to accommodate a candlestick, the sconce had a backboard with several openings and could be hung from the pegboard at various levels, depending on lighting needs. Another innovation, also typical of Shaker design and ingenuity, was a triple clothes hanger that was intended to be hung from pegs by leather thongs.

The relationship of Shaker design to American material culture is well established. In architecture, furniture, and the various crafts, the Shakers adapted the vernacular forms common to their region and period to suit a developing communal aesthetic. Shaker artisans, seeking simplicity, utility, and perfection as objectives of their religious faith, rejected "fancy" decoration or ornament. Thus, the "classic" Shaker furniture of the northeastern communities is spare but elegant, without decorative turnings, carving, or painting.

Among the Kentucky Shakers, however, furniture often exhibits subtle ornamental details such as beading, relatively elaborate turnings, tapered legs, and pear-shaped feet. Native walnut and cherry were the woods most often used, and poplar was the next wood of choice. Kentucky Shaker furniture, whether produced for sale or home use, is often related in design to the candle stands, chests of drawers, and chairs of the Shakers' neighbors in the

countryside of Kentucky and northern Tennessee. Regional forms of furniture, which were unknown to the Shakers of the northeastern communities, include a distinctive seven-foot-high pie safe at South Union, with a molded top and 24 punched tins that were originally painted red.

The Kentucky Shakers manufactured utilitarian fabrics of linen, wool, and cotton, but they became better known for their pioneering production of silk beginning in the late 1820s. With its iridescent character and luminous hues that ranged from rose, lavender, and purple to mustard, white, and brown plaid, Shaker-made silk was used, among other purposes, for the production of the kerchiefs that brought color to the Shaker sisters' traditional dress. An important industry among the Kentucky Shakers, especially at South Union, Shaker silk production waned after the Civil War and ended by the 1880s.

Beginning in the 1830s, rug or mat production was especially associated with Pleasant Hill. Although most Shaker hooked rugs are characteristically plain or geometric in design, often with rich colors, multiple borders, or braided edges, several late 19th-century examples attributed to Pleasant Hill are figurative, two of which use images of horses and another the word "Good" as central motifs.

Among the Shaker sisters, skills in needlework were fostered. A needlework sampler by Mariah Boil of Pleasant Hill, for example, may lack the imagery and decorative flourishes associated with worldly samplers in the traditions of American folk art, but nevertheless it is technically expert, artfully composed, and visually appealing. In dark blue silk on a linen ground and containing several alphabets and number progressions, this sampler exemplifies the simple eloquence of Shaker needlework.

The two Kentucky Shaker communities continued to thrive until the Civil War, after which an unremitting disintegration began to affect both villages economically and spiritually. Partially the result of a failure of leadership, Pleasant Hill closed permanently in 1910, while South Union managed to survive until 1922. This ended the Shaker presence in the South. Two late 19th- and early 20th-century efforts to establish Shaker communities in Georgia and Florida were too short-lived and small in number to have any influence. Today Pleasant Hill and South Union are public museums. A small number of Shaker items have appeared at auction.

GERARD C. WERTKIN
American Folk Art Museum

Beverly Gordon, *Shaker Textile Arts* (1980); Tommy Hines, *A Sense of Place: Kentucky Shaker Furniture and Regional Influence* (1996): James W. Hooper, *The Shaker Communities of Kentucky: Pleasant Hill and South Union* (2006); Jonathan Jeffrey and Donna Parker, *A Thread of Evidence: Shaker Textile Industries at South Union, Kentucky* (1996); Julia Neal, *By Their Fruits: The Story of Shakerism in South Union, Kentucky* (1947); Kerry Pierce, *Pleasant Hill Shaker Furniture* (2007); James C. Thomas, *The Magazine Antiques* (October 1970).

Shaver, Samuel Moore

(ca. 1816–1878)

Samuel Moore Shaver, one of Tennessee's earliest resident portrait painters, produced pictures of many of the state's most prominent families. Born in Sullivan County in east Tennessee circa 1816, he lived and worked primarily in the northeast vicinity of the state. Little is known of his early training, but he may have gained some knowledge of painting from William Harrison Scarborough (1812–71), another portraitist who was active in the area in the 1830s. Shaver's first professional position was as a drawing and painting instructor at Oddfellows Female Institute in Rogersville in 1851. At the beginning of the Civil War, Shaver moved to Knoxville, where he was instrumental in establishing the East Tennessee Art Association. He returned to Russellville in 1863. The last decade of his life was spent in Jerseyville, Ill., where he continued to take commissions for portraits—some from clients back in Tennessee—until his death in 1878.

Shaver's early paintings were simple and austere. His work became more elaborate after the mid-1850s, when he began incorporating detailed backgrounds into his portraits. Many works employ stylized conventional elements, such as columns and rich draperies. His more ambitious works contain detailed landscapes and buildings that provide information about the sitter and references to early Tennessee history. Among the more significant Shaver portraits is the painting of John Roper Branner (1822–69), president of the East Tennessee and Virginia Railroad, seated in front of a vista of his estate in Jefferson County. The Tennessee State Museum Library and Archives owns this painting. Another important portrait now in a private collection represents Joe Francis Foard (1836–1913), a prosperous businessman, shown with a panoramic view of Rogersville, Tenn. In 1862 the East Tennessee Art Association commissioned Shaver to paint portraits of 15 Confederate leaders, including President Jefferson Davis and General Robert E. Lee, although to date none have been located. Portraits by Shaver are located in the Tennessee State Museum.

MARILYN MASLER
Memphis Brooks Museum of Art

Budd H. Bishop, *The Magazine Antiques* (September 1971); James C. Kelly, *Tennessee Historical Quarterly* (Winter 1987); Prentiss Price, *East Tennessee Historical Society Publications* (1952); Carrel van West, *A History of Tennessee Arts* (2004).

Simpson, Vollis

(b. 1919)

Born 17 January 1919 in the same Wilson County, N.C., home in which he lives today, Vollis Simpson was the eighth of a dozen children born to Emma and Oscar Simpson—a farmer, whole house mover, and sawmill owner. During World War II, Simpson served in the United States Army Air Corps engineering unit in Saipan, where he used "busted" plane parts to build a windmill to power a giant washing machine. "Soap suds ran two to three blocks," he said.

Returning home, Simpson, like his father, farmed and moved houses. He

began building yard chairs and gliders and then opened his own repair shop for trucks, tractors, and lawnmowers. In 1947 he married 19-year-old Jean Barnes, who had worked for the FBI in Washington. The couple's first car was a surplus army jeep. Together they raised three children. Simpson's eye for value in government surplus continued for decades. Simpson built from scrap a windmill to power the family's home heating system. One of his earliest artistic whirligigs was "Carolina Blue," made to celebrate his eldest son's graduation from the University of North Carolina at Chapel Hill. Another was a memorial to a beloved dog. When the artist was around 60, the artistic whirligigs started "fillin' my head 24 hours a day." They ranged in size from 2 to 50 feet and more, with hundreds of moving, recycled, and hand-painted parts.

Simpson soon filled a large field surrounding a pond with his whirligigs, adding highway reflectors and glow tape on the moving parts that gave them a spectacular appearance at night. Windmill Park was born, attracting tourists, collectors, school groups, and reporters. To satisfy collectors, Simpson began to construct smaller tabletop and floor pieces. Simpson welcomes visitors but remains modest. With a shy sense of humor, Simpson says, "I had a lot of junk and I had to do something with it."

In 1995 Baltimore's American Visionary Art Museum commissioned a 55-foot, 3-ton, colorful whirligig, *Life, Liberty, and the Pursuit of Happiness*, for the center of its harborside campus. A local newspaper recognized Simpson's sculpture as "Baltimore's Most Beloved Piece of Outdoor Sculpture," and Simpson was awarded the key to the city. The exhibition of work by self-taught artists that accompanied the 1996 Atlanta Olympics featured four 40-foot whirligigs specially commissioned from Simpson for the occasion; these whirligigs now stand at Courtland Street Bridge, as part of Atlanta's Folk Art Park. In late 1996, the Science Museum of Minnesota made the film *From Windmills to Whirligigs*, featuring Simpson working with fourth graders who learned to build their own wind-powered sculptures.

The sheer scale of Simpson's environment and the artist's inventive assemblage have earned print and TV coverage throughout the United States, Europe, Canada, and Japan. Articles about Simpson's work have appeared in *Raw Vision*, *Folk Art Messenger*, and numerous other publications. Television programs have also celebrated Simpson's kinetic environment. The High Museum of Art, the North Carolina Museum of Art, and the Smithsonian American Art Museum have also added Simpson whirligigs to their collections. A coalition of art and government organizations plans to open the *Vollis Simpson Whirligig Park* in Wilson, N.C., in 2014. The park will contain and preserve 29 of the artist's enormous whirligigs.

REBECCA ALBAN HOFFBERGER
American Visionary Art Museum

Jane M. Joel, *Folk Art Messenger* (Spring 1996); Kelly Ludwig, *Detour Art* (2007); John Maizels, *Raw Creation: Outsider Art*

and Beyond (1996); Roger Manley and Mark Sloan, *Self-Made Worlds: Visionary Environments* (1997); Betty-Carol Sellen with Cynthia J. Johanson, *Twentieth-Century American Folk, Self-Taught, and Outsider Art* (1993).

Sims, Bernice

(b. 1926)

Born on Christmas Day to Robert and Essie Johnson in the Hickory Hill community near Georgiana, in south Alabama, Bernice Johnson Sims was the eldest of 10 children. Raised by her grandmother, Sims lived in a racially mixed neighborhood where a neighbor encouraged Sims's interest in drawing by giving her brushes and paint. Sims dropped out of school, married Willie James Sims when she was a teenager, and moved to Brewton, Ala., where she still lives. After her husband left the family, Sims was the sole provider for six children. She worked as a housecleaner, seamstress, and insurance saleswoman. She also trained and worked as a nurse's aide. In the 1960s, Sims was active in the civil rights movement, participating in voter registration drives, and, in Brewton, secretly coordinating the activities of the NAACP, which the state had outlawed. She took part in the famous Selma-Montgomery march and witnessed the events of Bloody Sunday at the Edmund Pettus Bridge in March 1965.

In 1975, after knee surgery forced Sims to retire, she went back to school, receiving a high school diploma in 1978. She enrolled at Jefferson Davis Community College, where in 1984 she earned an associate's degree. That same year, she took an art course taught by Larry Manning, now a retired professor and potter, who rekindled her enthusiasm for art and later became her first patron. Sims participated in a class trip to the Montgomery Museum of Art and the home of Alabama folk artist Mose Tolliver. Inspired by Tolliver's example, Sims decided to follow her childhood dream of becoming an artist.

Working mostly in the afternoons while she listens to television, Sims paints in oil or acrylics on canvas. Mimicking nature is not important for Sims; she sees in her mind's eye the event she wants to represent. Using cheerful colors, she creates flat, decorative memory paintings, whose bucolic images of black rural life in Alabama call to mind the farm life, church activities, and social gatherings of her childhood — scenes of picking cotton, butchering hogs, fishing, baptisms, weddings, Sunday school picnics, playgrounds, and dancing couples. Her figures bend, twist, twirl, gesticulate, and interact in scenes that are often rendered with an idea to detail — painted signs, reflections in a pond, hanging lights, lawn mowers, checkered tablecloths, lady's hats, a school bell. Perhaps in remembrance of Sims's early life in Hickory Hill, she depicts scenes in which black and white people work and play together — picking strawberries, shopping, swimming, and playing schoolyard games. Sims also portrays scenes inspired by the civil rights movement, where black and white people are sometimes but not always at odds. These include depictions of the Birmingham riots, the Lorraine Motel in Memphis,

and the Martin Luther King Jr. funeral procession. Perhaps her most famous depiction represents the crossing of the Edmund Pettus Bridge, a subject selected by the U.S. Postal Service in 2005 as one of 10 stamps intended to commemorate the 40th anniversary of the Voting Rights Act.

Sims has served as artist in residence at the New Orleans Museum of Art, and in 1994 she was inducted into the Louisiana Black History Hall of Fame for her contributions to black culture. Sims's work can be found in the Tubman African American Museum, the Morris Museum of Art, and the Julie Collins Smith Museum of Art at Auburn University.

CAROL CROWN
University of Memphis

Carol Crown, ed., *Coming Home! Self-Taught Artists, the Bible, and the American South* (2004); Claudia Dreifus, *AARP: The Magazine* (April 2004); Kathy Kemp, *Revelations: Alabama's Visionary Folk Artists* (1994); Roy Hoffman, *Alabama Afternoons: Profiles and Conversations* (2011); Randall Lott, *Folk Art Messenger* (Summer–Fall, 2008); Wayne Slynt, *Alabama in the Twentieth Century* (2004).

Singleton, Herbert
(1945–2007)

Algiers, Louisiana, artist Herbert Singleton created painted and deeply carved cedar panels that both skewer and exalt his life and times. A high school dropout principally employed in the construction trade, Singleton wore the scars of adversity without complaint. He overcame many hardships—some compounded by his own misdeeds—

surviving a near-fatal shooting, drug addiction, and nearly 14 total years in prison, many of them in the infamous Louisiana State Penitentiary at Angola. "When it come down to it, if you gonna go straight at your problems then you can deal with your problems," he succinctly opined in the 2001 independent film *Life & Death at Barrister's*, "you know . . . can't nobody solve your problems but you."

Singleton first derived meaningful income from artistic endeavors in the early 1980s, carving walking sticks for buggy drivers and "voodoo protection" stumps for friends. After his final stint of incarceration, the dispirited artist was encouraged by a French Quarter gallery owner to carve out his pain. Singleton dismantled an old chifforobe and carved his first bas-relief panel. He referred to the haunting work, depicting a stark-white skeletal figure contrasted by a black background and blood-red border, as *Dog Worms in Me*. The heads of serpents are shown peering from the infected figure's ribcage.

Singleton displayed keen insight into the socioeconomic limitations imposed upon many residents in the New Orleans area. He railed against hypocrisy on both sides of the racial divide, outing the transgressors in the process. Often, he incorporated condemning text into his designs that admonished the offender and provided clarification for the viewer. In *Who Speak for Man*, Singleton depicted a defrocked Baptist minister sucking a serpent-like pipe abetted by a crack-cocaine-clutching demon. Next to the figures, he addressed our seeming inability to

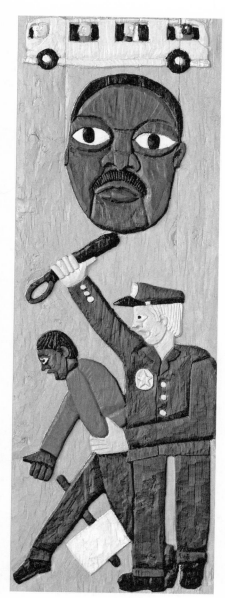

Herbert Singleton, Ain't Goin' Back, n.d. (1980s), paint on wood relief, 60" x 20" x 1" (Collection of Gordon W. Bailey)

meet the standards we set for others by painting, "He that cannot speak for himself speak for God, then who speak for man." Singleton's monumental oak doors are particularly stunning artistic achievements. He carved a series of biblically inspired scenes into one and added the words "Whoso ever causeth a man to go astray in an evil way he shall fall himself into his own pit."

Favoring reclaimed materials, he salvaged a 6-foot-tall cypress log from the Mississippi River and cut self-destructive indulgences—drugs, gambling, sex—into its near-petrified carcass. The masterwork, which was exhibited in the 2002–3 exhibition *High on Life: Transcending Addiction* at the American Visionary Art Museum as the *Algiers Rosetta*, was referred to by Singleton with characteristic directness as the *Tree of Death*. In other more festive works, like his Jazz Funeral and Mardi Gras pieces, he paid tribute to the uniqueness of the New Orleans "Big Easy" culture.

Sadly, because of failing health, Singleton was unable to complete a post-Katrina testament. He succumbed to lung cancer on 25 July 2007. In the New Orleans *Times-Picayune* tribute, William A. Fagaly, former assistant director for art at the New Orleans Museum of Art, affirms, "He was a major force in the world of self-taught art, not only in our community, but nationally. He wasn't imitating anyone else. He had his own voice, a very strong voice. He addressed African American issues, race issues, inequality. His pieces are not just powerful but beautiful."

Singleton's works are in numerous

important public and private collections worldwide including the Smithsonian American Art Museum in Washington, D.C., the New Orleans Museum of Art, the High Museum of Art in Atlanta, and Collection de l'Art Brut in Lausanne, Switzerland.

GORDON W. BAILEY
Los Angeles, California

Paul Arnett and William Arnett, eds., *Souls Grown Deep: African American Vernacular Art of the South*, vol. 1 (2000); Gordon W. Bailey, *Raw Vision* (Winter 2007); Doug McCash, *New Orleans Times-Picayune* (1 August 2007); Kathy Moses, *Outsider Art of the South* (1999); Bill Sasser, *Raw Vision* (Fall 2002); Betty-Carol Sellen with Cynthia J. Johnason, *Twentieth-Century American Folk, Self-Taught, and Outsider Art* (1993); Marcus Whittman, dir., *Life & Death at Barrister's* (2001).

Smith, Mary Tillman
(1904–1995)

Mary T. Smith is known for her expressionistic paintings on corrugated tin and wood board. Her images are often accompanied by thought-provoking messages, private symbols, and enigmatic letter combinations. From an early age, Smith had a hearing impairment that made her speech difficult to understand. Her siblings recognized that she possessed exceptional intelligence, but schoolmates and strangers often avoided her. She found an outlet in drawing. While other children played games, she drew pictures in the soil and wrote captions.

Both of Smith's marriages ended abruptly. She caught her first husband deceiving her, so she left him. Her second husband, a sharecropper, left her by request of his landlord—she had threatened the landlord after she discovered that he was cheating her husband out of his rightful earnings. In 1941 while she was living in Hazlehurst, Miss., she gave birth to her only son, Sheridan L. Major (Jay Bird). Although she did not marry, her son's father built her a house in town. Hazlehurst offered a new beginning.

Smith delineated the space around her house by splitting corrugated tin and using the strips to construct a whitewashed fence, which she adorned with art. She also constructed a series of outbuildings and furnishings, which she similarly painted, including a de facto studio in which to work and display her most recent paintings. As she grew older, Smith redesigned her work space to function more technically. Her hearing worsened, and she was no longer comfortable going into Hazlehurst. "I don't go nowhere no more," she said. "I can't hear nothing. I don't need nothing. I got it all here. My church. The Lord. Jesus."

Religious iconography, such as portraits of Jesus and the Christian Trinity, appeared in abstracted form all along her fence. Phrases such as "My name is someone The Lord for me He no," which often accompany her self-portraits, expressed her faith. Her yard was both a message board and a diary with self-portraits and pictures of her family, friends, and visitors. She adopted the advertiser's method of presenting a picture and a terse line of copy by de-

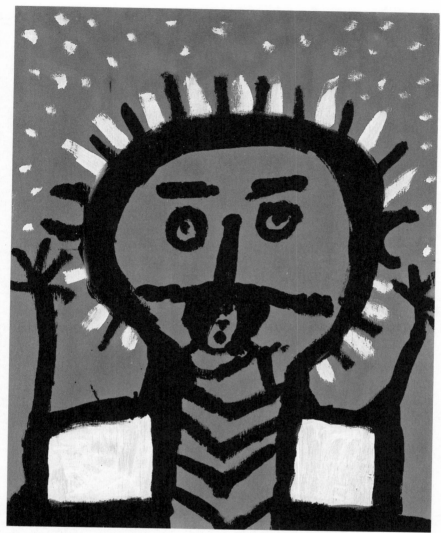

Mary Tillman Smith, untitled, 1988, paint on wood, 31⅜″ × 24⅛″ (Collection of Mississippi Museum of Art, Jackson, Gift of Warren and Sylvia Lowe)

picting bold, easy-to-recognize images with a quick explanation, a pithy slogan, a name, or a reverential declaration.

By the time of her death, Mary T. Smith had become a major artist exhibited and collected throughout the United States and included in almost every important folk art show. Her Hazlehurst environment survives in photos. Smith's works can be found in the collections of the American Folk Art Museum, the Smithsonian American

Art Museum, and the High Museum of Art.

WILLIAM ARNETT
Souls Grown Deep Foundation

STEPHANIE BURAK
Atlanta, Georgia

William Arnett and Paul Arnett, eds., *Souls Grown Deep: African American Vernacular Art*, vol. 2. (2001); Carol Crown, ed., *Coming Home! Self-Taught Artists, the Bible, and the American South* (2004); Frank Maresca and Roger Ricco, *American Self-Taught: Paintings and Drawings by Outsider Artists* (1993); Andy Nasisse and Maude Southwell Wahlman, *Baking in the Sun, Visionary Images from the South* (1987); Lynne E. Spriggs, Joanne Cubbs, Lynda Roscoe Hartigan, and Susan Mitchell Crawley, *Let It Shine: Self-Taught Art from the T. Marshall Hahn Collection* (2001).

Spelce, Fannie Lou Bennett
(1908–1998)

Fannie Lou Bennett was born 19 June 1908, in Dyer, Ark., the first of five children of her farming parents. After completing public school, Fannie Lou left home for Fort Smith, Ark., and trained to become a nurse. She became a registered nurse in 1929 and worked in the profession for more than 40 years. She married Neal L. Spelce in 1934, and the couple had two sons, Neal Jr. and Bennett. Fannie Lou and Neal separated and eventually divorced, and Fannie Lou raised her sons in Clarksville, Ark. In 1954 she relocated to Texas to be nearer her sons, who were both attending the University of Texas at Austin. After several years as a cardiac nurse in Houston, she worked as a private school nurse in Austin for 11 years until retiring in 1971.

During the summer of 1966, Spelce attended a painting class at Austin's Laguna Gloria Art Museum. The first assignment was to paint a still life. Spelce began painting but, dissatisfied with her first attempt, took her paints home and completed the still life from memory. When she returned the following week with her painting, the instructor was quick to recognize her unique talent. He declared her a "true primitive," to which Spelce retorted, "I may be old, but I'm not primitive!" Spelce may not have welcomed her new designation, but she did accept her instructor's advice to remove herself from the class in the interest of preserving her unspoiled style. Her artistic training was limited to learning how to stretch and prime canvases and how to use oil paints and sable brushes.

Fannie Lou Spelce quickly found an eager audience for her work. In the wake of the unrivaled international Grandma Moses phenomenon of the 1940s, Texas had subsequently embraced its own Grandma Moses counterpart, "Aunt" Clara McDonald Williamson (active 1945–76), the retired cowboy artist H. O. Kelley (active 1948–55), and former shoe repairman Velox Ward (active 1960–89). The 1960s also witnessed the discovery of other self-taught Texas artists, most notably Austin psychiatric hospital patient Eddie Arning (active 1964–73) and Huntsville prison inmate Frank Jones (active 1964–69). In 1969, just three years after Spelce began painting, one of her works was included

in a juried exhibition at the Dallas Museum of Art. In 1972 her first solo exhibition was held at Kennedy Galleries in New York. Texas now had its second "Grandma Moses."

From the outset, Spelce's motivation to paint was her desire to record her memories and share them with others. Like many memory painters, she was highly selective in her choice of subject matter. She banished what she referred to as "ugly" memories from her work, preferring to focus on happy times. As she painted, her pictures often triggered other memories, and Spelce began immediately to capture them. She often had as many as six paintings under way at the same time. For two decades, memories were the wellspring for the creation of more than 400 paintings.

Spelce's technique involved using the tiniest 000 sable brushes, from which she often plucked hairs until only a single hair remained. Despite the minute detail of her work, she rarely used a magnifying glass. She painted from the top of the canvas down, to keep the painting from becoming messy. If the composition included figures, Spelce added them last. It was a time-consuming undertaking: her celebrated work *The Quilting Bee* took a year to complete. The detail in the painting, which measures 28 x 38 inches, is nothing short of astonishing: each of the tiny figures seated around the quilt wears a thimble and holds a threaded needle; each is a woman whom the artist knew. Details of crocheted doilies and curtains are painstakingly rendered as are the piano keys.

The tilted perspective and high horizon line of her paintings provide a spacious foreground, where Spelce pictures a panorama of tiny figures and elaborate details.

Spelce's subjects include portraits, interior scenes, and panoramic landscape that capture the bustle of rural and small-town life. Whatever the subject, her work remains fresh, colorful, and lively, always reflecting the joy she sought to share with her viewers.

After two decades, Fannie Lou Spelce's painting career was brought to an end by failing eyesight caused by macular degeneration. She died at her Austin home on 11 April 1998, at the age of 89. Her art is represented in numerous private collections.

LYNNE ADELE
Austin, Texas

Lynne Adele, *Spirited Journeys: Self-Taught Texas Artists of the Twentieth Century* (1997); Chuck Rosenak and Jan Rosenak, *Museum of American Folk Art Encyclopedia of Twentieth-Century American Folk Art and Artists* (1990); Robert Thomas Jr., *New York Times* (19 April 1998).

Speller, Henry
(1900–1997)

Henry Speller was born 6 January 1900 to a family of sharecroppers in the Panther Burn settlement, near Rolling Fork, Miss. His maternal grandmother and her husband raised him until the husband was forced to leave the farm. Speller then dropped out of school at the age of 12 and helped plant cotton, working on Delta farms and on the levees of the Mississippi River. Speller

and his first wife, Mary Davis, moved to Memphis, where they lived near Beale Street, famous for its musicians and musical venues. Speller held many jobs. He worked as a "junky" collecting scrap metal, a landscaper, a sanitation worker, a janitor, and a groundskeeper for the city parks commission. He retired from the parks job in the mid-1960s, and at about the same time he met Georgia Verges, who became his second wife. Speller has been recognized not only as a folk artist but also as an accomplished blues musician, who has played guitar with Howlin' Wolf and Muddy Waters.

Although he had started to draw regularly after moving to Memphis, he produced most of his art near the end of his life while living in a public housing project. Speller's drawings, scenes from his own experiences, depict houses, cars, riverboats, animals, and architectural fantasies. Sometimes his work addresses the social, economic, and racial experiences of his life and time. The artist also found inspiration in television shows he watched; his "characters from Dallas" are among his best-known and most sought-after works. Speller's round-faced and long-limbed men and women wear highly decorated, patterned, and perhaps Western-style clothing. In many sometimes funny, colorful scenes Speller shows his characters with exposed breasts and genitalia. Rhythmic, wavy lines and vibrant, invented architectural backgrounds surround and highlight the figures and fill the entire pictorial space. Speller's process was simple; he made almost all of his drawings on 19 x 20 inch paper, and

first outlined his composition in pencil before completing it with crayon and colored pencils. Speller's eyesight began to fail toward the end of his life. He died in 1996.

Speller's work is in the permanent collection of numerous museums including the Smithsonian American Art Museum, the High Museum of Art, and the Mississippi Museum of Art.

KATHERINE HUNTOON
Santa Ana, California

Paul Arnett and William Arnett, *Souls Grown Deep: African American Vernacular Art of the South*, vol. 1 (2000); Kinshasha Conwill and Arthur C. Danto, *Testimony: Vernacular Art of the African-American South* (2001); Russell E. Laurie and Raymond R. Allen, *International Review of African American Art* (1997); Andy Nasisse, *Baking in the Sun: Visionary Images from the South* (1987); Chuck Rosenak and Jan Rosenak, *Museum of American Folk Art Encyclopedia of Twentieth-Century American Folk Art and Artists* (1990); Dennis Thomison, *The Black Artist in America* (1993).

Sperger, Hugo

(1922–1996)

In the early 1970s, Hugo Sperger's wife surprised him with the Christmas gift of a set of oil paints. From then on, Sperger painted at a fervent pace, completing more than a hundred works by the time he died. Becoming an artist was not an obvious choice of profession. Born in Mirano, Italy, he immigrated with his German parents to the United States in 1929, at age seven. The Sperger family settled in upstate New York, where his mother found work as

a cleaning woman and his father toiled in sweatshops. Education was not paramount to Sperger, who enlisted in the United States Army before graduation from high school. During World War II, Sperger was stationed in Fort Hancock, N.J., and later in New Guinea. Upon his return to the States in 1948, Sperger married and followed his father's career path, finding work at numerous plants in New York, Michigan, and Indiana. In 1955, the couple relocated to his wife's hometown of Salyersville, Ky., where Sperger continued working in factories until his health declined in the 1970s. Around this time, Sperger opened the paint set his wife had given him for Christmas and began painting. Making art sustained Sperger intellectually and emotionally as he struggled with cancer during the next 26 years, eventually succumbing to the disease in 1996 at the age of 84.

Just as Sperger's poor health stimulated his artistic creativity, the countless hours of menial labor that he performed over a lifetime must have kindled his imagination. Along with the paintings for which he is best known, Sperger carved toys, puzzles, and erotic statuettes. Typically painting with acrylic or oil, Sperger created works that range from 24 x 16 inches to 4 x 8 feet on canvas or Masonite. They are filled with a frenzy of people, animals, demons, and angels floating through undefined space, earning Sperger the moniker the "Kentuckian Hieronymus Bosch." His colors are pure, undiluted hues that saturate large areas and form flat-patterned figures.

Even though Sperger asserted that he was not a religious man, his primary subjects are biblical scenes. The Bible is a source for inspiration, he emphasized, and "it has fifty paintings on every page." Sperger relates his Bible stories to the viewer through several strategies. In some of his works, the artist expressed action and narration by employing several registers similar to the conventional arrangements of comic strips. He conveys a sense of otherworldliness by framing his subjects with architectural elements and utilizing an exaggerated perspective somewhat similar to Georgio De Chirico, an early surrealist. He often includes text that furthers the painting's narrative, emphasizing themes of life, death, salvation, redemption, and hope. Sperger's paintings, at the same time menacing and hopeful, contain contradictory elements that reflect the artist's longtime struggles.

Hugo Sperger's work can be found in such collections as the Smithsonian American Art Museum, the Owensboro Museum of Fine Art, and the Kentucky Folk Art Center at Morehead State University.

MELISSA CROWN
University of Memphis

Carol Crown, ed., *Coming Home!: Self-Taught Artists, the Bible, and the American South* (2004); Lynda Hartigan, *Contemporary Folk Art: Treasures from the Smithsonian American Art Museum* (1999); Ramona Lampell and Millard Lampell with David Larkin, *O Appalachia: Artists of the Southern Mountains* (1989); Ann Oppenhimer, *Folk Art Messenger* (Winter 1996).

Spitler, Johannes

(1774–1837)

Undoubtedly one of the most innovative and imaginative furniture decorators in America was Johannes Spitler, who began his career in the Shenandoah Valley. Spitler belonged to a group of eight Swiss Mennonite families that had entered America through the port of Philadelphia and passed through Lancaster County, Pa., to settle in the 1720s on the eastern slope of Buffalo Mountain. Their community, in present-day Page County, Va., became known as Massanutten. The interrelated families brought their language and customs from the Old World to this region, and their descendants have practiced age-old traditions of farming and folkways from the 18th century to the present day.

Records show that Johannes (John) Spitler was born on 2 October 1774 at Mill Creek in Massanutten, Va. On 8 March 1796 he married Susanna Buswell. In 1807 his parents moved to Ohio, and he and Susanna followed shortly. They settled in Pleasant Township in Fairfield County, where Johannes Spitler apparently lived until his death on 18 April 1837.

Spitler decorated a significant number of pieces of furniture in Virginia, many of which he initialed, numbered, and dated. There is no evidence to determine whether he also constructed the pieces. Spitler apparently continued to decorate furniture after he moved to Ohio, because similar pieces were found there. His decorated pieces include clocks, hanging cupboards, blanket chests, and smaller chests or boxes. Most of the pieces were made of pine and painted with a blue background. Only a few designs include freehand ornamentation; Spitler laid out most of his designs with a compass, stencils, or a template. However, these simple design methods still allowed Spitler to create a remarkable variety of imaginative motifs.

Spitler used three distinct types of decorative elements. One type consists of geometric elements such as squares, circles, diamonds, diagonal bands, and compass-drawn flowers, which also appear on other community objects such as quilts, pottery, coverlets, and fraktur. Some of these pieces are numbered and dated, such as a chest, "No. 48 1798," and a clock "No. 3 1801." A second group of motifs from nature, such as stenciled birds, hearts, vines, crescent moons, and compass-drawn flowers, further relates to decorations found on objects within the larger communities of Swiss Germans in Virginia and in other parts of America and in Europe. The third, and probably the most unusual, decorative elements reproduce in paint the inlay or carvings of furniture made in urban centers. For example, Spitler faux-painted a broken scroll pediment on a clock and frequently copied in paint inlaid patterns such as quarter fans and running vines with leaves and flowers. Because Spitler used the same templates or stencils on different pieces of furniture, the exact same bird, flower, or moon appears on diverse pieces of furniture. However, his imagination in combining so many different elements from a variety of sources created such

innovation that his works are easily identifiable and obviously the creations of an exceptional decorator.

RODDY MOORE
SALLY MOORE
Blue Ridge Institute and Museum Ferrum College (Virginia)

J. Roderick Moore, *The Magazine Antiques* (September 1982); Cynthia V. A. Schaffner and Susan Klein, *American Painted Furniture* (1997); Donald Walters, *The Magazine Antiques* (October 1975).

Stovall, Emma Serena Dillard (Queena)

(1887–1980)
Queena Stovall painted scenes of everyday life in early 20th-century rural Virginia. In close to 50 completed works, Stovall depicted vivid scenes of people, places, and events that were important to her and the community. She painted people gathering and canning peaches, picking blackberries, taking in the laundry, butchering hogs, socializing at a country auction, relaxing indoors in front of a fireplace, or napping in a chair. A white woman, Stovall also painted scenes of African American life.

Emma Serena Dillard Stovall was born in 1887 to a prosperous family living near Lynchburg, Va., in Amherst County. As a child, she acquired the name "Queena," a nickname probably derived from Serena. She chose to work during her senior year at high school and did not graduate. Around 1907, while working at a railroad ticket office, she met Jonathan Breckenridge Stovall, 14 years her senior and a traveling businessman. After their marriage, the couple had nine children, five sons and four daughters. Between 1913 and 1923 the Stovalls rented a farmhouse in Amherst County, near Elon, where they farmed. Stovall learned self-sufficiency and independence during her husband's periodic absences, and she demonstrated self-reliance as she raised her family, performed domestic chores, and attended to the family farm.

At age 62, and already a great grandmother, Stovall enrolled in an art course at Randolph-Macon Women's College in Lynchburg and developed the art ability she demonstrated as a young girl. Her instructor, Pierre Daura, was impressed with *Hog Killing*, her first oil painting, and encouraged her. Within three years Stovall's paintings were featured in a one-person exhibition at the Lynchburg Art Center (1952).

Many of Stovall's paintings were composites conceived from her memories, experience, and imagination. She occasionally used magazine illustrations and other print sources that she adapted for her original compositions. She painted from a slightly elevated perspective and blocked out the broad areas of the landscape or interior before adding figures and specific foliage. During the last 15 years of active painting (1960–75), she further honed her skills in figural depiction by practicing figure drawing in her sketchbooks and made patterns for transfer. In addition to large easel paintings, she also created smaller works—decorations on functional objects such as the lids of cardboard boxes and on paper sacks as mementos for her friends. Stovall's strong narrative ability

is evident in *Fireside in Virginia*, *What'll I Do*, *Family Prayers*, *Dressing Turkeys on the Farm*, and *Lawdy, Lawdy*, among others.

Jack Ofield, a professor of film at San Diego State University, produced a short film, *Queena Stovall: Life's Narrow Spaces*, which appeared in 1981. Stovall is represented in the Oglebay Institute's Stifel Fine Arts Center, in the Fenimore Art Museum, the Chrysler Museum of Art, the Virginia Museum of Fine Arts, and the Maier Museum of Art at Randolph College.

LEE KOGAN
American Folk Art Museum

Louis C. Jones and Agnes Halsey Jones, *Queena Stovall, Artist of the Blue Ridge Piedmont: An Exhibition* (1974); Claudine Weatherford, *The Art of Queena Stovall: Images of Country Life* (1986).

Strickler, Jacob

(1770–1842)
Born on 24 November 1770, Jacob Strickler was a fraktur artist who lived in a primarily Mennonite settlement known as Massanutten in Shenandoah County, Va. Now part of Page County, this area is located in the fertile region between Buffalo Mountain (now Massanutten) and the Shenandoah River, near the modern-day town of Luray. Massanutten was settled as early as 1733 by a group of Swiss and German pioneers from Lancaster County, Pa. On the basis of the school-related fraktur he produced and sermon books he owned at the time of his death on 24 June 1842, Jacob Strickler is thought to have been a schoolmaster and Mennonite preacher.

Approximately one dozen fraktur documents are signed or attributed to Strickler, including drawings (some of them unfinished), birth certificates, and *Vorschriften* or writing samples. A *Vorschrift* inscribed "Jacob Strickler living in Shenandoah County, Va., March the 17 1787" is the earliest known work. Because Strickler signed few of his works, some attributions to him have been contested. A group of frakturs made for the Banawitz family, in the collection of the Free Library of Philadelphia, was formerly attributed to him but is now thought to have been made by a different, anonymous maker. Strickler's most famous fraktur, on which attributions to him are based, is an elaborately decorated composition (sometimes referred to as a *Zierschrift* by modern scholars), owned by the Winterthur Museum, Garden, and Library, dated 16 February 1794 and signed "Jacob Strickler, living in Shenandoah County, Va., made this picture," to which he added in rhyming German phrases, "The paper is my field and the quill is my plow. That is why I am so clever. The ink is my seed with which I write my name Jacob Strickler." The exuberant floral designs that fill the upper portion of the page, as well as the sawtooth border that frames the document, provide a basis for attributing other works to Strickler.

Jacob Strickler was related by marriage to Johannes Spitler, the Shenandoah County folk artist to whom a sizable body of paint-decorated chests as well as several hanging cupboards and tall-case clocks are attributed. Strickler's name and the date 1801 appear on a tall-case clock decorated and signed

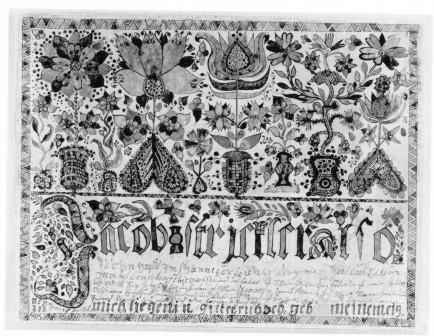

Writing specimen (Vorschrift) of Jacob Strickler, Massanutten, Va., 16 February 1794, watercolor and ink on paper, 15⅛" x 12⅛" (Courtesy Winterthur Museum)

by Spitler, who lived on an adjoining farm. The tulips and floral decoration painted on the clock case may have been inspired by Strickler's own fraktur. The Winterthur Museum, Garden, and Library and the American Folk Art Museum both own examples of Strickler's fraktur.

LISA M. MINARDI
Winterthur Museum and Country Estate

Russell D. Earnest and Corinne P. Earnest, *Papers for Birth Dayes: Guide to the Fraktur Artists and Scriveners* (1997); Cynthia Elyce Rubin, ed., *Southern Folk Art* (1985); Don Walters, *The Magazine Antiques* (September 1976), *The Magazine Antiques* (October 1975); Frederick S. Weiser and Howell J. Heaney, *The Pennsylvania German Fraktur*

of the Free Library of Philadelphia (1976); Klaus Wust, *Virginia Fraktur: Penmanship as Folk Art* (1972).

Sudduth, Jimmy Lee
(1910–2007)

Known for using natural materials, especially the mixture of earth and a sugary binder he called "sweet mud," Jimmy Lee Sudduth is among the best known of the rural southern self-taught artists who rose to prominence during the late 1970s. He worked in a lively style that reflected the delight he took in the act of painting.

The son of field hands, Sudduth was born on 10 March 1910 in Caines Ridge, a community near Fayette, Ala. He learned about the local flora from

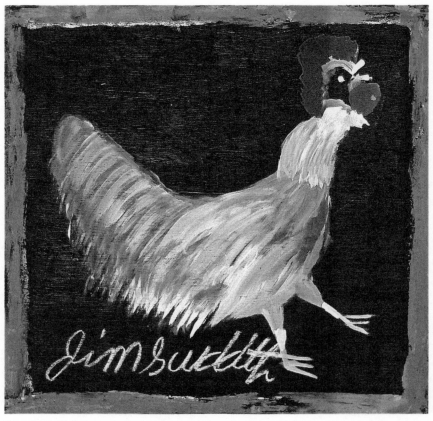

Jimmy Lee Sudduth, Rooster, 1993, paint and mud on wood, 24" x 24" (Collection of James G. Thomas Jr.)

his mother, a medicine woman who had Native American ancestors. He later used that knowledge to make his paintings, which he often colored with plant juices. While still a toddler, he started to paint with mud on trees and stumps and began to look for a way to make the mud adhere to the wood. Sometime around 1930, while visiting a syrup maker, he hit upon the binder he needed to fix his mud paint. Thereafter, he mixed the dirt with syrup, molasses, sugar and water, or Coca-Cola.

As an adult, Sudduth painted prolifically at night after work, giving away most of his early efforts. In the 1960s one of his paintings caught the eye of Fayette's local newspaper publisher, Jack Black. He brought it to the attention of Christina Baklanoff, a Stillman College professor who, in 1969, curated Sudduth's first exhibition at the college. A series of solo and group exhibitions and appearances in the Smithsonian Institution's Bicentennial Festival of American Folklife and on NBC's *Today* show brought him national recognition before 1980. In 1995 he received a Fine Arts Award from the University of Alabama Society for the Fine Arts and

in 2005 the Alabama Governor's Arts Award.

Although he is best known for paintings that contain primarily mud (he claimed to have as many as 36 colors available) and other natural substances, Sudduth's earliest extant works incorporate paint. Tight and carefully drawn, they already show a sophisticated grasp of linear perspective, a skill highlighted by his frequent portrayal of buildings. During the late 1970s and early 1980s, the period during which he produced what are generally regarded as his best paintings, his brushwork became looser and more painterly. In addition to paint and the earth pigments he so enjoyed manipulating, Sudduth tinted his paintings with virtually anything that came to his hand, including plant materials, dyes derived from soaking colored paper, coffee grounds, soot from a running engine, tar, and shoe polish, among many other substances. He worked straightforwardly, sometimes rubbing materials directly on his support, using his fingers and adding details with small sticks or twigs. While he occasionally painted on objects as diverse as cafeteria trays and musical instruments, he favored plywood throughout his career. In his late work, made after about 1990, he switched to sponge brushes and acrylic paints applied on a flat black ground, including mud only as a kind of painted frame for the scene. This late work, while formulaic, never lost the exuberance that marked Sudduth's mature style.

Sudduth commonly depicted buildings, conveyances of every sort, still lifes, agricultural genre scenes, famous people and those he knew, and his dog Toto. Although Sudduth usually represented the world he inhabited clearly and directly, among his most compelling works are lyrical, enigmatic pictures of figures quietly engaged in ambiguous activities before a featureless background.

The work of the extremely prolific Sudduth is represented in many private and public collections, including those of the Smithsonian American Art Museum, the American Folk Art Museum, the High Museum of Art, the Birmingham Museum of Art, and the Montgomery Museum of Fine Arts.

SUSAN CRAWLEY
High Museum of Art

Susan Mitchell Crawley, *The Life and Art of Jimmy Lee Sudduth* (2005); Tom Patterson and Lynne Ingram, *Not by Luck: Self-Taught Artists in the American South* (1993); Gail Andrews Trechsel, *Pictured in My Mind: Contemporary Self-Taught Art from the Collection of Dr. Kurt Gitter and Alice Rae Yelen*, Birmingham Museum of Art (1995).

Sullivan, Patrick Joseph
(1894–1967)

In 1967 the well-known art dealer Sidney Janis donated his private collection of works by major European and American artists to the Museum of Modern Art. Among the paintings by Picasso, Mondrian, and Klee was a fascinating painting entitled *The Fourth Dimension* (1938) by a self-taught painter from Wheeling, W.Va., named Patrick J. Sullivan.

Janis had become interested in folk art during the 1930s and began traveling around the country searching for un-

known primitive painters. He "discovered" a painting by Sullivan at the Independent Artist's Show at the Grand Central Palace in New York, and soon he and Sullivan began corresponding. Janis purchased Sullivan's first original work, entitled *Man's Procrastinating Pastime* (1936), agreed to buy every subsequent painting, and encouraged Sullivan to continue painting. Sullivan sent Janis a long explanation of the symbolism in the work, and thus began a professional friendship.

Thanks to Janis's interest, Sullivan's works received wide exposure in the late 1930s and early 1940s. In 1938 his first three original completed works were shown at the Museum of Modern Art's exhibition *Masters of Popular Painting: Modern Primitives of Europe and America* and many other exhibits throughout the country. In 1942 Janis published *They Taught Themselves: American Primitive Painters of the 20th Century*, which contained a long chapter on Sullivan and illustrations of four of his paintings. Illustrations of Sullivan's work also appeared in *Art News* and the popular magazines *Newsweek* and *Cue*.

Sullivan was one of 12 children born to his Irish-immigrant parents, but he grew up in an orphanage. He became interested in art sometime around 1920, after serving in the army during World War I. He was working as a house painter and apprenticing with a house painter named James DeShon, who taught Sullivan the techniques of wood graining and marbling. Sullivan married and had two daughters. His studio was a corner of his bedroom. He worked in a slow, meticulous style, using primarily house paint and building it up in layers, sometimes a quarter of an inch thick. He often used sandpaper to enhance the texture of the work. Sullivan places his figures in the foreground. These main figures, backs to the viewer, peer into the distance at a forest of broccoli-shaped trees.

Sullivan's allegorical paintings contain complex, personal, and often landscape-based iconography. His powerful works have been compared to Northern Renaissance paintings in that each carefully placed object is heavy with symbolic meaning. Fortunately, Sullivan left detailed explanations of almost all of his paintings. He was a deep thinker, an intellectual, and a philosopher. He repeatedly wrote that the main reason he painted was to make people think. His compositions are well planned, and his subject matter, drawn from his religious beliefs, current events, and everyday relationships, are imbued with a dreamlike quality. *Man's Procrastinating Pastime* (1936) deals with humankind's constant struggle in a world of good and evil. One of Sullivan's daughters remembers her father's saying that he had painted the work in order to recreate a vision. *An Historical Event* (1937) portrays Sullivan's thoughts on the abdication of Edward VIII to marry the divorcee Mrs. Wallis Simpson. *Haunts in the Totalitarian Woods* (1939) shows Hirohito, Hitler, and Mussolini rampaging through Europe and Asia. *A-Hunting He Would Go* (1940), Sullivan's only genre scene, shows a man pleading with his girlfriend to let him go hunting without guilt. *Tranquility* (1941) was painted to calm the United States in the

face of inevitable involvement in World War II. Other paintings have spiritual overtones, as their titles suggest: *A Rendezvous with the Soul* (1938), *The Fourth Dimension* (1938), *Solitude* (1938), *First Law of Nature—Not Self-Preservation but Love* (1939), *Why Should the Spirit of Mortals Be Proud?* (1939).

Sullivan was unable to make a living with his artwork, and his labor-intensive jobs usually left him too tired to paint. Only 11 original paintings by Sullivan are known. He painted little following his main productive years of 1936 until 1941. Besides the Museum of Modern Art, works by Sullivan can be found in the Oglebay Institute's Stifel Fine Arts Center.

JENINE CULLIGAN
Huntington Museum of Art

Gary Baker, *Sullivan's Universe: The Art of Patrick J. Sullivan, Self-taught West Virginia Painter* (1979), *Goldenseal* (April–June 1980); Sidney Janis, *They Taught Themselves: American Primitive Painters of the 20th Century* (1942).

Swearingen, Johnnie S.

(1908–1993)

Rev. Johnnie Swearingen was born near Chappell Hill, Tex., on 27 August 1908. He recalled that he had begun to paint when he was 12. Because his parents were sharecroppers with little money, he painted on walls and anything else that he could find, using house paint and sometimes shoe polish. Except for a brief time in the far West, he spent most of his life in rural Texas, where he chopped cotton, raised chickens, and worked on the railroads. Swearingen painted when time and money were available. His earlier paintings reflect the life and land in which he lived; in 1961, when he received a call from God to preach the Gospel, he began painting scenes from the Bible, of heaven and hell, of saints and sinners, of the devil leading the church to hell. He said, "I could always draw. It was a gift from God."

Using oil paints mixed freely on the canvas, Swearingen achieved vibrant colors. His paintings are characterized by multiple perspectives and rhythmic lines, which create pockets of space for simultaneous vignettes. Swearingen's compositions are naive and simple yet sophisticated; his strategy of continuous movement leads the eye through the canvas in a detailed narrative. Swearingen's paintings are included in many private and museum collections across the country, including the Smithsonian American Art Museum, the Blanton Museum of Art at the University of Texas at Austin, the Chappell Hill Historical Society, whose holdings include 60 of Swearingen's paintings, the Menil Collection, and the Fred Jones Jr. Museum of Art at the University of Oklahoma. Swearingen died on 14 January 1993.

STEPHANIE SMITHER
Houston, Texas

Lynne Adele, *Black History / Black Vision: The Visionary Image in Texas* (1989), *Spirited Journeys: Self-Taught Texas Artists of the Twentieth Century* (1997); Frank Maresca and Roger Ricco, *American Self-Taught: Paintings and Drawings by Outsider Artists* (1993); Elizabeth V. Warren, *The Perfect Game: America Looks at Baseball* (2003).

Taylor, Sarah Mary

(1916–2003)

Born in Anding, Miss., just south of Yazoo City, Sarah Mary Taylor grew up in the Mississippi Delta during the period of Jim Crow. The daughter of Pearlie Posey and niece of Pecolia Warner, both noted Mississippi quilters, Taylor learned by the age of nine how to piece quilts by working on her mother's quilts. By 1931, the same year she turned 15, Taylor left home, married, and began making quilts for her own household. Like many African Americans of the era, she also worked at a variety of jobs. As a black woman in the Mississippi Delta, Taylor found work on plantations as a field hand, nanny, cook, and housekeeper.

Taylor often made pieced quilts, composed of long strips of colored and printed cloth sewn together to form geometric and abstract designs. She is best known for her appliqué quilts, which she made by sewing designs onto the quilt's background fabric. Taylor's decision to make her first appliqué quilt seems to have been prompted by the attention her aunt Pecolia Warner received when folklorist William Ferris interviewed her for his film *Four Women Artists* (1978). Wanting to sell her own work, Taylor made a quilt of nine blocks and appliquéd her name, address, and phone number onto each block. Soon, she was making a series of appliquéd quilts, which also included figurative designs, such as Taylor's *Men* quilt (1979), *Mermaid* quilt (1979), and *Purple Hand* quilt (1985), which was commissioned for use in the film *The Color Purple*. To make such quilts,

Taylor sometimes drew the patterns she used freehand. Other times she copied illustrations from magazines, newspapers, catalogs, feed sacks, and cereal boxes. Sometimes she drew inspiration from three-dimensional forms: a plastic ornament hanging on her bathroom wall inspired the fish design that decorates one of her quilts. Her quilts with a hand motif feature a pattern she made by drawing around her own hand. Taylor used such patterns, rendered in cardboard, over and over again.

Whether Taylor was making strip or appliquéd quilts, she generally preferred bright colors and simple, bold designs, often in multiple patterns. She sewed strips of different sizes and colors together in a seemingly haphazard fashion or cut appliqué designs in different materials and colors and laid them out in a random arrangement that pleased her eye. Neither highly ordered nor symmetrical in design, Taylor's quilts evidence a preference for the irregular and asymmetrical. Such design principles—bold colors, simple designs, multiple patterns, and asymmetry—have been perceived as demonstrating continuities between African and African American textile traditions. For example, appliqué quilts made by African Americans have sometimes been associated with the appliqué textiles of the Fon of Benin and the Ewe, Fanti, and Ashanti of Ghana, where similarly abstracted figurative patterns also appear. Similar motifs have also been related to African American cloth charm traditions. For instance, the hand motif in several of Taylor's quilts has been associated with an African

American charm known as a mojo, another word for "hand," as in "helping hand." It is important to note, nonetheless, that Taylor rejected an interviewer's attempt to link this motif to Haitian Vodou and asserted her Christian faith as a Missionary Baptist.

Taylor's quilts can be found among the holdings of the American Folk Art Museum, Hampton University, the Montgomery Museum of Fine Arts, the Philadelphia Museum of Art, and the B. S. Ricks Memorial Library, Yazoo City.

CAROL CROWN
University of Memphis

Liz Lindsey, "Sarah Mary Taylor: Identity in Context" (M.A. thesis, University of North Carolina at Chapel Hill, 2003); Mary Elizabeth Johnson Huff, *Just How I Pictured It in My Mind: Contemporary African American Quilts from the Montgomery Museum of Art* (2006); Maude Southwell Wahlman, *Signs and Symbols: African Images in African American Quilts* (1993); Maude Southwell Wahlman and Ella King Torrey, *Ten Afro-American Quilters* (1983).

Theus, Jeremiah

(1716–1774)

Jeremiah Theus was born in 1716 in or near Chur, Switzerland, the son and oldest child of Simon Theus and Anna Alser Theus, who had married in 1715. In 1736 the Theus family immigrated to South Carolina with a large group of Swiss Protestants who had received land grants in Orangeburg Township. The artist's parents and his brothers Christian and Simon (or Simeon) were among those who settled in the area.

In 1740 Jeremiah called himself a limner in his first advertisement in Charleston, the city where he established his business and residence. In this same notice he indicated that he painted portraits, *landskips* (landscapes), crests and coats of arms for coaches, and other decorative work. The only other artists in Charleston during this time were Daniel Badger, who had moved from Boston, and Mary Roberts, the miniaturist whose late husband, Bishop Roberts, had executed a watercolor-and-ink view of Charleston harbor a year or two before.

On 13 January 1741 Theus married Cathrina Elizabeth Shaumlefall (Chaumloffel), the daughter of John Chaumloffel of Orangeburg. The painter remained close to his family, especially to his brother Christian, who was ordained a minister in 1739 in Charleston. He went to Saxe Gotha, near the Congreve River below Columbia, S.C., to practice his ministry. Both Christian and Jeremiah were acquainted with the German Lutheran missionary Henry (Heinrich) Melchoir Muhlenberg (1711–87), who stayed in their respective houses several times.

By 1744 Jeremiah was advertising his evening drawing school as well as the repertoire of work mentioned earlier. A year later he was elected a member of the South Carolina Society, a social and charitable group, and his first child, John, was born. A son, Simeon, was born soon thereafter; daughter Anne and her mother died in childbirth in 1754. It was probably the next year that Jeremiah married Eva Rosanna Hilt, widow of George Hilt. In September 1755 the couple moved into a new home,

where they lived for 19 years and raised their children.

Theus practiced a conservative and polished baroque type of portraiture probably learned through some training in his country of origin. However, like many painters who either came to the American colonies or were born there, he had to augment his easel painting with ornamental and related work, as indicated by his first advertisement. Some of his portraits are copies of English prints. The use of prints was certainly an accepted practice, but some of these portraits are comically awkward. Although several other artists were working in Charleston by the mid-18th century, Theus did not have significant or long-term competition. So far as is known, he made only one painting trip outside of Charleston, to Georgia in 1772. His will included seven slaves, his house in Charleston, a large property in Orangeburg, additional property in Charleston, and nearly £3,000 in cash. When he died in May 1774, the South Carolina *Gazette*'s notice called him a "very ingenious and honest man who had served as a portrait painter for 30 years." Theus was one of the most prolific of American colonial portraitists, and his widely seen work influenced many self-taught painters. Theus's portraits are in many museums, including the Metropolitan Museum of Art, the National Gallery of Art, the Smithsonian American Art Museum, Colonial Williamsburg Foundation, and the Museum of Early Southern Decorative Arts.

CAROLYN J. WEEKLEY
Colonial Williamsburg Foundation

Margaret Simons Middleton, *Jeremiah Theus: Colonial Artist of Charles Town* (1991).

Thomas, James "Son"

(1926–1993)

Born 14 October 1926, in Yazoo County, Miss., James Henry Thomas ("Son") embodies the expressive vitality of Delta culture. His singular blues performances and clay sculptures are at once a reflection of deep regional folk traditions and an individualized response to his upbringing and experiences.

Raised by sharecropping grandparents in Eden near Yazoo City, Thomas was admittedly a loner growing up. When he was not helping his grandfather on the farm, he occupied himself by making such items as fishnets and figurative clay pieces. Thomas was also exposed to music at an early age through his grandmother's piano playing, his grandfather's guitar blues and dance numbers, and the commercial 78s he heard on the family gramophone. As a result, Thomas's repertoire, like that of many Delta blues players, became a personalized mix of regional folk tradition and commercially popularized standards. Thomas's biggest influence, however, was an uncle, Joe Cooper, who taught the child both how to play blues guitar and how to sculpt in clay. When an 11-year-old Thomas started making Ford tractors out of clay, he earned the lasting nickname Son Ford, often shortened to Son. Although Thomas continued to sculpt and play blues throughout his adulthood, he was primarily a farmer until he moved to Leland, Miss., in 1961,

James "Son" Thomas, Skull, 1987, clay, teeth, and tin foil (Collection of Mississippi Museum of Art, Jackson, Gift of Warren and Sylvia Lowe, 1993.022. Copyright © estate of the artist)

where he dug graves for much of the rest of his life.

Beginning in the 1960s, Thomas's music and art were documented extensively by folklorist William Ferris, who was largely responsible for introducing the Delta bluesman/sculptor to a public audience. The last 25 years of his life found Thomas in demand at festivals and clubs throughout the United States and Europe. From 1985 on, Thomas often performed with Swiss harmonica player and blues scholar Walter Liniger. Thomas also recorded prolifically, mostly for European labels. Performances can also be found on compilations and solo albums, notably *Gateway to the Delta*, which won a 1989 W. C. Handy Blues Award for best traditional blues album.

Perhaps because Thomas did not record professionally until the 1960s, when he was already in his 40s, he is considered one of the last great Delta bluesmen. His repertoire blends the traditional and popular into powerfully lean reinventions of such standards as "Standing at the Crossroads," "Cairo Blues," "Rock Me, Mama," "Good Morning Little Schoolgirl," "Highway 61 Blues," and, arguably, his signature tune, "Catfish Blues." Thomas appeared in several films, including the award-winning *Delta Blues Singer: James "Sonny Ford" Thomas* (1970), *Mississippi Delta Blues* (1974), and *Give My Poor Heart Ease: Mississippi Delta Bluesmen* (1975). His playing slowed down in the early 1990s after he had brain tumor surgery. He died 26 June 1993 of heart failure at 66. His Leland-based son, Raymond "Pat" Thomas, continues his father's dual legacies as a blues guitarist and singer and sculptor of clay art objects.

Inclusion in the Corcoran Gallery's landmark exhibition *Black Folk Art in America, 1930–1980* introduced Thomas's work to a wider art world that appreciated the artist's idiosyncratic style and unusual media. Thomas customarily made his unfired sculptures from what he called gumbo clay obtained from the hills in nearby Greenwood, Miss. While animals—mules, rabbits, squirrels, snakes, horses, rabbits, fish, and birds—are a continuing theme, the artist's most analyzed and collected sculptures are heads and skulls. The skulls, with eye sockets accentuated with reflective tinfoil and animal or human teeth, were first made to scare the artist's superstitious grandfather. Macabre yet dignified, somber in

pose and yet full of the signifying spirit of the blues, these skulls may double as utilitarian ashtrays and containers or as openings for the dramatic placement of candles. Thomas's skulls seem to reinforce what Ferris has dubbed the "aesthetic of the ugly" in black folk art and are further imbued with elements of African American vernacular traditions of the South, such as effigy vessels. Museums with works by Thomas include the Center for Southern Folklore, the University of Mississippi Museum, the Mississippi State Historical Museum, the Smith Robertson Museum and Cultural Center, the High Museum of Art, and the Smithsonian American Art Museum.

WILLIAM L. ELLIS
Saint Michael's College

Paul Arnett and William Arnett, eds., *Souls Grown Deep: African American Vernacular Art of the South*, vol. 1 (2000); William Ferris, *Blues from the Delta* (1984), *Local Color: A Sense of Place in Folk Art* (1982); Jane Livingston and John Beardsley, *Black Folk Art in America, 1930–1980* (1982); Robert Nicholson, *Mississippi: The Blues Today!* (1999); John Michael Vlach, *The Afro-American Tradition in Decorative Arts* (1978).

Thompson, William Thomas
(b. 1935)

Born on a dairy farm north of Greenville, S.C., William Thomas Thompson, a self-taught painter, was reared in a Baptist family. He became a member of the Pentecostal Holiness denomination at age 13 and was baptized at 15. Thompson served in the U.S. Army Signal Corps in the mid-1950s and, after discharge, opened up a variety store in Greenville, where he began wholesaling artificial flowers and seasonal decorations in 1961. His business prospered, leading him to establish a Hong Kong office and making him a millionaire. However, when the silk-flower import business fell in the late 1970s, Thompson's business collapsed and he went bankrupt. His financial downfall may have contributed to a gradual, physical decline that led in 1988 to full paralysis below the waist. Said to suffer from Guillain-Barré syndrome, Thompson, now also semiparalyzed in his hands, learned to walk with the aid of crutches. Stripped of his business, physical health, and worldly goods, Thompson moved with his family into a small house that his wife's sister-in-law loaned them. It was at this low point in his life that Thompson underwent a revelatory experience.

In 1989, attending a church service on the Hawaiian island of Oahu, where he was receiving treatment for his paralysis at a Veterans Administration hospital, he experienced a sudden vision of the apocalyptic future. In his mind's eye, Thompson saw a rush of clouds and colors as the roof of the church opened to reveal the Lord descending in flames in the midst of a windstorm. So intense was this experience that Thompson was immediately transformed: God had charged him with a new raison d'être. With little exposure to art and no background in it, Thompson began painting. Filled with what he calls a "rage to paint," he embraced a new avocation.

Five years later, Thompson painted his magnum opus, *Revelation Revealed*,

a 6 x 300 foot canvas illustrating the apocalyptic future as envisioned by John in the book of Revelation. Painted off and on between 1994 and 1997 and exhibited at the American Visionary Art Museum in Baltimore in 1997, Thompson's gargantuan, acrylic painting displays Revelation's end-time prophecy. Rendered in broad brushstrokes that sometimes quiver as they echo the trembling of his hands, the scenes unfurl, revealing John's visions of the cosmic end-time battle. Extraordinary passages of color—oranges, reds, blues, black, translucent whites, and golden yellows—pulsate with frenetic energy and bring to life the Bible's anguished vision of history's end. The "Seven-headed Beast," "That Old Serpent, Called the Devil," "The Whore of Babylon," and "Christ of the Second Coming" occupy center stage along with pictorial references to historical and contemporary events, Bible verses, and Thompson's own commentary.

Later, in 1999, using the same stylistic language, Thompson created a 150-foot version of *Revelation Revealed*, which was exhibited by Campus Crusade for Christ at an international conference in Lausanne, Switzerland, in 2000. Equally mesmerizing are Thompson's huge, 12 x 16 foot *7 Days of Creation*, a work commissioned by the American Visionary Art Museum in 2006 for its permanent collection. While most of Thompson's paintings are grounded in the Bible, others deal with social issues, such as the use of drugs, the homeless, and abortion, as well as political subjects, including the Holocaust, atomic warfare, and the U.S.

war in Iraq. Thompson also collaborated with Norbert H. Kox, a Wisconsin self-taught artist, on several paintings dealing with end-time themes. Thompson's works can be found in the permanent collections of the South Carolina State Museum, the Las Vegas Art Museum, and the American Visionary Art Museum. Thompson maintains his own website at www.arthompson.com and one with Norbert Kox at www.thecolorfulapocalypse.com.

CAROL CROWN
University of Memphis

Greg Bottoms, *The Colorful Apocalypse: Journeys in Outsider Art* (2007); Carol Crown, ed., *Coming Home! Self-Taught Artists, the Bible, and the American South* (2004); James Mann, *Raw Vision* (Winter 2000); William Thomas Thompson, *The Art World of William Thomas Thompson* (2006), *7 Days of Creation in Visual Art* (2011).

Tolliver, Mose Ernest

(ca. 1920–2006)
When Mose Tolliver died in 2006, he was one of the South's most celebrated contemporary artists. He was the last surviving artist represented in the seminal exhibition, *Black Folk Art in America, 1930–1980*. The exhibition, which opened at the Corcoran Gallery of Art, Washington, D.C., in 1982, led to a groundswell of interest in contemporary self-taught African American visual art, in particular, and American folk art, in general. Tolliver painted a wide variety of subjects—trees, flowers, turtles, birds, mules, real and imaginary people, self-portraits, vehicles such as buses, and an occasional airplane. His prolific output and the accessibility of

his works made him a favorite of collectors. Over the years, Tolliver was included in virtually every important comprehensive exhibition of southern folk art.

Moses Ernest Tolliver was one of 12 children born to tenant farmers Ike and Laney Tolliver in the Pike Road community southeast of Montgomery, Ala. He attended school until he was eight or nine, and as a young teenager he worked for a truck farmer in nearby Macedonia. Following his father's death, he moved with his elderly mother to Sternfield Alley, a neighborhood in Montgomery. Tolliver helped support the household with a variety of jobs, including lawn and garden maintenance, house painting, light carpentry, and plumbing. He served a short time in the U.S. Army during World War II, and upon being discharged he married Willie Mae Thomas. The couple had 13 children, two of whom died in infancy. Tolliver worked for McClendon's Furniture Company in Montgomery for almost 25 years, retiring in the late 1960s after a crate of marble fell from a forklift, crushing his left ankle and damaging tendons in his leg.

Raymond McClendon, the company owner's brother and an amateur painter, encouraged Tolliver to paint to help relieve the depression he experienced from his forced retirement. In following McClendon's advice, Tolliver found great pleasure. "Painting keeps my head together," he once remarked, and he sometimes painted as many as 12 pictures a day. Tolliver displayed his early pictures just outside his front door. The paintings attracted local patrons and,

later, visitors from all over the country and world.

Tolliver used many available surfaces, including wood, cardboard, and Masonite. He often finished a work by painting a frame directly on the ground and adding a signature, "M. T." or "Mose T" in a corner. His style was lyrical, with forms often emerging from flowing graceful curves. Tolliver's paint application was bold. He preferred a basic palette of two or three colors of house paint, and occasionally he used an object, such as an old chest of drawers, tabletop, or a suitcase, as his painting surface. Tolliver's painting technique was wet on wet—that is, he applied new paint to a wet painting surface, blending colors directly as he created his forms and myriad hues in the process.

Subjects of Tolliver's paintings were inspired by his African American heritage, vernacular and popular culture, the natural world, his life experience, and his extraordinary imagination. Many pictures featured basic subjects that the artist returned to again and again, using variations of color, shapes, and moods. He had a wry sense of humor and delighted in painting erotic pictures, which were popular with his patrons. His paintings are in the permanent collection of the High Museum of Art, the Birmingham Museum of Art, the Montgomery Museum of Fine Arts, the Abby Aldrich Rockefeller Folk Art Museum, the American Folk Art Museum, the Smithsonian American Art Museum, and at least a dozen more.

LEE KOGAN
American Folk Art Museum

Paul Arnett and William Arnett, eds., *Souls Grown Deep: African American Vernacular Art of the South*, vol. 1 (2000); William Arnett and Paul Arnett, eds., *Souls Grown Deep: African American Vernacular Art*, vol. 2 (2001); Carol Crown, ed., *Coming Home! Self-Taught Artists, the Bible, and the American South* (2004); Anton Haardt, *Mose T A to Z: The Folk Art of Mose Tolliver* (2007); Paul Manoguerra, ed., *Amazing Grace: Self-Taught Artists from the Mullis Collection* (2007); Mose Tolliver and Robert Ellis, *Mose T's Slapout Family Album: Poems* (2002).

Tolson, Edgar

(1904–1984)

Edgar Tolson was born and raised in rural Wolfe County, Ky., the fourth of 11 children of a tenant farm family. As a young man familiar with the rural Appalachian whittling tradition, he carved utilitarian objects and toys. In 1925 he married Lillie Smith and relocated to Breathitt County. The couple had five children. In 1941 Tolson received a two-year prison sentence for deserting his family, and the couple divorced. After early release in 1942, Tolson married Hulda Patton and fathered 16 additional children.

Around age 20 Tolson began to preach locally and continued preaching for many years, but he was increasingly conflicted between Baptist doctrine and a heavy drinking habit. It has been variously reported that Tolson was responsible for bombing a church at this time. Tolson told several versions of the event, perhaps the most colorful being that he and his buddies blew up a church as a youthful prank. Another version recounts that he blew up the church as a 30-year-old preacher, trying to make a point to his congregation. At any rate by 1961, he had stopped preaching entirely.

Tolson had various jobs, including shoe repair, carpentry, farming, working on the railroad and at sawmills, stone cutting, logging, and chair making. In 1943 he moved to Dayton, Ohio, and worked in a factory, rejoining his family in Kentucky at the end of World War II. Tolson continued carving wooden items in his spare time. In the late 1940s he sculpted several stone pieces and arranged them in and around the family home. In 1957 he suffered a stroke and met Dr. Paul Maddox, who later endowed Morehead State University with the Tolson Folk Art Library. Over the following two decades, Tolson paid Maddox with carvings, which the physician displayed in his waiting room. As he recuperated, Tolson increasingly focused on his art making. Figures that he once described as "dolls" he soon referred to as "statues" and later as "sculptures." The proportions of his figures grew more squat and their eyes, once marked with a pen, were now carved in more detail.

Volunteers in Assistance to America (VISTA) documented Edgar Tolson's work in the mid 1960s. Tolson began selling his works in 1967 through the Kentucky Grassroots Craftsmen, a cooperative that marketed local crafts. Carl Fox, manager of the Smithsonian's gift shops, saw Tolson's work, purchased it to sell, and soon contacted him for more carvings and invited him to Washington. There, Tolson met Ralph Rinzler, the Smithsonian Folklife Festival director, who invited Tolson to partici-

pate in the 1968 and 1969 festival in the Capitol. In 1973, when the Smithsonian honored the state of Kentucky, Rinzler showcased Tolson as a featured artist. Between 1968 and 1976, Tolson's work was displayed in the Smithsonian Museum of American History (now known as the Smithsonian National Museum of American History).

Artists Miriam and John Tuska, she, a textile artist and he, a ceramicist and sculptor at the University of Kentucky, visited Tolson in 1968 and later that year encouraged artist/collectors Michael and Julie Hall to make the trek from Lexington to Campton. Like the Tuskas, the Halls purchased his work and quickly spread the word to other trained artists. The Tuskas encouraged Tolson to make nude figures, so the carver took up the subject of the nude Adam and Eve. The more complex, sequential series portraying the fall of man, for which Tolson is now best known, was prompted by the Tuskas and further advanced by encouragement from the Halls. Today scholars raise questions about trained artists' impact on Tolson's art making.

Tolson's sense of his creative role evolved during the 1960s and early 1970s, from craftsman working in Appalachian tradition to contemporary American artist. In 1973 Tolson was included in the Whitney Museum of American Art's Biennial, which purports to represent the current state of art making in the United States. He remains the preeminent Kentucky folk carver of the 20th century. His son, Donny Tolson (b. 1958), is an active carver whose work is reminiscent of his father's. Tolson's

works are included in the collections of the Albuquerque Museum of Art, the Museum of International Folk Art, the Milwaukee Museum of Art, the Kentucky Folk Art Center, Morehead State University, the Smithsonian American Art Museum, the University of Kentucky Art Museum, the Owensboro Museum of Art, and the Huntington Museum of Art.

ADRIAN SWAIN
Kentucky Folk Art Center

Julie Ardery, *The Temptation: Edgar Tolson and the Genesis of Twentieth-Century Folk Art* (1995); Russell Bowman, with Michael Hall and Julie Hall, *Common Ground / Uncommon Vision: The Michael and Julie Hall Collection of American Folk Art* (1993); Priscilla Colt, *Edgar Tolson: Kentucky Gothic* (1981); Lynda Roscoe Hartigan, *Made with Passion: The Hemphill Folk Art Collection in the National Museum of American Art* (1990); Herbert W. Hemphill Jr. and Julia Weissman, *Twentieth-Century American Folk Art and Artists* (1974); Chuck Rosenak and Jan Rosenak, *Museum of American Folk Art Encyclopedia of Twentieth-Century American Folk Art and Artists* (1990); Alice Rae Yelen, *Passionate Visions of the American South: Self-Taught Artists from 1940 to the Present* (1993).

Toole, John
(1815–1860)
Like a countless number of his peers, John Toole had to travel constantly to find customers for his portraits. While maintaining a permanent home outside Charlottesville, Va., Toole found work all over the region now encompassed by the states of Virginia and West Virginia. In major cities such as Richmond and Norfolk, Toole rented residences

and advertised his presence in the local newspapers. While traveling in the countryside, Toole sometimes resided in his patron's home for the duration of his commission. Toole's portraits, most remaining now in family collections, have received little scholarly attention. Nonetheless, Toole had a prolific career, producing more than 300 known works in a variety of media. An 1860 obituary in the *Virginia Advocate* reported that "he was a Portrait Painter, and in that capacity was well and favorably known in many parts of this Commonwealth."

Born in Dublin, Ireland, John Toole (originally O'Toole) immigrated to Charlottesville, Va., after the sudden death of his father in 1827. Toole lived with his uncle George, a tailor and cobbler. Little else is known about Toole's life between the period of his immigration and 1838, when he took up his artistic career. Though family tradition asserts that Toole attended the University of Virginia, none of that institution's records lists him as a registered student. Nonetheless, copious numbers of letters and paraphernalia indicate that Toole was well read and an eloquent writer.

Although Toole may have experimented with portrait painting as early as 1832, he worked during the mid-1830s as a pharmacist and tavern keeper. He did not turn to art making as his primary career until 1838. His decision to take up portrait painting was possibly motivated by the desire to earn a more substantial living. No records indicate that Toole had any training other than copying fine art engravings and magazine illustrations; infrequent observations of other artists' work; and the study of books, particularly of an English translation of Charles LeBrun's 17th-century lectures to the French Royal Academy on the appearance of passions in human countenance. Toole's main patrons were upper-middle-class Virginians, whose acquaintance Toole sought through involvement in the Democratic Party and membership in the Freemasons.

Although portrait painting was the main source of the artist's income, he did not limit himself to that genre. A few extant landscapes and history paintings indicate that Toole also attempted to expand his skills. All of Toole's known landscapes, certainly inspired by contemporary illustrations, depict locales that the artist never had the opportunity to visit. These works were not commissioned but were displayed in the artist's studio as an advertisement of his skill.

During the 1850s the increasing popularity of daguerreotypes infringed upon the market of itinerant portrait painters, and in 1857 Toole entered into a partnership with the G. W. Minnis daguerreotype studio in Petersburg. Toole painted portraits after daguerreotypes, thereby eliminating the customer's need to sit for extended periods. When John Toole died of tuberculosis in 1860, his profession was rapidly waning as the next generation preferred the speed and price of photographs. Institutions with works by Toole include the National Gallery of Art, the University of Virginia Art Museum, and the Virginia Historical Society.

CHRISTOPHER C. OLIVER
University of Virginia

William B. O'Neal, *Primitive into Painter: Life and Letters of John Toole* (1960); Papers of John Toole, 1838–92, Accession #6638, Special Collections, University of Virginia Library, University of Virginia Art, Charlottesville.

Toomer, Lucinda Hodrick

(1888 or 1890–1983)

Lucinda Toomer grew up on her parents' farm in Stewart County, Ga., and at the age of 12 learned to sew and quilt from her mother, Sophie Hodrick. Toomer recalls that her mother "would take her thimble and thump me in the head and wake me up and learn me how, and I'm so glad she done it." When Lucinda married at the age of 18, she received the quilts she had made under her mother's supervision. Toomer lived with her husband, Jim, for "sixty-nine years, two months, and a few days." The Toomers lived on a 40-acre peanut and cotton farm in southwestern Georgia, near Dawson. Both their children died as infants. Lucinda's creative quilt making may have been a substitute for children. When questioned about the great number of quilts she produced, Toomer replied, "I didn't make them to use. I just made them 'cause I know how."

Toomer preferred to cut out quilt pieces in the morning, sorting them according to shape and color. She used scraps from her own sewing to make her quilts and purchased bags of scraps from local garment factories. She used strips, or sashing, to organize her patterns because "a strip divides so you can see plainer." Toomer also chose strong contrasting colors to organize her quilts.

"I get any color, you know, and I try to match with a different color to make them work. That makes it show up." Red was her favorite color: "I put it where it will show up the pieces. Red shows up in a quilt better than anything else. You can see red a long while." Visibility from a distance is characteristic of the communicative function of West African textiles, meant to indicate the wearer's status and the type of greeting.

Toomer improvised on patterns that she learned from her mother and saw in books and magazines. She did not duplicate patterns in successive quilt squares but juxtaposed inventive variations on her primary pattern. Toomer received a National Heritage Fellowship in 1983. Her quilts are in many museum collections including the American Folk Art Museum.

MAUDE SOUTHWELL WAHLMAN
University of Missouri at Kansas City

Anna Wadsworth, *Missing Pieces: Georgia Folk Art, 1770–1976* (1976); Maude Southwell Wahlman, *Signs and Symbols: African Images in African American Quilts* (2001); John Michael Vlach, *The Afro-American Tradition in Visual Arts* (1990).

Traylor, William

(ca. 1854–1949)

Bill Traylor, who drew plantation memories and passersby while he sat on the sidewalks of Montgomery, Ala., ranks among the most highly regarded artists the South has produced. Since his drawings first appeared, their radically simplified forms, produced with low-grade materials on discarded paper and board, have attracted viewers accustomed to the reductive forms of mod-

ernism. That kinship with the prevailing style has brought Traylor acclaim from quarters not typically attuned to the aesthetics of self-taught art; at the same time, his stature in the field of self-taught art is unsurpassed.

Sometime between 1852 and 1856 William Traylor was born into slavery on the George Hartwell Traylor plantation in Lowndes County near Benton, Ala. After being freed by Emancipation in 1863, he remained for most of his life on the plantation. By the mid-1930s he was living homeless in Montgomery, where he sat on Monroe Street sidewalks drawing all day. There, the artist Charles Shannon encountered him in 1939. Recognizing Traylor's talent, Shannon and his friends, who had founded New South, an organization and a community arts center in Montgomery, provided the older artist with materials and bought his work for small sums, ensuring its preservation. During the war years, Traylor moved north to stay with a series of relatives and lost a gangrenous leg. After the war, he returned to Montgomery to live with a daughter and resumed drawing, but declining health soon forced him into a nursing home, where, according to hospital records, he died in 1949.

Traylor produced all of his known drawings (some 1,500 to 1,800) in Montgomery between 1939 and approximately 1947. Any he may have created during his stay in the North are unknown today. In 1940 Shannon organized a solo show at New South in Montgomery. A year later, Shannon showed the drawings to Victor D'Amico, director of education at the Museum of Modern Art, who organized an exhibition of Traylor's drawings in 1942 at the Fieldstone School in the Riverdale section of New York City. After the Riverdale show, some drawings were presented without Traylor's or Shannon's knowledge to Alfred H. Barr Jr., director of the Museum of Modern Art, who wished to buy several for MoMA and for his own personal collection. Shannon was unaware of this matter until he received a check for the drawings—at the rate of one or two dollars apiece. He refused the payment and reclaimed the drawings.

After Traylor's death, interest in his work lay fallow until Shannon and his wife, Eugenia, cataloged their collection and brought the drawings back to public notice through an exhibition at New York City's R. H. Oosterom Gallery in 1979. Traylor's inclusion in the Corcoran Gallery's *Black Folk Art in America, 1930–1980* and the appearance of his picture of a coiled snake on the catalog cover exposed his work to a large, receptive public and created excitement that led to more exhibitions that year. In the following two decades Traylor's drawings appeared in at least 86 group and 29 solo exhibitions. Today, examples rotate on permanent display at the High Museum of Art in Atlanta and the Montgomery Museum of Fine Art. They are included in the collections of the Metropolitan Museum of Art, the Smithsonian American Art Museum, and the American Folk Art Museum. Prices for Traylor's works continue to escalate.

Traylor drew on discarded paper, such as shirt cardboard. When his sup-

ports are oddly shaped, Traylor's dynamic compositions often follow the supports' irregular outlines. Traylor created his early drawings with graphite and sometimes colored pencils, using a stick as a straight edge. Traylor's works became even more dynamic after Shannon introduced him to show-card tempera paints, which brought bold, flat color to his pictures. Traylor built up human and animal forms from simple geometric shapes, which he then overlaid with more subtle features; for example, torsos began as rectangles or trapezoids that the artist refined by adding clothing or buttocks. In many of Traylor's works, penciled foundations are visible beneath the color.

Traylor's first drawings portrayed rows of objects, such as blacksmiths' tools, but he soon expanded his subject matter to include the simplified forms of passersby on Monroe Street, animals, and scenes remembered from rural life. He recorded lively sights, such as street preachers, drinkers, couples arguing, and children tormenting their elders, and deftly captured his subjects' animated, significant gestures. His animals, though flat, are carefully observed and naturalistically rendered, their elegance reflecting easy familiarity with scenes of rural life.

Among the most intriguing of Traylor's witty compositions are those he called "Exciting Events," populated by antic characters who caper on or around constructions of uncertain purpose or identity. Characters and structures float, without ground lines to orient them or the viewer. Their indeterminate quality provides ample latitude for the viewer's own interpretation.

Critical readings of Traylor's work, classifying it as atavistic, modernistic, or outsider, have tended to track with art world trends. Recent criticism, however, has focused on perceived affinities with blues music, use of drawing as a form of storytelling, and the presence of African-derived elements. These recent attempts to view Traylor's drawings within their southern, rural, African American context promise a richer understanding.

SUSAN CRAWLEY
High Museum of Art

Susan Crawley and Leslie Paisley, *Bill Traylor: Drawing from the Collection of the High Museum of Art and the Montgomery Museum of Fine Arts* (2012); Carol Crown and Charles Russell, eds., *Sacred and Profane: Voice and Vision in Southern Self-Taught Art* (2007); Lynda Roscoe Hartigan, *American Art* (Summer 2004); Josef Helfenstein and Roman Kurzmeyer, eds., *Deep Blues: Bill Traylor, 1854–1949* (1999); Josef Helfenstein and Roxanne Stanulis, *Bill Traylor, William Edmondson, and the Modernist Impulse* (2005); Betty M. Kuyk, *African Voices in the African American Heritage* (2003); Michel Sobel, *Painting a Hidden Life: The Art of Bill Traylor* (2005).

Tripp, William Blevins (Billy)
(b. 1955)
Billy Tripp is a Brownsville, Tenn., sculptor and author whose lifework is an immense self-made, self-referential structure called the *Mindfield*. Described by the artist as an "outdoor steel church," the environmental art assem-

blage spreads across a half acre of land near the town square and is arguably the most massive statement of autobiographical art ever undertaken.

What began in 1989 as a way to contain items in his overgrown yard has become in two decades an increasingly complex and fantastic medley of steel girders and discarded metal: lawn chairs hoisted mid-air, enigmatic symbols and silhouettes, a crucifix made of piping, an almost-Dadaist-like use of limned messages ("doG Bless What e?ver"), and the colossal juxtaposition of 110-feet fire and water towers. Combined with a centerpiece third tower that rises 127 feet, the *Mindfield* is taller than the most comparable self-made American environment, Simon Rodia's *Watts Towers*.

Born the middle son of a Methodist minister in nearby Jackson, Tenn., Tripp has spent most of his life in Brownsville and lives behind his creation at 1 Mindfield Alley next to the car wash he has owned for 25 years. Fascinated by welding from a young age, he has had little formal training, notably six weeks of trade school and a year at Memphis State University (now the University of Memphis), where he learned of abstract expressionist sculptor David Smith, an admitted influence. In the mid-1970s Tripp began experimenting with small metal and wooden sculptures and started work on the *Mindfield* in book form, a 725-page semiautobiographical novel published in 1996 as *The Mindfield Years (Billy Pyrene's Biography of Ned)* vol. 1, *The Sycamore Trees*. In fact, the *Mindfield* is at once book *and* sculpture, and the biographemes of one populate

the other (not unlike the visual and literary worlds of Henry Darger).

Unlike many examples of environmental art, the *Mindfield* is not particularly religious (Tripp admits to being something of an atheist), nor is it imbued with patriotic, historical, or ethnic commentary. It is not even intended as a social act. Instead, Tripp likens the *Mindfield* to an open-ended visual and verbal conversation with himself, one that will be finished only when he dies. "I didn't make it big for others to see it," he said. "I made it big so I could see it. I want it to talk back to me." The *Mindfield* also functions as a cenotaph to his deceased parents.

Tripp has obtained permission from the city of Brownsville to be buried at the *Mindfield*; he has also arranged for the Kohler Foundation to assume ownership after his death. Billy Tripp's *Mindfield* has become a tourist destination advertised by state and local government.

WILLIAM L. ELLIS
Saint Michael's College

Dennis Adkins, *Arts Tennessee* (Winter 2004); Mark Décimo and Sandra Persuy, *Southern Quarterly* (Fall–Winter, 2000–2001); Randy Mason and Michael Murphy, *Rare Visions and Roadside Revelations: Southern Flavor* (DVD, 2004); Billy Tripp, *The Mindfield Years (Billy Pyrene's Biography of Ned)*vol. 1, *The Sycamore Trees* (1996).

Trott, Benjamin

(ca. 1770–1843)
Benjamin Trott was born in Boston. His first known works are bust-length oil portraits of residents of Nottoway

and Amelia counties in Virginia that he may have painted with William Lovett in 1793. In late 1793 Trott advertised his drawing school and miniature painting skills in Boston; in May 1794 he noted his ability to execute "miniature painting and devices in hair." These devices include memorial jewelry made from the hair of the deceased or hair designs enclosed behind glass on a miniature's reverse. This hair could be the hair of someone deceased or the hair of a loved one. By 1794 Trott had moved to New York City, where he painted miniature watercolor-on-ivory copies of Gilbert Stuart's oil portraits; Stuart may have also trained him.

William Dunlap notes that Trott "followed or accompanied Stuart" to Philadelphia in 1794. During his early years there, Trott's ties to Stuart provided him with commissions. Although Trott is listed in the Philadelphia directories in 1805, William Dunlap noted that "in 1805 Mr. Trott visited the western world beyond the mountains, traveling generally on horseback, with the implements of his art in his saddle-bags. This was a lucrative journey." During this trip, Trott worked in Lexington, Ky., producing at least seven miniatures. After returning to Philadelphia, Trott probably made at least one trip to Baltimore.

Trott painted miniatures in Philadelphia from 1806 to 1819, the height of his career. He taught drawing classes at the Society of American Artists and exhibited at its shows from 1811 to 1814. He benefited from a close association with Thomas Sully, who may have introduced Trott to Benjamin Chew Wilcocks. Wilcocks provided both men

with extensive patronage and was a pivotal figure in Trott's career. Trott's Philadelphia patrons largely comprised young men and women whose families had dominated the city and state in the 18th century but by 1800 had largely lost political control and increasingly shared economic power with a burgeoning merchant community.

Trott moved about during the 1820s and 1830s, probably in pursuit of commissions. He visited Charleston ("his prospects bad," according to Dunlap) during 1819 and 1820. Trott may have painted in Newark, N.J., in 1823; he worked in New York City from 1828 to 1833. Although he is listed in the directories as a portrait and miniature painter, no late oil portraits are known. Trott lived in Baltimore in 1838 and 1840–41, where he painted at least one of his three late portraits of George Washington after Stuart's Athenaeum portrait.

Trott parlayed his ties to Stuart into commissions throughout his career, although there is no evidence that they worked together after the 1790s. Others connected the artists; Trott's obituary notes that "it was his proud boast that he had been the intimate friend of the celebrated GILBERT STUART. Mr. Trott was an enthusiastic follower of his profession. His mind was vigorous, his genius undoubted, and his reputation equal to that of any other engaged in similar pursuits. His style of miniature coloring was rich and decisive, and bore a strong resemblance to the oil paintings of his friend STUART." The obituary indicates that Trott associated himself with Stuart until the end of his

life, and that others recognized a similarity in their work. Trott's paintings are included in the collections of the National Portrait Gallery, Smithsonian American Art Museum, Metropolitan Museum of Art, New-York Historical Society, and Philadelphia Museum of Art.

ANNE VERPLANCK
Winterthur Museum, Garden, and Library

William Dunlap, *A History of the Rise and Progress of the Arts of Design in the U.S.*, vols. 2 and 3 (1834), *The Diary of William Dunlap*, vols. 2 and 3 (1931); Dale Johnson, *American Portrait Miniatures in the Manney Collection* (1991); Anne Verplanck, "Benjamin Trott: Miniature Painter" (M.A. thesis, College of William and Mary, 1990).

Tyler, Valton

(b. 1944)

Even within the diverse field of self-taught artists' art, the work of Texas-born Valton Tyler is hard to classify. This is primarily because this native of Texas City, an oil-refining center near the Gulf of Mexico, paints with oil on stretched canvas using a glazing technique he developed himself. Tyler's materials and techniques, and the skilled draftsmanship that is the foundation of his painting, are more closely associated with high-art forms of the Western art-historical canon dating back to the Renaissance than they are with the typically cruder technical approaches, like the use of house paint on board, that characterize the work of many self-taught artists of the American South. Tyler's painted images share stronger, unintended thematic and technical affinities with the art of such definitive European surrealists as Yves Tanguy or Salvador Dalí than they do with the rooted-in-local-culture creations of his regional, self-taught counterparts.

Tyler was three years old when the so-called Texas City Disaster took place in 1947. Considered the worst-ever industrial accident in U.S. history, it began with the explosion of a cargo ship loaded with ammonium nitrate; the blast ignited nearby oil-storage and chemical tanks, and its impact was felt as far away as Louisiana. The horrific event became the defining experience of Tyler's life. His futuristic-baroque, fantasy images, with their broad, flat backgrounds that recede into the distance or are limited by neat horizon lines, evoke the coastal topography he knew as a child. The techno-organic, architectural forms he concocts and sets on flat grounds against fiery skies of gradated color recall the industrial structures of oil refineries and factories he observed as he was growing up.

Tyler draws prolifically in pencil on paper and sketches out his paintings' subjects in charcoal on canvas before laying down oil washes, then more solid color, to model his oddly shaped forms. He has said he sees whole compositions in his mind and that he feels compelled to render them in paint immediately. He considers the imaginary forms he depicts and the negative spaces around them to be charged with uncertain but genuine, emotional energy.

Although Tyler dropped out of high school, he earned a high-school equivalency certificate and enrolled at the Dallas Art Institute, leaving not long

after beginning studies. He once dismissed its formal instruction by saying, "I wasn't interested in their commercial art." Later, he taught himself several print-making processes, including the making of etchings. In the 1970s he created some 50 different etching images in which he developed the formal vocabulary of blended-together biomorphic and mechanical shapes that would become the signature subject matter of his mature, oil-painting style.

Tyler's work has been shown at commercial galleries in Dallas and New York and at the McKinney Avenue Contemporary, an arts center in Dallas. In recent years, Tyler has continued to refine the unusual visual language that distinguishes his art, both in the large-scale canvases that he favors and in small-format paintings that retain, proportionately, all of the mysterious atmosphere and the stylistic sophistication of his more monumental works.

EDWARD M. GOMEZ
New York, New York

Edward M. Gomez, *New York Times* (13 June 2000), *Raw Vision* (Summer 2001); Valton Tyler and Rebecca Reynolds, *The First Fifty Prints: Valton Tyler* (1972).

Von Reck, Philip Georg Friedrich
(1710–1798)
Born on 10 September 1710, Philip Georg Friedrich von Reck was a lifelong court administrator in Europe and one of the earliest artists of colonial Georgia. The family Reck, ennobled as barons, had been longtime high officials in the Hartz mountain region of Europe. Upon the recommendation of his uncle, ambassador for England at the Diet of Regensburg, Philip Georg Friedrich von Reck became agent for the Trustees of Georgia in England. Von Reck recruited colonists and traveled to Georgia with the Salzburgers, a group of German-speaking Protestants barred from its home in the Catholic principality of Salzburg.

In 1734 the Salzburgers, some British colonists, and von Reck sailed for Georgia aboard the *Purisburg*. Despite many hardships, they established the town of Ebenezer in what is now Effingham County, Ga. Von Reck remained in Georgia only a few weeks before returning to England, but his diaries and descriptions of Georgia were quickly published and translated in several different editions. His diary from that first journey to Georgia, 1733–34, was published in London in 1734 and in Halle in 1735.

In 1736 von Reck, then only 25 years old, again sailed with colonists to Georgia. In the summer of 1736 he, sketchbook in hand, visited the Indian communities near the Salzburger settlement. His images, including written captions in the local, native languages, feature Indian life among the Yucki and the Creek. They show in detail the clothing, equipment, houses, and activities of the Indians. The drawings also include pictures of a waterspout, reptiles, birds, and the plant life of Georgia. He returned to Europe later that year and spent the remaining years of his life working as a public servant in the German provinces. He attended law school at the University of Halle, served as chamberlain for a prince in Anhalt Köthen, counselor of state in Sachsen-

Weimar-Eisenach, and royal tax collector in Hessen-Kassel. He lived until 1798 and served the last three decades of his life in Barmstedt, north of Hamburg, working as a district revenue administrator for Frederick V, king of Denmark.

The von Reck archive at the Royal Library of Denmark in Copenhagen comprises a sketchbook with 45 drawings and watercolors, 13 loose drawings, a few letters, and the manuscript of a memoir, published in 1777, of his Georgia sojourns. The Royal Library of Denmark has published online a complete digital facsimile edition of von Reck's 1736 drawings from Georgia.

PAUL MANOGUERRA
Georgia Museum of Art

Kristian Hvidt, ed., *Von Reck's Voyage: Drawings and Journal of Philip Georg Friedrich von Reck* (1980).

Voronovsky, Jorko (George)

(b. unknown; d. 1982)

Judging from the enchanting art-filled environment that George Voronovsky constructed for himself, an observer would never have imagined that such beauty could spring from a life laced with hardship. Yet it was the artist's silent suffering that was the very source of his creativity. The bucolic imagery of his wonderful youth in Ukraine, which he later painted, concealed the hard reality of the artist's life. After immigrating to the United States in 1951, Voronovsky worked at a number of physically demanding jobs. During the last decade of his life, which ended in 1982, he lived in a single room, supported only by a small railroad pension. His one-room world was amid the then-whitewashed strip of dilapidated hotels on Ocean Drive in what is now the center of Miami's trendy South Beach. Voronovsky had chosen the room because of the Atlantic Ocean view that allowed his mind to wander and imagine a perfect world. Because the room's blank walls drew his thoughts to painful places, he covered them with dozens of colorful paintings of a dream world that existed between matters of fact and memory, desire and despair. Between the paintings, on every surface, and even suspended from the ceiling, were tin stars that he had cut from soda cans and flowers fashioned from candy wrappers. Paintings, sculptures, and decorations were scattered everywhere. On and on the visual cacophony went, covering the entire space: kitchenette, refrigerator, dresser, chair, and bed. His radio dial, frozen to the classical music station, was always on, while sea air and tropical light washed his room.

Voronovsky was a solitary figure, alone among a multitude of elderly Jewish retirees who populated South Beach in the 1960s and 1970s. He remained the quintessential outsider there, as he had throughout his life. Always alone, he committed his memories to discarded cardboard with cheap watercolors. No one saw these astonishing images. Recollections of his charmed youth in Ukraine were reflected in his paintings. These recollections, obviously, were preferable to experiences of war, concentration camps, and a family to which he could never return. Valiantly, he chose to live within the beauty of nature.

Fueled by his longings, Voronovsky was disenfranchised, self-taught, and passionate. He was not a modern-day Fauve but rather a fastidious memory painter. Voronovsky's artwork encourages us to reflect upon how our technological world has become increasingly alienating. While offering a respite from the effects of dehumanization, his paintings do not instruct as much as describe, to inspire rather than wallow in doubt. Simply put, they embody wonderment.

GARY MONROE
Daytona State College

Gary Monroe, *Extraordinary Interpretations: Florida's Self-Taught Artists* (2003).

Walker, Inez Nathaniel

(1911–1990)

Born in 1911 and raised in rural Stedman, S.C., Inez Nathaniel Walker primarily created portraits using pencil, marker, and crayon on paper. Married at a young age and the mother of four children, she moved north around 1930 and worked in a pickle plant and in an apple-processing plant. Incarcerated at the Bedford Hills Correctional Facility in New York for the murder of a reportedly abusive man, Walker turned to art during her confinement. Many of the drawings from this period depict Walker's fellow inmates, referred to as the "Bad Girls," who are often drinking, smoking, or talking. In other drawings Walker created portraits of fashionably dressed women and men. A teacher in the prison's English class noticed Walker's work and showed it to a local folk art dealer.

After Walker's release from prison in 1972, she remarried and lived in the Finger Lakes region of upstate New York. She continued to create art and soon began to earn attention for her work. Her drawings were shown at the Webb-Parsons Gallery in Bedford in 1972 and featured in the exhibition *Six Naives* at the Akron Art Institute in 1973. Walker was one of 20 artists included in the landmark traveling exhibition *Black Folk Art in America, 1930–1980*, organized by the Corcoran Gallery of Art in 1982.

Walker's turbulent life ended in 1990 when she passed away in a psychiatric center in Willard, N.Y. Today, Walker's drawings are included in the collections of the American Folk Art Museum, the Museum of International Folk Art, the High Museum of Art, and the Smithsonian American Art Museum.

PAUL MANOGUERRA
Georgia Museum of Art

Stacy C. Hollander and Brooke Davis Anderson, *American Anthem: Masterworks from the American Folk Art Museum* (2001); Jane Livingston and John Beardsley, *Black Folk Art in America, 1930–1980* (1982); Paul Manoguerra, *Amazing Grace: Self-Taught Artists from the Mullis Collection* (2007).

Ward, Velox Benjamin

(1901–1994)

Velox Benjamin Ward was born 21 December 1901 near Winfield in Franklin County, Tex., where his father was a farmer. His mother named him Velox after her German-made sewing machine. From the years 1910 to 1918 the family moved between east Texas, west Texas, and Arkansas, where Velox's father tried

several unsuccessful business ventures before dying in the 1918 flu epidemic.

In the seventh grade at the time of his father's death, Velox was forced to end his formal education. He began to try a number of vocations to support himself. These included trapping wild animals and selling the skins, raising cotton, working in a machine shop, and painting cars. He also tried his hand at preaching and had a brief career in professional wrestling under the name "Bullet Head" Ward. In 1925 Ward married, and he and his wife raised three children. The family moved frequently, and Ward repaired shoes and furniture to support his family and put his children through college.

Ward's art career began in 1960 when his children asked him to paint each of them a picture for a Christmas present. Considering it a good deal, Ward purchased brushes, some tubes of oil paint, and several canvases. He found that he enjoyed painting, so he purchased more canvases. He began to hang his paintings in his shoe repair shop, where he studied them during the day before taking them home at night to make improvements. Soon customers began to see the paintings and to ask him to paint pictures for them. As his painting business developed by word of mouth, Ward eventually stopped repairing shoes, settled in Longview, Tex., and devoted himself to painting. Painting became his final and longest career.

Ward's painting technique involved creating paper cutouts, which he called "dollies," arranging them on the canvas, tracing the shapes, and then painting them. He referred to his paintings as "buildups," because he relied on various sources, including photos, memories, and his imagination to create them. Ward's wife, Jessie, was the model for many female figures in the paintings, and his beloved dog, Muggs, modeled for the canine figures. His desire to preserve his memories of "the good ole days" of his rural childhood inspired his subjects, which included rural homesteads, farm landscapes, and agricultural activities such as sorghum making, hog butchering, and hay baling. Ward labored over his paintings and took great pleasure in the enjoyment people experienced when viewing them.

The owners of Valley House Gallery in Dallas, Donald and Margaret Vogel, took an interest in Ward's work and began to represent him. In 1972 the Amon Carter Museum in Fort Worth held a solo exhibition of his work. Ward continued painting until 1989, when failing health ended his career. He died 19 December 1994, two days before his 93rd birthday. In the three decades that comprised his art career, he completed an estimated 200 paintings documenting his memories of early 20th-century rural Texas life. Examples of Ward's work can be found in the Amon Carter Museum of American Art, the Longview Museum of Fine Arts, and the Museum of Modern Art.

LYNNE ADELE
Austin, Texas

Lynne Adele, *Spirited Journeys: Self-Taught Texas Artists of the Twentieth Century* (1997); Cecilia Steinfeldt, *Texas Folk Art: One Hundred Fifty Years of the Southwestern Tradition* (1981); Donald Vogel and Margaret Vogel, *Velox Ward* (1972).

Ward Brothers

(Lemuel T. Ward Jr., 1896–1984;
Stephen W. Ward, 1895–1976)

Lemuel T. Ward Jr. and Stephen W. Ward of Crisfield, Md., were brothers who became nationally famous for their wildfowl carvings. Lem and Steve, as they were better known, were barbers by trade. They carved decoys in their down time between customers. The brothers carved the first few birds for their own use; however, as their skills and reputation developed, they acquired a regular customer base.

Stephen Ward and Lemuel Ward, Pintail Drake, Crisfield, Somerset County, Maryland, ca. 1935, paint on wood with glass, 7⅛″ x 18″ x 6⅛″ (Collection American Folk Art Museum, New York, Gift of Herbert Waide Hemphill Jr., 1964.1.4)

By 1930 the pair had fallen into a general pattern for producing large numbers of decoys for hunting clubs and rigs for individual hunters. Although both brothers carved and painted, Steve usually carved the birds using original patterns, and Lem, a perfectionist with the brush, usually painted them. During the Great Depression, when local residents turned to wildfowling for food and guided-sport gunning parties for income, the demand for well-made decoys rose. Between 1930 and 1959 the Ward brothers turned out thousands of birds. Ward decoys are particularly lifelike, with individual expressions and unusual poses. The Wards examined the colorations of dead birds, watched birds in the wild, and studied images in books. By the late 1940s Lem, who had always enjoyed experimenting, began to create more and more of the decorative pieces that have become icons of American folk art. As plastics and mass production threatened the market for hand-carved decoys in the 1950s, these decorative birds be-

came the brothers' livelihood. Around 1965 the barbershop closed its doors, and the pair reopened their business as "L. T. Ward & Bro. — Wildfowl Counterfeiters in Wood."

Although the brothers had only elementary educations, they often recited poetry together and occasionally added their own verses to their patterns or to the bottoms of their decoys. Lem also took up painting with oils on canvas. Although they achieved national recognition through features in *National Geographic* and other publications, the brothers remained rooted in their small community for their entire lives. Even when collectors were willing to pay considerable amounts for their decoys, the Wards resisted raising their prices to avoid alienating their local customers. The Ward brothers carved and painted wildfowl together until Steve died in 1976. Lem continued to work until his eyesight became so poor that he was forced to stop. In 1983 Lem was awarded a National Endowment for the Arts National Heritage Fellowship.

The Ward Foundation was established in 1968 to promote the art of decoy making. A museum—now known as the Ward Museum of Wildfowl Art and affiliated with Salisbury University in Salisbury, Md.—preserves many of the Ward brothers' carvings, poems, and paintings as well as an extensive collection of other antique decoys and contemporary carvings. The Ward Foundation also sponsors the annual Ward World Championship Wildfowl Carving Competition held each spring in Ocean City, Md.

CYNTHIA BYRD
The Ward Museum of Wildfowl Art
Salisbury University

Glenn Lawson and Ida Ward Linton, *The Story of Lem Ward* (1984); Steve Ward, *Closed for Business: The Complete Collection of Steve Ward's Poetry* (1992).

Warner, Pecolia

(1901–1983)
Born 9 March 1901 near Bentonia, Miss., raised on plantations in the Mississippi Delta, and educated in Yazoo City, Pecolia Warner was taught to sew at the age of seven by her mother, Katherine Brant Jackson. One of seven children, Pecolia Warner learned from her schoolteacher mother to cook, clean, wash and iron, sew, and make quilts. Her first quilt was made from little strings of rectangular cloth, sewn into long strips alternately pieced with solid strips to fashion a top quilt. The pattern, called Spider Leg by Pecolia Warner's mother, is the oldest one known for African American quilters. It is a string quilt similar to African textiles made by sewing woven strips together, and it is the one most often first taught to young children.

Warner considered her quilt-making skills a gift from God. Although inspired by memories of her mother's quilts, by dreams, by quilt pattern books, by household objects, and by farming artifacts, Warner's quilts are in the mainstream of African American textile traditions. Pecolia Warner was as articulate verbally as she was visually, and interviews with her clarified those features that distinguished African American quilts from Euro-American textile traditions: organizational strips; bold, contrasting colors; large designs; asymmetrical arrangements; multiple patterns, and improvisation. Warner often commented on how important it was for colors to "hit each other right," how "stripping" a quilt brought out the designs, and how varying parts of a pattern made quilt designs more interesting.

Pecolia Warner lived in New Orleans, Washington, D.C., and Chicago, working as a domestic servant for whites. She first received attention as a folk artist in 1977 when she was "discovered" by folklorist William Ferris and featured in his film *Four Women Artists*. Her quilts were featured in *Folk Art and Craft: The Deep South*, a traveling exhibition organized by the Center for Southern Folklore. She was a featured artist at folklife festivals in the late 1970s, but her health became progressively worse in 1982. She suffered a series of small strokes and died at age 82 in March 1983. Warner's quilts are found

in the collections of the American Folk Art Museum.

MAUDE SOUTHWELL WAHLMAN
University of Missouri at Kansas City

Patti Carr Black, ed., *Made by Hand: Mississippi Folk Art* (1980), *Something to Keep You Warm* (1981); William Ferris, ed., *Afro-American Folk Art and Crafts* (1983); Robert Farris Thompson, *Flash of the Spirit: African and Afro-American Art and Philosophy* (1983); John Michael Vlach, *The Afro-American Tradition in Decorative Arts* (1978); Maude Southwell Wahlman, *Signs and Symbols: African Images in African American Quilts* (1993), with Ella King Torrey, *Ten Afro-American Quilters* (1983).

Welfare, Christian Daniel (Christian Daniel Wohlfahrt)

(1796–1841)

Christian Daniel Welfare, the third and youngest son of cabinetmaker Johann Jacob Welfare and his wife, Anna Elisabeth Schneider, was the first portrait and landscape painter born in the church-governed community of Salem, N.C. At the age of 14, Daniel worked briefly as a cabinetmaker's apprentice before deciding that cabinetmaking was not his calling. He tried his hand at a variety of jobs in the community. He worked as a teacher in the Salem Boys' Boarding School and as a night watchman. Later he worked for the hat maker Joshua Boner. In 1831 he became the community tavern keeper, and in 1836 he served the community as a delegate of the Salem Congregation to the worldwide Moravian synod.

Welfare was painting in oils by 1816 while he was teaching at the Boys' School, although no record remains of any formal training he might have received. Evidence in church records suggests that he may also have been teaching drawing classes for the school. The 1824 minutes of the church board note that "Daniel Welfare has gone to Pennsylvania on a visit and to perfect himself in the art of painting," indicating that he had decided to pursue formal training. Although his methods for doing so remain unrecorded, Welfare secured for himself the privilege of studying with Thomas Sully in Philadelphia. In 1825, while under the tutelage of Sully, he submitted a still life depicting fruit and wine to the Pennsylvania Academy. Sully and Welfare remained close for the rest of Welfare's life. In fact, Welfare named his only son Thomas Sully Welfare (b. 1835), demonstrating his esteem for his mentor and friend.

Welfare returned to Salem in 1826, and by 1829 he had built a gallery in which he painted and exhibited paintings by others. Most of the surviving examples of Welfare's work depict residents of the community of Salem, N.C., and landscape views of the Moravian town. He also completed several religious paintings, other landscapes, a series of portraits of United States presidents, and a striking portrait of the Marquis de Lafayette, some of which were most likely based on examples he saw in Philadelphia.

Although Welfare never achieved the technical skill of Thomas Sully, his post-Philadelphia portraits show improved use of shadows, experimentation with the presentation of fabrics, and improved facial modeling. Even with his training, Welfare never fully

Christian Daniel Welfare, hand-colored lithograph view of Salem on paper, Salem, N.C., 1824, original painting and colored lithograph 16″ x 20″ (Collection of the Wachovia Historical Society, courtesy Old Salem Museums and Gardens, Winston-Salem, N.C.)

achieved the capability for realism in the depiction of the human form, and his portraits retain the shallow picture plane, abstraction of form, and minimal shading characteristic of self-taught artists. Although Welfare's landscapes are more realistic than his portraits, his depictions of the world around him similarly retain the unsophisticated spatial composition and mixed perspectives of artists with little training. The largest number of Daniel Welfare's surviving works is in the collection of Old Salem Museums and Gardens in Winston-Salem, N.C.

JOHANNA METZGAR BROWN
Old Salem Museums and Gardens

Barbara Batson, "Daniel Welfare, 1796–1841: American Artist" (M.A. thesis, University of Virginia, 1985); Robert Bishop, *Folk Painters of America* (1979); John Bivins Jr. and Paula Welshimer, *Moravian Decorative Arts in North Carolina* (1981).

Wells, Yvonne

(b. 1940)

Yvonne Wells, a retired schoolteacher from Tuscaloosa, Ala., had no training and only limited exposure to quilting during her childhood. She says, "I started quilting in 1979 after making a small wrap to be used by the fireplace. I had seen my mother quilt but did not help in making them. I taught myself

and have had no formal training in quilt making. I consider myself a quilt artist and take pride in making big, bold and unusual quilts." The art dealer Robert Cargo notes that the colors, designs, techniques, and materials Wells uses reflect her independent spirit and her lively imagination. Her appliqué quilts display large, bold patterns, frequently of her own creation; unusual color combinations; and occasionally manufactured elements, such as socks, lace, and upholstery materials.

Growing recognition of Wells's work has not affected her drive to satisfy herself rather than the public. Her quilts are dense in meaning, and their visual impact is deliberately enhanced by the use of naive figures and strong colors. Wells says that she can always recognize the conventional quilters who come to see her quilts. "They sort of cringe. They fold their arms in front of them as if to protect themselves from the cold. When they come up to my work they think to themselves, 'God, what has happened here?'"

Wells's work employs Christian symbolism, and her appliquéd quilts often depict personal experiences of faith and biblical themes, such as the Crucifixion. Little triangles, which the artist calls "my little friends," are a personal trademark that represents the Holy Trinity, and her use of the color purple signifies God's presence.

Yvonne Wells also notes the important contribution of the civil rights movement to her art making. The artist explains, "I know there were a lot of things going on in Alabama, and in all parts of the South, and I could imagine, I could add to some of the things that I thought were being displayed at that time. It was a turbulent time, and that turbulence gave me the inspiration to create some of the images that I put on the quilts."

Wells's quilts are in major quilt and folk art collections across the United States. The Birmingham Museum of Art, the American Folk Art Museum, and the Montgomery Museum of Fine Arts include Wells's quilts in their permanent collections, and the International Quilt Study Center at the University of Nebraska in Lincoln owns 24 of her early textiles. In 1998 Wells received the prestigious Alabama Arts Award and Visual Arts Craftsmen Award. The Hallmark Card Company has used three of her quilts on greeting cards. Her quilts have been exhibited in Japan, France, and Italy.

MAUDE SOUTHWELL WAHLMAN
University of Missouri at Kansas City

Cuesta Benberry, *Always There: The African-American Presence in American Quilts* (1992); Roland L. Freeman, *A Communion of the Spirits: African-American Quilters, Preservers, and Their Stories* (1996); Mary Elizabeth Johnson Huff, *Picturing It in My Mind: Contemporary African American Quilts from the Montgomery Museum of Fine Arts* (2006); Carolyn Mazloomi, *Spirits of the Cloth: Contemporary African American Quilts* (1998); Georgette M. Norman, *Yvonne Wells: An Exhibition of Quilts* (2006); Robert Shaw, *Quilts: A Living Tradition* (1997); Maude Southwell Wahlman, *Signs and Symbols: African Images in African American Quilts* (2001).

West, Myrtice Snead
(1923–2010)

Myrtice Snead West, who lived in Centre, Ala., and was called "Sissie" by her friends, was born 14 September 1923 in Cherokee County, Ala. As with many rural southerners at that time, religion played a predominant role in her life. The significant event of West's youth was her baptism at age 14 in Spring Creek. Three years later, she married Wallace West, and, after living briefly in Atlanta and on military bases around the South during World War II, they settled on a farm in northeast Alabama.

West began teaching herself to paint around 1952. For years she painted rural scenes, riverboats, flowers, and occasionally angels. In 1956, after miscarriages and illness, West gave birth to a daughter, Martha Jane. In the 1970s, West became anxious for the safety of her only child, who, at age 15, had married James Brett Barnett. For comfort, she began painting religious themes.

West first attempted a large painting of Jesus ascending into heaven in 1977. Pleased with the results, she started to interpret the New Testament book of Revelation in 1978. Working mostly in the early morning over seven years, West painted the prophetic book in 13 large works. Three of the pieces, painted on wood are double sided. West painted other works in the series on upholstery stretched over window-screen frames.

The Revelations Series became West's comfort and passion as Barnett became increasingly abusive to Martha Jane and their two children. At their daughter Kara's birthday party in 1986, Barnett shot and killed Martha Jane in Centre. The Wests adopted their grandchildren, and Myrtice turned to religious painting with ferocity.

In the late 1980s West exhibited her paintings at area festivals. She offered her rural scenes for sale, and she also displayed her Revelation paintings to proselytize. The religious works came to the attention of the Alabama State Council on the Arts and appeared in their 1991 catalog, *Outsider Artists of Alabama*. In 1996 the Art Museum of the University of Memphis featured West's Revelations Series in an exhibition *Revelation: The Paintings of Myrtice West*. The paintings also served as the subject of the accompanying catalog essay, which was later refined for publication in the book *Wonders to Behold: The Visionary Paintings of Myrtice West*.

From 1993 to 2006 West continued to create series of paintings that illustrate the biblical books of Ezekiel, Daniel, Zechariah, and Genesis. Her work has been exhibited at many museums, including the American Visionary Art Museum, the Abby Aldrich Rockefeller Folk Art Museum, the Art Museum of the University of Memphis, the Georgia Museum of Art, the Museum of Biblical Art, and the Birmingham Museum of Art. In 2003 West appeared on the nationally televised *700 Club*, hosted by Reverend Pat Robertson.

West suffered additional tragedy in 2005, when her home burned to the ground. She lost all but 13 paintings and most of her personal possessions. A few months later, she lost Wallace to cancer, after 64 years of marriage. Her own

health had begun to fail as well; she suffered from heart problems and failing eyesight, but despite her hardships, West continued to express her deep faith on canvas until her death in 2010. Her work can be seen at the Lehman Loeb Art Center at Vassar College.

ROLLIN RIGGS
Memphis, Tennessee

Carol Crown, ed., *Wonders to Behold: The Visionary Art of Myrtice West* (1999), *Coming Home! Self-Taught Artists, the Bible, and the American South* (2004); Carol Crown and Charles Russell, eds., *Sacred and Profane: Voice and Vision in Southern Self-Taught Art* (2007); Miriam Fowler, *Outsider Artists in Alabama* (1991); Kathy Kemp and Keith Boyer, *Revelations: Alabama's Visionary Folk Artists* (1993).

Wickham, Enoch Tanner

(1883–1970)

Beginning in the late 1950s, retired farmer and self-taught artist Enoch Tanner Wickham created a park known as the *Wickham Stone Park* or *Wickham's Sculpture Park* of more than 50 concrete statues near Palmyra, Tenn. The subjects ranged from religious to historical figures and measured 6 to 30 feet in height. Tanner worked on these figures until his death in 1970. The grouping of local and national heroes, which includes a giant sundial articulated by New Testament religious figures, has since suffered three decades of vandalism from a skeptical community. Misunderstood and underappreciated, much of Wickham's work has been reduced to what are locally known as the "headless statues." Once, however, they conveyed the visual sensibility

and moral convictions of a dedicated and talented artist similar to the grassroots artists S. P. Dinsmoor, creator of the *Garden of Eden* in Lucas, Kans., and Fred Smith, who constructed the *Wisconsin Concrete Park* in Phillips, Wisc. In 2006 Wickham's family moved the 14 intact sculptures to nearby family property. The statues continue to be displayed to the public.

Although the original site stretched along a quiet country road near Tanner's home outside the small town of Palmyra, in Montgomery County, Tenn., Wickham's electrical lighting of the site and its relationship to the road indicate his desire to convey a message. Local and state dignitaries attended public ceremonies at which newly finished works of historical and political figures were unveiled annually throughout the 1960s. The religious figures, however, were constructed across the road and were further secluded by woods. One of Wickham's most-noted works is an oversized blue bull being ridden by what appears to be the artist himself. Wickham states on the concrete base, "E. T. Wickham Headed to the Wild and Woley West—Remember Me Boys While I Am Gone." This self-reference is unique to the site. More serious and moralizing in character is his Civil War monument that pictures the Confederate hero Sam Davis and Bill Marsh (Wickham's grandfather), who voted against Tennessee's secession from the union. They shake hands in reconciliation.

Once Wickham began the series of sculptures, he built himself a small log cabin at the site and lived there with his

wife until his death. Much of the site is in ruins today, with only a few remaining statues. However, the original site still conveys a sense of monumentality and heroism that few works of art achieve. Wickham succeeded in bringing historical figures and moral lessons via his choice of controversial figures, such as John F. Kennedy and Estes Kefauver, U.S. senator from Tennessee, to the attention of his fellow men and women living in and around Clarksville, Tenn.

DIXIE WEBB
Austin Peay State University

Susan Knowles, *E. T. Wickham: A Dream Unguarded* (2001); Daniel Prince, *American Art Review* (November–December 1975).

Widener, George
(b. 1962)

Born in 1962 in Covington, Ky., George Widener is one of a number of artists along the autism spectrum who have found art as a realm of mediation between inner and social worlds. Widener's works, filled with lists, schematic drawings, dates, and calendars, exhibit the strong desire shared by many people with autism to establish a sustaining order. Widener's impulse is perhaps also compounded by a turbulent family life and a history of psychological problems. As a child, Widener, although assigned to special education classes, exhibited superior abilities in mathematics, spelling, drawing (always a pastime), and memorization. As a child he also became mesmerized by calendars, which he collected.

Widener's fixation with calendars

and dates and his remarkable abilities to determine the days of the week for any date far into the past or far into the future or to recall events that have occurred across history on any given date make him a calendar savant. Widener's remarkable calendar operations, like those of other savants who can calculate with impossibly long numbers but not know how to count, or savants who can play complex musical compositions after one hearing, remain inexplicable "islands of genius." In 1998 Widener began to combine his interests in drawings that reveal fixations with disasters, including the sinking of the *Titanic*, which had a passenger named George D. Widener.

Widener left school at the age of 17 to join the Air Force, and after he was discharged he had difficulty living on his own. After a number of admissions to psychiatric institutions, where he was diagnosed with schizophrenia and depression, he became homeless. Widener's fortunes changed in 1994, when his performance on psychological tests administered at a homeless shelter in Knoxville, Tenn., allowed him to enroll in a University of Tennessee degree program for students with disabilities, from which he graduated cum laude. At the same time, Widener benefited from enormous changes in the medical treatment of people with atypical mental states.

Widener's mysterious works, which have received considerable art world attention, not only embody the intensity of his interests but also encode his fascination with time. Drawn with India ink on sheets of layered paper fashioned

George Widener, Megalopolis: The Day When Time Ran Backwards, 2006, ink and poster paint, 16" x 26" (Courtesy of the Henry Boxer Gallery, London)

from tea-stained napkins and touched with bursts of unmixed color, Widener's drawings appear to be timeless documents. Time and again, Widener surrounds cross-section renderings of the *Titanic* with lists of the passengers arranged state by state, with charts of the ship's compartments, and lists of the provisions taken aboard: 8,000 cigars, 16,000 lemons, 6,000 pounds of butter. Other favorite subjects—calendars, inventions, disasters, and cities—similarly accompanied by accumulations of facts and ordered through schema based on sequences of dates—also share with the viewer glimpses of Widener's fascinations. Widener, who now lives in Asheville, N.C., has enjoyed his interactions with the art world. He attends the Outsider Art Fair and delights in explaining his works. The American Folk Art Museum, the Collection de l'Art Brut, abcd, and Die Kröller-Müller Museum have acquired works by Widener.

CHERYL RIVERS
Brooklyn, New York

Roger Cardinal, *Raw Vision* (Summer 2005); Bruno DeCharme, *George Widener* (film, 2008); Rob Hartell and Kenny Scott, *My Brilliant Brain Accidental Genius* (film, 2007); Colin Rhodes and Roger Cardinal, *The Art of George Widener* (2009); Darold A. Treffert, *Extraordinary People: Understanding Savant Syndrome* (2000).

Williamson, Clara McDonald
(1875–1976)
Clara Williamson, affectionately known as "Aunt Clara," recorded memories of her life in Iredell, the north central Texas frontier community where she was born and spent her childhood years. Iredell, known for its cotton, was a stop on the Old Chisholm Trail, the cattle road that connected southern Texas to Kansas. In more than 100 works, Williamson painted cattle drives, camp meetings, square dances, plantings, harvestings, and the town's first railroad. Her subtle color harmonies elicit distinct atmospheric qualities that enhance the narratives. In the painted panorama

Git Along Little Dogies, a signature auto-biographical work, a little girl, the artist, witnesses the steady stream of longhorn cattle deftly guided by cowboys as they cross the Bosque River. The rhythmical movement of the dense drove contrasts with the stillness of the stream; the pale blue-gray water provides a quiet backdrop for the delineated brown cattle. The bend in the river, with corresponding curving banks and rows of trees and hills, creates a dynamic counterpoint to the side view of the generally horizontal procession. When she was 91, Williamson completed a canvas called *My Birthplace*, a picture that featured the cabin in which she was born. The central placement of the cabin and the horizontal spatial handling of the fields, fencing, road, drainage ditch, and clouds are balanced by the vertical trees unifying all the separate elements into an integrated whole.

The second of six children, Williamson attended school when she could, but domestic chores prevented her from getting the education she desired. An uncle, a town clerk in Waxahachie, offered her a job that allowed her to leave Iredell. She eventually returned to Iredell, married John Williamson, and nurtured her own children and stepchildren. She also assumed the responsibility of working in her husband's dry goods store. The family moved to Dallas in 1920, where they also ran a successful business.

Williamson had a longtime interest in painting but did not begin to express herself artistically until 1943, after her husband, who thought painting was a waste of time, died. There was a precedent for art making in Williamson's family; her mother pieced quilts, hooked rugs, and painted one picture. With fewer family responsibilities, Williamson enrolled at the Dallas Museum School. There she met the artist and gallery owner Donald Vogel. He encouraged Williamson, began to represent her, and exhibited and sold her paintings.

While working mostly with oil on canvas, Williamson also did some watercolors and charcoal sketches. Her method was to begin at the top of the canvas and work her way down so as "not to get her hands in the paint." In her words, "I try to accomplish realism, truth, beauty, and some amusement in my pictures . . . and record my memories."

Paintings by Williamson are in the permanent collections of the Museum of Modern Art, the Dallas Museum of Fine Arts, the Amon Carter Museum, and the Wichita Art Museum.

LEE KOGAN
American Folk Art Museum

Chuck Rosenak and Jan Rosenak, *Museum of American Folk Art Encyclopedia of Twentieth-Century Folk Art and Artists* (1990); Cecilia Steinfeldt, *Texas Folk Art: One Hundred Fifty Years of the Southwestern Tradition* (1981); Donald Vogel and Margaret Vogel, *Aunt Clara: The Paintings of Clara McDonald Williamson* (1966).

Wooldridge Monuments

The Wooldridge Monuments—an assembly of 18 life-size statues of men, women, and animals—stand in a corner of Maplewood Cemetery in the city of Mayfield in western Kentucky. The

A postcard from the 1920s picturing the Wooldridge Monuments (Courtesy of Kentucky Historical Society)

monuments, which mark the tomb of Henry G. Wooldridge, have attracted curious visitors since Wooldridge's death in 1899. The statues, popularly known as the "strange procession that never moves," include likenesses of Wooldridge's closest family members. Also in the formation are Wooldridge's favorite hunting animals. A stone sarcophagus contains the remains of Wooldridge—the only person buried at the site.

Henry Wooldridge moved from Williamson County, Tenn., to Graves County, Ky., in 1881. He came from an affluent family and spent much of his life breeding and trading horses and hunting wild game. Some sources claim that "Colonel" Henry Wooldridge was a Civil War veteran, though the title might instead be an adopted honorific that reflects southern aspirations to aristocratic status.

About 10 years before his death,

Wooldridge began planning his burial site. Though he was not especially well known or particularly admired, Wooldridge had the desire and resources to create an elaborate memorial for himself. The first piece was not a statue but a tall, marble tombstone engraved with his name, his birth date, a Masonic emblem, and a rendering of a horse. Next, he ordered a sculpture of himself to be made in Italy. The finely detailed statue, made of Italian marble by an unnamed Italian artist, depicts Wooldridge standing next to a book on a pedestal. While the book might represent a Bible, Wooldridge was thought to have been unconcerned with religion or spirituality.

Pleased with the first statue, Wooldridge desired a second, an equestrian statue of himself mounted on his favorite horse, Fop. Wooldridge commissioned this piece from self-taught stonecutter William Lydon, who worked

at the Williamson Monument Company in Paducah. Lydon carved this impressive work of folk art from an enormous slab of sandstone mined in southern Indiana. The monument was delivered to Mayfield by rail. According to legend, a town drunk mounted the stone horse in Paducah and enjoyed a free ride into town. Lydon created a total of 12 pieces of the procession, all made of sandstone. Later in his life, Lydon operated a marble, stone, and granite works in Paducah and became the city's sanitary inspector. Unidentified masons and sculptors in western Kentucky carved the remaining sandstone statues in the Wooldridge lot. Besides the two figures of Henry Wooldridge, the stone procession includes Wooldridge's mother, three sisters, two great-nieces, four brothers, two dogs, a deer, and a fox. Wooldridge never married; as the story goes, he had lost his true love in a riding accident before moving to Kentucky. After some early vandalism, including broken antlers and tails, a protective fence was placed around the monuments. A Kentucky Historical Marker, which describes Wooldridge as a "famous fox hunter," now stands at the site.

In assembling this unlikely collection of monuments, Wooldridge evidently wished to be remembered as a man who valued his family, his pets, and his pastimes. The gravesite stands in contrast with the norms of Wooldridge's contemporary southern neighbors who were accustomed to far more modest memorials. Even Wooldridge's closest family thought of the affluent Wooldridge as eccentric. Older pamphlets and newspaper articles repeatedly describe him as "odd," "queer," and "peculiar." Local lore holds that Wooldridge's monuments were an embarrassment to his family.

The bold, eccentric expression of the Wooldridge Monuments continues to appeal to popular imagination. In September 1984 the television show *Ripley's Believe It or Not!*, which featured sensationalist explorations of the bizarre and unexplained, brought unprecedented attention to the monuments. The 1989 film *In Country*, shot in Mayfield, shows footage of the monuments as well. Today, the site is highlighted in brochures and tourist guides, especially those featuring unusual sites. In January 2009 a tree felled in an ice storm crushed the monuments. Only two statues remained intact. In 2010 the monument was restored. The Wooldridge Monuments are listed in the National Register of Historic Places.

MARK BROWN
Kentucky Folklife Program

J. Winston Coleman, *An Outdoor Hall of Fame: The Wooldridge Monuments* (1982); Melba Porter Hay, Dianne Wells, and Thomas H. Appleton, *Roadside History: A Guide to Kentucky Highway Markers* (2002); Jeffrey Scott Holland, *Weird Kentucky: Your Travel Guide to Kentucky's Local Legends and Best Kept Secrets* (2008); Kentucky Progress Commission, *Kentucky Progress Magazine* (1931); Monument Conservation Collaborative LLC, *Restoration to Wooldridge Monuments* (PDF, 2010).

Wythe County, Virginia, Chests

As early as the 1750s, Scots-Irish and German Swiss immigrants had settled in the section of August County, Va.,

that in 1790 became Wythe County. Mostly farmers and craftsmen who had been encouraged to come by land companies, they had traveled south from Pennsylvania and Maryland through the Shenandoah Valley in search of inexpensive land. The majority of the German Swiss, members of the Lutheran or Reformed faith, had established by 1800 four churches in western Wythe County. Many continued to speak and write in German into the 1850s, thereby creating a language barrier that contributed to their cultural isolation from the English-speaking Scots-Irish in the eastern part of the county. Among the artifacts that remain as evidence of their cultural heritage are a number of painted blanket chests.

All the Wythe County chests share certain characteristics of ornamentation and construction. Their decoration must have been influenced by a group of chests from Jonestown, Pa., that are very similar in design and manufacture, but the exact connection between the two groups has not been determined.

The decorator, or decorators, of the Wythe County chests used templates and compasses to lay out their designs, which were then scratched onto the surface. They then applied thick paint to create bold, well-defined patterns. Two or three panels containing an urn and several tulips decorate each chest's front; an arc, or halo, of small petals and diamonds surmounts at least one of the tulips. Most of the chests also have decorated lids—either two large circles with sponged decoration or two oblong panels with notched corners and stars in their centers.

All Wythe County chests have dovetailed cases. They are made of poplar, and all are virtually the same size. Some have no drawers, but chests with two or three drawers are also common. They all have simple strap hinges and inner tills on the left side. Although common construction and decoration link the chests, variations in the decoration divide them into several groups.

The most intricately decorated are the seven chests of the dahlia type, so named because each has at least one dahlialike flower on it. The dahlia chests all have three astragal panels. It appears that the same hand decorated this group. The second group, lacking decoration between the petals of the small tulips that ornament their astragal panels, is called the hollow-tulip type. The third group, also with astragal panels, is called the three-tulip type because exactly three tulips adorn each chest. The decoration of this group is the least uniform, and there may be either two or three panels on these chests. Because of these variations, it is possible that two or more people may have provided the decorations. The fourth type with astragal panels consists of just one chest, referred to as a transition chest. This chest displays astragal panels on the front, and rectangular, notched-corner panels on the top. It has the same panel decoration as the fifth group. The last group, the fifth, consists of chests with two oblong panels on the fronts, each decorated with a different motif. The decoration on these chests' tops varies only in the arrangement of the colors.

These strong similarities indicate that one person most likely decorated

the entire group. All these chests bear dates, ranging from 1812 to 1829, and two have a signature, interpreted to be "Johannes Hudel." This is the German spelling of John Huddle, probably the decorator and possibly the maker. Family history claims that John Huddle and his two brothers spent their youth with their step-uncle Jacob Spangler in Ceres, Va., then in Wythe County. While there is no documentation that any of the Spanglers or Huddles were painters or cabinetmakers, Jacob Spangler's inventory and those of John Huddle and his brothers do include a great number of woodworking tools. It does not seem too speculative to suggest, therefore, that all the Wythe County chests could have been made and/or decorated by one or more members of the Huddle-Spangler family.

RODDY MOORE
SALLY MOORE
Blue Ridge Institute and Museum Ferrum College (Virginia)

J. Roderick Moore, *The Magazine Antiques* (September, 1982); Gerard C. Wertkin, *Encyclopedia of American Folk Art* (2003).

Young, Purvis

(1943–2010)

Decades ago, Purvis Young began combing through the rows of art books he found at the Miami Public Library. Soon librarians started giving him discarded books that he used to fabricate his own works of art, his own monographs. In the late 1960s Young's murals began to appear on boarded storefronts and on wooden fence barriers in Miami's Overtown neighborhood. His scrawled images portrayed wild horses, floating angel heads, soldiers, and musicians. His cityscapes depicted revelers and protestors, hovering insects and pregnant women. Like a cryptographer codifying his world, Young created dream images that also encapsulated a time and a place.

Young created obsessively, painting on scrap wood figures that sprang from his sensitivity to his environment. Always inventive, he made books by gluing his sketches and small paintings onto the pages of recycled discarded volumes. Many of these redefined books echo the estrangement that his paintings express, while others capture neighborhood realities and diversions. In deciphering Young's visual daydreamings, a viewer is challenged to determine how works so abstract can feel so real and how such antiaesthetic creations can be so beautiful.

In his cityscapes, Young painted squiggles that approximate the human form, often repeating them while slightly metamorphosing these shapes as if to discover their identities. Stacked cubes about to topple represent downtown. Insects have crept in, some engulfing police cars. The bugs have come down to earth to clean up the manmade mess. Many paintings show horses with noble riders—his "freedom fighters." His portraits of anonymous people now sport halos; in the turbulent past they wore helmets. He depicts funeral marches and pregnant women balancing locks on their heads; these locks symbolize "locking out knowledge." He describes struggling people, victims of their circumstances.

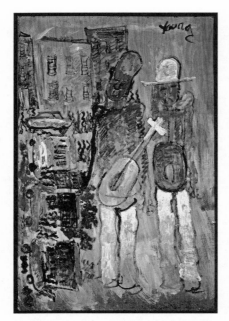

Purvis Young, Musicians, n.d. (1990s), mixed media on wood, 54½" x 36½" (Collection of Gordon W. Bailey)

Although he created countless paintings, Young had very few material possessions. Through the years he lived on and off the streets, all the while observing life. He was probably unimpressed when a well-known collector of contemporary art purchased thousands of his paintings that had accumulated in Young's studio-warehouse-home during the 1990s. Indeed, he was still painting as the work was being hauled off. The considerable attention that ensued brought him recognition and admiration. Since then, Young's work has appeared in numerous museum exhibitions and collections, including the Smithsonian American Art Museum, Smithsonian National Museum of

African American History and Culture, the American Folk Art Museum, the Corcoran Museum of Art, the Hampton Museum of Art, Hampton University, the High Museum of Art, the Kentucky Folk Art Center, Morehouse College, and the Ogden Museum of Southern Art. Both popular and scholarly books discuss Young's work.

GARY MONROE
Daytona State College

Paul Arnett and William Arnett, eds., *Souls Grown Deep: African American Vernacular Art of the South*, vol. 1 (2000); William Arnett and Paul Arnett, eds., *Souls Grown Deep: African American Vernacular Art*, vol. 2 (2001); Kinshasha Conwill and Arthur C. Danto, *Testimony: Vernacular Art of the African-American South* (2001); Donald Kuspit, *Purvis Young: Social Expressionism* (2008); Elsa Longhauser and Harald Szeemann, eds., *Self-Taught Artists of the 20th Century: An American Anthology* (1998); Paul Manoguerra, *Amazing Grace: Self-Taught Artists from the Mullis Collection* (2007); David Raccuglia and Shaun Conrad, *Purvis Young of Overtown* (film, 2006); Charles Russell, *Self-Taught Art: The Culture and Aesthetics of American Vernacular Art* (2001); Purvis Young and Paula Hayes Harper, *Purvis Young: Paintings From the Street* (2006).

Zoettl, Michael (Brother Joseph)
(1878–1961)

Brother Joseph Zoettl, born in Germany, immigrated to the United States as a recruit of the Benedictine Order in 1892. Brother Joseph served as housekeeper at several parishes in Tennessee, Virginia, and Alabama before taking up residence at St. Bernard Abbey in

Cullman, Ala. There, Brother Joseph worked 17-hour days as the operator of the monastery's powerhouse. While the work could be backbreaking, it also offered hours of inactivity. To pass time, Brother Joseph began in the late 1910s to construct his miniature Holy Land. He unintentionally created a roadside attraction; and when tourists began to ask to see "Little Jerusalem," the abbot requested that Brother Joseph cease his work. Brother Joseph then spent his spare time fashioning small grottoes for the abbey's gift shop. The popularity of these small shrines and reports of grotto shrines built at midwestern Catholic institutions, however, soon convinced the abbot that a tourist attraction might bring welcome revenue and inspire religious sentiment. He allowed Brother Joseph to reinstall his miniature buildings near the monastery's entrance.

The grotto shrine, brought to America by European immigrants, has its roots in the ancient belief that caves are sacred places where one could seek supernatural aid or discharge religious obligations. Incorporated into Christianity through associations with the Nativity and Entombment of Christ, caves took on specifically Catholic connotations through accounts of miraculous apparitions of the Virgin and saints near caves. Thus, the baroque grotto, an artificial cavern embellished with fragments of glass, stucco stalactites, and seashells, became a conventional setting for the display of religious statuary. With dramatic contrasts of light and dark, grottoes replicated the emotional quality of mystical experience.

Brother Joseph's impressive central grotto, decorated with cement stalactites, shells, broken glass, fragments of white marble, and polished stones, houses commercially produced statues of the Virgin and Saint Benedict and Saint Scholastica, founders of the Benedictine Order. With a full-scale altar, this grotto was blessed as an oratory in 1934. Smaller grottoes enclosing statuettes or diminutive stained-glass windows serve as wayside shrines. Brother Joseph also interspersed tiny grottoes among the miniature buildings he arranged on raised platforms amid flowering plants.

Brother Joseph's creativity is most fully developed in the miniature tableaux he created from donated materials such as marbles, glass bottles, and costume jewelry. He based his tableaux on postcards, travel brochures, and illustrated encyclopedias. Replicas of Holy Land sites include the Temple in Jerusalem, Herod's Gate, the Cave of the Nativity, Gethsemane, Calvary, and Jesus's open tomb. Other biblical scenes include the Tower of Babel, labeled in many languages, and Noah's Ark. An Italian tableau includes St. Peter's Basilica with colonnaded piazza, notable churches, the Coliseum, and the Leaning Tower of Pisa. American tableaux include California missions, St. Bernard Abbey, and the Cathedral of the Immaculate Conception in Mobile, Ala. For children, Brother Joseph constructed a fanciful scene entitled *Hansel and Gretel Visit the Fortress of the Fairies*. Patriotic scenes include a miniature Statue of Liberty, an American flag,

and memorials to St. Bernard alumni who lost their lives in World War II and in the Korean War. A Vietnam memorial was added after Brother Joseph's death. The Abbey intends to construct additional structures.

Ave Maria Grotto, named a National Historic Site in 1984, continues to attract visitors who delight in spotting the replicas of well-known buildings. Some visitors, as the abbot hoped, also enjoy the opportunity for quiet contemplation.

CHERYL RIVERS
Brooklyn, New York

John Beardsley, *Gardens of Revelation: Environments by Visionary Artists* (1995); Carol Crown, ed., *Coming Home! Self-Taught Artists, the Bible, and the American South* (2004); Leonard Graziplene, *Ave Maria Grotto—Cullman, Alabama* (film, 1991); John Maizels and Deidi Von Schaewen, *Fantasy Worlds* (1999); Roger Manley and Mark Sloan, *Self-Made Worlds: Visionary Environments* (1997); John Morris, *Miniature Miracle: A Biography of Brother Joseph Zoetl [sic], O.S.B.* (1990); Lisa Stone and Jim Zanzi, *Sacred Spaces and Other Places: A Guide to Grottos and Sculptural Environments in the Upper Midwest* (1993).

INDEX OF CONTRIBUTORS

INDEX

Page numbers in boldface refer to articles.

Wust, Klaus, 303
Wythe County, Va., chests, 93, **457–59**

Yaeger, Charles Philip, 193
Yaeger, John Philip, 193
Yaeger, Louis G., 193
Yard art, 295; Latino, 128
Yard shows, 30, 36, 47, 69–70, 74, 300,
 307–8, 360, 378–79
Yazoo City, Miss., 426, 428

Ybarra-Frausto, Tomás, 127, 130
Yelen, Alice Rae, 31
Yoakum, Joseph, 144
Young, Purvis, 85, 119, 120, **459–60**

Zegart, Shelly, 22
Zoettl, Michael (Brother Joseph), 27, 74,
 78, **460–62**
Zorach, William and Marguerite, 3
Zug, Charles G., 19